A History of
RUSSIAN PAINTING

A History of
RUSSIAN PAINTING

Alan Bird

Phaidon·Oxford

Phaidon Press Limited, Littlegate House
St Ebbe's Street, Oxford OX1 1SQ

First published 1987
© Phaidon Press Limited 1987

British Library Cataloguing in Publication Data
Bird, Alan
 History of Russian Painting.
 1. Painting, Russian
 I. Title
 759.7 ND681

ISBN 0-7148-2203-5

Typeset in Sabon by Peter MacDonald, Twickenham

Printed in Great Britain by Butler & Tanner Limited,
Frome, Somerset.

Frontispiece: Detail from Kuzma Sergeevich Petrov-Vodkin,
Petrograd 1918, 1920 (Plate 129).

The publishers would like to thank all the private owners,
galleries and museum authorities who have kindly allowed
works in their collections to be reproduced. Acknowledgement
for specific photographs is made to the following: Plates 2, 11,
48, 63, 65, 67, 69, 71, 72, 74, 76, 79, 81, 84, 89, 91 and Col.
Plates 2, 12, 14, 15, 16 Courtesy of Novosti Press Agency;
Plates 8 and 88 Courtesy of A La Vieille Russie Inc, New York;
Plates 24 and 58 Courtesy of Hammer Galleries, New York;
Plate 23 Courtesy of La Princesse de Ligne, Château de Belœil,
Belgium; Plate 26 Courtesy of Inverkeithing Burgh Museum;
Plates 27, 30 and 53 Courtesy of the National Museum,
Warsaw; Plate 28 Courtesy of the State Museum of Fine Art,
Copenhagen; Plates 32, 44 and 45 Courtesy of the late Mrs
Merriweather Post, Hillwood, Washington DC; Plate 35
Courtesy of the late André Harley, New York; Plate 54
Courtesy of the National Museum, Prague; Plate 73 Courtesy of
the M. H. De Young Memorial Museum, San Francisco; Plate
94 Courtesy of John Stuart; Plates 113 and 120 Courtesy of
Messrs Sotheby's; Plate 114 Courtesy of Fischer Fine Art Ltd,
London; Plates 130 and 135 Courtesy of the Royal Academy of
Arts, London.

The Works of Aleksei Georgievich Jawlensky and Mikhail
Fedorivich Larionov are © ADAGP 1987, and those of Pavel V.
Kuznetsov, Vladimir Vasilievich Lebedev, Andrei Goncharov,
Aleksandr Grigorievich Tyshler, Boris Vladimirovich Ioganson,
Arkady Aleksandrovich Plastov, Andre A. Mylinikov, and Janis
Osis are © DACS 1987.

Contents

Artistic Centres of Russia

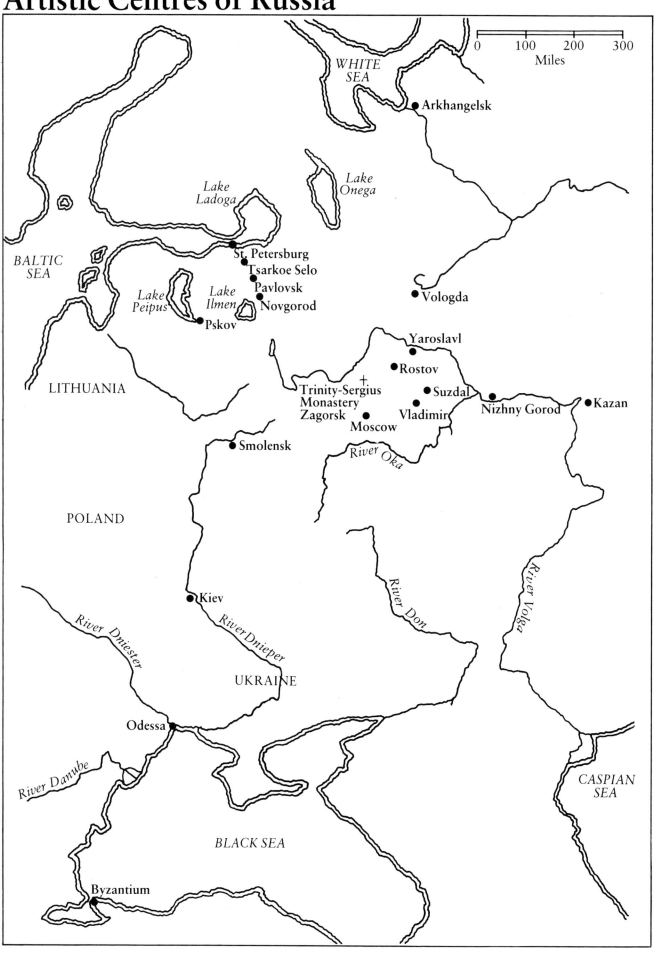

Acknowledgements

I should like to thank the many people who have kindly and patiently answered my queries or offered their assistance in various ways. During my visits to the USSR I have been indebted to Mrs Tatyana Zhukova and Miss Margaret Mudrak who at the request of the Society for Cultural Relations with the USSR arranged meetings for me with art critics and historians, both at the House of Friendship, Leningrad, and at the House of Artists. I was introduced to a number of scholarly and generous people whose acquaintance I was able to renew when I was given a Cultural Exchange visit by the British Council. On that occasion I was able to view the celebrated collection of modern Russian painting belonging to George Costakis (to whom I am also indebted for hospitality), to meet the staffs of the Tretyakov Gallery and the Pushkin Museum of Fine Arts, Moscow, and the Russian Museum, Leningrad, and also to have informative conversations at the Institute of Art History, Moscow. At the Bakhrushin Theatrical Museum I was able to study original theatrical designs in large numbers. I would stress, however, that the views expressed in this book arise from my own study of Russian and Soviet paintings and were neither inspired nor influenced by my contacts within the USSR.

The helpfulness of American scholars, collectors and institutions is proverbial and in no way exaggerated, as I have happily discovered. I am grateful for help received from Dr John Bowlt, Professor Vladimir Markov, Victor J. Hammer of the Hammer Galleries, New York; the Curator of the M. H. de Young Memorial Museum, San Francisco; Mrs Rudenstine of the Guggenheim Collection, New York; the late Mrs Merriweather Post, Hillwood, Washington DC, and the late Marvin C. Ross, Curator of her famous collection and himself a notable scholar; George R. Mann; Professor Ann Farkas of Columbia University; Mr Harley, New York; the late Boris Pregel, New York; Professor Elizabeth Valkenier, New York; A La Vieille Russie, New York; and the Curator of the Hartford Collection.

I have also received help from Miss Elizabeth Fabritius of the State Museum of Fine Art, Copenhagen; Mr Bjarne Jornaes of Thorvaldsen's Museum, Copenhagen; the Galleria d'Arte Moderna, Florence; the Galleria Nazionale d'Arte Moderna, Rome; the Louvre, Paris; the National Museum, Stockholm; the Malmo Museum, Sweden; the Department of Prints and Drawings of the British Library and Museum; the Victoria and Albert Museum; the National Museum, Warsaw; the Museum of Art and History, Geneva; the National Gallery, Prague; the A. M. Gorky Museum of Art, Kiev; the Novosti Press Agency; the Stedelijk Museum, Amsterdam; La Princesse de Ligne, Belgium; several private collectors; and, above all the Russian Museum, Leningrad, and the Tretyakov Gallery, Moscow.

To the names of these institutions I must add those of several individuals who have given me assistance of varied kinds, notably Miss Mary Chamot, Troels Andersen, Hugh Honour, the late Max Hayward, Dr Margrit Velte, John Stuart, Tamara Talbot-Rice and Madame Larionov of Paris. There must, I am sure, be others who have given me help and whose names I have inadvertently failed to record here; and to them I offer sincere thanks and apologies.

ALAN BIRD

Note on Transliteration

The rendering of Russian names presents distinct problems. I have sought a compromise between the usual systems of transliteration and forms commonly used in English. To be consistent, every Russian name should appear in transliteration, but it seems preferable to call the painter Aleksandr Benua 'Alexandre Benois' (which is how he signed himself), and Pyotr the Great 'Peter'. In general I have adopted a slightly modified version of the system used by *Soviet Studies*, published by the University of Glasgow; but I have tended to leave established or traditional forms. Where I have noted the title of a Russian book already in transliteration I have retained the form. The results may seem inconsistent in parts, but may I hope prove helpful to the reader with little knowledge of Russian.

The changes of nomenclature by the principal teaching establishments are confusing. In 1918 the Moscow School of Painting, Sculpture and Architecture and the Stroganov School were integrated to form the Free State Art Studios (SVOMAS). In 1920 the name was changed to VKhUTEMAS and in 1926 to VKhUTEIN. In Petrograd the Academy of Arts became the Petrograd State Free Art Educational Studios (PEGOSKhUMA), then SVOMAS, and finally became known again as the Academy. Where artists taught at an institution through all the various changes of name I have, except in specific cases, referred only to the last official name.

Introduction

Half-way between Europe and Asia, Russia is a battlefield across which invading forces have made their way in successive centuries. Tatars from the eastern hinterlands, Scythians and Greeks from the south, and Vikings from the north, to name but a few, have all left their traces in the western area of what is now the Soviet Union. Indeed, the Vikings had a significant connection with the formation of the state known as Rus from which the word Russia derives.

By the ninth century a Slav people had established a peaceful trading area with Kiev as its centre in the south, and made river links with the important city of Novgorod in the north. Kiev had as its eastern neighbours the Khazars, a people of Turkish origin, who formed a useful bulwark against the Persians and the Arabs. From the middle of the century, however, the Vikings, known as Varangians, made their way through Russia, even reaching and threatening Constantinople still further south. Fierce as they were, the Varangians were employed as mercenaries by the merchants of Kiev and Novgorod; and, indeed, in this last city a Varangian prince called Ryurik gained control. On his death in 879 a kinsman, Oleg, guardian of Ryurik's infant son Igor, took possession of the whole range of waterways and extended the power of Rus. After the death of Igor, the state was governed by his widow Olga, born of a Scandinavian family long settled in Pskov, a wise and able woman, who embraced Christianity in 957. Her son Svyatoslav I was killed returning from an unsuccessful campaign against the Bulgarians and eventually the throne fell to one of his sons, Vladimir, who became the sole ruler of Kiev in 980. He was the first prince of his line to consider himself in any way 'Russian' and to declare Kiev as the capital of Rus. Unfortunately he did not establish the right of primogeniture and his heirs split cities and territories between them, opening the way to invasions, attacks and disastrous internecine feuds.

It is in this period, as we shall see, that the artistic history of Russia begins. Invasions and wars, famines and floods brought with them wholesale movements of the population who had little to leave behind them in terms of material possessions, and little to look forward to except for the consolation of such communal life as they could enjoy on river banks in tiny settlements carved out of the surrounding dense forest lands. This loneliness, this isolation, bred a conservative spirit in which there was little searching after novelty. On the other hand, the few artistic influences from abroad which were eventually accepted and absorbed were to be lastingly stamped with the Russian genius. The independence born of centuries of isolation, hardship and a continual struggle against the forces of nature manifested itself in an attitude to external artistic influences which seems peculiarly Russian. An art historian of Russian origin has concluded that:

> No great art is ever purely indigenous, and although Russian art is perhaps more heavily indebted to foreign influences than the arts of many other great European nations, her own artistic heritage is not only considerable, but it is also peculiar to herself. It is entitled to be judged according to its own standards, which must be understood and comprehended for themselves, and does not deserve to be regarded merely as an offshoot of other styles.[1]

About AD 988 there occurred an event of the greatest importance in Russian history and cultural life: Vladimir of Kiev followed the example of his grandmother Olga and became a Christian, connecting himself closely with the Byzantine empire by marrying Anne, sister of Basil II and Constantine VIII, the joint ruling emperors at Constantinople. He ordered the general conversion of his people and a mass baptism took place in Kiev in the waters of the Dnieper. He also set about the task of establishing and spreading his newly adopted religion in a

manner worthy of Constantinople, a city which had filled his emissaries with admiring awe; and to this end he required priests, churches, vestments, books of ritual, altar vessels and sacred decorations of all kinds.

Vladimir's ambitions were of a high order, and he turned directly to Constantinople, a city which represented the peak of Western civilization, for the priests, architects and artists whose services he needed for the ordering of his city of Kiev. Byzantine art forms and dogma were accepted without a deep or even more than a cursory examination of their complex philosophic and metaphysical background. It must be remembered, however, that behind this ready acceptance of Byzantium there was an astute measure of political convenience for Vladimir and his successors in his people's acceptance of the Byzantine conception of the Prince anointed of God, declared his Representative on earth, and never therefore to be opposed in any way whatsoever. Art which demonstrated the glory and omnipotence of the Creator also demonstrated in an indirect fashion the glory and omnipotence of his Representative on earth; and it is no accident that the arts of Byzantium flourished so vigorously on Russian soil that by the last quarter of the fourteenth century they had become unmistakably Russian in character.

The first and most obvious result of the coming of Orthodoxy was the erection of vast numbers of churches, not only in Kiev, which was spoken of as 'the rival of Constantinople' in this respect, but all over Christian Rus. Indeed a passion for church building – often on an immense scale to compete with Sancta Sophia in Constantinople – was to remain an enduring activity with Russians. Both before and during Vladimir's reign there existed pagan temples made of wood and painted with frescoes, so that there were some rudimentary, traditional skills which he was able to motivate towards Christian purposes under the direction of imported artists capable of creating mosaics and painting murals in the prevailing Byzantine style. Cities such as Novgorod (and its satellite Pskov) and Vladimir-Suzdal were to equal Kiev in the fervour with which they constructed churches.

From its inception the Russian Orthodox church was upheld and strengthened by a sense of Messianic destiny and exclusiveness. Whereas Western Europe had inherited a fairly primitive and uncodified form of Christianity largely rescued from the ruins of the Roman Empire, Russia adopted from the yet unvanquished Eastern Empire a vital if already calcified creed which she believed it was her divine mission to preserve. Furthermore, it was her predestined purpose to await that tremendous moment of the Second Coming when all mankind would be ranged before the Judgement Seat of the Creator. The fact that the basic literature of Orthodoxy had been translated into Church Slavonic, a language created from vernacular Slav and transformed into a written language well suited for Byzantine ritual but which was barely comprehensible to laymen, only served to increase the power, mystery and isolation of the church. Without some understanding of the existence of these conservative and Messianic elements in Orthodoxy, it is impossible to appreciate the nature of Russian life, faith and culture both at this time and in succeeding centuries. It must also be said that religious painting and ecclesiastical architecture provided Kievan Rus with its principal means of artistic expression; and it was only in mosaic work and in painting, whether of icons or frescoes, and in church building that anything important or lasting was accomplished in early Russia.

Following the example of Constantinople, churches were decorated with mosaics, frescoes and icons but never, it would seem, with carved effigies. It is likely that the larger towns had workshops (with artisans' living quarters attached or nearby), perhaps under the patronage of a principality, great monastery or ecclesiastical hierarchy. Here icons were painted and larger commissions planned and estimated; but clearly groups of artists (*arteli* or *druzhiny*, to use the terms of the chroniclers) must have moved from church to church, from city to city, when so required. In any case, decorative work could only proceed during the summer months because of the rigours of the Russian climate; and in no case could walls be painted until at least one year after a church had been built.

Mosaic work was traditionally Byzantine in character and limited in usage, for although the tesserae could be, and were, frequently produced locally, this type of decoration remained extremely expensive in terms of material and man hours. Fresco was comparatively cheap, so that as the Kievan state fell into decline mosaic was replaced and finally entirely supplanted by wall painting. It was also speedy since the artists, unlike their Italian counterparts, worked with the minimum preparation of the plaster ground, not always with detailed preliminary designs, and in difficult climatic conditions, all of which necessitated a highly ef-

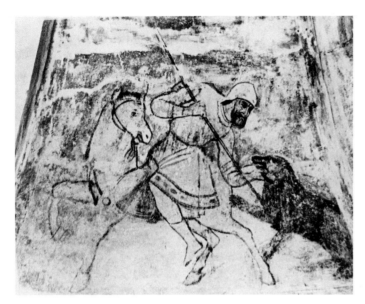

1. *Mounted Warrior fighting a Bear*, c. 1120–5. Fresco. Kiev, S. Sophia

ficient organization of labour and the utilization of a concise and accurate artistic language.

The range and variety of subject-matter are best seen in the Kievan state where Yaroslav, son of Vladimir and Grand Duke of Kiev, who reigned from 1019 to 1055, was responsible for the erection of many churches. S. Sophia, founded in 1037 to commemorate his victory over one of the nomadic tribes which had threatened his lands, became the seat of the Metropolitan as well as the cathedral in which the Grand Duke of Kiev was to be seen enthroned amidst the utmost splendour and glorious solemnity. From about 1042 the church was decorated with mosaics and frescoes. The vast structure of S. Sophia, the complexity of its design and the magnificence of its interior make it the greatest religious building of the old Russian lands. As might be expected, the mosaics and frescoes show the force of the Byzantine tradition but there are deviations in the murals, not the least being the introduction of secular images such as the group portrait painted in 1045 on the western wall of the central nave, and on the adjoining southern and northern walls, of Yaroslav's family, including his daughters Elizabeth, Ann and Anastasia, who were respectively to become Queens of Norway, France and Hungary. Some of the scenes in the south-west tower, which was probably added during the reign of Vladimir Monomakh (1113–25), are absolutely secular, depicting sporting events taking place in the Hippodrome in Constantinople watched by the Emperor and his

retinue, and also various activities connected with hunting (Plate 1). Far from being the whimsical creations of individual artists these frescoes were almost certainly painted by command of the Kievan princes to demonstrate that they were the direct successors of the Byzantine emperors and of equal status in grandeur.

The portrait of Yaroslav and his family is best known through a copy made in 1651 by the Dutch artist Abraham van Westervelt (d.1692) when the frescoes were already in a poor state of preservation. In those which are still visible, particularly the hunting scenes of the south-west tower, it is obvious that the Kievan artists felt themselves free in a significant degree to break away from the restraints of Byzantine correctitude and at liberty to introduce aspects of secular life which they had witnessed at first hand, or motifs which they took from the silverware, the decorative fabrics, the painted pottery and the other precious objects which were imported into the city from Western Europe and the cultures of the Eastern world. The frescoes of S. Sophia provided prototypes of traditional Byzantine imagery which were to spread throughout western Russia and also prepared the way for the cautious introduction of elements taken from secular life. In this sense Kiev furnishes us with the first instance of a process that persists in the history of Russian painting – the conflict between external forms and indigenous impulses or, to express the concept in another way, a rapid creative reaction against an adopted mode which is in origin both foreign and external.

From the first there seems to have existed in Rus a taste for intimate works of art unlike the great brooding and forbidding images that lined the walls and domes of cathedrals and dominated the crowded worshippers. Moreover, in the many churches built of wood – the material most available in the Russian countryside – there were no opportunities for murals. The craving by the ordinary people for an intimate and personal image was satisfied most adequately by the icon, a word derived from the Greek *eikon*, an image or representation. In fact, the popular idea of Russian art equates it with the icon – a misconception because the icon has a long history which demonstrates its underlying continuity with Byzantium, although the originality of its development on Russian soil cannot be denied. Though there is probably an unbroken chain of development from the funereal portraits found on many coffins in Egypt and Syria and the

encaustic icons remaining in the ancient monasteries in those lands,[2] it was in Byzantium in about the late fifth century, at a period which saw a startling growth of monasticism, that images of Christ and the Virgin Mary, the Apostles, prophets and angels were first created as objects of systematic veneration, as were those scenes which represented the festivals of the church and the events which manifested biblical and religious truths. Such secular imagery as the icon possessed at that time was drawn from life around and was basically Hellenic in its realism.

In AD 726, however, there arose in Byzantium a bitter controversy between those who worshipped images (iconolaters) and those who detested graven images and who set out to break and destroy all such obscenities (iconoclasts). When the iconolaters triumphed and icon veneration was officially endorsed at the Second Council of Nicaea in 787 a doctrine of imagery was established and was to last until comparatively recent times. Since so many works had been destroyed by the iconoclasts the Byzantine empire was, comparatively speaking, artistically bankrupt at the time of Vladimir's conversion, although already in the throes of a rediscovered enthusiasm for religious art. There were to be two later artistic revivals: the first in the age of the Macedonian and Comnenus dynasties in the tenth and eleventh centuries; and the second in the Palaeologan era of the fourteenth century. But throughout this period the empire was in slow but irrevocable decay and unable to support its artists, many of whom migrated to Russia, which thus benefited from these upsurges in Byzantine cultural life. In fact, the oldest icon in Russia, the famous *Our Lady of Vladimir* (Plate 2; Col. Plate 1), which probably dates from the early twelfth century, must almost certainly have been brought to Kiev from Constantinople.[3] The Eastern church, it may be added, showed a marked bent towards Mariolatry well before Latin Christendom: the Virgin Mary was to become the patron of Kiev and of Novgorod, as she had been of Constantinople. In 1155 this famous icon was carried from Kiev by the Grand Duke Andrei Bogolyubsky to the city of Vladimir, where it was employed in a wonder-working capacity and most devoutly worshipped in times of national distress. Marking the northward movement of Russian culture, it was taken to Moscow at the end of the fourteenth century and preserved in the Cathedral of the Assumption in the Kremlin where it became a symbol of national unity long before such

unity became a historical fact. The centuries have taken their toll of this work and only the heads of the Virgin and Child are original, the robes having been repainted at a later date. Yet the tenderness with which the Virgin presses the Child's cheek to her own, the delicate seriousness of the Child himself and the serene but grave intimacy of the image served to inspire generations of icon painters.

Icons were painted on wooden panels, either of one piece or of several boards joined together by wooden pins or dowels. Very often they were roughly shaped by an axe, more rarely by a plane, and sometimes strengthened across the back to prevent warping. The woods used were those such as cypress, lime, pine, alder or fir which were easily obtainable locally. On the front a rectangular area known as the 'ark' or 'shrine' was hollowed out to form a shallow, tray-like depression leaving a slightly raised border which served as a kind of frame. In order to make the painting surface as smooth as possible the panel was covered with canvas, or left bare and then coated with a fine plaster-like paste made of powdered alabaster or chalk mixed with animal or fish glue. When this surface dried hard it was polished and a design borrowed from another icon or book of icon patterns was laid on freehand or by transfer or, in the case of more recent icons, by tracing or engraving with a needle of some kind. Backgrounds and details such as crowns and haloes were decorated in gold leaf and then covered with *poliment*, a mixture of reddish earth colours in an egg-yolk medium. For the painting of the figures a mixture was made of egg yolk, thin glue and wine or beer added to the vegetable and mineral colours most available, principally white, soot black, ochre, crimson, maroon, chrome yellow, cinnabar, green and umber. Eventually the painted icon was covered with a varnish of boiled linseed and amber and left to dry before being given a final polish. It is knowledge of and familiarity with these factors which help to determine the age and place of origin of icons. The manner of making the highlights, the colours used, the composition, the use of gold as part of the drawing (although only after the first half of the sixteenth century), and the style of outline are aids in differentiating between the various schools. Against this is the fact that icons were frequently repainted or retouched so that the original surfaces were lost to sight or grew darker and darker with successive coats of varnish, making it almost impossible to detect the subject-matter with any certainty, let alone the exact age. In later periods

forms of extraneous decoration were utilized, generally to the detriment of icon painting: for instance, the edges would be covered by a *basma* (thin strips of embossed or gilded silver which were pinned to the icon), metal haloes were set around the heads, and decorative plates in the shape of crescent moons called *oklady* hung from the shoulders of the figures. From the seventeenth century onwards much of the surface was covered by a *riza*, a kind of protective shield of precious metal set with jewels which was cut away in parts to expose the face and hands of the image. In the final degeneracy of icon painting in the late nineteenth century only this exposed area was painted and the parts concealed by the *riza* were left bare.[4]

Icons were found not only in churches, where they might be as much as six feet high, but in private

2. Byzantine icon of *Our Lady of Vladimir*, early 12th century. Tempera on panel, 78 × 55 cm. Moscow, Tretyakov Gallery

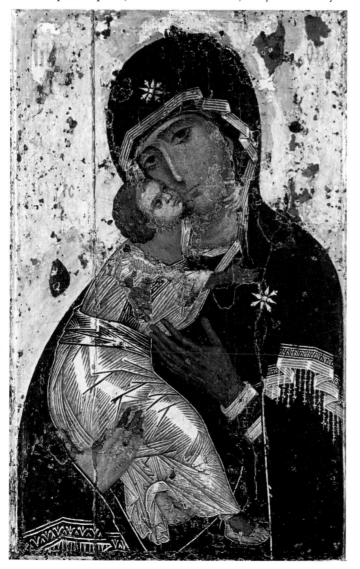

houses where small examples about eighteen inches by twelve were customarily hung high up in the inner right-hand corner known as *krasny kut* or *krasny ugol*,[5] the beautiful corner or place of honour, terms more particularly used in peasant huts. In the homes of the rich there was a room known as 'the room of the cross' where icons were hung in rows on one wall and which was reserved for worship. But stable-doors, well-heads and crossroads also boasted icons with images of the saints who were credited with the responsibility for safeguarding the interests of horsebreeders or travellers and other members of the peasant community. Dissatisfaction with the performance of such a saintly image might result in its being punished by the removal of its ornamentation, having its face turned to the wall or, even, being whipped. Icons which had darkened beyond cleaning were consigned to little huts where they were hung on poles, or floated on a river or lake and left to the mercies of the waves and currents as directed by God. Sometimes they were pounded to a dust which was added to the sacred oil used during church rituals. Even when a church had been destroyed by fire and its icons devoured by flames it was always said that they had been 'received into heaven'. In churches and cathedrals, where they could be comparatively safe from accidental damage if not from fire, icons were often clustered in corners or recesses dimly lit by lamps or flickering candles, but more usually they were fastened to the screen which separated the sanctuary from the nave, the screen which in the coming days of Muscovite supremacy was to command increasing importance as the iconostasis.

There is a pious and quaint but totally erroneous belief that icon painting was confined to monks and priests until workshops in which laymen worked came into being. In fact, there is evidence that the *arteli* which decorated ecclesiastical buildings with frescoes, mosaics and icons comprised workmen who could undertake commissions of many kinds, including the production of personal ornaments and jewels. Among their commissions was the supply of appropriate icons. However, since it was felt that the icon could invest all who touched or owned it with heavenly grace, it was expected that the workman himself would be good and righteous; and, equally, the more beautiful and spiritual the icon, the more likely were worshippers to see the intervention of heavenly power in its creation. Exceptionally lovely icons were credited with miraculous powers of aid, healing and guidance.

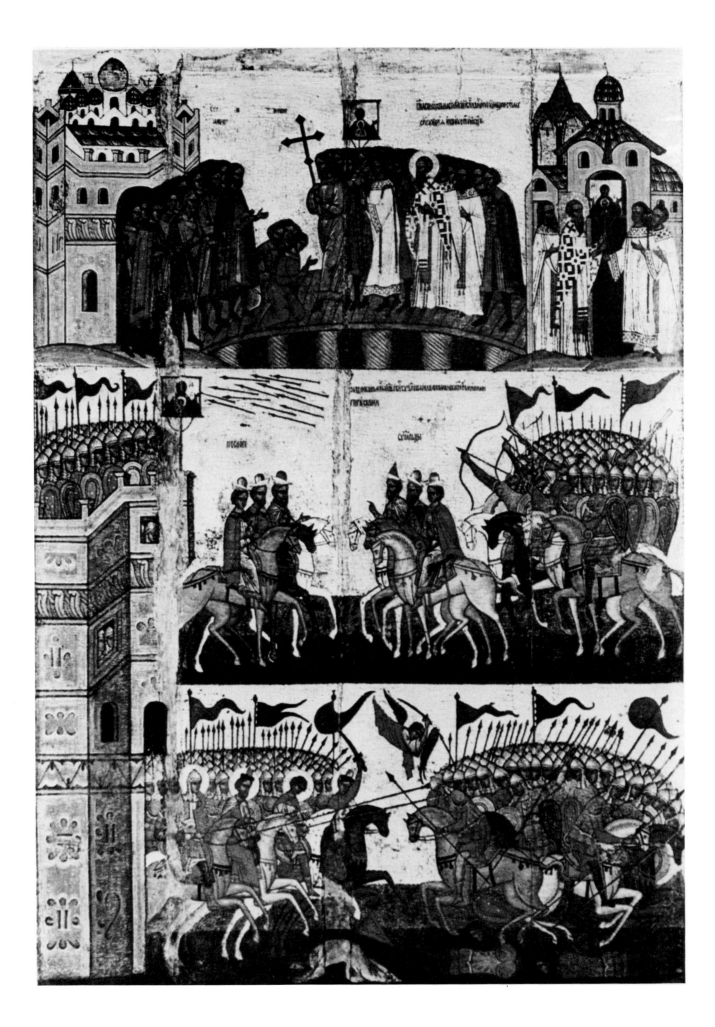

The icon also served a vital function as the epitome of theological formulation and expression in early Russia. By the chance of having been converted directly from Byzantium and not through any intervening agency, Russia was cut off from Latin Christianity and from such thinking as went on in Western Europe during the Middle Ages. She could not compensate for this cultural (and theological) isolation by an exploration of the riches of authentic Greek civilization because instead of Greek she had adopted the barely understood Church Slavonic, because her lay and religious scholars had neither the desire nor the ability to investigate the treasures of Greek and Latin literature, and because many of the princes and priests who came to power had narrow territorial preoccupations. The combined religious enthusiasms and aesthetic impulses of early Russia could express themselves legitimately through the offshoots of religion proper – architecture and icon painting. Thus painted lives of the saints replaced theology; and it was in icons that veneration found an object. Edification was attained through contemplation of the visual images produced by the icon-maker and by listening raptly to the fabrications of the hagiographers.

Initially no freedom of invention in the icon itself was allowed: both imagery and style were strictly controlled. In Byzantine times there had evolved a comprehensive set of prescriptions for the depiction of the sacred personages, their features and other characteristics having been codified and established. Various manuals dictated technique, manner and context to the artist, and sets of patterns were created which enabled painters all over the Byzantine world to make icons which cannot easily be identified as coming from any particular area. Such pattern books, in fact, are still in use today. Despite official injunctions that anonymity should be preserved, individual differences crept into icon painting, particularly as local saints were created and hagiographers invented new details, and when the conservative Byzantine influence began to fade during the fifteenth century. It was decreed that all personages represented should retain the contours of ordinary human beings – although, at the same time, they should show the signs of asceticism which distinguished them from mortal men: figures of

heavenly origin had to be invested with such celestial characteristics as would at once differentiate them from the saints, prophets and fathers of the church who were of merely earthly origin. Thus every figure on the icon had to be recognizable and yet instantly proclaim its sacred character.[6]

The Kievan period in Russian history was comparatively short. The city was vulnerable because of its dependence on the Byzantine world, its relative proximity to Constantinople and Greece, both in decay, because its possession was disputed by jealous and warring princes of the same family (one of whom reduced the city to rubble towards the end of the twelfth century), but more especially because it was a rich prize for invaders, standing as it did in the heart of Russia's grain lands. Its spiritual and cultural isolation could not save it from the Mongol hordes of central Asia or the rapacious advance of the Teutonic Knights. In 1240 the Mongols overran Kiev and most of western Russia, only the northern and remoter lands managing to survive unspoiled.

4. Detail of Plate 3

3. Icon of *The Battle between the Men of Novgorod and the Men of Suzdal*, mid-15th century. Tempera on panel, 171 × 126 cm. Novgorod Museum

Little or nothing in icon painting has survived from the days of Kiev's greatness. The few icons which may possibly have emanated from its workshops in the twelfth century show only one or two figures against a plain background, often of gold or silver. The figures painted in dark, earth colours, with an oriental cast of features and large, heavily outlined eyes of a severe or sorrowful expression demonstrate that Byzantine influences persisted until Kiev's days of freedom came to an end.

In the century before the Tatar invasion of 1240 some schools of painting related to that of Kiev grew up in Yaroslavl, Pskov, Novgorod and in Vladimir, where the influence of the *Our Lady of Vladimir*, removed there from Kiev by Prince Andrei Bogolyubsky in 1155, may have exerted a lyrical and humanizing force on the local style of painting. Each of these centres was to become the starting-point of differing artistic developments.

It was in Novgorod, cut off from Byzantium but in communication with Europe since it was an entrepôt for the Western fur trade and a stronghold of the Hanseatic League, that icon painting began most obviously to assume a regional character. As early as 1108, despite the known presence there of Greek artists of whom Petrovits and Feofan are the most famed, the frescoes in the cathedral of S. Sophia, heavy, severe and archaic in style, nevertheless reveal that Novgorod had embarked on the quest for artistic independence even though this involved a return to the similarly archaic style to be found in Kiev. Starting from this base, by the second half of the twelfth century Novgorod had found the style which best suited its character – figures painted in a bold, resolute manner using a range of fresh tones, the character of the faces being emphasized by varied highlighting; there is a distinct softening and humanizing of the Byzantine severity apparent in both the frescoes and the icons of the period, as for instance in the icon of St George (*c*.1170), now in the Cathedral of the Assumption in Moscow. The people of Novgorod, independent, strong, active and shrewd, evolved for themselves an art which entirely suited their temperament. Burly in physique, social and acquisitive by nature, fond of display and opulent luxury, and yet piously devoted to the Orthodox religion, they seemed to have had a distaste for the remote formality and obscure mysticism typical of Byzantine works at their most formal and also for the excessive and complicated symbolism of the later work of the Moscow school.

By the turn of the fourteenth and during the fifteenth century, when much of the Byzantine influence had been shed and there had been a gain in strong local and regional qualities, the school of Novgorod reached the height of its development. Many icons were devoted to the patron saints of the tradesmen, merchants and peasants, such as St Florus and St Laurus, the protectors of horses; the prophet Elijah revered as 'The Thunderer' or 'Rain-bearer' and as a defender of wooden houses from fire; and St George, guardian of cattle, protector of peasants, the embodiment of chivalry and the protagonist of justice. A celebrated icon of the fifteenth century aptly demonstrates the introduction of secular and purely local interests: *The Battle between the Men of Suzdal and the Men of Novgorod* (Plates 3 and 4) illustrates the siege of Novgorod in 1169–70 by the army of Prince Andrei Bogolyubsky and the miraculous deliverance of the city by the aid of an icon named *The Virgin of the Sign* or *The Virgin Orans*. The city's victory is narrated in three tiers which depict with topographical accuracy how the icon was taken from the Church of the Saviour to the Cathedral of S. Sophia where it was exposed before the besiegers: they were panic-stricken when the figure of the Virgin recoiled after the icon had been struck by one of their arrows. The bottom tier shows the men of Novgorod exploiting this miraculous intervention by pouring out of the city to put the Suzdalians to flight. The viewer is entitled to ask whether *The Battle between the Men of Suzdal and the Men of Novgorod* is an icon in the traditional sense of the word or merely an important and interesting depiction of a historical event, and also whether it marks a stage in the decay of the icon as the major art form of Orthodoxy.

Icons from Novgorod are characterized not only by the elongated figures but by a patterned angularity which becomes more and more attenuated as an essentially linear style develops to the exclusion of modelling and shading. There is a continual stress on the vertical, even in decorative elements such as crosses on priestly robes, and frequently the figures have no claim to shoulders. Despite the strong facial lines and the stalwart bodies there is a degree of elegance as can be seen by comparing Novgorodian icons of St John the Baptist with the ascetic but formal, raggedly-wild but conventional John of early Byzantine art: it is as if the townspeople of Novgorod could not understand why the Forerunner should not be as well clad and refined a figure as Christ Himself. The confident temperament and material prosperity of the town are well

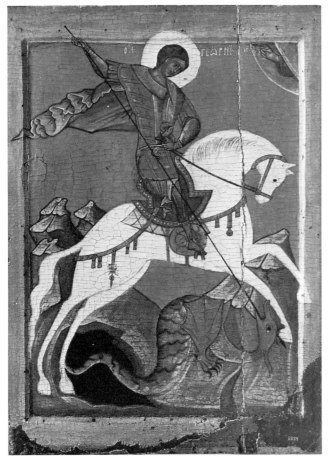

5. Icon of *St George and the Dragon*. Novgorod School, late 14th century. Tempera on panel, 58 × 48 cm. Leningrad, Russian Museum

expressed in simple and firmly constructed compositions, in purposefulness in drawing and brilliance in colour. There is little subtlety in the colouring of its icons – flaming vermilion and emerald green predominate – but there is a remarkable tense dynamism which arises from the conflict between these vibrant tones and the bold rigidity of the design (Plate 5).

As early as the twelfth century there were local schools at Vladimir-Suzdal, Yaroslavl and Pskov; and others sprang up at Kargopol, Rostov and Tver.[7] In general, they were all distinguished by their fondness for brighter colours and for a more decorative, rhythmical patterning than was customary in Byzantine-influenced art (Col. Plate 2). These

northern cities created what is called 'The Northern School' manifesting itself in a style which relied heavily on the achievements of Novgorod but which tended increasingly towards simplification of shapes, the employment of areas of intense green and orange-red and a conservative use of gesture by the central figures. In Tver, on the other hand, pale and delicate colours were frequently used and there is a peculiarly local delight in blues of varied shades.

The work of the Northern School, particularly that of Novgorod in the fifteenth century, has been seen as a distinct stage in the development of Russian icon painting;[8] and it has been said of Novgorod icon painting in particular that

> In it there is more of the entertaining narrative than of philosophical contemplation. A Novgorod artist tends to admire rather than to think.... There is much in common between the Novgorod icons and folk poetry, songs and sagas. At the same time they display a high degree of artistry, brilliance of execution.[9]

But even after it has been admitted that these icons have a splendid and imposing spaciousness and a striking intensity of colour as well as a vividness of conception, a totality which both surprises and moves the emotions, it is still difficult to agree with the statement that the Novgorod school represents a developmental stage in the history of icon painting – if development is taken as synonymous with progress. Rather, its achievement, bearing in mind the inherent dangers of its tendency towards the material and local and secular, is an indication of what might have been possible in the regions had not Moscow, by reason of its political and artistic supremacy, obliged artists from every area to come and work there. It is better, perhaps, to see the separate, intrinsic merits of each age and period, of the different schools, of the masters of whose identities we are aware, and even of individual icons regardless of their origins. There is no progress in icon painting; there are simply changes of style and subject-matter. And it may be truly said that the icon in Russia was greater at its commencement than at its shabby end.

1

The Development of the Icon

Kiev had thought of itself as the 'Second Jerusalem' but was only briefly able to sustain this claim.[1] Although the city, its monuments and its art works became legendary throughout Russia, much was destroyed during the struggles of the thirteenth century when it was pillaged time after time. At this period, too, it lost every shred of political and economic strength. In fact, after Kiev was sacked by the Mongols in 1240, Russia drifted aimlessly through a dreary twilight made gloomier by the grim shadows of passing invaders and the occasional flares of fire as ruthless depradators ravaged and laid waste towns and cities. Novgorod survived, but was isolated from the rest of the country. Moscow itself was little more than a fortified settlement with a meagre population much of which had fled from Kiev and Tver. But it contained a line of ambitious young princes who (abetted by the heads of the Orthodox church who now made their permanent seat in Moscow) treated with the Tatars, exacted tribute money from neighbouring territories on their behalf and sometimes fought them. A number of states joined with Moscow and under the leadership of Dmitri Donskoy temporarily defeated the Tatars on the plain of Kulikovo in 1378. Freedom from the occupying hordes was soon to become a reality. Tribute payments were terminated in 1480. No longer terrorized by the Tatars, Moscow began to reveal its own aggressive nature: seeing itself as the centre of Orthodox Christendom, the 'Third Rome', as well as the destined capital of the Russian peoples, it overcame and absorbed Novgorod between 1465 and 1488. Yaroslavl was taken over in 1465 and in 1485 peace was concluded with Tver.

Thus Moscow came to power as the second great city of Russian culture. Until the fourteenth century it had hardly existed as a town, its population had been small and its cultural life non-existent; the very few artistic traditions it then enjoyed were derived from the older Russian cities, in particular Vladimir-Suzdal, the principality to which it had long been tied and from which it gathered much that was best in early icon painting. To some extent the artistic development of Moscow may be said to have begun in 1326, when the seat of the Metropolitan was moved there from Vladimir and was followed by the building of a large number of churches within the Kremlin. However, many of its tenuous cultural links as well as the treasures it had accumulated were destroyed during Tatar raids, especially in 1382 when the Khan Yokh Tamysh sent up in flames the furnishings and decorations that were said to have 'filled the Moscow churches to the rafters'. Moscow's rise to power was accompanied by feverish activity in the foundation of monasteries in the comparative safety of northern Russia. The monastery of the Holy Trinity founded by St Sergius just outside Moscow became the second *lavra* or parent monastery in Russian ecclesiastical history and supplied for Moscow the place held by the Monastery of the Caves (Pecherskaya lavra) in Kievan history. The rulers of Moscow were thought of as icons or earthly images of God; and their supremacy in Russian lands rested on the total support of the church and, more emphatically, on the monasteries where such artistic creativity as existed was safeguarded and carried on.

It would be unnatural in view of Russia's comparative isolation from cultural channels to expect any revolutionary developments or changes in the nature of her arts: mosaic work had long since been abandoned, and architecture and fresco and icon painting continued to hold their customary and traditional sway. There was, however, a demand for illuminated manuscripts and for decorative calligraphy as a result of the growth of hagiography and chronicle writing. But the phenomenon in which the ideology of Muscovite Tsardom received its fullest

expression was the evolution of the iconostasis or icon screen. In both Byzantium and Kievan Rus the screen between the sanctuary and the nave had been a simple construction of two 'royal' doors (Plate 6), the use of which was restricted to priests and rulers, and an intervening panel or doorpost on which illustrated cloths and icons were sometimes hung. On the beam which ran over the door were carved and painted scenes of religious significance. From the end of the fourteenth century (and possibly before then) we find in the Muscovite state a whole screen of icons extending high above the sanctuary doors and offering a kind of simple encyclopedia of Christian belief. Not only was the screen itself – the central area and the doors – covered with icons but above it were up to six further rows, reaching in some cases to the ceiling itself. The oldest surviving icon screen is the beautiful three-tiered one created by Rublev and two colleagues from the Archangel Cathedral in the Moscow Kremlin and which dates from the end of the fourteenth century.

At the centre of the main 'prayer' row of icons immediately above the doors was Christ Enthroned flanked by the Virgin Mary and John the Baptist, the Archangels Michael and Gabriel, St Peter, St Paul and other saints and Apostles. Above this, the tier of festivals had the Crucifixion as its centrepiece, while from the left there unfolded the life of Christ, beginning with the Birth and Presentation of the Virgin, and followed by the Annunciation, the Nativity, the Presentation in the Temple, the Raising of Lazarus, the Entry into Jerusalem, and the Transfiguration, while on the right were the Deposition, the Entombment, the Harrowing of Hell, the Incredulity of St Thomas, the Ascension, the Trinity, the Descent of the Holy Spirit, and the Dormition and Intercession of the Virgin. The fourth tier was given over to the Prophets, David, Solomon and the *Virgin Orans*: and the fifth tier held icons of God the Father and the Patriarchs surrounded by Cherubim.

This splendid creation represented a pictorial volume by which believers became familiar with the intricacies of a religion whose doctrinal complexities were well beyond the intellects of all but a dedicated and learned few. Placed between the sanctuary and the worshippers, the iconostasis became a vital bridge between heaven and earth, illustrating in human terms the variety of incarnations assumed by God in his determination to redeem his people. Lit by candelabra and the tapers of the faithful, the iconostasis became a window into the mysteries of sanctification and salvation. The forbidding figures

which had menaced from the walls and glared down from the cupolas of earlier Byzantine churches now descended and benevolently took up their places on the screen where they surrounded a Christ who had surrendered his awful splendour as the *Pantokrator* and taken his place on earth, alone in sorrowful but comprehending isolation (Plate 7).

Although the iconostasis undoubtedly represented a humanizing of Byzantine Orthodoxy it would be too simple to see its development as either a purely religious or artistic process, for in absolute terms it was neither the one nor the other. Dramatically and effectively it reminded worshippers of God's involvement in all aspects of human life, but it also reminded them that they were part of the earthly order divinely prescribed for Russian society; for

6. Details from the Royal Doors of the Iconostasis, 1684. Zagorsk, Cathedral of the Dormition, Monastery of the Trinity and St Sergius

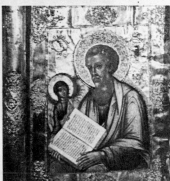
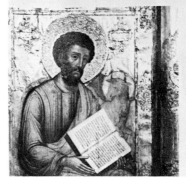

just as the relationship of each icon to every other one was ordered and changeless, all being united by a common relationship to the central icon of Christ Enthroned (and above him that of God the Father), so the Russian people were bound to accept the laws laid down for them by the Tsar, that 'living icon of God'. It is surely significant that the iconostasis flowered in the theocratic state of Muscovy at the very time when its princes were asserting their command over all Russian lands (Plate 8).

Relations with Byzantium, which were never entirely severed, were now resumed for the few years that remained before its final devastation by the Turkish hordes that were already overrunning Bulgaria and Serbia. From these territories craftsmen and scholars fled to Russia, sometimes bringing with them works of the Palaeologue Renaissance. Both Novgorod and Moscow gained from the presence of these Greek artists. The most important

of them was Theophanes the Greek, in Russian known as Feofan Grek, a painter who had worked in Constantinople and the neighbouring quarters of Galata and Chalcedon, and in the colony of Caffa (now Feodosiya) in the Crimea, on the route from Constantinople into Russia, where he is believed to have decorated numerous churches. As El Greco, another son of Byzantium, did in Spain, Theophanes quickly absorbed the character of his adopted land. His reputation was estabished in Novgorod in the mid-1370s when he created the remarkable frescoes of the Church of the Saviour of the Transfiguration, the only works which can be firmly associated with his name. Elsewhere his murals have perished, although several churches boast examples which may have come from the brushes of his pupils or associates. By the 1390s he had arrived in Moscow where he appears to have found appreciative and enlightened patrons. The murals he painted in churches and palaces there have all gone. In a letter dated 1415 which the chronicler Epifany the Wise wrote to Kirill of Tver there is an account of the revolutionary methods developed by Theophanes, who,

> when he portrayed or painted all this ... was never seen by anyone to stare at models, as certain of our icon painters do, who, in perplexity, constantly stare at them, looking hither and thither, and do not so much paint with colours as just look at their models. In his case, however, his hands seem to do the painting while he himself is perpetually walking about, chatting to visitors and pondering wise and lofty thoughts in his mind, seeing goodness with his thoughtful and sensitive eyes.[2]

It is clear that Theophanes possessed remarkable pictorial gifts which he was able to translate on the walls of the churches he decorated into large monumental shapes, simple colour schemes and quick, decisive strokes of white, red and bluish grey which highlighted and emphasized what he considered to be the important areas of clothing or physique. The results are hauntingly strange as in his figure of the Egyptian St Macarius from the Church of the Transfiguration. Seen full face, partly outlined by an immense halo, the saint is represented as a grave and austere, bearded old man. But what is astonishing is the simplicity of the pictorial means employed to

7. General view of the Iconostasis, 1684. Zagorsk, Cathedral of the Dormition, Monastery of the Trinity and St Sergius

8. Royal Sanctuary Doors, c. 1700. Height 161.9 cm. Private Collection

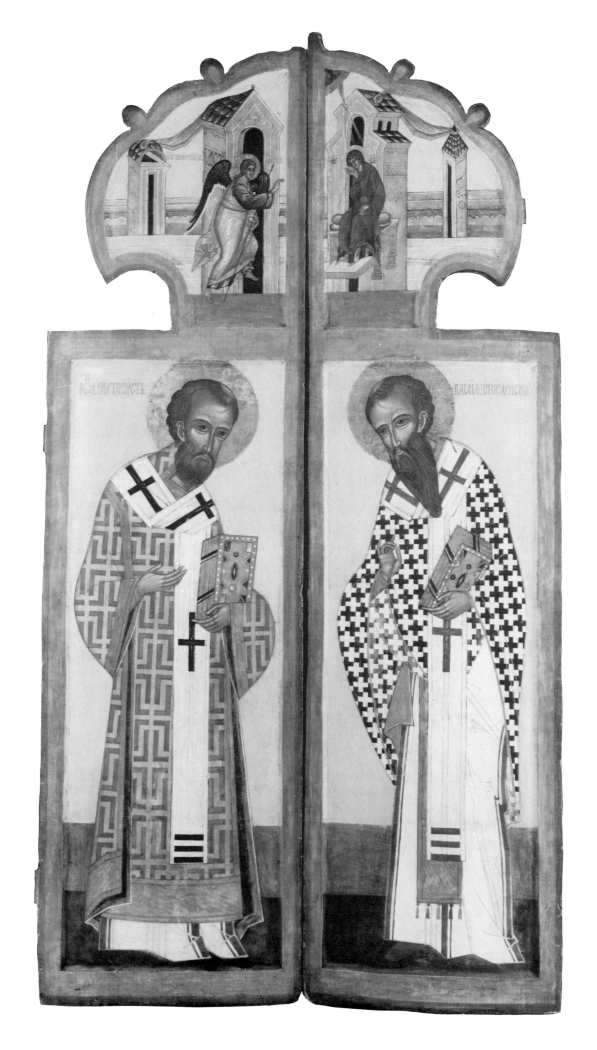

secure this massive effect: a few basic areas of plain colour, hands silhouetted in rigid protest, some slashes of light paint for facial expression, the whole united by the interweaving curves and circles of hair, beard, clothing and halo (Plate 9).

With such amazing gifts for combining image and pattern it is little wonder that Theophanes was equally famous as an icon painter. In 1405 he helped to execute the iconostasis of the Cathedral of the Annunciation in the Moscow Kremlin, of which the most important tier, depicting the Enthroned Christ flanked by the Virgin and John the Baptist and by figures of archangels, Apostles and saints, is claimed as his work. The elongated vertical outline of the Virgin broken only by her pleading hands presents itself as an overwhelmingly tragic monody, and despite its stark severity is pathetically moving. In the presence of such a masterpiece, intensely individual and yet formally restrained, classical in its controlled rhythms, we can read the story of a man, an immigrant from distant, southern lands, who realized that he was not merely one of the pious masses but an artist with a duty both to the world and to himself, a duty to use his own great gifts to the full. In other words, with Theophanes, the first artist of whom we are truly aware in medieval Russia, the presence of a pictorial genius imposes itself on our consciousness (Plate 10).

This is even truer of a painter with whom the Greek must have come into contact when he was working in Moscow, Andrei Rublev (c.1370–1430), the first Russian artist of whose identity we have records. Rublev, a monk, began his career in the important St Sergius and Trinity monastery from which he moved to the Spas Andronikov monastery (now the Rublev Museum) on the outskirts of Moscow. Here he was exposed to the influence of the many Greek and Serbian painters who had arrived in the principality. About 1400 he may have completed the frescoes in the Cathedral of the Dormition in Zvenigorod and, in 1408, together with an older painter named Daniil Chorniy, he worked on the decorations of the Cathedral of the Dormition in Vladimir. Remarkable as were the frescoes he created throughout his life, it was as an icon painter that he excelled; and his masterpiece – perhaps the noblest of Russian icons – is his Old Testament Trinity (Plate 11; Col. Plate 3) painted about 1411 for the iconostasis of the St Sergius and Trinity monastery. Depictions of the visit of the three angels to Abraham and Sarah were popular in Byzantine art as foreshadowings of the Holy Trinity, but

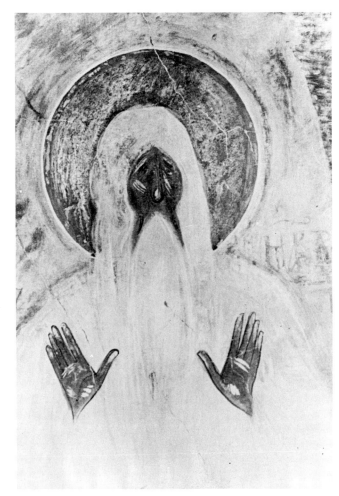

9. Theophanes the Greek: *St Macarius*, 1378. Fresco. Novgorod, Church of the Transfiguration

10. Theophanes the Greek: *Our Lady of the Don*, late 14th century. Tempera on panel, 33 × 26 cm. Moscow, Tretyakov Gallery

Rublev invested the scene with a dreamy grace and serene spirituality which are far removed from previous anonymous versions. The rhythms which arise from the stances of the angels seated at the table, their linked bodies and wings as well as the contrasts between the angular folds of their garments and the curves of their wings are echoed in the outlines of the trees, rocks and houses, while the joyful tints of the clothing and furnishings create a haunting impression of tranquil peace and spiritual harmony. The Russian critic and scholar Lazarev saw a connection between Rublev's icons and the northern landscape:

The colours of his palette are taken not from the traditional canons of colour, but from the landscape

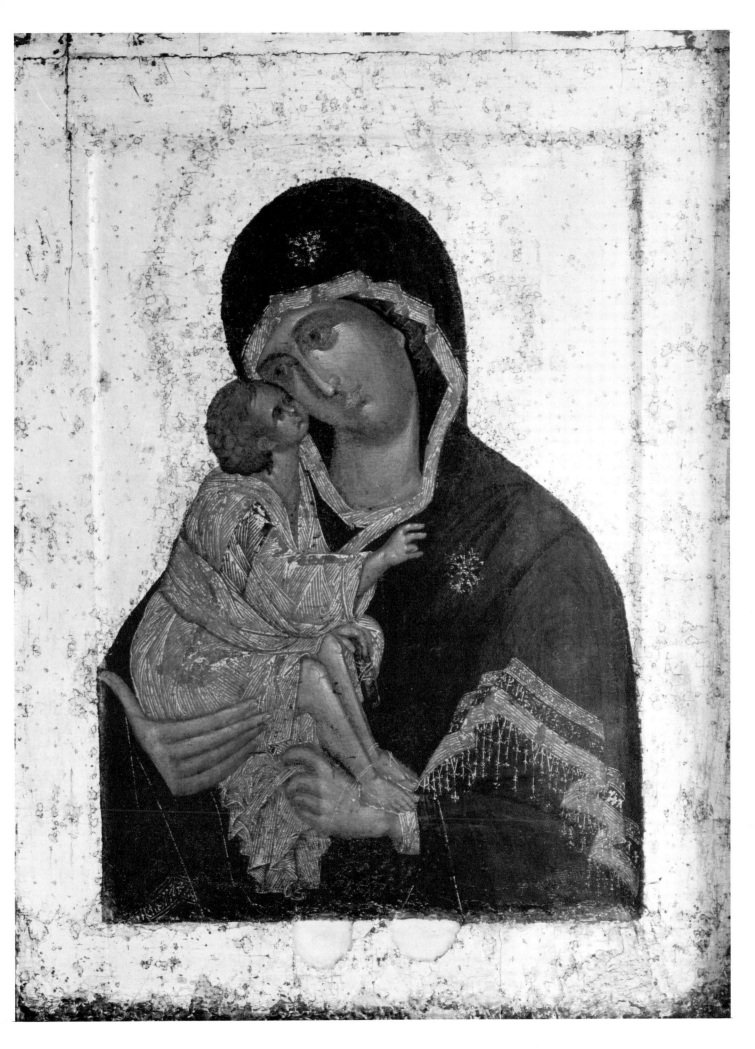

around him.... His marvellous blues are suggested by the blue of the spring sky; his whites recall the whites of the Russian birch trees; his green is close to the colour of unripe rye; his golden ochre summons up memories of fallen autumn leaves; and in his dense greens there is something of the twilight shadows of the Russian pine forests. All the colours of the landscape are translated by him into the lofty language of art.[3]

At approximately the same time, Rublev was painting the icons of the Saviour, the Archangel Michael and the Apostle Paul, works which are a revelation of his devout and unassuming personality as well as of his delicate religious fervour and which serve to show his understanding of the needs of the icon as a form in itself and of the nature of the iconostasis. At some unknown date between 1427 and 1430 he died in the Spas Andronikov monastery. In tribute to his life and work he was accorded the rare distinc-

11. Andrei Rublev: *The Old Testament Trinity*, early 15th century. Tempera on panel, 142 × 114 cm. Moscow, Tretyakov Gallery

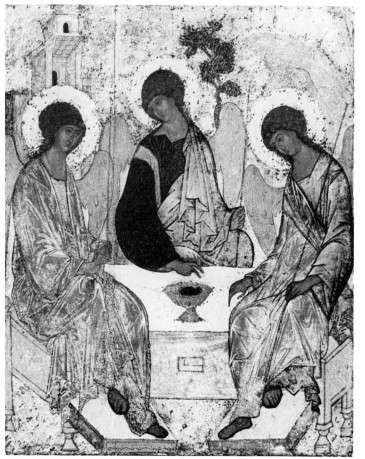

tion of beatification by the Orthodox church. Rublev's career has been justly appraised in these words:

A monk of the Monastery of the Holy Trinity, he nurtured all his life the precepts of the founder of that monastery, St Sergius of Radonezh, who had worked for peace and understanding among men. The images of Theophanes, tragic and full of inner conflict, probably had little appeal for him; his own strivings were towards an art which would be straightforward and lucid. Coming into contact during his lengthy career with those sections of Russian society which were most active in the struggle for total freedom from Tatar domination, Rublyov [*sic*] no doubt felt a keen awareness of the absolute need to break with alien traditions. He must have come to realize that this new era of national fervour also required a new art, which could express the thoughts and feelings of its time in forms not only entirely original but also aesthetically perfect. Setting out along this road, Andrey Rublyov was to become the greatest Russian master of the fifteenth century.[4]

Although it is true that Rublev's Old Testament Trinity was probably painted in honour of St Sergius of Radonezh, a leader of the struggle against Tatar domination, and he was, therefore, associated with national aspirations, his influence as an artist was no greater than that of Dionysius (*c*.1440–1508), who was his immediate successor. Rublev's gentle colours, the peaceful yet spiritual harmony of his composition and the absence of drama did not make for easy popularity although his reputation remained high.

The last years of the fifteenth century are dominated by Dionysius, who ranks with Theophanes and Andrei Rublev among the artistic geniuses of medieval Russia. He was a singularly prolific artist who employed a large number of assistants, among them his sons Fedor and Vladimir. Of his numerous works the only ones which now survive are the frescoes in the Church of the Nativity of the Virgin in the monastery of St Therapont (near the town of Kirillov in the Vologda region) painted in 1500–2, and those in the chapel of the Praises of the Virgin in the Cathedral of the Dormition in the Moscow Kremlin (although these are not always accepted as being by Dionysius); and a very small number of icons which are thought to be his by virtue of their distinctive style, which employs elongated, slender figures with tiny heads, hands and feet, and faces

unmarked by strong emotions. The *Crucifixion* (Plate 12) which he painted in 1500 for the iconostasis of the church in the Pavo-Obnorsky monastery is an excellent example of his ability to create a timeless moment of sorrow by exploiting an elegant but expressive distortion, swooning rhythms, and colour touched by a delicacy which a contemporary described as of 'surpassing refinement'.[5]

The successful career of Dionysius (himself, it is believed, rigidly Orthodox) coincided even more than that of Rublev with the initial development of a centralized Russian state, with Moscow as its all-powerful capital. The fall of Constantinople in 1453 had intensified Russian devotion to Orthodoxy, resulting in an ever-increasing call by the aristocracy and the merchant classes for icons of all kinds, especially the more decorative examples, and also by the common people who wanted them for their homes, however primitive or poor. Peace brought with it a remarkable growth in the prosperity of the state, which was accompanied to some extent by a sense of worldliness which seemed more and more at odds with the austerity of old Russia. In Dionysius' stately figures and his delicate colouring can be seen a hint of the decadence that was already threatening religious art, for he is too concerned with the pleasing, decorative aspects of colour and line, rhythm and pattern, and too little with the religious significance of the characters he depicts. Unlike Rublev he does not seek to portray contemplative mystery, but lives in a world of celebration and praise. He questions neither the outer world of appearances nor the inner world of the spirit. His faintly stereotyped and monotonous faces were to become the prototypes of the many tedious icons of the sixteenth century. But, for all this, Dionysius' icons with all their splendid sweetness and gracious dignity are correctly recognized as the last masterpieces of the Middle Ages (Plate 13).

Movements in style during this period were gradual but no less marked; and to a degree politically motivated. Ivan IV, the Terrible (1533–84), who had come to the throne at the age of three, decided when he was 16 not to be crowned as Grand Duke of Muscovy but as Tsar. He was determined to establish his authority by any and all means. To further his prestige it was ordered that ancient Orthodox works and relics from the outlying parts of the state should be brought to Moscow for safe-keeping and display. The Metropolitan Makariy transported the icon painters of Pskov and Novgorod to Moscow, housing them in the Oruzheinaya

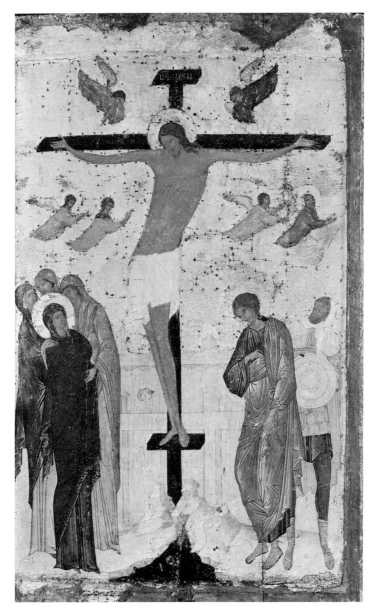

12. Dionysius: *The Crucifixion*, *c.*1500. Tempera on panel, 85 × 52 cm. Moscow, Tretyakov Gallery

Palata (Palace of Arms, or Armoury) where they were instructed in the painting of icons which should serve the glorification of the Orthodox church, the Tsar and the Russian state. Under the direct supervision of the Tsar and the Metropolitan these and other artists were ordered to supply decorations for the churches and cathedrals that were rising apace after the great fire which had destroyed Moscow in 1547, the year of the Tsar's coronation. When it was necessary to renovate the Cathedral of the Annunciation some of the damaged icons were repainted in a new style. Makariy was himself an

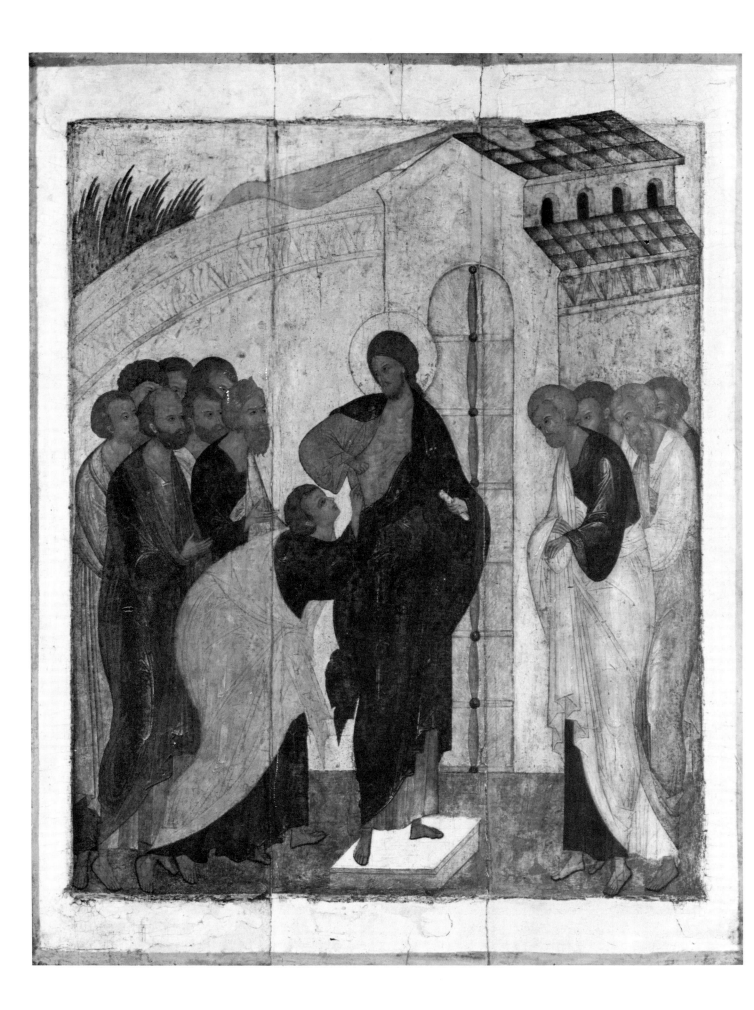

icon painter and a chronicler of the lives of the saints, and was able to influence religious art both in style and by the provision of new hagiographical material. There were hostile reactions from the more conservative ecclesiastical authorities which were largely stilled in 1551 when Tsar Ivan called a council of the clergy (later known as the *Stoglav* or Council of a Hundred Chapters)[6] which eventually published a comprehensive list of measures designed to re-establish orthodoxy in church ritual and art. Icon painters were to be 'humble and mild men, not given to vain words, who were to live piously and not indulge in quarrels or drink, who were to keep their souls pure and live under the supervision of their spiritual guides'.[7] Painters were forced into associations subordinate to the power of the church. Bishops were ordered to insist rigorously that master painters, craftsmen and apprentices should copy ancient patterns and not paint the Deity out of their own inventions. In an extraordinary concession it was decreed that Rublev's work should henceforth serve for a true model worthy of imitation — together with that of the 'Greek' painters.

Important for Ivan's control over church and state was the answer to his question whether it was fitting for figures of ordinary, living mortals to appear on icons beside those of sacred characters: the holy fathers gave judgement that this had been the practice in ancient times and that in 'icons of the Day of Judgement ... there appear the figures not only of saints but even of unbelievers ...'.[8] These ambiguous words of guidance sufficed. The image of the Tsar began to dominate icons as in the celebrated *Church Militant* showing Ivan IV, Constantine the Great, the Virgin Mary and Infant Christ, the Archangel Michael and the two legendary and saintly princes Boris and Gleb against a background of trees, the burning city of Kazan, soldiers and Jerusalem the Golden, the entire group certainly designed to validate Ivan's claim to be in the direct line of descent from the Byzantine emperors. A central chamber of the Granovitaya Palata (Palace of Facets) was decorated with pictorial genealogies, one of which showed that the Muscovite rulers were descended from Augustus Caesar, while another depicted the legendary scene of the Byzantine Emperor Constantine Monomakh sending the Imperial regalia to Prince Vladimir of Kiev.

There were other changes in subject-matter. Sacred and profane events were seen side by side in the new decorations in the Kremlin, most strikingly those of the Zolotaya Palata (the Golden Chamber) where violent indignation was aroused by a nude figure intended to represent Lust, which like other allegorical and religious elements found in icons and murals of the period must have been derived from Western engravings and woodcuts.[9] Symbols associated with Roman Catholicism began to appear on icons, as did new legends of the church. A typical instance of this trend is *The Vision of the Ladder* (Plate 14), which was inspired by John Climacus, abbot of a monastery on Mount Sinai in the seventh century, a guide to monastic life which is seen as a steady but difficult climb to salvation. In the icon the saintly author is seen reading his work to the assembled brethren, while on the right is the ladder to the open gates of heaven in which stand Christ, the Virgin Mary, John the Baptist and the Archangel Michael, who are gathering in the righteous souls who have succeeded in the ascent. Other popular subjects included the *Benedictus*, which enabled the artist to lavish his skill on animals and plants, real and imaginary, and the lives of popular saints, with various episodes and anecdotes related in a series of square panels bordering the central figure.

The extravagance, immorality and excessive worldliness now openly flaunted in church and monastic life was criticized in icons such as *The Parable of the Lame Man and the Blind Man* in which the blind man takes the lame man on his shoulders to pluck fruit from a forbidden tree, an allegory of the unrighteous pastors who fail to preserve the truths of the heavenly garden. But was the icon's function to extend the prestige of the Tsar? And was its true purpose to criticize the abuses in religious and public life? Its history, its traditions and its very nature hardly fitted it for such a task.[10]

Meanwhile towards the end of the sixteenth century there came into existence one last school of icon painting, the so-called Stroganov school. The name came from its association with the Stroganovs, an immensely wealthy family from Novgorod, much favoured by Ivan the Terrible who gave them large estates near the Urals in Siberia with permission to work the metals and salts there and to extend their trading empire beyond the mountains. It is ironical that worldly merchants should have patronized the last school of icon painting, but the Stroganovs were an exceptional family to whom several areas of Russian life were indebted, not least that of cuisine.

13. School of Dionysius: *The Convincing of Thomas*, late 15th century. Tempera on panel, 100 × 82 cm. Moscow, Tretyakov Gallery

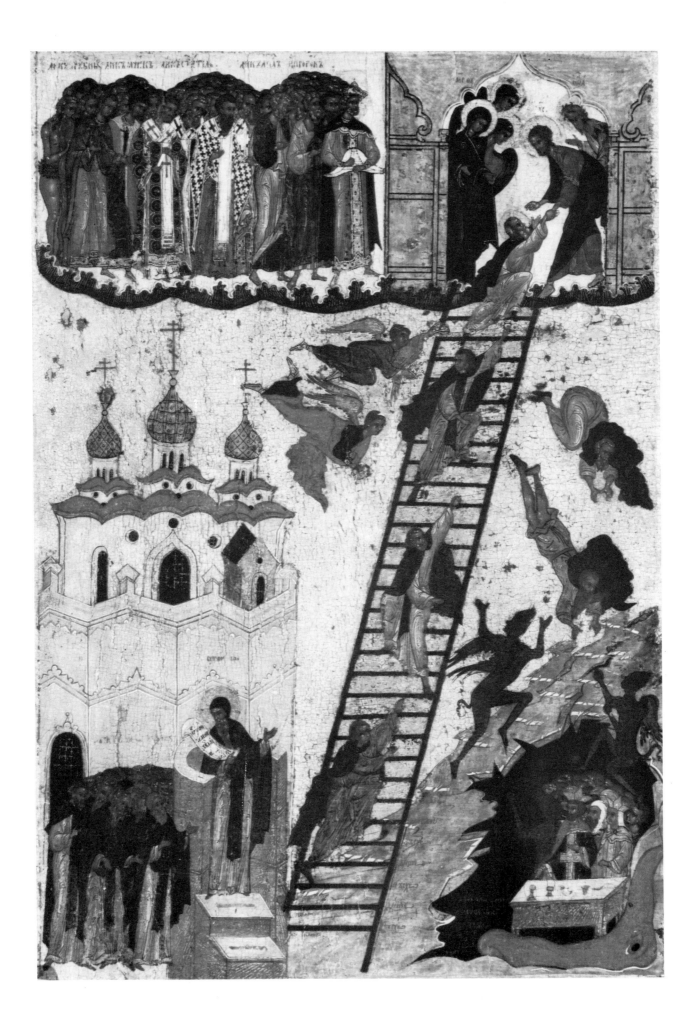

In particular, the cousins Maxim Yakovlevich (*c*.1550–1623) and Nikita Grigorievich (*c*.1550–1619) were generous in their encouragement and support. Through the treasures they had collected by means of their many trading links, the Stroganovs had come to appreciate Persian and oriental art; and this enthusiasm spread to their artists, who consequently developed a new style of icon, small in size, brilliant in colouring with a predilection for pale pinks, greens, brownish reds and yellows, vermilion and gold. These diminutive and ornamental works created for private collections and private patrons, and occasionally signed and dated, were filled with vegetation, animals, sacred characters, hills and intriguing architectural features of a peculiarly Russian kind, all lavishly embellished with gold. The sinewy but compact style is basically oriental – and one should never forget the extent and depth of the Tatar occupation of the country – yet there is also something of the elegance of Dionysius present (Plate 15). There are grounds, notably the expressive draughtsmanship, for considering these icons the last products of the Novgorod school of the later Middle Ages; on the other hand, the emphasis on repeated patterns and forms and the joyous use of colour indicate an even greater indebtedness to the schools of Suzdal and Moscow.

Thematically the Stroganov artists (and the term must necessarily include artists who never actually worked for the family or who were attached to other families in Moscow, perhaps even that of the Tsar Boris Godunov or the Metropolitan) relied on the new currents of theological dogma in the capital and above all on the narrative and emblematic conceptions offered by the Apocalypse and Book of Revelations. They were, in a general sense, didactic rather than elevating. The inclusion of secular material demonstrates some aspects of another issue which had opened up in Russian life, the growing struggle between Tsardom and Orthodoxy for control of the Russian destiny. In their attention to realistic details of vegetable and animal life, their concentration on individual saints who are portrayed as wholeheartedly engaged in worship and in spiritual exercises, their evident sense of spatial relationships, their visual depiction of doctrinal matters, and the self-consciousness which can

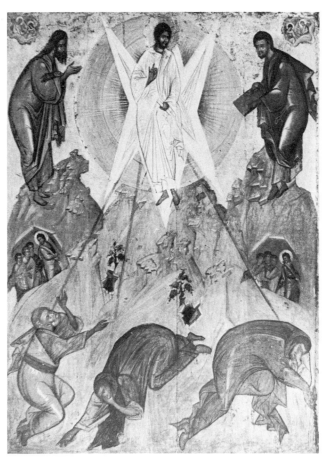

15. Icon of the *Transfiguration*. Moscow School, early 15th century. Tempera on panel, 184 × 134 cm. Moscow, Tretyakov Gallery

be glimpsed equally in style and in subject-matter, the Stroganov artists reveal an awareness, albeit limited, of artistic developments in the West.[11] Their advocacy of the painted surface of the icon was especially beneficial in the face of the all too common tendency to cover icons, especially new ones, with gold and silver decorations. In a sense the Stroganov school never died, for its icons served as patterns for succeeding painters even in the remotest provinces but particularly those in artists' villages, Palekh for instance, where religious artefacts and secular objects decorated in the Stroganov manner were turned out on a large scale as is still the case today.[12]

It is probable that the style of the school had affinities with the sophisticated skills shown by Russian illustrators of manuscripts. *The Illustrated Collection* (*c*.1550–70), commissioned by the Tsar, depicted the history of the world from its creation, but

14. Icon of *The Vision of the Ladder of St John Climacus*. Novgorod School, first half of the 16th century. Tempera on panel, 63.3 × 44 cm. Leningrad, Russian Museum

dwelt on the establishment of the Princedom of Muscovy and the neighbouring states. The six volumes which have been preserved contain something like 10,000 miniatures illustrating Russian life in the mid-sixteenth century. But already another art form had arrived which not even the power of the Orthodox church could banish: printed books with woodcut decorations began to appear in the 1550s. The skill of the miniaturist was no longer required. Woodcuts of religious and profane subjects began to occupy the artist's attention, introducing him to the problems of perspective, the anatomically accurate portrayal of the human figure, and the technical difficulties of engraving and printing. At the same time he lost the freedom to create time and spatial relationships which were impossible and unreal in the naturalistic sense but which were true to the psychological and spiritual truths he wished to express. The realism that accompanied woodcut engraving was one of the factors that most decisively spelled the end of the icon as the major art form of Orthodox Russia.

2
The Establishment of Moscow as Capital; the Decline of Icon Painting; and the Growth of Secular Art

It is all too easy to exaggerate Russia's isolation from the fifteenth century onwards. There is no evidence to support the theory held by some nineteenth-century art historians that Russian icons show the impact of Sienese art; on the contrary, it is probable that they inherited a common style from Byzantium. Yet West European influences were not unknown. From the reign of Ivan IV – that is, towards the end of the fifteenth century, after Tatar domination had been terminated – Russians had become increasingly aware of Europe. There had always been visiting merchants; ambassadors bearing gifts which were in themselves superb and representative examples of Western arts and technical skills; itinerant teachers; travellers from the West; imported artisans; and influential dynastic links. The example of Byzantium was only one of the several which Kievan Russia emulated. Throughout the country, along the lines of her rivers, were trading routes which opened Russia both to East and West. By the beginning of the sixteenth century there were contacts with European courts and many events in the West involved and affected her, even against her will. Among these were participation in the Council of Ferrara-Florence when the question of union between the Christian churches was discussed; the fall of Constantinople to the Turks in 1453; the marriage of Ivan III with a Palaeologan princess; the spreading of the Hussite movement into Russia; the establishment of various religious sects in the country itself; the insidious and much-feared spread of Roman Catholicism from Poland; and the activity of the Italian architects and builders hired by Ivan III to reconstruct the Moscow Kremlin and fortify its walls, which they did in the Renaissance style. On the other hand, Russia spread her own influences abroad; and her impact on icon painting in Macedonia and the Balkan countries has never been properly investigated.

The point is that Russia, in common with other European countries, was undergoing a political upheaval which was distinctly reflected in her cultural life. Not only was Moscow asserting its supremacy but its princes were fighting not merely for survival but for absolute control – and this was a struggle which brought them into direct conflict with the church. After the death of Ivan the Terrible in 1584 and during the reigns of Fedor (1585–98) and Boris Godunov (1598–1605), Russia was afflicted by disastrous harvests and general discontent which almost inevitably resulted in revolts and uprisings led by imposters and pretenders to the throne of Muscovy. With the connivance of boyars and landowners Poland (which had united with Lithuania in 1569) gained territory including Moscow itself; while the Swedes, then at the height of their power, occupied northern Russia.

Under the guidance of the Orthodox church there developed a movement for the expulsion of foreign oppressors and the re-establishment of Russian independence. This resulted in the election as Tsar (in 1613) of Mikhail Romanov, founder of the last dynasty to rule over Russia. The dangerous period of stress and tribulation, the Time of Troubles, began to draw to an end; but the country still faced difficult and convulsive days. The dynamism of Russian life during this epoch manifested itself in diverse ways: the union of the Ukraine with Russia which both enlarged and enriched the empire; the conquest of Siberia and the northern territories; expeditions to the East; closer trading links with the West and Near East; the importation of foreign technicians and tradesmen; the reconstruction of cities; and the physical growth of Moscow. As dangers ended the Muscovite princes regained sufficient confidence to disregard and deny the theocratic pretensions of the church. In this struggle for supremacy the two sides took up their own

individual positions with regard to icon painting: the church seeking to maintain the traditional styles and traditional subjects, theatening that 'he who shall paint an icon out of his imagination shall suffer endless torment', while the Tsars established their own workshops (emulating the example of such nobles as the Stroganovs), trained their own painters, and encouraged different styles and attempts to encompass within the nature of the icon the vast fields of knowledge and experience now being revealed to the Russian people through the ambitions of their temporal princes. The Tsars should have realized – but did not – that the icon was entirely unsuitable for their purposes.

Inevitably two opposing trends can be discerned in the art of the seventeenth century. On the one hand there was a quest for new forms which were to be secular in character and closer to ordinary life and untrammelled by the dogmatic traditions and artistic restrictions of the past; while on the other hand there was the ingrained and now more urgent need on the part of the church to maintain conventions, to erect the images of the past into systems which could not be questioned, to declare their absolute and unchanging validity, and to defend them against the malign influences of the forces of the contemporary world in which foreign religions and ambitious princes were thought to play too potent a role. These tendencies give the age its own particular individuality. Such conflicts were to be expected since there were also movements for reformation and counter-reformation within the Orthodox church, symptomatic, perhaps, of the fact that its power was on the wane. What one can say of Russian culture as a whole and of art in particular is that there was a growth of secularization during which the authority of the church diminished (except when it suited the Tsars to revive it), and that lay influences which were in close relation to everyday life asserted themselves. Not unexpectedly, though lively in character, the art of the age was clearly transitional.

An understanding of the struggle within the church is essential because of its repercussions on painting. Its power and authority were greatest in the mid-sixteenth century when, as has already been observed, it had fostered national independence, conferred religious approval on the reign of the Muscovite Tsar and theoretically acknowledged the right and duty of the state to act as guardian over the church. But as the state developed there was no corresponding change in the Orthodox church,

whose rigid formalism was inevitable in view of the abysmal standards of religious thought which had characterized it since its advent in Russia. When there were attempts at reform the consequences were bitter. The leading protagonist was the patriarch Nikon, consecrated in 1652, who determined to draw Russian Orthodoxy into closer unity with the Greek church as a whole and to eradicate the local practices which had crept into religious life and customs. He met fanatical opposition from among the credulous masses and clergy who believed that Moscow was the chosen centre of Christendom, that Russian Orthodoxy was the one true faith, and that its ritual and dogma were above criticism and in no need of reform. These arch-conservatives came to be known as the Old Believers. Archpriest Avvakum, their leader, opposed both Nikon and the Tsar, and after imprisonment and exile was finally burnt at the stake, leaving to his followers a heritage of unappeasable hatred of church and state which continued through the centuries.

One of the areas of conflict between Avvakum and Nikon (who was to fall from power himself) which had consequences for Russian art was that of icon painting. Without objecting to newer techniques, the patriach Nikon insisted that the subjects of icons should be copied from Greek-Byzantine models sanctified by age and tradition, thus in a sense reversing the decisions of the Stoglav council of 1551. He ordered icons with novel images, that is 'those drawn after the fashion of Frankish and Polish pictures',[1] to be brought to him, whereupon he pierced out the eyes of some and ordered others to be smashed and burnt even in the presence of the Tsar. Avvakum was also opposed to innovations, detesting the realistic representations of saintly and sacred personages. In a singularly vitriolic passage he stated:

> God hath allowed the wrong makers of icons to multiply in our land. They paint the images of Immanuel the Saviour with plump faces, red lips, dimpled fingers, and large fat legs and thighs, and altogether make Him look like a German, fat-bellied and corpulent, only omitting to paint a sword at His side ... and all this was invented by the dirty cur, Nikon, who contrived it to represent the holy figures on the icons in the Friaz or German manner.[2]

It will be remembered that the 'dirty cur Nikon' also attacked the 'Friaz' (Frankish) and Polish styles, and those 'imported by the Germans from the German land'. But neither of these men could stem the

advance of new developments. Avvakum was to die in 1682, and in 1666 the Tsar allowed Nikon to be imprisoned in a monastery. The regulations against new ideas and images in icon painting which were published in 1665 had come too late: they were ineffective and futile.

What we have been witnessing on the part of these religious leaders was an attempt (in which there were varying elements of xenophobia, religious fanaticism, and political conservatism) to preserve the purity and strength of Orthodoxy of which the icon was an integral part. In this they received little more than lip service from the Tsar Mikhail Romanov (1613–45) whose ambitions were opposed to the theocratic state which the church was seeking to maintain. He was himself the

agency for the secularization of painting in Russia, for he invited Polish and German artists to appear at his court and commissioned them to paint portraits and other works.[3] The influx of these artists increased after the 1640s; and the Russians they took as pupils were quick to incorporate Western techniques, styles and pictorial elements into the icons and other works they painted. This development was accentuated by the centrality of the painting schools and workshops. We have seen that when the extensive task of restoring the frescoes in the churches and cathedrals of Moscow damaged by fires and by Tatar raids had been undertaken in the sixteenth century there had been an order for artists from all over Russia to come to the capital, where they were housed in the Kremlin; the process was to be repeated when the restoration of the Cathedrals of the Assumption and of the Archangel Michael was carried out in 1653, 1657 and 1660, and a decree was issued that all painters who remained in the north-west should be sent to the capital, where

16. Simon Ushakov: detail from *The Holy Virgin of Vladimir*. Moscow School, 1668. Tempera on panel, 105 × 62 cm. Moscow, Tretyakov Gallery

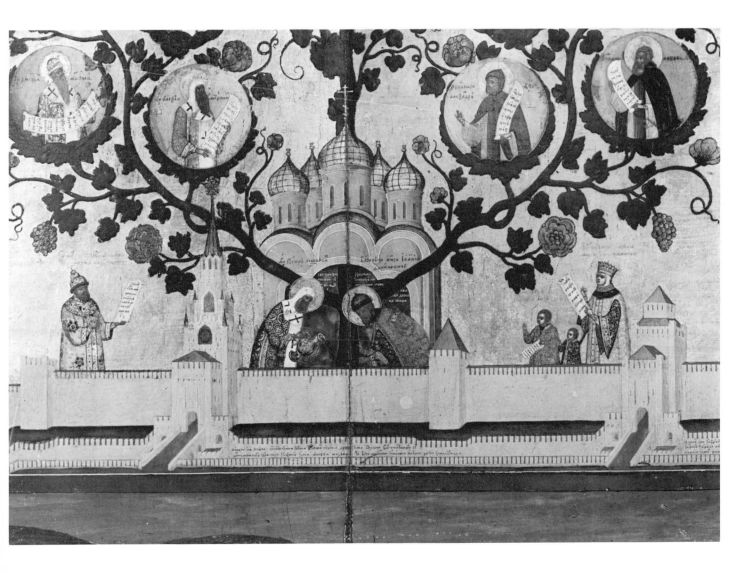

they were housed in government workshops for icon painting. A number of selected artists became members of the Tsar's household as his permanent, salaried and accredited icon painters. Thus, in effect, Tsar Mikhail Romanov had created an official academy whose members were under his absolute control. A special department of arts was set up to control these painters as well as those employed by wealthy and influential families.

The Tsar's workshop became the centre for new thinking on the arts. Among its members was Iosif Vladimirov, who campaigned for a fundamental change in artistic principles and practices. In his *A Treatise on Icon Painting* he attacked those ignorant painters who did not understand what was bad and what was good, who held on to ideas that were out of date, and who senselessly attributed a special virtue to those things that had long since fallen into decline and decay. He asked where these thoughtless lovers of tradition had discovered the injunction to paint the faces of the saints in an unchanging way, always with dark and swarthy faces. His concern, it must be noted, was technical rather than spiritual.

More important was Simon Ushakov (1626–86), a leading artist of the century. He was also a man of administrative ability who was appointed a court painter at the age of 21 and rapidly rose to become head of the Armoury school. To Ushakov we owe some valuable pages of art history, for he recorded details of the frescoes in the Kremlin when he restored or repainted them. His *Words to the Lovers of Icon Painting* called for greater veracity in representation. He created naturalistic illustrations to the Bible, of which the best known are the engravings representing the Seven Deadly Sins. His icons combined the traditional style of the old school with a superficial realism (Plate 16). In his *Saviour not made with Hands* (1657), a representation of Christ's Head on the Vernicle, and in his *Christ, the Great Archbishop*, he treats the head in a realistic, three-dimensional manner, working out in detail every feature of the face, the hair and even the folds of the cloth in the background. *The Trinity* (1671) uses Rublev's schema of the three angels seated at a table, leaning forward as if in discourse. Strangely enough, despite his views on icon painting, the colours he uses are dark and monotonous and the figures outlined in gold as if he were returning to an earlier style of painting, while in the background a solidly rendered tree and building show his attention to naturalism and command of perspective. The attempts at realism exact a price: his heads of Christ

17. Spiridon Timofeev: *The Annunciation.* Moscow School, 1652. Tempera on panel, 39 × 34 cm. Moscow, Tretyakov Gallery

are inclined to a dull and vapid sentimentality; and his *Trinity* lacks the harmony and profound religious significance of Rublev's icon of the same subject. Gone is the rhythm, the music and the spirituality, to say nothing of the magnificence and monumentality of the old icons.

Ushakov was evidently in request as a portraitist, although it is not known whether he worked from the model or from memory. Written sources suggest that he created portraits of the Tsars Aleksei Mikhailovich (1645–76) and Fedor Alekseevich (1676–82); and a leaning to portraiture is clearly evident in his depiction of the Tsar Aleksei and the Tsarina Mariya against the background of the Kremlin and the cathedral of the Assumption in his *The Tree of the Russian Kingdom*.

There were other somewhat earlier painters in the seventeenth century whose names are recorded. Emilyan Moskvitin was known for his free technique and for the richness of his harmonies, which has given rise to the term 'Emilyan manner' applied to icons painted by his pupils and followers. Prokopy Chirin who worked in Moscow for some thirty years after 1620 shows the transition from the old schools of Novgorod, Suzdal and Moscow to the

newer styles encouraged in the Armoury. Some distant knowledge of contemporary Western styles is revealed in his bright tones, liking for patterned fabrics and the smooth shading of facial features. Tikhon Filantiev, Nikita Pavlovets, Fedor Zubov and Spiridon Timofeev (Plate 17) also shared in this movement in which simplicity and restraint, austerity and faith, gave way to an excessive preoccupation with elaboration and detail. Simple, pure colours were rejected in favour of rich schemes derived, it may be, from oriental and Persian art. Backgrounds became crowded with rows of saints and vistas of the wondrous churches and bulbous domes of Moscow. The old simplicity and nobility of design were increasingly usurped by a vulgarity which was frequently tastelessly ornate. Icon painting lingered on until 1917 but without any true inner life.

An important Russian critic has written of this period:

> It seems that Russian art, living in the atmosphere of religious exaltation, stood at that moment on the threshold of another revival of Christian painting, similar to the one experienced in the West during the fourteenth and fifteenth centuries. Had it been left to its own devices, Russian art perhaps could have followed the same path as that of Western art, and three or four centuries later would have attained its classical epoch.[4]

There is not the slightest justification for this statement. Russian artists of the seventeenth century were only too keen to surrender themselves to Western styles and, indeed, were encouraged to do so by the Tsars; and the chances of a revival of religious art in that period of increasing secularization were something more than remote. To other critics the advent of naturalistic and realistic detail has been welcomed as part of an inevitable historical process and, therefore, an achievement of revolutionary importance whereby Russia was able to participate fully in the major trends of European art. It is believed by these critics that a realistic awareness of everyday life is a vital aspect of the Russian character which necessarily finds expression in the art of the people, whereas the religious mysticism and significant abstractions of the icon were totally alien, an exotic importation from Byzantium. Inevitable the decay of icon painting may have been and to regret it is futile, but the fact remains that Russia had lost an art which she had made entirely and peculiarly her own.[5]

One way which artists found of avoiding the fulminations of both the Old Believers and the followers of the patriarch Nikon was to concentrate on secular work, for which there was a growing demand. It will be remembered that in 1551 Tsar Ivan IV had asked the Council of Stoglav whether it was permissible to make portraits of people still alive and had received an affirmative answer. In consequence, portraits of the Tsars began to appear on icons together with the main religious matter. There also came into existence a new art form – the *parsuna* (from the Latin *persona*), the representation of an ordinary and living human being. This was something of a cross between an icon and a realistic representation, though it was not a portrait in the usual sense; and the distance which separates it from sixteenth-century English portraits of, say, Queen Elizabeth I is not so great as might be imagined.[6]

The Ukraine – home of much that was new and progressive in Russian life – and Moscow were the centres in which the *parsuna* and other represen-

18. Parsuna of *Prince Mikhail Skopin-Shuisky*. Moscow School, early 17th century. Tempera on panel, 105 × 62 cm. Moscow, Tretyakov Gallery

19. *Portrait of Yakov Turgenev*, late 17th century. Oil on canvas. Leningrad, Russian Museum

tational forms were developed. Generally speaking, the *parsuna* was painted, as were icons, on wooden panels, but canvas was occasionally used. The figures were drawn in a rigid manner, without any sense of physical life, and with no attempt at perspective. The comparatively widespread introduction of the *parsuna* is evident when one reads that in 1655 the tombs of the Archangel Cathedral had hung above them 'a figure of the occupant as he was in life'. The identity of the artist was of little or no concern; and his name is rarely recorded.[7] That there was considerable variety may be proved by comparing the formal and less realistic portraits of Tsar Aleksei Mikhailovich Romanov on icons of the time with that of the seventeenth-century statesman and soldier Prince M. V. Skopin-Shuisky (Plate 18) whose round face, tight lips and somewhat oriental eyes suggest the veracity of the portrayal, and also with the life-size *parsuna* of Prince V. F. Lyutkin (1698), painted on canvas, which shows a close relationship with Western techniques. Clearly Russia was moving towards a genre at which her painters were to excel, that of portraiture. But it is absolutely imperative to note that the *parsuna*, a bastard form of the icon, was born of an Imperial need, brought into existence to serve the greater glorification of the Muscovite rulers, and that its purposes were radically secular. Although there were strong stylistic influences emanating from Persia and Armenia on the *parsuna* and its birthplace was probably the Ukraine rather than Moscow, it seems in spirit to be entirely Muscovite and to be innovatory rather than conservative (Plate 19). As far as icon painting and religious art were concerned Russia had reached the end of a road from which there was no return; and perhaps this was inevitable when one reflects that despite the growth of the Papacy, the Reformation and the Counter-Reformation there was a continuous decline in religious painting throughout Europe. Yet the art of old Russia had not died out altogether, for folk art and culture remained comparatively untouched and even prospered during the next two centuries; but icon painting which was also an art of the people never regained its former grave splendour. This was an immeasurably tragic loss to Russian art. One can sympathize with the heartfelt postscript which the patriarch Joachim added to his last will in the year 1690:

I herewith beseech and entreat Your Exalted Tsaristic Majesties to decree that the holy pictures of the God Incarnate Jesus Christ, of the holy Mother of God and of all the saints be painted in the old Greek manner, in which are painted all our old miracle-working icons, and that they are not to be painted according to the vexing, recently invented indecent conceptions of Latin and German pictures, which are due to the sensuality of those heretics, and which are contrary to the traditions of our church. Should pictures of this kind be found anywhere in the Empire in one of our churches, it is essential to throw them out....[8]

The beauty of Russian icons and the devotion, both artistic and religious, which they arouse is often a source of bewilderment to art-lovers who despite a catholicity of taste find the apparently stereotyped figures and backgrounds and the dark tones which have crept over some of the older examples a matter for repugnance rather than admiration. This is understandable, especially in view of the poorer icons, particularly those dating from the later nineteenth century, which are to be seen in salerooms and galleries. But the art-lover who is fortunate enough to find himself in a great Russian museum such as that of Leningrad cannot fail to be enthralled by the ravishing beauty of the icons, so confidently grand, so serenely grave, and so strikingly decorative not only in the lavish use of pure gold and silver but also in the harmony of their pinks, greens, yellows, browns, blues and reds, and in the wonderful assonances that arise from colours of natural origin gathered and extracted from plants and rocks and earths and which age has soothed and united in joyous but solemn chords. Moreover, the sheer sizes of these works impress, ranging as they do from the monumental to the minute. Never do they lose the quiet authority invested in them by the painter, the artist-believer whose bequest to the world and posterity remains an everlasting joy. This was the art which Russia put behind her in the seventeenth century – unwillingly and sadly on the part of the patriarch Joachim and others whose similar prayers were lost to the winds.

As has been suggested the craft of icon painting never died in the actual sense since icons were produced up to the 1917 revolution. But the operative word must be 'produced', for no longer were they painted with the love and devotion that had been significant elements in the act of creation in former times. Many of the leading painters of the nineteenth and twentieth centuries began their careers as humble assistants in icon-painting factories such as

that attached to the Pecherskaya lavra in Kiev; and if they learnt little that was progressive they may at least have acquired a modicum of technical skill which would be useful when they branched out into secular areas of painting. Some artists were to learn more: Goncharova, for instance, was to adopt the icon style in a number of her early canvases, and Malevich may have derived the cruciform image he frequently used from the icon. The vivid colours, the linear characteristics, the very simplification of line, the stylization of figures and landscape and the emphasis on the surface of the painting may have contributed to the art of the early twentieth century throughout Europe, although the fact that some of the leading artists were Jewish and brought up in strictly religious homes in which icons would be detested and abhorred for their representational character should restrain us from overstressing the icon as a pervasive or as a direct pictorial influence. Only too often the interest in the icon was in its decorative, 'furnishing' quality; and its revival in the twentieth century was without lasting or ultimate significance.

To return to the seventeenth century, it must be stated that it saw the establishment of firm contacts between Russian painting and the art of the West:

Engravings, buildings and treatises on architecture, realistic pictures which displayed a complex system of perspective and chiaroscuro, all these things of Western origin, began to penetrate and invade Russia on an increasingly large scale. All of this awoke and stimulated thought, encouraged research of a new kind, emboldened men to break with a worn-out and exhausted tradition. Thus it was that at the very heart of Russian culture of the seventeenth century the ground was prepared for the coming reforms of Peter the Great.[9]

The art of Byzantium which had withstood the sturdy reaches of the Romanesque as well as the more nebulous fingers of the Gothic had gone forever as a vital force in Russia, maimed, weakened and destroyed as it had been by the Muscovite princes; and Russia, bereft in the main of an art of her own, had now to fight for a place in the field of European art.

3
The Triumphs of Russian Painters
in the Eighteenth Century

Before the course of painting in eighteenth-century Russia can be fully appreciated it is necessary to glance at conditions in that country at the beginning of the century. Peter the Great, born in 1672, son of the Tsar Aleksei, was declared Tsar at the age of ten, married at the age of 17 and at the age of 18 became the father of a son whom he was to murder some 28 years later. A man of incredible and near-intolerable energy, he reigned for 43 of the 53 turbulent years of his life over a country which had been exhausted by conflicts of all kinds, social, religious and ethnic. Conditions in Russia have been dramatically catalogued:

> Both depravity and illiteracy seem to have been ubiquitous. Women were universally secluded; the Kremlin had the look of a monastery, a night-club and a bazaar all at once. Since reading was virtually unknown, especially for secular purposes, there was no standard of education that meant anything at all. There was no question of any knowledge of Latin or Greek even in the highest clergy. A great many noblemen could not read at all.... The cultural level was so low that no social differentiation could be based on it. Boorishness was the keynote of all milieux, from peasant to nobleman to priest. Aristocrats and plebeians were much the same in manner, while moral standards, such as they were, indicated few graduations in behaviour from one end of the social spectrum to the other.[1]

Although Peter was born in Moscow, he hated the city and visited it as rarely as possible. It was only towards the end of his reign that he had a new capital in St Petersburg. Founded in 1703, perhaps in emulation of two centres of European culture, Amsterdam and Venice, it is built on mud flats, marshes and wooden piles driven deep into the quagmire edges of the river Neva, and cost the lives of many thousands of peasants and serfs forced to labour there. This city was the great window through which Peter intended to look into Europe; and through which he eventually imported everything he needed for his policy of Westernization.[2]

Opportunist as he was, Peter had a genius for government, which is more than can be claimed for the majority of his successors down to the revolution of 1917. A man of absolute directness with little time to think of anything beyond the emergencies of the moment, the laws he put into effect were to serve Russia for over two hundred years. By the slaughter of his son Aleksei and his decree in 1721 that each ruler had the right to elect his own successor, Peter made of the throne of Russia a gigantic lottery. The social evils of his country, chief among them serfdom, were already notorious; and Peter aggravated the complex situation by creating a new governing class, a land-owning gentry, with absolute power over the subject population below them, and followed the example of Louis XIV (who also detested the city in which he had been brought up) by obliging this class to live at court away from their lands. Thus was created a powerful body which had a vested interest in maintaining the social order and in supporting the autocracy of Peter and his successors, ensuring that their own welfare was not in any way threatened.

On Peter's death in 1725, which was followed by violent struggles among the various claimants, the throne was taken by his second wife Catherine, a Lithuanian servant girl who had proved herself a loyal comrade both at court and on the battlefield but who had no right whatsoever to the succession. Two years later it passed to Peter's grandson Peter II, son of the murdered Aleksei. When Peter II died in 1730 at the age of 15, the throne went to his distant cousin Anne of Kurland, a childless widow unfitted for government. On her death in 1740 her grand-nephew Ivan VI, a baby not yet one year old,

was proclaimed Tsar only to be dethroned before his second birthday. The crown then reverted to Elizabeth, the pleasure-loving daughter of Peter the Great. When she died in 1761, unmarried and childless, the election fell on her stupid nephew Peter III, who was ousted within the year by his wife Princess Sophia of Anhalt-Zerbst, who had taken the name of Catherine on her acceptance of Orthodoxy. Although a German with no right to the Russian throne, she proved herself the only ruler of the country comparable in ability to Peter I. Of the latter's immediate successors three were women of limited political capacity and only moderate interest, one a boy of 12, another a baby, one a near idiot and the last, Catherine, something of a political genius. Squalid and witless adventurers were one after the other planted on the throne by a ruling class which sought more and more to maintain its power in the face of millions of starving serfs who were bought and sold, tortured and executed at the absolute whim of their masters. None of these monarchs was in a position to check or even challenge the power of this class, which took advantage of the fact to free itself from all public responsibility both to the social and economic groups below it and to the state itself. Catherine II alone had the ability to curb its power and frequently intended to do so, but her foreign birth precluded her from reforming the vicious social system she saw about her or from opposing the class which had chosen her as sovereign and maintained her in power.

A historian has cried, 'Who would take this miserable record as the history of a people?'[3] He might have asked how in these circumstances there could exist a culture of any kind. But culture there was, however slow and tortuous its growth. There was, as has been mentioned, a folk art which expressed itself in various ways, in embroidery, decorations, the interiors of peasant huts and in popular prints from woodblocks known as *lubki*, rather like the English ballad broadsheets; but the unsettled and wretched conditions of peasant life did not aid the development of a folk culture to which, in any case, the upper classes were quite indifferent. As for literature, in 1726 only seven books were printed in the whole of Russia; but by the end of the 1750s about 23 were printed each year; and towards the end of the 1760s the number had increased to about 150, of which almost half were secular, a contrast with the beginning of the century when books printed in Russia were, with rare exceptions, entirely religious in character. It was Peter himself who corrected and

simplified the Russian alphabet for general use, edited the first public newspaper, ordered the translation of technical books, and brought out a manual on social behaviour. A certificate of education was made compulsory for the marriage of the gentry. Thousands of young Russians were sent abroad to study and European experts imported by the hundreds. When Peter I travelled in Western Europe in 1697–8 he stayed in Holland, London and Vienna, tireless in his desire to know everything that was to be known, especially if it concerned a practical craft like shipbuilding. His mission, actually led by his friend the able Swiss adventurer François Lefort, and in which he travelled under the name of Peter Mikhailovich, carried a crest with the words: 'I am among the pupils and seek those who can teach me.' To this end he visited factories, shipyards, picture galleries, anatomical theatres and commercial institutions of all kinds. He had numerous portraits made of himself; and in London posed for Kneller.[4] His stay in Vienna was cut short and a projected visit to Venice cancelled when he had to return home through Poland to put down yet another revolt. To punish the insurgents Peter ordered that all beards should be shaved off and that no one should enter his presence with a beard, on the wearing of which he imposed a tax.[5] The old Russian costume of his army was replaced by one of European pattern. He himself always wore European clothes, symbolic of his admiration of the Western way of life he had done so much to encourage and implant in Russia.

When Peter inaugurated his capital of St Petersburg (after vanquishing the Swedes from the old fort of Nyenschanz), he intended to make his city as civilized as any in Europe. This was to be done mainly by the erection of fine buildings and palaces, somewhat in emulation of Versailles, but also by the creation of a school of Russian painting. To achieve this he tried to persuade foreign artists and architects to come to Russia both to work and to train artists; while from Russia he despatched promising young boys for an artistic education abroad. Aware that there was hardly a Western picture or work of art in his empire from which painters could copy and learn, he resolved to start a picture collection. Practical as ever, Peter took effective steps to implement his policy. In 1702 he issued a manifesto inviting European artists to come to Russia where they would be granted special privileges. In 1711 he tried still more firmly to establish his new capital as the artistic centre of Russia by transferring there the

official icon workshop from the Armoury in the Moscow Kremlin.[6] He intended to use this body as the basis of an art school, although in effect it was not until after his death that in November 1757 an Academy of Arts was opened by Count Ivan Shuvalov.

From the first Peter determined that painting, sculpture and architecture should be the means of establishing the validity, prestige and permanence of the new Russian state he was engaged in forging. For this purpose he sought craftsmen of a practical nature and with a command of several arts. He wanted portraitists and history painters; and as far as his collection was concerned he rejected the hagiography peculiar to much of the baroque art of Western Europe. Peter had no wish to alienate the Orthodox church without good reason; and, in any case, despite the wildness of his youth, he was a pious man who loved singing in the church choir and who even had a temporary chapel made in his home during his last sickness. He wanted portraits of himself and of his wife and the eminent men and women of his court, engravings, topographical views and architectural drawings. There is no evidence of any desire to create a specifically Russian form of art or to build on the traditions of the icon; such a course would have been anathema to a man who devoted much of his life to fighting and eradicating the forms of old Russia. He appreciated the most commonly accepted forms of international art and had, it must be admitted, a pronounced leaning towards work of an immediately practical nature. His policies were continued by his successors at an even more emphatic pace, partly because they saw in the exploitation of art the same advantages that Peter anticipated, and partly because their tenuous hold on Russian society and their basic political impotence left them free to indulge in extensive if somewhat whimsical patronage.

When Peter the Great began buying pictures he initiated an activity which was to have an immense appeal to the extravagance of Russia's rulers in the eighteenth century. On his first visit to Holland in 1697 he was much taken with the marine pieces of Ludolph Backhuysen and Adam Silo and, as might have been expected of a man so devoted to all things connected with the sea, retained an affection for these paintings all his life. Later he was to command the purchase of works by another marine artist, Adriaen van der Werff.[7] In 1715 he sent his agent Yury Kologrivov to Holland to buy pictures to line the walls of his newly built pavilion of Monplaisir

in the park of Peterhof. In 1717 Kologrivov purchased 43 pictures at The Hague and another 117 at Antwerp and Brussels. Count Yarakin, Ambassador at The Hague, and Osip Soloviev, commercial agent at Amsterdam, acquired another 120 works from dealers and at auctions. These transactions were closely watched by Peter and on his second visit to Western Europe in 1717 he not only inspected the pictures that had been bought for him but personally attended auctions and visited artists' studios. He was responsible for the purchase of the superb *David's Farewell to Jonathan* by Rembrandt, the first of many works by the artist to be acquired by Russia. The rooms at Monplaisir were overflowing by 1721 and pictures were taken to the Hermitage pavilion or kept in storage. In 1724 a small picture gallery of 119 poorish Dutch and Flemish works was opened in St Petersburg, the first public gallery in Europe.

The purchase of works of art was continued by later monarchs on a massive scale. It was to have important repercussions on the development of painting during the eighteenth century, since Russian artists were allowed to study and copy the new acquisitions, a practice which confronted most of them for the first time with perspective and chiaroscuro and which also brought them into line with a recognized aspect of art training as practised throughout Europe.

Although he was successful in buying works of art, Peter was less fortunate in buying artists, probably because of the unhappy experiences of the disgruntled technical experts whom he enlisted and to whom both exit permits and wages were denied when they wanted to leave. His agents sounded many of the leading European practitioners without scoring any great results. The Czech Jan Kupetsky (1667–1740),[8] one of the ablest portraitists in central Europe, painted Peter at Karlsbad but refused to follow him to Russia. The Swabian Gottfried Dannhauer (or, more probably, Tannhauer) (c.1680–1733/7), a man of many trades, clockmaker, sculptor, musician and miniaturist, exactly the kind of worker Peter tried to attract to his court, was engaged and spent the rest of his life in Russia. He had studied in Italy under the Venetian Sebastiano Bombelli (1635–1716), from whom he may have learnt an intimate but direct style of portraiture. He was working in Holland when Peter met him there in 1697, and came to Russia in 1709. Of the few existing works attributed to him the portrait of Peter and his wife has a competent

sobriety which might also be said of his touching portrait of the ill-fated Tsarevich Aleksei, and of *Peter the Great on his Death-Bed*; and, perhaps equally deservingly, of the *Battle of Poltava* which is sometimes claimed for him. He is mentioned as a teacher; and one may hope that this activity and his other talents compensated for his deficiencies as a painter.

Towards the end of his life Peter had begun to make overtures to France as part of his political manoeuvring, and with hopes of marrying his daughter Elizabeth to the future King Louis XV visited Paris in 1717, and was overwhelmed by Versailles and other palaces of the French monarchy. Whereas he had formerly adopted Dutch and German names for his palace and city, he now proclaimed his enthusiasm for French culture by christening the pavilions in his park at Peterhof with such names as Marly, Monplaisir and Hermitage. He also tried to recruit French artists. J. M. Nattier (1685–1766) was asked to go to Amsterdam in 1717 where he painted for Peter a *Battle of Poltava*, his sole historical picture, which so enchanted the monarch that he commissioned a portrait of his wife, begun in The Hague and completed in Paris. Despite a tempting offer, Nattier excused himself from visiting Russia. J. B. Oudry (1686–1755), who executed a portrait of Peter from sketches, agreed to come in company with Louis Caravaque, the architect J. B. Leblond (1679–1719) and the decorative painter N. Pineau (1684–1754), but changed his mind and withdrew at the last minute. Caravaque (d.1754), born of a family which had worked at various branches of the decorative arts in Marseilles for over a century, was engaged by Peter's agent Konon Zotov for three years but remained in Russia until his death. He planned theatrical entertainments, painted ceilings for the Winter Palace, designed tapestries and executed portraits of members of the royal family. Equally valuable was the teaching he gave in the art department which had been established in the Academy of Sciences and where he evidently spread the rococo styles of Rigaud and Largillierre.[9]

It was not until 1716 that the first group of young Russian artists sponsored by Peter left for training in Europe. The Nikitin brothers went to Italy; Andrei Matveev accompanied by the architects Ustinov and Korobov went to Holland; and the engraver Stepan Korovin went to France. They went as an act of faith on Peter's part, for they were hardly more than boys and, in fact, he was to see little of their work during the remainder of his life. Of these fledglings it was probably Andrei Matveev (1701–39), member of an aristocratic family, who in his short life seemed to show the greatest promise. After studies at the Antwerp Academy of Arts he went to Rome before returning to St Petersburg in 1729. The unfinished *Self-Portrait of the Artist and his Wife* (1729) shows that he had learnt something of the modified baroque popular in Holland, such as we see in the work of Lely and Kneller. There are indications that he also worked on icons for the new Cathedral of Peter and Paul at St Petersburg, which may account for his comparatively scarce output of easel pictures.

Of the brothers Roman and Ivan (Maximovich) Nikitin sent to the schools of Venice and Florence there remain few works which can be attributed with any certainty. In fact, the careers of these artists are ill-documented; and even the dates of their births are uncertain. Ivan (*c*.1680–1742) began his career as a singer in the court choir and then had some training in art, possibly at the hands of Gottfried Dannhauer. The flat, awkward *parsuna* style evident in his *Portrait of the Tsaritsa Praskovya Fedoróvna* (*c*.1714) gave way after his study under Tomaso Redi and other masters in Italy to an unpretentious and straightforward but naturalistic presentation as in his portraits of Peter, the finest being painted at Kronstadt in 1721. So little difference is there between his work and that of Dannhauer that both have been credited with the painting of *Peter I on his Death-bed*. A *Battle of Kulikovo*, probably the first example of history painting in Russia, which has been claimed for him, seems to indicate that this genre came even harder to these pioneer Russian artists than it did to its uneasy practitioners in the West. In a single painting, *Portrait of a Hetman* (Plate 20), Ivan Nikitin showed his command of Western techniques, particularly of the Dutch Rembrandtesque school, as well as a distinctly personal eye. The rough skin and features of the soldier and his untrusting dourness are admirably observed and conveyed with masculine forcefulness. Ivan Nikitin was exiled to Siberia in 1736, and the cause of his offence still remains doubtful, although it is thought that he had identified himself with the religious movements opposed to innovation in Russia. He was recalled by the Empress Elizabeth on her accession in 1741

20. Ivan Nikitin: *Portrait of a Hetman*, *c*.1720. Oil on canvas. Leningrad, Russian Museum

but died on the long journey home.[10] His brother Roman (*c*.1680–1753), an even more shadowy figure as an artist, had eschewed St Petersburg and preferred to work in Moscow, where there was considerable patronage among the old aristocracy who favoured the *parsuna* style in which, to judge from the portraits of the Stroganov family attributed to him, he showed an obvious ability (Plate 21).[11]

Peter's reign was followed by a period of mediocrity in all aspects of life until the enthronement of his second daughter Elizabeth (1741–61), whose domestic and foreign policies were essentially a continuation of those he had initiated. A little of her father's genius had descended to her. She was capable of the large gesture and abolished for ever the death penalty, although it was later to be reintroduced for certain military and political offences. As one of her principal advisers she chose Count Ivan Shuvalov, an enlightened statesman of the highest integrity, under whose guidance she carried through a remarkable programme which included the foundation of the first Russian university, that of Moscow, in 1756. Living in apartments which were chaotically untidy, the floors littered with unpaid bills, the wardrobes stacked with some 15,000 dresses, perpetually on the move from temporary palace to palace, from debauches, masquerades and hunting parties to shrines and monasteries, with arrears in the budget in 1761 amounting to eight million roubles, she delighted in collecting and commissioning paintings and was to rebuild the Winter Palace in St Petersburg at the cost of ten million roubles.

Elizabeth had no love of the petty German courts which littered Russia's southern frontiers and against which there was a national revulsion after the reign of the Empress Anne (1730–40), who had been notorious for the German favourites she had collected round her. An impertinent remark of Frederick the Great brought Elizabeth into a coalition with France and Austria to dismember Frederick's small kingdom. The floodgates were opened to the dominance of French culture, although the Empress also welcomed Italian practitioners to her court. Encouraged by Shuvalov, she carried out her father's project of founding an Academy of Fine Arts and in 1757 ordered the Senate to publish a *ukase* (decree) establishing the Academy of St Petersburg which, nevertheless, was to remain an administrative department of the new university of Moscow until 1763.[12] She increased the powers of the Imperial Office of Building which,

in addition to erecting and maintaining palaces and other public buildings, was responsible for commissioning and supplying decorations of all kinds, among the more interesting being the ephemeral arches and settings for theatrical events and allegorical festivities. She opened picture galleries in the palaces of Oranienbaum and the new Great Palace on the outskirts of St Petersburg, which was later to be called the Catherine Palace and eventually, together with the Aleksandrinsky Palace, became known as Tsarskoe Selo (Village of the Tsar), now known as Pushkino.

Elizabeth was hardly more fortunate than her father in finding native artists in sufficient numbers and of sufficient merit for her needs. As her major artist she had Ivan Vishnyakov (1699–1761) who worked on the decoration of many buildings in the capital but whose portraiture was still tied to the *parsuna* style, as is shown by the pictures of William and Sarah Fermor which are among the works with which his name is linked. He displays a decorative sense in his pretty, somewhat naïve depiction of this young girl in a dress of turquoise watered-silk (Plate 22). His career is still a matter of conjecture.[13]

The deaths of Matveev and I. Nikitin created a hiatus which was temporarily filled by a lively and intimidating flow of foreigners of varied nationalities and even more varied abilities. The brothers George Christopher and Johann Friedrich Grooth arrived in 1743 and worked on decorations for the palaces being erected or rebuilt. George Christopher (1716–49) also painted portraits, among them one of the Empress (1745), while his brother in addition to producing animal and bird studies acted as an agent, particularly when 115 works of art were purchased in Prague in 1745. From Italy in 1742 came Giuseppe Valeriani (d. in Russia, 1761), a Venetian decorative artist of some renown; Pietro Rotari (1707–62), in 1756; and six years later Stephano Torelli (1712–84), who, like Rotari, had studied with the Neapolitan master Francesco Solimena.

Count Pietro Rotari, for whose travelling expenses alone Elizabeth was obliged to pay the enormous sum of 1,000 gold roubles, was her most talented and productive acquisition. A pupil of Antonio Balestra in Verona, of Piazzetta in Venice, Trevisani in Rome and Solimena in Naples, he came

21. Roman Nikitin: *Portrait of Madame Stroganov*, early 18th century. Oil on canvas. Leningrad, Hermitage Museum

trailing clouds of glory, well qualified to demonstrate the typical curriculum of an eighteenth-century Italian atelier.[14] His portraits are usually fairly small, presenting the head and shoulders against a minimal background with the sitter, invariably a girl, presented in a rather coquettish pose, smiling, crying, dozing or gazing in seductive innocence from half-closed eyelids. The palette is almost always composed of greys, soft browns, olives, pinks and blacks, with white highlights used on eyes, pearls and lace. Elizabeth presented 50 such heads to the newly founded Academy of Arts. Her successor was to gather together 360 portraits at Peterhof in a gallery aptly entitled Cabinet des Muses et des Graces so that the palace held, it was claimed, some 863 pictures by Rotari, the majority depicting young and charming girls of various ethnic types. The production of so many works in six years argues massive duplication, incredible industry and an army of assistants. By the simplicity and directness of his style, Rotari greatly influenced the younger Russian painters of his day, most of whom studied in his studio; and he created a taste, not unlike that exemplified by Greuze, for pictures of young girls in coy, not to say simpering, poses.

Until the Revolution the majority of French painters were fully occupied in their native land with commissions from the court or the wealthy bourgeoisie, but Louis Tocqué (1696–1772) stayed in Russia for two years and painted a number of portraits.[15] He was followed immediately by Louis Joseph le Lorrain (1715–59), who came to St Petersburg as Director of the Academy of Arts. When he died a year after his arrival he was succeeded by Louis-Jean-François Lagrenée (1725–1808) and his younger brother Jean-Jacques (1739–1821) who left for Rome in 1763 while Louis-Jean-François stayed on until 1765. These artists brought with them the full force of the rococo, a style already imperilled in France by the growing taste for the neo-classic. Tocqué (whose father-in-law Nattier had painted Peter the Great in 1717) brought not only his prestige as a popular and successful painter but also the styles of Rigaud and Largillierre which he had adopted and modified and which were to prove an immediate inspiration to the Russian painters then coming to maturity.[16] An equally important influence was that of the lesser-known artist George Frederick Schmidt (1712–75), whose classical draughtsmanship served as a model to students during the five years he taught at the Academy from 1757 and over the next hundred years.[17]

22. *Portrait of Sarah Fermor*, attributed to Ivan Vishnyakov, c.1750. Oil on canvas. Leningrad, Russian Museum

Elizabeth was succeeded by her nephew Peter, whose wife had come to Russia at the age of 14 with three dresses bought out of the travelling allowance sent to her by the Empress, and who as Catherine the Great was to reveal herself as one of the most remarkable women in Europe. Quickly recognizing that her husband was a semi-idiot who spent his time in the company of his latest mistress playing with toy soldiers, she said that while she would be pleased to part from him at any time she could not endure to part with the Russian crown. She had not long to wait before her wishes were gratified. No sooner had Peter come to the throne in 1762 than he proceeded to alienate every influential section of society, going so far in his childishness as to put out his tongue at the priests during services. He openly insulted Catherine and threatened to divorce her; wisely she was seen to refrain from either speaking or acting against him. When the army rose in revolt he at once abdicated, asking only if he might retain his fiddle, his dog, his negro slave and his mistress. Days later, during a fracas at dinner in the village of

Ropsha to which he had been removed, he was assassinated, probably at the instigation of Catherine, to whom the crown instantly passed.

The Empress Catherine (1762–96) was not only brilliant in herself but a cause of brilliance in others. Whenever possible she surrounded the throne with men of distinction: her court poet was Derzhavin, a man of considerable and varied talents; her minister in Paris was Prince Dmitry Golitsyn, friend of the philosopher Diderot and of the artist E. M. Falconet and other intellectuals, an enlightened man of his age. Among her correspondents and intimates she counted some of the ablest men in Europe, including Voltaire, Diderot, d'Alembert and Grimm.[18] Even her lovers were chosen for their prowess not only in love but in other fields such as music and war. She rose at five, lit her own fire at six, and worked with unflagging energy for 15 hours. A historian (of no great merit), a sculptor, engraver and painter, she was also a superb, lively and entertaining conversationalist and writer of letters.

Catherine was intensely interested in the arts and had the good sense to retain for some time the services of Shuvalov, although when she permanently established the Academy of Arts in 1764 she appointed as Director a man of wide interests, General Ivan Ivanovich Betskoy, who had served in France and was in a position to make use of the contacts he had established there. He copied the rules and regulations of the French Academy (then considered the finest in Europe), except that in St Petersburg the minor arts together with architecture, painting and sculpture were taught under one roof and there was a school in which children received an education from the age of six.

Catherine's indefatigable activities as an art-collector call for a study in themselves. Her galleries in the Winter Palace soon overflowed with works of art. Among her major acquisitions were the pictures of the Berlin manufacturer Gotzowski in 1763; in 1769 some 600 paintings belonging to Count Brühl of Saxony; the extensive and wonderful Crozat collection in 1772; and the Walpole collection in 1778. She read catalogues, wrote notes and talked endlessly about her treasures, for she saw the erection of palaces and state buildings and the foundation of art galleries as an integral part of her policy of establishing monarchic prestige in the Western fashion, following the example of the sovereigns of her time, for whom Louis XIV remained the unequalled paragon. Catherine's own taste was wide but sometimes strikingly undistinguished. She rated

Mengs above his contemporaries (but so did Winckelmann and many connoisseurs), worshipped Greuze and preferred Angelica Kauffmann to Madame Vigée-Lebrun. A portrait by the indifferent English artist Richard Brompton (1734–82) was described as 'not disfigured by the Van Dycks in my gallery'.[19] Anxious but unable to put her German origins behind her, she retained an affection for a *gemütlich* mixture of the elaborately idealist and the sentimentally lyrical. At best conventionally neo-classical, her taste was generally for a narrow drawing-room commonplace, although such was the unpredictable and generous nature of the woman that she was prepared to admit a degree of honest realism in portraits of herself. As early as 1774 the *Catalogue des tableaux qui se trouvent dans les galeries et dans les cabinets du Palais Impérial* listed 2,070 works of art. Certainly by the end of the century the Russian monarchy owned the finest collection of art in Europe.

As far as enlisting artists of repute was concerned, Catherine found it even more difficult than her predecessors. In 1765 Diderot wrote that great painters were then extremely scarce in Italy; he might almost have said the same of France in the same period. The advent of neo-classicism in the 1750s spelled the death of the rococo styles of Venice and France which had performed sterling service in glorifying the monarchs of Europe and their splendid courts. Now there were only benevolent despots who posed as ordinary mortals or as the patriotic sons and daughters of classical Rome.

Catherine's artistic patronage reflected both her changes of taste and the repercussions of political events abroad. Early in her reign she commissioned *A Spanish Concert* (there were several versions) from Louis-Michel Van Loo (1707–71), who had been a court painter at Madrid, and also offered him the directorship of the Academy of Arts, which he refused. She was lucky enough to secure for two years one of the last of the Venetians, Francesco Fontebasso (1709–69), a history and decorative painter who had studied under Ricci and who left Russia in 1768 to become head of the Venetian Academy. About that time she acquired from G. B. Tiepolo, then in Spain, several canvases, among them one representing Mars and the Graces, intended for a ceiling at Oranienbaum. The Swede Alexis Roslin (1718–93), master of a belated and flirtatious rococo style, visited St Petersburg where he painted several portraits of the Empress. Close relations

with the Danish Academy of Arts seem to have been established in the middle of the century; among the Danish artists who worked in Russia were the miniaturist Cornelius Hoyer (1741–1804), who visited the country in 1781–3 and in 1797–8,[20] and the important Virgilius Erichsen (1722–82), who worked there between 1757 and 1772.[21]

A last wave of painters, most of them French, sought fortunes and, after the outbreak of revolution, safety, in Russia. J. B. Perroneau (1715–83) spent the year 1781 in St Petersburg but his restless, itinerant nature did not permit him to linger there. Jean-Louis Voille (1744–*c*.1804) left for Russia in about 1770 and except for a short visit to Paris stayed there till his death. Hubert Robert (1733–1808), whose nostalgic compositions of classical ruins were tremendously popular at Catherine's court, was twice invited in 1782 and 1791 but seems to have been aware of Russia's bad reputation for holding on to artists who ventured there and declined the offers although he accepted formal association with the Academy of Arts. J. B. Lampi (1751–1830) worked in Russia (1792–7) where he apparently made a fortune. His less talented son G. B. Lampi (1775–1837) followed in his father's footsteps and also became a member of the St Petersburg Academy. Among the last of the international visitors of repute was Marie-Louise Elizabeth Vigée-Lebrun (1755–1842), who left France at the time of the revolution and wandered across Europe making a comfortable living wherever she went. She stayed in Russia from 1795 to 1801, her portraits calling forth a number of sardonic comments from the elderly Empress whose taste was now for the neo-classic and who took no pains to disguise her preference for Kauffmann.

With galleries crowded with miles of European paintings and with so many European artists working around them Russian painters must surely have felt dismally inferior. They must also have believed that the *parsuna* was an outdated and anachronistic art form below the contempt of visiting Europeans whose work they were encouraged and even forced to ape. In such circumstances it would be too much to expect from the native painters a consistent development of style.[22] But that there was no lack of talent is proved not only by the abundance of sturdy portraits by anonymous artists to be found in Russian galleries but more outstandingly by the work of Aleksei Petrovich Antropov (1716–95) and Ivan Petrovich Argunov (1729–1802), the two painters of the mid-century.

Antropov was the son of a military carpenter who worked in the Moscow Arsenal.[23] He was trained by Caravaque and Matveev and, later, by Vishnyakov and Rotari. Appointed principal artist to the Holy Synod, he began work in 1752 on icons and decorative panels for the Cathedral of St Andrew in Kiev designed by the famous Italian architect Rastrelli, who also created many of the finest buildings in St Petersburg. At the age of 41 he began work with Rotari at Peterhof and absorbed the Italian's polished manner. Despite an over-anxious attention to details of costume and setting, as in his *Portrait of Ataman Krasnoshchekhov* (1761), in which the *parsuna* influence still lingers, he succeeds in conveying the essential character of the man himself. His large state portrait of the ill-fated Peter III (1762) shows an elongated body, a tiny face full of pathetic vanity and a grandiose setting derived from late European baroque. The swags of tasselled and embroidered drapery, the heavy gilded furniture, the crown, orb and sceptre, the ermine robes, the distant view through the pillars of Cossacks galloping across the snow – all this is a trifle anachronistic in

23. Aleksei Petrovich Antropov: *Portrait of Catherine the Great*, 1780. Oil on canvas, 88 × 66 cm. Private Collection

24. Aleksei Petrovich Antropov: *Portrait of Peter III*, 1726. Oil on canvas, 58 × 47 cm. New York, Hammer Galleries

an age when absolute monarchs passed themselves off as flautists, philosophers, hermits and milkmaids. Of course, the monarchs of Europe still commissioned state portraits and they never went entirely out of favour; but those commanded by Peter III carry the genre to excess. But this is not to deny Antropov's achievements. And, to be fair, his portraits of V. A. Sheremeteva (1763), M. A. Rumyantseva (1764), Vice-Chancellor A. M. Golytsin (1766) and his depictions of Catherine the Great show that he could paint with a direct frankness and was rarely overwhelmed by his sitter's greatness (Plate 23). Time has not dealt kindly with the surfaces of his pictures, which are sometimes excessively reddish in tone, but his materials and methods as well as years of neglect on the part of owners may have been responsible (Plate 24).

Ivan Argunov was born a serf of the Sheremetev family and benefited from the artistic tastes of his owners who were engaged in transforming their house at Ostankino outside Moscow into a magnificent palace.[24] After studying under G. C. Grooth he became a teacher: many eighteenth-century

painters studied under him, including A. P. Losenko, his sons Nikolai and Yakov and a third son who became an architect. At the same time he was obliged to work as a superintendent of the Sheremetev houses in Moscow and St Petersburg. Such works as his portraits of the Countess Sheremeteva (1766) and Admiral M. M. Golytsin (*c.*1750) show a thorough grasp of rococo styles even if there is an observable indebtedness to Western models; but his well-known *Portrait of a Peasant Woman in Russian Costume* (Plate 25) which argues the beginnings of an interest in rustic life and folk costumes has a charming directness of representation. About 1770 he painted Admiral Samuel Greig of Inverkeithing (Plate 26) who had joined the Russian navy in 1764, utilizing a pose which well expressed the blunt character of the Scottish seaman, but which surely must have been derived from a European source, possibly from an imported engraving. It seems likely that Argunov was employed to paint portraits of a number of the foreigners in the Russian armed services; and his forthright style, which clearly grew in confidence, was admirably suited to that purpose (Plate 27). It is opportune here to mention Argunov's son Nikolai (1771–after 1829). Like his father he painted portraits of the Sheremetev family. Although his work varies in quality he painted some excellent portraits, such as his study of A. M. Dmitriev-Mamonov (1812), in which he combines splendour of setting and dress with informality of pose. The achievements of the Argunov family have not yet received adequate appreciation.

Other interesting portraits of the last decades of the eighteenth century are attributed to Y. P. Chemesev (1737–65), engraver and painter, and to P. Drozdin, G. Serdyukov, I. Yaroslavsky and I. I. and A. Belsky. Mikhail Shibanov (d. after 1789), a serf artist belonging to G. A. Potemkin, painted a portrait of Catherine in travelling costume which was such a favourite with her that several replicas were made for distribution as gifts (Plate 28). In addition to portraiture, Shibanov painted scenes of peasant life (Plate 29), possibly the first genre pictures of their kind. In recent years a number of charming portraits have come to light on an estate which formerly belonged to the Cherevin family near Soligalich and which have been identified as the work of Grigory Ostrovsky, probably also a serf artist. Typically, although the quality of the sitters' expressions is limited, the emphasis on the texture of the clothing, hair and decorations is interesting. The

26. Ivan Petrovich Argunov: *Portrait of Rear Admiral Samuel Greig*, *c*.1770. Oil on canvas, 144 × 115 cm. (Possibly a contemporary copy painted in Russia.) Scotland, Inverkeithing Burgh Museum

25. Ivan Petrovich Argunov: *Portrait of a Peasant Woman in Russian Costume*, 1784. Oil on canvas, 67 × 54 cm. Moscow, Tretyakov Gallery

example of Ostrovsky demonstrates that if Russian art of the mid-century is rarely free from a certain 'primitiveness' it also provides firm evidence of much native talent and of an increasing command of Western techniques and styles.[25]

The second half of the century saw the appearance of three portraitists of an altogether superior quality, one of them, D. G. Levitsky (1735–1822), the equal of any European painter of his time. Fedor Stepanovich Rokotov (1736–1808), Vladimir Lukich Borovikovsky (1757–1825) and Levitsky himself have all been separately described as 'the Russian Gainsborough', which betrays an inadequate acquaintance with their work and with that of the English artist.[26] Despite the fact that there is only one portrait by Gainsborough in Russia – and that was acquired late in the nineteenth century – it

must be admitted that circulating in the country in the eighteenth century were an enormous number of mezzotints and engravings after Gainsborough, Reynolds and other Western artists, which may have influenced these Russian portraitists.[27]

Comparatively little is known of Rokotov, and he has been variously claimed as the son of peasants born in the village of Vorontsovo outside Moscow which belonged to the Repnin family and as a descendant of a poor aristocratic family.[28] It is not certain where he first studied but he was admitted to the Academy of Arts in 1760, by which time he seems to have gained his freedom. It has been conjectured that he probably attached himself to A. P. Antropov and to Tocqué during the latter's visit of 1756–8, and also that he belonged to the group of artists and intellectuals around Lomonosov (1711–59), himself a skilled worker in glass mosaic. He may have worked with Rotari on the series of portraits of young girls at Peterhof. His early works, which include a portrait of the infant Tsarevich Paul, a study in silvery greys dated about 1757,

27. Ivan Petrovich Argunov: *Portrait of an Unknown Man*, *c*.1790. Oil on canvas, 100 × 77 cm. Warsaw, National Museum

show that he had little need of academic training. In 1765 he was elected an Academician but chose to leave St Petersburg for Moscow, where he purchased a house and studio. Distance from the capital and life among the less sophisticated Muscovites may have aided the development of a more personal and intimate style. Since he had been commissioned to paint Catherine on the occasion of her enthronement in 1763 he enjoyed very considerable renown, especially for his portraits of women (Plate 30).

Rokotov's preference was for bust-length works with a neutral background which set off the vigour and liveliness of his sitters. Through the years his colours became increasingly silvery: there was a varied use of olive-green and rose shades, apparently derived from his days with Rotari. More and more he made use of *sfumato*, a soft, indirect light which veiled the features (Plate 31). In a work such as *Portrait of the Tsarevich Paul* (1770) he displayed his skill in the rendering of furs and fabrics and introduced elements of *trompe l'œil*, but he became indifferent to outlines, textures and the pictorial trappings beloved of the rococo and baroque, preferring to concentrate on the essential character, the soul as it were, of his subjects. Among the more delicate and representative of his later pictures are those of V. Y. Novosiltseva (1780), P. N. Lanska (1780) and Countess Santi (1785). This last portrait, a study in the use of olives, browns and pinks, seems to show a distant affinity with Gainsborough in the swift and subtle brushstrokes evident in the painting of the velvet gown and the muslin fichu. A slight angularity in the poses, sometimes only in the carriage of the head, as well as the exaggerated and somewhat gauche use of flowers and ribbons, notably in his early works, betrays Rokotov's distance from the rococo of Boucher and Fragonard.

Rokotov's fame is not merely historical or national. He was a close and earnest student of the characteristic features of his models, and a sensitive portraitist of the distinguished men and women of his period. Unfortunately, his colours appear to have faded and the reds have spread and intensified so that it has become difficult to judge the original delicacy of his tones. Recent cleaning has revealed a command of pearly textures and the refinement of his painting style. His undeniable command of technique, his ability to suggest a poetic atmosphere and the ease of portrayals make his haunting pictures of women some of the finest successes of the modified rococo manner in Russia.

Despite the merits of Rokotov it is generally rec-ognized that the greatest painter in eighteenth-century Russia was Dmitry Levitsky. His father was a priest who worked as an engraver in the printing office of the Pecherskaya lavra monastery in Kiev where the young Levitsky came into contact with engravings of sixteenth- and seventeenth-century European paintings. Kiev had been dominated by the Poles who had transformed the city into a centre of scholastic and Latin education and adorned it with baroque architecture. In the eighteenth century it was probably the most literate city in the Russian empire, cosmopolitan in character and the source of much that was reformist and progressive. When in 1752 Antropov went to Kiev to paint the iconostasis in the Cathedral of St Andrew he saw and acclaimed the talents of the boy – who must have been singularly precocious – and arranged for him to come to St Petersburg in 1756. By 1762 Levitsky was a registered painter and in 1770 he became an Academician. It is known that he studied with Jean-Louis Lagrenée, who was at the Academy in 1760–2, with Antropov and with Giuseppe Valeriani; but doubts have been expressed as to whether he actually studied at the Academy itself.[29]

28. Mikhail Shibanov: *Portrait of Catherine the Great in Travelling Costume*, c.1770. Oil on canvas. Copenhagen, State Museum of Fine Art

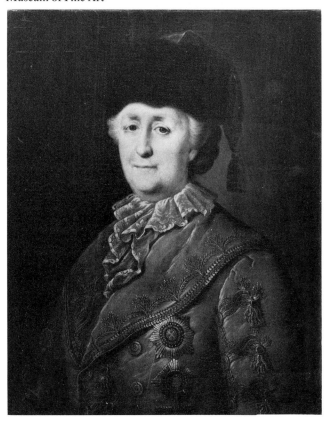

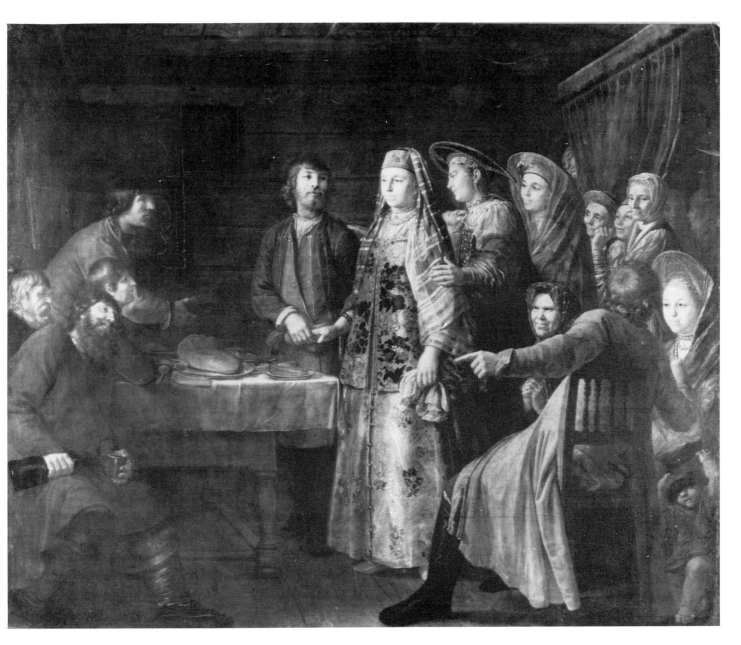

29. Mikhail Shibanov: *The Wedding Contract*, 1777. Oil on canvas, 199 × 244 cm. Moscow, Tretyakov Gallery

Little is known of Levitsky's early career, and his first known work appears to be a portrait of A. F. Koronikov (1769), architect and director of the Academy of Arts, in which the painting of the sitter's brown velvet coat, the fine bureau in the style of Louis XV, the plans for an academy which rest on it, and the manner in which he turns to us, all proclaim the artist's mastery of rococo sinuosity and his command of painted surfaces. This is a magnificent picture enriched by the close and superb rendering of surfaces. Was it, one wonders, a test piece to proclaim his supremacy even over foreign artists? At the first exhibition of the reorganized Academy in 1770, Levitsky showed himself a master-magician by exhibiting no fewer than twenty pictures and won instant fame for himself. His *Portrait of Prince A. M. Golytsin* (1772) was engraved in Vienna the following year, while his *Portrait of Diderot* (1773) was eventually acquired by the city of Geneva. Catherine commissioned a number of state portraits of herself for presentation to friendly monarchs and potentates (Plate 32). In 1773 she ordered a series of pictures of pupils at the Smolny School for Aristocrats' Daughters, an institution she had founded

when she found herself playing the unlikely part of a Russian Madame de Maintenon. For each of these portraits Levitsky created a different pose and setting, sometimes derived from the girls' studies and sometimes from their theatrical entertainments, forming an intimate and light-hearted gallery of carefree, privileged youth.

In the last years of her life, particularly after the revolution had frightened her away from French culture, Catherine began to look to England and encouraged at her court an appreciation of English landscape, architecture, decoration and manner of life. The example of English painting may have spread in St Petersburg and reached Levitsky through the younger Falconet, who had studied in England under Sir Joshua Reynolds, and through the presence at court of Richard Brompton, to say nothing of the architect Cameron and other English residents in St Petersburg. Levitsky began to modify his style, although in a way that seems to anticipate Ingres rather than the more romantic English manner. A new, simpler presentation is seen in his portraits of Catherine's grandchildren, the son and daughter of Paul I. In 1788, however, Levitsky retired from the Academy where he had been ap-

31. Fedor Stepanovich Rokotov: *Portrait of V. N. Surovtseva*, *c*.1780. Oil on canvas, 67.5 × 52 cm. Leningrad, Russian Museum

32. D. G. Levitsky: *Portrait of Catherine the Great*, *c*.1785. Oil on canvas. Private Collection

30. Fedor Stepanovich Rokotov: *Portrait of Darya Dmitriev-Mamonova*, *c*.1780. Oil on canvas, 74 × 58 cm. Warsaw, National Museum

pointed professor of portrait painting, apparently for reasons of ill-health. After Catherine's death he was out of favour with the Emperor Paul, who was reluctant to pay for a series of portraits of the Knights of St Vladimir commissioned by his mother. In 1807 Levitsky returned to the Academy where he had been appointed to the Council, but withdrew after a short while on grounds of failing sight. Both Levitsky's self-portrait (1780) and the portrait of him by his pupil Borovikovsky dated 1797 show a little man whose face carries an excessively alert, nervous, almost irritable expression (Plate 33); and there is evidence that he had become deeply religious, which possibly further increased his alienation from court circles. Although he continued painting, the last decades of his life are something of a mystery; and he may well have died poor and forgotten like his contemporaries the sculptor Shubin and the architect Bazhenov.

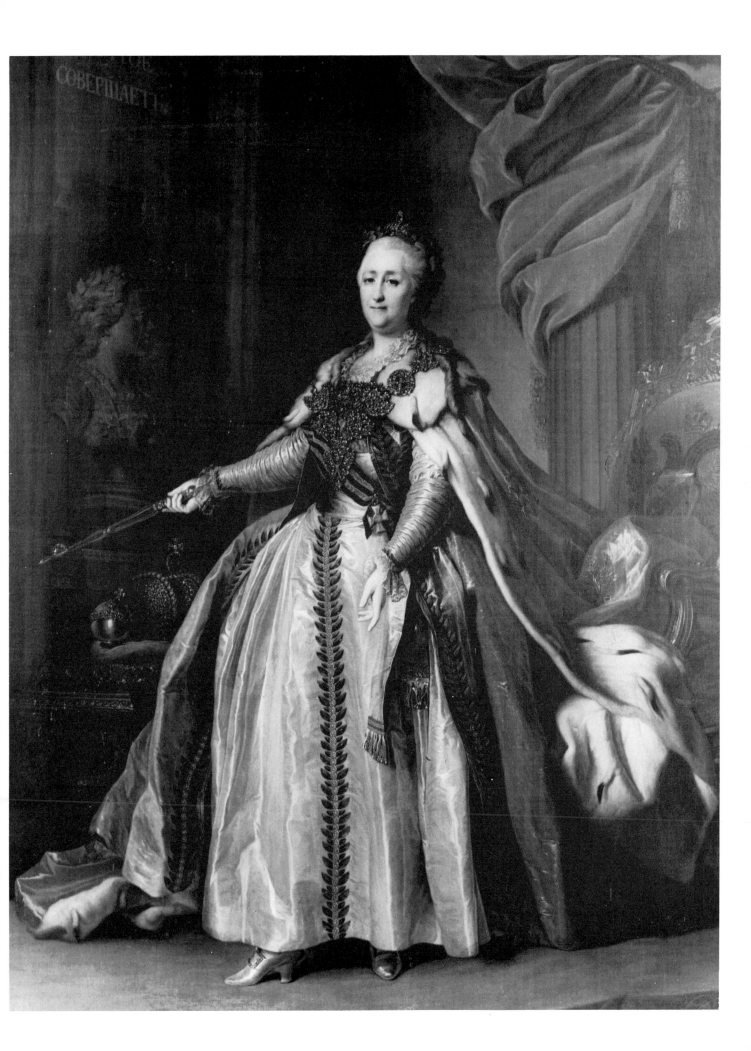

Levitsky's triumphs clearly showed that Russian painters had come of age and could face Europe without shame or any sense of inferiority. Entirely a Russian painter, never leaving his native land or seeking training and fame in the artistic centres of Western Europe, Levitsky's versatility in portraiture was quite amazing. By presenting Catherine surrounded by all the appropriate baroque symbols of a monarch at once vaguely autocratic and vaguely constitutional he created some of the most imposing state portraits of the eighteenth century. The paintings *Catherine the Great in the Temple of the Goddess of Justice* (Plate 34 and Col. Plate 4) are typical of a number of compositions which depict the Empress of Russia in the guise of a statuesque and singularly well-draped goddess of antiquity, a sibyl about to deliver herself of a new liberal decree (*nakaz*). The court poet Derzhavin was inspired to describe such a scene in verses which lose nothing by translation into prose:

> A woman descends from the clouds. A priestess or a divine being. She is draped in a white robe which falls to the ground. She bears a crown on her head; a breastplate of gold shimmers round her middle.

33. Vladimir Lukich Borovikovsky: *Portrait of D. G. Levitsky*, c.1797. Oil on canvas, 14.5 × 12.2 cm. Leningrad, Russian Museum

Like a rainbow, a ribbon of glimmering purple hue descends from her right shoulder to her left side. A hand stretched out to the altar bears a dish of incense in honour of the all-powerful God. An immense eagle, the Northern eagle, companion of her triumphs, messenger of her heroic glory, has taken its perch on a pile of books, guarding the sacred laws promulgated by the Empress. In his talons he holds an extinct thunderbolt and branches of olive and laurel, while he seems to slumber in confident peace.[30]

Almost the opposite of this public image is the series of portraits of pupils from the Smolny Institute with their infinite variations in pose, costume and revelation of character, which have rarely been equalled for sheer charm. These girls are direct descendants of the putti of the rococo era as well as of the cupids of the ancient world. Levitsky captured their eternal youth: Alimova will forever play her harp;[31] the Princesses Khovanskaya and Krushchova will never leave off play-acting, mimicking the coquetry of their elders; Levshina and Nelidova dance on into eternity, the one against a silvan setting, the other against baroque pillars and draperies; while Oltanova continues to testify to the seriousness of studies at the Institute, frowning over the pages of her textbook, with a physics apparatus in the background to demonstrate, incidentally as it were, that Russia has entered the age of scientific enlightenment. There is a bubbling vitality, a sense of fun and incredible technical skill in these works which instantly proclaim the master painter.

Another aspect of his genius is demonstrated by the portrait of the commercial and mining magnate V. Demidov which shows us a homely figure in the same pose as Scheemakers' celebrated monument to William Shakespeare, except that Demidov happily rests his arm on a watering-can and points to two rather spindly plants symbolic of the institutions he had recently founded in St Petersburg. The monstrous Ionic pillars and drapery in the background serve to point an ironic and absurd contrast with the little millionaire in his loose clothes, fur hat and what looks suspiciously like an open accounts book. Faced with a similar commission Batoni (to whom Levitsky was remotely indebted) would have striven to invest the sitter with some shreds of dignity: Levitsky, possessed of a delicious sense of humour which at times verged on the malicious, painted what he saw in front of him.

Levitsky was a versatile and eclectic portraitist who seems to have eagerly seized on any source of

although the English artist's dazzling but sketchy manner and informality do not seem to have appealed to Levitsky, who for the greater part of his career was essentially a painter in the mature baroque tradition. Nevertheless, his *Portrait of the primadonna Anna Davie Bernuzzi* (1782) has striking correspondences with Gainsborough's *Giovanna Baccelli* (1782) in its rococo theatricality.[32] And like the English artist he copied poses and costumes from Van Dyck, as in his *Portrait of F. P. Makerovsky* (1789). Doubtless he borrowed from many sources: from Tocqué, Largillierre, Mengs, Van Dyck, Torelli, Batoni, Roslin and even from the Dutch masters of the seventeenth century, as in the portrait of his daughter in Russian costume (1785). It has been suggested that Virgilius Erichsen was an initial influence, but little of the Danish artist's frolicksome rococo is evident in Levitsky's work, nor did he adopt his bright pastel tones, although effective cleaning of the Smolny portraits, for instance, might show them to be much brighter than at present they appear.

While there is little difference in style between his picture of the Vice-Chancellor Aleksandr M. Golytsin (1772) and that of Catherine's favourite Aleksandr Lansky painted ten years later, Levitsky recognized the advent of neo-classicism towards the end of the century, especially the sentimental variety of Madame Vigée-Lebrun who had such a success during her stay at St Petersburg and, to a lesser extent, that of Lampi, and modified certain elements in his work accordingly. This is clearly so in the brilliant portrayal of Ivan Ribeaupierre with its astonishing command of compositional rhythms and in a subtler degree in his *Portrait of A. F. Labzin* (Plate 35) dressed informally and set against a pyramid and miniature sphinx. Even more marked is the neo-classical element in his *Portrait of Anna Stepanova Protasova* (1800), in which the sitter's flowing and unpowdered hair, semi-classical gown and blood-red shawl announce a new era of heroic struggle, a mood intensified by the low horizon of the background. Most unusually for Levitsky he presents Protasova out of doors against a gloomy and forbidding sky of olive green, warmed only by a few streaks of light from a feeble sun hidden behind trees and hills. This picture is not untinged by sadness – prophetic, perhaps, of Levitsky's declining career, of the coming struggle against the French invaders, of the sitter's increasing blindness and, at the same time, infused with a regret that borders on romanticism for the joys of the past century which

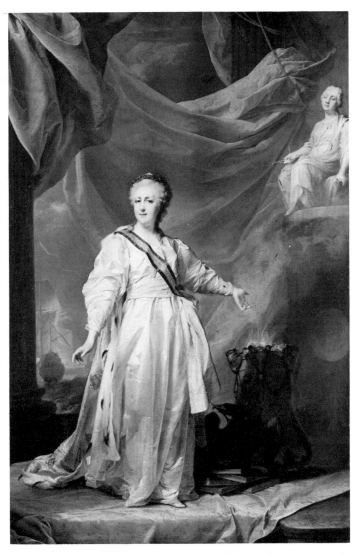

34. D. G. Levitsky: *Portrait of Catherine the Great in the Temple of the Goddess of Justice, c.* 1780. Oil on canvas, 110 × 76.8 cm. Moscow, Tretyakov Gallery

inspiration, intelligently and perceptively adapting it to his needs. Do not his full-length pictures of the pupils of the Smolny Institute engaged in dancing owe a little to Lancret's *La Camargo* acquired by Catherine some time before 1774, and also to Roslin's costume pictures? In any case, are not these works a conscious attempt to prove his superiority to Rotari, even going so far as to use the greens, pinks and whites of which the Italian was so fond? The elongated features and swirling draperies of *Portrait of Agafokleya Poltaratsky* (1790) seem indebted to Parmigianino, whose *Entombment* had come to Russia as part of the Walpole collection in 1779; whereas the simplicity of *Portrait of Count Santi* probably owes a little to Gainsborough,

had ended in so unexpected and violent a fashion, with revolution and wars beyond but menacing Russia's frontiers.

The tragedy of Levitsky's later years arose from the fact that at the beginning of his career his style was already outdated. One might say that, outside England, in the last quarter of the eighteenth century the portraitist had become the sick man of Europe, that the confused age of Greuze, Kauffmann, Batoni, Roslin, Vigée-Lebrun and Vien offered neither manner nor style for his use, for they themselves were uncertain. Similarly David in the midst of his grandiose neo-classical history pictures turned to the rococo style when he painted his study of Pierre Desmaisons (1782), as did Mengs when he also turned to portraiture. Possibly Levitsky's dazzling facility occasionally concealed a superficial or over-flattering view of his sitters (for instance, in real life Protasova was said to be as 'black as a Tahitan'); and it may be objected that he did not always penetrate deeply into character, utilizing a set of stock poses and basic settings which could be varied by the introduction of different pillars, tables and curtains, but in which a bust of Catherine invariably

35. D. G. Levitsky: *Portrait of A. F. Labzin*, 1790. Oil on canvas. Private Collection

occupied the place which in Italy would have been given to putti or to a guardian angel. If he sometimes appears to lack that penetrative gift which some lesser artists had, he possessed an ample sense of magnificence and a discriminating talent for the appropriate gesture, for the telling rhetorical pose, that is more than abundant compensation. But even here one must be on guard against over-generalization; although early in his career he preferred to display the function rather than the man, an attitude with which his patrons were fully in agreement, he could strike to the heart of a character, as in the superb picture he painted in 1773 of Diderot, who was visiting St Petersburg at the invitation of Catherine: the philosopher is shown in an informal pose, without a wig, in a dressing-gown of red and creamy white, as if to show himself a man of ordinary sensibility, in whom the heart could speak quite simply, and in whom, despite his philosophy, cheerfulness kept breaking through.[33] But as Levitsky moved towards this more informal style Catherine's tastes had swung violently away from anything that smacked of egalitarianism or which was in any way associated with revolutionary France; and he was not only unfashionable but out of favour. Dr Johnson, like many of his generation, would rather have seen the portrait of a dog he knew than all the allegorical paintings in the world; the generation at the end of the eighteenth century felt guilty about such a preference; whatever their inner feelings, they believed they ought to like history (and allegorical) painting. Levitsky's portraiture had little appeal for such a generation, and neglect was the inevitable result, particularly in Russia where a painter relied absolutely and entirely on the whims of his autocratic patrons.

Much more to the taste of the period was the work of Borovikovsky, born in the Ukraine, the son and pupil of an icon painter.[34] He went into the army in 1774; and having attained the rank of lieutenant he retired to devote himself to painting. The work he did for the iconostasis in the church built at Mogilev for Catherine to celebrate her meeting with Joseph II of Austria delighted V. Kapnist, poet and Marshal of the Nobility of Kiev Province, who then invited him to paint allegorical decorations for the temporary palace constructed at Kremenchug on the Dnieper, visited by the Empress

36. Vladimir Lukich Borovikovsky: *Portrait of Mutaza-Kuli-Khan*, 1796. Oil on canvas, 74 × 53.5 cm. Leningrad, Russian Museum

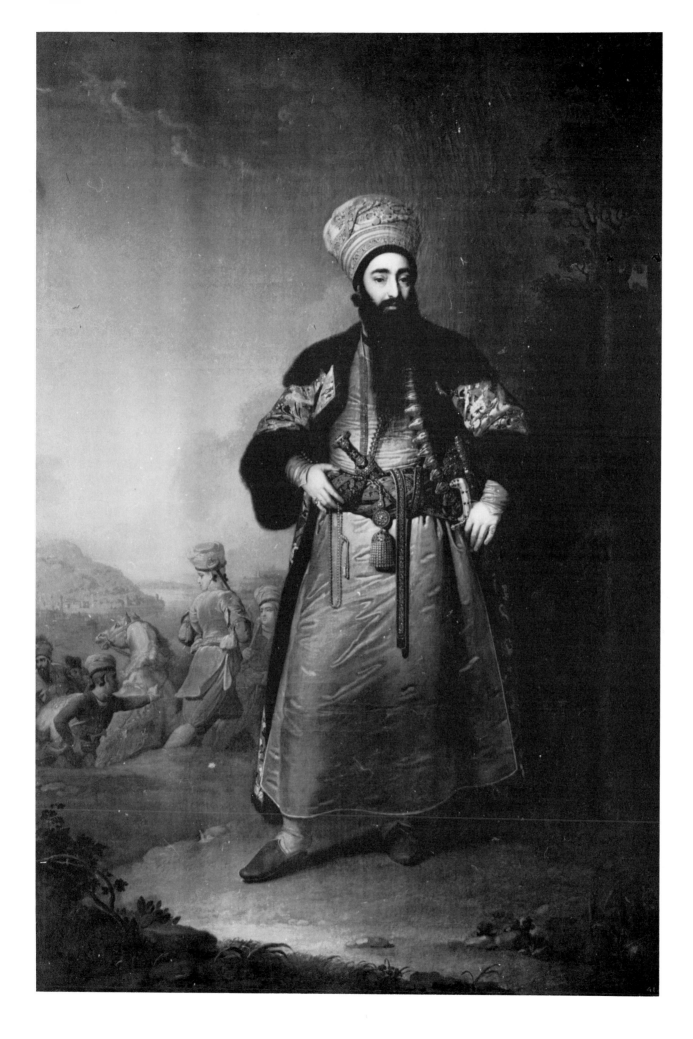

during her triumphal tour of the Crimea in 1787. Catherine was so delighted by his work that she had him sent to St Petersburg for training. By 1790 he was working there under Levitsky and J. B. Lampi the Elder, and soon became a favourite both with the Empress and her successor Paul I. In 1795 he was named Academician and in 1802 he became Councillor of the Academy of Arts. In the following years he was called upon to organize the decorations of the Mikhailovsky Palace and the vast Kazan Cathedral which was being built on Nevsky Prospekt. He taught a small group of pupils, among them Aleksei Venetsianov who was to become a teacher with widespread influence on the next generations. Borovikovsky's character seems to have contained apparently contradictory elements: in 1802 he joined the Freemasons, entering 'The Dying Sphinx' lodge, and yet he was a religious mystic, going so far as to join a sect of flagellants. His sense of artistic independence and professional dignity was quite remarkable for the period.

Borovikovsky's first secular works were miniatures, sometimes reduced versions of pictures

37. Vladimir Lukich Borovikovsky: *Portrait of Skobeeva,* *c.*1790. Oil on canvas, 72 × 57 cm. Leningrad, Russian Museum

by other artists. He quickly learnt to paint on a larger scale, eventually specializing in large state portraits. The technique he had been taught by Levitsky, Venetian in origin, here proved an enduring strength. His portraits of the unstable Paul I (1785), the cunning Mutaza-Kuli-Khan (Plate 36), brother of the Persian Shah (1796), the vain Prince A. B. Kurakin (1799) and of General A. A. Borovsky (1799) reveal a confident, vigorous style and a gift for expressing the emotional characteristics of his sitters. The spectator is reminded at times, especially by his male portraits, of Reynolds and Raeburn as well as Lawrence; and there can be no doubt that his true ability lay in passing beyond the trappings of office and ceremony to depicting the character of the men of action at the Imperial court. But it was for his portraits of women and children that Borovikovsky was most eagerly sought after. Away from state rooms and the formality of palaces, he posed his girls in a dreamy setting of trees and parkland, frequently placing in their hands a rose or an apple. Despite the neo-classic draperies, the Empire gowns, the flowing hair in Grecian style and the loose shawls and sashes, the early Borovikovsky did not despise such decorative elements borrowed from Boucher and the French rococo as roses, ribbons, pedestals and broken pillars. The sentimental poses and groupings of his sitters and the wistful melancholy with which they are presented owe much to Greuze, Grassi, Vigée-Lebrun and even more to Lampi the Elder. It would be a mistake, however, to assume that Borovikovsky was not an exact and accurate portraitist: his girls are sharply differentiated and even the apparently summary backgrounds vary from picture to picture. Like many another artist who has found an effective composition he was wont to repeat it: comparison of his portraits of V. I. Arsenieva (1796) and of Skobeeva (Plate 37) reveal the same pose, the same positions of the hands which are holding the same apples, and the same silvan setting, although Arsenieva's straw bonnet is surely entirely Russian in its delightful informality. If it is true that Borovikovsky turns his aristocratic young women into simple and artless children of nature fresh from a reading of Rousseau, he nevertheless preserves their Russian and Slav identity. The popular *Portrait of Mariya Ivanovna Lopukhina* (1797) shows the conflicting elements of observed naturalism, the heritage of the rococo and the simplification of neo-classicism: Lopukhina was a boisterous young woman with many admirers but is here depicted as a wistful and

38. Vladimir Lukich Borovikovsky: *Portrait of Catherine the Great in the Park at Tsarskoe Selo*, 1794. Oil on canvas, 94.5 × 66 cm. Moscow, Tretyakov Gallery

the engravings taken from it) would create in Russia and, more important, in the countries of Western Europe. Borovikovsky was thus the appropriate artist to perpetuate the image not of an Empress in regal splendour (as Levitsky had painted her), nor of a serious and brooding citizen of the post-revolutionary era (as Levitsky might have done in his later style), but of a shrewd and benevolent old lady strolling with a favourite dog past the column erected in her park to the memory of her lover's martial triumphs. Although the veracity of the actual portraiture conflicts with the somewhat weakly painted background there is no denying the unique character of this work, which deliberately stresses the relationship of man to nature, the woman to her past and to her lover, and the person rather than the office, and yet at the same time brilliantly illuminates the nature of Catherine's intentions as Empress of Russia.

In the last years of the century there came a distinct change in Borovikovsky's work which paralleled that which also took place with Levitsky. The affection for pearly whites, light blues and dimly shimmering golds and yellows remained, although their tones became muted. But the woodland settings disappeared to make way for dark interiors in various shades of grey. The relaxed poses were abandoned and a stark, frontal presentation took their place: there was a rigid patterning of the sitter and the clothing in which the exact rendering of fabrics had an important value. Line became more and more significant. The fragile and wistful young beauties he had painted with such charm were replaced by virtuous matrons of unimpeachable respectability whose massive dignity was emphasized by every device of pleating, tucking, edging and frilling known to the ingenuity of the dressmaker. Sensibility gave way to sense of an extremely cold and frigid kind. Levitsky's A. S. Protasova had something of the proud and heroic dignity of a Charlotte Corday who could face with stoic quiet the burning of Moscow; Borovikovsky's old ladies clutch their shawls around them against the draughts of bloody revolution sweeping in from France. The *Portrait of an Unknown Woman* (*c*.1812), sometimes claimed to be that of Madame de Staël, seems generally though not necessarily in colour to be related to the work of the young Ingres even if Füger in Vienna and Graff in Dresden present themselves as more accessible models. Brilliant in its composition and in its effective use of clothes and ornaments to stress the character of the sitter it is

fragile creature in a pose and dress that might have come from David, with a rose of the somewhat artificial variety that festoons the erotic idylls of Boucher and Fragonard, and surrounded by accurately painted vine leaves and ears of corn of a kind that only Gainsborough would have included in the scene.

Nature was never far away in Borovikovsky's works; and he was capable of the most honest observation. He painted a celebrated portrait of Catherine (1794) walking in her park at Tsarskoe Selo which is typical in this respect (Plate 38). With her keen sense of the fitting gesture Catherine was only too well aware of the effect the portrait (and

not without a slightly flashy vulgarity such as the Empire style rarely lacked. After the Napoleonic Wars an element of excitement disappears from his work to be replaced by stodgy complacency, especially in his portraits of superannuated generals and their respectable spouses.

More than Levitsky or Rokotov, Vladimir Borovikovsky was alert to the recent movements of European art. He relinquished the baroque and rococo borrowings of his contemporaries, assimilated the prevailing cult of the sentimental and finally adopted the linear style of late neo-classicism. He depended less than any other Russian artist before him on the examples of Italian and Dutch art; he did not attempt to compete with European artists of the past; and he turned increasingly to contemporary artists in France and, to a degree, England for inspiration. This was not accomplished without a loss of charm. The straw bonnets of his pretty girls were supplanted by jewelled turbans, and everywhere a spirit of stern duty prevailed. Yet to the end he preserved his greatest gift: a lively and innate sense of style.

The impresario Serge Diaghilev, a pioneer historian of this period, wrote of it as 'rich in talented artists, which came to a sudden flowering after the timid, apprentice-efforts of the period of Peter the Great, but which as suddenly faded away in the stentorian neo-classicism of the early nineteenth century'.[35] Only a few scattered works remain to indicate the lesser talents around this outstanding trio. For instance, there are few, if any, originals by Serdyukov (1753–78), Golovachevsky (1734–1823), I. A. Ermenev, P. I. Sokolov, Y. P. Chemesov and M. Shibanov – and there were, doubtless, many other portraitists of more than local merit.

Another dim figure is Ivan Firsov (1733–85), who adopted the less popular kind of painting, that of genre scenes.[36] All that is known of him (and it is more than is known of others) is that he studied at the Paris Academy between 1748 and 1756. On the evidence of a few decorative panels and his *The Young Painter* one would argue a close acquaintance with the work of Chardin from whom the central figures are almost certainly derived. A young artist, a mere boy, is engrossed in painting a little girl who leans back wearily against her mother – a scene which might have intrigued the French artist too; and it must be admitted that the clothes of the characters and the pictures on the wall suggest Paris rather than St Petersburg. It is strange that there are so few paintings by this artist (and *The Young*

Painter was itself at one time attributed to the neo-classicist Losenko), but Firsov may well have fallen under the influence of Chardin's laboriously slow working methods as well as his general style. However, in the field of portraiture alone enough works exist to justify Diaghilev's generalization – and there are other areas of which he knew nothing or in which he was not greatly interested.

One such area, for instance, is that of landscape painting. In Peter the Great's day Russia was little more than a straggling wilderness dotted here and there with peasants' huts and wretched villages, apart from a few towns like Moscow, Kiev and Kazan. But during his reign and that of his successors there was a serious interest in the building of palaces and country houses, and in the cultivation of parks and gardens. By the end of the century the country had been seized by a mania for building. There was justifiable pride in the transformation of towns and countryside although much of it was superficial. Engravings of newly erected palaces and recently laid-out gardens spread throughout the West and created the impression of an extraordinarily refined and cultured life in Russia under its kindly and far-sighted rulers. Peter the Great learned to engrave 'with a style and aquatint under the guidance of Adrian Schoonebeck of Amsterdam', as is inscribed on an etching done by him and dated 1698, and established a tradition of topographical drawing and engraving. Several young Russians studied with Schoonebeck and one of them, A. F. Zubov (1682–1744), engraved a panorama of the buildings erected by Peter in St Petersburg. Peter engaged A. Wortmann, who taught engraving (and, in particular, the etching of portraits) until 1745 when his place was taken by G. F. Schmidt.

Meanwhile Russian engravers were showing their ability. Chief among them was P. I. Sokolov, to whose outstanding pupil Mikhail Ivanovich Makhaev (1716–70) we are indebted for maps of St Petersburg (1753) and views of the city which are invaluable to students of the development of Russian architecture. A whole pleiad of artists continued the work of Makhaev and, indeed, a special class for the instruction of topographical engravers was instituted at the Academy of Arts. Until the last quarter of the century landscape painting as such was not taught there and unless imitative of Poussin and Claude any such painting had little attraction for Russian collectors and connoisseurs. But during the course of the century, as elsewhere in Europe, there was an increasing

39. Fedor Ya. Alekseev: *View of the Palace Quay from the Peter and Paul Fortress, St Petersburg*, 1794. Oil on canvas, 70 × 108 cm. Moscow, Tretyakov Gallery

appreciation of landscape, especially when Catherine the Great had the gardens at Tsarskoe Selo laid out in the English taste after 1772.[37] Disappointingly few artists ever concerned themselves with the scenery of their own country, partly because travel outside Moscow and St Petersburg was exceedingly difficult and dangerous, and partly because there were so few commissions. When landscape painting was eventually introduced into the academic syllabus Semyon Shchedrin (1745–1802) became the first teacher.

Shchedrin had studied abroad and evidently learned to make the best of his modest talents: his success was due to the growing fondness for parks in the English manner (which were better suited to the Russian climate than the formal gardens of France and Italy), to romantic vistas inspired by Hubert Robert and Savator Rosa, and to the desire of aristocratic landowners for records of their homes and gardens laid out with fountains, statues, lakes and shrubs. His *View of the Neighbourhood of Staraya Russa* (1803) is typical of his peaceful scenes of St Petersburg and its suburbs, often painted in watercolours. Shchedrin's contemporary Mikhail M. Ivanov (1748–1823) began his career as a war-artist depicting episodes from Potemkin's Turkish campaign and then devoted himself to watercolours of landscapes in which groups of figures played a useful and decorative part.

A greater artist than either Shchedrin or Ivanov was Fedor Ya. Alekseev (1753–1824), who studied at the Academy of Arts under Antonio Perezinotti (1708–1778) before going to Venice in 1774. He was obviously influenced by the work of Canaletto and Bellotto, and understandably so, since St Petersburg, like Venice, was a city founded on water. His *View of the Palace Quay* (Plate 39),

painted on his return home, displays an indebtedness to the *vedutisti*. Alekseev travelled widely in southern Russia painting scenes in the towns of Nikolayev and Bakhchisarai, and in 1800 made careful studies of Moscow. In St Petersburg he painted luminous views of the stately embankments and the superb sweep of the river Neva at the time when the city's wooden and brick houses were being transformed into the splendid stone palaces and public buildings associated with the reign of Alexander I. The architect A. N. Voronikhin (1759–1814) painted several accurate views of the capital and the buildings he had constructed there: *A View of Stroganov's Summer House* (1797) is a charming example of his work, showing the house he had built on the Bolshaya Neva and the avenue of trees along the river side. These artists and their followers were chiefly interested in work of a topographical nature, in which there was only a modest appreciation of nature for its own sake. In general, it must be admitted that landscape painting belongs more properly to the nineteenth century and will be considered later.[38]

Decorative art played the most utilitarian of roles during the reigns of Elizabeth and Catherine the Great. Elizabeth and to some extent Catherine were addicted to travelling in a splendid manner, taking the whole court with them, and having temporary but lavishly decorated palaces erected wherever convenient. Decorative panels and ceilings were in continual demand for these new buildings and also for the permanent palaces in St Petersburg and the surrounding countryside, which were constantly in process of renovation and modernization. The fondness of these sovereigns for theatrical entertainments kept artists busy supplying ornate scenery and properties and decorating the interiors of the theatres themselves. These were arts in which the Italians excelled and it is not surprising to learn that the Russian sovereigns employed large numbers, including Giuseppe and Serafino Barozzi, Pietro and Paolo Gonzaga, Piero and Francesco Gradizzi, Bartolomeo Tarsia and Antonio Perezinotti, whose work we have already noted.[39] They trained many Russian artists whose names survive only in inconsequential references – D. Soloviev, T. Ulyanov, P. G. Bogomolov and P. T. Balabin among them – but whose work was often of a high order.

Aleksei Belsky (1729–96), better known than most, studied under Perezinotti, and applied himself to stage decorations and also to decorative panels in which he occasionally used arrangements of flowers,

fruit, foliage and birds observed more accurately than is usually the case in this genre. However, he preferred the groups of classical ruins, overgrown colonnades and pillars beloved of Pannini, Hubert Robert, the *vedutisti* and Catherine herself. Apart from the short-lived Farafontiev (1758–98), who had studied architectural composition under De Machy in Paris, and G. N. Teplov (1717–79), known for his pretty *Still Life with Music and Parrot* (c.1737), Belsky's successors remain obscure; and the art of the decorative painter died in Russia with the advent of the landscapist and the austere neo-classicism of the early nineteenth century. Sadly, because of the destruction caused by war, age and neglect there remain few pictures by these artists in their original condition, but they reveal a mastery of *trompe l'œil* and of intricate decorative patterning. These skills were treasured in the theatre; and were to astonish Europe in the first decades of the twentieth century.[40]

There are several points we must remember about the development of Russian painting in the eighteenth century. As we have seen, at the beginning of the century there was no tradition of secular painting nor was there any widespread knowledge of Western techniques involving perspective or anatomy or the use of such mediums as oil, watercolour and engraving, although these were rapidly learnt and practised. For many years portrait painting was inhibited by the *parsuna*; and it is legitimate to wonder whether the influence of the icon did not continue to manifest itself in the undoubted concentration on portraiture during the century. Secondly, it must be remembered that Russian painting was largely functional, mainly limited to likenesses which served to stamp on a rebellious, backward and divided nation the icon of its rulers. As the century advanced, portraiture took on a further aim: the propagation abroad of the image of a court as dignified and civilized (in its fashion) as that of Louis XIV, but with infinitely more humanity and benevolence. Thus Russian painting of the eighteenth century is entirely bound up with the vicissitudes of the monarchy and the ruling class, and is obedient to their changing whims and fancies. Whereas Gainsborough, Reynolds and Romney – to take the example of another country which had no strong tradition of painting – could live comfortably on the support of the wealthier middle classes and the minor aristocracy, Russian painters were absolutely dependent on commissions from the court. Consequently they flourished only so long as they

met the needs of the sovereign or the landowners and satisfied the taste of the moment. The artist existed as a functionary whose task, broadly speaking, was not to depict the character of the sitter but by means of an exact visual image to record and establish for posterity his glorious and elevated place in society and the structures of government; the personality of the artist was of very little concern. Thus we know little or nothing of many eighteenth-century painters. The reader will have noticed how many of them seemed to have died in neglect and obscurity. Nor will it have escaped him how often they were expected to turn their hands to decorative and religious painting since the Orthodox church still held sway, although its temporal power had been purposefully diminished by the various rulers during the century. The more pious artists may have had to wrestle with their consciences before surrendering themselves to a worldly career of painting women and beardless men (the beard still being regarded as a sign of religious devotion); and this struggle may account for the number of artists who returned to icon painting in their last years.

In her entertaining *Memoirs* Madame Vigée-Lebrun has some reflections on her stay in St Petersburg: 'I see here Russians who are ordered to be sailors, huntsmen, musicians, painters or actors, and who become all these things according to their master's will. And they are alert, attentive, obedient and respectful.'[41] How such talents should have emerged from the foul morasses that lay beneath the aristocratic culture of eighteenth-century Russia defies understanding; but so dynamic was the innate genius of the Russian people that musicians, poets, actors, dancers, sculptors, architects and painters did arise. The palace of Ostankino with its beautiful architecture, furnishings and decorations was constructed for the Sheremetev family entirely by serf labour: it was enough for these workers to be shown an example for them faithfully and obediently to produce a master copy. But in the example of Ostankino lies part of the tragedy of the century: the inability of the Russian artist to find his own artistic path. Those artists who were sent abroad as boys found themselves in a world in which artistic values were changing with frightening speed and in which no one style was stable.[42] Hungry to devour all they could of Western painting they often found that they had swallowed the recipes for composition and technical bravura and lost their own capacity for invention and observation. When they returned

home too much was expected of them by their royal masters. And as for the young artists who had studied only in Russia, it seemed that each new foreign teacher and each new painting acquired from the West for the Imperial collections brought about a crisis of indecision. Which style were they to follow? Which style pleased their master most? Was there a true style, as there had been with icon painting from time immemorial? The itinerant Western artists who came for a while increased the complexity of the problem, since they brought with them so many distinct national styles.

Ever conscious of a patron restless for novelty at his back, the Russian painter was forced to adopt a wide-ranging eclecticism for better or, not infrequently, for worse. And yet, although so comparatively few paintings have survived destruction by owners, the uprisings which plagued Russia in the eighteenth century, the revolutionary activities from 1905 onwards and the monumental indifference to the heritage of the past illustrated so poignantly by Chekhov in *The Cherry Orchard*, the evidence of technical mastery is irrefutable. It is clear that during the eighteenth century there was a distinct growth and original development as far as painting was concerned, to say nothing of the other related arts, a splendid flowering in which the three names of Rokotov, Borovikovsky and Levitsky shine most brilliantly.

While it can certainly be argued that these three painters – and others associated with them or working in isolation – were indebted to the West, it must also be emphatically stated that not only did they reveal the ability of the Russian artist in the field of secular art but that they demonstrated that Russian painting had come of age. They excelled in two ways – and this is equally true of Argunov and the Antropovs – which are as related to each other as are the two sides of a coin: they brought the large state portrait to dazzling heights which it never reached elsewhere; and they brought to the portrayal of men and women, even those of the most exalted station, a perceptive intimacy which may have had its origins in English portraiture but to which they gave sharper penetration and wider sympathy. In doing so they compensated in a measure for the decay of the icon both in its modest domestic form and in the large representations that faced worshippers from the iconostases of the great cathedrals.

Russia had borrowed from the West and would continue to do so until the twentieth century, when she would astonish the Western cultural world with

the abundance of her artistic riches and her unlimited creative vitality, but already by the end of the eighteenth century she had shown her strengths. If, as Madame Vigée-Lebrun had commented, artists were created by the autocratic social system regardless of their own desires or abilities, it may also be true that this very system, indirectly perhaps, aided the rise and progress of the artist as a man of genius. By the end of the century he could, with exceptions, rely on commissions to give him the basic means of life and could count himself a full member of the society in which he lived. Available to him were the great collections acquired by Catherine the Great and her predecessors as well as the lesser galleries of the aristocracy and the rich merchants. The government was probably the most despotic in Europe but, paradoxically, private and public galleries were open to the public – and to the artist – a privilege enjoyed nowhere else in such liberal measure. Free of the domination of the church, the Russian painter faced in the coming century the need to free himself from the tyranny of the court and the aristocracy: the influence of the Western art world was already declining and was to be increasingly of minor concern. The real struggle for the artist was within and against the social system of his homeland.

4
The Apotheosis of Academic Art

Catherine II, the last indisputably great sovereign of Russia, was followed by a line of mediocrities of whom the most that can be said is that some few were earnest in intention if less so in deed. Her diplomacy advanced the frontiers of the Russian Empire till it was face to face with Europe, Europe of the French Revolution, against which she reacted in terror. She died on 17 November 1796, the year in which Napoleon won his first victory in Italy, and was succeeded by her son Paul, born in 1754 but removed from her care by the then Empress Elizabeth who had seen to it that he received a sound education. In 1776 he married as his second wife Princess Sophie Dorothea of Würtenburg with whom he made a lengthy tour of Europe in 1782–3.

Paul detested his mother, who kept him out of all affairs of state and took away from him his two eldest sons, the Grand Dukes Alexander and Constantine. She intended to bypass Paul and make his son Alexander her successor but the final step was never taken and Paul became Emperor in 1796 at the age of 42. Although he seems to have intended to set himself up as an enlightened monarch his foreign policy was not noticeably successful nor were his reforms effective. At his coronation, however, he defined the order of succession to the throne on the basis of primogeniture and deposited a document to that effect on the altar. At the same time he restricted the labour which a serf had to do for his master to half the week, with no work on Sundays, but in practice he granted away crown peasants into serfdom far more lightly and in far greater numbers than had Catherine, who was no paragon in this respect herself. He reduced the power of the gentry somewhat and instituted an elementary bureaucracy to run the country. A man of inexplicable and rapidly changing moods, he was constant in one thing only: a horror of the French Revolution.

Russians who were travelling abroad were recalled; Frenchmen were obliged to present Bourbon passports at the Russian frontiers; European books and music were proscribed; and, it was said, so great was the general fear of imprisonment and exile that married couples slept arm in arm lest the husband should be arrested in the night without his wife's knowledge. Paul's wilfulness was such that he was believed to be mad and did little to contradict this impression. When liberating the Polish patriot Potocki – the most generous of his actions – he said, 'My advisers want to lead me by the nose but unfortunately I have not got one'; which was more or less true in every respect. Inevitably there were plots against him and on 23 March 1801, with the tacit agreement of his eldest son Alexander, conspirators entered the newly built Mikhailovsky Palace in which he had immured himself and strangled him.

Alexander's succession was rapturously received throughout Russia. He had inherited from his mother superb blue eyes, fair hair and a splendid stature. In character, however, he was an even greater enigma than his father, a consummate actor and a born diplomat. Not without reason Napoleon called him 'the Northern Talma' and 'the Northern Sphinx'; and there was no lack of critics to describe him as an inveterate hypocrite. Alexander had been educated by a Swiss tutor called Laharpe who had come to Russia in 1783 and who inculcated into his pupil the virtues of French radicalism; but the young man was also under the powerful influence of Aleksei Andreevich Arakcheev, his father's chief adviser, a fanatical disciplinarian, brutal, blunt and short-sighted in political affairs. Later Mikhail Speransky was appointed counsellor, an official of brilliant practical ability in administration although continually hampered by his humble birth. Somehow Alexander contrived to give the impression of accepting advice from all three but went his own

individual way. In his youth he had friends who expressed distinctly revolutionary sentiments to which he appeared to subscribe, especially when the 'cursed question', the problem of the abolition of serfdom, had been raised in their discussions on home affairs. But Alexander was yet to face the reality of Napoleon's domination of Europe. When the decisive event of his reign – the invasion of Russia on 23 June 1812 – was forced upon him, he successfully organized resistance against the French and aroused the patriotic fervour of his countrymen, even including that of the peasants and serfs.

With the coming of peace in 1815 Alexander showed himself (as he had done already in his dramatic encounters with Napoleon) an expert in diplomatic duels which strengthened Russia's frontiers and extended her prestige in Europe. His countrymen were, unfortunately, not rewarded for their sacrifices. Instead, Alexander grew more and more reactionary, seeking biblical and religious authority for his autocratic wishes and repressive acts so that those who had come to see the need for reform despaired of any lead from him. When on 18 December 1825 it was announced that Alexander had died of protracted gastric fever the news was received with little regret by the populace at large but with eager interest by a group of intellectual and aristocratic conspirators, most of them in the Palace Guard, who were united by a desire to reform or end the autocracy, if necessary by radical means. They were to become known as the Decembrists.

Alexander had no son to succeed him; in a typically devious manner he had encouraged and accepted his brother Constantine's abdication of any right to the throne in favour of their young brother Nicholas – without telling anyone. Three copies of this declaration had been deposited in St Petersburg and Moscow to be opened on Alexander's death. Nicholas, who was in the capital, had been kept ignorant of this decision and proclaimed his brother Constantine as Tsar, while Constantine, happily domiciled in Warsaw where he was Viceroy, proclaimed Nicholas. Unable to agree on which procedure to follow the two brothers engaged in a vexatious and farcical correspondence which was brought to an end in an unexpected and bloody fashion. The conspirators raised some 2,000 of the soldiers under their command in revolt. In the December snows, outside the Council of State, these troops shouted for 'Constantine and Constitution' which latter, in Russian *Konstitutsiya*, many of them took for the name of Constantine's wife. After

the Governor-General of St Petersburg had been shot in the back, Nicholas gave the signal for cannon to be put into action.

The last of the revolts to have been engineered from within the palace and the first one to have a political programme, however vague and ill-defined, which aimed at reform on behalf of the Russian masses, the rising of the Decembrists was to become a legend in the long struggle for freedom; and everyone except the monarch himself recognized its tremendous significance in the cultural and political and social development of the Russian Empire.

Nicholas I who now came to the throne had been born in 1796 and was 19 years younger than his brother Alexander. He had never known his brilliant grandmother and was only 16 at the time of the Moscow campaign. His life had been overshadowed by his brother Alexander's strange personality and reactionary mentality. The first decision of his reign was sufficiently dramatic and left no doubt as to his own character: he hanged five of the Decembrists. There had been no death sentence under Alexander, so that this action made a strong and unhappy impression and further served to confirm the Decembrists as martyrs in the cause of national liberty.

The attitude of Nicholas towards the abolition of serfdom appeared enlightened, at times more so than that of the bureaucracy with which he surrounded himself, but for the most part he was an oppressive reactionary with a narrow and limited vision. Terrified by the French revolutions of 1830 and 1848, he tried to stifle all thought in Russia. A sole outlook prevailed – his own, banal, stupid and tyrannical. 'Obey without discussion' was his invariable command. In 1854 he found himself opposed to France and England in the Crimea, involved in a war which he could not hope to win and from which there was no promise of gain. The conflict cruelly demonstrated the inefficiency, corruption and incompetence of his bureaucratic regime and the courage of the private soldier who was, in fact, treated worse than any slave of the Muslim world. Amid the ruins of his government Nicholas declared, 'My successor must do as he pleases; for myself I cannot change.' Stricken with a severe chill against which few precautions were taken, Nicholas died on 2 March 1855. With him perished the European predominance of St Petersburg, founded by Peter I, built up by Catherine II and strengthened by Alexander I.

Russia had passed through a dark night. In 1826

Nicholas had tightened the laws of censorship so that all works on logic and philosophy were forbidden, except for school text-books. Each Ministry was encouraged to set up a censorship of its own so that Nikitenko, most liberal of the censors, was able to joke that one year there were more censorships than books published. Through this miasmic obscurantism towered the two greatest poets of Russian literature, Pushkin and Lermontov. Pushkin had to some extent supported the Decembrists until the failure of 1825 when he began to despair of the liberal cause and devoted his life to literature. Like Byron he was sometimes at odds with the society of his time and in 1837 when some (not undeserved) assertions were made against his wife's honour Pushkin called out his rival and was mortally wounded. Bitter verses attacking the society which had hounded Pushkin to his grave announced the precocious talents of Lermontov (a remarkable artist, incidentally, both in oils and watercolours) who at an even younger age was also to perish in a duel, leaving behind him a Byronic poem, 'The Demon', and his sardonic novella *A Hero of Our Time*, which were to inspire many later artists and musicians. The lesser lights of this period were Krylov, writer of satirical fables, published from 1809 onwards, eventually with the approval of Nicholas himself, and the dramatist Griboedov, who attacked the servility of Russian society in *The Mischief of being Clever*, a play which was never produced in his lifetime.

The mediocrity and ineptitude of Nicholas's bureaucracy were bitterly satirized by Gogol, one of the greatest writers of the period, in his *The Government Inspector* and the unfinished novel *Dead Souls*. Yet, like so many Russian writers and artists, Gogol dreaded and denied the implications of his own work, fell into a personal and obscure form of mysticism and tragically accepted (apart from self-imposed exile in Rome) the unquestioning obedience, unthinking loyalty and servile abasement which were counted as virtues by Nicholas. Most of the best intellects turned to the study of German philosophy – for, under Nicholas, all things German were encouraged – and especially that of Kant, Fichte, Schelling and Hegel. The most forceful group of thinkers, led by the artist-philosopher Stankevich, had been students at the University of Moscow: Vissarion Belinsky, Ivan and Konstantin Aksakov, Mikhail Katkov, Mikhail Bakunin and Aleksandr Herzen. These men turned their critical attention to all aspects of Russian life, art, music and literature.

Their enthusiasms and criticisms were communicated to their friends among the creative artists; and there was thus developed a cohesiveness which was a uniquely Russian phenomenon for which one cannot find a true parallel anywhere else in Europe. It gave the arts in Russia an invigorating social purpose during the nineteenth century – a purpose which was not, however, entirely beneficial in its effects on painting.

In a sense we are seeing the birth of the Russian intelligentsia which despite social, political, ideological and physical persecution has lasted to the present day. Artists – now accorded a measure of social and intellectual recognition which had hitherto been denied them – writers, musicians, singers and actors kept in close contact with each other, shared ideas and thus formed a body that was progressive in almost every way. Ironically, nowhere was this stronger than in Italy where in the first decades of the century Russians took their place in the brilliant international society assembled there. Financed by the Academy or by the Society for the Encouragement of Artists (afterwards Arts), students arrived for periods of three years and were usually attached to a teaching studio where, for instance, there might be lessons in anatomy by Camuccini, Canova or Thorvaldsen.[1] Continual attempts were made to control these artists. It was expected that the Russian Ministers and aristocrats living in the city would report on their behaviour; and Nicholas I actually instituted an organization with responsibility for keeping them in order, visiting Rome himself to take stock of the situation in 1845.

During these decades Aleksandr Ivanov, Bruni, the Chernetsov brothers, Kiprensky, Fedor Matveev, Moller, Raev, Silvestre Shchedrin, Maksim Vorobiev, V. K. Sazonov, Basin and Bryullov all worked in Rome. They were sometimes familiar with other foreign writers and artists residing in Italy – both Bryullov and Kiprensky knew Ingres, who worked there in 1806–24 and 1835–41, although he had little effect on their work; Bruni knew the Nazarenes; Ivanov was acquainted with Overbeck; Bryullov also knew John Gibson and Sir Walter Scott; and Kiprensky was especially friendly with Thorvaldsen. Contact was easily maintained in the area of Piazza del Popolo where they had lodgings and the Café Greco (still in existence), which was especially popular with foreign artists and visitors to Rome as a meeting place. From about 1820 Princess Zinaida Volkonskaya stayed in the

city, finally establishing a salon which attracted the more intellectual of her countrymen. Further north, just outside Florence, lived the Demidov family who were generous if exacting patrons of Russian artists in Italy. It will be remembered that Levitsky had painted an earlier member of the family; and one of his descendants, son of the Russian envoy to the court of the Grand Duke of Tuscany who became Principe di San Donato by virtue of marrying Napoleon's niece, had himself portrayed by Bryullov. The Demidovs purchased the artist's *Last Day of Pompeii* and presented it to Nicholas I. It is interesting that V. Stasov, later to become an influential writer on his country's art, was for a while secretary to the Demidovs. In addition to the artists there were philosophers, writers and musicians, Gogol and Glinka being among the best known.

Among the intelligentsia in Russia – artists included – there was a distinct sympathy with the Decembrists who had sought an enlightened monarchy or, more drastically, a confederacy, and whose demonstration had been so brutally punished. The ferment of the time continued to express itself in a number of ways, not always clearly reformist. There was a serious attempt to promote Russia as the spiritual leader of Europe, the Christian nation above all others, which lasted until the 1820s, by which time Alexander had begun to fear that the growth of new sects and the spread of Christian mysticism might eventually turn into a political movement in opposition to the monarchy. The Orthodox church also increased its powers during this period, involving itself in the universities where it tried to secure the introduction of syllabuses which would have returned Russia to the early days of Orthodoxy. At the same time it began to look to the East where the immense Asian population seemed proper material for conversion. The building of new churches and cathedrals was one consequence of this religiosity; and painters were called upon to provide decorations which would combine the spirit of the old icons and those aspects of Western European Christian art which were thought to be particularly suitable to Russia in a new and complex symbolism.

Side by side with these tendencies of an obscure religious nature went a growth in the Masonic movement which was at the same time obscurantist and egalitarian. In *War and Peace* Tolstoy describes the proceedings of a Masonic Lodge in detail; and he obviously regarded Masonry as a progressive force in Russian life, in which view he was probably

mistaken. Like mysticism, Masonry was essentially anti-Enlightenment although it served, however indirectly, to promote the social prestige of writers and artists. A more effective agency, established in 1801, was the Free Society for Lovers of Literature, the Sciences and the Arts which organized lectures on aesthetic topics and thus paved the way for consideration of romantic attitudes. Of even greater relevance were the various salons which were held in St Petersburg, emulating those which exerted such influence in France. These increased the self-consciousness of contemporary creative artists – in the case of painters leading to a growth in searching self-portraiture – since they were thus made aware of their individual standing and self-importance as well as the increasing prestige of their role in society. In this connection an important influence was that of Aleksei Romanovich Tomilov (1779–1848), a Mason, artillery engineer and aesthete who set out to oppose the prevailing canons of neo-classical art by proposing a greater part in creativity for imagination and feeling. He also claimed a wider autonomy for the artist, and emphasized the importance of the artist's subjective response to the world around him. Tomilov expressed himself in a number of essays, among which *Mysli o zhivopisi* (*Thoughts on Painting*), written early in the second decade of the century, is the most forthright.[2] Besides Tomilov there were other writers on aesthetics who served to introduce elements of romanticism, especially those of a Germanic nature, among them Aleksandr Galich (1783–1848), Ivan Kronberg (1788–1833), Molodoi Vladimir Odoevsky (1803–69) and Orest Somov (1793–1833), but the repercussions of their lectures and writings on painting were limited.

In the previous century Russia had been dragged into the mainstream of European painting by the advent of foreign painters and teachers, many of them of Italian extraction or fame, and by her own artists who had studied abroad. The Italian pictorial genius had now petered out, artists from France were less welcome, and those foreign painters who were allowed into the country were generally of an inoffensively minor character. The French artists included J. L. Mosnier (1745–1808), who had emigrated to London at the time of the revolution and who was appointed Court Painter at St Petersburg in 1802, Henri François Riesener (1767–1828), who had studied with David, Adolphe Yvon (1817–93), teacher at the Academy and painter of battle scenes, and Richard de Montferrand (1786–1858), who

was to create the vast and imposing cathedral of St Isaac. The Swede Carl Peter Mazer (1807–84) worked there for a short time as did from about 1839 the Scottish miniaturist Christina Robertson (1796–1854).[3] The Englishman George Dawe (1781–1829), expert in a kind of flashy bravura which he had learnt from Lawrence, was commissioned by Alexander I in 1819 to paint a series of portraits of high-ranking Russian officers who had fought against Napoleon, leaving Russia shortly before his death.[4] Other British artists included J. A. Atkinson (1755–after 1818), who was drawing-master to the young Alexander; Edward Miles (1755–1828), Court Painter between 1797 and 1806; Sir William Allan (1782–1850), Court Painter from 1805 to 1814; Sir Robert Ker Porter (1777–1842), Historical Painter to the Emperor from 1804 to 1806;[5] and the marine painter Alfred Gomersal Vickers (1810–37).

It is probable that Russian painters may have learnt something of the style of English portraiture with its quiet but emphatic underlining of the sitter's personality from these visiting artists.[6] But the flow of British artists soon dried up;[7] and from the reign of Nicholas I onwards various pedestrian artists, many of them of the Munich school, including two Nazarenes, Hippius (1796–1856) and Ignatius (1794–1824), provided the commonplace portraits and battle scenes for which the Imperial court had an insatiable appetite. Martin Ferdinand Quadal (1736–1808) brought charm and competence to a series of still lifes, portraits and allegorical scenes, although his rococo manner was already outdated. Much to the taste of Nicholas I after his accession were the rather humdrum portraits of Franz Krüger (1797–1857).

With the exception of Dawe these artists could hardly be considered romantic; and they remained apart from Russian painting. Whatever his own inclinations, the Russian painter was not free to work as he wished, for he was subjected to control of both matter and manner (except by a few enlightened patrons), patronized and commissioned by the conservative land-owning gentry (by whom as a serf he was sometimes owned) and trained at the Academy of Arts which was directly responsible to the crown. After graduating there he usually went to Rome, which at the beginning of the nineteenth century had become the art centre of Europe, a position in which it was confirmed, as far as Imperial patronage was concerned, by its healthy distance from Paris. Artists, who were subsidized for three years, were frequently placed in the care of an established painter such as Camuccini, the celebrated neo-classicist. As elsewhere in Europe, these students were expected to develop their skill by making copies of Leonardo, Raphael, Michelangelo and the accepted Old Masters; and on their return home were required to decorate the Imperial palaces, new churches, chapels and cathedrals. It could hardly be expected that all students would survive the rigours of the academic courses which they followed from childhood without crippling and stultifying their initial talents; nor that artists of integrity and genius should submit to the dreariness of a career in the service of the emperor. But they were not expected to emerge from their training as individuals but as functionaries. Some few of the more independent artists were encouraged and aided by commissions from private patrons either in Russia or abroad (such as the Demidovs), or from the Society for the Encouragement of the Arts (founded in 1822) which supported them with travelling scholarships, although in general tendency it was hardly less conservative than the Academy. To opt out of the system of academic training (which, it should be remembered, was financed directly from the Imperial purse) and the final reward of secure service with the state and, instead, to attempt to work independently was to bring down on one's head poverty, loneliness and increasing social isolation.[8]

Small wonder, then, that romanticism did not manifest itself in painting with any force despite the aesthetic arguments being published and the changing social rôle of the artist. The Soviet art historian D. V. Sarabyanov has stated that romanticism in Russia was born in a deracinated, atrophied form because the appropriate 'social conditions' necessary for its development were not present in full force. The spirit which motivated it was European rather than Russian; and it derived its nature from the romanticism present in neighbouring states – presumably, although Sarabyanov does not directly say so, Germany and, to a lesser degree, France. He goes on to argue, perhaps more pertinently, that 'it developed not after but at the same time as neo-classicism'. He adds that the typical trait of the Russian school was that 'tendencies which succeeded each other in other schools coexisted in Russia; and instead of being rivals they happily agreed with each other. Their merits were not diminished in this way and on the contrary the artistic quality of these first products of Russian

romanticism drew from them an original and specific colouring.' He finds the years 1800–20 were especially rich in portraiture and, less obviously, landscape; and the years 1820–30, the ultimate phase of Russian romanticism, saw the development of a new mode of portraiture in which psychological insight played a great part and in which there was a hint of romantic disillusionment; it is best represented by the work of Bryullov, whose influence was far-spread.[9]

Interesting and useful as are Sarabyanov's arguments they do not cover the entire field of painting, for these are the years when history painting reached towards its greatest heights and when a novel form of monumental religious painting developed. Bryullov's *Last Day of Pompeii* (1828–33) represents the apogee of history painting, as does Ivanov's *Appearance of Christ to the People* (1833–57) of religious painting. But around these great artists clustered lesser artists of merit. A. E. Egorov (1776–1851), V. K. Shebuyev (1777–1855), V. E. Raev (1808–71), G. G. Gagarin (1810–93), N. A. Lomtev (1816–59), F. A. Moller (1812–74), A. T. Markov (1802–78) and F. G. Solntsev (1801–92) worked on religious paintings, the latter even making copies of mosaics at Constantinople and Kiev. Lomtev also painted history pictures, developing a personal, misty style.[10] It should be noted that Sarabyanov's time scale of the years 1820–30 does not cover major works by Ivanov, Bryullov and Bruni, which are later in date. Nor does he adequately recognize that neo-classicism was a much earlier element in painting and that it lasted at least until the mid-nineteenth century.

Before discussing painters in the unique Russian romantic style it is first necessary to turn to the Academy itself, the style it propagated, and its early practitioners. In effect, this means a review of its earliest days.

In establishing the Academy as a pedagogical institution in 1763, Catherine's director Betskoy adopted and combined the regulations and practices of every other academy of arts in Europe, as well as the ethos common to them all which was, almost without exception, regulated by the achievements of the Renaissance and the Bolognese school, and neo-classical in aim and intention, if not always in effect. The ideals of Betskoy, which are so characteristic of eighteenth-century enlightenment, had astonishing results. Alexandre Benois described the state of the establishment soon after its foundation:

The ground-floor of the Academy was occupied by an infant-school. Boys of from three to five were taken there, being sometimes taken from the foundling hospital. After they had gone through the elementary course of teaching they entered the more advanced school, being then from eleven to thirteen years of age. There they were drilled to become artists, and finally sent abroad, where Mengs and David stood at the zenith of their glory. In St Petersburg young Russians were compelled with the knout to make Oriental reverences before Poussin and the Bolognese. When they came to Rome they transferred their servile veneration to the two younger princes of painting who the world delighted to honour. And so the classicism of Mengs and David – icy rigidity and tediousness aiming at style – found their way into Russia. Like a new Minerva, armed with diplomas and arrayed in academical uniform, Russian art descended to the earth ready-made.[11]

The earth to which this 'ready-made' art descended was far from hostile, perhaps, indeed, over-ready to accept the spirit of neo-classicism, especially in architecture, so that St Petersburg became and still remains the most classical of all European cities.

Neo-classicism not only flourished but also enjoyed a tremendous vogue under Catherine the Great and her immediate successors Paul I and Alexander I and in court circles generally because it seemed to embrace the distant glories of Raphael and the Italian Renaissance, the splendours of the Roman Empire, and the exoticism of newly discovered Pompeii and Herculaneum and remote Egypt, all of them far away in space and time from Russia. Catherine, ever eager for the latest European novelty, had appreciated a restrained classicism as manifested, for instance, in the decorations of Cameron, but her enthusiasm waned when its most celebrated practitioner threw aside his artist's smock and proclaimed himself as *citoyen* David, Member of the Convention, a painter who voted with fervour for his sovereign's execution. Her successors ignored these revolutionary associations and saw in classicism a means of perpetuating and, in fact, of spreading their own Imperial glory. It was the architectural style most beloved of Napoleon, that of Imperial Rome, that was approved by Alexander for public buildings in St Petersburg. On his accession he so encouraged a strict and formal classicism in architecture that it is not idle to talk of the Alexandrian Empire style. But whereas in architecture and city-planning such classicism seemed

entirely admirable, its manifestations in painting were less attractive to the crown, for if it seemed to extol sacrifice and discipline, it also proclaimed liberty and republicanism and was indirectly tainted by revolutionary sentiments. It was not for Russia. Nor were the outdated baroque and rococo.

Something of Alexander's basic unreliability, not to say shiftiness, infected painting, which lacked the necessary confidence and boldness to evolve a style that could equal the splendid strength of the Alexandrian style in architecture. The fact that painters as well as writers were subject to a censorship which intensified after the Napoleonic Wars did not improve matters; and there was a widespread sense of deflation when peace was restored and none of the reforms which had been so confidently expected actually materialized. The revolutions of 1789, 1830 and 1848 established France as the most dangerous country in Europe and yet French culture held sway until the advent of Nicholas I to the throne when it was supplanted by much that was Germanic in philosophy, literature, painting and living styles. For some inexplicable reason it was then that painting showed its strength, although in a style that was an extraordinary hybrid of neo-classicism, academicism and romanticism.

Returning once more to the early days of the Academy as already described by Alexandre Benois we find that there were a number of painters in the neo-classical style whose work commands attention and, of course, many more later painters whose art was essentially academic, even when vaguely touched by romanticism. The painter who combined academicism with classicism in the eyes of the public was not himself a total product of the Imperial Academy. And, paradoxically, he has also been hailed as a harbinger of romanticism because of his *Portrait of F. G. Volkov* (1763), the popular actor, which is said to anticipate the portraits of the early nineteenth century which tend to investigate the sitter's inner character and which cover a wider range of the social strata. This artist was Anton Pavlovich Losenko (1737–73), who first served an apprenticeship under I. P. Argunov before going on to the Academy where he stayed only a short time studying under Le Lorrain.

Losenko was born into a peasant family in the Ukraine. At an early age he was sent to St Petersburg to sing in a church choir; and when his voice broke a career as an artist was decided for him. Fortunately he possessed real talent as an artist (which Falconet at once recognized when he saw the drawing Losen-

ko had made of his own sketch for the monument to Peter the Great); but, it seems, very little confidence. To some extent this explains the rather paradoxical nature of the comment that he was 'one of the most gifted and neglected Russian painters of the early years of Catherine's reign'.[12] He exemplifies the treatment described by Benois – which was not calculated to bolster self-esteem. In 1758 Losenko went to study with Restout in Paris where he painted a showpiece, *The Miraculous Draught of Fishes* (1762), which he brought back to St Petersburg where it so impressed the court that he was allowed to return to Paris. There (like *citoyen* David) he continued his studies under Vien and painted yet another large religious picture in the neo-classical style, *The Sacrifice of Abraham* (1765). A further bursary enabled him to visit Rome, where he copied Raphael and acquainted himself with classical and contemporary art. Even more unusual, he went to Venice for further study. When he finally returned home in 1769 he was created professor of history painting at the Academy and three years later he was appointed to the directorship. The cares of administration are said to have worn him out, but he managed to compile a work on human proportions for use by his students. It is obvious that Losenko moved in influential artistic and intellectual circles, his position being somewhat analogous to that of Reynolds. His long training abroad gave him a prestige which is not always justified by his surviving religious and historical paintings. Of these the most celebrated was *Vladimir and Rogneda* (Plate 40). Acting on the advice of the sculptor Falconet the Empress Catherine promptly acquired it for the nation, although it seems unlikely that she viewed its neo-classical characteristics with much favour.[13] In the few remaining years of his short life Losenko never again repeated its success.

Vladimir and Rogneda was and remains a landmark because of its iconographical and iconic nature, and not because of any intrinsic artistic quality: in theatrical terms in which the baleful sentimentality of Vien is more than apparent, the canvas depicts the dismay felt by Vladimir, prince of Novgorod (and, later, of Kiev), who ransacked and looted Polotsk, when his amorous advances were rejected by its princess, Rogneda. He killed her father and brothers and against her will carried her off as his wife. After these acts he was filled with remorse and begged her forgiveness. In effect, the canvas refers to the liberal and humanitarian ideas which were circulating in Russia at the time and

which Catherine had tried to embody in her *nakaz*. The painting, for all its patriotic and humanist references, is no more valid than the Empress's nebulously benevolent words. It looks like an illustration to a historical drama, since the figure of Vladimir was posed for by the actor Dmitrievsky dressed in the semi-classical costume adopted by actors of the period. The composition is awkward, the gestures stilted and clumsy, the various borrowings from other works are ill-digested, and the whole work is a hotch-potch of attitudes from Greuze, Vien, Mengs and classical statuary. And in total, the picture is not neo-classical but strangely baroque. But art may be none the less potent for being bad; and an icon – for that is what this painting is – may have other values than those of style or execution. There is no denying that Losenko gave history painting a tremendous impetus and prestige – but without increasing its popularity – and because of his use of national and semi-historical costumes he endowed it with a specifically Russian character. He is, thus, the forerunner of the serious and devoted artists of the nineteenth century, of Aleksandr Ivanov and others. He also served to open up a range of subject-matter derived from Russia's vast territories, such as Pushkin was to use in his *The Fountain of Bakhchisarai*.

It is unfair to judge Losenko on this one work, for he was a sensitive portraitist as is proved by his paintings of Count Ivan Shuvalov, founder and first President of the Academy of Arts, Shumsky the actor (1760) and Sumarokov the poet and playwright (1760). His large studies of male nudes and allegorical and classical works such as *Hector and Andromeda* (*c*.1773) demonstrate his capacity to organize on a scale hitherto unattempted by Russian painters. Nor was he a negligible colourist; and it is a pleasure to see paintings which have not only retained their original tints but have gained an additional resonance through the able and effective use of pigments, a sensitive taste in colour and an undeniably sound technique.

Losenko introduced several innovations to his generation, chief of which was the correct representation of the nude, a representation which had not hitherto concerned Russians and in which there was no tradition of any sort. His career also indicated to his fellow-artists that apart from portraiture there were other areas worth following, notably the aspect of the neo-classical which might be described as Bolognese religiosity and of which his own *St Andrew*, *Cain* (1768) and the *Death of Abel* are

sternly representative. He introduced to Russian painting the *pompier* style and bequeathed it to the artists who followed him such as A. A. Akimov (1745–1815), who studied in Rome and Bologna and then returned to manage the Imperial tapestry factory; and then in 1796 was appointed director of the Academy itself. P. Sokolov (1753–91) followed Losenko's example with grandiose works through which there pranced or stumbled the somewhat chilly figures of Athena, Prometheus, Mercury and Argus. G. I. Ugryumov (1764–1823), who received some tuition from Losenko but was more properly a pupil of Akimov, tackled national subjects in his gigantic *The Capture of Kazan* (*c*.1800) and *The Coronation of Mikhail Fedorovich* (*c*.1800) painted for the Mikhailovsky Palace; but despite their subject-matter these works and his *Alexander Nevsky* (1792) and *Prince Vladimir and Yan Usmar* (1797) are the hybrid offspring of a singularly Graeco-Roman stable. Nevertheless, they do testify to the technical progress made by students of the Academy.

Aleksandr E. Egorov (1776–1851), long known as the Russian Raphael – and not without reason, considering his many pastiches of that artist – studied in Italy before becoming a professor of historical painting at the Academy in 1812. He worked on religious decorations, published two albums of engravings on religious themes, and painted portraits which are often of a high order such as those of M. P. Buyalskaya (1824) and A. R. Tomilov (1831). Egorov's rival V. K. Shebuyev (1777–1855), decorator of the new Cathedral of Kazan and the chapel of Tsarskoe Selo, was proclaimed the Russian Poussin for which title, it must be said, his patriotic *The Feat of Igolkin* (1839) offers little justification. On the other hand, his *Self-Portrait with Fortune-Teller* (1805) is an extraordinary work, utilizing material from Van Dyck and Tiepolo and proclaiming romantic tendencies which are hardly to be found in any other painter of his background. Andrei I. Ivanov (1776–1848), another pupil of Ugryumov, produced *The Kiev Youth's Act of Bravery* (1810) and, two years' later, *Mstislav in Combat with Rededa*, in which vague suggestions of martial glory are used to arouse the national patriotism that was so evident in Russian

40. Anton Pavlovich Losenko: *Vladimir and Rogneda*, 1770. Oil on canvas, 211.5 × 177.5 cm. Leningrad, Russian Museum

life during the struggle with Napoleon. His work, too, is eclectic – an odd mixture of the baroque and the classical – and almost wholly detached from a Russian background. D. I. Ivanov (1782–after 1810), with his *The Hermit Feodosy Boretsky handing the Sword of Ratmir to Miroslav* (Plate 41) is even more of the *pompier* school, as is V. K. Sazanov (1789–1870), with his *Dmitry Donskoi on Kulikovo Field* (1824). Yet it would be a mistake to regard these works simply as dull academic exercises in the neo-classical style on remote historical themes; there was a genuine patriotism in people's hearts at the turn of the century, a patriotism which had been stirred to life by the threat of the

Napoleonic invasion; and even the most nationalistic of Russians believed that his country had unique links with the classical past which were proved by the Byzantine origins of the Orthodox church and the ancient Hellenic settlements in southern Russia. Besides, by presenting characters from Russian history in the semi-nude or in classical draperies the artists were able to avoid any charges that might have been brought against them of arousing revolutionary sentiments; their art is deliberately intended to avoid contemporary political reference. There is yet another consideration: these academic painters undoubtedly revelled in the opportunity to work on large-scale pictures and a sense of excitement is frequently observable in the breadth of handling and in the complexity of the composition. More significantly, we see here the commencement of the Promethean spirit which is associated with the Academy, the fervent desire to equal the great masters of the past and to create

41. Dmitri Ivanovich Ivanov: *The Hermit Feodosy Boretsky handing the Sword of Ratmir to Miroslav, the youthful leader of the People of Novgorod, who was designated by Martha the Regent as husband for her daughter Xenia*, 1808. Oil on canvas, 160.3 × 196 cm. Leningrad, Russian Museum

masterpieces on a scale larger than anything attempted in Europe at that time, an urge which was to manifest itself in the work of Bruni, Bryullov and Ivanov later in the century.

The majority of these painters were involved in the creation of vast decorations for the immense new cathedrals of St Isaac of Dalmatia (built 1817–57) and the Virgin of Kazan (1801–11) in St Petersburg, and of the Saviour (1839–83) in Moscow; and were also pestered by commands for domestic and public icons. P. V. Basin (1793–1877) painted a huge *Sermon on the Mount* which was well suited to the eclectic classicism of St Isaac's for which it had been commissioned, but his *Marsyas teaching a Young Olympian to play the Flute* (1821), a curiously popular subject with Russian artists of the period, and his *Achilles* (1828) not only show a mastery of the nude possibly learned from Camuccini and Pinelli in Rome, but also hint at the decorativeness which was, still later in the century, to infect the gravity of the neo-classical mode. Basin's pictures of the wooded landscapes around Rome seem to betray an incipient romanticism. A. T. Markov (1802–78) decorated the cupola of the Redeemer with the mysteries of the Holy Trinity utilizing a Raphaelesque manner, and furthered his reputation with the Titianesque *Wealth and Poverty* (1836). Russians received their last vapid visitations from the Greek and Roman past with G. I. Semiradsky (1843–1902), who covered acres of canvas with photographic scenes of remotely classical festivals, rites and customs, all calling for hosts of thinly draped females, in the sugary mildly erotic style popular all over Europe towards the end of the century until the coming of Art Nouveau, and exemplified in Britain in the works of Leighton, Alma Tadema and Moore.

Towering above these were Karl Pavlovich Bryullov, Fedor Antonovich Bruni and Aleksandr Ivanov, whose undoubted academicism was modified by the elements of romanticism which are to be increasingly observed in Russian painting from 1800 onwards.[14] It is paradoxical that of these three artists who were to dominate painting in the first half of the nineteenth century and blazen abroad the glory of the Academy, both Bruni and Bryullov were, as their names suggest, of foreign origin. All three were possessed by a passion to create the great work, the masterpiece that was to challenge comparison with the landmarks of earlier painting and perpetuate their names for eternity. They brought about the apotheosis of both the Academy as the

centre of art education in Russia and St Petersburg as the artistic capital; after them the Academy waned, and Moscow assumed the dominant role in the history of Russian painting. Yet it is ironic that, unlike their predecessors, all three spent many years studying and working in Italy and produced their major works there. Weakened as it was to be, the Academy still maintained its power, and its methods and syllabus and very existence were perpetuated up to the revolution of 1917, although its glory had long since faded.[15]

Bryullov (1799–1852) was descended from an artistic family. His grandfather came to Russia in 1773 to work in the Imperial porcelain factory, while his father taught wood carving at the Academy. When a boy Bryullov was ordered by his father to practise drawing before being allowed to eat his breakfast: like so many nineteenth-century artists and writers (the example of John Stuart Mill comes to mind) he suffered from parental domination. In 1809 he went to the Academy, working under A. Ivanov (whose son was to excel him), Egorov and Shebuyev, but in 1822 he left after a quarrel with the President, having been fortunate enough to have obtained a travelling scholarship from the recently founded Society for the Encouragement of Artists, which had been much impressed by his large *Narcissus* (1819). Apart from a visit to Greece and Turkey he stayed in Italy until 1836. He sent back copies of Raphael's *School of Athens* and sentimental genre scenes of his own such as *Italian Girl washing at a Fountain* (1825) and *Italian Girl picking Grapes: Italian Noon* (1827). The Society was neither impressed nor amused by these picturesque efforts. Nor did it much appreciate his fondness for watercolour and pencil sketches or his discovery of earlier Italian artists, among them Giotto.

However, the Academy had done its work well. Bryullov longed to produce a picture which would reveal his greatness and earn him undying fame. Casting about for a likely subject he was eventually inspired by Pacini's opera *L'Ultimo giorno di Pompeii* (1825) and the keen interest of his architect brother in the excavations taking place outside Naples. He obtained a commission from Count Anatol Demidov who accompanied him to Pompeii where the initial sketches were made. For three years Bryullov toiled on his portrayal of the last hours of the stricken city and its doomed citizens. In 1828 the first version of *The Last Day of Pompeii* (Plate 42) was unveiled before the awe-filled and admiring

42. Karl Pavlovich Bryullov: *The Last Day of Pompeii*, 1833.
Oil on canvas, 456.5 × 651 cm. Leningrad, Russian Museum

public which flocked to his studio in Rome. He had
closely followed the descriptions of the last days of
Pompeii given by Pliny the Younger in his letters to
Tacitus and also visited the newest excavations
and examined the objects found there. As a result we
see a town falling in ruins, the walls crumbling, the
sky covered by an ominous and fearful pall with
bluish-white streaks of lightning and red flames
illuminating the terrified flight of the inhabitants,
women and children, old men and young, citizens of
all kinds and classes, some of them already over-
whelmed by the heat and dust. The observant viewer
will recognize elements selected from Raphael's *Fire*

in the Borgo, Michelangelo's frescoes in the Sistine
Chapel and works of the Bolognese and Venetian
schools, but will also acknowledge the grand con-
ception and superb execution of this enormous
work. An Italian critic remarked that it combined
the majesty of Michelangelo with the grace of Guido
Reni. It is said that the dying Sir Walter Scott sat in
front of it and observed that it was not a painting
but an epic.[16] Bulwer Lytton was inspired by it to
write *The Last Days of Pompeii* (1834). It gained
the Grand Prix at the Paris Salon of 1834. Member-
ship of the Academies of Bologna, Florence, Milan
and Parma was bestowed on Bryullov. Exhibited in
Florence, Milan and Rome the picture created a
furore but despite the award of a medal by Nicholas
I to the artist its reception in Russia was somewhat
cool. Demidov presented it to the Emperor who

promptly passed it on to the Academy – did he, perhaps, see in this depiction of the destruction of a city of Imperial Rome a hidden, subversive attack on his own autocratic empire? The poet Lavrov exclaimed: 'The Last Day of Pompei/Has been the first day of Russian Painting!'[17] Gogol described it as 'one of the most vivid phenomena of the nineteenth century'. He continued:

This picture by Bryullov can be called a complete universal creation. It answers the longings of our contemporaries who attempt to fight the prevailing fragmentation by drawing phenomena together into a unity, to single out mighty crises which have been shared and experienced by a mass of people.... When I looked at the painting for the third or fourth time, I felt that the perfect sculpture of the ancients had been transmuted into painting and touched with a hidden music. Every human figure in the work radiates beauty, even their tears and terror gain in beauty. The colours burn and dazzle the eyes. In a lesser artist than Bryullov they would be unbearable but he creates a harmony of them.[18]

Gogol is actually speaking in terms of the tenets of Winckelmann and Mengs, so appreciated by Catherine the Great, which called for a classical calm and the avoidance of violent expression. And although Bryullov worked from living models (he included a self-portrait on the left of the picture), he made no attempt to secure any particular realistic truth of expression. Despite the exaggerated gestures and awe-stricken faces of the citizens, neither ashes nor debris mar their clothes or soil the classical perfection of their bodies. Bryullov comes perilously close to the *pompier* style of Delaroche, Scheffer and Martin[19] who were his contemporaries. His academicism in style and subject-matter is strikingly demonstrated if *The Last Day of Pompeii* is compared with such truly revolutionary and romantic works as Géricault's *The Raft of Medusa* (1819) and Delacroix's *The Massacre on Chios* (1824). Yet if we can set aside our prejudices against the academic and theatrical manner we will find his huge machine still has power to astonish us and to remind us forcibly of the electric effect it must have had on Russian painters. For the first time, a Russian painter, trained at the Imperial Academy of Arts of St Petersburg, had enraptured and dazzled the West; probably no other picture since David's *Oath of the Horatii* had so captured Rome; no other picture of modern times had aroused so much awe and admiration.

Bryullov's fame now seemed secure. Painting after painting issued from his studio. Nicholas I (who was not above suggesting poetical topics to Pushkin) wanted to commission a series of historical frescoes for the Winter Palace; he also saw to it that the artist was kept fully occupied in decorating the Cathedral of St Isaac. Bryullov was appointed a professor at the Academy. In 1839 he began work on *The Siege of Pskov by the Polish King Stefan Batory*, an enormous picture which was to outshine *The Last Day of Pompeii*, but historical painting had lost its attractions for him and four years later he abandoned it. Still later, in 1851, he made preparatory sketches for a work to be entitled *All-conquering Time* which seems also to have been abandoned.

Bryullov amazes by his industry and versatility. Many aspects of romanticism are exemplified in his *The Death of Inez de Castro* (1834), *The Destruction of Rome by the Vandals* (1836) and *Beersheba* (1832). This last picture has more than a hint of eroticism in the black hand of the negro laid on the pearly-white flesh of the bathing Beersheba. His watercolours of Italian life, *Festivities at Albano* (1830–3), for instance, are full of lively and amusing observation as well as a sense of warm, happy life. Another Italian work, *The Wayside Shrine* (1835), a charming decorative piece, has elements of the rococo. But Bryullov was above all a dazzling portraitist.[20] As a youth he had studied Rubens and Van Dyck and made numerous studies of the pictures by Velázquez in the Imperial collection. He was to exploit their compositional effects later in his career. While in Italy he studied a number of artists, including Veronese, whose use of bright colours he tried to emulate. This was unusual for a painter in a period which preferred the dark tints and thick, glossy paint of the old masters. Bryullov was distinctly catholic in his tastes. In Rome he spent days in the Sistine Chapel and in the year he died said, 'I never loved Michelangelo as much as I do now.'

In portraiture Bryullov always sought to introduce additional significant background material and to incorporate effects he had observed in nature itself or which he had studied in the works of his contemporaries, not least those in France and England, and also to aim for a variety of poses which best expressed the characters of his sitters. His *Portrait of Nestor Vasilievich Kukolnik* (Plate 43) presents a memorable image of the writer, who sits facing us, top hat and cane in hand, his pallid and melancholy face dramatically set off by his dark clothing and the sombre background. Here Bryullov

captures the essence of Byronism, the mode which spread throughout Europe in the 1830s. The portrait of yet another writer, Aleksandr Nikolayevich Strugovshchikov (1840), is a penetrating work which hints at the man's quietly feline nature and in which there are distant memories of Titian and of Lawrence's portrait of Pope Pius VII.[21] When he painted the archaeologist Lanci in 1852 he brought out the man's quizzical humour and cynical good sense. These pictures, despite an indebtednes to Lawrence and his school, are not without a degree of Biedermeierish intimacy; and it is as well to remember how strong German influences were under Nicholas I, who was extremely amenable to their more rigorous and disciplined aspects.

As well as the comparatively reticent but perceptive style which he reserved for portraits of his friends, Bryullov evolved another manner, superbly and dazzlingly opulent, which he employed in gala portraits of the aristocracy. Princess E. P. Saltykova (1841) is shown as languid and pensive, surrounded by hot-house plants, a fan of peacock feathers in her hand, a leopard skin at her feet, in a setting of the utmost splendour – dramatically heightened by the skill with which Bryullov has painted the various and contrasting textures. Attention to surfaces and to surroundings does not mean he neglected the characters of his female sitters. His *Portrait of the Grand Duchess Elena* (Plate 44) demonstrates how early he had developed as a portraitist. It is a singularly elegant work, in which the slender figure of the duchess seems menaced by the overpowering draperies, the enormous vase of flowers and the monstrously over-carved table on which rest three volumes of sketches; yet there is no mistaking on the face of the duchess the quiet determination which brought her to form the first group of Russian nursing sisters (and thus to rival Florence Nightingale's achievements in the Crimean War) and to exert a decidedly liberal influence on the Emperors Nicholas I and Alexander II, especially in the struggle to abolish serfdom.

Nowhere does Bryullov's personal romanticism show itself more vividly than in his celebrations of female beauty, intelligence and distinction. He was supreme in the portrayals of the great love of his life, the Countess Y. P. Samoilova (1803–75), praised by Pushkin for her charm and wit; and was entirely at

44. Karl Pavlovich Bryullov: *Portrait of the Grand Duchess Elena Pavlova*, c.1840. Private Collection

home with her and her entourage, which included the girl she had adopted from the family of the composer Pacini (whose opera *L'Ultimo giorno di Pompeii*, it will be remembered, had inspired his masterpiece). In painting the countess, which he did several times, he treated every element of wealth and luxury as a further facet of her fascination for him: furniture, draperies, carpets, ornaments, silks, satins and furs combine in a hymn of praise, an earthly and material benedictus for her dazzling and Olympian beauty. In the splendid *Portrait of the Countess Samoilova and her Adopted Daughter* (Plate 45) the young countess with her adopted daughter and a negro page are grouped in a room which may have been part of an Italian palazzo or a great house on the Crimea. The negro page is a happy touch, mischievously suggestive of Rastrelli's statue group of the Empress Anne taking the crown from a negro page. The composition is a subtle but dramatic

43. Karl Pavlovich Bryullov: *Portrait of Nestor Vasilievich Kukolnik*, 1836. Oil on canvas, 117 × 81.7 cm. Moscow, Tretyakov Gallery

interweaving of diagonals and horizontals augmented by the rich patterns of the carpet, sofa and Kashmir shawl held by the page. The velvets, satins, laces and silks add to the overall magnificence. And yet the central point is the adored face of the countess, happy, carefree and benevolent. An even greater triumph is the *Portrait of Countess Samoilova and her Adopted Daughter leaving a Masquerade* (not later than 1842), a large work executed with tremendous panache. The countess and child stand at the top of a flight of stairs, in front of a pillar and a wide curtain, with masked figures in the distance. By the bold disposition of his favourite reds and blues used to emphasize the verticality of the composition, Bryullov secures an imposing, near-overwhelming monumentality.

These works, still in pristine condition, with unfaded colours and healthy surfaces, link Bryullov with Levitsky and the master portraitists of the late eighteenth century. But going further back in time he took from Velázquez and Van Dyck the concept of the equestrian portrait, adapting it to his own particular interests and his love of feminine grace, so that instead of mounted monarchs we have a series of haughty amazons as in *Horseriders* (1832), *K. A. and M. Y. Naryshkin* (1827) and *O. P. Fersen* (1835), in which a prancing steed has been supplanted by a humble donkey. Bryullov's gallery of distinguished women, which included the singers Anna Ya. Petrova (1841) and Pauline Viardot-Garcia (1844), later the mistress of the novelist Turgenev, and the ballerina S. I. Samoilova, give a posthumous glory to the reign of Nicholas I which it little merited. His technical ability is demonstrated in his watercolour portraits such as that of G. N. Olenin and his wife (1827), both firmly ensconced on some ruined stonework, with St Peter's in the background and the wife's fine Kashmir shawl in the foreground, a charming souvenir of their Italian tour; or that of the moodily handsome V. A. Kornilov in naval uniform on board the brig *Themistocle* (1835), painted by Bryullov when a member of Count V. Davydov's expedition to the Ionian Islands.

Bryullov also delighted in pencil drawings and watercolours of lively scenes of peasant life in Italy. His topographical sketches culled from his travels in Greece and Turkey are deservedly famous and were partly utilized by Count Davydov in his *An Atlas to my Travel Notes* (1840). In his religious works he sometimes appears to be emulating the Caracci, especially in preliminary studies and sketches; but

45. Karl Pavlovich Bryullov: *Portrait of the Countess Samoilova and her Adopted Daughter*, c.1834. Oil on canvas. Private Collection

his decorations for St Isaac's are unusually restrained, possibly reflecting a study of the Nazarenes. His brother Aleksandr Pavlovich (1797–1877), well known as an architect and watercolour portraitist, sometimes worked side by side with him.

Bryullov was remarkably handsome and famed for his classical features, curly fair hair and athletic torso, which earned him comparisons with the Belvedere Apollo and, more distantly, with Byron. His pupils, including Ilya Repin, adored him as 'Karl the Great'. In true romantic fashion he painted self-portraits, documents which clinically reveal his physical deterioration as disease took a crueller and more devastating hold on him. He was admired by Pushkin, to whom he wrote complaining of the cold and damp of St Petersburg and of the annoyance caused him by interfering officials. The poet wrote to his wife: 'Bryullov is going to St Petersburg

with a sinking heart. He fears the climate and loss of independence. I try to console and encourage him....'[22] When Bryullov's *The Crucifixion* was exhibited in 1836 sentries were placed about it to keep off the crowd, which inspired Pushkin to write his poem 'Secular Power', which ends:

> Fear you the mob's affront to Him who won remission,
> Whose death has saved the race of Adam from perdition?
> Is it to keep the way for strolling gentry clear
> That thus the common folk are not admitted here?[23]

In general, however, Bryullov preferred to remain apart from political activity, happily debating aesthetic questions with the writers, musicians and artists he helped and whom he counted among his friends and admirers. This sense of the interconnection of the arts was particularly strong in the reign of Nicholas I, the more so because creative workers felt a need for unity in the struggle against censorship, autocracy and mediocrity. The period was a watershed in the history of Russian culture; and it should not be forgotten that *The Last Day of Pompeii* appeared in the same decade as Gogol's *The Inspector-General* and Glinka's patriotic opera *A Life for the Tsar*. Bryullov felt a particular affinity with Pushkin and illustrated several of his works in watercolour as well as labouring for over ten years from 1838 on a picture inspired by 'The Fountain of Bakhchisarai'.

Bryullov was admired for his generosity to other artists and for his quick readiness to recognize and praise talents different from his own. Knowing he was a doomed man, he lived feverishly, remarking shortly before his death that he had lived so intensely that he never expected to live beyond 40 and that having stolen ten more years from eternity he had no right to complain. He told Countess Samoilova that he could never marry her since he was already married to his art; but he knew he was already affianced to death. His self-portrait (there are several versions from about 1848), painted with a rapidity and fluency of brushwork that invites honourable comparison with the Delacroix portrait of Chopin, presents a restless and explosive genius. By painting himself in a black velvet coat against a background of red upholstery Bryullov was better able to emphasize the ashen colouring of his face and his almost lifeless hands. Yet though the cheeks are sunken, the whole body ravaged and worn and

the Apollonian beauty has dimmed, his eyes maintain a steady and relentless scrutiny which proclaims the man whose craft knows neither deceit nor self-deception. In that portrait, as much as in his masterpiece, Bryullov demonstrates that he was a true child of the Academy, taught to see what lay before him and to paint it truthfully without sentiment or falsehood.[24] In 1848, ravaged by tuberculosis and with a weak heart he left for Madeira and then for Italy, where he remained until his death in 1852 in Marciano, near Rome.

Inevitably there was a reaction against Bryullov among the artists who followed him, few of whom possessed a tenth of his energy or resplendent genius.[25] Artists belonging to later groups such as the *peredvizhniki* and Mir iskusstva detested and execrated him; and a leading historian of Russian culture has described him as 'opinionated and vainglorious'.[26] Yet none of his critics seriously challenged his place in the history of Russian painting or in the development of the Academy as a training school for artists, for his genius, romantic and classical and academic, is surely beyond doubt and, on the evidence of his portraits alone, cannot be overestimated.

Fedor Antonovich Bruni (1799–1875) dedicated his talent and career to the glory of the Academy where from the early age of ten he studied under Aleksei Egorov, Andrei Ivanov and Vasilii Shebuyev, showing early promise. He was born in Milan, the son of a decorative painter of Swiss-Italian descent, who settled in Russia about 1807. In 1819 Bruni went to Rome, where he encountered the work of the Nazarenes whose influence was not, however, to be seen in his work until much later. Among his first pictures painted in Rome was a portrait of Zinaida Volkonskaya (who not only composed but sang in her own opera) as Tancredi. His *Death of Camilla* (Plate 46) won him election to the Roman Academy of St Luke. On his return to Russia he was appointed professor at the Academy, but left for Italy again two years later, this time at the state's expense. His most famous work *The Bronze Serpent* (1838–41), a canvas of enormous size which he painted in Rome between 1838 and 1841, won him honorary professorships in Rome, Milan, Bologna and Florence. He was partly responsible for the decorations of the cathedral of St Isaac in St Petersburg and the Saviour (now destroyed) in Moscow. He was director of the Hermitage Museum from 1849 to 1864 and rector of the Academy until a short time before his death. Bruni's

46. Fedor Antonovich Bruni: *The Death of Camilla*, 1824. Oil on canvas, 350 × 526 cm. Leningrad, Russian Museum

artistic gifts (which had in turn been inherited) descended through his children to the present generation.[27]

It was in a singularly bold but academic fashion that Bruni began his career, for his *Death of Camilla* not only competed with the neo-classicism of Camuccini but challenged comparison with a picture painted in Rome some forty years earlier, the *Oath of the Horatii*, the quintessential neo-classical work which David had actually begun as *The Death of Camilla*. The actions of the Horatii had been portrayed by many artists at the turn of the century, among the first being Girodet with his *Death of Camilla* (1785); and similar topics from the legendary history of Rome were no less popular, as witness Camuccini's *Death of Virginia* (1804) with which Bruni may have been familiar. But whereas David eventually painted a scene of patriotic exultation

proclaiming the virtues of self-sacrifice and devotion to the fatherland, ridding his stage of all unnecessary detail, Bruni created a theatrical tableau in which a careful mosaic of gestures and attitudes selected from the art of the past was assembled with skill but with no other purpose than to show the artist's technical and academic proficiency.

In Russia his name was made with *The Bronze Serpent*, which showed the fate of the Jews during the days in the wilderness when God punished their wickedness by inflicting them with poisonous serpents, preserving only those who gazed with faith upon the pillar crowned with a bronze serpent, symbolic of God's power. In the preliminary sketches Bruni had intended to make Moses the central figure, but he eventually thrust him into the background concentrating the viewer's attention on the rewards of obedience and the retribution which overtook the disobedient. The subjects of Nicholas I, accustomed and ordered to obey, did not find the message hard to read. The vast canvas is, of its kind, a powerful justification of the skills taught at the

Academy, a kind of pictorial apotheosis of its excellences, although Bruni had broken with the academic tradition which forbade the depiction of emotion on the faces of the characters, deliberately using the expressive facial characteristics illustrated by Le Brun and Lavater. But coming, as it did, ten years later than Bryullov's *tour de force*, it was too late to present any serious rivalry and was viewed indifferently by a public which was growing weary of such monstrous machines. Moreover, whereas *The Last Day of Pompeii* seemed to the intellectuals of the day to augur the end of Tsarist repression, no such revolutionary message was to be found in Bruni's work. Yet *The Bronze Serpent* more than bears comparison with *The Last Day of Pompeii* which it was intended to rival, for it is an altogether more complex composition, certainly more original, and in its dramatic exploitation of light and shade certainly more romantic in tendency. Bruni's artistic

47. Fedor Antonovich Bruni: Detail from *The Flood*, 1843. Fresco executed in oil, total area 23.27 sq.m. Leningrad, St Isaac's Cathedral

genius showed itself in his powers of composition and organization on a vast scale which is true only in a lesser sense of Bryullov, to whom portraiture was probably more congenial. After the comparative failure of *The Bronze Serpent* Bruni's life flowed on in a steady and undisturbed stream. He never knew what it was to struggle: there were orders for church decorations in abundance; his smaller paintings and icons were always in request; and teaching, mostly of mosaic work, occupied his free time.

It is easy to say that Bruni never lived up to his early promise and that his ready acceptance of academic discipline helped to stifle any originality he possessed, but there are sufficient paintings of his in evidence to cast doubt on any generalized condemnation. A youthful success *Bacchante and Amor* (1828), an astonishingly sensual work which is heavily indebted to Caravaggio's androgynous Bacchus, reveals a capacity for tight but complex compositional rhythms which are entirely opposed to the free (and skilful) arrangements of Bryullov. His drawings, notably those for his religious works, reveal still further the origin of his pictorial tendencies – the pure line and detachment of the Nazarenes. The quality of his decorations for the cathedral of St Isaac, clearly indebted to Cornelius, is hard to judge: his panels are inaccessible, difficult to see with any clarity, and have been damaged by the vicissitudes of war, neglect and the fumes from inefficient heating systems. But his preliminary sketches and the actual painting of *The Flood* (Plate 47) in St Isaac's show an individual exploitation of the Michelangelesque *terribilità* and a highly original austerity of both design and execution: he uses about a dozen figures and a limited range of cold blues and ochres in a sparse but telling arrangement which owes just a little to the Nazarenes, anticipates Puvis de Chavannes and suggests that Bruni had imaginative gifts of an altogether higher order than those of Bryullov.

It must be remembered that Bruni was highly esteemed in his day as a mystic; and a thorough examination of his works (assuming they are available for study) might produce a surprising revaluation. Strange as it may seem, he was admired by the succeeding generation of painters – he instituted a number of reforms at the Academy – including those of the fastidious Mir iskusstva. To ordinary spectators he must as yet – and the judgement does not have a firm enough base – seem a painter devoid of imagination and any flamboyancy of personality,

hardly touched by romanticism (except for its concern with masterpieces and its assaults on the impossible), overshadowed by more remarkable artists and thoroughly amenable to the aims and orders of the Academy and the national dominance of Nicholas I.

Bruni outlived both Bryllov and Aleksandr Ivanov (1806–58), the other great painter produced by the Academy. In Ivanov's person and career, however, the struggle between the neo-classical and the romantic was almost violent in its intensity. Like Bryullov and Bruni he was seduced by the idea of the masterpiece, although for different reasons from his contemporaries to whom it was a means of displaying their genius, extending their prestige and commanding respect in the European art world. Ivanov was one of those dedicated men like Milton or Dante who wish to create a work of enduring significance into which they can put all their genius and through which they can justify or reveal to mankind some hidden and mysterious aspect of God or the Universe or – in his case – the Russian destiny. But, as so often happens, Ivanov revealed himself – the last thing he could have wished.

Aleksandr Ivanov was trained at the Academy by his father Andrei I. Ivanov, professor of history painting and a neo-classical painter in the direct line of descent from Losenko, and also by Egorov, the brilliant draughtsman and religious artist. It is interesting to note, in parenthesis, that both of Ivanov's teachers were to be stripped of their professorships at the express command of Nicholas I: his father in 1830 and Egorov in 1842. Ivanov's skill was soon evidenced in *Priam supplicating Achilles for the Dead Body of Hector* (1824) and *Joseph interpreting the Dream of the Butler and Baker* (1827) which won him the Gold Medal. In 1830, aided by a grant from the Society for the Encouragement of the Arts, he left Russia for Dresden, Munich, Vienna and northern Italy before reaching Rome, where he was to spend most of his life in voluntary exile, together with Gogol, as a member of the Russian colony which had gathered around the 'Corinne du Nord', Zinaida Volkonskaya. His first years there were mainly spent on *Apollo, Hyacinth and Zephyrus*, much indebted to Mengs and never satisfactorily completed, and on *The Risen Christ appearing to Mary Magdalene*, which was sent to Russia where it earned him the title of Academician. In reply to words of congratulation from his much-adored father he wrote, 'You think that a lifelong salary of six to eight thousand rou-

bles, and a safe place in the Academy, is a great blessing for an artist ... but I think it is a curse.... The Academy of Arts is a relic of the last century.... It is too concerned with money-making ever to help art to progress....'[27]

Ivanov was not, however, revolting against the Academy as such but against the rigidity of its outlook on subject-matter and style. Like so many of his contemporaries he was immensely indebted to it for the excellence of his draughtsmanship and painting techniques. His major work *The Appearance of Christ to the People* (Plate 48) was in itself a supreme example of academicism. Partly inspired by his mystical beliefs Ivanov seized the moment when John the Baptist sees Christ approaching from afar and prepares to announce him to the people. When the painting was finally unveiled the population of Rome filed through the artist's studio for ten days in order to gaze in wonder at this enormous work (of which there are several replicas) into which he had put over twenty years of study and for which he had made over 600 preliminary studies. 'He has left us behind him', cried the Nazarene Overbeck, his friend and mentor, while the Roman *facchini* were reported to have exclaimed, 'Per Bacco è proprio vivo!' Encouraged by this enthusiasm various impresarios proposed touring the picture, a suggestion which Ivanov indignantly spurned.

Ivanov had been left a small inheritance by his father, who had died in 1848, and he managed to live on this until 1857. The following year he set about returning home and on the way called on Aleksandr Herzen in London – he tried to keep abreast of all the major currents of thought in Europe. In Russia his great work was badly received – Bryullov and Bruni had sated the appetite for enormous, breath-taking pictures – and there were difficulties about its acquisition by the state. He tried to arouse interest in his dream of a temple dedicated to the history of mankind's beliefs and faiths for which he was to paint a cycle of frescoes. Lonely, isolated, sick at heart, Ivanov met only a few admirers such as the philosopher Chernyshevsky with whom he could discuss his work. Uncertain as to whether or not his picture had been bought by the state, he died, apparently of cholera, although there were suggestions that he had taken his own life.[29]

The Appearance of Christ was a work of more than historical or religious significance: Ivanov saw the coming of the Messiah as the moment when the world shook off all forms of slavery, mental and physical, when society everywhere was transformed,

when there was a new awareness of life based on the recognition of the dignity and humanity of the common man, a process which vitally concerned Russia's redemptive spiritual mission. To show the enlightenment of 'all the ages, social classes, types and conditions of men' was his aim. The seriousness with which he undertook this labour is evident in the sketches, studies and paintings he made in preparation. He selected from many studies – from life and, as befitted an academically trained artist, from Raphael and other artists of the Renaissance, and from the abundant classical sculpture in Rome. Through his contacts with the Nazarenes he was aware of early Italian painting but it appears not to have influenced his work. He went round the Italian cities seeking out public baths and beaches where he could further study the male nude. He sought funds to travel to Palestine but had to content himself with

painting the hills and marshes around Rome as background landscape (Plates 49 and 50). The vitality, freshness and clarity of these impressionistic sketches sometimes carried out in watercolour, sometimes in oil, are barely evident in his finished masterpiece, a not unusual phenomenon in the history of painting; but there are other reasons behind the failure of *The Appearance of Christ*. In the first place, he made a prime artistic error, the result of his sense of visual truth, in placing Christ in the distance, so that lost in the aerial perspective and hazy summer heat, the Messiah became a visually insignificant character. Yet somehow he was unable to redesign the composition. And, secondly, the actual subject lost much of its original meaning for Ivanov. Like so many thinking men and women of the mid-century he was overwhelmed by religious doubt. Thus he wearied of his task before its completion, partly because he had become aware of the new scepticism which had developed in biblical scholarship under the guidance of D. F. Strauss (whom he visited in Germany and whose *Life of Jesus* he read in a French translation (1852)), and

48. Aleksandr A. Ivanov: *The Appearance of Christ to the People*, 1833–57. Oil on canvas, 540 × 750 cm. Moscow, Tretyakov Gallery

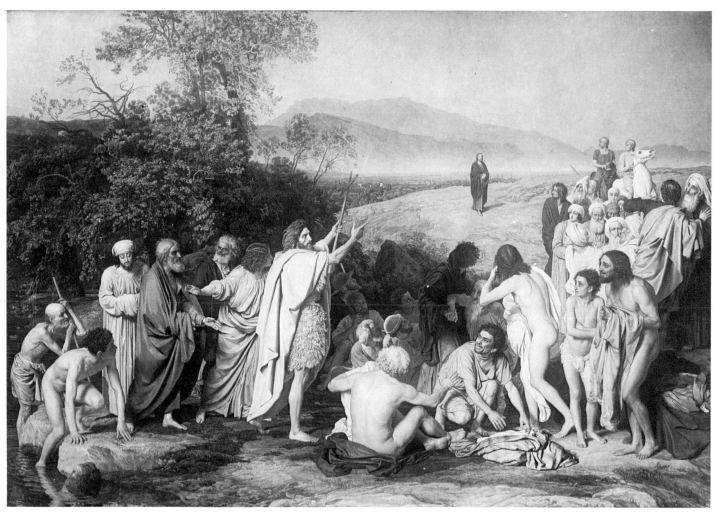

49. Aleksandr A. Ivanov: *New Moon: Olive Trees near the
Cemetery at Albano*, *c.*1841. Oil on canvas, 62.5 × 42.5 cm.
Moscow, Tretyakov Gallery

partly because he had moved to a form of mysticism
in which the Tsardom of Nicholas I, the coming of a
Russian Messiah, the destiny of Russia as the home
of Orthodoxy, his own role as an artist, and Free-
masonry all played mingled parts. He wrote:

> My labour – the great picture – has sunk lower and
> lower in my eyes. In the light of the latest findings of
> scholarship the basic idea of my picture has become
> lost. While I have left behind me the old forms of art, I
> have not been able to build any foundations for the
> new and thus find myself, despite myself, an artist of
> transition.[30]

Ivanov's self-appraisal is not inexact: rooted in the
academic tradition – his picture has borrowings
from the Belvedere Apollo, *The Last Supper* of
Leonardo, Masaccio's *Calling of St Peter*, Raphael's
Vatican tapestries, the head of Jupiter Otricoli,
Raphael's depiction of John the Baptist in his *Ma-*

donna de Foligno, and also the Byzantine mosaics of
Palermo and Monreale – he was indeed an artist of
transition who paved the way for the painters whose
careers began towards the end of the century and
who were concerned not only with Russia's Slavonic
past but also with her still uncertain destiny as
leader of Christian Europe. His conception of Christ
as a man of doubt, suffering and loneliness was
taken up by these later artists who shared Ivanov's
ambition to create the image of a Russian Christ.
Turgenev, his friend, wrote a critical appreciation of
The Appearance of Christ, a few sentences of which
are well worth repeating:

> Indefatigable as he was, Ivanov fell like a martyr; his
> disciple should march along the road trodden by the
> master and should go far.... By nature Ivanov was truly
> Russian and nearer to the hearts of all young Russians
> than the great masters of the West. This idealistic
> painter, also a thinker, still has the rare merit of being
> able to inspire great works, of continually arousing
> thought, of preventing artists from becoming self-
> content....[31]

The critic Khomiyakov wrote in similar terms in a letter of 1858 on the occasion of Ivanov's death:

> He was in painting what Gogol was in writing and Kireevsky in philosophy. Such people do not live long, and that is not accidental. To explain their deaths it is not enough to say that the air of the Neva hangs heavy or that cholera causes honorary citizenship in Petersburg ... another cause leads these labourers to the grave. Their work is not mere personal labour.... These are powerful and rich personalities who lie ill not just for themselves; but in whom we Russians, all of us, are compressed by the burden of our strange historical development.[32]

Talking with Chernyshevsky a few days before his death Ivanov spoke of the future direction of art which he thought should speak to ordinary men and women, adding that painting should 'combine the perfect technique of Raphael with the larger ideas of a new civilization. I tell you that art will then regain the significance in the life of society which it has wholly forfeited today through failing to satisfy the deeper spiritual needs of mankind.'[33]

These various comments demonstrate how highly Ivanov was regarded as a unique phenomenon in the history of Russian art; and how seriously he regarded his chosen vocation. Possibly only Holman Hunt among his contemporaries showed a similar conscientiousness and he too, like Ivanov, had fallen under the sober spell of the Nazarenes. Inevitably one thinks of Ruskin's dogmatic pronouncements on the religious and social nature of art, many of which Ivanov would have agreed with. But there were sides to Ivanov's thought which were every bit as eccentric as any of Ruskin's late meanderings: he was overwhelmed by the coronation of Nicholas I, rapturous when the Tsar visited his studio during a trip to Rome in 1845 and full of plans for a temple to be built in Moscow (for which he was to supply two immense frescoes depicting the Holy Land and the faiths of mankind) in which would be celebrated the Second Coming of Christ – in the earthly form of Nicholas I. He was encouraged in this belief by Gogol, the closest of his friends – his features can be seen in *The Appearance of Christ* – and pasted some of Gogol's words in a sketching album: 'God grant you His aid in your labours, do not lose heart, be of good courage, God's blessing be on your brush and may your picture be gloriously completed. That at any rate is what I wish you from the bottom of my heart.'[34] He was convinced that great as were the responsibilities of the political leader, those of the

artist were even more vital, since on the development of his capabilities depended not only the aesthetic life of humanity but its social future. It will be realized that Ivanov, albeit in a confused and muddled way, not only anticipates the public concerns of many late nineteenth-century painters but also takes on himself the civic and religious responsibilities felt by the medieval icon painters.

Ivanov would have a place in Russian culture by reason of his beliefs alone, but the plain truth is that he was a great artist. Unfortunately, while *The Appearance of Christ* is a magnificent testimony to the training he had received at the Academy, it does not reveal the range of his genius; as he saw too late it belonged to the outmoded past. Herzen was the only writer of the time who saw this: with charity and absolute clarity he wrote:

50. Aleksandr A. Ivanov: *An Olive Tree: Valley of Ariccia*, c.1841. Oil on canvas, 61.4 × 44.4 cm. Moscow, Tretyakov Gallery

Ivanov's life was, unfortunately, an anachronism. Such reverence for art, such a religious dedication to its cause, such fear and faith and distrust in his own powers, we find only in legends of medieval painters who prayed while they worked, for whom art was a moral struggle and a sacred skill.[35]

It is especially misleading that Ivanov should be judged by *The Appearance of Christ*, for he was even more versatile as a painter than Bryullov. His works fall into several categories: early academic exercises which demonstrate a sound academic training and the influences of Poussin, Raphael, Overbeck and Cornelius; copies of Tintoretto, Titian and other Renaissance artists; delightful and amusing watercolours of life in Rome in the 1830s; oil and watercolour studies for his masterwork, many of them male nudes; Italian landscapes which are by no means inferior to Corot's early work and which have an airy openness which anticipates and

51. Aleksandr A. Ivanov: *Three Nude Boys on Red, White and Blue Draperies*, *c*.1850. Oil on canvas, 47.7 × 64.2 cm. Leningrad, Russian Museum

rivals the Impressionists; and a series of watercolours of biblical and mythological scenes drawn in a free, near-mystical style partly intended for the temple frescoes already mentioned and partly for an illustrated book which he planned on the development of man's faith. Had Turgenev and other critics known of these works their estimate of Ivanov would have been dramatically different. In them we see an artist in love with light, with the warmth and sunshine of Italy; we see a man who delights in the beauty of the Italian landscape and the everyday life around him. His open-air studies like those of nude boys in Naples and elsewhere show him a careful student of the effects of light and shade and of sunlight and clouds on the landscape and the human body – which he saw as part of the totality of nature (Plate 51). His views of the Italian coastline are alive with shimmering blues and greens of the most beautiful shades, in their joyous freedom (Plate 52) sometimes eclipsing anything by Monet. And his studies of horses and their riders are the equal of any made by Manet. His impressions of the Roman Campagna, direct and vigorous, show a loving obsession with this romantic and time-caressed

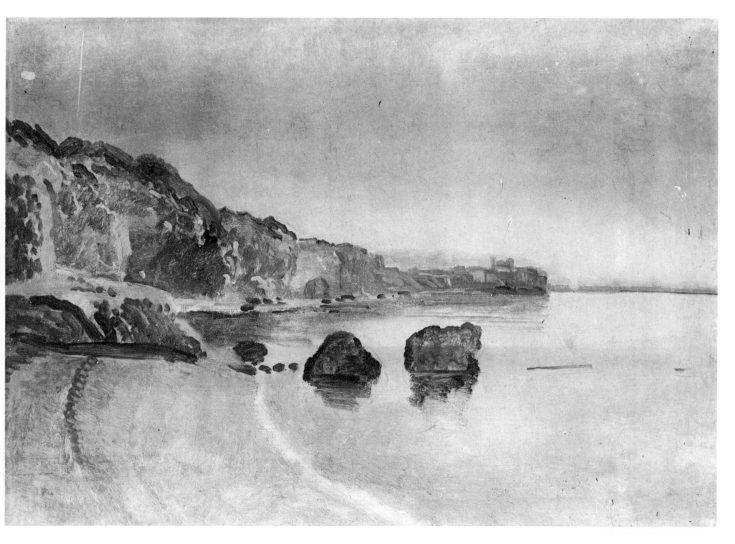

52. Aleksandr A. Ivanov: *Coastline in Southern Italy*, 1856. Oil on canvas, 39 × 56.7 cm. Moscow, Tretyakov Gallery

scenery.[36] His skill in portraiture is revealed in the many studies for the great picture, in depictions of the people around him such as his landlady Vittoria Marini and his *Portrait of Gogol* (1841).[37] Far from being a failure, Ivanov was one of Europe's greatest artists in the first half of the century and, quite certainly, the foremost Russian painter of that period.

Ivanov reflects the situation of the thinking creative artist in the nineteenth century; he is afflicted by all the typical ailments of the age such as loss of faith, religious scepticism, despair over the future of mankind, doubts as to the value of art, sexual repression, and concern for Russia and with the need for radical reform without upsetting the prevailing

order. He shared, unhappily, in his age's belief in largeness: enormous buildings like the Crystal Palace, gigantic exhibitions of which the Great Exhibition of 1851 was the paradigm, immensely long operas such as those of Meyerbeer and Berlioz, monstrous temples such as he planned for Moscow, and huge canvases like those on which Murger's Bohemians laboured so futilely. Although the Academy was to produce many fine artists he was the last of the major academic artists; and with him died both classicism and romanticism. Whereas Bruni displayed no particular intellectual gifts and Bryullov mixed easily and dashingly with the creative artists of his day and the cream of aristocratic society, Ivanov was (apart from the invaluable company of Gogol) a natural solitary, an earnest recluse, a lonely and despairing soul, often on the point of suicide. Driven by delusions of a dark and demonic kind there were times when he came to believe in himself as Christ – in order that he might

paint His Own Image – and then he would recover his reason sufficiently to put aside the conviction that he had been charged to spread everywhere a Messianic message and would, instead, declare that Christ was to be revealed through the Tsar in the person of Nicholas I. Possibly Gogol was behind some of these obsessions. Ivanov studied every artistic manifestation of Christ's image, from Byzantine frescoes and mosaics to pictures in Italian galleries, trying to incorporate the beauty of classical statuary into his representations. And here it is pertinent to suggest that Ivanov sought throughout his life for a father-substitute, whether John the Baptist, Christ, God the Father or Tsar Nicholas I. And, perhaps also, it might be suggested that his sense of despair was linked with repressions and longings, the nature of which are indicated by his many studies of male adolescents in the nude and for which the panacea of hard work was ineffective. In this sense, his *Appearance of Christ* was a failure because his deepest interest was not in the remote and draped figure of Christ but in the semi-nude males in the foreground recorded with conscientious and loving attention. Little of this can have been known to the urchins of Rome and Perugia and Naples whose naked antics were watched and recorded and reconstructed with such secret joy by the caricature of a foreigner wearing dark spectacles, a tall straw hat, a shabby cloak, galoshes and an umbrella eternally under his arm. An Englishman who visited Ivanov's studio in Rome wrote, 'In my mind's eye, I see him now, silent and sad, careworn and broken in health, as he stood beneath the immense canvas which embodied the anxious toil of twenty years. He had borne up against poverty, he had struggled manfully through obscurity, and then as the goal was reached he died.'[38]

There are some men, as it happens, whose achievement is great despite their own unwitting efforts to frustrate their genius and force it into false moulds prescribed for them by tradition, teachers, parents and friends. Such a man was Aleksandr Andreevich Ivanov. He chased every will-o'-the-wisp whether political, religious or social; autocracy and revolution both held him in thrall; common sense, his own emotional nature and wilful dreams warred within him. He made countless studies of tremendous range, variety and interest, usually in

the cause of the great picture. He drew biblical sketches of a haunting intensity, visionary and mystical, and yet rooted in what he thought was the actuality of the biblical scene.[39] He possessed artistic gifts equalled by no other painter of his generation; and nothing he did or could do to thwart his own genius negated the fact. In his short life he encompassed and anticipated the work of painters as disparate in their styles as Bryullov, Bruni, Overbeck, Rousseau, Manet, Monet, the Pre-Raphaelites and Vrubel. Indeed Vrubel made a deep study of *The Appearance of Christ* and admired Ivanov above all other Russian painters. He brought to his work – that remarkable mixture of neo-classicism, romanticism and realism – an intellectualism, a seriousness which is enduringly impressive however misguided and misdirected it now appears to us. More than any other painter of his time he forced himself to believe in the importance of the idea as embodied on canvas and yet only too clearly, unknown to himself perhaps, the idea became of decreasing importance to him as a painter. What the sketches and studies and landscapes and biblical scenes brilliantly proclaim is his innate pictorial genius. In art he was not, despite what is so often written about him, a mystic: whereas Blake, for instance, by the strength of his own inner vision forged from the unlikely combination of the Gothic and the neo-classic styles of his day an art which is truly esoteric, Ivanov, even in his biblical sketches, remains firmly committed to the world of men and women and of natural life. Always with Ivanov one can sense the deep joy he continually experienced both in the earthly world around him and in the astonishing pictorial gifts which enabled him to capture and perpetuate this world with brush and pencil and paint. The tragedy is that his art and his belief were at odds – and it was the latter that was wrong. Paternal domination, an over-respect for authority, a divided emotional nature, and a sense of failure all overwhelmed Ivanov, whose misery and despair, as was also the case with Tchaikovsky, have come to seem typical of the Slav soul.[40]

Bruni, Bryullov and Ivanov were the most distinguished and ambitious painters produced by the St Petersburg Academy: never again was it to mould and shape artists to whom the term academic could be applied in its finest and most imposing sense.[41]

5

Art Outside the Academy: Tropinin, Kiprensky, Venetsianov and Fedotov

It is worth while at this point to consider the careers of two painters, the ablest and most interesting of their kind, who bridged the eighteenth and nineteenth centuries, and who illustrate the impediments which faced artists during that period both inside and outside the Academy, especially those who failed to conform to the expectations of official patronage. One of them, Vasily Andreevich Tropinin (1776–1857), was only remotely connected with the Academy and later worked at the Moscow School of Painting and Sculpture which had been established in opposition to it, while the other, Orest Adamovich Kiprensky (1782–1836), although trained in the academic tradition, spent the greater part of his short life in revolt against it.

In a historical account of Russian painting written in 1896 Alexandre Benois does not even mention the name of Tropinin;[1] nor does a recent history.[2] Yet Tropinin's life illustrates for us the peculiarly Russian situation of serf and artist in the early 1800s. Born a serf on an estate at Karpov in the province of Novgorod, the young artist was presented to a Count Markov as part of a wedding dowry. He was then sent to St Petersburg to be trained as a confectioner, but succeeded in becoming a part-time external student at the Academy of Arts where he worked under Shchukin beween 1799 and 1804. Intending his serf's skills to be confined to the culinary arts, Count Markov recalled him to his estates in the Ukraine where he was obliged to stay until 1823, when at the age of 48 he was given his freedom and allowed to qualify at the Academy.

From St Petersburg Tropinin went to Moscow where he spent the remainder of his life, occasionally teaching at the School of Painting and Sculpture which opened there in 1843. He was much sought after as a portraitist, particularly by foreigners living in the city, but was less popular with the aristocracy, possibly because of his serf origins and because of their preference for the work of foreign painters. There is an anecdote that he was summoned by a princess who had admired one of his pictures: however, when he gave his name she exclaimed, 'What! Tropinin! Off with you! I thought you were called Tropini – but you're only a Tropinin! Off with you!' That Tropinin should have succeeded in overcoming so many obstacles and vicissitudes and earned himself a worthy place in the history of Russian painting is a striking vindication of the Russian artistic genius.[3]

Throughout his life Tropinin painted versions of paintings by the Italian and Dutch masters, frequently reduced in size. But he was principally a portraitist who trod an uneasy but not unsuccessful path between the polished sentimentality introduced by Rotari, a vigorous sketchy style which he evolved for himself, and a forceful, precise manner, perhaps adapted from Ingres and the French school. The charming portrait of his son painted in 1818 shows by its easy informality and its almost romantic appreciation of boyhood how he had broken away from the rigid attitudes of the previous century. His lively depiction of the benign K. E. Ravich whose flowing cravat, unbuttoned shirt and loose clothes go so well with his clever, earthy face illustrates how skilled and confident was Tropinin's art by 1825. Face to face with a subject of his own choice his response was frank and direct (Plate 53). Among his important portraits are those of the actors, artists and writers of the 1830s. When Bryullov sat for him in Moscow in 1836, Tropinin placed him against a background of vine leaves and a smoking Vesuvius, admirably suggestive of Bryullov's Italian ancestry and of the subject of his great painting. His sketch of Pushkin sitting at a table in his dressing-gown is among the precious documents of Russian romanticism; as is his *The Treasurer's Wife* (1841) inspired by Lermontov's poem of that title. *Portrait of the*

Countess E. P. Rostopchina (1853), an unusual study in red and black, concentrates our attention on the character of the old and saddened woman to whom literary fame seems not to have brought happiness. *Portrait of an Old Woman with a Hen* (1856), despite its sentimentality, is a remarkable achievement for an artist of 80, and testifies to his enduring interest in the world about him. In these later works – for example, *Portrait of an Unknown Man holding a Cigar in his Hand* (1847) – he used a smooth technique on which time has wrought no ill effects.

Tropinin also painted small, pretty pictures, usually of girls, in the tradition initiated by Rotari but modified by a knowledge of Greuze. *The Lace-Maker* (1823) and *The Embroidress* (1825) are works of this kind, possibly relating to his days of servitude in the Ukraine. Towards the end of his life, influenced perhaps by La Tour and the Dutch genre painters of the seventeenth century, he experimented with restricted sources of light, as in *Girl with a Candle* (c.1840). One may presume that such pictures were popular with the richer merchant classes in Moscow; and one of his last works was of this genre: *Girl with a Pot of Roses* (1850).

53. Vasily Andreevich Tropinin: *Portrait of a Ukrainian Peasant*, c.1820. Oil on canvas, 34.5 × 28.5 cm. Warsaw, National Museum

From a career such as Tropinin's one might have expected a flow of 'primitive' pictures, naïve bucolic scenes and amusingly clumsy paintings; instead he measured himself against the great portraitists of the past and the famous ones among his contemporaries, seeking to rival them, which in a modest measure he did. He avoided the grandiose baroque of his predecessors and even the more splendid aspects of the rococo and absolutely disregarded the neo-classicism of the Academy. Only in his paintings of girls does he invoke the rococo – but with a difference, for he depicts them actually working, not at play or in flirtatious attitudes: the tools and equipment of his lace-makers are set out in painstaking detail. If the portraits of the men of his day show a restrained clarity derived from France, the exactness and attention to detail in the genre scenes are clearly drawn from the Low Countries; and Tropinin is, without doubt, the first Russian artist in the nineteenth century to show this particular influence.

Tropinin's style veered from a painterly sketchiness as in the *Portrait of P. A. Bulakhov* (1823) to the bold exactitude of his *I. P. Vitali* (Plate 54), but was always admirably suited to his purpose of depicting the whole man, the man who had a body and soul, and whose bearing, stance, life-quest and lines of thought are peculiarly his own. Tropinin's *œuvre* carries the impress of a sensible and sensitive personality, of an artist who had to struggle every inch of the way to a career as a painter and who felt, at the end of his life, a justifiable degree of self-satisfaction.

Orest Adamovich Kiprensky had a no less unfortunate start in life, but was given opportunities denied to Tropinin, who never left his native land. Kiprensky was born the illegitimate son of a nobleman, Aleksei Diakonov, and one of his serfs, at a small settlement near St Petersburg. He had been named Koporsky after his birthplace but later changed it to the faintly Italianate Kiprensky. At the age of six he was freed, perhaps by a process of adoption, and sent to the Academy of Arts where he stayed for fifteen years apart from a brief and misguided period in the army. He was taught by G. F. Hoyen and the neo-classicist G. I. Ugryumov, but the influences of Rubens, Van Dyck and Rembrandt, whom he studied in the Hermitage, were equally important. On his graduation as a history painter he presented *Dmitry Donskoy on the Field of Kulikovo* (1805), in which he cleverly mingled various ethnic types in an anthology of heroic gestures and poses derived from the Italian masters – and for which he

was awarded the Gold Medal of the Academy. He was named as Academician in 1812, Councillor in 1815 and Professor in 1830. He worked in Moscow, Tver and St Petersburg until the end of the Napoleonic Wars when, at the age of 34, he was given a travelling scholarship to study in Rome. Like the Russian artists who followed him he worked under Camuccini, Canova and Thorvaldsen. The Danish sculptor took him at night to see the classical statues in the Vatican Museum and demonstrated with the aid of torches how cold marble could be given a pulsating warmth, an aspect of female beauty about which Kiprensky certainly knew more than did his sober friend.[4] His fame spread rapidly when the Uffizi requested a work for its gallery of artists' self-portraits and when the Paris Salon invited him to exhibit in 1822. He spent a year in Paris acquiring expertise in the novel techniques of lithography. In 1823 he returned to Russia where he may have become involved with the Decembrists and during which time he painted Pushkin. In 1828 he went back to Italy where he remained, despite orders to return home, until his death in Rome in 1836, in a house on the Pincio where, it was believed, Claude Lorrain had lived.

His life had been much touched with scandal. He drank, had several casual romances, and was constantly in debt, writing begging letters to Count Sheremetev and asking Beckendorff for an official decoration in recognition of his services to Russian painting. During his first stay in Rome the model with whom he was living was found burnt to death and his manservant also died a few days later in hospital. He placed the model's daughter in a convent school and on his return to Italy in 1828 became a Roman Catholic and married her. They wandered fretfully through Italy, avoiding the society of Russian artists whom, with the exception of Bryullov, he detested. He died of tuberculosis in wretched circumstances.[5]

Although he had been trained as a history painter, Kiprensky's true genius lay in portraiture of a kind which had hitherto been rare in Russia, that of the man himself rather than the holder of an office. To him we owe a fascinating portrayal of the restless, turbulent and romantic age in which he lived.[6] He managed, as Levitsky, Rokotov and Borovikovsky had not, to capture the spirit of an era which had been inaugurated by the French Revolution. As early as 1804 a painting of his stepfather Adam, Rembrandtesque as it was in the honest strength of its style and the accentuated contrasts of light and shade, revealed his capacity for penetrating into the basic character of the sitter – in this case a man who undoubtedly meant a great deal to him personally. The canvas breathes inner tension, indomitable energy and wrathful determination: the brows are knit and the lips compressed as if in anger; the hands resolutely grasp a heavy staff – the whole forming an icon of parental authority.

Kiprensky's career coincided with the Napoleonic Wars and the heights of European romanticism; and although comparatively little was known inside Russia of many aspects of the romantic movement Kiprensky was endowed by nature with a temperament which was so restless that he was well able to portray the leading Russian writers and intellectuals of the period (and Goethe, whom he painted in Marienbad), as well as the handsome and virile soldiers and their delicate ladies whom the wars had brought into prominence.[7] From 1804 his work showed an increased ability, fluency and strength. Count Rostopchin (1809), believed to have fired Moscow in defiance of the French invaders, and his wife Ekaterina (Plate 55), the actor Mosolov (1811) and the young soldier Olenin (1813) were among the many subjects painted by him in the early years

54. Vasily Andreevich Tropinin: *Portrait of I. P. Vitali*, 1830. Oil on canvas, 81.3 × 66 cm. Prague, National Gallery

of his career. The finest of these early works, his characterization of E. V. Davydov (1809), exactly captures the insouciant elegance of Hussar officers at the very time when they were becoming out-moded in warfare. The picture is full of good things: the excellent use of paint in the creamy white of the pantaloons, the vivid flesh of the left hand grasping the sword, the glittering ornamentaton of the uni-form and the officer's seductive stance which seems to embody the distant echo of a resting faun. Were it not for the early date and the fact that he cannot have seen any of their work, Lawrence and Dawe might have been adduced as influences – but Kipren-sky seems to have arrived unaided at this flashing manner.

From the first it was not the example of the Eng-lish school that he followed but the French in the persons of Ingres, Gros and Gérard, although time after time he actually seems to anticipate their example as his portraits of S. Shcherbatova (1819), A. M. Golytsin (1819) and N. P. Trubetskoy (Plate 56) (the latter a splendid half-length military depic-tion) clearly illustrate. The grave *Portrait of Ekater-ina Avdulina* (1822) not only demonstrates his fluid draughtsmanship but the fact that his true genius lay in portraiture: the meditative mood of the sitter is quietly emphasized by the heavy storm clouds in the background and the falling petals of flowers in a glass. The style is neo-classical; the influence that of Leonardo's *Mona Lisa*. His best-known work is the portrait of Pushkin (1827), in which the poet stands, arms folded, a tartan shawl draped over his shoul-ders, his eyes cold and blue, his hair loosely curled, his expression disdainful, his features carrying a slight hint of his negro ancestry, while in the back-ground a carefully painted classical statue seems to hint at the conflict between classicism and roman-ticism experienced by creative artists of the age. During his years in Italy Kiprensky was impressed by the prevailing neo-classicism (and, after all, his friend Thorvaldsen was the most classical of north-ern artists); yet there is an almost alarming dicho-tomy between the romanticism inherent in his portraits and the academicism, the neo-classicism of his allegorical and historical pictures which, despite many preparatory sketches, he rarely ever com-pleted. He was determined to succeed in this field – but failed lamentably as *The Tomb of Anacreon* (1819–21) shows.

It has been claimed that Kiprensky's work degen-erated as a result of his lengthy stays in Italy and his dissipated life. There is surely a definite loss of characterization in his portrait of the dancer Ekater-ina Telesheva as Celia in Didelot's ballet *The Hunt-ing Adventure* (1828) which suggests romantic lithography rather than painting. This is also true of his *Poor Lisa* (1827), an illustration to Pushkin's poem. But sentimentality had always intruded into his work; and from the first there were weaknesses of characterization. On the other hand, with some exceptions, as for instance the portrait of K. I. Albrecht, a retired major-general (1827), where the drawing is weak and the oil painting has become transparent, his technique improved, as the con-dition of his later works demonstrates. The truth is that he was too often at the mercy of his own mer-curial temperament, but even so his painting is less uneven than might be expected; and although he rarely equalled his portrait of Davydov the works of the twenties and thirties show no deterioration of quality. However, it could be argued that in Italy his ardent and impulsive nature was given so much scope that he rarely worked with sufficient concen-tration and discipline.

55. Orest Adamovich Kiprensky: Detail from *Portrait of Countess Rostopchina*, 1809. Oil on canvas, 77 × 61 cm. Moscow, Tretyakov Gallery

56. Orest Adamovich Kiprensky: *Portrait of N. P. Trubetskoy*, 1826. Oil on canvas, 93.5 × 76.5 cm. Moscow, Tretyakov Gallery

Kiprensky was the first Russian painter of whom it can be said that he was romantic by temperament as well as in his style of portraiture. He yearned for the successful social and financial careers which he believed were enjoyed by artists in Western Europe, knowing that such independence was impossible in Russia where artists were ranked as functionaries, but failed to take into account the comparative stability offered by a professorship at the Academy (which he did not take up) and the other benefits of a career attached to the Imperial court. His inability to find the patronage which he thought would enable his powers to develop fully was a constant gall. He had faith in his artistic gifts; and fundamentally he was not mistaken. But his art was vitiated by its lack of any sense of commitment to country or society, to ideals or criticism, to humanity at large or to the men and women around him, a deficien-

cy which was to grow during his years outside Russia.

Kiprensky was one of the first *emigré* artists to wander aimlessly in Western Europe, relying on meagre financial support, and always on the point of succeeding in some apparently impossible field. In Russia he felt stifled and yet much as his genius was acclaimed abroad he was unable to make a living there and had to beg for financial assistance from his countrymen and despised homeland. He never managed to recapture the glorious years of the Napoleonic struggle, after which life came to seem emptier and emptier. It may also be that he physically exhausted himself by the vast amount of work he undertook in those years. He is a prototype of the listless and sardonic hero evolved in literature by Pushkin and Lermontov, the purposeless man who is the Hero of Our Time, to whom existence is 'stale, flat and unprofitable'. He tried a number of styles – as in his *Portrait of V. A. Perovsky in Spanish Costume* (1809), where he emulates Van Dyck and, more distantly, Velázquez, and his *Portrait of A. P. Tomilov* (1808), where Gérard seems to be the favoured source – but triumphed only when the sitter's character and circumstances excited him. In fact, he painted Tomilov thrice – in 1808, in 1813 and in 1828. When all else failed he turned to an analysis of his own nature; and to this ceaseless introspection, this unhappy narcissism, his many self-portraits (all of them different) bear full witness. In 1809 the eager painter, his brushes stuck behind his ears, looks directly at us, confident of his powers and the grace of his youth. In the following portraits, painted with increasing power and a vivid if nervous intensity, his face grows more haggard, the eyes desperately miserable, the clothing unsuitably jaunty. The tonality is a strange one of greens, olives and sombre browns which find their equivalents in self-portraits by Géricault and P. O. Runge of a similar intensity. Such self-consciousness in a creative artist had been hitherto unknown in Russia (Plate 57).

Equally unknown previously was Kiprensky's unwillingness to devote his life to propagating the principles, methods and styles of the Academy to which he owed all his training, for he believed his gifts to be above the claims of society and nationality (although in 1831 he painted what is in effect a portrait group of four young Polish students reading a newspaper carrying details of the insurrection of that year), reserving for himself the individual freedom which artists appeared to enjoy in Western

57. Orest Adamovich Kiprensky: *Self-Portrait*, *c*.1809. Oil on
canvas, 41 × 37.7 cm. Moscow, Tretyakov Gallery

Europe. Yet that is not the whole story. If he had been asked to render accounts for all the benefits bestowed on him and to list the useful services he had rendered the Academy in return for the considerable sums of money spent on him, Kiprensky might have answered, like an earlier artist in revolt: 'I do not belong to the Academy but to mankind.... I can develop myself only here, amongst the best works of art that exist in the world, and shall continue to the best of my powers to justify myself to the world by my work....'[8] Those citizens who would maintain that public encouragement of and assistance to the arts is not primarily intended for the benefit of self-sufficient and wilful genius but for the benefit of the community at large may well feel that Kiprensky brought misery on his own head and that his character was both ungrateful and self-destructive.

A superb portraitist at his best, a history painter of no great merit, and an even weaker composer of neo-classical pictures and decorations,[9] Kiprensky is the only truly romantic painter in the annals of Russian painting, the only man who might be said to approximate in a limited degree to Géricault, Delacroix or Wilkie; and the unhappy aspects of his life, like those of Pushkin, Lermontov and many other romantic intellectuals and creative artists, were partly self-created. Kiprensky is also the first Russian painter whose private life was the subject of national concern. Much of the importance of his career rests in the fact that he lived in a period when questions about the responsibilities of the artist were being seriously considered, and nowhere more than in Russia. The debate was to be taken up three-quarters of a century later; and it could be argued that it has never ceased.

Sharing in Kiprensky's delight in martial splendour was an artist of Polish origin, Aleksandr Osipovich Orlovksy (1777–1832), who was also a friend. After studying with Bacciarelli and Norblin de la Gourdaine in Warsaw, Orlovsky went in 1802 to St Petersburg where he won fame as a depicter of battle scenes and events of military life. He became an Academician in 1809 and was actually attached to the General Staff in 1819. Despite his training, it was the influence of the Dutch masters and of Salvator Rosa which predominated in his paintings of robbers, horsemen, shipwrecks and cavalry charges. He painted many portraits of the leaders of Russian society and the various ethnographical types of the empire. Like Kiprensky he was fascinated by lithography and the opportunities it offered

for a quick recording of impressions in a more permanent form than the sketch. Orlovsky travelled widely and even took part in the Polish liberation movement and the rebellion of 1794. It was natural that he should have greatly admired the numerous portraits executed by George Dawe for the military gallery in the Winter Palace. Orlovsky certainly belongs among the artists touched by romanticism; and his adventurous life probably represents the kind that Kiprensky longed for without having the strength of will to achieve for himself.[10]

The lives of both Tropinin and Kiprensky serve to illustrate the dilemma in which Russian painters found themselves in the early nineteenth century, especially if they lacked patrons or wished to cut themselves off from the benevolent authoritarianism of the Academy. Tropinin's case points at hidden reserves of talent which because of the pernicious social order often lay neglected, unexploited and even suppressed among downtrodden and illiterate and inarticulate serfs and peasants. On the other hand, Kiprensky made his way up the social ladder, largely thanks to the skills imparted by the Academy, but possibly found too easy a solution to his personal and artistic problems in escape from Russia, a road which many of his successors were to follow. The golden skies of Italy were eventually to be changed for the sombre clouds of Munich and the heady air of Paris, but essentially the basic idea was to escape from Russia. Inevitably, as we shall see, this was to lead to a reaction against West European art and to a xenophobic preoccupation with internal social problems with dubious benefits for painting and extremely doubtful, if any, effects on the conditions of ordinary men and women whom their paintings were intended to help.

As in many other European countries the popular art form of the nineteenth century was not history painting nor landscape nor portraiture but genre; and the favoured treatment was realistic in intention if not always in effect. Nevertheless, in line with the main trends of romanticism, if somewhat belatedly, there was a growth in appreciation of the landscape, especially as the larger cities gained an industrial aspect and their former picturesque character became the subject of nostalgic reminiscence, frequently embodied in paintings. The advent of the railway and improved communication systems opened the countryside to tourism. Remembering the increasingly Germanic nature of the Imperial court it is not surprising to find that much of the impetus to landscape painting came from Germany,

particularly from the Düsseldorf school. From there came the example of a form of landscape which had already found sympathetic expression among Russian painters – that is, of scenes of human activity in which nature or particular environments play a significant part, for Russian painters were especially sensitive to man's relationships with nature. There were, on the other hand, no painters to match the romantic geniuses of Turner and Constable; and Russian landscape painting will generally be found to be of a singularly realistic kind, although rarely lacking a generous breadth of treatment and a deeply sympathetic appreciation of nature in her varied forms.

We have seen that Fedor Ya. Alekseev worked in the styles of Canaletto and Bellotto which were especially suitable for evoking the long vistas of St Petersburg;[11] and one might have thought that later artists would have followed in his footsteps. Apart from S. F. Galaktyonov (1779–1854) and A. E. Martynov (1768–1826), the two 'poets of St Petersburg', and M. N. Vorobiev (1787–1855), the 'dreamy artist of St Petersburg's sunrise, sunset and moonlight', this was not to be, for instead there was an interest in the natural Russian landscape and the older, more characteristic towns, Moscow among them. Alekseev's contemporary F. M. Matveev (1758–1826) turned to Poussin, whose influence is apparent in his large pictures of Finnish, Swiss and Italian scenery chosen because of its abundance of lakes, waterfalls, trees and mountains. Grigory and Nikandr Chernetsov (1802–64; 1805–79), pupils of Vorobiev, painted the landscape of the Crimea and the Caucasus which were then enjoying the kind of romantic aura with which Sir Walter Scott had invested the remoter parts of Scotland. In 1838 the brothers (who were also portraitists) made a painting trip down the Volga from Rybinsk to Astrakhan, accompanied by a serf they had purchased, Anton Ivanov (1818–63), who displayed a talent of his own in his *Interior of the Chernetsovs' Boat* (1838).[12] The medium preferred for landscape work – in imitation of the English – was watercolour; and among the artists who were adept in its use were Bryullov, A. A. Ivanov and P. F. Sokolov (1791–1848), excelling by reason of their technical skill and pictorial sensibility.

It was primarily to the Italian sunshine that artists of the early nineteenth century turned, as did their contemporaries in England, such as Turner, Callcott and Eastlake. Gogol spoke for his countrymen when he wrote:

Our artists often have a true talent but only in the fresh air of Italy can they develop like a plant taken out of a room to grow in the open air.... What is an artist from St Petersburg, an artist from this land of snow, an artist from this Finnish soil where everything is damp, flat and soggy? Such an artist has nothing in common with the artists of Italy, fiery and ardent as Italy and her sunny skies....[13]

Among those artists who escaped the foggy atmosphere of St Petersburg was Silvestr Feodosievich Shchedrin (1791–1830), who was descended from a line of artists, his uncle Semyon Fedorovich having taught landscape painting at the Academy and his father Feodosy (1751–1825) being deservedly celebrated as a sculptor.[14] After study at the Academy under F. Alekseev and M. Ivanov he went in 1818 to Italy where he was enchanted by the sea, the ports, the fishing villages, the ruins, the whole Mediterranean ambience (Plate 58). His use of colour, originally derived from a study of Claude and Poussin, gained in freedom and accuracy. He created sentimental pictures of fisherfolk on the seashore at Sorrento and elsewhere, in which echoes of Salvator Rosa's bandits and Teniers's Flemish boors are modified to accommodate the taste for Neapolitan life expressed in Auber's opera *Masaniello* (1828) and Bournonville's ballet *Napoli* (1842). Doubtless, too, he gained by working in the company of artists of the Neapolitan school whose picturesque scenes were popular with foreign tourists. Shchedrin is the first Russian landscapist of some genius who showed the colour and vitality of nature at first hand; he was immensely hardworking, enjoyed international patronage and was still developing as a landscapist when he died in Sorrento.

Another young painter whose promise was never confirmed, since he died of cholera in Naples when he was only 26, was Mikhail I. Lebedev (1811–37). After studying under Vorobiev he painted a few Russian scenes before exchanging the brown water of the Neva for Italy's sunny shores. In Rome he had the good fortune to meet Aleksandr Ivanov, who encouraged him to develop a personal and poetic style in which the retention and transmission of direct impressions were of major importance. His paintings of Castelgandolfo and Aricci show a delight in the lacelike effect of sunlight breaking through the trees and striking against the golden walls of Renaissance buildings.

Greater than any of these was Fedor Aleksandrovich Vasiliev (1850–73), who with Savrasov

and Levitan inherited the pioneering triumphs of Shchedrin and Lebedev.[15] Vasiliev had begun his training under the auspices of the Society for the Encouragement of the Arts, but his education was continued informally during discussions with friends and on a painting trip down the Volga in the company of Repin and other artists. Kramskoy, whom we shall meet as a leading member of the *peredvizhniki* group, was particularly encouraging. By 1871 Vasiliev was seriously ill with tuberculosis and aware that he was doomed. He vainly sought refuge in the mild air of the Crimea. On the sole evidence of *The Thaw* (1871), a desolate and wintry

scene infused with a subdued and elegiac pathos, it can be seen that he was one of the great casualties of Russian painting. His output of landscapes both of the Volga region and of the Crimea is astonishing.

Vasiliev was especially fond of painting in autumnal colours, preferring misty lake scenes or distant views in which there rarely appears a human figure, or views of deserted avenues of trees. His work, carefully finished and painted with a sound technique, is somewhat reminiscent of that of Parkes Bonington in its happy combination of an unaffected observation of nature and a serene, elegiac idyllicism. Like the English painter he, too, was a precocious artist, already exhibiting at the age of 17. He is the first Russian to bring to canvas a just vision of the effects of light, of sky and of water in his native land. Had Vasiliev enjoyed the normal span

58. Silvestr Feodosievich Shchedrin: *Italian Village Road*, *c.*1825. Oil on canvas, 48 × 61.2 cm. New York, Hammer Galleries

of life he would undoubtedly have changed the course of Russian landscape painting and, perhaps, have challenged the prevailing trend towards pictorial moralizing. He was adept at portraiture and genre scenes as numerous sketches indicate; but his heart seemed to lie in capturing the variety and heart-stirring beauty of the landscape. His achievement in terms of quality and quantity is astonishing when the pitiful brevity of his life is remembered. As it was, he not only made his significant mark on the history of Russian painting but also prepared the way for another landscapist of rather similar tendencies, I. Levitan, whose career began a decade after Vasiliev's death.

It is pertinent to mention here a distantly related aspect of landscape painting, that of the domestic interior.[16] There is an unusual number of paintings of interiors by known and unknown painters extant in Russia, most of them dating from the first half of the nineteenth century although there exists a version of a painting by the portraitist Rokotov, dated 1759, of a room in one of the Shuvalov palaces hung with numerous paintings. Most of these paintings are of charming interiors, sparsely decorated and furnished in the Biedermeier style, nearly always peopled, and often showing activities such as painting, writing or entertaining. These small colourful works, usually executed in watercolour or gouache, provide us with a glimpse into rooms belonging to all classes of society. Among the known painters of such interiors is Fedor Petrovich Tolstoy (1783–1873), a member of a distinguished aristocratic family, who first attended the Naval School in St

59. Fedor Petrovich Tolstoy: *Classical illustration*, 1829. Ink and paper. Moscow, Tretyakov Gallery

Petersburg and then joined the Life-Guards of the Preobrazhenski Regiment before devoting himself to art. He was a sculptor, medallist, painter, engraver and illustrator.[17] His line drawings and engravings, much in the manner of Flaxman, are possibly the purest examples of neo-classical art carried out in Russia. Yet he had consulted Kiprensky about taking up a career as an artist and his small gouache pictures such as *At the Window on a Moonlight Night* (1822) have a distinctly romantic reference as do his exquisite studies in watercolour of birds and flowers. Even his *trompe l'œil* works carried out in pen and ink and gouache seem intended simply to please rather than to dazzle and perplex. Tolstoy also worked with silhouettes portraying scenes of village and country life, sometimes hinting at strange violences as in *At the Outpost*. There is omnipresent the sense of an aristocratic restraint and a cultivated sensibility. He executed nothing of importance on a large scale, preferring to work at a miniature level – at times strangely anticipating the decorative tendencies of the Mir iskusstva group much later in the century. With these considerations in mind it seems rather paradoxical that from 1828 to 1859 Tolstoy was vice-president of the Academy of Arts, the centre of neo-classical academicism (Plate 59).

Tolstoy's work bordered on genre which was becoming increasingly fashionable. It is true that there had long been a 'class of domestic exercises' tolerated by the Academy which had encouraged work in the manners of Teniers and Wouwerman, but an inspiration of a different kind came from visiting artists such as Le Prince and Atkinson, who with their sketches of the more colourful aspects of town and country life made Russians more conscious of their own folk customs and traditions. In addition, a taste for genre pictures became evident as the rapidly growing classes of merchants and entrepreneurs sought smallish easel-pictures for their comparatively modest homes. Dutch genre scenes, for which there was an insatiable rage in England, would have been acceptable to collectors, but were as unobtainable in Russia as elsewhere since connoisseurs in the Low Countries rarely parted with their treasures. Inevitably, Russian painters began to turn their hands to this field in an attempt to satisfy the fashion.

Nicholas I, possibly despite himself, had brought into play a new spirit, that of a mild satire, which was to manifest itself in literature and art – principally in the work of Fedotov which could be said to parallel that of Gogol. Fedotov's work was directly related to that of the Dutch genre painters. Side by side was the genre school initiated by Venetsianov and carried on by his students and, in part, by the *peredvizhniki* in the second half of the century. In effect, there are at least two influences operating at the same time, that of Italian and French neo-classicism and that of the British portraitists and the Dutch genre painters, the last manifesting itself especially in still lifes, intimate portraits, and the interiors already discussed which often had a *gemütlich* quality much to the taste of Nicholas I. He is said to have appreciated satire – but it can only have been to a limited extent. The existence of these trends demonstrates the limited and precarious nature of Russian romanticism; and in the first decades of the nineteenth century, more than in any other country in Europe, Russian painting seemed to oscillate between extremes.

Much of genre painting concerned itself with the daily life of ordinary men and women away from the Imperial court, even with the serfs and peasants. A few painters had previously shown something of the existence of these classes. I. M. Tonkov (1739–99) had idealized the squalor and misery of the peasants in his *A Village Festival* (1779); O. S. Drozhdin (1745–1805) painted scenes of family life among the poor; I. A. Ermenev (1746–after 1789), working in watercolours, created some haunting pictures of destitute peasants of which *Blind Men Singing*, where a group of beggars is seen outlined against an angry sky as they stumble across a barren field, is outstanding;[18] and I. V. Luchaninov (1780–1824), as well as painting religious scenes heavily indebted to Murillo, also evoked events from the Napoleonic Wars of which his *Blessing a Guardsman off to the Front* (1812) anticipates the narrational works which were to become popular in the second half of the century when, however, their content was intended to carry greater social comment.

The artist who more than any other focused attention on the charm (and, only rarely, the misery) of rural life was Aleksei Gavrilovich Venetsianov (1780–1847).[19] In doing so, he created a novel pictorial form – that of an isolated figure set against a comparatively empty landscape, a compositional device which was to be exploited by later painters such as Nesterov and those artists in Western Europe who followed the Frenchman Bastien-Lepage. Son of an enterprising Greek trader from Epirus who had set up business as a picture dealer in

Moscow, Venetsianov was meant to be trained in government service as a surveyor of woodlands. In St Petersburg he took lessons from Borovikovsky and learned his technical methods. Never a student at the Academy, nevertheless he was designated Artist Without Rank and Academician. He spent his spare time at the Hermitage copying the Dutch masters of genre for whom he had a strong predilection as is obvious in all his paintings. He worked a great deal in pastel which may account for the lack of chiaroscuro in his work. In 1807 he obtained permission to publish a magazine of caricatures which ran to three issues before attracting the repressive attentions of the censor. A few years later, caught up by patriotic fervour, he issued prints satirizing Napoleon's aggressiveness and the failure of his Russian campaign. In 1817 the periodical *The Magic Lantern* published his scenes of life in St Petersburg. Tired of life in the capital and having possibly received intimations that his career as a social commentator should come to an end, he retired to a small estate he had bought at Safonkovo, in the province of Tver. After a last attempt in 1818 to win public fame by a series of prints and commentaries on Russia's great men, a plan for which the authorities would not grant permission, he once again settled down – so it appeared – to the quiet life of a country squire.

Although he may not have realized it at the time, Venetsianov had begun a major new period in his career, this time as a teacher. On his estate he encouraged his neighbours to take up painting and to allow their serfs to do so. As a result he collected about him more than seventy students. When he went to live for a while in St Petersburg on Vasilievsky Island he took a number of them with him. In some cases he was able to redeem the serf students from their legal bondage. Venetsianov wrote voluminously on his teaching methods and it is clear that he turned his students' attention directly to nature, 'to depict nothing in any way different from how it appears in nature, and to obey it alone, without recourse to the style of any other artist.'[20]

Venetsianov did not, however, always follow his own precepts. He was a complex artist and an even more complex individual who seems to have assumed a kind of deliberate simplicity both as a mask for his own adventurousness and as a defence against the hostility of the world. He worked in a variety of styles and at a variety of subjects, but since his religious pictures and his enormous *Peter the Great* seem no longer on exhibition, it is difficult

to estimate his total ability. But copies he made of religious works by Giordano and Murillo exist.

The beginning of his career as a painter of genre is marked by a pastel of 1820, *Cleaning the Sugarbeet*, which amalgamates pictorial elements derived from his studies in the Hermitage; Boucher seems to be the source of the rococo foliage in the background while Le Nain or Dutch pastoral scenes may have inspired the grouping of the peasants. His popular and gently erotic studies of peasant girls feeding cattle or performing farm work have an affinity with Rotari whose influence few portraitists wished to escape. His female nudes, which come as a surprise from so apparently sedate a painter, are indebted to the French eighteenth century. But in 1821, his work in genre was given a sharper purpose by his discovery of *Mass at the Capucine Monastery in Rome* by his contemporary, François-Marius Granet (1775–1849); the calm and diffused light he admired in the picture (and other Russian painters were no less impressed) seemed absolutely appropriate for the kind of interiors which he wished to evoke. *The Morning of the Mistress of the House* (1823), which shows his wife giving instructions to two young peasant servants, admirably captures the simple dignity of the room as well as the quiet understanding between the three characters. Despite all this eclecticism (other influences included Chardin and de Hooch), Venetsianov created an inimitable style for himself which is best seen in his famous *The Threshing Barn* (1820–3), which was bought by Nicholas I for 5,000 roubles, enabling him to continue his informal art school. A little possessed of the ambition to paint a masterpiece, he entered an enormous picture on the theme of *Peter the Great at Saardam* in a competition financed by Demidov in 1838 – with no success. In the winter of 1847 he was thrown from his sleigh and died soon afterwards.

Although it is true that Venetsianov escaped the stultifying atmosphere of the Academy, it is equally true that he never rid himself of a certain weakness in composition and figure drawing, nor did he ever master the rules of perspective. He had a firm, somewhat touching belief that only from a study of the masters of the past could an artist learn the art of composition; and yet, at the same time, he was wont to disclaim the benefits of studying these masters. The ambivalence of his attitude is well illustrated in a picture by his pupil Aleksandr Alekseev, *In Venetsianov's Studio* (1827), which shows some students working from a clothed model while

others use casts of classical statues. There is a degree of awkwardness in all his work, a kind of deliberate and cultivated amateurism, a note of the *faux primitif*. This serves to account for the charm and memorability of his pictures in which there is often a strange emptiness and a lack of balance in the composition. The log walls in *The Threshing Barn* (Plate 60) actually suggest a proscenium arch through which his peasants should move after arising from the dreamlike poses into which Venetsianov has charmed them and begin to dance to the music of Stravinsky's *Les Noces*. *The Return of the Soldier* and *Girl in a Hayloft* (both *c*.1830), which fall among his weakest pictures, carry a suggestion of the theatrical, as does his later *Fortune-Telling* (1842).

60. Aleksei Gavrilovich Venetsianov: *The Threshing Barn*, *c*.1821. Oil on canvas, 66.5 × 80.5 cm. Leningrad, Russian Museum

Venetsianov made several valuable innovations. He believed, for instance, that a human being should form part of the landscape, 'should merge into a painting as naturally as the floor on which he stands, or the chair on which he sits' – and we can see how Granet's work confirmed him in this idea. Thus, when composing an interior such as *Prince Kochubei in his Study* (Plate 61; Col. Plate 5), Venetsianov saw man as part of the whole scene, just as his peasants were essentially linked with the landscape and the buildings in which they performed their tasks. Moreover, he was the first Russian painter to appreciate the general importance of light. Explaining the success of *The Threshing Barn* he wrote:

> It was said that its fascination was created by the focus of light ... and that with full light it was quite impossible to paint objects with such forceful vitality. But I decided to overcome the impossible, went to the country and set to work. In order to succeed I departed from all the rules and methods

61. Aleksei Gavrilovich Venetsianov: *Prince V. P. Kochubei in his Study*, *c*.1834. Oil on canvas, 144 × 106 cm. Leningrad, Russian Museum

learnt by me during the twelve years of copying at the Hermitage, and then in the most natural way Granet's methods were revealed to me. The idea was that nothing should be represented except as it appears in nature: to follow its dictates and not to mix with it the methods of any painter, that is not to paint *à la Rembrandt* or *à la Rubens*, but simply, so to speak, *à la nature*.[21]

In order to gain more light with which to illuminate his figures he had (as can be seen in the picture) part of the wall of his threshing barn cut away. This method of working, apparently *en plein air*, was a radical departure for Russian painting. Venetsianov was also the first Russian painter to use peasants, even if in a somewhat idealized way, as subject-matter for his pictures which were, despite the

background and surroundings, essentially genre works.

Venetsianov had an affection unexpressed by any other Russian painter before him for the cornfields and the open, rolling countryside. Barns, cornfields, birch and fir woods, peasant huts and sheds, low hills and endless plains often bathed in a mellow and golden glow form the idyllic backgrounds of works like *The sleeping Shepherd Boy* (1823–6), *Boy tying a Shoe* (1823–7), *Peasant Children in the Fields* (*c*.1820) and *Two Boys with a Kite* (1820). He shares Brueghel's delight in the inventiveness of children's games. His peasant children and their elders are seen in the fields, sowing and reaping, receiving orders in the home, herding cattle and, occasionally, resting. Even when he painted the children of the aristocracy as in his *Children of Prince Putyalin* (1825) he preferred to pose them informally out of doors playing with pet animals. If Venetsianov verges on an easy lyricism, he also achieves a peaceful austerity and a touching resignation which closely approaches the sober calmness of Chardin. But unlike Chardin, who confined himself to interiors, Venetsianov is close to nature, deriving from it a gentle serenity, which gives his work a truly romantic quality. It is as if he wished to show that however wretched were the lives of his peasant children born to unceasing toil there was always a measure of alleviation for them in the constant and comforting presence of nature.

Here we come to a paradox in Venetsianov's character in which it is impossible to distinguish between a timid naïvety and a strongly developed sense of discretion. He was careful in later life to stay on the right side of authority. In connection with Alexander I's rebuilding of St Petersburg he wrote:

It sometimes seems to me that I am not in St Petersburg nor the Academy but in Athens or the Parthenon. There must be some kinship between the third century BC and our nineteenth century. Purity of taste, elegance and charm feed my imagination and fill my soul. Poetry, prose, painting and architecture all flourish. Our people are being properly developed, most of all in the political and moral spheres.[22]

He hankered after honours and humbled himself before Nicholas I from whom he gained the title of Court Painter in 1830; and painted religious pictures of a most conventional and sentimental nature which were extremely unlikely to disturb the social consciences of the worshippers who knelt before

them. Yet he concentrated his skill on painting peasant life; and although he shrinks from illustrating the harsh and hopeless misery of serfdom he does not shirk the depiction of bare feet, poor clothing and an emphatically joyless attitude to the task in hand. In his *Cleaning the Sugar-Beet* (Plate 62) the grouping of the peasants initially suggests a rococo scene of bucolic jollity and amorous festivity, but closer inspection discloses that the women are huddled together as if for comfort or warmth and that the dumb misery of the central girl and the serious expressions of the others are occasioned by the appearance of yet another basket of beet to be

cleaned.[23] Venetsianov lived among the peasants, understood them and was moved to express their constant sorrows and fleeting joys. Yet he tried to dignify the hardship, the weariness and the endlessness of working life, extolling the virtues of rustic toil, even though he knew that serfs could be sold like beasts, separated from parents, wives and children at the will of their masters who, as he said, were drowning 'in the stagnant mud of feudalism'. And we know of Venetsianov's friendship with Krylov, Gogol, Pushkin and other leading spirits of his age, so there is little reason to doubt that he was concerned with reform and the general improvement of Russian life. It is, perhaps, natural that he should also have painted many portraits in which is manifested a firm resolve to seek out the sitter's personal character as distinct from his rank or

62. Aleksei Gavrilovich Venetsianov: *Cleaning the Sugar-Beet*, 1820. Pastel and paper, 53 × 63 cm. Leningrad, Russian Museum

office: he is among the first of the romantic portraitists.

Venetsianov also caught the taste of early romanticism for the exploitation (and preservation) of national characteristics, ranging from historical legends to folk costumes, so that he is an altogether more nationalist painter than his contemporaries such as Bruni, Bryullov and Ivanov, who were internationalists by training and in choice of subject-matter. The pupils and friends of Venetsianov followed his pioneering steps in rendering scenes of peasant and traditional life; and imitating his work they acquired a sound technique in several media (he used pastel, graphite and crayon), so that their work is usually still in better condition than that of many painters of the time. Chief among them were: A. V. Tiranov (1808–59), A. Alekseev (1811–78), N. S. Krylov (1802–31), V. M. Avrorin (1805–55), K. A. Zeltentsov (1790–1845), Y. Tukharinov (dates unknown), N. A. Burdin (1814–57), Y. F. Krendovsky (1810–after 1853), L. K. Plakhov (1810–81), S. K. Zaryanko (1818–71) and A. G. Denisov (1811–34). Denisov is noted for two oddly disparate works: *The Raising of the Alexander Column* (1832), in which he shows the scaffolding and immense preparations made for the erection of the huge monolithic column to the memory of Alexander I in the square outside the Winter Palace, St Petersburg, on 30 August 1832; and *Sailors at a Bootmaker's* (1832), a genre scene showing a young cadet explaining his requirements to two young bootmakers. They may perhaps be explained by the fact that he went to finish his training under Franz Krüger in Berlin, where he died. Grigorii Vasilievich Soroka (1823–64), initially self-taught but later a student under Venetsianov, was freed from serfdom in 1861, took part in the peasant uprisings which followed the Act of Emancipation and was sentenced to flogging but hanged himself before the sentence could be carried out; yet his *View of Lake Moldino* (c.1840) and *Chapel in the Park of Ostrovski* (c.1850) have a glowing tranquillity reminiscent of Vermeer or of the near-contemporary American painter George Caleb Bingham; and his portraits are extraordinarily controlled, his *Portrait of L. N. Miliukova* (1845–50) bringing to mind the exact placidity of a Bronzino.[24] Although Soroka was undoubtedly the most talented of Venetsianov's pupils, the majority of them attained a degree of success, F. M. Slaviansky (c.1819–76), A. V. Tiranov and S. K. Zaryanko being especially popular as portraitists.

Venetsianov's pupils exhibited with him from 1827 in the triennial exhibitions at the Academy and thus served to reinforce his particular emphasis on national subject-matter, quiet interiors, placid parklands and domestic portraiture. The fact that some of them had little talent, that others turned away to imitate Bryullov, the reigning idol, and that others died young hardly detracted from the impact of the group so different in aims and styles from the Academy. Moreover, Zaryanko and another pupil, Apollon Nikolaevich Mokritsky (1810–71), became teachers at the Moscow School of Painting, Sculpture and Architecture and so transmitted Venetsianov's ideals and methods to succeeding generations.

The example of Venetsianov and his school in establishing another kind of painting outside the confines of the Academy was of undoubted importance but it was Pavel Andreevich Fedotov (1815–52) who had the more immediate impact.[25] Fedotov was born the son of a minor official in Moscow, where he became familiar with the everyday life of the residents of the lonely and shabby suburbs. He joined the army and was eventually commissioned in the Finland regiment of the Imperial Household troop stationed in St Petersburg where he was able to attend evening classes. Fedotov amused his fellow officers with anecdotal sketches of military life, while his painting *The Blessing of Regimental Banners in front of the Winter Palace* (1837) spread his reputation as a talented amateur further afield. It was not until 1844 that he resigned his commission, a singularly unfortunate time to quit the military scene and take up the palette, for he was to fall foul of the censorship which was even further intensified in 1848. Meanwhile he studied at the Academy under the battle painter A. M. Zauerveld and received encouragement and advice from Bryullov. In 1848 he was awarded the title of Academician. In 1847 he exhibited *The New Suitor* and *The Newly Decorated Knight* (1846), typical of his social comedies. In the former he showed an ugly, leering hunchback down on his knees paying his addresses to a simpering girl who is clearly on the verge *d'un certain âge*, while her anxious parents eavesdrop behind a curtain. *The Newly Decorated Knight*, which shows a dishevelled officer the morning after a riotous party given to celebrate an honour which had been bestowed on him, aroused official opposition. The work proved so popular that a lithograph was made, but the censor intervened and banned its distribution until the medal pinned on the

63. Pavel Andreevich Fedotov: *The Major's Courtship*, 1848.
Oil on canvas, 58.3 × 75.4 cm. Moscow, Tretyakov Gallery

officer's dressing-gown had been obliterated and the print retitled *The Morning after a Party*! Like so many creative artists in the reign of Nicholas I Fedotov was suspected of being a free-thinker, an irreverent and irresponsible social satirist to whom it would be dangerous to allow excessive freedom. After his guardian angel Bryullov left Russia for Italy, the envy and spite of the Academy and Imperial circles were vented on Fedotov and his work was not accepted for the Academy exhibition. His comment, 'The newspapers wept, not finding any of my pictures in the Academy', betrays his increasing nervous tension. He had been in the habit of standing in front of his works and declaiming jingles

which were meant to convey their hidden depths of meaning, but now, reduced to poverty, he lapsed into melancholy silence. His servant found him sobbing in the snow. He was brought home only to fall into violent madness and was then removed to an asylum where death brought a speedy and welcome end.

Fedotov was not simply a satirist. He himself supplied a clue to the nature of his art: 'I did little work in my studio, only a tenth part of my labours. I worked mainly in the streets and in people's houses. I studied life and I laboured, working with both eyes open.'[26] Nor was Fedotov content merely to observe: he commented without allowing his work to deteriorate into mere illustration of social topics. He did not attack specific abuses but like his contemporaries Gogol and Ostrovsky sought to expose the greed, the hypocrisy, the materialism and the lack of

spirituality to be seen everywhere in the Russia of Nicholas I. His early pictures were, it must be admitted, near to caricature, perhaps because of weakness of draughtsmanship, which he quickly rectified to become a master of line. Thus *The Visit to the Regiment of the Emperor Nicholas I* (1837) is no more than the sketching of a minor artist, but his powers matured quickly, especially in portraiture; and the startlingly honest picture of his father which he painted in the same year (in watercolour) belongs to quite a different order of talent. A number of miniatures of young girls demonstrates the happier side of his nature. His self-portrait is a remarkable work: a haunting face, something like that of Baudelaire or Gérard de Nerval, with strange eyes at once patient, sorrowful and obsessive. His study of the Dutch masters of genre also bore fruit; while his discovery of Hogarth gave direction to his social awareness.

Like many artists of the day, including Kiprensky, Orlovsky and Venetsianov, Fedotov recognized the value of lithography and in 1848 began work on a series of topical drawings entitled *Moral and Critical Scenes from Daily Life* which he intended to publish by lithographic reproduction. In that year he produced a fine work *The Major's Courtship* (two versions, 1848 (Plate 63) and 1851), in which we see a rich merchant's daughter dressed and groomed for the approval of an elderly major, who stands preening himself in the open doorway, while a matchmaker goes ahead with the introductions. Despite the comic details – the anxious and vastly overdressed mother clutching the daughter, the humble father in his caftan, the interested whisperings of the servants, the obsequiousness of the matchmaker and the peacock strut of the impoverished major – we sense that we are at the beginning of one of those disastrous marriages so frequent in Dostoevsky's novels. Generally regarded as his masterpiece, it earned him the recognition of the Academy.

A Poor Aristocrat's Breakfast (Plate 64) slyly depicts a young man about town covering his breakfast – a slice of dry bread – with a paper-backed novel as his poodle barks to announce the arrival of an unexpected visitor. Small details such as a broadsheet advertising oysters which hints at the young man's extravagance and at the same time contrasts with the meagre breakfast are used to intensify the satire. The elaborate furnishings, decorations and ornaments of the apartment demonstrate an artist for whom the painting of velvets, different kinds of woods and varieties of textures presents no difficul-

ties. The mordant satire of these and other works sometimes inspired by Krylov's fables soon gives way to a vein of melancholy. *The Young Widow* (1851: several versions) is a work of sincere pathos: surrounded by wedding gifts now claimed by creditors, the young woman about to bear a fatherless child, isolated in a room dimly lit by a single candle, reflects on the empty future before her. There is not even a dog or cat to keep her company – and Fedotov rarely leaves an animal out of his pictures. *The Young Widow* was inspired by his sister whose husband had died the previous year; and Fedotov further involved himself in her plight by including his own portrait in at least one version. A last desperate work *Encore! Encore!* (1851–2) shows an officer stationed in the remote countryside whiling away his boredom by making a dog jump over a stick, a memorable picture of animal and master trapped in the weary tedium of their situations. Leaving behind the overfurnished Biedermeierish interiors of his earlier paintings he gives us here a simple hut furnished with no luxuries except for a guitar – and with a single candle for illumination. As a final irony the actual painting has almost disappeared beneath the darkening and cracking which have attacked Fedotov's works in oil.

Fedotov's career belongs entirely to the reign of Nicholas I, a period in which the manifold abuses of government were openly jeered at despite the ceaseless intervention of the censor. The unabashed romanticism of Lermontov, of Tropinin and Kiprensky, and the tumultuous romantic-academicism of Bryullov, Bruni and Ivanov were beginning to seem irrelevant, while a nervous period of heart-searching and questioning self-consciousness exemplified by Venetsianov and Fedotov had begun. We must remember that these last two masters were mature individuals before they became artists; and thus, for better or for worse, painting became the vehicle with which they expressed their convictions and attitudes. The critic Stasov said that the first gleam of a new orientation in Russian art came with Fedotov. In the sense that Fedotov established genre as a medium for social satire and bequeathed the form to the generation that followed him, notably the *peredvizhniki*, this is certainly true. But at heart Fedotov was less a satirist than a commentator on the tragicomedy of human life: the quality which informs his

64. Pavel Andreevich Fedotov: *A Poor Aristocrat's Breakfast*, 1849. Oil on canvas, 51 × 42 cm. Moscow, Tretyakov Gallery

work is not satire but pathos. His sympathy extends even to animals, for, like Hogarth and Cruikshank, he delighted in painting pet dogs whose frivolous and idle and sometimes miserable, not to say unnatural, existences reflected only too bitterly those of their owners. He is moved by humans in solitary anguish or endless ennui: girls forced into marriage, young women frozen in the sorrow of early widowhood, soldiers gambling to relieve the monotony of their lives, card-players who suddenly realize they have lost and at what cost to their lives, and men and women futilely trying to keep up appearances. He laughs, yes – but the tears are never far away. Loneliness, isolation, hidden pain, drunkenness, miserable marriages, debt, weeping children, poverty, boredom and despair are the basic themes of his pictures, which are in actuality projections of his own alienation from society in his last years. In this sense he is nearer to Dostoevsky's portrayal of the lower depths of city life than to Gogol's country bumpkins. Even his command of surfaces, of the varied textures of silk and furs, woods and bricks, suggests the heartlessness of the material world – the world of dimly-lit interiors which imprison and also seduce humanity into a false sense of security and which even intensify the hours of isolation and enforced loneliness. It is for these moving reasons that Fedotov retains our interest and affection when the works of some of his more ambitious contemporaries and more socially minded successors have palled. And yet, it must be said in conclusion, that his technical skill belonged to the past, to Holland of the seventeenth century, and that however much he contributed to Russian painting in terms of subject-matter and tone, he did nothing to enlarge or vary its style.

It is impossible to chart any single development of major importance in the very first decades of the century. It is clear that the Academy had firmly established itself and was improving the technical efficiency of its students, that landscape had begun to develop as a legitimate form of art, and that genre painting had begun to make its appearance in Russian houses; but it is extremely difficult to discern, let alone describe, large-scale trends. Even romanticism, so potent elsewhere in Europe, was singularly muted in its effects on painting. The dominant influence was, in fact, that of the Academy of Arts. The dominant spirit, however, was to be that of social satire, realism and a direct appeal to the mildly critical political inclinations of the increasing numbers of the bourgeoisie on whose patronage and financial support artists were to become more and more dependent.

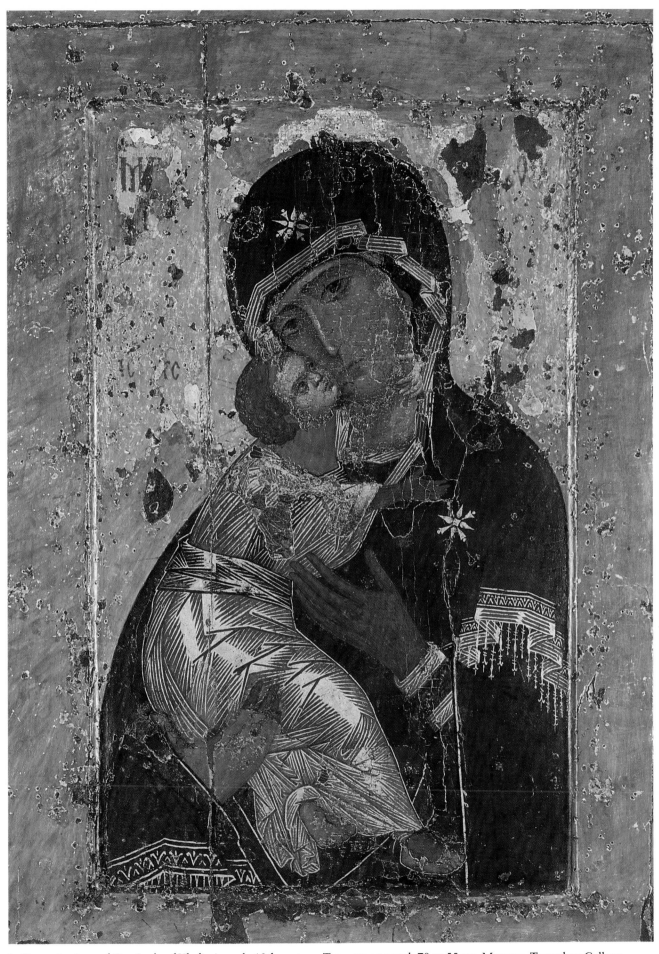

1. Byzantine icon of *Our Lady of Vladimir*, early 12th century. Tempera on panel, 78 × 55 cm. Moscow, Tretyakov Gallery

2. Icon of *St Dimitrius of Thessalonica*, Pskov School, early 15th century. Tempera on panel, 87 × 67 cm. Moscow, Tretyakov Gallery

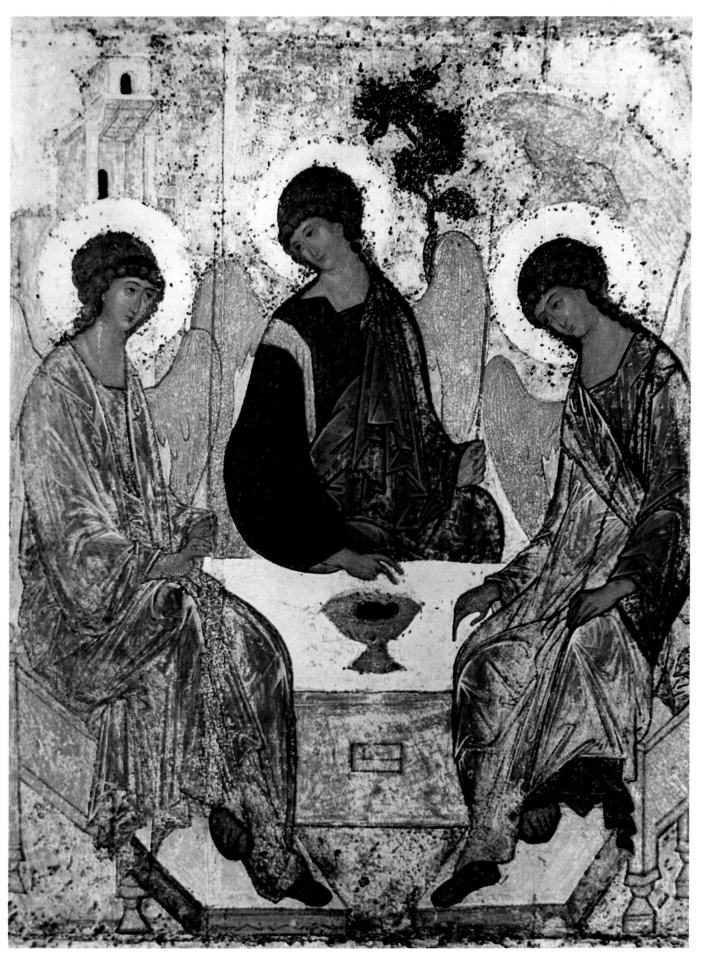

3. Andrei Rublev: *The Old Testament Trinity*, early 15th century. Tempera on panel, 142 × 114 cm. Moscow, Tretyakov Gallery

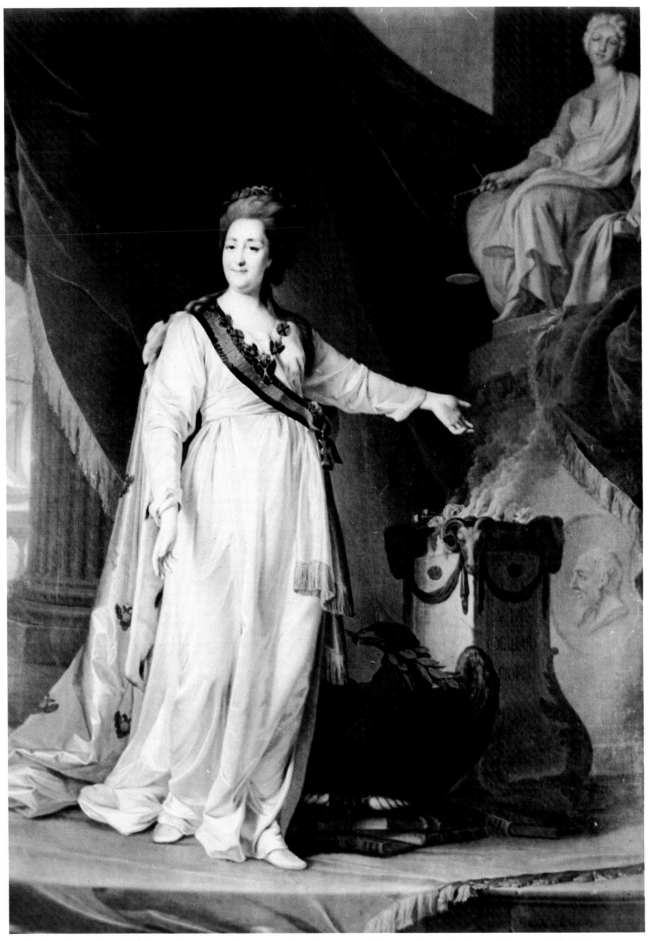

4. Dmitri Grigorievich Levitsky: *Portrait of Catherine the Great in the Temple of the Goddess of Justice*, 1783. Oil on canvas, 110 × 76.8 cm. Leningrad, Russian Museum.

5. Aleksei Gavrilovich Venetsianov: *Prince V. P. Kochubei in his Study, c.* 1834. Oil on canvas, 144 × 106 cm. Leningrad, Russian Museum

6. Vasily Grigorievich Perov: *The Village Easter Procession*, 1861. Oil on canvas, 71.5 × 89 cm. Moscow, Tretyakov Gallery

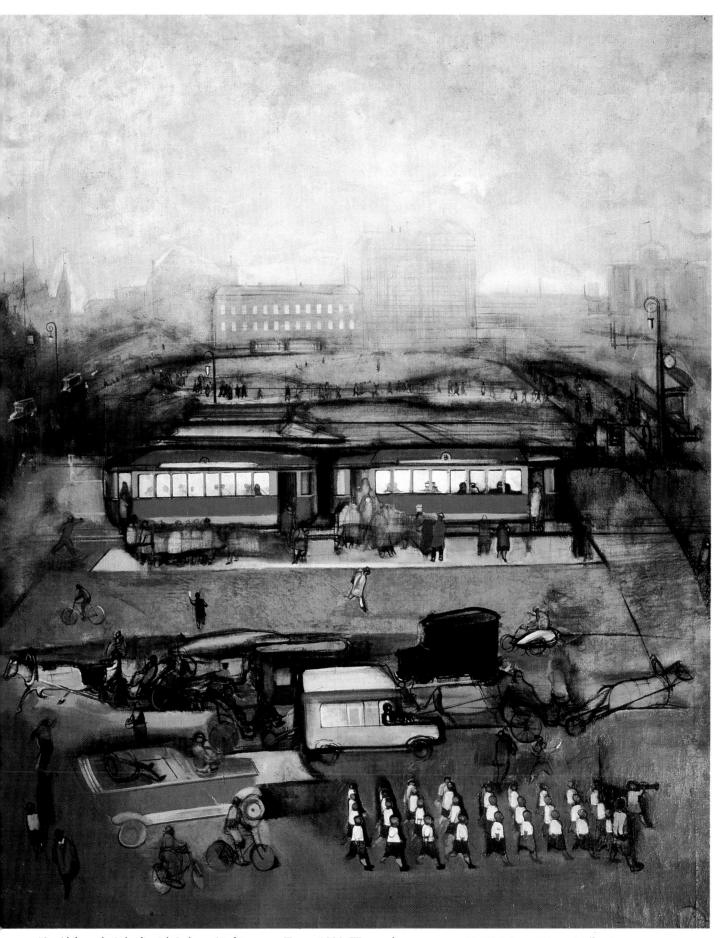

13. Aleksandr Arkadievich Labas: *Airship over a Town*, 1932. Watercolour on paper, 44 × 30.5 cm. Private Collection

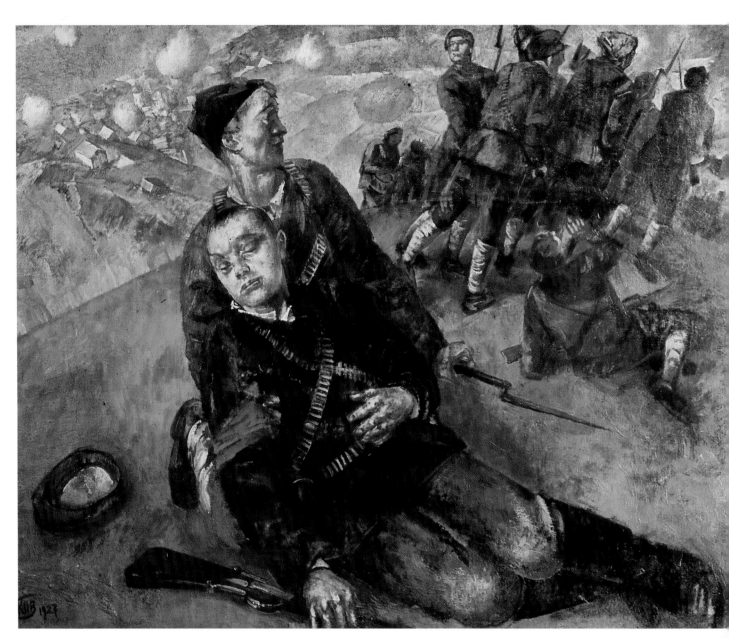

14. Kuzma Sergeevich Petrov-Vodkin: *Death of a Commissar*, 1928. Oil on canvas, 198 × 248 cm. Leningrad, Russian Museum

15. Petr Petrovich Konchalovsky: *Portrait of Vsevolod Meyerhold*, 1935. Oil on canvas. Private Collection

16. Ilya Glazunov: *Tsarevich Dmitri*, 1968. Oil and inlay. Private Collection

6
The Revolt against the Academy and the Growth of a Self-consciously Nationalist School

Before his accession Alexander II (1855–81) had seemed in every way as authoritarian and illiberal as his father had been; and during the last years of his father's reign had several times intervened to secure a stricter, less tolerant application of the law. But his advent to the throne in 1855 brought him face to face with the reality of government and consequently saw an astonishing change of policy. In 1856 he ended the Crimean War. A comparatively liberal atmosphere was created by allowing travel abroad, giving greater autonomy to the universities and ending the censorship, although from time to time without warning or excuse it would be reimposed. Newspapers and specialist journals of all kinds were published; and there developed in clubs, universities and private houses that passion for critical debate which was to become a marked feature of Russian intellectual life in the second half of the century. Alexander faced the problem of serfdom which his predecessors had too long disregarded and in the face of great opposition from gentry, aristocracy and middle-class landowners forced through the emancipation of the serfs by a decree dated 3 March 1861. At heart Alexander seems dimly to have perceived the need for still further reform without having the ability or courage to take effective measures. In 1881 he was killed by a bomb thrown by young terrorists who despaired of the intellectual and political paralysis which had grasped their country.

Alexander's reign saw a decisive change in the history of the Russian people. Hitherto developments in thought and culture had affected only a small section of the population. After the emancipation of the serfs and the conquest and colonization of vast stretches of the Empire millions of peasants were obliged to submit themselves to squalid urbanization and heartless industrialization. The growth of railways and the opening up of the

Pacific Ocean and Black Sea as outlets for oceanic trade brought still further widespread involvement in Western ways of life and work which had little connection with those which had held sway in the Russian countryside for centuries. These processes were intensified by Russia's defeat in the Crimean War which left a legacy of national bitterness; there followed something of an inquest with the ruefully returned verdict that Russia's defeat was largely due to her anachronistic and retarded social system.

Since it was clear that there was no single solution to Russia's problems, a number of disturbing ideologies were born, of which the most central, original and important was that which Turgenev investigated in his novel *Father and Sons* (1862) and personified in his hero Bazarov, who rejected all aesthetic, moral and religious convictions, declaring that 'two and two is four and everything else is rubbish'. Turgenev used the term 'Nihilism' to describe this new ideology which horrified conservative Russians. Prose replaced poetry as the vehicle of literary expression and there was a sudden fervour for meticulously presented scenes from everyday life, particularly those which embodied a moral or social dilemma. A decade of strident insistence on the social responsibility of the arts – from Chernyshevsky's doctoral thesis *Aesthetic Relations of Art to Reality* (1855) to Pisarev's *Destruction of Aesthetics* (1865) – resulted in the creation of a self-consciously social and reformist movement called Populism to which educated young Russians were attracted. As a result between 1859 and 1862 there was a tremendous fashion for students to work in the countryside and to teach in Sunday schools where peasants received elementary education; and by 1871–3 the movement had begun to direct itself at the urban workers, especially those in St Petersburg. An extraordinary, near hysterical climax was reached in 1874 when thousands of students and

idealists set out from the cities to preach in the countryside a doctrine of social progress and self-renunciation for the common good. Perplexed and annoyed, Alexander's government reacted by arresting some 4,000 people, a typically thoughtless gesture which served only to embitter the followers of the Populist movement.

As for the art of these decades, closely linked as it was to Populism, it was bound to be unwieldy since it attempted to combine (and present in literary or pictorial form) a growing respect for the traditional values of peasant life, a relentless determination to see things as they really were and a passionate desire to reform social and political life. These apparently incompatible aims were reflected in the works of the period – in the vivid reality of Tolstoy's novels no less than in the muddled moralism of his religious tracts – and were to result in mental illness for a number of artists and writers. The painting of the second half of the century moves slowly from realism to historicism (which held within itself Pan-Slavism and nationalism), from moral agonizings to religious perplexity and disbelief, and finally to a kind of mystical and erotic hysteria. Much of this is clearly demonstrated in the work of the *peredvizhniki* ('Members of the Society for Travelling Exhibitions', also known as 'The Wanderers' or 'The Itinerants'), the movement which eventually came into being as the result of a clash within the Academy of Arts.[1]

To some extent the Academy had already liberalized itself by abolishing the system under which its students were obliged to lodge and study within the actual building under conditions involving the most rigid discipline. From 1840 they had been free to live wherever they pleased (at the state's expense) and were required to attend a minimal number of compulsory classes. The establishment in Moscow in 1843 of the School of Painting, Sculpture and Architecture already referred to in connection with Venetsianov's students further weakened the prestige of the Academy, which remained essentially an eighteenth-century institution with syllabuses and methods of teaching which had evolved side by side with neo-classicism.[2] A trifling incident served to spark off a revolt. On 9 November 1863 14 students, candidates for the Gold Medal (which, incidentally, would have entitled them to a bursary to travel abroad), refused to accept the title set for the examination piece 'The Entry of Wotan into Valhalla'.[3] Since the jury would not change this Germanic subject for one which was both Russian and

contemporary the students walked out *en masse*. The censorship intervened to forbid any discussion in the press, but news of the action soon spread and the dissidents were acclaimed as heroes. They realized that any strength they possessed lay in unity and thus formed a working community, an *artelchik* in which they lived together and shared commissions among themselves. By November 1870, under the guidance of the painter Grigory Grigorievich Myasoedov (1834–1911), their aims had further clarified: they had decided to take art to the people by means of Travelling Exhibitions. They gathered young and progressive artists around them for this purpose, and were able to exercise a comparatively unchallenged Populist influence on Russian painting until the 1890s, although the Society lasted in name until 1922. It is ironic to note that had these students entered the class of genre works instead of the traditional and prestigious historical area they could have tackled a new theme, 'The Liberation of the Serfs', which was entirely appropriate to their democratic sympathies. The Academy was not altogether inattentive to prevailing social trends.

Several initial comments must be made about the *peredvizhniki*. In the first place it is important to note that they originally revolted against the choice of subject-matter, technique having only minor value for them. After mastering traditional European techniques these artists were not prepared to surrender them in quest of esoteric experiments with light and colour as were the Impressionists in France whom, in any case, they tended to ignore until the last decade of the century. In fact, most of them trained at the Academy under P. V. Basin, M. I. Scotti (1814–61) and the most important teacher of the period P. P. Chistyakov (1832–1919); and many of them were to end up as professors either in Moscow or St Petersburg. They were influenced by Rome and Munich, for the predominant and noblest example for them was that of Ivanov and, indirectly, that of the Nazarenes whose community spirit made a strong appeal to the Populists. But unlike the Nazarenes who (in the first flush of enthusiasm at any rate) had chosen a monastic life of prayer, religious observance and earnest labour, the *peredvizhniki* had a comparatively unsophisticated and simple ideal – that of taking art to the people. Hitherto painting had been concentrated in St Petersburg where it had catered to the tastes, almost wholly decorative, of the aristocracy and the wealthier classes; now it was intended that not only

Moscow – which had been unjustly neglected – but the new industrial cities, indeed the whole of the country, should enjoy pictures directed by and infused with entirely new aims from those pretended by the Academy. Quite how the Russian masses would be able to buy these paintings and thus afford the artists a living seems to have been a matter below their consideration. In fact, the *peredvizhniki* were following the major tendency in European painting in the second half of the century, the taste for narrative and problem pictures carried out with finical, not to say excessive attention to realistic detail.

However, unlike painters in the West, behind the *peredvizhniki*, as has already been indicated, lay a formidable bulwark of ideology. From about 1879 students were possessed by the idea of serving the peasantry. Partly motivated by the *Historical Letters* of Colonel Lavrov, a moralist who preached that the world would be changed by education and persuasion, partly by Mikhail Bakunin who, writing from exile in Switzerland in 1868, urged students in his *Cause of the People* to raise revolts in villages, and partly by Nikolai Tchaikovsky who pressed intellectuals to dress like peasants and to take up the most menial work in the countryside, by which means they would be able to circulate seditious ideas and literature, many young artists joined in the spirit of the movement. The ostensible aim was the education and elevation of the ordinary people. The philosophical background was supplied, as has been noted, by Chernyshevsky's *Aesthetic Relations of Art to Reality* in which he claimed that the greatest beauty was that met by men in daily life and not the beauty created by artistic effort. Since works of art were tedious and paled before reality itself, it was logical that the role of art should be to copy reality as closely as possible without attempting to interpret it. Moreover, art had no value in itself but only as an agent in the service of social progress, its merit lying in its power to aid the economic, social and intellectual emancipation of the masses.

Chernyshevsky's later teaching (and his notoriously bad novel *What is to be done?*, published in 1863) propagated the idea of co-operatives in which students, intellectuals and workers would participate for their mutual good. There was no shortage of material dealing with the relationships of art and morality and social progress – the writings of Proudhon and Robert Owen were known in Russia – but there is no evidence that they were studied by the *peredvizhniki* who were extraordin-

arily provincial and limited in their intellectual outlook. Their social awareness was of a general nature.

Most important was the continuous criticism and guidance of Vladimir Vasilievich Stasov (1824–1906) who had turned from a study of law to become Head of the Art Division of the St Petersburg Public Library. From this fairly safe position he was able to inform himself about the state of the arts in Russia, particularly painting and music, although his interests included architecture, sculpture and literature. He travelled widely in Europe on many occasions (in 1883 with Repin), attended numerous exhibitions abroad and represented Russia at European scientific congresses. He was unceasing in his efforts to bring together Russian creative artists and to keep them on the paths of realism and nationalism which he believed were in no sense divergent. In this sense he continued the work of Chernyshevsky. However, he also attacked the Academy, denouncing its innate, stifling conservatism which he saw as most truly manifested in its classicism, and encouraged revolts such as that which had led in 1863 to the organization of an artists' *artel* and ultimately, on 2 November 1870, to the establishment of the *peredvizhnik* movement. For half a century he promoted the idea of a truly national art form which had as its principal aim the creation of art for man's sake. It was logical, therefore, that the artists who fell under his proselytizing spirit should have depicted the abuses of government, the corruption of the aristocracy and the drunkenness of priests, workers and nobility alike.

The *peredvizhniki* never achieved all their aims, as we shall see. Immensely as they valued the encouragement of Stasov (who occasionally arranged the purchase of their pictures), they were obliged to seek commissions in order to live. From the first they had to compromise, for they were supported by the patronage of the new class of industrialists such as Kozma Terentievich Soldatenkov (1818–1901), Savva Ivanovich Mamontov (1841–1918) and Pavel Mikhailovich Tretyakov (1832–98) whose basic interests in the destruction of the old feudal and agricultural systems were directly linked with the bringing into being of a large and unattached urban labour force to serve their industrial enterprises, both aspects being diametrically opposed to the earnest aims of the *peredvizhniki*. Nevertheless, Tretyakov was generous in his purchases of works by contemporary Russian artists and undoubtedly stimulated the growth of a national school. It was

his ambition to leave a gallery which would show to future ages the variety and strength of the arts of his day.

Stasov had declared, it will be remembered, that the first gleam of a new orientation in art came with the work of Fedotov, whose sly and restrained satire opened the door for more direct social criticism, especially after the accession of Alexander II had brought with it the hope of greater political freedom.[4] Several artists were quick to grasp this chance, among them Vasily Grigorievich Perov (1833–82), who had, in a sense, been born into political strife since his father, Baron G. K. Kreudener, had been exiled to Siberia. In the fervour of his political activities the Baron neglected the formality of marriage, so that his son was nameless until he received the nickname of Perov.[5] He studied at Arzamas, some four hundred miles east of Moscow,

at the school of art founded there by Academician A. V. Stupin in 1800, and after two years left for the Moscow School where he studied from 1853 under Scotti and two former pupils of Venetsianov, Mokritsky and Zaryanko.

Perov began exhibiting in 1858 with his *The Arrival of the Police Officer* and *The Newly Appointed Registrar of the Board*, both directed against corrupt officialdom – heartless and merciless oppressors of the peasantry. In 1861 his *The Village Sermon* (which showed the local landowner sleeping in his pew while his wife carried on a flirtation) and *The Village Easter Procession* (which showed drunken priests staggering out of a village tavern) were withdrawn from exhibition at the instigation of the ecclesiastical authorities and any reproduction of them was forbidden (Plate 65; Col. Plate 6). His *riposte* came the following year with a moving picture in which a priest sits outside an inn, apparently drinking tea, indifferent to two mute beggars, a crippled father and child. Perov was, thus, the successor of Fedotov and the forerunner of the *peredvizhniki*. His days as a social critic came to

65. Vasily Grigorievich Perov: *The Village Easter Procession*, 1861. Oil on canvas, 71.5 × 89 cm. Moscow, Tretyakov Gallery

an end in 1862 when he was awarded a travelling scholarship by the Academy and went to Germany and France where he studied the work of Meissonier and Courbet. Under these two disparate influences he painted picturesque scenes of Parisian life, particularly concentrating on the streets with their beggars and workmen. Unlike preceding artists whose greatest joy it had been to escape to Europe, Perov was homesick and pleaded to be allowed to renounce his scholarship and return home:

> To my mind, rather than devote several years of my life to the study of a foreign country, it would be far more worth while to exploit the inappreciable treasury of subjects presented by the urban and village life of our country. I have in mind a few subjects drawn from Russian life and I hope to have more success with these than with subjects from a people I hardly know.[6]

When he came home in 1864 he found the social and intellectual repression had intensified rather than decreased and that there was no place for a 'few subjects drawn from Russian life'. He abandoned his meticulous and painstaking style and affected a broader, sweeping brushwork. A melancholy which seems associated with the reformist spirit of the time crept into his work from about 1865 as is testified by *Accompanying the Dead* (1865), *The Arrival of the Governess* (1866), *Aged Parents at their Son's Grave* (1867) and the numerous versions of *The Drowned Woman*. In order to become an Academician he produced several large historical works. Towards the end of his career he taught at the Moscow School. In 1870 he formally joined the *peredvizhniki* but withdrew in 1877, a few years before his death.

It is easy to ridicule Perov's works for their frankly anecdotal content; and he certainly has affinities with the genre and narrative painters whose products were popular all over Europe at that period. A few of his comic scenes do not rise above the level of vulgar postcards. But he was the first Russian painter of note to represent scenes of peasant life in a realistic manner devoid of the elegiac simplification of Venetsianov; and his youthful satire was bitterer than that of Fedotov – as the Orthodox church, his principal target, recognized. He learnt little in the West, but from Courbet he may have acquired the ability (which could never have been taught by Meissonier who so sadly lacked it) to simplify a situation so that the pictorial elements spoke directly for themselves. *Accompany-*

ing the Dead and *The Last Inn at the Toll Bridge* (Plate 66), which demonstrate this development in his art, convey the weariness, the tedium, the isolation and the sadness of peasant life, underlined by the introduction of snow-filled horizons, vast expanses of empty landscape and poor, anonymous humans driven to suicide, to labour in hostile environments, to exist in poverty and despair, or to combat the cruel forces of nature in frost-bound fields. It is this particular achievement which enables us to speak of Perov as the painter who leads naturally from Venetsianov to Fedotov and through his own art to the avowedly critical *peredvizhniki* whom he anticipates. If he is an artist whose pictures still speak to us in pathetic accents of the short and simple annals of the poor, he is also the painter who produced a gallery of portraits of his distinguished contemporaries, Turgenev (1871), Ostrovsky (1871) and Dostoevsky (1872) among them, showing he had a recognized place in the intellectual society of the seventies. An uneven artist, Perov veers from a photographic realism to sentimental anecdotalism but at his best is the creator of pictures where fussy detail gives way to a symbolism which catches at the heart and still moves us today.

The actual founder of the *peredvizhniki* was Grigory Grigorievich Myasoedov, who graduated from the Academy of Arts where he had specialized in history painting and went to study in Europe from 1863 to 1869. On his return he set about forming an association which would tour exhibitions of paintings of a populist kind around Russia; and by enlisting Kramskoy and other dissidents managed to form an active society. His best-known work, *Reading the Declaration of the Abolition of Serfdom* (1873), had some slight commemorative value, but his radicalism was extremely short-lived. In common with a number of his associates he turned his back on critical realism and embarked on a series of works extolling the joys of agricultural labour under benevolent landowners. Before long he settled down to an undistinguished career as a teacher, crowned in 1893 by his appointment as a professor at the Academy.

The undisputed leader of the group was Ivan Nikolaevich Kramskoy (1837–87), who while not a great artist had gifts of another kind. He had a natural authority, knowing how to listen and to pacify, rare gifts among the artists of this period whose tendency lay towards intellectual and spiritual anarchy – a tendency that, unfortunately, did

66. Vasily Grigorievich Perov: *The Last Inn at the Toll Bridge*, 1868. Oil on canvas, 51.1 × 65.8 cm. Moscow, Tretyakov Gallery

not find a sufficiently creative outlet in their paintings. A friend and travelling companion of Stasov, he was primarily responsible for the ideological unity of the movement. From working as a retoucher in photographic studios in Kharkhov and St Petersburg he went to the Academy in 1857. In 1863 he was foremost among the dissidents. It was time, he proclaimed, that Russian artists stood upright on their own feet and cut off the foreign apron strings. Thanks be to God, Russian artists were grown men with beards on their chins! Why, then, should they always walk about holding the skirts of their Italian nursemaids? It was time to think of creating a Russian school! Elected chairman of the *artel* of painters, he succeeded in finding commissions for his friends and despite numerous

difficulties managed to hold together the original core of dissidents until they were transformed into the *peredvizhniki*. As an organizer he excelled, but was hardly fitted to create a new (and national) school of painting because his more obvious gifts lay in portraiture of a photographic realism which differed not a jot from that of his contemporaries in Western Europe. There are over 400 portraits in which he showed he could capture a likeness but this gift is not altogether compensated for by their dull backgrounds, drab finish and the limited sombre palette.

Appearances for their own sake could not satisfy Kramskoy and like others of his generation he moved from remorseless realism towards a brooding and mystical pathos. Earlier in his career he had produced religious works aimed at the general public, but when he saw Ivanov's *The Appearance of Christ to the People* he felt that his true vocation had been revealed to him: it became his mission to

create a Russian image of Christ. 'The Italian Christ is handsome, one may say divine,' he wrote in 1873, 'but he is alien to me.' He began work on his *Christ in the Wilderness* (Plate 67; Col. Plate 7), of which he declared, 'This is no Christ: it is the image of the sorrows of humanity which are known to all of us',[7] but the figure desolately crouched in a stony waste in the cold blue light of daybreak, finely painted as it is, hardly justifies the claim of universality, let alone claims to be the portrayal of a Russian Christ. For Kramskoy had no talent for flights of the imagination, but he could paint the ordinary working man with an affectionate and sympathetic strength (Plate 68). His achievement was the recording on canvas of

the identity of an age (begun by Perov with his excellent portraits of Dostoevsky, Borodin and other creative intellectuals), an era in which Russian novelists and musicians were creating a body of work which, although limited in quantity, was to prove a potent force in European culture. His portrait of Tolstoy (1873), for instance, is a revealing study of the young writer in whom the fires of passion and libertinage still strongly smouldered. Equally revealing – and a finer picture – is his portrait of Nekrasov (1877), which commands respect if not affectionate admiration. Towards the end of his short career he gave fuller expression to his melancholy nature in works like *Inconsolable Sorrow* (1884), which seems to harken back to Fedotov's *The Young Widow* and shows that like many Russian painters he had the gift of evoking quiet interiors and of utilizing a restrained stance or gesture for pathetic effect.[8] With a group of artists

67. Ivan Nikolaevich Kramskoy: *Christ in the Wilderness*, 1872. Oil on canvas, 180 × 210 cm. Moscow, Tretyakov Gallery

68. Ivan Nikolaevich Kramskoy: *The Miller*, 1873. Oil on canvas, 73.5 × 58 cm. Leningrad, Russian Museum

Kramskoy worked on decorations for the Cathedral of Christ the Saviour in Moscow. Visits to the West in 1869, 1876 and 1884 seem to have had no effect on his art. There can be no doubts as to Kramskoy's abilities; but his last works indicate that he was moving towards a new freedom and passing beyond the mediocre taste of his day.

At one time or other the *peredvizhniki* included within their ranks almost every Russian painter of note. A brief account must suffice to indicate the range of their work. Nikolai Vasilievich Nevrev (1830–1904) criticized serfdom in his *The Market* (1866) and, like Perov, satirized the church. During the seventies when Populism waned he retired from painting and it was not until vaguely historical scenes became fashionable in the next decade that he resumed work and became a full member of the *peredvizhniki*. Vasily Vladimirovich Pukirev (1832–90) trained at the Moscow School before going to the Academy, where his *The Unequal Marriage* (Plate 69) won him a professorship. Basically a nineteenth-century narrative painting which

might well have illustrated a scene from Dickens (who shared with the Russians a morbid interest in marriages between young girls and old men), the misery of the young bride is given added significance by the indifferent or calculating faces of the onlookers, the heavy gold vestments of the priest and the virginal whites and greens of the wedding dress on which a lighted candle throws an appropriately symbolic patch of red. *Studying an Icon at an Art-dealer's Shop* (1863) shows a rapid falling away in style and ability although the Daumier-like atmosphere and heavy use of paint indicate capacities which were never adequately utilized. An extremely limited output and an indifference to contemporary aesthetics render him of minor significance.

Ilarion Mikhailovich Pryanishnikov (1840–94) moved from a narrow preciseness to a looser, more colourful style, well fitted to capture aspects of peasant life as in *Boys on a Fence* (1883) and *A Religious Procession in a Village* (1893), this last a lively composition with forceful critical features. His *Peasants driving Home* (1872) has affinities with the work of Perov in its depiction of the mournful, snowbound wastes and the lonely, weary figures. Pryanishnikov became a teacher at the Moscow School where he was both popular and influential.

Konstantin Apollonovich Savitsky (1844–1905) trained at the Academy and accepted the customary grant to travel abroad. At the third exhibition arranged by the *peredvizhniki* in 1874 his *Repairing the Railway Track*, which drew attention to the plight of workers on the railways, was bought by the industrialist Tretyakov who gave Savitsky sufficient funds to return to France where he worked with Polenov and Repin who were there already. Compassion and a restrained satire fight for supremacy in *Meeting the Icon* (1878) and *Off to the War* (1880) which demonstrate his sympathy with the wretched conditions of the peasants and labourers. Struggling with these narrative canvases (and teaching in Moscow and the provinces), Savitsky produced comparatively few works.

Vasily Dmitrievich Polenov (1844–1927), a man of wide culture and learning, studied at the Academy under Chistyakov. With his friend Repin he went to study in France on the usual six years' scholarship but like so many of the Populists did not

69. Vasily Vladimirovich Pukirev: *The Unequal Marriage*, 1862. Oil on canvas, 173 × 136.4 cm. Moscow, Tretyakov Gallery

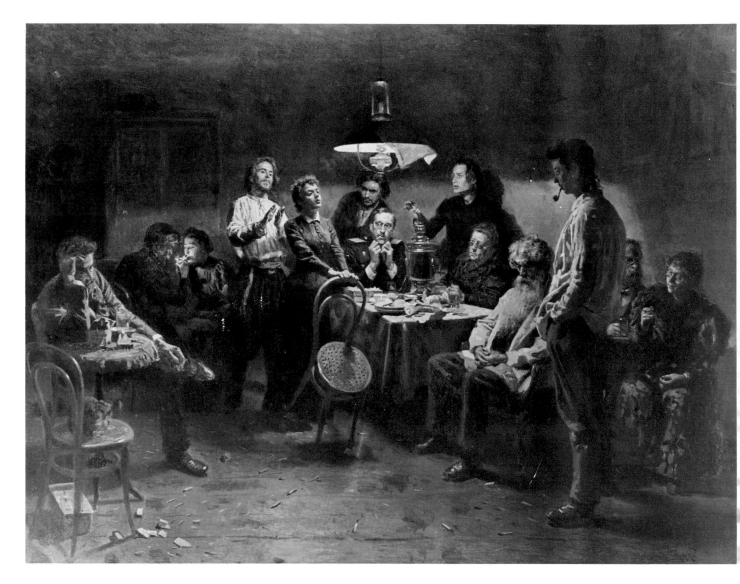

72. Vladimir Egorovich Makovsky: *A Social Evening*, 1875–98. Oil on canvas, 108.5 × 144 cm. Moscow, Tretyakov Gallery

Collapse of the Bank (1881) and *The Released Prisoner* (1882) he showed large airy rooms in which he cleverly assembled crowds of people. The calm of these works, possibly derived from Granet via Venetsianov, is broken in the 1890s by simpler, bolder (and melodramatic) anecdotes such as *You shall not go* (1892) in which a young wife flings herself before the door of a beershop which her husband is about to enter and *A Social Evening* (Plate 72) where a group of young men and women argue fiercely (presumably about politics) behind locked doors. Still later he painted the dreadful scene on Khodyn Field outside Moscow where

hundreds of people lost their lives during the coronation ceremonies of Nicholas II and, in 1905, he depicted the Tsarist troops firing at the peaceful demonstration headed by Father Gapon. Makovsky was the only member of the *peredvizhniki* to remain true to the Populist and reformist ideals of the 1860s. Although there are elements of French Impressionism to be seen in his last works, his unquestioning devotion to nineteenth-century narrative pictorialism is a trifle dismaying.

Makovsky's elder brother Konstantin (1839–1915), a pupil of Tropinin and Zaryanko, had been among the dissidents in 1863 and had joined the *artel* but became dissatisfied and left, although he later exhibited with the *peredvizhniki*. His *The Russian Bride's Attire* (Plate 73) and *Shrove-tide Fair in St Petersburg* (1896) are examples of his concern with traditional Russian life of a colourful

variety and demonstrate his command of large swirling groups of figures. He preferred an international career, living luxuriously in Paris, creating brilliant confections (under the influence of the Hungarian painters Zichy and Makart) and selling his work to European and American patrons.

Nikolai Alekseevich Kasatkin (1859–1930) must be counted among the last of the Populists, providing the link with Socialist Realism. A pupil of Savrasov, Perov and Pryanishnikov, he did not devote himself entirely to painting until 1890 when he began exhibiting with the *peredvizhniki*. He joined the Moscow School as a teacher in 1894, travelled to Italy in 1908 and as late as 1923 came to

England where he painted miners. This was an area of industrial life which had absorbed his interest for over thirty years since he first came to fame in 1895 with a series of pictures of miners in the Donets Basin (for which his drab colours and clumsy draughtsmanship were admirably suited). Earnest and industrious, Kasatkin commands respect for his determination to make of his limited artistic ability a weapon for social and industrial reform. Like so many of the *peredvizhniki* he seems to have believed that the pictorial presentation of an abuse, of miscarriages of justice, of wretched working and living conditions was a sufficient aim for his art and that considerations of technique or even of stylistic matters were irrelevant; and yet it is hard to argue away the validity of Kasatkin's stance.

Some of the aesthetic problems aroused by a consideration of the *peredvizhniki* are associated with the career of Ilya Efimovich Repin (1844–

73. Konstantin Egorovich Makovsky: *The Russian Bride's Attire*, 1889. Oil on canvas, 334 × 423.3 cm. San Francisco, M. H. De Young Memorial Museum

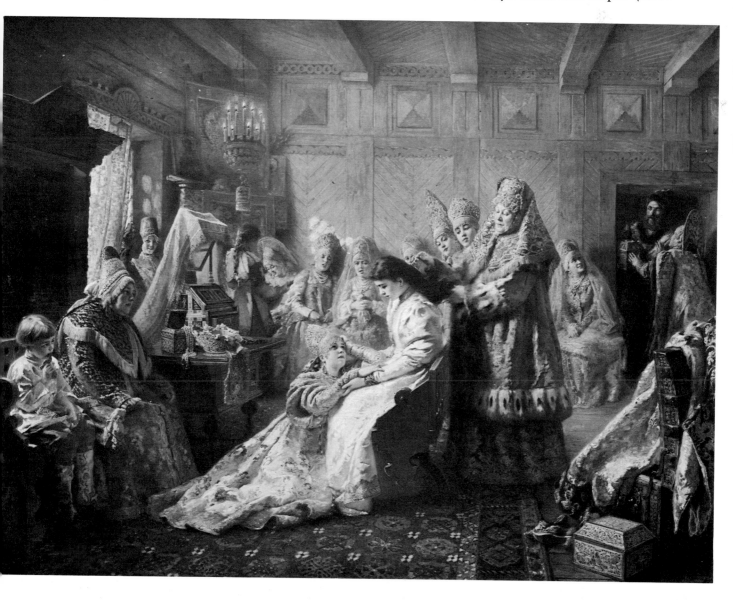

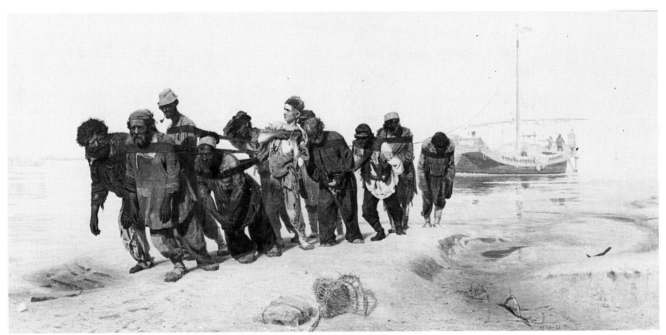

74. Ilya Efimovich Repin: *Barge-Haulers on the Volga*, 1870–3. Oil on canvas, 131 × 281 cm. Leningrad, Russian Museum

1930), the longest-lived and best-known member of the group.[11] Born of poor parents at Chuguev in the Ukraine, he began his studies with Bunakov, a local painter, and also worked in an icon workshop. He was 20 when he started formal training at the Society for the Encouragement of the Arts – a later age than was usual with Russian painters – and he then went to the Academy where he remained for some seven years – which, again, was somewhat unusual. His teachers were Bruni and Kramskoy, a rather odd combination in view of their careers but which possibly foreshadowed aspects of Repin's own career. The award of the Gold Medal and a travelling scholarship enabled him to visit Rome in 1873. He went on to France from where he visited London. Repin found nothing to admire in European painting – he had more than his fair share of arrogance – and was only too happy to return to Russia. As a student he had shown his brilliance with portraits, and with the large *Job and his Comforters* and *The Raising of Jairus' Daughter* (1871), both of them awarded medals; and won the title of Academician with *Sadko, the Novgorod Guest* (1876), actually painted in France, a vast fantasy which anticipates the horrors of the full-blown Art Nouveau. Towards the end of the 1880s he became friendly with Tolstoy whom he painted several times

as the ploughman-sage of Yasnaya Polyana. Indeed, Repin counted most of the creative artists in Russia among his friends, although it was the critic Stasov who yielded the greatest influence for over thirty years. Repin had built himself a house in the village of Kuokkala in Finland (then Russian territory); and it was there he retired in 1917, although his relations with the new Soviet government were cordial (he was aided financially), and he was visited by friends including Gorky whose career, like his own, had (comparatively speaking) been from rags to riches.

Repin had the good fortune early in his career to win instant fame in Russia and abroad with his memorable picture of *Barge-Haulers on the Volga* (Plate 74; Col. Plate 8), a study in human drudgery and degradation. Yet Repin's haulers are not without hope, as viewers noted, for among the team is a young lad who has defiantly lifted his eyes from the ground and who stares towards the Volga and the distant plains. Here was the pictorial call to action for which students and revolutionaries were waiting; and Repin's canvas (bought by the Grand Duke Vladimir Alexandrovich) became an icon of suffering Russia to which all thinking people responded. Without actually expressing Populist views, Repin placed himself at the forefront of the *peredvizhniki* and their vaguely reformist attitudes. The painting was admired by Dostoevsky and, less unexpectedly, by Stasov. A series of works demonstrated Repin's sense of the injustices then prevailing in his homeland. *The Procession of the Cross in Kursk Province*

(1880–3) depicts a crowd of villagers, marshalled by priests and brutally manhandled by mounted police, following a portable shrine down a hot and dusty country road, while the titles of *A Revolutionary awaiting Execution* (1880), *The Rejected Confession* (1882) and *The Arrest of the Propagandist* (1880–9) speak for themselves. But his most subtle and haunting work of this nature is *They did not*

expect him (1884), which exists in two versions, the second illustrating the moment when a revolutionary unexpectedly freed from exile is shown unannounced into his own home and faces the startled reactions of his mother, wife and children (Plate 75). Was Repin here asking whether Russia was prepared to accept the terrors of civil strife and revolution? Or was the picture an allegorical presentation of that Second Coming which played so important a part in Russian Messianism? What the picture reveals, technically speaking, is that he was capable of lightening his palette and of adopting the ap-

75. Ilya Efimovich Repin: *They did not expect him*, 1884–8. Oil on canvas, 160.5 × 167.5 cm. Moscow, Tretyakov Gallery

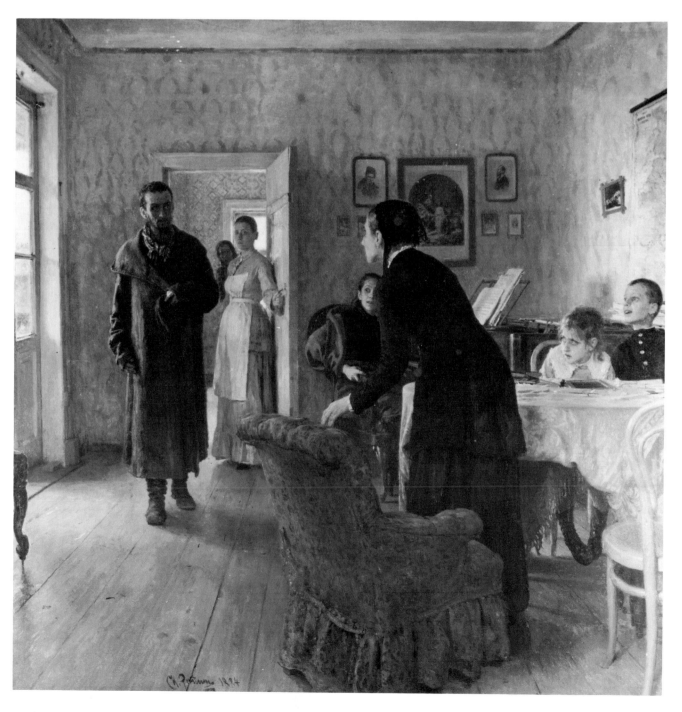

parently random nature of the photographic snapshot. This had already been apparent a year earlier in 1883 when, revisiting France in company with Stasov, he painted *The Gathering at the Wall of the Communards*, the commemoration of the brutal events which had taken place after the Paris uprising of 1871, displaying his skill in exploiting the brightness and clarity of Impressionism as well as the compositional methods of Degas and Manet. Much of this he seemed to reject when he moved his residence to Moscow, the capital of old Russia, and embarked on several historical works of which *The Tsar Ivan the Terrible with the Body of his Son, 16 November 1581*, shown at the thirteenth exhibition of the *peredvizhniki* in 1885, reveals a mastery of the anecdotal manner. This historical episode had significance for the radicals, for when Ivan IV murdered his own son he broke the sacred chain of descent from Byzantium which meant that the Romanovs could not claim to have been divinely chosen or appointed. The painting was banned from exhibition for three months on the orders of Alexander III.[12]

76. Ilya Efimovich Repin: *The Zaporozhian Cossacks writing a Reply to the Turkish Sultan*, 1880–91. Oil on canvas, 203 × 358 cm. Leningrad, Russian Museum

By the late 1870s Populism had lost much of its force and Repin began to turn to other subject-matter than social reform. Between 1886 and 1891 he worked on *The Zaporozhian Cossacks writing a Reply to the Turkish Sultan* (Plate 76; Col. Plate 9), a restless work crowded with portraits of the racial types of southern Russia in which he contrived to mingle social criticism (the Cossacks had once been as famous for their love of freedom as their regiments were now notorious for the savagery with which they put down demonstrations and riots on behalf of the Tsars), an assertion of his Ukrainian sympathies and an idealized picture of an exuberant and independent people communally defying their would-be oppressors. But for all its cheerful boisterousness it remains at core drearily empty: Repin was not a humorist. The religious aspects of the *peredvizhniki* (as well as his friendship with Tolstoy) are reflected in his inadequate *St Nicholas the Miracle-Worker saving the Lives of Three Innocent People* (1888), a picture which also had links with Orthodox mysticism and Russia's rediscovery of its medieval past. But Repin, so entirely a man of this earthly world, had no gift for the expression of religious mysticism.

By 1890 Repin saw that Populism had failed, that a spirit of violence had entered the reformist move-

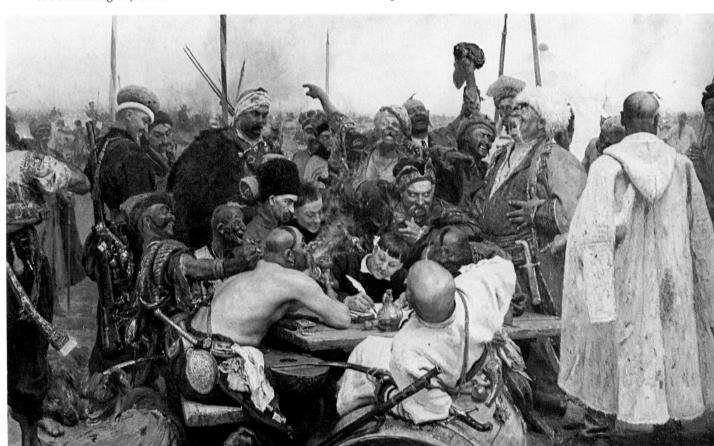

ments, that there was an increasing sense of despair and that, despite the fervent counsels of Stasov, the arts could not of themselves redeem his country. From the mid-seventies he had been drawn to the artistic circle associated with Savva Mamontov whose fortune had largely come from constructing railways. Mamontov maintained a splendid house in Moscow and also owned a small country estate nearby at Abramtsevo where he held open house during the summer months. Intensely dramatic and musical by nature, he arranged theatrical productions in his houses and in 1885 founded his own private opera company which gave the first performance of several important operas by Russian composers and where the settings and costumes were designed by leading artists. Repin was especially attracted by Mamontov's encouragement of research into old Russian arts and ways of life, which resulted in the building at Abramtsevo of a small church in the medieval Novgorod style. His *Selecting the Tsar's Bride* (1884) is representative of this phase in its rich colours and fresco-like style.

Repin was not, however, the man to link himself too closely with any one group or movement; and he began to turn increasingly to portraiture. His portrait of Mussorgsky in March 1881, a few days before the composer's death, has fixed for all time the image of a drink-sodden, irresponsible genius. *Surgeon V. V. Pavlov in the Operating Theatre* (1888) is a superb and restrained work in which he shows a mastery of whites and greys, probably his finest use of colour. His portraits of the much-painted Tolstoy created an icon of the novelist as a Russian patriarch, but he failed completely with the less ostentatious Turgenev. His sketches for the enormous *The Ceremonial Meeting of the State Council, 7 May 1901* leave no doubt as to his skill in quick but piercing characterization and occasional psychological insight.

In his own time Repin was compared with Velázquez and Hals; and it is true that nature had given him a tremendous skill and panache which link him with these artists. His fecundity, industry, skill and sheer cleverness in portraiture and the restless versatility of his other pictures are astounding. But that art had any other aims than depiction and narration escaped him; nor could he see that there is as deep a reality in technique and manner as in photographic realism. Neither the sermons of Stasov, sincere and well-meaning as they were, nor Kramskoy's belief in political reform had any effect on Repin's development – or lack of development

– as a painter. He did, it is true, borrow from Impressionism; but in outlook he remained narrowly chauvinistic. On one occasion he wrote:

> The 'Jockeys' of Degas that are sold for 40,000 are at the most worth 400 roubles. On the other hand one can buy works by Meissonier and Fortuny far below their value. If one introduced a nymph by Kneff unknown into a picture by Puvis de Chavannes you would burst with enthusiasm; if the picture *Ivan the Terrible* by Plakhanov had been signed by Delacroix you would have praised it to the skies; if with his yellows and lilacs Monet had once managed to obtain the effect of Aivazovsky's *Deluge*, you would have hoisted it like a flag. Perhaps you will believe that I am the sworn enemy of all new tendencies in art. Nothing of the sort! I have an infinite admiration for all original talent and in the present decadence there are some shining pearls like Böcklin, Stuck and Klimt.[13]

What the letter reveals is the innate academicism of Repin in painting and his detestation of the French school; and his preference for Böcklin, Stuck and Klimt (who make extremely odd bedfellows in the context of his letter) against such artists as Monet and Degas and Delacroix – none of the Post-Impressionists meriting a mention. In fact, Repin was not a thinker; and his work is rarely free of a fussy insensitive vulgarity. Worse still, it seems completely lacking in any kind of consideration as to the true nature of painting, its purpose or its aims – although, it is true, he gradually introduced into his work the technical advances of the West and, in particular, those of Paris – in itself something revolutionary, for hitherto Munich and Rome had been the Mecca and Medina of Russian painters. It is also true that Repin had considerable success in weaning his contemporaries away from the drab palette of early Populism; but, in general, he was content to paint whatever he saw before him or to put on canvas the most effective and startling dramatic tableau he could devise. The fact that he rarely painted a landscape – although he certainly had the ability to do so – may indicate a distaste for solitary work and a dislike of the unpeopled vistas of the countryside. If, in the last resort, one cannot give him the highest praise it is because while his overflowing energy, vitality, industry and fertility intimidate and overawe the spectator he seems fundamentally shallow, even heartless. In art he was essentially conservative; emotionally he was superficial. A fiercely bold and undaunted painter, to whom a brush was a weapon to be used in the

conquest of the canvas, he never set out on a voyage on which his powers could be sufficiently tested, preferring to stay at home with an admiring public which adored his conjuring tricks with brushes, paints and canvas. Exploration meant nothing to him. Superficially he seems to exemplify the spirit of the *peredvizhniki* yet he lacks their fundamental earnestness, the seriousness which distinguishes their work as much as it often deadens it. He seems to have sensed that he was of an earlier period in Russian painting. He may be classified as the last of the great painters from the Academy, the direct but lesser successor of Bryullov. Yet – despite all these reservations – and if his paintings too often show a brash vulgarity and a dull complacency – these are minor considerations set against the magnitude and extent of his total achievement.[14]

It would be quite false to give the impression that the *peredvizhniki* devoted their talents wholly to social reform, for, rather surprisingly, they were also concerned with painting religious and historical scenes – sometimes the two elements were mixed in the same work. There was, too, an interest in landscape, which would seem to be an area devoid of political or social consciousness – but apologists for the *peredvizhniki* are quick to claim that even when there is no representation of humans one always feels that mankind is near.

As a generalization, one might say that religious painting in the traditional sense had ceased with Peter the Great. The descendants of the icon painters of previous centuries cheerfully forfeited the gifts of Byzantium. Many painters, among them Borovikovsky, Bryullov and Bruni, had worked in the new churches and cathedrals, but in a hybrid style derived from the Renaissance and baroque works in the Imperial collections or the many engravings which found their way to Russia, or from their study abroad, although religious art which savoured of Roman Catholicism was nowhere welcome in Russia. It was only towards the end of the nineteenth century, especially with the revival of interest in Moscow and the ancient cities of Russia, that artists came once more under the old and faded enchantments of Byzantium and remembered the traditions that marked their country as the true seat of latter-day Christianity. Several of the most gifted artists tried in different and individual ways to create a specifically national form of religious art, a quest which had, indirectly, been begun by Ivanov, whose influence was felt by almost every painter in the second half of the century.

Nikolai Nikolaevich Ge (1831–94), grandson of a Frenchman who had settled in Russia at the time of the Revolution, was to become famous for his representations of Christ.[15] Initially he was torn between the study of mathematics (at the universities of Kiev and St Petersburg) and painting at the Academy under the neo-classicist Basin, but the award of the Gold Medal and the customary travelling scholarship dispelled his doubts. He travelled and painted in Italy before settling in Florence where, apart from a brief visit home, he lived until 1869. Although he painted a number of landscapes, he had begun to turn to religious art. Impressed by the earnestness of Ivanov's aims, he submitted to his influence and followed his example by studying the most advanced literature, such as the books of Strauss and Renan, on the life of Christ. A founder member of the *peredvizhniki*, in 1871 he showed his realistic costume piece *Peter the Great interrogating the Tsarevich Aleksei* which served to introduce the fashion for this new style of history painting. In 1876 he retired to a farm in his native Ukraine where he continued his philosophical and religious meditations, ultimately accepting (with some degree of fervour) the teaching of Tolstoy that formal beauty was incompatible with spiritual truth, a conclusion which, happily, was not reflected in his work.

During his years at the Academy he had painted several creditable portraits; and in Italy he made sketches and studies in the style of Veronese and Tintoretto for his neo-classical *The Death of Virginia* (1857–8), which he never finished to his satisfaction. He painted some delightfully fresh impressions of the coastline between Leghorn and La Spezia, a region frequented by Ivanov before him. Much of his time and energy went into a series of episodes from the life of Christ, of which the first result was *The Last Supper* (1863), a painting which horrified St Petersburg by its exaggerated chiaroscuro and departure from iconographical traditions, despite the fact that there was little that could not have been found in Caravaggio or Rembrandt. The painting won him a professorship at the Academy. Betwen 1869 and 1880 he laboured on large canvases detailing the last hours of Christ on earth (Plate 77). *What is Truth?* (1890), in which Christ and an imperious Pilate face one another, is a theatrically lit composition which does not entirely convince the spectator. *Judas* (1891) is seen as a solitary figure wandering aimlessly through the night beneath a ghostly moon, a figure devoured by

remorse. This work illustrates the dramatic, almost hallucinatory elements which are rarely absent from his religious paintings. An agonized Christ who clutches his head as he awaits the dreadful preparations for his crucifixion is the subject of *Golgotha* (Plate 78). Here Ge embodies his friend Tolstoy's belief in the spiritual beauty of the New Testament and purposely emphasizes the outward ugliness of Christ in his sufferings as well as the horrifying surroundings – this painting, which still makes a tremendous impact, was banned by the ecclesiastical authorities. Tolstoy was moved to tears by *The Crucifixion* (1891), in which Christ is seen as a tortured slave, a persecuted serf, a suffering peasant

(for Ge also claimed to have created a Russian Christ), tied to a low cross at the side of a thief who is howling in the anguish of his tormented limbs. In yet more nightmarish versions Christ has slipped through the bonds which hold him to the cross and is distended in positions of unspeakable agony; while his eyes, blinded by a pitiless sun, seem to search the indifferent heavens for succour and relief. In these heart-rending scenes with truly Russian directness and truly Russian ruthlessness, Ge puts aside artistic considerations and, burning with hysterical passion and religious intensity, strives to paint what he considers to be 'truth'.

Ge's portraits of Nekrasov (1872) and Tolstoy (1884) are well known, and demonstrate his gradual adoption of a lighter palette and an increasingly vigorous and direct style. His portraits are devoid of cheap emphasis and triviality of any kind. An aspect of his adherence to Populism is revealed by his

77. Nikolai Nikolaevich Ge: Preliminary sketch for *Christ and His Disciples leaving for Gethsemane after the Last Supper*, 1888. Oil on canvas, 65.3 × 85 cm. Moscow, Tretyakov Gallery

historical pictures, among them *Catherine II at the Bier of Elizabeth* (1873) and *Pushkin at Mikhailovskoe* (*c.*1875), which are, unfortunately, no more distinguished (and no less popular) than the waxwork historicism of their European counterparts such as *When did you last see your Father?* and *The Princes in the Tower.* But it should be remembered that historical painting of this kind was comparatively new to Russian artists and that Ge was living in a period of national self-consciousness and heart-searching, when the achievements of Peter the Great and Catherine II were being questioned and the two great rulers were being accused of having led Russia from her Slav and Orthodox destiny and delivered her into the hands of the decadent West.

The indebtedness of Ge to Ivanov has ready been mentioned; and both artists were unique in creating for themselves an iconographical vocabulary with which to express their religious feelings and visions, although Ivanov found watercolour the most effective medium for his immediate inspiration whereas Ge confined himself to oils. Yet towards the end of

78. Nikolai Nikolaevich Ge: *Golgotha, c.*1892. Oil on canvas, 222.4 × 191.8 cm. Moscow, Tretyakov Gallery

his life (he also worked in sculpture and engraving) he found the laboriousness of oil painting inadequate to express the flow and strength of his emotions and abandoned attempts at an illusionistic technique: it was enough to place some streaks of paint, some fevered brushstrokes and a few scratches on a bare, untinted canvas. His simple compositions, raw colours and exaggerated lighting (or lack of it) challenged previous concepts of religious art. In these ways, Ge shows himself to be the first and only Russian expressionist of his day; he embodies on canvas the religious fervour and unbridled hysteria of which Dostoevsky was a literary master. Ge's painterly qualities and his spiritual nobility also distinguish his portraits which are among the best of the second half of the century. It is impossible not to admire the earnestness and deep seriousness which link him as man and artist with his great literary peers and establish him as the true and only successor of Aleksandr Ivanov.

In his account of Russian painting Alexandre Benois remarked how easily the Populists passed from realism to history painting – history painting which was anecdotal and, in its intimacy of approach, near to genre:

> One of the peculiar traits of Russian Realism was that the boldest and most resolute followers of an art based on the study of the surrounding world very willingly abandoned this reality and turned to history, that is to a domain where the immediate connection with actuality is, naturally, lost.[16]

By 1881, which year saw the deaths of Mussorgsky and Dostoevsky, historical painting moved toward a form of Slavic mysticism in which the age most frequently evoked was that of late Muscovy, a time apparently similar in its spiritual crisis and social upheavals. The background to this renewed interest in history painting was complicated.

For many years, in fact ever since the Napoleonic invasion had aroused a national consciousness, Russia had experienced a conflict between those thinkers who wished to proceed with its Westernization and those who looked for another separate identity in which the Orthodox Church and the Slav past would play a dominant part. In 1836 there was published a letter by Chaadaev in which he drew a picture of his country's moral plight, stressing that she belonged neither to the West nor the East, and in which he stated his belief that she must turn to union with the great body of European civilization, but must eventually and inevitably, in the cause of

Christianity of which she was the great and divinely destined protagonist, overleap the materialistic West. This document served to initiate the debate between the opposing factions of Slavophiles and Westernizers. Encouraged by Alexander II and his government, the Slavophiles believed that Russia had an ancient culture of her own which she should share with all the Slav peoples. Those Russians who sought the unity of all the Slav people under the hegemony of Russia – the Pan-Slavists – shared this belief in the distinctive greatness of their country's culture. Both Slavophiles and Pan-Slavists turned to the ancient city of Moscow and rejected St Petersburg, even expressing an actual hatred of Peter's creation. There now burst out a rivalry between the two cities. About 1860 Ivan Aksakov wrote to Dostoevsky (who shared his mystical Pan-Slavist convictions) that the first condition necessary to revive national consciousness was to detest St Petersburg and to spit in its face. Behind much of this emotion lay the whole force of European romanticism in which glorification of the national past played a cardinal role. The formation of archaeological and historical societies in Russia in the latter half of the century intensified interest in the past and resulted in painters and musicians turning to subjects of historical and national concern, frequently historical episodes in which there was some attempt at pictorial accuracy.

The artist whose work is most representative of these trends is Vasily Ivanovich Surikov (1848–1916), who was born in Krasnoyarsk, Siberia, of a Cossack family.[17] After many difficulties he obtained a place at the Academy where he studied under Chistyakov and gained the Gold Medal in 1875. From 1875 he lived in Moscow. He travelled widely in Siberia; and between 1883 and 1910 visited a number of European countries, including Spain which became increasingly popular with Russian painters. In 1881 he joined the *peredvizhniki*. Early in his career he was commissioned to paint frescoes for the Cathedral of the Saviour in Moscow; but his interest in early Russian painting took second place to an investigation of the Venetian masters, Veronese in particular, in order to learn the secrets of their palette and techniques. He was also inspired by Ivanov who became the greatest influence of his life.

Surikov's *Morning of the Execution of the Streltsy* (Plate 79; Col. Plate 10) was first exhibited in St Petersburg in the ninth *peredvizhniki* exhibition on 1 March 1881, the very day on which Alexander II was assassinated. It was singularly prophetic of the executions which followed that event. Dawn is breaking in Red Square, Moscow; on the right are the Kremlin walls, on the left the many-coloured domes of St Basil's Cathedral. Carried in peasant carts, holding candles which flicker in the cold, grey morning light, bound and destined for the gallows in front of which looms the impassive and implacable figure of Peter the Great mounted on horseback, are the leaders of the Streltsy who had rebelled against him. The crowd weeps and comforts the men, one of whom flings a look of hatred and defiance at Peter. The curiously horizontal composition, the strangely muted chromatics and the sparse, dry brushwork were widely acclaimed: it was clear that at last Russia had a history painter of some genius, more than comparable with Delaroche, Menzel, Matejko, Viktor Madarász and Louis Gallet – to name a few of the history painters whose works were admired there. Surikov's next work, however, was a lesser achievement: he attempted to emulate Ge's *Peter the Great interrogating the Tsarevich Aleksei* (1871) with his *Menshikov in Berezov* (1883), which shows Peter's former favourite in exile in Siberia, living in a comfortless, icebound hut, attended by his son and two daughters who have the air, most unfortunately, of unhappy Victorian misses dominated by a stern papa. When exhibited the picture was a great success. The artist Nesterov recorded in his memoirs that all the young painters greeted this canvas with enormous enthusiasm and went into ecstasies before its divine tonality and prodigious colouring 'sonorous as precious metals'.[18] Of all the dramas to be created by Surikov, his contemporaries felt that *Menshikov in Berezov* was the most Shakespearian because of its theme of unpredictable human destiny. The characters, the drama of their lives, the clarity and sensitivity of the composition and the terrible despair of Menshikov subjugated all the spectators. The merits of the painting as we see it today are not commensurate with the rhapsodies of his contemporaries and it was clearly a *point d'appui* both for the emotions of the Slavophiles and for the young painters who were revolting against the deadly monochrome and excessive detail of previous history paintings. Surikov had found a subject and a manner which seemed to his contemporaries to be essentially Russian. Their belief was confirmed by his next major work *The Boyarina Morozova* (1887) which had a double source of inspiration: he had read a novel *The Great Schism* about an Old Believer who, rather than abjure her

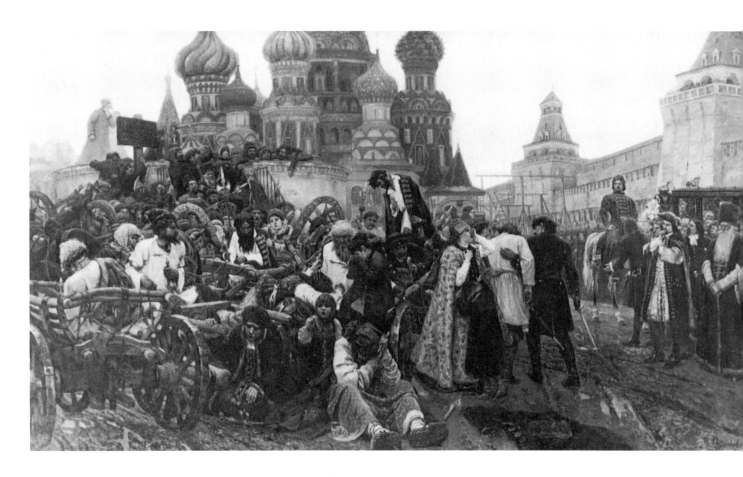

79. Vasily Ivanovich Surikov: *Morning of the Execution of the Streltsy*, 1881. Oil on canvas, 218 × 379 cm. Moscow, Tretyakov Gallery

faith, was dragged off to punishment, resting on a crude, straw-bestrewn peasant sledge, her pallid face livid with fanaticism, her hand raised in a gesture of prophecy to the crowd whose attitudes show despair, pity and fear; and, in addition, he had seen a black crow alighting on the winter snow, which suggested to him the central figure of the boyarina (Plate 80). Surikov used as the setting for his drama old Moscow and its snow-filled skies, employing the curiously muted colours of which he was so fond – blues, whites and purples like the tints of faded enamels.[19]

Surikov's career was interrupted when he returned to his native Siberia after the death of his wife in an attempt to solace himself. Work was resumed with an untypical *Christ healing the Blind Man*. In 1891 a return to national themes was celebrated with a joyful scene of winter games, *The Taking of the Snow-Town*. The 400th anniversary of the conquest of trans-Urals was recorded in *The*

Conquest of Siberia by Ermak (1895), which shows the crowded boats of the Cossacks attempting to cross the cold waters of the Irtysh in the face of the Tatar hordes gathered along the banks and nearby ridges. This was followed by *Suvorov crossing the Alps* (1899), his evocation of the Napoleonic period, a silly work in which the troops slithering about the Alps seem likely to descend in a clumsy heap at the spectator's feet. In 1907 came his last major work, which pictured Stenka Razin in pensive mood listening to music while being rowed on the Volga by his Cossack henchmen. Surikov also painted portraits and watercolour sketches as well as landscapes, for which the backgrounds of his historical scenes indicate he had a true gift.

Despite minor failings in historical accuracy Surikov was an artist of great visual power who brought historical painting out of the dismal depths into which it had fallen during the seventies. He travelled incessantly in search of exact local colour and prepared his large works by making vast numbers of sketches and studies, in which he followed the example of his admired Ivanov. He was also aware of history painting elsewhere in Europe, as has been noted, and the influence of a number of

painters, not least the Czech Yaroslav Chermak, can be detected at times. His compositions seldom varied – a high horizon to which two lines of action lead – the frame of the boyarina's sledge or Stenka Razin's boat – a compositional feature derived possibly from his experiences as a mural painter. The colour schemes, those of Venice transported to Russia, muted like the shades of medieval embroidery, were repeated time and time again to the delight of his young followers. And yet Surikov was the only artist of his time who created historical works which were neither masquerades nor charades, but which were truly pictorial and happily bereft of external, moralistic tendencies and free of the excesses of the sentimental and superficial radicalism of the sixties and early seventies which had actually inhibited progress in painting. It can be justifiably claimed that he was the first painter of the open air, of scenes and landscapes which were truly and vividly Russian. No other painter had the power or imagination to evoke the vast plains, snow-filled skies, crowded streets, grey roofs and craggy towers of old Russia. To Surikov – as to the composers Borodin and Mussorgsky – we owe a memorable vision of the land before 1700, its heroes and heroines, its searing passions, burning faiths and bloody rivalries.[20]

In the eighties and nineties when Surikov was so worshipped it was natural that echoes of his ideas, colours, forms and compositions should be found in the work of the younger artists. The brothers Viktor Mikhailovich (1848–1926) and Apollinary Mikhailovich Vasnetsov (1856–1933) were among those who cultivated Slavonic and legendary themes.[21] Viktor Vasnetsov had been expected to follow his father into the priesthood but left the seminary where he was studying and apprenticed himself to a lithographer. He entered the Academy where from 1868 he studied under Chistyakov until 1875 when he went to Paris for a year. He began exhibiting with the *peredvizhniki* from 1874 and his scenes of village life, *The Village Shop*, *The People's Newspaper* and *From Home to Home* were included in their 1876 showing. Realizing that the realistic phase of Populism was losing favour he turned to the medieval past, to the epic poem *The Lay of Prince Igor* which was the inspiration for his *After Igor Svyatoslavich's Battle with the Polovtsy* (1880), showing a field strewn with corpses over which vultures ominously hover. This was followed by other realizations of ancient history and legend: *The Battle of the Scythians and the Slavs* (1881) and

Knight at the Crossroads (Plate 81). The visions he created of a past at once strange, mythical, chivalrous and, above all, Slav continued with *The Three Tsarinas of the Underworld* (1884) and *Tsarevich Ivan on the Grey Wolf* (1887).

Vasnetsov had a pioneer interest in Byzantine art which he studied in Italy and Sicily. He also joined in the chimerical pursuit of the Russian Christ, winning for himself a tremendous reputation with his frescoes in the Cathedral of St Vladimir in Kiev and his decorations for the Historical Museum, Moscow. His frescoes on the exterior of the Tretyakov Gallery are familiar to the millions of tourists who have queued for admission there. A versatile man, Viktor Vasnetsov also worked as an architect utilizing a fussy style which might be described as the Russian business man's Byzantine. He was associated with the industrialist Mamontov for whose private theatre he designed a setting for Ostrovsky's *Snow-White*, the most convincing

80. Vasily Ivanovich Surikov: Study for *The Boyarina Morozova*, 1887. Oil on canvas, 68.5 × 55.5 cm. Kiev, A. M. Gorki Museum of Art

picture of medieval Russia hitherto presented on the stage. Despite a mannered charm and a remarkable gift for pictorial invention his oil paintings are often singularly turgid compositionally speaking; and in his hands the strange beauty of Surikov's palette becomes merely muddy.

Apollinary Vasnetsov was trained by his brother Viktor. He was a serious young man who joined the Populist movement of the seventies and taught in a village school. From 1883 he exhibited with the *peredvizhniki*, becoming chairman of the group in 1888. He shared his brother's interest in the medieval past and painted pretty scenes of picturesque life in old Moscow. Towards the end of the century he took charge of the landscape department of the Moscow School of Painting, Sculpture and Architecture. For Mamontov's theatrical productions he created dazzlingly vivid settings, notably for Mussorgsky's *Khovanshchina* and Rimsky-Korsakov's *Sadko*, *The Legend of the Invisible City of Kitezh*, *The Maiden Fevronia* and other operas. He illustrated books, including Lermontov's *Song of the Merchant Kalashnikov*. There is more than a suspicion of pastiche about the productions of both

these brothers; and their work, religious and historical, coincided opportunely with the growth of Slavophilism, much encouraged as it was by the government and the loudly heralded 'rebirth' of Russian Orthodoxy in the reign of Alexander III. On the other hand, they brought colour into theatrical design with such force that their influence was to extend far beyond Mamontov's private theatre. The painters of the next decade were to find revolutionary inspiration in the Vasnetsovs' use of folk motifs and the brilliant colours of peasant art. Moreover, they also helped to change the course of Populism in art by moving still further away from the reforming realism of the sixties and by introducing native fairy tales and legends – material also exploited by such musicians as Rimsky-Korsakov, Lyadov and, later, Stravinsky.

Apollinary Vasnetsov was much associated with Mamontov's small estate at Abramtsevo, some forty miles from Moscow. It was he who designed the small church in the Novgorod style which was built in 1882 and decorated by Repin and the other artists who were so frequently long-staying guests at Abramtsevo. Very few of the interesting artists of the period did not stay there. Consequently, through the example of Mamontov's own tastes and the work of the Vasnetsovs, it became important as a

81. Viktor Vasnetsov: *Knight at the Crossroads*, 1882. Oil on canvas, 167 × 299 cm. Leningrad, Russian Museum

centre for the promotion of a revival of the styles of early Russian art thus advocating, in effect, a neo-Russianism.

Among the artists who chose to work in the styles and to exploit the ways of pre-Petersburg Russia was Klavdy Vasilievich Lebedev (1852–1916) who studied at the Moscow School from 1875 to 1881 before becoming a teacher at the Academy in 1894. He began exhibiting with the *peredvizhniki* in 1884, and while he never entirely forsook realistic scenes of urban life he began to concentrate more and more on the past as in his pedestrian *Boyar Wedding* (1884). Andrei Petrovich Ryabushkin (1861–1904), another student of the Moscow School where he had worked under Perov and Pryanishnikov, turned away from the example of these teachers and sought inspiration in the past. During his comparatively brief career he created scenes like *A Wedding Procession in Seventeenth-Century Moscow* (1901) which carry a fragrant and poetic charm. Unpretentious but greatly talented, he was indifferent to the reformist aims of the *peredvizhniki*.

Other artists were less successful in moving from contemporary genre scenes to historical reconstructions. Karl Federovich Hun (1830–77), a professor at the Academy from 1870, could turn from painting *On the Eve of the Massacre of St Bartholomew* (1868) to *The Sick Child* (1869), displaying in both works a sturdy, photographic technique but no real conviction. An artist who moved more successfully between the past and present was Sergei Vasilievich Ivanov (1864–1910), whose pathetic *Death of a Migrant Peasant* (1889), excellent as it is as a record of the sufferings of the peasantry, is really a piece of belated Populism as is his *Foreigners arriving in Seventeenth-Century Moscow* (1901), an equally belated example of neo-Russianism. His *Soldiers firing on the Demonstrators* (1905) is a memorable record of the uprising of that fateful year.

The artist who drew together many of the diverging strands of Populism and neo-Russianism was Mikhail Vasilievich Nesterov (1862–1942).[22] He studied at the Moscow School under Perov and Pryanishnikov, went to the Academy for three years between 1881 and 1884, and then returned to the Moscow School for further study. He had become acquainted with Viktor Vasnetsov while staying with the Mamontovs at Abramtsevo, and finding a common interest in Byzantinism they worked together on the decoration of St Vladimir in Kiev. Nesterov first exhibited with the *peredvizhniki* in 1889, and in 1903 he joined the Union of Russian

Artists. He travelled widely in Europe and in Russia itself, visiting most of the ancient cities. Apart from his few years of study at the Academy under Chistyakov he lived away from the capital.

By simplifying landscape into a series of flat planes, by a careful choice of representative detail, and by a decorative use of line and colour Nesterov evolved a style which owed a little to Puvis de Chavannes and the Art Nouveau movement. He may have created a compositional mode which was to become a commonplace throughout Europe – that of a landscape with an extremely high horizon in which the variety comes through a series of horizontal planes made up of lines of trees, fields, paths, rivers and river banks (Plate 82). He seemed to his contemporaries to have truly captured the spirit of old Russia, a lost world of saints, anchorites and holy women. Nesterov was, at that time, under the spell of a deep and simple faith, periodically withdrawing to monasteries and making pilgrimages to remote shrines. No other painter of the time was so acquainted with the traditional ways of Orthodoxy that had existed since the conversion of Vladimir of Kiev at the end of the tenth century and which had taken root among the unspoiled and remote vastnesses of the countryside. His *The Child Bartholomew's Vision* (Plate 83) and *The Bride of Christ* (1897) showed a further refinement of his compositional devices: he uses a religious procession as yet another horizontal, but dramatically breaks the rhythm by a sole upright figure.

With Nesterov the realism and overt social commentary which had seemed so innate a part of the *peredvizhniki* movement appeared to come to an end. Yet it can be claimed that his lyrical scenes of untroubled medieval or pre-Petersburg life were in themselves a criticism of the political order which had allowed and created the abject condition into which the peasantry had fallen. Nesterov's critical sense had been only temporarily in abeyance: his journals reveal that he was never detached from political and social events and they are now important records of artistic developments in Russia in the sixty years up to his death in 1942. He was to shed his mystical preoccupations and turn to incisive portraiture and to scenes of contemporary life, a transformation which was startling but demonstrative of his remarkable talents.

Nesterov had evolved a kind of genre which combined figures and landscape derived, it may be, from Ivanov's sketches of boys and men in Italian landscapes. In fact, few Russians appreciated

the landscape of their own country even in the mid-nineteenth century, a natural reaction to the difficulties of travel in the countryside, the harsh weather and the sheer tedium of much rural life. Nevertheless, it is possible to claim that there was a change of taste in the seventies when almost for the first time Russian painters began to value the beauty of their motherland for its own sake and not merely as a background to portraiture. The pioneer artist in this respect was Aleksei Kondratievich Savrasov (1830–97), who began his studies at the Moscow School in 1857 but was dismissed in 1862 and apparently gave himself up to drink.[23] He travelled widely in Russia and Europe and had a wide circle of friends among whom Perov exerted most influence on him. In fact, he was a founder-member of the *peredvizhniki*. His students included Levitan and Korovin, two important artists of the next generation. Savrasov became famous in 1871 with his *The Rooks have returned* (Plate 84), still one of the most popular of Russian landscapes: the snow has melted on the church roof and spires, the lake waters have begun to thaw, the sky is no longer overcast and grey, and the rooks have begun to build their nests in the budding larch trees. A series of equally fresh landscapes followed, none of which achieved the fame of *The Rooks*, a picture which not only served to bring about the regeneration of Russian landscape painting but was also seen by the Populists as prophetic of happier days ahead for the masses.

Other landscapists included Ivan Ivanovich Shishkin (1832–98), who studied at the Moscow school under Venetsianov's pupil Mokritsky and at the Academy under Vorobiev.[24] After receiving the Gold Medal in 1860 he was offered the travelling

82. Mikhail Vasilievich Nesterov: *Autumn Landscape*, 1906. Oil on canvas, 101 × 134 cm. Moscow, Tretyakov Gallery

scholarship which he took up in 1862 when he went to Prague, Munich, Düsseldorf and Zurich. He was a founder-member of the *peredvizhniki*; but was soon a professor at the Academy and, in 1894–5, director of the course in landscape painting there. Shishkin specialized in meticulously detailed woodland scenes in which any sense of place is lacking (since they could as easily have been of Switzerland or the surroundings of Düsseldorf as of Russia), and which quickly pall by their repetitiveness (Plate 85). In the last decade of his life, possibly inspired by the French Impressionists, he began to lighten his palette and look more perceptively at the landscape around him.

Baron Mikhail Konstantinovich Klodt von Jurgensburg (1832–1902), son of an engraver and nephew of the sculptor P. K. Klodt whose four colossal bronze groups of horse-tamers on the Anichkov Bridge in Nevsky Prospekt are one of the notable monuments of Leningrad, also studied under Vorobiev at the Academy of Arts. He was a distinguished student and was awarded the travelling scholarship which enabled him to visit Switzerland and France. He did not stay abroad for the full length of his scholarship but in any case a lengthier stay could hardly have alleviated the dullness of his landscape work: at his best, as in *In the Field* (1871), he seems to retrace the footsteps of Venetsianov. Aleksandr Aleksandrovich Kisselev (1838–1911), pupil and professor at the Academy, tried to depict the landscapes of central Russia, but his semi-realistic technique and uninspired vision were inadequate.

Almost within a decade a new attitude to landscape painting began to manifest itself. Although many of these artists avoided France when travelling abroad, the influence of the Barbizon school and, later, of the Impressionists affected their painting however indirectly and distantly. Increasingly there was an emphasis on mood as well as on more apposite techniques. Arkhip Ivanovich Kuindzhi (1841–1910), of Greek descent, was self-taught until he entered the Academy for two years between 1868 and 1870.[25] He joined the *peredvizhniki* but left them after several years. His extended landscapes generally have a low horizon, moonlit or stormy skies and bare foregrounds. Such pictures as *Night in the Ukraine* (1876) rely for their effect on an absolute simplification of form and an intense contrast of light and shade which makes them dangerously close to theatrical backdrops or 'calendar' art. But his studies of the vast Ukrainian skies

83. Mikhail Vasilievich Nesterov: *The Child Bartholomew's Vision*, 1889. Oil on canvas, 160 × 213 cm. Moscow, Tretyakov Gallery

and the near-empty landscape show that he had little to learn from the Impressionists (with whose work he was well acquainted); and the restraint evident in all his pictures is welcome after the over-detailed character of previous landscape work. Above all, his great gift to Russian painting was a constant stress on the importance of atmosphere and the use of light (or darkness) to bring about effects of luminosity (Plate 86). The absence of human forms, the lack of social comment, the strangely distanced landscape and the simplified forms were to endear Kuindzhi to the Russian symbolists in the twentieth century.

In his own day Kuindzhi was attacked for alleged crudity of painting technique and casualness of composition, although the general public recognized his innovatory talents and he did not lack for wealthy patrons. Among fellow-members of the *peredvizhniki* Yaroshenko recognized and defended his talents. Kuindzhi's pigments have darkened to the detriment of his pictures; and it is less easy to judge the exactness of luminosity seen by his contemporaries. Kuindzhi was also something of a financial genius and bequeathed a fortune to help poor artists.

Sergei Ivanovich Svetoslavsky (1857–1920) had a delicate sense of colour and brought a note of melancholy to his depictions of tumbledown corners and decaying buildings in poor provincial towns and of the flooded roads that are so much an aspect of the Russian spring.

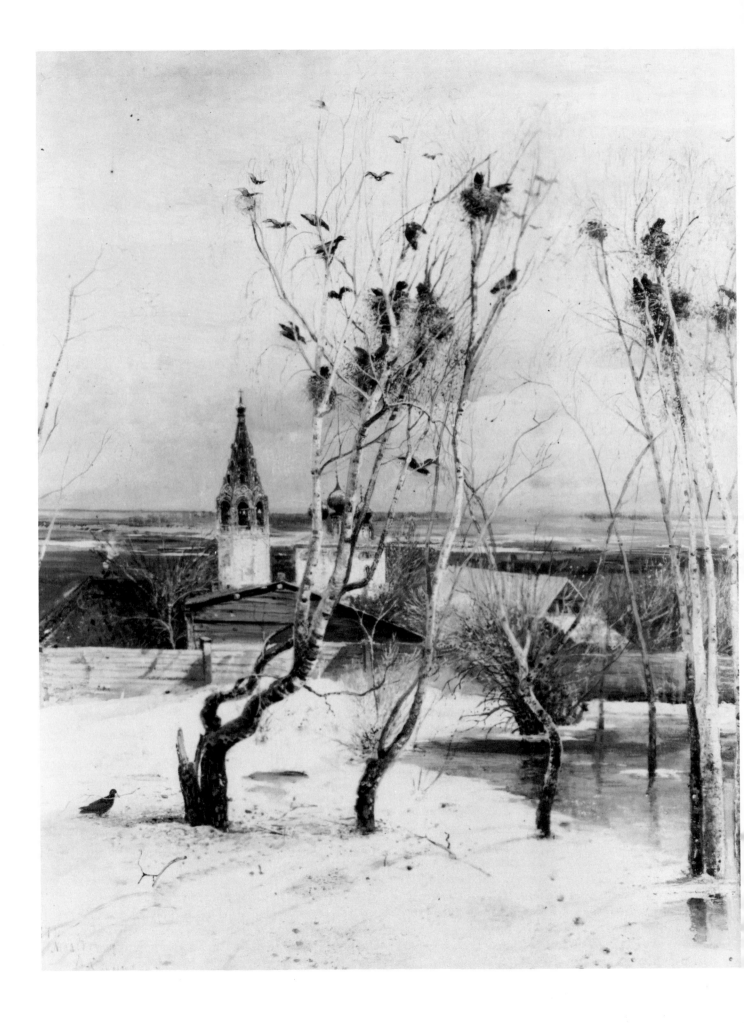

85. Ivan Ivanovich Shishkin: *An Oak Grove*, 1887. Oil on canvas, 125 × 193 cm. Kiev, A. M. Gorki Museum of Art

84. Aleksei Kondratievich Savrasov: *The Rooks have returned*, 1871. Oil on canvas, 62 × 48.5 cm. Moscow, Tretyakov Gallery

As we move towards the end of the century, there is a distinct lightening of the palette and adoption of a near-Impressionist technique. Aleksei Stepanovich Stepanov (1858–1923) painted scenes of wild life of which his *The Cranes are Flying* (1891) was especially popular. Ilya Semenovich Ostroukhov (1858–1929), a wealthy amateur of the arts and a picture-collector, was a pupil of Repin, Kiselev and Chistyakov.[26] Despite the strength of these forceful personalities, he rapidly formed his own distinctive style. His landscapes, of which *Siverko* (1890) is typical, show an austere but lively gift for capturing and simplifying in form and tonal range the vast stretches of the Russian countryside. His abilities have been somewhat neglected. A pupil of Polenov at the Moscow School, Sergei Arsenievich Vinogradov (1869–1938) also employed a bright palette which clearly showed the impact of Impressionism and which he intelligently exploited in his decorative landscapes. Stanislav Yulianovich Zhukovsky (1873–1944), one of the last landscapists of this somewhat transitional period to join the *peredvizhniki*, had even more directly absorbed both the Impressionist palette and technique: he was to end his days in a Nazi concentration camp in his native Poland.

Even when one is conscious of lapses of taste, uneven qualities and weakness of composition, one also recognizes in the work of these *peredvizhnik* landscapists an endearing sympathy with nature.[27] Isaak Ilich Levitan (1860–1900), a late member of the *peredvizhniki*, was the finest landscapist of the last decade of the century and is their worthy heir. But his career must have separate consideration with other *fin-de-siècle* painters.

86. Arkhip Ivanovich Kuindzhi: *The Birch Grove*, 1879. Oil on canvas, 97 × 181 cm. Moscow, Tretyakov Gallery

Although the *peredvizhnik* movement lasted until the 1920s it was a spent force in political and social terms before the end of the nineteenth century. A singularly complex association of painters, the task of defining its achievement is not an easy one. It is evident that its aims attracted many of the ablest artists in the second half of the century although there were others who stayed outside its ranks. It was an inbred movement, many of its leaders becoming the teachers of later adherents. It amply demonstrated the effectiveness of Russian teaching (especially in the person of Chistyakov, who commanded universal respect), and proved that the Academy was capable of reform from within.[28] It also demonstrated the radical qualities of the Moscow School of Painting, Architecture and Sculpture from where most of the revolutionary artists of the first decades of the twentieth century graduated.

Despite the obvious academic qualities of the pictures – correct draughtsmanship, careful perspective and convincing pictorial organization – the actual quality of the painting is far from exciting. Faced with the competition of photography, the early *peredvizhniki* did not, in general, challenge its apparent realism by presenting an alternative painterly realism such as that developed by the Impressionists; on the contrary, they painted, so to speak, photographically, obliterating brushstrokes, using paint thinly, and restricting themselves to a near sepia palette, which is why they often seem at their best in melancholy or sombre scenes. In fact, they seemed to aim at a photographic realism the more effectively to convey their message, although it must be admitted that this is less and less true as the century was drawing to its close and a variety of styles was to be seen. In general, however, the style, manner and nature of the painting counted for little: the message was all.

If the exhibitions of the *peredvizhniki* seemed to differ little in content from the various Salons and academic exhibitions held in Western capitals, there was, in fact, an important and crucial difference which must be taken into account: the Russian painter dedicated his art not to literary or decorative or technical purposes nor even to self-advancement, but to moral and social reform and national progress. His work served aims which were at the same time reformist, nationalist, religious, radical, critical and Messianic. Rarely were these aims artistic in the wider sense. Whether the painters understood these

aims and whether their means were adequate to their fullest expression will surely be doubted by sensitive observers of the acres of canvas which line the gloomy walls of the Tretyakov Gallery. At the same time, the point must be made – and insisted upon – that few groups of artists since the Renaissance (we can except the Nazarenes whose influence on the *peredvizhniki* has not been sufficiently recognized) have been so closely bound to one another in a worthwhile cause or have felt so deeply committed to securing a better life for their countrymen. Were not their intentions, despite all the criticisms that can and have been made of their work, vastly to their credit as artists and human beings concerned with the welfare and destiny of their fellow-men?

Must we look to the *peredvizhniki* as being the first distinctly Russian school of painters, however alien to modern taste their subjects and styles? This is certainly the view of most Soviet art critics; and in justification it could be said that Soviet Socialist Realism is a direct descendant of the movement, although, of course, circumstances within Russia have changed beyond recognition, modifying the task of her artists. It can be argued that from the 1850s a new style of art came into existence, a hybrid form which was realistic and moralistic, and which left behind it the classical canons – but this is also true of Western Europe. It can also be argued that this painting is romantic in its concern for reform and freedom. But it is difficult to sustain these premises with relation to the *peredvizhniki*. The students who revolted at the Academy in 1863 did so because they disagreed with the choice of subject for their set examination piece in history painting, not because they objected to the teaching methods of the Academy itself. The *peredvizhniki* came into existence because Russian painters wished to treat national subjects which they considered of interest or of social concern, and not because of any dissatisfaction with academic curricula. In its general tendencies and particularly in its preoccupation with genre painting it was not basically different from the great body of painting elsewhere in Europe. However, there is no denying that the movement's disciples turned their faces against developments in France, possibly (but not, it must be admitted, very probably) because they felt that the Impressionists lacked sufficient social concern. It is possible, too, that they were not free of xenophobia; and their outlook might well be described as neo-Russianist in that when their pictures were devoid of reformist content (and this is more often

the case than Soviet critics care to admit) they exploited nationalist subjects, as is the case, for instance, with N. P. Bogdanov-Belsky (1868–1945) with his anecdotes of village school life (Plate 87). The social conscience of the *peredvizhniki* evolved and developed, and it cannot be denied that this concern is its major claim to serious consideration. At the same time, it does not present a cogent or even a historical reason for accepting it as an entirely authentic Russian artistic development. It is Russian only by its (limited) use of local subject-matter and, to a lesser extent, by the attitude of its artists. It can be regarded as an aberration from the road opened up by Venetsianov with his genuine and noble instinct for the basic roots of Russian life and art. The artists of the end of the century were to have a heroic struggle to restore to painting a truly national character.

By 1894, when the Academy reformed its syllabus, most of the professorships had been filled by present or past members of the *peredvizhniki* who,

87. N. P. Bogdanov-Belsky: *Mental Arithmetic*, 1895. Oil on canvas, 107 × 79 cm. Moscow, Tretyakov Gallery

with the exception of Kuindzhi who even took his students, gratis, on a visit to Paris, encouraged work in a realistic style. However, there had already arisen a reaction. Among the younger *peredvizhniki* was Nesterov whose pictures, it is true, were poems of old Russia, but in content and manner were linked with Puvis de Chavannes and the French symbolists. Nesterov was undoubtedly the instigator of the first tentative stirrings of symbolism in Russia. In retrospect, it is not difficult to see how Nesterov's pictures, mystical, simple, static, unintentionally symbolical perhaps, posed an unspoken challenge to the reformist aesthetics of the Populist movement as enunciated by Chernyshevsky and Stasov, and became a source of inspiration to the next generation of painters. In fact, although the aims of the *peredvizhniki* had the allegiance of most Russian painters and were, therefore, widely shared, the actual depth of their commitment fluctuated; and the movement flourished at the most from 1870 to 1890 – no more than two decades. It was compromised from its inception by its dependence on the patronage, generous, benevolent and considerate as it was, of Tretyakov and other members of the industrial class responsible for the wretched working conditions and social evils which the *peredvizhniki* ostensibly sought to eradicate by means of their art. Such radical change was, in fact, the *raison d'être* of their existence. Many of the artists began as students at the Moscow School even if they ended up as professors at the Academy in St Petersburg. And although Moscow had stood initially for an accurate depiction of urban and peasant life and for a stark exposure of social and political evils, it was there, on the Abramtsevo estate of the industrialist Mamontov, that some of the members of the *peredvizhniki* became fascinated with the colours, patterns and rhythms of folk art (thus in a sense complementing the religious themes of Nesterov and the historical images of Surikov), and consequently turned their attention to book illustration and stage-design, relinquishing their reformist aims and replacing them with decorative pursuits. The concern with music at Abramtsevo is perhaps significant in that it is surely the least useful of the arts – considered from a social point of view.

It would be interesting to attempt an assessment of how influential were the industrialist patrons in directing the course of *peredvizhnik* painting away from radical Populism by the exercise of their purchasing power and by financial support. The movement which began as an academic revolt, grew almost at once into a Populist, reformist school, and drifted fairly imperceptibly into decorativism, was basically lifeless by 1900. Interest in the decorative arts was to pass to St Petersburg, where it came to fruition in the Mir iskusstva group and the Ballets Russes of Serge Diaghilev. However, St Petersburg's triumph was short-lived, and Moscow soon regained her position as the centre of all that was vital in Russian painting.

Although rarely noted in art histories, there were artists who stood aside from the *peredvizhniki* or who were actually opposed to their aims. There were others who simply used the annual exhibitions as a convenient venue for displaying their works. In general, these were painters whose output commanded respectable prices among the middle-class devotees of an outmoded, insipid but clever academicism or of entertaining, uncritical genre scenes. Typical of this group was Konstantin Dmitrievich Flavitsky (1830–66), famed for his *Christian Martyrs in the Colosseum* (1862), a picture which is replete with groups drawn from Bryullov, Bruni and the Italian masters, and *The Princess Tarakanova* (1864) in which the well-developed and attractive heroine is too mindful of the perils before her to be concerned with her state of undress. Flavitsky won the Academy Gold Medal when he was 25 and there can be no denying his redoubtable facility in draughtsmanship and the handling of paint. G. I. Semiradsky (1843–1902), an artist of Polish origin who travelled widely in Europe, became famous for his photographic scenes of classical festivities. Around him were D. K. Smirnov (1858–90), celebrated for his immense *Death of Nero* (1888); V. I. Yakobi (1834–1902), whose work varies from the moving *Convicts at the Resting-Place* to trivial costume-pieces; and the popular S. V. Bakalovich (1857–1919), who also churned out reconstructions of life in classical times; while A. D. Litovchenko (1835–90) produced scenes drawn somewhat vaguely from Russian history.

Among the artists who paid only lip service to the *peredvizhniki* or showed indifference were Aleksandr Ivanovich Morozov (1835–1904), one of the original dissidents, whose narrative scenes and peaceful landscapes do not seem to differ one jot from similar works by his former colleagues; Aleksei Ivanovich Korzukhin (1835–94), another of the dissidents who drifted back to the shelter of the Academy, although his pictorial indictments of the squalor of peasant life revealed his basically Populist sympathies; and Kirill Vikentievich

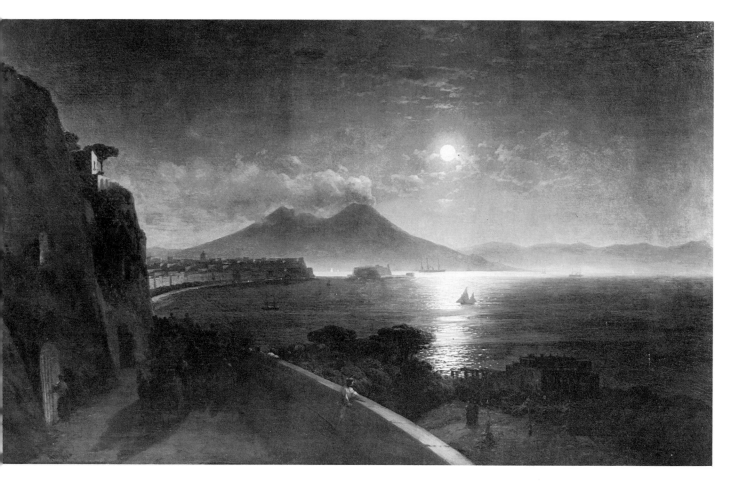

88. Ivan Konstantinovich Aivazovsky: *The Bay of Naples by Moonlight*, 1892. Oil on canvas, 107.1 × 177.2 cm. New York, A La Vieille Russie Inc.

Lemokh (1841–1910), whose innocuous scenes of peasant life were much collected by the aristocracy and who taught painting to the Imperial family – while he continued to exhibit with the *peredvizhniki*. Nikolai Andreevich Koshelev (1840–1918) was yet another painter who professed adherence to the movement but never joined it, preferring to seek early promotion as a professor at the Academy. Realistic in his early genre scenes and sometimes pleasantly evocative, as in his picture of Kramskoy listening to his sister playing the piano, he also specialized in religious work which led to his being invited to decorate the Russian Orthodox cathedral in Buenos Aires. P. O. Kovalevsky (1843–1903) became head of the department of battle painting at the Academy, using his experiences as an artist in the Balkan war, but the majority of his agreeable pictures are of horsemen, hunters, sleighs and coaches moving through the countryside at different seasons of the year. Yet another painter of classical life, F. A. Bronnikov (1827–1902), professed allegiance to the *peredvizhniki* but lived permanently outside Russia, in Rome, where his claim to reformist ideals was hardly likely to be challenged nor his flirtatious Italian peasants and pious Christians capable of arousing much controversy.[29] To this brief account could be added the names of many other noted painters of the time but sufficient have been listed to indicate that, important as were the *peredvizhniki*, they were far from enlisting the sympathies of every Russian painter.[30]

Two widely celebrated painters who were associated with Populism but who stayed clear of the *peredvizhniki* were Vereshchagin and Aivazovsky, both of whom enjoyed enormous success all over Europe and in the USA. Ivan Konstantinovich Aivazovsky (1817–1900) was born in Feodosiya in the Crimea and studied at the Academy under Vorobiev from whom he learned the traditional devices of the *vedutisti*, as is apparent in his early works, which are curiously old-fashioned both in style and composition.[31] He also studied under Philippe Tanneur who worked in St Petersburg

between 1835 and 1837 and who taught him the rudiments of seascape. Continuous travel abroad, particularly in the eastern Mediterranean, taught him to look closely at the sea in its many moods: the pictures which ensued, crowded as they were with naval battles, sinking ships, storms, rocky shores and tempestuous waves, caught the public taste and his fame spread to Europe very quickly. These works, in which the influences of Claude Lorrain and Joseph Vernet were apparent, gave way to wildly romantic visions of sunshine or moonlight sparkling on the limitless waters of sea and ocean (Plate 88). In Rome, Ivanov conferred his blessing on the young artist by stating (rather ambiguously, it must be admitted): 'Nobody here paints water as he does.' Nicholas I commissioned a series of pictures of Russian ports; and in 1857 one of his *Four Seasons* was purchased for the Empress Eugénie of France. The Florentine Academy asked in 1847 for a self-portrait to hang in the Uffizi collection. Even the Vatican bought a canvas, appropriately entitled *Primitive Chaos*. He was appointed painter to the Naval General Staff in 1845 and recorded the naval manoeuvres of the Russian fleet under Admiral Litke in the eastern Mediterranean. He was honoured by the Academies of Amsterdam, Florence, Rome and Stuttgart.

Aivazovsky shared in the nineteenth-century taste for the mammoth; he was not partial to anything on a small scale, preferring to paint large pictures; and the cynical remarked that if they did nothing else they kept other pictures off the walls; in addition he organized over a hundred exhibitions of his own works. When art failed him (it rarely did), he turned to writing verses:

The great ocean heaves beneath me.
I see the distant shore,
The magic regions of a sunlit land:
With agitation and longing, thither do I strive.[32]

It is easy to write off Aivazovsky as a one-man picture factory — although his incredible production of some 4,000–5,000 pictures was made possible by a host of assistants — but he was genuinely fascinated by ships and water all his long working life. Just before his death he was planning another sea journey in search of material; and died while actually working on a picture, *Destruction of a Turkish Warship*. Aivazovsky has a valued place in Russian nineteenth-century painting, not entirely for the intrinsic merit of his work: his vast *The Storm*

which shows a sinking ship and tiny lifeboat overwhelmed by tempestuous seas was interpreted as an allegory of the instability of the Romanov line; while *The Ninth Wave* (1859) which portrays the last wave of the final flood predicted in the Book of Revelations was said to be prophetic of the downfall of Tsardom. Contemporary viewers are more likely to see in it a mixture of Géricault's *The Raft of the Medusa*, the lurid sunset effects of Turner's rhapsodies, and the bathetic fantasies of Martin which were widely reproduced in engravings and popular everywhere in Europe. Acquainted with many of the brilliant men of the age – Glinka and Bryullov, Ivanov and Gogol – he was a man of considerable sensitivity and seriousness whose Promethean struggles on canvas cannot and should not be easily dismissed as disquieting symptoms of the century's obsession with the grandiose and spectacular.

If Aivazovsky demonstrates Russia's desire to obtain direct access to the seas and oceans of the world, Vasily Vasilievich Vereshchagin (1842–1904) illustrates its growing empire and bellicosity.[33] He was born into an aristocratic family and sent to be trained as a naval officer. In 1860, however, he decided on an artistic career and went to the Academy which he left in 1863 when he became dissatisfied with the syllabus. The following year he spent several months studying with Gérôme in Paris. He began but never finished a large work intending to expose the wretched conditions of the Volga barge-haulers, thus anticipating Repin's great work. When war broke out between Russia and the Emirate of Bokhara in 1867 he rushed to the battlefield and made innumerable studies which he took with him to Munich, where he produced 121 pictures detailing episodes from the conflict. They made a great impression when exhibited in St Petersburg in 1874 and were immediately purchased by Tretyakov. The following year Vereshchagin left for India where he collected material for a cycle to be entitled *The History of the British Oppression of India*. In 1876, however, news of the war between Russia and Turkey sent him speeding to the Balkans. Between 1879 and 1881 he completed 19 pictures showing the tragedy of the campaign in which the ordinary Russian soldier suffered cruelly from the incompetence of the general staff and its suppliers. The taste for religious works which was so marked in the 1880s caught his attention and he travelled to India and Palestine from where he brought back sketches for a group of pictures which were critical of the development of religion through the ages. In

1889–90 he also turned to history painting and produced 20 large works on the theme of Napoleon's invasion of Russia. The war between the USA and the Philippines next caught his attention and he set off to the Pacific where he painted between 1901 and 1902, and then went on to Japan where he found himself on the outbreak of the Russo-Japanese conflict. He was killed on board the battleship *Petropavlovsk* in 1904.

Vereshchagin had a brilliant sense of colour and a technique which can only be described as photographic; with his untiring energy and extraordinary visual memory he was, in a pictorial sense, the perfect war correspondent. Yet his whole life was spent demonstrating the futility of war. In this he was at one with Tolstoy, while his reforming zeal and social consciousness linked him with the early days of the *peredvizhniki*. He was nothing if not a realist, but the dazzling colours, the clever stage-management of figures and lighting, and the remorseless but anonymous brushwork weary the spectator. For all his pictorial gifts and personal nobility of character, Vereshchagin lacked the memorability of expression which is often given to lesser men. Like Repin and Aivazovsky, he did not know the meaning of technical difficulty. That his work has had less effect than he wished may have been due to the excessive publicity attracted by his pictures and the theatrical nature of his exhibitions which were arranged with dimmed lights and accompanied by sound effects. These exhibitions were held all over Europe and even reached the USA where they proved to be failures, America having no taste for pacifism. Yet it must be admitted that in Europe the contemporary critics had the highest opinion of his work; and the three pictures which made up *All Quiet on the Shipka Pass* (1878–9) inspired his friend the poet V. M. Garshin (1855–88) to contrast the horrors shown in the work with the indifference of the spectators strolling past.[34]

Occasionally Vereshchagin created a picture which rose above the level of pictorial journalism: his *Apotheosis of War* (Plate 89), which depicts a

89. Vasily Vasilievich Vereshchagin: *Apotheosis of War*, 1871. Oil on canvas, 127 × 197 cm. Moscow, Tretyakov Gallery

vast pyramid of human skulls piled up on a former battlefield, now a desert waste, evidently an imaginative reconstruction of a remembered reality (of a nightmarish, surrealist kind), continues to linger in the visual memory. Vereshchagin shared something of the demonic energy and seriousness of attitude which Ivanov had brought to Russian painting; and there is an essentially Russian quality in his fierce concentration on an apocalyptic message, and a dedication to reform which marks him as a personality typical of the 1860s and 1870s.

In the late 1870s it became apparent that Populism was giving way to neo-Russianism, to a preoccupation with religious, historical and nationalist themes, encouraged by Tretyakov, Mamontov, the Slavists and by Alexander III, whose ambition it was to establish a national school of painting. In effect, if not in intention, by the end of the 1890s the *peredvizhniki* controlled academic teaching and had become part of the Imperial establishment. Stasov's ideals were entirely honourable, laudably patriotic and sensibly attuned to the divided and unhappy nature of Russian society, but he was unable to see that art speaks in many ways and not necessarily or most effectively by pictorial realism. By trying to contain painting within a strict ideology personal to himself he tended to divert painting from a truly revolutionary role into representational neo-Russianism – thus unwittingly allying himself with the strategies of Alexander III. Worst of all, perhaps, he closed the door against technical innovation and, at the same time, placed an entirely false historical emphasis on the development of Russian painting in the second half of the nineteenth century.

7
Fin-de-siècle Movements and Reactions against the Nationalist School

Alexander III (1881–94) began his reign, as had his grandfather Nicholas I, with a series of state executions – in his case, of the five revolutionaries who had been responsible for the assassination of his father. This ghastly event, cruelly bungled by the drunken hangman, was witnessed by massed troops, a crowd of sightseers estimated at 80,000, and representatives of the diplomatic corps and the foreign press. The act was sufficiently representative of the man and of his reign. Alexander had been unconvinced by his father's comparatively liberal policy and saw his murder as proof of its failure. German influences, which were increasingly strong during these years, advised against any reform or concession; and the Tsar was only too pleased to accept this counsel. Meanwhile, however, Russia was witnessing a change from the old feudal relationship of master and serf, gentry and peasantry, to that of an industrial nation, crossed and served by railways and communication systems built and maintained at immense expense of human life and suffering.

Politically, Alexander III encouraged Pan-Slavism and the growing spirit of conservative nationalism within Russia, while opposing any tendency of political liberalism. His reign was marked by general unrest, especially in the universities and among the new industrial and urban dwellers, the latter moving into the position from which they were to have an as yet unforeseen but decisive impact on history. The period has been summed up thus:

> The main characteristics of the last two decades of the century, extending into the next reign and indeed up to the war with Japan in 1904, are stagnation in agriculture, progress in industry, retrogression in education, russification of the non-Russian half of the empire's population, and an overall attitude of nostalgic, obscurantist, and narrowly bureaucratic paternalism.[1]

Nicholas II who succeeded in 1894 did little to change matters even after the disastrous Japanese war of 1904 and the serious uprisings of 1905. He was capable of greater sensitivity than his father, was even a shade more intelligent, but resembled his predecessor Alexander I in his inability to make up his mind, to allow open disagreements, or to tell the exact truth to any one person at any one particular time. He distrusted intellectuals and disliked Jews. Several of his important ministers were dispatched by the assassin's bomb or bullet, and his own life was to end in an equally violent and even more squalid fashion. His wife, a cousin, Princess Alix of Hesse-Darmstadt, had been chosen for him by his parents, as had his one and only mistress. After his wife's conversion to Orthodoxy she became fanatically religious, to the point of credulous superstition. Like that of her husband her artistic taste was mediocre; and her intelligence even more limited. Their reign was marked by disaster after disaster. At the coronation ceremony in Moscow the traditional public distribution of kerchiefs, cups and money was followed by an uncontrolled riot when about a thousand people were killed. In 1905 a series of riots and strikes was suppressed with open brutality; and the Tsar left the Winter Palace in St Petersburg to which he returned infrequently and with reluctance. The outbreak of war in 1914 revealed the inefficiency of the state organization as had the Crimean war sixty years before. When the Empress began interfering in politics and the war administration there was further deterioration. Revolution broke out; and on ~~15 March 1917~~ Nicholas II and his family were executed in a cellar at Ekaterinburg. The Romanov dynasty had ended.

Himself largely indifferent to artistic activity of any kind, Nicholas II reigned in a period of vulgarity, when tasteless buildings reflected the ruthless philistinism of their owners, and when accessories of

the utmost triviality and costliness were everywhere in fashion. Boastful self-confidence, stupid arrogance, material extravagance and a facile, brash emotionalism marked public life until it exploded in the holocaust of war and revolution. But there was also an unslaked thirst for all that the West had to offer in artistic and spiritual experience side by side with a lively rummaging among the styles of early Russian art, a partly antiquarian and folk-loric interest which accelerated as it was realized, instinctively perhaps, that the days of the Romanov dynasty were numbered.

For some time it has seemed that music and ballet were the two dominant arts of the decades before 1914; and certainly dancers like Pavlova and Nijinsky, singers like Chaliapin, and composers as diverse as Scriabin and Tchaikovsky, Taneev and Stravinsky, Rimsky-Korsakov and Glazunov appear to provide justification for this belief. But there were also great poets and writers of whom it is sufficient to mention Blok and Gorky, Tolstoy and Turgenev, Dostoevsky and Chekhov, Ostrovsky and Balmont, and stage producers such as Meyerhold and Stanislavsky. We are beginning to appreciate that this period saw a great flowering of painting and of creative experimentation in the arts, invigorated, as we have said, not only by contacts with the West but also by the electrifying discovery of strands of inspiration from within Russia itself.

The years from the accession of Nicholas II are of the greatest importance in the history of Russian culture; and in one sense the years up to and including the revolution saw the heights of an artistic turmoil peculiar to Russia, a turmoil which was basically romantic and belated, but nevertheless overwhelming in the abundance of its achievements. Currents of thought which had always existed, usually in inarticulate form, were now reborn as forces which still exist in Russian thought and behaviour today. Chief among them was a sense of man's absolute and omnipotent ability to solve the problems of the human race. Creativity was a way in which the human spirit could free itself from the prison of ordinary (and increasingly industrial) life, for behind every artistic feat was the attempt to forge another way of life and to depart from this 'chaos-laden distorted world to the free and beautiful cosmos'.[2] Liberation for mankind could come through the creativity of art or equally through the creativity of mechanical engineering, for as man advanced rapidly on the road to immortality he created his own destiny; and through the use

of machinery he could gain possession of the universe; extend his species into the distant cosmic regions and take over the whole of the solar system. Through the creative act Man becomes a God, building the world afresh and shaping it to his own needs and ideals. Potent but less widely held was a mystical conviction that religion alone could change the world, that it was man's express and destined purpose to seek God as the sole means of salvation. Yet, in reaction, it may be, against idealism and religion there was a resort to shocking sensuality of all kinds and its expression in primitive styles of art, in pornographic scenes, obscene words incorporated within the pictorial elements of a canvas, outrageous cabarets and feverish orgies – as students of the behaviour of Rasputin and of his murderers will be aware. There was everywhere a sense of the apocalyptic, a mystic element never far below the surface in Russian religious life, but now excessive in its stridency. The new age would come, it was believed, through art, for it was discovered to be something which could be enjoyed for its own sake and at the same time be exalted for the sake of all mankind.

So strong was this fervour of artistic activity and worship of man's creative powers that analogies with the Italian Renaissance have been suggested. The interrelatedness of the arts, observable as an artistic tendency throughout Europe during the last two decades of the nineteenth century, was never stronger than in Russia. Obsessed by the correlation between musical notes and the colour spectrum, Scriabin dreamed of a lighting device by which the concert hall could be flooded with chords of colour which would correspond in a mystical way to the music then being played. He dreamed of a Mystery to be enacted by two thousand performers in a fusion of dance, oratory, music, colour projections, emissions of perfume – the whole providing a multi-sensory polyphony. The 1914–17 war provided a multi-sensory cacophony of carnage and destructiveness which not even Scriabin (who died in 1915) could ever have foreseen.

It is possible to separate artistic developments from 1894 onwards into three periods, although it has to be admitted that there is a deal of overlap and that it is hard to specify exact boundaries. The initial years might be described as belonging to the *fin-de-siècle* movement as it generally manifested itself in Europe. Then comes the Mir iskusstva or World of Art group which is certainly *fin-de-siècle* in spirit but also aware of contemporary developments in French painting and in the

discoveries being made in the history of Russian painting. And then, from 1905, as if anticipating revolution, there begins a period of hectic and violent experimentation in the arts. Russian painters threw all the earnest passion which they had hitherto reserved for forms of Populist realism into a quest for new forms and techniques and into an investigation of the very nature of pictorial art. Appropriately, it was in the old capital of Moscow that this search commenced.

In the meantime, however, St Petersburg tried for the last time to cast her spell – vainly, as will be seen. By the end of the century, probably even earlier, the *peredvizhnik* movement was exhausted in spirit; and had been succeeded by an artistic and literary reaction against the prevailing banality, a tendency towards over-refinement and preciosity which sometimes degenerated into hysteria and madness. In compensation there was also a kind of rococo elegance based on the exploitation of the curving lines incorporated in such forms as creepers, reeds, lilies, or the necks of swans, flamingos, languorous women, and the motifs of peasant art. With this decorativeness went the production of emotional, personal and aesthetic portraits and landscapes. The style found expression in applied work, in book decoration, in graphic work and in theatrical design.

The key word to this period, a word to be found in the speeches and writings and artistic declarations of writers, musicians and artists, is symbolism. Nikolai Berdyaev affirmed that, 'All true art is symbolic: it is a bridge between two worlds, it evokes a more profound reality and it is the essence of true reality.'[3] Symbolism is strongly marked in the work of such poets as Balmont, Bely and Bryusov; it was a vital element in Stanislavsky's production of Chekhov's plays; and was a determinant factor in the painting of several artists whose brief lives remind us of the poets in the first luscious period of English romanticism – Byron, Shelley and Keats. The artists who might – in a limited sense only – be termed *fin de siècle* (and romantic) were Levitan, Serov, Vrubel and Borisov-Musatov. While they were linked to some degree with the *peredvizhniki* (whose tenuous yet pervasive programme it would have been hard to escape), and never indifferent to the cause of reform, they were also deeply concerned with the progress of the arts both in Russia and in Western Europe. All four were men of exceptional culture who recognized their places in the creative world around them. Of the four, Serov

was the most socially aware, with a compassionate concern for the victims of Tsarist government; and at the same time he seems the one least certain of his path in art. What is astounding about these painters is the readiness and facility with which they adopted and adapted the current European trends while retaining their own individual styles. In happy contrast to the xenophobic *peredvizhniki*, they fell hungrily upon all that Western painting had to offer. In one short bound they leapt through the movements that had convulsed French painting since the 1870s and brought the painting of their own country directly into the twentieth century. Thus the influence of the Impressionists, the Nabis, the Fauves and the Symbolists is apparent in their work. It is a mistake to think of them (as some critics have done) as simply summing-up and concluding the past century, since they were, despite their short lives, forerunners of the new age; nor should the mention of the French movements which affected their progress be used to cloud their distinctive achievements. It can be reasonably argued that their work contradicts the prevailing belief that the *peredvizhniki* had instituted an ethos which, guided by Stasov, lasted beyond the end of the century. Levitan, Vrubel, Serov and Borisov-Musatov were, to say the least, exploratory men of genius, who hewed for themselves, at whatever cost to their own sanity and well-being, a truly personal form of artistic expression which had validity and lasting value for their fellow-men.[4]

Isaak Ilich Levitan (1860–1900) struggled all his life to find the most expressive means of depicting the splendid serenity of nature. Born into a humble Jewish family in the provinces he is among the first of the many Jewish artists who were to make such a tremendous contribution to the history of Russian painting. At the age of 12 he entered the Moscow School where he stayed until 1885, studying under Savrasov and Polenov, and to which he returned as a teacher in 1898, since like most Russian painters he was unable to make a living by his art alone. Early in his career he made the first of several trips down the Volga, using the sombre palette favoured by the *peredvizhniki*, with whom he exhibited from 1884 although he was not admitted as a full member until 1891. In 1889, however, he went to Paris to visit the Universal Exhibition where he saw and was profoundly moved by the landscapes of Corot, Rousseau, Daubigny, the Impressionists and members of the Barbizon school. The true scope of his vocation as a landscapist was suddenly revealed to

90. Isaak Ilich Levitan: *After the Rain: The River Bank*, 1889.
Oil on canvas, 80 × 125 cm. Moscow, Tretyakov Gallery

him; and he grasped at techniques which had hitherto been beyond his conception. He took over the Impressionists' palette and the skills they had discovered for themselves, particularly the effectiveness of stained canvases and the potency of lively brushwork (Plate 90). His paintings began to glow with life and colour. These acquisitions from France were combined with a peculiarly Russian love of the inner life of a landscape, a deep commitment to the spirit of place. *The Peaceful Convent* (1890–1) is the first revelation of these developments. It was quickly followed by *Vladimirka* (1892) and the idyllic *By the Pool* (1892). He made numerous studies of landscapes at dusk or in the gentle grip of autumn, and even emulated Monet with his *Haystacks* (1899), in which the landscape dissolves in the evening mist and the light of the setting sun. His last work A *Sunny Day: By the Lake* is a serene por-

trayal of a blue lake lazily caressed by a warm haze and dappled by the shadows of the passing clouds.

Levitan was a close friend of the playwright Chekhov and might well have stepped out of the pages of one of his plays. Kind and gentle in character (but distressingly debauched, according to Chekhov), he was an unhappy, melancholy, tormented soul, seeming to carry within him the stamp of some fatality. He wrote:

Is there anything more tragic than to feel the infinite beauty of nature that surrounds us ... to see God in all things and to feel one's impotence to express these great sensations? When will I live in harmony with myself? That will never be. That is my curse. Every day I feel the will to struggle against these black moods diminishing within me.[5]

He suggested a dead seagull as a symbol of pathos to Chekhov, who used it in his first great play as title and theme. Not a single human figure appears in Levitan's last paintings: nature seems to be un-

troubled by pestilent mankind. Yet little of the unhappiness which was described as even showing in his eyes is apparent in his paintings of Venice or his more typical landscapes in which he presents a Russian Eden untroubled by human folly, lit by warm skies and shaded by generous, soft clouds; long lines of gentle, blue water reflect the surrounding fields and trees, the whole landscape frequently touched by the bloom of a sun that is taking a tenderly reluctant farewell of the landscape. Into these Arcadian scenes which enjoy a true affinity with the golden visions of Poussin there enters the faintest sense of regret or melancholy which is, perhaps, inherent in the noble beauty of the Russian rivers, lakes, streams, plains and woodlands and which no other artist before him had succeeded so entirely and consistently and without sentimentality in capturing on canvas (Plate 91; Col. Plate 11).[6]

91. Isaak Ilich Levitan: *Eternal Peace*, 1894. Oil on canvas, 150 × 206 cm. Moscow, Tretyakov Gallery

Valentin Aleksandrovich Serov (1865–1911) was also a fine landscapist and one of the greatest portraitists since Levitsky.[7] Like Levitan he demonstrated that landscape painting had no need of the sentimentality which had vitiated much of the work of the *peredvizhniki* and that the adoption of newer techniques evolved in Western Europe actually strengthened the modes of Russian painting. He was born into a cultivated family: his father, an ardent Wagnerian, was a leading music critic and an able composer whose operas *Judith* and *Rogneda* still receive occasional performances in Russian opera houses. When his father died prematurely in 1871, Serov was taken abroad by his mother who, struck by her son's gift for drawing, asked Repin who was in Paris at the time to give him lessons. These were resumed in Russia until 1880 when Serov entered the Academy, where he studied under Chistyakov for four years. Later, between 1897 and 1909, he taught at the Moscow School where he had many pupils of distinction, including Yuon, Saryan and Petrov-Vodkin. In 1889 he accompanied Levitan to

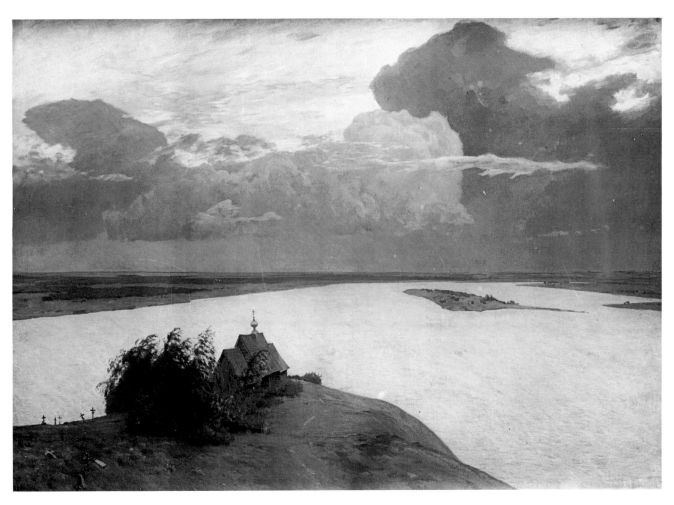

the Universal Exhibition in Paris where he was attracted by the genre scenes of Bastien-Lepage (which had been included in an exhibition of French painting in St Petersburg the previous year), and the bravura effects of the Swedish portraitist Zorn. In 1907 he travelled to Greece with Léon Bakst and brought back many delightful sketches as well as ideas for pictures on mythological themes. His unexpected death was deeply regretted throughout Russian society although he had made no secret of his belief that the cruel inefficiency of the Romanovs would lead to their downfall. Early in his career, like Levitan, he showed a measure of sympathy with the ostensibly reformist aims of the *peredvizhniki*; but although he exhibited with them for several years it was not until 1894 that their leaders abated their hostility to his style and technique and allowed him membership. In 1905, indignant at the brutal way in which the uprisings had been suppressed (he had witnessed events in the palace square from a window in the Academy) he renounced the title of Academician which had been awarded him in 1898. The courage of his action contrasts with Repin's

92. Valentin Aleksandrovich Serov: *Girl with Peaches*, 1887. Oil on canvas, 91 × 85 cm. Moscow, Tretyakov Gallery

decision to do nothing about the matter since he had no proof that the Tsar had ordered the troops to fire on the crowd.

Serov was sympathetic to the various art groupings at the turn of the century, especially to the Mir iskusstva. From childhood he had been encouraged by the Mamontovs and spent many happy days at Abramtsevo where he painted his first successes: *Girl with Peaches* (Plate 92), a study of the daughter of the house, Vera Mamontov, in a sunlit room, and *Girl in the Sunshine* (1888), a celebration of the summer of carefree youth, both works capturing the easy formality of life on the small, country estate. Undoubtedly, it was in the nationalist art and craft atmosphere which prevailed there that Serov imbibed the decorative features of his art; although the linear, silhouette-like manner of Degas and Toulouse-Lautrec as well as the curvaceousness of Art Nouveau were more important influences.

Serov painted a few scenes of peasant and village life, a small group of historical scenes, landscapes (at the beginning of his career he was thought of primarily as a landscapist) and stage settings, but was most at home in portraiture. Established in the last decade of the century as the leading Russian portraitist, he received commissions from Tsar Nicholas II, other members of the Imperial family, and the aristocracy. He eschewed an official manner, preferring intimate characterizations for which he frequently used watercolours. A series of sketches of the ceremonies connected with the coronation of Nicholas II, brilliant in style and technical freedom, illustrate his command of this medium. Very few of the artistic celebrities of the time failed to sit for him and in a variety of manners he captured Korovin (1891), Levitan (1893), Tamagno (Plate 93), Rimsky-Korsakov (1898), Chaliapin (1905) and Stanislavsky (1908 and 1911). A sketch of Anna Pavlova was used as a poster for the first season in Paris of the Ballets Russes of Serge Diaghilev in 1911. His daring nude portrait of the mime Ida Rubinstein, famed for her skinny angularity and exotic beauty, was acquired for the Russian Museum in St Petersburg despite protests over its alleged indecency and the remarkable technique he employed – he left the canvas untinted and used extremely thin, greyish colours for the outlines. Serov never descended to the empty bravura of which Repin and Zorn were sometimes guilty; and the brilliance of his palette made a strange contrast with that of Bastien-Lepage whom he never ceased to admire. There is no denying the effortless wonder

93. Valentin Aleksandrovich Serov: *Portrait of the Singer Francesco Tamagno*, 1893. Oil on canvas, 78.3 × 69.2 cm. Moscow, Tretyakov Gallery

of his skill in oil, watercolour and crayon, nor the striking fluency which links him with Boldini and Sargent. He was clearly indebted to the Impressionists for his vivid but subtle use of colour, to Degas and Toulouse-Lautrec and the Nabis for compositional devices and the firm but sinewy use of line, and to the Post-Impressionists for simplification of shapes and coloured areas: in, for instance, his portrait of Morozov (1902) all these qualities can be seen. Although he could depict with restraint the dignity and dedication of a great actress like Mariya Ermolova (1905) using greys, blues and blacks, towards the end of his life he evolved a bold, painterly style admirably suited to the capture of those shimmering satins, gauzy veils, sables, pearls and opulent luxury with which the society women of the day surrounded themselves. This can be seen in his portrait of the Princess Orlova (1911). His illustrative and narrative work is less happy; and his *Peter I* (1907), pictured as striding along, outlined against the rooftops of his new city of St Petersburg, hardly compares with the work of Menzel from which it seems derived. His *The Rape of Europa* (1910), which exists in seven seemingly unfinished

versions, lacks the forcefulness of his portraiture and is similar to the decorative *panneaux* to be found all over Europe at this time. On the other hand, like Perov, he painted melancholy scenes of peasants making their way across snowy wastes, and he also created a different kind of landscape, sometimes of water, sometimes of land, with horses and men working or relaxing after the day's toil.

Gloomy, bitter, and even rude in behaviour, Serov was a man of difficult personality who in the company of strangers would maintain an awkward silence. His ideals, however, were absolutely sincere; his nature innately aristocratic; and his deep sense of beauty both natural and unforced. His early death was a serious loss to Russian painting. He had brought to it a much-needed note of cosmopolitanism in addition to a distinctly personal manner which never lapsed into mere virtuosity, which was supremely pictorial, and which served to redeem painting from the drabness into which it had fallen at the hands of the less effective members of the *peredvizhniki*.

A friend of Serov and a member of the Mamontov circle was Mikhail Aleksandrovich Vrubel (1856–1910), who began his career as a law student and then went on to the Society for the Encouragement of Art, and from there, in 1880, to the Academy where he studied for four years under the teacher whose name is so frequently recalled with honour, Chistyakov.[8] Born at Omsk in Siberia, of mixed Polish and Danish ancestry, Vrubel was Russian by reason of his birthplace – however, he seems never to have felt an alien in his adopted homeland. His studies in law, interest in literature, and his unusual background lent him a sophistication which was completely foreign to the *peredvizhniki* for whose aims he had no liking. This dislike was mutual and they rejected all the works he sent in for exhibition. As early as 1883 he wrote to his sister that, '... once recognized, the artist does not need to be servile; he has his proper independence, special business of his own, of which he is the best judge, business which he ought to respect and not destroy its significance to that of a journalistic tool.'[9] This comment made in respect of Repin's *Procession of the Cross in the Kursk Province* (1883) indicates that Vrubel had set himself another path from that of tepid social comment. Nor had Repin's easy facility any appeal for him.

In 1884 the Academy was asked to nominate a young artist who could assist with the restoration of wall-paintings in St Cyril in Kiev and its choice fell

on Vrubel who with characteristic fanaticism prepared himself by an extensive tour of Byzantine works in Europe. In Venice, where like many nineteenth-century aesthetes he fell under the spell of Bellini and Carpaccio, he began to understand the Venetian preoccupation with colour. There, too, he saw that the essential quality of Byzantine work rested on its use of mosaic on an immense scale, its disregard of dimension and proportion and its emphasis on monumentality involving the exploitation of large flat or curving walls. He also came to appreciate the overwhelming importance of colour in its relationship with pictorial space, sometimes dominant, sometimes subservient. Without knowing it, he had laid the basis of his own art which was to disdain perspective and naturalistic illusionism and in which the colours corresponded primarily to his own emotions.

His opportunity to win public success seemed to come in 1887 when there was a competition in Kiev for decorations for the Cathedral of St Vladimir built there in the revived medieval style; but the prize went to V. M. Vasnetsov, and Vrubel was asked merely to paint the low side panels to which he eagerly and humbly agreed. First in Odessa and then in Kiev from 1884 to 1889 he lived in poverty, often unable to afford oil paints. He eked out a living by colouring photographs and icons, and even designed costumes for a circus. He was rescued from this plight in 1890 when his friend Serov introduced him to the banker Konchalovsky who asked him to join with Surikov, Vasnetsov and Serov in illustrating *The Demon* by Lermontov. That Vrubel had been fascinated by this poem for years was well known, and not unnaturally his outstanding contribution won him instant fame. Mamontov commissioned work (later in 1897 Vrubel was to paint him sitting in his private theatre looking decidedly Mephistophelean). In the five decorative panels illustrating the legend of Faust requested by the industrialist Morozov historical accuracy and academic realism were thrown overboard as Vrubel surged ahead into swirling seas of colour and violent form. For ten years, he was at the peak of his genius, turning out decorative work of all kinds in pottery, watercolours and oils at breathless, hysterical speed.[10] He was especially fond of pencil drawing, creating for himself an expressive form of cross-hatching. Inspired as always by literature, he studied the verse tales of Pushkin to create startling realizations of *The Swan Princess* and *The Queen of the Sea*; but the subject which continued to hold him in

thrall was *The Demon*. He produced many variations on this subject (which, incidentally, had inspired A. Rubinstein to compose his opera of that name in 1875), moving from visions of a beautiful Lucifer, seated and thoughtful, to a broken and distended creature which united in itself male and female elements and which lies or sits staring wildly into space or glares madly at the spectator. Vrubel's conceptions changed endlessly; he would return to finished canvases and elongate and distort his demon still further or intensify the mosaic of colours. Sometimes he sought relaxation by painting flowers or landscapes, but even in these pictures his impressions of forms jostle, struggle and fight for supremacy as they cascade over the canvas. At other times he turned to sculpture, pottery, stage design

94. Mikhail Aleksandrovich Vrubel: *Design for Jewellery.* Watercolour. Private Collection

95. Mikhail Aleksandrovich Vrubel: *Pan*, 1899. Oil on canvas, 124 × 106.3 cm. Moscow, Tretyakov Gallery

and architecture, particularly from 1889 when he was part of the cultural circle of Mamontov in Abramtsevo, where he was one of the directors of the ceramic workshops there (Plate 94). His draughtsmanship increased in skill and jagged strength, anticipating in its style the monumental simplifications and fragmentation of Cubism and also the energetic restlessness of Futurism. There seemed no limit to his demonic energy. But such terrifying struggles are not without their cost. Mental illness began to overtake him; and from 1902 he was frequently confined to a lunatic asylum until in 1910, his faculties entirely eclipsed, he died.

Vrubel belongs to the group of *peintres maudits* found everywhere in Europe towards the end of the century, restless, unhappy men, ceaselessly striving to express their inner selves, adrift in the wild seas of their own warring emotions, and doomed to early death. Like Munch, Toorop, Gauguin, Van Gogh, Beardsley and Klimt – and especially the latter – his

art was entirely personal, its arabesques and abrupt distortions reflecting the fantastic conflicts of his own soul. Like these artists he created so subjective a style from so many novel and disparate elements that there can be little reference to eclecticism; and he probably travelled more widely than any other Russian artist before him. He was acquainted with the aesthetic movements of the day including Symbolism and Jugendstil, both still comparatively unknown in Russia among artists, and there is a distinctly decorative *fin-de-siècle* appearance to much of his applied work. He moved from an adoration of all things Byzantine to a worship of Persian carpets and oriental glass, seeking in them the strange, iridescent harmonies he introduced into his own work. From the broken reflection of the mosaic cubes he may have gained the idea of using thick slabs of paint to give a refractive quality to his canvases. He showed a predilection for twilight or night scenes as in his *Pan* (Plate 95) and *Nightfall* (1900); and thus was able to restrict the tonal ranges and to concentrate on harmony of mood. High horizons and sightlines helped him to create a tapestry of dark greens, reds, browns and cold blues among which colours he subtly placed touches of lighter blue, violet or red so that his compositions quiver and scintillate. Sometimes he would plaster his canvas with great slabs of paint or construct monstrous floral shapes or he would barely stain the cloth, thus obtaining textural contrasts previously unknown in Russian painting. The poet Bryusov praised the 'peacock sheen of outstretched wings' that Vrubel raised above the 'desert' of contemporary life; and in a funeral oration over the artist's grave Blok rhapsodized about the colour of his sunsets: 'As through a broken dam, the blue-lilac twilight of the world bursts in, to the lacerating accompaniment of violins and tunes reminiscent of gypsy songs.'[11] An apt comparison might be made with Scriabin with whose investigations into the cosmic relationship between sound and colour and symbol his own strivings have clear affinities. And it was the poets of his day, especially such Symbolists as Blok and Bryusov, who recognized the individuality of Vrubel's work and its kinship with their own tendencies in poetry. There can be no doubt of the strong impact of Jugendstil on his development (but Jugendstil had no literary propagandists or poets); and although he was so vastly appreciated by the Russian literary Symbolists it would be factually inexact to claim that he was purely and simply a Symbolist as were, for instance, Redon and Moreau.

96. Konstantin Korovin: *Paris at Night: Boulevard des Italiens,* 1908. Oil on canvas, 64.5 × 53.7 cm. Moscow, Tretyakov Gallery

Vrubel's troubled life both artistically and aesthetically heralds the end of one era and the commencement of another. In his devotion to one major theme, that of *The Demon*, as also in his industry, he resembled Ivanov, but while the latter's originality as a painter, as distinct from the seriousness of his attitude as an artist, had no real effect on Russian painting, Vrubel's example liberated the techniques of succeeding artists and gave them absolute freedom in the choice of subject-matter. Ivanov and some of the *peredvizhniki* saw in the figure of a Russian Christ a symbol of hope for the coming age; Vrubel's life had as its focal point the visual representation of a diabolic force whose divided nature, at once triumphant and melancholy, became a startling and prophetic icon of the horrors that were to be unleashed on Europe in the next decades. It is surely not coincidental that Vrubel exploited the distortions and elongations (in his case, often horizontally) employed by the medieval icon painters, for he was giving to the Russia of his

day a new and terrible icon; and thus, ironically, he asserted the continuity of the icon as a major strand in Russian painting. He brought colour back into Russian painting, disregarded its illusionist values, and exploited its emotional strengths. There is no evidence in his letters that he knew of the Nabis but his use of the canvas space perfectly exemplifies the dictum of Maurice Denis that a picture, whatever it represented, should be in the first place a surface covered by lines and colours arranged in a definite order. In fact, Vrubel almost single-handedly broke the strangling bonds of *peredvizhnik* painting and set Russian painting on a new and vital course.

By the end of the eighteenth century, Levitsky, Borovikovsky and Rokotov had demonstrated the technical mastery of the Russian painter; and so, too, at the end of the nineteenth, Levitan, Serov, and Vrubel proved the dynamism and emotional force and innovative power of the true Russian school of painting.

Naum Gabo likened the impact of Vrubel on late Imperial Russia to that of Cézanne on modern Western artists.[12] And while Vrubel's life and work had an extraordinary effect on his successors, it was another artist of a much less dramatic character whose impact can be seen in painting styles from about 1890. Konstantin Korovin (1861–1939) turned his back on the timid and tentative approaches of the *peredvizhniki* towards Impressionism and eagerly embraced its pictorial methods.[13] He studied at the Moscow School between 1875 and 1886, working under Savrasov and Polenov, and then, in 1882, at the Academy. Korovin soon found his *métier*, that of a theatrical designer; and during the years 1885–91 and 1896–8 he worked for Mamontov's private opera company in Moscow. Later he was to become principal designer for the Bolshoi Theatre and to oversee the work of a major group of Moscow theatres; and he also taught at the Moscow School from 1901. Despite his association with Mamontov he showed little involvement in the neo-Russian decorativeness associated with Abramtsevo, for which, in any case, his dashing Impressionist style was quite unsuitable. He cultivated a broad stroke, brilliant colouring and a deliberately sketchy quality which were evident as early as 1883 in his *Chorister*; and by 1908 his *Paris at Night: Boulevard des Italiens* (Plate 96) seethes with movement and the sparkling colours of Paris at night. No doubt Korovin's theatrical work heightened the tendency to high colouring and the wide effect, but it was possibly a manifestation of his reaction

against the conservatism of the *peredvizhniki*. He remained firmly cosmopolitan, frequently visiting Western Europe. Korovin wrote little; he propounded no artistic theories of an esoteric nature; and his career in Russia was happily, almost absolutely successful; but his achievements and influence outside the theatre have received insufficient attention, much less than is merited by his artistic and technical (as distinct from theoretical) importance.

The artist whose subject-matter embodied the milder aspects of the *fin de siècle* was Viktor Borisov-Musatov (1870–1905), yet another short-lived artist, who chose the forties and fifties of the nineteenth century as the period for his decorative panels.[14] Born the son of a minor railway official who was an ex-serf, Borisov-Musatov had an accident in childhood which crippled his spine. He came from Saratov, a Volga town with strong provincial traditions and a fine art collection. He first studied there, then went to the Moscow School, and, in 1891, studied at the Academy where he was among the last pupils of Chistyakov. He spent less than two years in St Petersburg before returning to the Moscow School and then set off for Paris where for three winters from 1895 he studied under Fernand Cormon and Moreau, then a leading teacher at the Ecole des Beaux-Arts. He was thus brought into direct contact with French Symbolism; and its pictorial side was reinforced by his interest in the poetry of Verlaine and Balmont, a leading Russian Symbolist. Musatov admired Puvis de Chavannes, whose monumental simplifications had a great impact throughout Europe, and Bastien-Lepage whose effect on him is not obvious. With these influences fresh in his mind he returned to Saratov where he discovered a deserted country house built in the neo-classical style of Alexander I and surrounded by a formal but overgrown park, a setting which he used time and time again in his paintings and in which he posed crinolined ladies of the Biedermeier period. Musatov was unashamedly a decorative artist, evoking an earlier and more romantic epoch in which women gaze sadly at their own reflections in a pool or wander in mysterious loneliness through the empty spaces of a silent park, as in *The Reservoir* (Plate 97) or *Sunset Reflections* (1904). Slowly we find ourselves drawn into this shadowy world of misty blues and faded greens in which the characters are too weary even to murmur:

> I am aweary, aweary,
> I would that I were dead!

These large pictures with their expanse of flat colour, often faintly blue or white or with the canvas left unstained, in which the drooping figures of women describe languid arabesques, are related to the so-called decadent movements of the *fin de siècle*, for which, in England, Symonds's *In the Key of Blue* provided the perfect title, and to the wider ranges of Symbolism of which the Blaue Reiter in Germany and the Golubaya roza (Blue Rose) in Moscow were the natural products; and there are other interesting correspondences with the work of Mucha, Munch and the Nabis. *The Pool* (1902) becomes a mirror in whose waters are reflected the artist's emotions, generally a nostalgic and barely defined love for his sister (somewhat akin to Beardsley's love for his sister Mabel) and his bride-to-be. Undoubted as was his belief in the redeeming splendour of womanhood, a proposition much evinced by Verlaine and Balmont in their poetry, there are times when his groups of women suggest a degree of malevolence, reminding us that a potent source of inspiration to the Symbolists were the sinister tales of E. A. Poe.

Musatov concentrated on securing a tapestry-like flatness similar to certain works by Vrubel and to this end he used thinned tempera, thus avoiding a surface sheen and forcing the canvas to be seen as a whole. Here his study of Puvis de Chavannes and

97. Viktor Borisov-Musatov: *The Reservoir*, 1902. Tempera on canvas, 177 × 216 cm. Moscow, Tretyakov Gallery

Maurice Denis came to his aid in solving problems of the organization of pictorial space and avoiding effects of illusionism. In fact, there was a fashion in Europe generally for *panneaux*, a revival of taste for the decorative rococo panels once so favoured an element in room decoration. Of all the Russians who interested themselves in artistic developments in France, it was Musatov who knew most; and references to his work purely in terms of Symbolism neglect his painterly concerns with developments in the work of Vuillard and Denis and Munch and other artists whose explorations were of direct relevance to his own progress. This is not to say he was not at one with the Russian Symbolists; indeed, he fully shared their beliefs in the mystical values of colour: blue, for instance, stood for spiritual harmony, the freedom of the skies, the water of an untroubled pool, and transcendental freedom. And, as with Vrubel, indistinct outlines and a twilight haze reflect the ambivalence and uncertainty of human emotions.

Borisov-Musatov's reputation in his native land was strengthened by reports of his successes abroad, notably in 1904 when he had one-man shows in Germany and in 1905 when a number of his works, including *The Pool*, were exhibited at the Salon de la Société des Artistes Français in Paris. He was friendly with the poets Bely and Bryusov. He became the recognized leader and organizer of the Moscow Association of Artists. After his premature death his fame increased rapidly as the full extent of his achievement became known. As a painter he brought into Russian art an elegant and restrained beauty tinged with mystical nuances which it was never to experience again. He called a halt to the clamorous dominance of the *peredvizhniki*, reasserted Russia's artistic links with Europe, and prepared the way for future innovators. The music of his style ceased with his death but there was no lack of disciples to follow his example.

Almost despite themselves, Levitan, Serov, Vrubel, Korovin and Borisov-Musatov were an inspiration to their contemporaries. Their allegiance to the realism and sentimentalism of the *peredvizhniki* was weak in the extreme; on the contrary they were linked by friendship and professional interest with the members of the group which was almost embarrassing in its self-conscious proclamation of art for art's sake – or, art for the sake of decoration. The group gave itself the grandiose title of Mir iskusstva (World of Art). The importance of Mir iskusstva has been much exaggerated in Western Europe; never-

theless, a brief account of its activities must be given, not only because of its fame throughout Europe, but also because it has a valuable place in the history of Russian painting.[15]

Towards the end of 1889 Alexandre Nikolaevich Benois (1870–1960), who belonged to a family of decorative artists, theatrical designers, architects and musicians, began to hold evenings at his home to which friends and acquaintances interested in art, music, or the theatre were invited. Beginning as the Society for Self-Improvement or The Pickwickians, the group was initially composed of Benois's school-friends but widened to include Konstantin Andreevich Somov (1869–1939) and Lev Samoilovich Rosenberg (who later assumed the name of Léon Bakst) and a well-to-do young provincial called Serge Diaghilev.[16] The artists Serov, Korovin and Nikolai Roerich became interested too. The association was a very loose one and as early as 1890 the members temporarily separated when they went abroad to study for a year or so. At this stage the artists who most interested them were Böcklin, Menzel, Bastien-Lepage, Zuloaga, Puvis de Chavannes, Zorn and the English Pre-Raphaelites. In 1889 they made the acquaintance of a junior French diplomat, Charles Birlé, who was briefly attached to the French Embassy in St Petersburg, and who introduced them to the work of Gauguin, Van Gogh, Seurat and the Impressionists. Another friend aroused their interest in the illustrations of Aubrey Beardsley. By 1896 the strain of earning a living and embarking on a career had begun to tell somewhat and the members of the group began to disperse. Their attention was recaptured by Diaghilev who was excited by the idea of presenting a small exhibition of watercolours by British, German and Finnish artists, and also of publishing a magazine similar to *The Studio*, then comparatively advanced in its devotion to Art Nouveau. This journal, to be entitled *Mir iskusstva*, was to include articles on 'the new brand of industrial art ... developing in Moscow and in Finland'. This reference to industrialism is partly explained by the fact that the journal was to be backed financially by Mamontov and Princess Tenisheva (whose husband was an enormously wealthy financier and industrialist) who herself had turned peasant art into a kind of flourishing cottage industry on her estate near Moscow. The first number, largely devoted to the work of Viktor Vasnetsov, appeared on 10 November 1898, and the last issue, prepared in 1904, came out in the spring of 1905.

Mir iskusstva did not confine itself to painting, for there were articles on music and literature, with particular emphasis on the musical and literary symbolism represented by Blok and Scriabin, Baudelaire, Verlaine and Mallarmé. The very last number was devoted to the Post-Impressionists and the names of Gauguin, Van Gogh, Cézanne, Bonnard, and the Nabis were brought before the St Petersburg public. A number of journals devoted to the arts in Russia continued its work, among them *Treasures of Russian Art* (which had been founded in 1901 under the guidance of Benois), *The Old Years* and *Apollon*.

Publication of *Mir iskusstva* represented only one aspect of the group's activities. Diaghilev's abilities as a writer were limited and he concentrated his gifts on gathering together paintings and works of art for the exhibitions he organized, and on researching for information about the eighteenth-century portraitists he admired. He intended to devote a series of monographs to these artists but only the volume devoted to Levitsky appeared and there exists some doubt as to whether the main text was written by Diaghilev or by the art historian Vasilii Gorlenko – and there may be yet another hand behind his well-known speech on the future of art in Russia 'At the Hour of Reckoning', which he delivered in 1905.[17] As an impresario, however, his genius was beyond doubt. After the minor exhibition of watercolours in 1897 he tried his hand in 1898 with works of the Finnish and Russian schools, including Vrubel, Levitan and Serov, as well as the Vasnetsov brothers, Korovin, Nesterov and Malyutin. A number of these artists had links with Abramtsevo and it was natural that when Mir iskusstva held a large-scale exhibition the following year it should include pottery from the *ateliers* there. In addition, there were embroidery designs by Polenova, glass by Tiffany and Lalique, and paintings from all over Europe, including minor pieces by Degas, Monet, Puvis de Chavannes, Carrière, Boldini, Whistler, Brangwyn and Böcklin. A second Mir iskusstva exhibition on 28 January 1900 showed Serov, Levitan, Nesterov, Benois, Vrubel, Golovin, Somov, Malyutin, Bakst, Lanceray, Dosekin and Yakunchikova, and also pictures by eighteenth-century artists. Next year the galleries of the Academy of Arts were invaded and a number of Moscow artists – Pasternak, Vinogradov, Rylov and Ryabushkin – were represented in addition to the usual members of the group. In 1902, the exhibition became more representative of Russian painting

when Moscow artists belonging to a new society, The Thirty-Six, collaborated. The following year these artists held a competitive exhibition of their own which drew away from the Mir iskusstva some of the more advanced artists; but however much the Moscow artists resented the domination of St Petersburg they continued to send their works for exhibition there, partly because of the economic necessity of finding buyers wherever possible and partly because of the prestige conferred by a showing in the capital.[18]

It was announced in 1905 that Diaghilev was arranging an exhibition of Historic Russian Portraits from 1705 in the Taurida Palace; and the endless pains he took in borrowing these portraits from all over Russia were entirely justified by the results, which the art historian (and painter) Igor Grabar described as of world-wide significance, for there came to light a host of Russian and foreign painters and sculptors ignored until then. Thus was inaugurated a new era in the study of Russian and European art of the eighteenth and nineteenth centuries.

In 1906 Diaghilev tried his hand at yet another Mir iskusstva exhibition of contemporary art which was, if anything, more successful than his previous efforts. Benois contributed a series of sketches of the park at Versailles, Serov showed some portraits including the well-known one of the actress Ermolova, Vrubel sent a portrait of the poet Bryusov in a style which anticipated Cubism, Korovin entered some vivid impressions of Paris, and Roerich had a number of the simplified mountain scenes which he was later to resurrect as backcloths for the ballet *The Rite of Spring*. A second generation of St Petersburg artists, including Bilibin and Stelletsky who specialized in pictures based on the decorative elements of old Russian art, were represented, as were the younger Muscovites. The great success of this exhibition was the retrospective devoted to Borisov-Musatov, an artist much admired by Diaghilev who had already discussed his work in the pages of *Mir iskusstva*. Part of this 1906 collection was sent to Berlin and a small section was shown in Venice in 1907. But also in 1906 Diaghilev presented Russian painting to the world at the Salon d'Automne in the Grand Palais, Paris; it represented a singularly personal choice since the visitor passed from Borovikovsky and Levitsky (the Smolny portraits and the superb portrait of Diderot from Geneva), to Bryullov and Bruni, and thence straight to Levitan, Serov, Vrubel, and artists linked with

Mir iskusstva. The 700 works displayed included a number by such *peredvizhniki* artists as Repin and Kramskoy. At the same time there were concerts of Russian music. The success of these and later ventures encouraged Diaghilev to travel abroad with an opera and ballet company in 1909. Thus was born the Ballets Russes of Serge Diaghilev which was to astonish and delight Europe until his death in 1929.

Among the artists associated with Mir iskusstva were Anisfeld, Bakst, Benois, Bilibin, Dobuzhinsky, Golovin, Korovin, Lanceray, Roerich, Stelletsky, Somov, Sudeikin and Yuon, most of them known in Western Europe for their theatrical designs. They were all decorative artists, although not without well-founded pretensions to be regarded as serious easel painters.

Léon Bakst (1866–1924), born in Grodno, studied at the Academy of Arts under Chistyakov from 1883, and then in Paris in the studio of Jean-Léon Gérôme, at the Académie Julian, and with A. Edelfelt. His remarkable talents as a draughtsman, portraitist and colourful theatrical designer – and although he is famed for the brilliant and barbaric colouring of his oriental settings, he was equally sensitive to ancient Greece, Egypt and both Italy and France of the seventeenth and eighteenth centuries – were recognized from the beginnings of his career, but this did not save him from the anti-semitism of Nicholas II's bureaucracy, and he was exiled from St Petersburg in 1909. Thereafter he worked in Paris where he had many patrons including Ida Rubinstein whose beauty he had helped to publicize. Levitan and Bakst mark the ascendancy of the Jewish artistic genius which becomes increasingly important in the history of twentieth-century Russian painting.[19]

Alexandre Benois was almost entirely self-taught apart from a year at the Academy (1887–8) and a spell in Munich in 1890. An able if somewhat prejudiced art historian and critic, he was a brilliant designer for the stage, as well as a decorative painter and illustrator. As an organizer of exhibitions and artistic journals he became a central figure in Russian painting during the pre-revolutionary years. From 1918 to 1925 he was curator of the picture gallery of the Hermitage. He frequently moved between France and Russia until 1926 when he made his home in Paris without, however, giving up his Soviet citizenship. Benois was a man of wide-ranging culture, most at home in eighteenth-century Russia and seventeenth-century France. His designs

for *Petrouchka* may not be very original, but they have never been surpassed in colouring, layout and effectiveness. He made many copies of his theatrical designs as well as sketches of the palaces and parks of Peterhof and Versailles; and although at first glance the dots, fragmented outlines and simple penstrokes which he used in his watercolours, rather in the manner of Guardi, appear to look amateurish they are actually part of the practised style of a cunning master who knew how to charm and beguile. Benois never possessed the bold colour sense of his rival Bakst, but he was more sensitive to the needs of theatrical production and certainly more versatile: his *Breton Dances* (1906), a finely composed picture in its own rights, shows his receptivity to Gauguin and aspects of Post-Impressionism as Bakst, slightly later, was to show his awareness of Fauvism. Benois was endowed with tremendous vitality and creative energy so that his long years as painter and critic had a far wider impact on the history of Russian painting than is generally admitted.[20]

Ivan Yakovlevich Bilibin (1876–1942) studied at the Academy of Arts under Repin. His principal interests lay in theatrical design and book illustration; and the series of fairy-tales he illustrated in 1899 are among the finest of that period. From 1908 he lived in England and France, but in 1936 returned to the Soviet Union where he became professor of theatrical design at the Academy of Arts in Leningrad. He died during the German siege in 1942. Bilibin assisted with the designs of the settings and costumes for Mussorgsky's *Boris Godunov*, one of Diaghilev's early triumphs in Paris, in conjunction with Yuon and Dmitry Stelletsky (1875–1947), who, like himself, specialized in pastiches of early Russian art, especially of icon painting but with particular emphasis on excellent draughtsmanship. Mstislav Valerianovich Dobuzhinsky (1875–1957) trained with the Society for the Encouragement of the Arts at St Petersburg, and then with Ažbe and Hollosy in Munich. In 1926 Dobuzhinsky left the Soviet Union and earned his living designing for theatres abroad. His pleasingly vivacious but rather fussy designs never met with the success they deserved – for he was sometimes the equal of Bakst and Benois with a seriousness, especially in his attitude to urban life, as in *Window of the Hairdresser's Shop* (Plate 98), which was usually beyond their range.[21]

Aleksandr Yakovlevich Golovin (1863–1930) possessed a talent of a different order. As an archi-

tectural student in Moscow he fell under the spell of the theatre to which he devoted his career. His portrait of *Chaliapin as Boris Godunov* (1912) is an impressive, dramatic piece which exactly captures the singer's personality. Above all, Golovin was a colourist, taking inspiration from folk art in his early career: his designs (those he made for Stravinsky's *The Fire-Bird*, for example) were beautiful, imaginative mosaics of colour, possibly indebted to Vrubel, even when they proved impractical and over-elaborate for the stage. His magnificent designs for Lermontov's *Masquerade*, presented on the eve of the 1917 revolution, were taken as both heralding and inaugurating a new era in the theatre.[22] Konstantin Korovin has already been mentioned for his spreading of the gospel of Impressionism and his success – despite an inclination to slapdash organization in too many of his paintings – in weaning Russian artists away from the dull palettes and finicky brushwork of the *peredvizhniki* and the

98. Mstislav Dobuzhinsky: *Window of the Hairdresser's Shop*, 1906. Charcoal, gouache and watercolour, 28.2 × 20.9 cm. Moscow, Tretyakov Gallery

fascinating but idiosyncratic tonality of Surikov. Despite his many pictures, often of French life, in which brilliant sunshine annihilates firm outlines and invests humans, furniture, flowers and architecture with a sparkling radiance, Korovin's qualities do not relate to the Mir iskusstva (of which he was an engaged member), for its modernism too frequently showed itself – paradoxically – as decorative antiquarianism or applied art. Even so, Korovin's inclusion within the Mir iskusstva shows its eclectic, tolerant nature.

Among the rather younger members of the group was Nikolai Roerich (1874–1947) who first studied law before going on to the Academy of Arts where between 1893 and 1897 he worked under Kuindzhi. In 1900 he was at the studio of F. Cormon. Throughout his life he showed a fundamental concern with anthropology, archaeology and esoteric religions rather than with pure painting. He created thousands of large decorative landscapes ·in some of which can be seen the simplified and heavily outlined figures of primeval men and animals. The flatness of these scenes which deliberately avoid any illusionistic effect is derived from Levitan, Puvis de Chavannes, Gauguin and the Nabis. For Diaghilev he created the costumes and settings for the Polovtsian Dances from Borodin's *Prince Igor* and for Stravinsky's *Rite of Spring*. His work changed little over the years. He travelled through America, Europe, India and Central Asia until his death at a Himalayan research station which he had directed since 1928.[23] The man who translated the designs of these artists into actual stage settings was Boris Israelevich Anisfeld (1879–1973), who had studied at the Academy and was an able landscapist and designer in his own right.

An artist of distinction whose style is sometimes close to that of his great friend Benois was Konstantin Andreevich Somov (1869–1939). He was one of the earliest members of the Mir iskusstva, but was estranged from Diaghilev by 1910 and thenceforth went his own way. Somov was a son of the Keeper of the Department of Paintings at the Hermitage and studied under Repin at the Academy. For several years he lived in company with the Benois family in Paris and then moved between Russia and the USA before finally settling in Paris. Somov was a sensitive portraitist as the very fine portrait of Blok (1907) amply demonstrates; but he found stylized rococo scenes set in formal gardens and bowers too easy and lucrative; his costume pictures of crinolined ladies and their cavaliers, harlequins, cupids and

99. Evgeny Lanceray: *The Empress Elizabeth at Tsarskoe Selo*, 1905. Gouache on paper, 43.5 × 62 cm. Moscow, Tretyakov Gallery

classical characters frequently degenerated from a sugary sentimentality to a coy eroticism – perhaps the consequence of his own despairing character. Yet he was as gifted as any artist of his generation; and study with Vereshchagin, Repin and Chistyakov, as well as with Colarossi in Paris, gave him a precision of line that bears comparison with Ingres.[24] Sergei Yurievich Sudeikin (1882–1946), a former student of the Moscow School, helped Diaghilev with the organization of the famous exhibition of Russian painting in Paris in 1906.[25] He also translated the sketches of Bakst and Roerich into effective theatrical backcloths, utilizing the experience he had gained with Mamontov's opera company in Moscow. After the revolution he worked in America and Paris where his witty designs for the *Chauve-souris* revues were much appreciated. Sudeikin was a colourful painter (as can be seen from his designs for ballets such as that based on Rimsky-Korsakov's *Sadko*), who was among the first of his generation to exploit folk art and, in particular, the *lubki* (books of popular and primitive woodcuts). Evgeny Evgenevich Lanceray (1875–1945), like Benois, to whom he was related, was of foreign descent. He studied with the Society for the Encouragement of the Arts and then went to Paris where he studied with J. P. Laurens and J. J. Benjamin Constant at the Julian and Colarossi academies respectively. On his return he became a close member of the Mir iskusstva group. He was drawn to St Petersburg of the early eighteenth cen-

tury (Plate 99), and specialized in evocative illustrations of life in that city, sometimes drawing inspiration from Menzel, but more often relying on his own excellent sense of architectural composition and design. After the revolution Lanceray was to enter another equally valuable phase of his career.[26]

There were several peripheral Mir iskusstva artists, among them Kustodiev, Bogaevsky and Serebryakova. Boris Mikhailovich Kustodiev (1878–1927) was born in Astrakhan and began his art studies there. He studied at the Academy under Repin, Stelletsky and Savinsky, and then in France and Spain. He presented a colourful impression of old Russia, its festivals and traditions – a world in which everyone is happy, exceedingly well-fed, richly clad and prosperous. His style is decorative based on firm outlines and glowing colours. There may be a sly irony behind these jolly scenes of Russian life but it is hard to detect; nor is it easy to find any of the symbolism which lay behind the work of most of the Mir iskusstva artists.[27] Konstantin Bogaevsky (1872–1943) studied with Fessler and Aivazovsky in Feodosiya, his birthplace, before going on to the Academy and, later still, the studio of Kuindzhi. Bogaevsky's landscapes, based perhaps on memories and visions of the Crimea, are imaginary, stylized, a little reminiscent of the backgrounds to Italian Quattrocento frescoes, linear and austere, and yet decorative. In contrast, Zinaida Serebryakova (1884–1967) returned to the scenes of peasant life which had been the subject-matter of Venetsianov and his pupils in the first half of the nineteenth century, but brought a wide range of colour and a more monumental aspect to her pictures.[28]

It might well be asked what effect Mir iskusstva had on Russian painting; and the answer must be, comparatively little. The original basic conviction of the *peredvizhniki* that art and literature should serve the ends of social, moral and national progress and that the subject-matter should count for more than technique was despised by Mir iskusstva, without, however, their being able to substitute other aims except a somewhat nebulous symbolism. They were themselves far from rejecting the concept of a national art but their frontiers were somewhat wider and less aggressively proclaimed. While the *peredvizhniki* declared that they could not breathe in St Petersburg, Mir iskusstva revelled in its history and former splendour. They adored the rococo of Elizabeth I as well as the baroque of Catherine II,

the neo-classicism and Empire style of Alexander I, and the Biedermeier of Nicholas I. At the same time they were strongly aware of the vulgarity of contemporary court life and the Tsar's lack of interest in things artistic: Benois noted with astonishment the indifference of Nicholas II to the superb portraits of his ancestors displayed at the Historical Exhibition of 1905. At the same time, for their journals and for their activities in Paris they relied on direct financial aid from Nicholas II. They tried to restore St Petersburg as Russia's artistic capital (although they intensely disliked the Academy which they believed had fallen under the control of the *peredvizhniki*), and without exactly proclaiming a doctrine of art for art's sake (an aesthetic with which Serov, who had a highly developed social conscience, would never have agreed) insisted on the decorative role of art and its independence of social criticism. The *peredvizhniki* were generally regarded as vulgar buffoons, albeit powerful and dangerous ones; and '*peredvizhnichestvo* ... meaning by this everything which reflected a literary, political or social tendency ...'[29] was the special object of their scorn. Even here they were divided. Diaghilev admired Viktor Vasnetsov whom Benois detested; and whereas Diaghilev thought most highly of Bryullov, Benois wrote, 'Bryullov is a vulgarian, and if no one has scored him off as he deserves, it is because our society, and even our painters, lack any real and true feeling for art.'[30] Besides, the Mir iskusstva painters themselves often tackled *peredvizhnik* subjects: Bakst laboured on *The Misalliance, Despair* (a woman about to throw herself under a train), and *Judas conversing with Christ*, while Benois covered yards of canvas with *Peter the Great looking out over the Gulf of Finland*. Benois went so far as to arrange an exhibition of the Moscow *peredvizhniki* in Munich in 1895; and, largely in connection with his journal, Diaghilev had contacts with such realists as Repin, Malyavin, and Elena Polenova (1850–98) and Mariya Yakunchikova (1870–1902), the last two illustrators of the neo-Russianist variety with a particular interest in applied folk art. There was even a social link since Bakst married the daughter of Tretyakov for whose encouragement (and money) the *peredvizhniki* had been vastly indebted. On the other hand, there were considerable social differences between members of the two groups, for, in general, the Mir iskusstva artists were neither sons of serfs nor peasants, nor were they orphans or illegitimate, but came from middle-class or aristocratic homes with parents of an intellectual

or artistic nature and, frequently, of foreign descent. Igor Grabar summed up the nature of the group:

> Above all, it would be profoundly wrong to consider the World of Art, though an error frequently made, as a sort of ideological and aesthetic front, composed of artists of the advanced groups, who with a symbolism borrowed from the west, opposed our native realism. There never was, either in its dawn or evening twilight, a moment when the World of Art presented a common united front, whether political, social or even purely artistic....[31]

The work of the Mir iskusstva designers now forms part of the cultural tradition of the West and since none of Diaghilev's productions was ever seen in Russia (although *Carnaval, Les Sylphides* and *Pavillon d'Armide* were conceived and presented in their first form there), they can hardly be said to have influenced the course of painting in Russia. It was ironic that the ballets most prized by the group and which seemed to them to reflect the European links and traditions of St Petersburg – *Giselle, Pavillon d'Armide*, and *Sleeping Beauty*, for instance – were the least popular in Western Europe, whereas the barbaric savagery of the Polovtsian Dances from *Prince Igor*, the exotic *Cleopatra* concocted from various pieces of Russian music, *Le Festin*, a potpourri of folk dances, and the sensuous and startling *Scheherazade* were the victories of the first seasons. The French art critic Louis Réau was justified in exclaiming that Russia now showed she could export new forms of art and send artists abroad who no longer came as pupils but as initiators and innovators capable of actually giving lessons to Western Europe. This was, in fact, a major justification of Mir iskusstva, apart from its own artistic successes. It also enabled Russians to become familiar with a limited number of aspects of Symbolist and decorative (or, as Stasov had it, decadent) art in the West but, more important, it absolutely proved the genius of the Russian painter for theatrical design.[32] Ironically, however, as artists in the past had gone abroad as pensioners of the Academy, and as the *peredvizhniki* had depended on the patronage of the new industrialists and the court circle headed by Alexander II, so Mir iskusstva also relied on assistance from industrialists and the exchequer of Nicholas II. Several years ago an art historian, herself of Russian birth, was able to state:

> This aspect of the activity (theatre design, that is)

of the 'Mir iskusstva' group is hardly known in Russia itself, and it is only natural therefore that their art should be very differently regarded in that country.... When reading accounts of 'Mir iskusstva' the Western reader should remember the very different evaluations of the group made in the country of its origins and abroad.[33]

This is no longer true, for the Mir iskusstva and its adherents have become the subject of scholarly research and public interest in the Soviet Union.

Mir iskusstva cannot be ignored in any history of Russian painting; and it was a potent and unique force in the history of European – and, indeed, world – culture. At the same time it can hardly be categorized as a moving force in Russian painting; it contributed nothing new in technique or subject-matter. In fact, Mir iskusstva was a cultural grouping, demonstrating once again the admirable propensity of the Russian intelligentsia to unite in a common cause whether it be artistic, social or political.

8
Painting in Ferment

The period from 1905 to the outbreak of war in 1914 produced an astonishing generation of artistic, literary and musical revolutionaries. Moscow and St Petersburg were intellectually linked with Paris, Munich and Milan whence came audacious artistic innovations, among which aspects of Post-Impressionism, Fauvism, Cubism and Futurism took leading place. In Russia were born in pell-mell fashion such movements as primitivism, Rayonism, Cubo-Futurism, Suprematism and Constructivism. All these 'isms' succeeded or overlaid each other with bewildering rapidity, astonishing fertility and ferocious fanaticism. Among the most distinguished names are those of Larionov and Goncharova, followed in time by those of Malevich and Tatlin; but the history of the period must be written as much in terms of groups and exhibitions as of personalities and movements. There are distinct difficulties in writing a lucid historical account of this period. To simplify is to ignore the richness and complexity of cultural life and the interrelatedness of the arts; to follow the careers of a limited number of artists is to neglect the contributions of others of real merit; and to concentrate on movements is to falsify the variety of the scene and the individual achievements of painters and poets – and many individuals were as able with the pen as with the brush. But two facts are clear enough: one is the vitality of artistic life and the other is the emergence of Moscow as the artistic centre of Russia.[1]

We must take account of a number of factors which in their various ways directed and influenced Russian painting from 1905 – collectors and patrons, art journals, exhibitions of foreign paintings, and political events. The patronage of the *peredvizhniki* by self-made millionaires, of whom Tretyakov, Tsvetkov, Mamontov and Prince Tenishev[2] were typical, ceased about this time. The activities of Princess Tenisheva, a gifted, artistic woman, will

be mentioned later. Pavel M. Tretyakov and his brother made only infrequent purchases after they presented their collection to the city of Moscow in 1892.[3] A younger generation of collectors arose in Moscow, among them Shchukin, Morozov and Nikolai Ryabushinsky. They were of a different order from their predecessors being investor-collectors who were not afraid to take risks in the field of advanced painting.[4] Sergei Shchukin (1854–1937) first came across the work of the French Impressionists in Paris in 1897 when Botkin (a son-in-law of Tretyakov and himself owner of an important modern collection) took him to Durand-Ruel's shop and called his attention to the works of Monet there. Shchukin immediately bought Monet's *Lilas d'Argenteuil*. From then on he specialized in contemporary French works, visiting Paris every year to make further acquisitions: Manet, Pissarro, Sisley, Degas and Fantin-Latour soon appeared on the walls of his home, a former Trubetskoy palace, to be joined by a Cézanne about 1904, and then by Van Gogh, Gauguin, Douanier Rousseau, Derain and the Nabis. He began to collect works by Matisse with whom he became friendly and who came to Moscow in 1911 to superintend the hanging of his pictures in Shchukin's home. In 1908 Matisse had introduced him to Picasso, fifty of whose paintings were to arrive in Moscow by 1914.[5]

Ivan Morozov (1871–1921), on the other hand, concentrated on the Nabis and, in particular, on Maurice Denis who paid several visits to Russia. After meeting Matisse in 1908, Morozov's tastes changed and he purchased a few of the artist's early works and then, as his enthusiasm grew, went on to acquire a large number. The important fact is that these collectors opened their doors to the public, allowing students, painters and connoisseurs an opportunity to see modern French painting in quantities and conditions which could not be equalled in

France – nor, indeed, anywhere else in Europe. Thus, in a sense, there took place an educative process not dissimilar to that of the eighteenth century when numbers of the distinguished practitioners of the West found their way to Russia and passed on their styles and techniques; for now, after the comparative xenophobia and isolated conservatism of the *peredvizhniki* (and the Mir iskusstva, several of whose members did not like contemporary French art), those young painters who so wished were able to see for themselves in a concentrated and potent form the dramatic changes which had taken place in French painting. Shchukin and Morozov between them brought to Moscow more than 350 Impressionist and Post-Impressionist pictures, a feat in which they came near to rivalling the *coups* of Catherine the Great.

Other means by which Russian painters became aware of recent developments both in and outside the country were the excellent journals available. When *Mir iskusstva* ceased publication in 1904 its place was taken by *Zolotoe runo* (*The Golden Fleece*), which began in 1905 (with its last number dated 1909) under the direction of Nikolai Ryabushinsky, member of a wealthy banking family, himself a painter of ability, who had a fine collection of French works, including some magnificent Rouaults which perished in a fire in 1911. The link with France was strongly emphasized (not unnaturally in view of the fact that the two countries were drawing close together politically and that France was paying out heavy cultural subsidies) by the magazine being printed in both Russian and French. There were other journals of importance which covered similar areas. *The New Way* of 1903–4, *The Scales* which appeared in 1904, and *Art* which came out in 1905, although short-lived in each case, underlined the interrelatedness of the arts. The *Art Treasures of Russia* which Benois began to edit in 1901 and the *Old Years* and *Apollon* which began in 1907 and 1909 aroused interest in the great collections inside Russia and its wealth of Byzantine treasures, oriental art and icon paintings. *Apollon* carefully listed and described exhibitions held from 1909 to 1917.

There were also exhibitions of West European art during this period. What was probably the first exhibition of contemporary French art took place in 1888 when works by Bastien-Lepage, Jules Breton, Fortuny and other fashionable, cosmopolitan artists were shown. There were frequent exhibitions in the following years, one of the most famous being that of 1891 in Moscow when Vasily Kandinsky saw and was enthralled by one of Monet's *Haystacks*.[6] There were also exhibitions of German art with works by a diversity of artists including Menzel and Lenbach. The importance of these exhibitions has been insufficiently recognized in comparison with the emphasis that has been attached to the private collections in Moscow, possibly because documentation is poor and partly to play up the more physical cultural links implicit in Russian artists studying in France or in officially sponsored cultural activities. In general, the Mir iskusstva group extended its sympathies, under the direction of Benois, towards France and England; but the predilection for French art (and social life) was marked in the majority of groups, certainly from 1900 onwards. Yet this is to ignore a vital indebtedness to mid-European painting: throughout the nineteenth century Russian painters were aware of artists whose work not only seemed in sympathy with their own tendencies but who also served to urge them forward or to provide models. Thus, we become aware of links between Karl Blechen and Shchedrin; Ferdinand von Rayski, Ferdinand Georg Waldmüller and Venetsianov; Emil Janssen, Johann Friedrich Overbeck and Ivanov; Adolf von Menzel and Repin and Surikov; Caspar David Friedrich and Vereshchagin; Arnold Böcklin and Alexandre Benois; Max Liebermann and Serov; M. Klinger, F. Stuck and Vrubel, to mention some of the more outstanding relationships.[7]

It must be remembered, too, that many Russian painters travelled, studied and worked in different areas of Europe at the turn of the century. Among them were a number who were to have a profound effect on the development of painting outside Russia, notably Kandinsky and Chagall. Paris was by no means the most favoured or effective school, and Munich was often preferred as being altogether more serious, especially since Ažbe, the leading teacher there, enjoyed a high reputation for skill and tolerance. The Russians in Munich formed a cultural circle on their own, the celebrated partnership of Marianne von Werefkin and Jawlensky paralleling that of Goncharova and Larionov in Moscow and (somewhat later) Paris. Artists who worked in the Western centres brought back word of the newest developments. The pre-revolutionary years saw the assimilation (and in some cases rejection) of Symbolism, Fauvism, Cubism and Futurism, and their integration with cruder and consciously Russian pictorial matter and manner or with

private semi-mystical, symbolical or non-figurative forms. Whatever seed came to Russia flourished in colourful vitality and was metamorphosed on its fertile soil. Without it being realized at the time there was under way a struggle for supremacy between the advanced art styles of the West – that is, of Munich, Milan and Paris – and qualities which were peculiarly Russian and Muscovite, a conflict sometimes veiled even to the participants. Thus these years are concerned with the establishment of a new Russian school, fertilized and fortified, it is true, by ideas from elsewhere, a school whose initial manifestation was primitivism and which drew on the heritage of Korovin, Serov and others.

One of the agencies behind the neo-Russianism of these years has already been mentioned – the artistic colony at the small house at Abramtsevo, near Moscow, belonging to Mamontov. Mamontov had bought this wooden house of historic interest in 1870 and together with his wife entertained leading artists, writers and musicians there during the summer months. The private opera company which he set up was later reorganized at the Krotkov Private Opera House. In 1899 Mamontov was charged with mismanagement of funds. He was tried and imprisoned for a short time but eventually released and allowed to go his own way. His fortune had gone and he was unable to support any artistic enterprise for any length of time.[8]

Abramtsevo had a revivalist, neo-Russianist approach, inherited in part from the Populist tendencies of the mid-seventies which, as we have seen, increasingly drew inspiration from folk art and Muscovite life before the changes of Peter the Great. It was this colourful and vivid ancient art which Abramtsevo endeavoured to revive and which through the media of furniture, embroideries, stage settings and costumes, pottery and illustrated books it was able to introduce to a wider public. Artists like Repin and Serov and Polenov who had been trained in the dominant school of socially significant genre painting found their way there, but it was above all Surikov who became the early idol of the group. He was the artist who seemed to have created a Russian palette which was to be borrowed and exploited by Korovin, Golovin, Vrubel, Bakst and other designers. Although his sympathies lay with Moscow and the more colourful aspects of neo-Russianism, Mamontov agreed in 1898 to finance the publication of *Mir Iskusstva* – which was almost wholly French in sympathy and devoted to the past of St Petersburg – to the tune of 12,000 roubles.

However, his luck broke the following year and it is doubtful whether he was able to continue this subsidy.

Another 12,500 roubles was provided by Princess Marya Kladievna Tenisheva (1862–1928), who founded an artistic colony on an estate at Talashkino, near Smolensk, bought by her second husband in 1893. Princess Tenisheva's interests flitted rapidly from opera (she had wanted to be a singer in Mamontov's private company), to factory schools, and to the foundation of an art college directed by Repin at St Petersburg between 1895 and 1898. To her estate she attracted artists, Roerich, Malyutin, Vrubel, Korovin and Golovin among them, most of them also linked with Abramtsevo. Like Mamontov, she was also under the spell of William Morris and the English Arts and Crafts movement. Although generally interested in the preservation, revival and propagation of Russian peasant art and craft, her atelier produced quite sophisticated iron work, enamels, wood-carvings and pottery. There was doubtless an element of aristocratic resistance to the pressure of industrialization in these artistic colonies (although Mamontov could hardly be said to be aristocratic in origin and Prince Tenishev's fortune came from industry), but, equally, there was a potent encouragement of craftsmanship, simplicity and artistic sincerity, as well as a recognition of the nation's artistic heritage. Yet it would be hard to maintain that Abramtsevo and, still less, Talashkino made a positive contribution to the progress of Russian painting as such – but they did provide generous hospitality to artists and indicated that there were valid areas of subject-matter and varieties of style other than those which had been reserved to themselves by the *peredvizhniki*.[9]

The art scene was complicated still further by the fact that as Moscow began to emerge as the creative centre of Russia there were struggles for supremacy between its artists and those of St Petersburg. The Moscow School of Painting, Architecture and Sculpture had for long been the most progressive and radical teaching institution in the country; although it is only fair to say that the Academy gave its students a training in draughtsmanship and techniques which forever distinguished their work however trite or uneven the quality of the pictorial composition. An important aspect of the conflict was the quest for patronage: there were too few collectors in Russia for the increasing numbers of artists striving to earn a living, especially after these collectors turned their attention to the acquisition

of foreign and, in particular, French works. What was educational for the artist (in the ready availability of contemporary French paintings in private collections) was, paradoxically, much less helpful to them in the struggle to earn a living by selling their own works because the collectors had neither the interest nor the money to buy these home products. This led to the frantic endeavours by Russian artists to overleap, as it were, the foreign schools of painting, partly by means of wild publicity and partly, but ineffectively, by their own advanced work – ineffectively because the artists of the period 1910–17 never found a patron to equal Tretyakov or Shchukin or Morozov.

An early manifestation of these struggles came when in December 1901 there was held at the Stroganov school, Moscow, the first exhibition of a new and heterogeneous group called The Thirty-six (because it was composed of thirty-six artists), largely in opposition to Diaghilev and Mir iskusstva who exercised (as they thought) too patronizing a control of the selection of Muscovites for inclusion in their St Petersburg exhibitions. Since 1893 there had existed the Moscow Association of Artists (which lasted until 1924), and there now came into being the Union of Russian Artists (1903–23), which held its first exhibition under the guidance of Leonid Pasternak at the Stroganov school in December 1903 and continued in 1904 with a showing at St Petersburg.[10] There was not at first any ostensible friction between the Moscow societies and Mir iskusstva and, in fact, both were under the influence of the more conservative elements in late nineteenth-century French painting. Painters from both cities participated in the major Mir iskusstva exhibition of 1906.[11] But Diaghilev was losing interest in contemporary Russian painting and had been preoccupied the previous year with the exhibition of Historical Portraits held in February 1905 at the Tauride Palace, St Petersburg, introduced by a catalogue compiled under the patronage of the Grand Duke Michael. This was a resplendent exhibition, hung with lavish care; and after its resounding success Diaghilev bowed himself out of the limited world of art within his motherland.

Little is heard of some of the Muscovite artists of the older generation, but their work is not without interest. Leonid Osipovich Pasternak (1862–1945) studied in Odessa and then in Munich, and was to end his days in Oxford whither he had emigrated with some of his family. He was a popular teacher at the Moscow School and an able portraitist in oil and crayon, often utilizing a tenebrous manner which was probably derived from Carrière. Filip Andreevich Malyavin (1869–1940) began adult life as a lay brother in the Russian monastery on Mount Athos but was encouraged to leave by a visiting artist.[12] He then studied at the Academy of Arts under Repin (1892–9); and in 1903 joined the Union of Russian Artists. In a short time he was an international artist of some repute. Malyavin was a clever draughtsman and portraitist, but made a speciality of highly coloured groups of peasant women, their scarlet and multi-coloured skirts awhirl on the wind, their tiny faces glowing brown above layers of clothing. Sometimes they laugh mockingly. These bright pictures, exuberantly dashed down on canvas with generous strokes of paint, have something fetishist about them – an undoubted fascination with women's garments and, at the same time, a frightening sense of suffocation, of being stifled beneath layer upon layer of clothing. Arkady Aleksandrovich Rylov (1870–1939) studied at the Stieglitz Institute and at the Academy under Kuindzhi.[13] He was noted for his clear landscapes, the best known of which is *In Blue Space* of 1918 which depicts white swans flying over the sea against a blue sky, a symbol of the new life afforded by the revolution of the previous year.

Sergei Arsenievich Vinogradov (1869–1938) specialized in landscapes and genre scenes, largely of peasant life, into which he introduced the bright tints associated with Impressionism. Igor Emmanuilovich Grabar (1871–1960), a distinguished art historian and museum curator, was one of the first Russian painters to take over the manner and the palette of Impressionism, producing some extremely sensitive scenes of the landscape under snow.[14] Sergei Vasilievich Malyutin (1859–1937), a portraitist of ability, illustrated folk tales in a style derived from traditional and peasant art; while Konstantin Fedorovich Yuon (1875–1958), a student under Savitsky, Arkhipov, Korovin and Serov, prominent as a teacher and as an organizer (he was the principal organizer of the Union of Russian Artists), was a painter of lively scenes of old Russian life as in *Driving to the Trinity Monastery* (1903). Among other artists associated with the Union were Piotr Petrovichev, Stanislav Zhukovsky and Leonard Vasilievich Turzhansky (1875–1945), well known for his scenes of rural life and for his teaching.[15] These fairly conservative artists, utilizing a technique derived from Impressionism, often with thickly laid on paint, represent the growing strength

of Moscow. The Union of Russian Artists, Mir iskusstva and the *peredvizhniki* were all to continue their activities through the years up to the outbreak of war; and we must remember this when more dramatic and sensational movements come to the foreground and grasp our attention.

The end of 1906 saw a void in the creation of new groups which was rapidly filled by Nikolai Pavlovich Ryabushinsky (1876–1951) whose home The Black Swan had pretensions to becoming a cultural centre in Moscow. He was keen to involve himself in the arts and this he did, as we have noted, by publishing *The Golden Fleece* from 1906 to 1910. It promoted painters of all tendencies, including among its *protégés* Nesterov, Vrubel, Lanceray, Benois, Malyavin, and Anna Petrovna Ostroumova-Lebedeva (1871–1955), a talented graphic artist and painter who had studied under Whistler (whose influence on Russian artists of this period was not inconsiderable), and who had informative links with the Russians in Munich.[16] Valuable as was *The Golden Fleece*, it was the exhibitions held under its auspices and its encouragement of the Symbolist movement which have ensured its fame.

There had emerged at Saratov – an industrial city on the eastern Volga which had a lively art school, a fine teacher called Baracci, and the Radishchev Museum which contained a collection of pictures by Adolphe Monticelli (1824–86) – a movement which was to have a brief but resounding existence. In May–June 1904 a number of former art-school students held an exhibition under the title of *Alaya roza* (The Scarlet Rose), in which the canvases of Borisov-Musatov and Vrubel which were shown had clearly served as exemplars to the other exhibitors: Kuznetsov, Sudeikin, Utkin, Sapunov, Saryan, Arapov, Knabe, Feofilaktov, and E. V. Aleksandrova, the wife of Borisov-Musatov. These painters decided to change the name of the group to the *Golubaya roza* (The Blue Rose), and held an exhibition in Moscow in March and April 1907. It was a carefully contrived exhibition, dandified in style, with carefully chosen floral decorations, a twilight blue-grey colour scheme and, in the evenings, displays of Greek dancing as well as performances by Scriabin, Rebnikov and Cherepnin. The poets Bely, Bryusov and Remisov read their latest work. There was not a realistic picture in the exhibition. In fact, the Blue Rose event was a manifestation of the unity of the arts under the prevailing banner of Symbolism.

The Blue Rose painters aimed at an effect which was as much psychological as symbolical, which was spiritual and personal and only remotely concerned with concrete reality. The origin of the name itself is in doubt. As has been remarked, the colour blue was especially significant for Symbolists throughout Europe, representing not only the sky, the higher universe into which the spirit soared but spirituality itself. There were undoubtedly links with 'die blaue Blume', the lovely blue flower which opens to disclose a tender human face in the novel *Heinrich von Ofterdingen* (1802) by Novalis and known to the Symbolists. Further uses of blue are to be seen in Maeterlinck's *The Blue Bird* (1906), Whistler's *Nocturnes* and Picasso's Blue period (1901–4). Esoteric cults, Symbolism among them, were common throughout Russian society at the time; but it was the poet Andrei Bely (1880–1934) who, as a very young man, delivered the vague but potent creeds that the Blue Rose painters tried to implement in their pictures. Like Walter Pater before him, Bely insisted on the supremacy of music to which the other arts aspired, particularly by the abandonment of realistic imagery. Instead there would be a new kind of imagery born of rhythm and movement which although an integral part of the picture would move beyond it into the sphere of endless space and time. Hence the imprecision of form, the indifference to illusionism, perspective and local colouring, the use of tints which referred to feeling and inner sensation, and the use of such themes as birth, fountains and nomadic life in which there is innate a sense of movement, rhythm and enduring time. The ideas of the Blue Rose painters, indistinct as they were, found expression in the short-lived journal *Iskusstvo* (*Art*) founded by Nikolai Tarovaty who was able to publish only eight numbers before closing down in 1905. The following year, as we have seen, their work became more widely known through the pages of *The Golden Fleece*.

The Symbolist movement in painting, largely as represented by the Blue Rose, was in existence only between 1904 and 1907. It found outlets in stage design, illustration and easel painting. The nucleus of the group comprised Kuznetsov, Sapunov, Saryan and, to a lesser extent, Sudeikin, since his interests were more theatrical. Pavel Varfolomeevich Kuznetsov (1878–1968) had studied first in Saratov and then at the Moscow School under Korovin and Serov, the commendation of the latter ensuring his acceptance in the Mir Iskusstva exhibition of 1906 and the Salon d'Automne in

Paris that same year.[17] Also in that year he studied privately in the French capital. He was a decorative painter who drew into his own service mannerisms derived from Borisov-Musatov, the colour harmonies of Polenov and Levitan, the elegant nostalgias of the Mir iskusstva painters, the dreamy masquerades of Monticelli, and the statuesque poses of Puvis de Chavannes and Maurice Denis. Matisse and Gauguin were also to shape his art, teaching him how to simplify outlines and shapes, and enabling him to evolve a style in which to portray the people of the steppes (Plate 100). In 1907, however, his pictures, fluid and shadowy in form, were concerned with visions of unborn children, foetuses, misshapen and misconceived embryos, fountains and arches, painted in misty greys and blues. Martiros Sergeevich Saryan (1900–1972), of Armenian origin, showed mysterious landscapes,

100. Pavel V. Kuznetsov: *Mother*, 1930. Oil on canvas, 102 × 120 cm. Moscow, Tretyakov Gallery

strangely eastern, silent and static, which anticipate Macke, Marc and the Expressionist Blaue Reiter painters, although his emphatic brushstrokes, simple, tinted canvases and uncluttered shapes recall Fauvist techniques. Like Kuznetsov, he studied at the Moscow School under Korovin and Serov; and although he was not to begin his travels to the Near East until 1910 his paintings had anticipated the heavy shadows, the dazzling sunshine, the simple outlines of men and women, houses and trees that he was to experience there. Already his art was one of abstraction – of taking away the fleeting, the impermanent and the occasional and in their place presenting the very essence of his experiences in terms of form, colour and pattern (Col. Plate 12). His subject-matter before 1907 was concerned with legend as in *Sacred Grove* (1905), but even then showed the neo-primitive characteristics which became overwhelming from 1907.[18]

Nikolai Nikolaevich Sapunov (1880–1912) had studied at the Moscow School under Levitan and then at the Academy under Kisselev. By the age of 21 he was translating Korovin's sketches into scenery at the Bolshoi Theatre. He worked for the Stanislavsky Theatre-Studio on Povarski Street, Moscow, for Vera Komissarzhevskaya's Theatre in St Petersburg as well as for the Tragedy Theatre there: the décors he created for *Hedda Gabler* (1906) had a black rhododendron, a blue, silver and gold tapestry, white furs on a sofa, silver lace curtains, white furniture, including a white piano, and glittering stars beyond the window – none of which seems to fit the intensely claustrophobic, unbearably provincial atmosphere of the play itself but which evidently made a most striking composition not unlike an underwater cavern. His still lifes and scenes from everyday life also demonstrate his love of the theatrical with their blurred impressions of trees, garden ornaments, and fleeting figures probably derived from Monticelli.[19] Sergei Sudeikin followed somewhat similar lines to Sapunov at this stage in his development, moving the theatre, as in his settings for Maeterlinck's *Soeur Beatrice* in 1906, towards a *tableau vivant* rather than seeing it as an arena for verbal and physical conflict. His contributions to the Blue Rose exhibition took the form of decorative *panneaux* largely carried out in blues, greys and subdued pinks. In their paintings the Milioti brothers, Nikolai (1874–1955) and Vasily (1875–1943), used as basic motifs the flowing hair, melancholy faces and flat patches of mauve, rose and turquoise beloved of Klimt,

Denis and Kandinsky in their formative years, as well as the more decorative aspects of Vrubel. Nikolai Krymov (1884–1958), Petr Bromirsky (1884–1919), Petr Savvich Utkin (1877–1934), Anatolii Aramov (1876–1949), Aleksandr Matveev (1878–1960), and Nikolai Feofilaktov (1878–1941), a graphic artist working in a style derived from Aubrey Beardsley, all showed, whether in painting or in sculpture, the soft outlines, the fluidity and the comparative formlessness which generally distinguish the artists of the Blue Rose up to 1907. Clearly, they were efficient at making themselves known not only by the exhibition of 1907 but by their stage designs, their participation in exhibitions in Russia and abroad, the support they gained from Ryabushinsky, and their illustrative work for the journal *Vesy* (*The Scales*) and other Symbolist publications.[20]

When these artists next exhibited it was not under the title of the Blue Rose but in the large showing held by *The Golden Fleece* in Moscow in 1908, when a number of paintings by French artists, including Cézanne, Van Gogh, Matisse, Braque, Rouault, Van Dongen and the Nabis, were shown side by side with a Russian section of some hundred works. A second exhibition in January 1909 mingled French and Russian works; and a third held from December 1909 to January 1910 which contained works by Larionov, Goncharova, Kuznetsov, Saryan, Utkin and Ryabushinsky himself, had no French entries. Included among the Russian artists were, of course, former members of the Blue Rose whose styles had changed dramatically in this short period. Kuznetsov had fallen under the influence of Gauguin and Matisse and developed a simple style (possibly derived from Picasso's 'Blue period') with which to portray the epic life of the Kirghiz nomads which was to be the major artistic concern of his life. In these pictures, bereft of any detail, the nomads are set against high horizons and clear blue skies, simply draped and veiled, their outlines traced in blues and faint reds. There is an exquisite melancholy in the heroic existence of these restless people ever facing new challenges and new trials. Saryan also simplified his style while retaining the strong outlines and flat colours, mostly browns, oranges and blues, which seem to carry the imprint of his native Armenia. A new sense of direction was evident. Already by 1907 Symbolism in painting had lost its force. Even the techniques changed: the flat colours and rather squiggly outlines which resulted from the use of

tempera and gouache and oil on cardboard or weakly primed canvases gave way to the more vivid impact of thickly laid on oil paint and resilient canvas. The immediate foreign influences were those of Gauguin and Toulouse-Lautrec whose angular shapes and distortions show in the early work of Larionov, of Matisse whose dancing figures are reflected in the work of several artists but most significantly in the compositions of Petrov-Vodkin, and, belatedly, of Cézanne, who was so admired by Falk and his friends that they became known as the Cézannists. The bright palettes everywhere evident came from the Fauves. These painters owed their *reclamé* initially to *The Golden Fleece*. Its exhibitions represented the apogee of French art in Russia; but it was obvious that Russian artists had the confidence and capacity to take from France and Germany those elements which most interested them and to amalgamate them with purely native qualities largely of a primitivist, pictorial and colourful kind.

A late-comer to the Symbolist movement who must be mentioned was the Lithuanian composer and artist Mikalojus Čiurlionis (1865–1911), who turned to art as a means of expressing his vision of a philosophical reality beyond experiential time and space for which he could find no musical equivalent: he called his works 'Sonatas' and his exhibitions 'Auditions'. Born the son of the church organist in a little village near Vilnius his musical talents were discovered early and with the aid of an aristocratic patron he went to the conservatoires of Warsaw and Leipzig. From 1903 he settled in Warsaw where he earned his living by music lessons but devoted his emotional and imaginative powers to painting. In 1907 he returned to Vilnius where he married and in 1909 went to St Petersburg in an attempt to secure recognition as a painter. He had a limited success in that his works were accepted for the exhibitions of the Union of Russian Artists in 1909 and 1910; and he was much admired for his sophisticated knowledge of Ibsen, Nietzsche and Wilde and, in the realm of art, Aubrey Beardsley and Puvis de Chavannes, for his interest in exotic cultures, and for his attempts, like Scriabin, to translate music into another art form – in his case, extremely linear, barely tinted pictures. He was overtaken by mental illness and removed to a home near Warsaw, where he died in 1911. Such works as *Celestial Sonata: Allegro* (Plate 101), largely composed of cones, circles and ellipses which he used as characteristic symbols of the rhythm of life, seem very close to

non-representation (and it must be admitted that his
declared purpose was philosophical and spiritual
rather than figurative), which has encouraged critics
to claim him as the first abstract artist. Uncertainty
as to his intentions and the exact degree of his
abstraction from nature, as well as the non-availa-
bility of his works (most of which are held in the
galleries of Vilnius and Kaunas) have not inhibited a
burst of recent interest in him. Despite a retro-
spective section of 125 pictures in the Mir iskusstva
exhibition of 1912 and articles in the journal *Apol-
lon* in 1911 and 1914 (in the latter he is described
as a *peintre maudit*), his work failed to evoke
any response among Russian artists, although his
presence in St Petersburg shows the increasing
cosmopolitanism of Russian painting and its grow-
ing links with the distant provinces and neighbour-
ing states.[21]

Čiurlionis was a discovery, somewhat late it is
true, of *Apollon*. Of less importance than *The
Golden Fleece*, this journal lasted from 1909 to
1917 and published articles on major artists. Its
director was Sergei Konstantinovich Makovsky
(1877–1962), who had previously written for
The Golden Fleece and *Iskusstvo*. In 1908–9 he
organized a Salon which held some 450 works
by seventy-two artists from the major groups,
including Munich. The only painters excluded were
Goncharova and Larionov, for whom he did not
care. There were other smaller exhibitions held at
frequent intervals when Petrov-Vodkin, Bakst,
Dobuzhinsky, Lukomsky and others were fea-
tured – and their work was described and assessed
in the pages of *Apollon* by the critics Voloshin,
Wrangel, Levinson and Neradsky. Typical of the
direction of the journal was its appreciation in 1912
of Konstantin Bogaevsky, who has already been
mentioned for his remote world of forests and
steppes, mountains, rivers and lakes, lonely scenes,
sometimes bathed in a vibrating moonlight or the
faint rays of the dying sun.

One last contribution to the varied nature of
painting during this period, that is, up to the out-
break of war in 1914, was made by the artists based
in Munich. That city seemed in the last years of the
nineteenth century to be a centre of artistic life with
painters like Bartel, Stuck and Lenbach, galleries
such as the Pinakothek and the Glyptothek, con-
certs, exhibitions, and famous teachers like Ažbe
and Hollosy.[22] Among the first to arrive there
from Russia were Aleksei Georgievich Jawlensky
(1864–1941) and Marianne Vladimirovna von

101. Mikalojus Čiurlionis: *Celestial Sonata: Allegro*, 1908.
Tempera on canvas, 72.2 × 61.4 cm. Kaunas, Čiurlionis
Museum

Werefkin (1860–1938).[23] Jawlensky had trained as
an officer and when stationed in St Petersburg
had taken the opportunity to begin his studies
at the Academy under Repin. In 1896 he left for
Munich to study under Ažbe and was soon joined by
Marianne von Werefkin, a daughter of the governor
of the Peter and Paul fortress in St Petersburg. She
had also studied under Repin who quickly recog-
nized her ability. Igor Grabar, yet another pupil of
Repin, had already arrived with his friend Dmitry
Nikolaevich Kardovsky (1866–1944), whose name
is found in the exhibitions of the day. In 1897,
Vasily Vasilievich Kandinsky (1866–1944) made his
way there.[24] A student of law and economics,
Kandinsky had turned to art when during a visit to
the provinces as a member of an investigating com-
mission he had been struck by the elaborate beauty
of peasant art. It was with some difficulty that these
artists found their own paths – Werefkin injured her
hand and could not paint for a time; and Kandinsky
had his paintings rejected by the Munich Secession
from 1903 to 1906 – but by the end of the first

decade of the twentieth century they had each found a personal language with which to express their beliefs, sensations, thoughts and emotions.

The links between Munich and Russia were particularly strong: Russians in Germany returned home at frequent intervals while Russians travelling through Western Europe never failed to call on their comrades in the Bavarian city. V. G. Bekhtiev came in 1902; and the closely-knit colony in which Russian was continually spoken was enlarged in 1908 with the arrival of Vladimir Alekseevich Izdebsky (1882–1965). David and Vladimir Burlyuk, Vladimir Alekseevich Denisov and A. Mogilevsky also studied in Munich, but always proclaimed the supremacy of Russian art. Indeed, all these artists were emotionally and nostalgically Slavophile with old Moscow and the Kremlin as a focal point of their memories. The spirit which animated them was not so much that of humble apprenticeship to Western art as that of missionaries or apostles spreading to Europe the grandeur and amplitude of the Slav soul. In January 1909 they founded the Neue Künstlervereinigung, which held two exhibitions in the Modern Gallery in Munich on 1–15 December 1909 and 1–14 September 1910. The press attacked the exhibitors as either incurably mad or intolerably impudent and so frightened the participating German artists that they began to intrigue against Kandinsky. He resigned his position as president and retired completely when the hanging committee of the third exhibition rejected his *Composition V* on the grounds that its size did not conform to the standard measurements.

The Russian artists were indifferent to the mercenary activities of many French artists and the financial speculations of the major Parisian art-dealers. Kandinsky rejected the fashionable trends of French painting, believing in the spiritualization of art, in abstraction from nature, and in the sympathetic use of the most primitive strands of folk art. These attitudes proclaimed with a mystical fanaticism tended to alienate him from his more worldly- minded colleagues although rarely from his compatriots. In company with Franz Marc he decided to launch a new grouping to be called Der Blaue Reiter (The Blue Rider), which published a single volume of artistic criticism and theory in 1912 and organized two exhibitions, both in Munich. The first, which took place in the Arco-Palais lasted from 18 December 1911 to 1 January 1912 and contained some forty pictures. Apart from Kandinsky, Marc and Gabriele Münter (Kandinsky's companion for

some thirteen years from 1902), there were works by Macke, the Burlyuks, Campendonck, Niestlé, Henri Rousseau, Delaunay, and Arnold Schönberg, the painter-musician. The exhibition struck a blow of immense importance at European naturalism. Although artistically and personally connected with members of the Blue Rider, Jawlensky and Werefkin did not contribute any pictures. The second exhibition, apparently of graphic work, was even more Russian in its representation but lacked the impact of the first.

The outbreak of war in 1914 temporarily halted Kandinsky's work in Western Europe. At this stage in his career his achievements were essentially Russian and must be seen against the cultural background of his native land. The titles of his works – 'impressions', 'improvisations' and 'compositions' – and his claim that each colour had a 'corresponding vibration of the human soul' link him with Rimsky-Korsakov who had pondered over the correlation of sound and colour, and with Scriabin who had actually tried to put such theories into practice with his 'keyboard of light'. Both Kandinsky and Scriabin were further linked by their fervent absorption in the teachings of Madame Blavatsky, founder of the Theosophical Society. Inspired by the *lubki*, Kandinsky had published in 1904 his *Poems without Words*, a set of woodcuts based on life in old Moscow which in style anticipate the primitivist movement.[25] His treatise *On the Spiritual in Art* was read and discussed at the All-Russian Congress of Artists in St Petersburg on 29 and 31 December 1911 immediately prior to its publication: the very strands of its mystical-symbolist thought were an integral part of his country's philosophical and aesthetic life; but it must be emphasized that Kandinsky's symbolist tendencies were of a deeper, more fundamental nature than those of the Blue Rose group. Moreover, Kandinsky wrote over six articles and literary compositions (such as his prose poems) in Russian, for publication in Russia itself, besides others preserved there which have not yet been edited or made public.

Marianne von Werefkin and Jawlensky also rejected naturalistic pictorial representation, seeking a harmony (and occasional dissonance) of tones quite independent of naturalistic factors; basing their images on forms of the human head or on the landscapes presented by the Bavarian Alps at Murnau (Plate 102). They did not proceed as far as Kandinsky along the road to abstraction; they did not ride on a blue steed into the illimitable world of non-

representation; but their areas of forceful, almost strident, thickly painted colours, outlined in black, greens or dark reds, representing mountains, fields, houses, fruit or faces, amply prove their simple faith and lonely, spiritual ethos, fortified, perhaps, by the close and traditional piety of the Bavarian villages in which they lived.

Many Russian painters were drawn to Paris; and, of course, there was direct Imperial encouragement for the establishment of Russo-Franco accords on the cultural plane to cement the political alliances. Sonya Terk (1885–1979) went there to study in 1905 and after a brief marriage to the German art-dealer William Uhde joined forces with Robert Delaunay to create a colourful form of abstract painting which Apollinaire baptized with the name of Orphism. Georgy Bogdanovich Yakulov (1884–1928) stayed with the Delaunays in Paris and later accused them of having stolen his ideas. During 1912–13 Lyubov Sergeevna Popova and Nadezhda Andreevna Udaltsova studied with Henri Le Fauconnier and Metzinger. The artist whose stay in the French capital was prolonged, who had the widest range of contacts, and who took the other Russian artists under her protection was Aleksandra Aleksandrovna Ekster. Friendly with Picasso, Apollinaire and Max Jacob, she gleaned news of the latest developments and dispatched them home in the form of articles. Although these painters had already contributed to exhibitions in Russia, there can be no doubt that their stays in Paris increased their sense of being at the forefront of advanced painting in Europe – and that meant an awareness of Italian Futurism in addition to French Cubism as their styles demonstrate.

One last manifestation of the vitality of the artistic scene must be mentioned here, since it demonstrates that appreciation of contemporary art was not confined simply to St Petersburg or to Moscow. Vladimir Izdebsky, as we have seen, was associated with Jawlensky and Kandinsky in forming the Neue Künstlervereinigung in Munich, but his ambitions did not stop there and he set about collecting 800 works for an exhibition devoted to contemporary Russian and Western painting for showing in the provinces. The International Exhibition of pictures, sculptures and drawings, which toured the country's cultural centres – Odessa, Kiev, Riga, Nikolaev, and St Petersburg – in 1909–10, listed an astonishing range of names, including Balla, Bonnard, Marquet, Braque, Laurencin, Altman, Matisse, Lentulov, Petrov-Vodkin, Kandinsky, Jawlensky, Ekster, and

even included four drawings by children, a token representation of the primitivist interest in child art. The following year Izdebsky held a second exhibition or Salon which toured Odessa and Nikolaev between 1910 and 1911. This time he confined his choice to 437 works, mainly by Russian painters from all the main groupings, including those in Munich. In the catalogue (which carried articles by Kandinsky, Kulbin, Schönberg and others) were to be found the names of the Burlyuk brothers, Larionov and his brother Ivan, Konchalovsky, Mashkov, Falk, Tatlin, Fonvisen, Utkin, Yakulov and Lentulov – in some cases names which were to acquire greater significance in the immediate years ahead. Izdebsky was himself a sculptor, a collector of paintings, and a wealthy man, but he found these two exhibitions over-taxed his resources and he was obliged to call a halt to this aspect of his life. Nevertheless, they represent the open attitude of the Russian public to the most advanced forms of art, an eagerness and tolerance to be found in no other European country; and they also show that Russian painters felt no disparity between themselves and their counterparts elsewhere.

It is impossible to list all the exhibitions held at this time, for artists, especially those from Moscow, were so keen to show their work that every occasion was seized upon as a valuable opportunity. As a result few, if any, painters maintained allegiance to any one movement but willingly changed sides the moment a chance came to exhibit, even if the offer came from a rival group which had hitherto been the subject of little else but vitriolic abuse. The prevalence and frequency of exhibitions in the major cities must always be borne in mind, because there is a danger that the reader's attention may be so captured by some of the more sensational and publicized events that the unusual range and variety of the total creative scene are inadequately appreciated.[26]

The end of the first decade of the century brought with it the demise of Symbolism as an inspirational force in painting: in the next few years painters were involved in rediscovering native sources of strength and pictorial material which led to a renewed appreciation of icon painting and a novel regard for folk art from embroidery, carved wooden dolls and decorations on peasants' houses to woodcut illustrations of a primitive kind.[27] Inevitably, the

102. Aleksei Georgievich Jawlensky: *Head of a Spanish Girl*, c.1913. Oil on canvas, 51 × 61.2 cm. Private Collection

question presents itself as to how original was Russian painting at this period and how much was it indebted to Paris. The answer must surely be that while the Russian painter preserved his own identity he was prepared to draw upon whatever sources presented themselves most cogently to his artistic needs – French Cubism, German Expressionism or Italian Futurism. That this resulted in a degree of eclecticism is understandable; but the same argument might well be applied with considerable force to Picasso and a number of other painters. But whereas Picasso turned to non-European, native art as inspiration for his *Demoiselles d'Avignon* (1906–7), and Gauguin had gone from Brittany to Provence and thence to the South Seas, Russian painters lived in a country that was still primitive and where they were everywhere surrounded by peasant art – still a living force. In fact, Russian painters continually emphasized that their art was national in its origins, that it was orientated towards areas of social concern or towards a higher reality, and pretended to despise Paris. Thus David Burlyuk is said to have claimed that primitivism was 'an expansion of a programme – a protest against formal art – art for art's sake – because art is for the people, art is for the masses'.[28] The art of Picasso was seen as being art for the art-dealers, for the wealthy, for the socially privileged. It was this conviction that Russian painting had a social strength and national basis, a spirituality, a purpose which enabled Nikolai Ryabushinsky to declare that the aim of his journal *The Golden Fleece* was 'to propagate Russian art beyond the country of its birth, to represent it in Europe in a whole and integrated fashion in the very process of its development.'[29] This aggressiveness of intent is one of the keynotes of the years from the uprising of 1905 to the outbreak of revolution in 1917.

9

Primitivism and Modernism before 1914

The four years immediately preceding the 1914–18 war are the most involved in Russian painting and it is impossible to extricate events of enduring significance from the welter of groups, clashes and movements. This said, some attempt must be made to present a comprehensible survey of the period, even if this means simplification and the passing-over of artists of distinction.[1]

Briefly, these years saw the rapid evolution of two areas of central importance in painting both linked with music and literature: one of a nationalist neo-primitivism in which the leading protagonists were David Burlyuk, Mikhail Larionov and Natalya Goncharova, and the other of a fierce modernism led by Vladimir Tatlin and Kasimir Malevich. Our investigation must rest at this stage with the first group although, quite obviously, there was much interreaction, sometimes of a personal and bitter nature, the ashes of which are still hot.

True to her basically chauvinistic traditions, Russia had not entirely accepted the artistic innovations of the West but had sought to modify them in accordance with her own artistic heritage, especially that of folk art. The years from 1907 to 1913 are particularly important in this connection; and as early as March 1907 the Moscow Association of Artists held an exhibition at the Stroganov school which included neo-primitivist canvases by Larionov, Goncharova, Malevich, Morgunov, Rozhdestvensky, Shevchenko and Yakulov. The cultivation of and investigation into folk art which had begun at Abramtsevo some thirty years previously was intensified among the younger avant-garde painters. The woodcuts to be found in the *lubok*, a kind of chapbook and broadsheet sold at fairs since the seventeenth century and which art-lovers had begun to collect, were now borrowed from and imitated, notably by Larionov in his 'hair-dressing' series (Plate 103). Yet another influence

was that of signboards, especially those painted by a peasant artist Niko Pirosmanashvili (1862–1918) from Tiflis. Patterns and floral designs were plagiarized from embroideries, shawls and painted trays. The wealth of national painting became clearer with the donation by Pavel Tretyakov of his magnificent collection in 1892, and in 1909 the numerous works owned by Ivan Evmenievich Tsvetkov also passed into the keeping of the city of Moscow. Most vital of all was the rediscovery of the old icons whose artistic value was being understood for the first time since the reign of Peter the Great. Diaghilev had displayed a selection of icons in Paris in 1906, and several wealthy collectors, among them Ryabushinsky, had splendid examples in their galleries. In 1913, in Moscow, there was to be a splendid exhibition of fully restored and cleaned icons which did much to reveal their glory. There was also an interest, artistic as well as historical, in Scythian and prehistorical treasures.

The renown of the neo-primitivist movement owed much to the Burlyuk brothers. Not only were they ardently involved in apostolic work in Munich, but they were also engaged in developments within Russia, especially in Moscow. In 1907 the three energetic brothers, David Davidovich (1882–1967), Vladimir Davidovich (1886–1917), Nikolai Davidovich (1890–1920), and their sisters Lyudmila and Nadezhda, all of them involved in painting and writing poetry, arrived in the capital and set about contacting other interested young people. Experienced in the ways of art groups and knowledgeable about artistic tendencies in Europe, they arranged an exhibition in 1907 under the title Stefanos. In addition to works by David, Vladimir and Lyudmila Burlyuk there were offerings from painters of the Blue Rose and also submissions by Larionov, Goncharova, Lentulov, Yakulov, Sapunov, Sudeikin and Fonvizen. Held at the Stroganov school from 27

December 1907 to 15 January 1908, the exhibition paved the way for a smaller one called Zveno (The Link), organized in Kiev in collaboration with Aleksandra Ekster. A second exhibition entitled Wreath was held in St Petersburg during March–April 1908 and included work by Larionov and Goncharova. The third exhibition, this time called Wreath-Stefanos, also took place in St Petersburg in a shop at 68 Nevsky Prospekt. There were fewer than eighty works by six painters: Vladimir and David Burlyuk, L. D. Baranov (otherwise known as Baranoff-Rossiné),[2] A. F. Gausch, Lentulov and Aleksandra Ekster. It seems extraordinary that neither Larionov nor Goncharova were represented at this last exhibition since the friendship of the two painters with the Burlyuks was at its height. On the other hand, the first exhibition (Stefanos) had been strongly representative of students at the Moscow School, an element less in evidence at the last showing.

In fact, after completing his nine months of military service, Larionov had spent part of the summer of 1909 with David Burlyuk at the latter's home at Chernyanka. There they conceived a new society for which they evolved the name of Bubnovy valet (Jack of Diamonds). The origin of the title is in considerable doubt but one explanation is that civil prisoners wore uniforms which carried diamond-shaped markings and by means of this association these young artists were able to demonstrate that they were both revolutionaries and social outcasts. Financial assistance was forthcoming from Aristarkh Lentulov, who had married a rich merchant's daughter. The first exhibition of the Jack of Diamonds was held from December 1910 to early January 1911 and included thirty-eight artists: among those represented were David and Vladimir Burlyuk, Larionov and Goncharova, Ekster, Lentulov, Kandinsky and his Munich compatriots, the Russian Cézannists – that is, Falk, Konchalovsky and Mashkov – Leopold Stiutsvage (who was to become a French citizen in 1927 and adopt the name of Survage already invented for him by Apollinaire), Malevich (Plate 104), and a group of French artists including Gleizes, Moreau and Le Fauconnier. It is easy to foretell from the catalogue that troubles were brewing because Larionov and Goncharova were outnumbered by the pictures of Konchalovsky, Mashkov and Falk, who had all been expelled from the Moscow School for 'leftism' – that is, too marked a devotion to the stylistic and compositional devices of Cézanne, Van Gogh, Gauguin and Ma-

tisse, an admiration shared by their friend Aleksandr Vasilievich Kuprin. They were attracted by the bright colours and simple, heavily outlined forms, distantly inspired by Japanese woodcuts, which they associated with the works of the French masters; and concentrated on still lifes and portraits. The charge of being 'Cubist' and 'Cézannist' was laid against them on account of their obvious interest in form and mass rather than in the introduction of new subject-matter, least of all that of a neo-Russian variety. They were artists of remarkable ability, especially Falk who was to develop along a most private and almost secretive path.

A split in the Jack of Diamonds came early in 1911 when Larionov, Goncharova and their allies formed a new group called Osliny khvost (The Donkey's Tail). On 12 February 1912 a discussion on Contemporary Art was organized by Dr N. I. Kulbin and David Burlyuk on behalf of the Jack of Diamonds at the Polytechnic College in Moscow, where an astonished audience heard that Raphael and Velázquez were philistines and merely photographic painters, that the subject of a painting did not matter, and that Cubism was the new force in art. The audience was even more surprised when Goncharova rushed forward and delivered a diatribe, alleging that the Jack of Diamonds was over-addicted to theory and denying that Cubism was anything new to Russia, which already had Cubist objects in the shape of wooden dolls sold at fairs and stones carved by the Scythians. She declared that she belonged to a new group called the Donkey's Tail which would take over the leadership of Russian painting.[3] The group's views were set out in letters she sent to several newspapers which either ignored them or only published extracts: she asserted that all art was either dead or decadent except in Russia.[4] In her eyes the Jack of Diamonds was unable to progress along new paths and had tied itself to the less adventurous aspects of French art (that is to say, Cézannism) and had become contaminated by 'Munich decadence' (significantly although Larionov and Goncharova had sent works to the German exhibitions they had never found favour there), and spoilt by the 'cheap Orientalism of the Paris school', presumably a reference to Gauguin's South Seas paintings and Japanese woodcuts. But while jealously and xenophobically asserting the supremacy of their Russian heritage they were simultaneously lifting up their eyes towards Italy from whence were coming the winds of Futurism – which they were also denouncing as 'emotional

103. Mikhail Fedorovich Larionov: *Officer at the Hairdresser's*, *c.*1909. Oil on canvas, 114 × 86 cm. Private Collection

Impressionism'.[5] It is remarkable how these painters and their fellow artists should appear to have found so little common ground; and it is equally remarkable that despite their abuse of one another they should so readily have agreed to exhibit together, as, for instance, with the Mir iskusstva and the Soyuz molodezhi (Union of Youth) which came into existence in February 1910 and was to have some distinguished associates including Filonov, Malevich and Puni.

It seems appropriate here to give some account of the careers of the protagonists in the struggle for leadership in Russian painting which we have seen developing. Mikhail Fedorovich Larionov (1881–1964) was born in Tiraspol near the borders of Poland and the Ukraine.[6] His father, an army doctor, sent him to Moscow where he attended a private school and, later, in 1898, the Moscow School where he studied under Levitan and Serov. He claimed he taught himself from art journals in which he read about the Impressionists, Symbolists and Fauves, all of whose influence can be found in his early painting of 1903–6, generally of landscape and still life. Before he completed his training in 1910 he had contributed to exhibitions and, in 1906, had been invited by Diaghilev, who was taking a selection of Russian art to Paris, to accompany him there as the representative of the younger generation both in person and in paint. He was able to visit London where the paintings of Turner inspired him with ideas of a non-representational art. On his return home he became convinced that he was a John the Baptist, a prophet and forerunner of all that was modern. In 1907 he assisted the Burlyuks with the Stefanos exhibition, but came fully into his own the next year at the Link salon held in Kiev and the Golden Fleece in Moscow. In the spring of 1910 he did part of his military service while his comrade Goncharova retired to the country, experiences which began to change the direction of their art, for on their return to Moscow they rejected French art and began to replace it with neo-primitivism. It must be pointed out that French and German painting had begun to assimilate primitive art forms (Larionov had been impressed by the Gauguin retrospective he had seen in Paris in 1906); and that for the Russians to exploit their own peasant art, the

primitive art that lay nearest at hand, was a logical step – although they seemed to have misconceived the nature of Picasso's interest in primitive art which he had mined in 1906 largely for stylistic purposes.

Nataliya Sergeevna Goncharova (1881–1962) was born in Tula (as was Marianne von Werefkin, whose Russian birth is often ignored), into a cultured and historic family, related to Pushkin's wife whose name she bore.[7] Goncharova also studied at the Moscow School under the sculptor P. P. Trubetskoy. She was fortunate in receiving some advice from Levitan and had a few lessons from one of his pupils, but it was Larionov, her lifelong companion, who really opened her eyes to the world of painting. More sensitive than him and with an infinitely greater sense of colour and composition, she used in the service of art everything that came her way, whether it was the French paintings she studied in Moscow, the peasant art she saw around her country home or during her travels into Asian Russia, the memories she carried from childhood of venerated icons in home and church, signboards and *lubki* collected on her travels, or Eastern carpets and hangings. All these elements, as well as the trends of Futurism, Cubism and Rayonism, she transmuted into paintings that were entirely feminine, and also forceful and revolutionary.

From 1907 onwards both Larionov and Goncharova were closely involved with David Burlyuk, whose contribution to primitivism has often been overlooked in favour of his better-known involvement in the Cubo-Futurist literary scene.[8] He served to put an end to the Symbolist tendencies in Russian art and to the reliance on French and other non-Russian sources. Burlyuk was a member of a family of burly giants whose father managed a large estate at Chernyanka near the Black Sea coast. They lived a simple life in which food and hospitality were abundant, amid limitless reaches of steppes inhabited only by flocks of sheep and pigs. David Burlyuk began writing poetry when he was 15 and studied art over a number of years in Kazan, Odessa, Moscow, Paris and Munich without, it must be confessed, any observable signs of improvement in style, technique or facility of expression. There was, however, a gain in productiveness (for which his native energy may be credited) since he claimed to have painted – and sold – more than 16,000 canvases during his career, none of them representing a real advance on the semi-Expressionist, primitive, and Cubist works painted between 1907 and 1911.

104. Kazimir Severinovich Malevich: *The Bather*, 1910. Gouache on paper, 105 × 69 cm. Amsterdam, Stedelijk Museum

The Headless Barber (1912), of which he was extremely proud, is surely derived from Larionov's *Hairdresser* series of a slightly earlier date (and both derive from *lubki* of Old Believers having their beards forcibly shaven off). We must remember that much as he was involved in Russian painting in the years from 1907 (when he was still a student at the Moscow School), he was also involved in the mainstream of modern European painting by reason of his links with Kandinsky and the Blaue Reiter.

Burlyuk had a nose for genius: in September 1911 he met a young art student – Vladimir Vladimirovich Mayakovsky (1893–1930) – whose gifts as a poet and talent as a painter he proclaimed to the world.[9] In December 1911, he met Benedikt Konstantinovich Livshits (1886–1939), a young law student who was to become a Futurist poet and the writer of a delightful book of memoirs concerned with this period. It might be claimed that without David Burlyuk's organizing energy and capacity to recognize talent the Russian Futurist movement might never have taken wing. He went from movement to movement with ease: at this stage in his career he felt no proprietary rights in the various literary and artistic developments, unlike Larionov who disliked rivals and wished to hold the distinction of having brought modern painting to Russia and, at the same time, of having aroused her to a recognition of her own genius. After the revolution of 1917 David Burlyuk settled in the USA where (perhaps through economic necessity) he played the part of a buffoon. He twice visited his native land before his death, once as an honoured and official guest. His brother Vladimir, on the evidence of his *Portrait of the Futurist Writer David Livshits* (1911), was possessed of a minor but adventurous talent.

Such were the three personalities who tried to dominate Russian painting from 1907. On reflection, it would seem that Larionov and Goncharova were the ultimate losers, since they became more and more isolated from the major trends. For a brief while they retained the loyalty of V. S. Bart, Kazimir Malevich, M. V. Ledantu, A. A. Morgunov, A. V. Shevchenko and Vladimir Tatlin, but the majority of these had deserted them by the time of the 1914 Moscow exhibition No. 4 (subtitled Exhibition of Futurist, Rayonist, and Primitivist Pictures), which, Larionov claimed, proved the continued evolution of art in Russia. In fact, several of the works had been shown previously. One discovery for which they certainly merit praise was the artist-philo-sopher Vasily Chekrygin, a friend of Mayakovsky's from his art-school days and illustrator of his *I* (1913), and an illuminating influence until his early death. Chekrygin showed twenty works in the No. 4.

Despite Goncharova's rejection of Western influences during her intervention in the debate at the Moscow Polytechnic, the Donkey's Tail, initially at any rate, was attracted by Italian Futurism but would not recognize Cubism as in any way innovatory.[10] Independent by nature, throughout their lives Larionov and Goncharova regarded Picasso as an insincere mountebank and charlatan whose effect on the history of painting had been wholly retrogressive. The leading members of the Donkey's Tail in 1912 all insisted that subject-matter was necessary in painting and continued to stress the neo-Russianism of their work.[11] There was no need, they felt, to break with the past from which the best should be retained: eclecticism was to be encouraged. Above all, it was artistic creativity that was important and not the theorizing to which, they alleged, Burlyuk was prone. In fact, the Donkey's Tail exhibition of 1912 was eclectic in character, although it summed up the underlying trends of the previous years, principally that of 'infantile-primitivism'. Larionov demonstrated the extraordinary potency of the obscene words and drawings scribbled on walls and fences by uneducated soldiers. By the use of crude colours and childish drawings he depicted the boredom, futility and wastefulness of the conscripts' days in barracks. At the same time his pictures of provincial and urban life were intended to reveal the sordid tawdriness of such events as a visit to the hairdresser or an encounter with a prostitute. By 1912 a more lyrical note came into his painting: the colours, intense in hue, rarely mixed, and seemingly taken directly from the tube with no regard for painterly effect sometimes achieve a sumptuous quality; words and slogans are placed on the canvas awkwardly but cannily; and the elements of parody, of infantilism and eroticism have the innocence of signboards and children's paintings. At the same exhibition Goncharova showed her *The Evangelists*, based on icon painting, and enjoyed having them condemned as blasphemous and removed by the police; her other works such as *Haycutting* were on agricultural themes. Chagall sent a small work, *Death*. Both Malevich and Tatlin, shortly to become the leaders of Russian modernism, were interested in workers and peasants; and hence Tatlin's *The Sailor* (1911)

and *The Fishmonger* (1911) and Malevich's *Argentine Polka* and (Peasant) *Heads*. The next year, 1913, Larionov and Goncharova were to hold an exhibition of icons and *lubki*, most of them from their own fine collection of works of art originating in Russia, China, Japan, Siberia and France.

A more important event in 1913 was Larionov's exhibition Mishen (The Target), which not only revealed his growing isolation after quarrels with the Burlyuks, Tatlin and Malevich, but also offered him the chance to launch a new style which he named *luchizm* (Rayonism). It was a freely interpreted version of Italian Futurism carried through a figurative stage to semi-abstraction; and, therefore, seemed to represent a surprising break with his neo-primitivism. While Larionov (and other Russian painters) was not above backdating his canvases, there is some evidence that he had sent Rayonist works to the Union of Youth and the Society for Free Aesthetics in 1912, but it was only in 1913 that their effect was noted. A key work is *Glass*, an abstract Rayonist picture, which Larionov claimed to have painted in 1909 and which would have put him among the founding fathers of abstract painting. As for this new style, Rayonism, he defined it as 'coloured lines and surface working', and said:

> The style of Rayonist painting which we are proposing is based on spatial forms which arise from the intersection of rays reflected from different objects chosen by the artist. A convention is adopted of representing the rays on the painting's surface by lines of colour. The objects we see in everyday life play no role in a Rayonist picture. On the contrary, the attention is held by those qualities which are the very essence of the picture: combinations of colours, their density and the relationship of coloured areas, depth and composition.[12]

The genius of the age, he declared, consisted of 'trousers, jackets, shoes, tramways, buses, aeroplanes, railways, superb ships ...', Futurist sentiments which, without any sense of incongruity, he announced side by side with protestations that he was against tendencies emanating from the West.[13]

Rayonism never played a vital part in the development of Russian painting largely because Larionov founded no school (and he was to leave Russia two years later), and because apart from a number of works by Alexander Shevchenko, Mikhail Ledantu (1891–1917), and a few others painted in the years 1913–14, no further Rayonist pictures were pro-

duced. In the Rayonist works by himself and Goncharova (such as her *Cats* (1910–1), and *Cyclists* (1912–13), where the subject is still recognizable despite the bands, rays and spikes of colour which tend increasingly to abstraction), there is a definite reference to Futurist pronouncements on refracted colour; and 1913 was the period when Larionov and his friends painted their faces with cryptic signs and walked about the streets thus putting into action the Futurist doctrine of 'Art into Life'. Yet those Russian critics who called Larionov and Goncharova the *vseki* ('Everythings') and their aesthetic credo *vsechestvo* ('Everythingness') were making a fair point: Rayonism proved to be a futile attempt to synthesize Cubism, Futurism and Orphism into a style which would be both modern and peculiarly Russian.[14] Time and time again this zealously neo-Russianist spirit is emphasized, as, for instance, in the book *Mikhail Larionov and Natalia Goncharova* (1913) by Ilia Zdanevich (1894–1975), writing under the pseudonym of Eli Eganbiuri, in which he praises them for reversing the situation at the beginning of the century when French art threatened to overwhelm national traditions, and for rediscovering the true spirit of Russian art. Nevertheless, the formulation of Rayonism and its publication by manifesto (together with the concept of *budushchniki* – Futurism of a peculiarly Russian kind) do mark a place in the transition of Russian painting from Symbolism to primitivism and to the non-figurative, abstract and Constructivist developments which rapidly followed on each other.

The industry of these painters was astonishing and it was no surprise that when Goncharova held a retrospective in Moscow in 1913 she showed some 800 pictures. Art-lovers and connoisseurs were impressed, among them Alexandre Benois who, recognizing her ability to control large and brilliant decorative ensembles, persuaded Diaghilev to meet the artist and commission designs from her for a production of Rimsky-Korsakov's *Le Coq d'Or*. A successful smaller exhibition was held in St Petersburg the following year. And later still in the year, as we have already noted, Larionov organized No. 4, and showed primitivist, Futurist and Rayonist works there, although already on the part of himself and Goncharova there was a return to the enticing neo-Russian primitivism which was to be their style henceforth. At the same time they were preparing for a showing in Paris at the Paul Guillaume gallery, for which Apollinaire wrote an introduction. The outbreak of war drew them back to Russia where

Larionov was sent to the front. After being wounded he was invalided out of the army. He contributed to several exhibitions, including Tramway V, and Vystavka zhivopisi 1915 god (Exhibition of Painting for 1915), and he flirted with Constructivism to the extent of showing a construction based on a fan, but his heart was in easel painting and in draughtsmanship, and he had no deep-seated desire to join in this latest movement. Goncharova contributed designs for a production of Goldoni's *The Fan* at the Kamerny Theatre in which she asserted her usual magic. Diaghilev was desperate for their collaboration and appealed to them to join him in Switzerland, which they were able to do on 16 July 1915. The excitement of the hectic years had taken their toll on Larionov, he lost his touch for the advanced movements in painting, and never again did he find himself in the forefront, although he continued to paint and to design for many outstanding productions. However, some of the more adventurous projects begun in Switzerland and Rome such as *Les Histoires Naturelles* never reached the stage.

The three phases undergone by Larionov of Impressionism, primitivism, and Rayonism were shared to a considerable extent by Goncharova. Before 1914, like Larionov, she exhibited in Berlin, Paris and London. As far as her personal and artistic integrity allowed she followed him, but retained creative qualities that were delightfully personal and which she was able to put to good use after she had left Russia and joined Diaghilev. A visit to Spain resulted in paintings which showed that she could absorb folk art from countries other than Russia (in fact, Spain inspired a considerable amount of Russian music and art at the turn of the century), although it must be admitted that her art never lost a vivid, emphatic quality based on natural shapes which seems unmistakably to derive from the folk art of her native land. It is typical of her forward-looking spirit that only a few months before her death, crippled with arthritis, she began a series of canvases on space flight.

Larionov and Goncharova were fortunate in that they attracted patrons and admirers early in their careers: works of theirs were purchased by the Tretyakov Gallery in 1907. As we have seen they were the subjects of Zdanevich's monograph of 1913; and in the same year they themselves published *Osliny khvost i mishen* (*The Donkey's Tail and The Target*), which contained a Rayonist manifesto and an article on Rayonist poetry – with

examples and quotations from writers who possibly never existed. It was, of course, common for Russian painters of the period to write verse; and Goncharova continued to do so to the end of her life. As well as encouraging the literary aspect of Rayonism, Larionov actively fostered the idea of 'everythingness' – for he was interested in every kind of artistic activity. As has been noted, he and his friends attracted notoriety (and put Futurist theory into action) by painting their faces with mystic signs during the year 1913 and probably considerably earlier, even writing an article about the practice.[15] He and Goncharova also created and acted in a Futurist film, *Drama in Cabaret No. 13* (1913–14), in which the action was largely confined to exits from and entrances to a Futurist café. They also gained public attention by letters to the press, interventions in public debates, and by threatening violent action, as when Larionov invited his fellow-painters to hurl rotten eggs at Marinetti (because of the Italian's supposed betrayal of Futurist ideals) when he came to Moscow in 1914 – although, in the event, he behaved most courteously to him. Together with various Cubo-Futurist groups he worked on the printing and illustration of books of poetry.[16] Larionov's disregard of pictorial convention, his childlike drawing, use of graffiti, of scribbled or scratched bawdy words, and the displacement of letters were often carried into the publications of the Futurists in which the poems were mostly handblocked, written out in the artist's handwriting, or deliberately scattered over the page.

A Russian artist has said that Rayonism was the most pathetic, even if experimental, period in Larionov's development, adding that it had an episodic character which 'did nothing to raise either his historical significance or artistic value'.[17] While most admirers recognize that both Larionov and Goncharova, in their different ways, were at their most engaging in the full and generous flood of their creative activity from 1907 onwards when they were concentrating on bringing traditional Russian pictorial elements into artistic life, and asserting the dignity and value of Russian painting *per se*, it is unfair not to admit that Rayonism was a serious attempt to embody a distinct and important element of Futurist thought on light and colour, an area in which the Futurist painters themselves made little progress. And even more than Goncharova with her wonderful combination of decorative and expressive elements of colour, Larionov was interested in the

realization of various forms of theatrical unity, particularly in the total integration in ballet of Russian neo-primitivism. Their apparent reversals of belief and opinion, their frequent quarrels, and their bold ventures into new artistic areas are explicable in the light of this fierce nationalism and their basic mistrust of what they considered to be aggressively arid movements in Western art. But no one should doubt the dedication and the sincerity that went into their 'primitive' paintings, so akin to the early ballets of Stravinsky, with their inspiration in peasant life, creating a sense of childlike gaiety and demonstrating sheer happiness in the visual world as well as a sense of respect for all things created.

Meanwhile the Burlyuks were venturing along different paths, in which literature played as vital a part as painting and etching and drawing. Shortly after their arrival in St Petersburg the Burlyuks had been drawn to the literary and cultural circles there and, in particular, to a group headed by Dr Nikolai Ivanovich Kulbin (1868–1917), who combined duties as a State Councillor, professor at the Military Academy and physician to the General Staff with his interests as an artist (in which he somewhat weakly combined the influences of Gauguin, icons, and both analytical and synthetic Cubism, although he was a more than average draughtsman), lecturer on contemporary art, sponsor of avant-garde causes, publisher, writer and organizer of outrageous exhibitions.[18] He was not lacking in foresight: he realized that a new aesthetic would enable Russian painting to free itself from the historical, social and national preoccupations by which it had hitherto been dominated. He was responsible for inviting Marinetti (whose *Manifesto* had been published in the Russian press in 1909) to come to Russia in 1914. An Exhibition of Modern Trends which opened on 25 April 1908 was his first major assault on public taste; and in the spring of 1909 he arranged a still larger exhibition under the general title of 'The Impressionists'. The title may seem outdated but it should be remembered that Russians became acquainted first with Picasso, Matisse, Marquet, Van Dongen, the Nabis and others, and then, in a number of cases, worked their way back to Symbolism and Impressionism which were, in fact, terms used more frequently in connection with literature than painting. Even the developments in Cubism became known simultaneously. At the exhibition Contemporary Trends in Art held in May 1908, Kulbin had stated that the contributing artists were impressionists in that they presented their own impressions without regard to the 'banal' ideas of local colour held by the critics. It must be admitted that some of these impressions were induced artificially. Kulbin and his friends, among them the poet Elena Guro (1877–1913) and her husband Mikhail Vasilievich Matyushin (1861–1934), a man of remarkable talents as artist, composer, musician and, in 1913, translator of *Du Cubisme* by Gleizes and Metzinger, had formed themselves into a group named The Triangle which had its first exhibition in March 1910, a joint showing with Burlyuk's The Wreath. The exhibition was an inclusive one, modern furniture, folk sculpture, and drawings and autographs of Russian writers also being on show. It was typical of Kulbin that he should have edited a book called *The Studio of the Impressionists* (1910) which contained critical essays (two of them on art and music by Kulbin himself), a poem by Viktor Vladimirovich Khlebnikov (1885–1922) entitled 'Incantation by Laughter' in which he introduced to the public his linguistic innovations – and nothing at all about French Impressionism. Another work, *Sadok Sudei* (*A Trap for Judges*), published later that year, was a miscellany of advanced verse and prose by members of The Triangle, among them David Burlyuk, Vasily Vasilievich Kamensky (1884–1961), Khlebnikov, Elena Guro and Mikhail Matyushin. It soon won itself notoriety, partly because it was printed on cheap wallpaper but largely because of its extraordinary style. It serves to mark the beginnings of a new spirit, predominantly Futurist, in advanced circles.

Thanks to the financial assistance of a wealthy businessman, Levkii Zheverzheev, The Triangle had been able to extend its activities into the holding of art exhibitions and public discussions which provided a platform for much violent but harmless controversy. Some dissatisfaction with Kulbin's multifarious interests and a desire for a change of nomenclature suggesting wider interests and a forward-looking spirit paved the way for the formation of a new group; and in February 1910 Soyuz molodezhi (Union of Youth) was formally registered.[19] It is possible to see the Union of Youth, which was to last from 1910 to 1914, as the last defiant assertion by St Petersburg of its cultural supremacy and of its cosmopolitan attitudes, in contrast with the xenophobic assertion of Russian primitivism which was the order of the day in Moscow, but it also provided an ethos in which Russian painting, for better or for worse, could move towards abstraction and a rejection of subject-matter.

Despite their defiant words Larionov and Goncharova perceived the value of the Union and contributed to its first exhibitions in St Petersburg and Riga in 1910, continuing to do so until 1913. They also worked with the Futurist poets in the illustration of their work. Meanwhile, the Burlyuks, their incursions into Cubism and Russian neoprimitivism rather at a halt, formed a group with definite leanings towards Cubo-Futurism in literature called the Hylaeans, deriving the name from their family home on the Black Sea coast in the area which the ancient Greeks had called Hylaea.

The Union of Youth was the last important movement in Russian painting before the advent of the 1914–18 war.[20] It paved the way for the Futurists to seize control of the cultural life of the nation after the revolution of 1917, and thus set the styles of post-revolutionary art, music and poetry. The fourth exhibition of 1911–12 (there were six in all) is especially significant since it marks a turning-point in the development of Russian painting. It was no longer concerned with the past (as was primitivism) but with the future, striving to create on native soil an artistic language, wildly optimistic, revolutionary in tone and attitude, and more than abreast of the latest stirrings in Western painting. It was with the Union of Youth that Larionov showed his Rayonist canvases (indicating what seemed an abandonment, albeit a temporary one, of his neo-primitivism and making a final attempt to maintain a footing in what appeared to be the progressive camp); and the fourth exhibition had works by Puni, Klyun, Morgunov, Shkolnik, Ekster, Altman, Guro (shown posthumously), Sinyakov, Rozanova and Filonov, in addition to Malevich and Tatlin (Plate 105) who had supplanted Larionov and Goncharova and the Burlyuks as the leading protagonists of the new movements. In addition to exhibitions, the Union of Youth also sponsored theatrical events, the nature and import of which will be mentioned later. The greatest achievement of the Union was, perhaps, the opportunity it gave young artists to reveal themselves to a public which had avant-garde expectations, and to experiment with the confidence that their most extravagant, serious, vital and heartfelt works would be supported by an eager and open-minded aesthetic promoted by Kulbin and his friends.

Neverthless, it would be unfair to neglect those artists who had come to associate themselves with the Jack of Diamonds and been christened (derisively) 'Cézannists'. The movement itself existed as an exhibiting organization from 1910 to 1916; and although it continued for a while, sometimes using its original title, after the revolution of 1917 it lost the vital and reckless energy which so characterized its earlier work. For the most part the organizers were born and educated in Moscow, usually at the Moscow School. Their major concern was with the representation of form, mass, volume and colour. Through still life and portraiture they strove for a synthesis of colour and form, emphasizing in particular the plastic form of whatever subject they painted.

Aleksandr Shevchenko (1882–1948) studied at the Stroganov School and then in Paris with Carrière, and at the Académie Julian with Dinet and Laurens.[21] Back in Moscow he attended the Moscow School from 1907 to 1910, under Korovine and Serov. He contributed large numbers of works to all the important exhibitions, being especially interested in combining aspects of Cubism with neo-primitive subjects and the Futurist attempts to convey movement. He was also a theorist whose researches into colour (he was to establish a group entitled Colour Dynamics and Tectonic Primitivism, together with the artist Aleksei Grishchenko, in 1918–19) have been largely unrecognized. Some measure of the respect in which he was held may be demonstrated by the fact that at the Union of Youth showing of 1912, both he and Tatlin showed designs for the drama *The Emperor Maximilian and his Son*, which had been produced in St Petersburg on 27 January and 17 February 1911 with Shevchenko's designs and in Moscow on 6 November of that year with Tatlin's. In 1913 he published two books, on the theory of neo-primitivism, and on the principles of Cubism and other contemporary artistic trends; the styles of his work at this time vary from *The Musicians* (1913), which had close relations to the work of Goncharova during her Rayonist phase, to *Still Life: Wine and Fruit* (1913), which is a curious amalgam of 'Cézannism' and synthetic Cubism.

Petr Petrovich Konchalovsky (1876–1956), son-in-law of Surikov and father of a leading art critic, trained at the Stroganov school, at the Academy of Arts, and at the Académie Julian in Paris between 1896 and 1898, and later in his career returned to France, Italy and Spain in search of inspiration

105. Vladimir Evgrafovich Tatlin: *Composition from a Nude*, 1913. 143 × 103 cm. Whereabouts unknown

106. Petr Petrovich Konchalovsky: *Cassis*, 1913. Oil on canvas, 81 × 99.5 cm. Leningrad, Russian Museum

(Plate 106).[22] He was a leading member of the Jack of Diamonds group, was frequently described as a Cézannist, and yet seemed to have more affinities with the abundant vitality of early Flemish painting than with the comparative restraint of the French school. Like Kandinsky, he had been astonished by one of Monet's *Haystacks* which he saw for the first time in 1911; he made a journey to Arles in honour of Van Gogh; and translated into Russian Emile Bernard's record of Cézanne's observations on painting. He moved into line with the primitivists when in 1912 he painted *Loaves* after seeing a street sign advertising sugar loaves, although he had been experimenting with a deliberately crude style for some two years. He always retains a deep-seated humanism, but he was concerned primarily with shapes arranged on the canvas, often using colour to express their form. Konchalovsky was a lively portraitist, but he also excelled in still life and in landscape. His robust style and varied textural surfaces seemed to strengthen the subjects he tackled.

Ilya Ivanovich Mashkov (1881–1944) studied at the Moscow School under Korovin and Serov.[23] He travelled widely in Turkey, Egypt and Europe. In 1910 he was a founder member of the Jack of Diamonds. Although he, too, was under the spell of Cézanne, he quickly developed for himself a style in which a major part was played by heavy outlines and bright colours. It is true there is a monotony in his endless variations on groups of jugs, fruit, pump-

kins and bread, all possessing a singularly granite-like texture, but he was prodigiously gifted with pictorial invention in the early part of his career (Plate 107). His *Sitting Nude with Vase and Fruit* is certainly indebted to the Fauves but almost exceeds Matisse in the audacity of its colour; his *Sitting Nude* (before 1913) shows how quickly he learnt from the negroid works of Picasso and Braque from 1907; and his *Self-Portrait* (1911) with its simplified forms and neo-primitive manner shows how potent his influence must have been on the younger artists, including Tatlin and Malevich. But Mashkov quickly settled to the kind of painting he loved most: the celebration of the riches of life – pretty furnishing, food, fruit, luscious women, and his many friends – in dark, glowing browns and reds. He and Konchalovsky were great friends and collaborators at this period, thus, in a sense, mirroring the equally fertile relationship between Braque and Picasso.

Robert Rafailovich Falk (1886–1958) studied at the Moscow School under Serov and Korovin and independently with K. F. Yuon, I. O. Dudin (1887–1924), and with Mashkov.[24] He was a founder of the Jack of Diamonds; and at that stage in his career seemed not yet to have evolved a truly personal style: his *Landscape with a Dog* and *The Dealer in Old Clothes*, both dated 1910, have affinities with the work of Goncharova and neo-primitivism, while his *Still Life with White Table-cloth* (1914) shows why he was described as a Cézannist (Plate 108). The truth of the matter is that it took Falk many years to attain the unique delicacy

107. Ilya Ivanovich Mashkov: *Fruit on a Dish*, 1910. Oil on canvas, 80.7 × 116.2 cm. Moscow, Tretyakov Gallery

of his style. But by the end of a lengthy stay in Paris (he returned to the USSR in 1938) his art had attained such a simplicity, such an austerity both of means and matter, that his pictures, frequently of a dish, a cloth, and a few apples or other fruit, held a resonance of colours, muted and fragile as they were, which approached to music. Falk seems to have sought above all for the expressiveness of the total pictorial surface, so that line and to some extent form disappear among the myriad tiny brushstrokes; and every picture carries a sense of hard-won profundity and an enveloping wisdom.

Not least among the Jack of Diamond painters was Aristarkh Vasilievich Lentulov (1882–1943) who had first studied at the Art Institute in Penza near his home, then with D. N. Kardovsky in St Petersburg, and in 1911 with Le Fauconnier in Paris.[25] He took as his subjects the old buildings – churches, kremlins and monasteries – of the Russian city, seeing them as vibrating and pulsating with an inner dynamism, as in his *Moscow* (1913). In a sense, through the precariously towering forms, the eccentric and whimsical constructions and the festive colours of the buildings he utilizes in his composition, he is glorifying old Russia, an area which had been dear to the hearts of the *peredvizniki* and other artists at the turn of the century. Vasily Rozhdestvensky (1884–1963)[26] and Aleksandr Vasilievich Kuprin (1880–1960) both derived elements of their styles from Cézanne – the tilted table top, fruit, linen still carrying its fold-marks, greys and browns and whites applied in patches – with comparatively little reference to Cubism proper.[27] Theirs is an expressive, representational art, cool and detached, and rarely lacking in compositional strength.

Although, as has been remarked, the Jack of Diamond painters were to be eclipsed by artists who were even more audacious and experimental, they merit further recognition than they have hitherto

108. Robert Rafailovich Falk: *The Crimea: Lombardy Poplar*, 1915. Oil on canvas, 108 × 88 cm. Leningrad, Russian Museum

received. Even by 1914, they were still experimenting and evolving and finding their true and personal paths; Falk, for instance, was not to show his merits until the mid-twenties. Even so, it is clear that when war broke out in 1914, Russia possessed a dazzling array of talent comparable to any in Europe. Among the groupings it was the Union of Youth and the associated Cubo-Futurists who led the field and who were to consider themselves the natural artistic leaders of the revolution of 1917.

10
1914–1917: Years of Hectic Modernism

When Russia went to war in 1914 defeat was almost inevitable: many soldiers went to the front without rifles, the Germans received information of troop movements by aircraft dispatched by a colonel in the secret service, ministers of ability and independence were dismissed, and through the Empress Alexandra the destiny of the nation was controlled by Rasputin, a priest with hypnotic powers and moments of prophetic insight. Despite the greatest bravery on the part of the ordinary soldiers and sometimes on the part of their leaders, the army was crushed by the Germans who overran most of the west and south-west of the country, creating two million refugees as an additional burden on the weak economy. Military demands for supplies (which for the most part were not forthcoming) overburdened the railways already disrupted by troop movements; and in the cities, food and fuel were short and badly distributed. Deserters roamed the countryside spreading defeatist rumours, while factory workers, aroused by revolutionary propaganda, became restive in their wretched living conditions.

In February 1917 the scale of strikes and riots was such in Petrograd (the city's name had been changed because St Petersburg sounded too Germanic) that a change of government became essential and unavoidable: long after the most moderate of men had sensed that the Romanov dynasty was doomed the Tsar resigned on 15 March 1917. The initiative of the revolution passed to the crowds on the streets who, from the moment when soldiers joined them, saw the autocracy topple over of itself. The Provisional Government which had been formed under the leadership of Kerensky was unable to command order. After Lenin and other revolutinary leaders arrived in Petrograd on 16 April 1917, there was a struggle between their Bolshevik party and the Provisional Government until the latter was vanquished in late October. Peace, essential for the country's recovery, was made with Germany on 3 March 1918 at Brest-Litovsk in a humiliating treaty which robbed Russia of nearly all the territory gained westward since the accession of Peter the Great and which allowed German economic exploitation of Russia herself. Control inside the country was made particularly difficult for the Bolsheviks by centres of resistance in Eastern Russia, by the activities of Czech prisoners-of-war who held the trans-Siberian railway, and by the unwarranted invasion of Murmansk and Archangel and the setting-up of seditious agencies of various kinds by the Allied Powers. Even when these difficulties had been overcome there were further troubles when Finland, Estonia, Latvia, Lithuania and Poland fought or struggled for independence with the encouragement of the West. By 1921, however, military operations had ceased and the Soviet government had practically established its authority over what remained of European Russia.

Meanwhile the country was ruined. During the Civil War production had almost ceased and there were few reserves. The peasants stopped producing more food than they needed for their own consumption; and when their farms were raided by starving townspeople it was seed corn which was taken. Famine came on a nightmarish scale, increased by the breakdown of transport, a great drought, and a terrible outbreak of plague. Lenin was obliged to modify the state's economic policies and in 1921 a degree of private trade and management was allowed in the New Economic Policy (NEP), which soon began to produce results: 'Theories and visions were cast aside and were replaced by steady practical work ... a task for which the bitter school of material necessity had trained more pupils than had ever existed before.' Lenin's health had deteriorated through these strenuous years;

he fell ill, and died on 21 January 1924. He was succeeded by a triumvirate composed of Stalin, Kamenev and Zinoviev.

It is now necessary to examine the development of painting from the outbreak of war and the troubled times of the early revolution. In 1914 Russians were recalled from Western Europe to undertake military service. Larionov, for instance, came from France, but was invalided out of the Army in 1915 and allowed to leave for Switzerland. This was exceptional; and 1914 saw an amazing reunion of artists who had trained and worked in the art centres of the West. They found Russian art basically Cubo-Futurist and dominated by two men of strong

convictions and near-fanatical devotion to their own distinctive visions, who had begun to diverge in a violent fashion: Kazimir Severinovich Malevich (1878–1935) and Vladimir Evgrafovich Tatlin (1885–1953).

Kazimir Malevich was born of Polish-Russian stock near Kiev, where he received some art training at the local art school.[1] He went on to the Moscow School where he studied between 1904 and 1905. Until 1910 he worked in the studio of Roerburg in Moscow. His earliest works reflected the influence of the Symbolists and Post-Impressionists, but also showed an analytical tendency which ran counter to the realistic depiction of the human form and of scenery, so that he was more at home with Cézanne, Van Gogh and Derain whose pictures he studied in reproductions or in Moscow private collections. Roerburg introduced him to Larionov who, natur-

109. Kazimir Severinovich Malevich: *Head of a Peasant Girl*, 1912. Oil on canvas, 80 × 95 cm. Amsterdam, Stedelijk Museum

ally, encouraged him to work in the neo-primitive manner using subject-matter drawn from urban and rural life, but he seems to have felt himself more in sympathy with Goncharova about whom he wrote, 'Goncharova and I worked on the peasant level. Every work of ours had a content which although expressed in primitive form revealed a social concern. This was the basic difference between us and the Jack of Diamonds group which was working along the lines indicated by Cézanne.' Under her influence he executed large paintings in bright gouache of peasant and village life. As early as 1909–10, however, his *Chiropodist in the Bathroom* based on Cézanne's *The Card-Players*, of which he kept a reproduction in his room, showed that his real interest was in form rather than in style and that he was rapidly learning the art of simplifying planes and outlines. The structure of his *Peasants in Church* series (1910–11) indicates that he had found inspiration in the old icons, especially in the cruciform element, which may have attracted him by the unique combination of spiritual significance and pictorial formality, although he was himself a devout Roman Catholic. By the time of his *Haymaking* series of 1911 he had more or less given up naturalistic form and was ruthlessly pressing on with simplifications which, he claimed, had their origin in Russian folk art. The monumentality of his peasant figures was asserted by emphasis on outlines and the reduction of the human body to tube or cone-like shapes, metallic in substance, and sharply lit along one side in the manner of Léger's work. The structural power of these works is intensified by the actual quality of the paint which is applied thickly but so worked as to present a hard, imposing sheen. But like so many other Russian artists he was eclectic and while painting works in the Cubist mode he was also swearing allegiance to Futurism. With typical Russian abandon he utilized the newest available styles and was prepared, for a while, to inject into the comparatively static qualities of Cubism something of the restless vitality of Futurism. Thus his *Knife-Grinder* (1912), exhibited at The Target in 1913, has Cubist features such as the architectural forms and the segmentation of the knife-grinder's body and machine, but the head and limbs are represented by sections spread out in a fan-like formation which is the manner used by the Futurists to suggest consecutive movement. It is difficult to reconcile this with the frightening *Head of a Peasant Girl* (Plate 109), which exceeds the analytical Cubists in the relentless path it treads

towards abstraction. For the next two years there was to be a conflict in his work between a degree of naturalistic representation and a turning away to an inner gnostic world.

Malevich snatched greedily at theories of colour, space, time and dimension which came his way and followed the latest developments in Russian Futurist literature – his own powers of literary expression were limited in the extreme although he wrote voluminously. In co-operation with Kulbin and Olga Rozanova he illustrated Futurist books; for instance, in 1913, he and Rozanova decorated Kruchenykh's *Igra v adu* (*A Game in Hell*), which in its original version of 1912 had been done by Goncharova. In 1913 he was a co-signatory of the declaration of the All-National Congress of Futurist Writers that they were to organize a Futurist theatre. On 3 and 5 December there were performances in the Luna Park, St Petersburg, sponsored by the Union of Youth, of Mayakovsky's *Vladimir Mayakovsky* and an opera, *Victory over the Sun*, with a libretto by Kruchenykh and music by Matyushin, for which Malevich designed costumes and settings in a non-naturalistic style, one of the backcloths being a square divided almost diagonally into black and white areas. The costumes were geometrical and partly made of rectangular pieces of cardboard. During the performance of this strange work, really neither play nor opera but a kind of *singspiel*, the audience heard language used in a manner which ranged from the absurd to the incomprehensible, words and phrases being fragmented or linked in an apparently illogical nature – in something of the order of James Joyce's late works. This linguistic style was known as *zaum*; and it corresponded to a degree with the fragmentation practised by the Italian Futurists and the French analytical Cubists. With his passion for theorizing Malevich advocated in painting the deliberate breaking-up of such objects as a saw, scissors or ladder and their displaced employment within a pictorial scheme. Another device practised by the Futurist writers was *sdvig*, the displacement of words, even their random re-ordering. Malevich also used this strategy. While seeking a visual equivalent for the text of *Victory over the Sun*, he found himself on the road to a new pictorial style of non-figurative painting. Yet for a time he continued to use images drawn from the world around him. 'Each form is free and individual. Each form is a world', he wrote.[3] He painted what he called 'alogic' compositions, in which painted objects were combined in a way which at

first appeared nonsensical but which worked on the subconscious to give a deeper and more significant portrait of the object or person than would a conventionally naturalistic representation. Sometimes, like the synthetic Cubists he utilized fragments of words, which were either pasted or painted on the canvas. Thus in his *Englishman in Moscow* (1913–14), exhibited in Tramway V, there is an overall reference to a British Parliamentary delegation in Russia but further allusions are implied by letters, scraps of words, a small Russian church, a lighted candle in its holder, a sabre and a ladder – some of these elements being drawn from *Victory over the Sun* – which float over the surface of the canvas in a tenuous yet unexpectedly witty relationship so that the picture becomes the pictorial equivalent of the mocking and outrageously disjointed, absurd Futurist literature.

Malevich exhibited with the Moscow Artists, then the Jack of Diamonds, and then the Donkey's Tail. He sent work to the Blaue Reiter exhibition in Munich. He ended his friendship with Larionov, preferring the Union of Youth with its highly theoretical and experimental character. It was possibly the more sophisticated atmosphere of the Union of Youth which led him to abandon neo-primitivism and peasant themes, and to begin an investigation into the creation of a new pictorial language and possibly, too, an interest in theosophy which was currently the rage in St Petersburg. In French art interest in the primitive, slight as it was, had resulted merely in a preoccupation with novel visual techniques and freedom in the arrangement, composition and representation of visual matter, but with Malevich it inspired an obsession, temporary as it may have been, with the spiritual and social beliefs that lay behind primitive art. He may have been aware that a number of German artists were similarly obsessed and that the subject had become a preoccupation of the Blaue Reiter. By 1914 he was passing through and beyond Cubo-Futurism and had given up the closely ordered, complex compositions which had hitherto engaged him. His imagination was now dominated by the simplest of geometrical forms and their relationships with monochrome backgrounds. Here there may be evidence of a continued indebtedness to Orthodoxy – the small, rectangular icon, with its intrinsic capacity for releasing the faith and mysticism of the worshipper, set against the white-washed temporality of church walls, may have been in his visual memory. Thus he began to seek a new form of

painting which would have no figurative associations (or only the most tenuous), but which would express an inner reality, a new kind of icon without pictorial content onto which the viewer would project his own spiritual emotions. He wrote that in 'Trying desperately to liberate art from ... the representational world, I sought refuge in the form of the square.'[4] He also said, 'Only with the disappearance of a habit of mind which sees in pictures little corners of nature, madonnas and shameless Venuses, shall we witness a work of pure, living art.'[5] Yet only months before Malevich had been experimenting with the alogic pictorial language of *Englishman in Moscow*!

The revolt against the *peredvizhniki*, against the narrative-ordered painting of the nineteenth century, was now complete. And it was most probably the Union of Youth with its questing interest in pictorial aesthetics, inner sensations, and its alertness to the latest developments in European art, not least Kandinsky's claims for the spiritual in art, that gave Malevich the bold and pioneering courage to move forward.

In December–January 1915–16 he showed thirty-five non-objective canvases and inaugurated a revolutionary artistic development, an art of pure sensation, to which he gave the name of Suprematism, although the term was not actually used in the catalogue in which he contented himself with the statement: 'In naming some of these paintings I do not wish to point out what form to seek in them, but I wish to indicate that real forms were in many cases approached as the grounds for formless painterly masses from which a painterly picture was created, quite unrelated to nature.'[6] The only references to commonplace visual reality occur in such titles as *Football Match* or *Portrait of a Peasant*, for the pictures themselves consist of lines and rectangles of various shapes and sizes and in primary colours floating on the white surface of the canvas. Some critics have seen derivations from his designs for *Victory over the Sun* but if they do indeed exist they are singularly hard to discern. Malevich made use of the fact that certain colours appear to come forward while other recede; and for him white is the colour of the heavens and of space itself whereas, as we have seen, for the Symbolists it was blue. This new and extraordinary pictorial vocabulary grew in the next years to include circles and curved shapes of a basically hemispherical nature and, first and foremost, the square (Plate 110), always painted in bright primary colours. The most famous of these

works was undoubtedly *Black Square* – actually a black square framed by a white one, neither of them dominant and yet posing an enigma since we do not know whether the black actually projects from the white square or whether we pass through the space of the white into the unfathomable infinity of the black square. The most painterly works – for even the flow of the brushstroke has significance – seem to deny meaning to the visual phenomena of the objective world; and, instead, assert the value, power – and supremacy – of sensation. That is the sensation projected into the picture by the viewer and not necessarily that of the painter. Malevich felt

a kind of timidity bordering on fear when I was called upon to leave the 'world of will and idea' in which I had lived and worked and in the reality of which I believed. But the blissful feeling of liberating non-objectivity drew me into the 'desert' where nothing is real but feeling; and feeling became the content of my life. This is no 'empty square' which I had exhibited but rather the sensation of my non-objectivity.[7]

Beside these compositions in which shapes and colours play vital parts, are others employing more complicated relationships and a device of fading away the edge of a large shape to produce a sense of distance or even of infinity, as in his *Sensation of a Mystical Wave from the Earth* of 1917. In that year he seems to have begun his purest non-objective statements with the *White on White* series which ended in 1918. In these works colour has been eliminated, all suggestion of form banished, and all that can be seen is the shape of a square imposed diagonally on the canvas, both painted white, and made perceptible only by a difference of brush-strokes or pencilled outlines. Here the imperative for the viewer to project his own emotions is even more urgently extreme than in *Black Square*.

The precise meaning and intent of Malevich's work up to 1918 cannot be adequately expressed in words: his letters, statements and explanatory articles are couched in declamatory and allusive language and are by no means easy to understand.[8] He claimed for his pictures 'a new reality', but critics have persisted in seeing in them objective forms, including Christian symbolism (as in his use of the

cross shape to which he frequently returned), relationships with optics and Tantric art (emphasis on the square), an investigation of space, a metaphorical affinity with the flight of Icarus, the embodiment of the mystical sensations of theosophy, and an investigation of the nature of reality or of the cosmos. At this stage he seems to have believed that Suprematism was the purest and most spiritual form of art, claiming that he had 'felt only night' within him during the time he had conceived his new art. He stated that 'the square of the suprematists ... can be compared to the symbols of primitive man, whose primary intent was to express the feelings of rhythm and not to produce ornaments.' Presumably by 'rhythm' he is alluding to the Symbolist belief that rhythm began in the creative work and passed on into infinity. Analogies with Malevich's words that come to mind are the mystical statements of St John of the Cross and St Theresa of Avila, but there must also be more mundane links with Kandinsky's *On the Spiritual in Art*, particularly since the book had been widely discussed in Futurist circles. Malevich's emphasis on emotion may be a Russian challenge to the French Cubists whose approach to their art had been so ostensibly cerebral and allegedly scientific. Whatever the case – and it should be remembered that like the poet Rimbaud he was in later years to turn his back on these audacious experiments – few artists have brought to their work such fanatical devotion or intensity of thought on the nature of the visual translation and representation of sensory or religious or mystical perception. After the revolution of 1917 Malevich was to use the language of Suprematism for quite different ends; unlike Rayonism before it, however, Suprematism was adopted as a style by the majority of the advanced painters.

The artist with whom the name of Malevich is closely linked is Tatlin, a fierce rival for the leadership of Russian art.[9] The two men were greatly interested in each other's careers, frequently bitterly so. Tatlin was born in Moscow into an educated family, his father having been trained as an engineer at the Technical Institute in St Petersburg and his mother enjoying some reputation as a poet. It has been claimed that the father visited the USA. Although little is known of Tatlin's childhood it seems certain that it was an unhappy one, especially after the death of his mother in 1887. In 1902 he began his studies at the Moscow School working under Korovin and Serov. He seems to have been a somewhat casual student in the academic sense; and in

110. Kazimir Severinovich Malevich: *Supremus no. 50*, 1915. Oil on canvas, 97 × 66 cm. Amsterdam, Stedelijk Museum

1904 he went to sea, visiting a number of Mediterranean countries as a sailor. By 1908 he had become friendly with the Burlyuks and with Larionov, who painted two portraits of him. At different times he sought training at the Moscow School and elsewhere; his independent and prickly character was formed by 1910 when together with Larionov, Goncharova and Malevich he exhibited in the Jack of Diamonds (1910), the second Union of Youth (1911), and the Donkey's Tail (1912) exhibitions. His subjects were usually seamen (himself included), and other workers connected with the sea. An influence strong on him at this time and which probably came through Goncharova was that of the old icons, as can be seen in the emphatic curves and angular groupings of his compositions. Tatlin was never much enamoured of the primitivism advocated by Larionov and the Burlyuks, nor did he greatly admire Cubo-Futurism although he illustrated books of verse such as Kruchenykh's anthology *Mir s kontsa* (*The World Backwards*) of 1912, and the Futurist miscellany *Trebnik troikh* (*The Missal of Three*) of 1913, and much admired V. Khlebnikov, one of whose plays he was to produce in 1923.[10]

By 1912 Tatlin had broken with Larionov and was accepted as a member of the Jack of Diamonds, then allegedly French-inclined, but left it almost immediately and instead sent works to Mir iskusstva and the Union of Youth from which, however, together with Malevich he resigned the following year. In 1913, as a bandura-player with a Ukrainian folk group he visited Berlin and Paris where he sought out Picasso, whose genius he revered together with that of Cézanne, Léger, and the veteran Russian teacher Chistyakov. Among the works he sent to the Donkey's Tail of 1912 was a set of designs he had made for a production by Tomashevsky of the folk drama *The Emperor Maximilian and his son Adolf* presented by the Union of Youth on 17 December 1912, which served to reveal his interest in objects in space; an interest heightened by the wooden reliefs with musical instruments which he saw in Picasso's studio, inspiring him on his return home to experiment with similar compositions which he exhibited in his studio on 10 May 1914 as 'synthetic static compositions'. Next year at the exhibitions Tramway V, the Year 1915, and 0.10, all in Petrograd, he showed 'painterly-reliefs' including one on a background of plaster; and at 0.10, in December, he showed his 'corner-reliefs' or corner 'constructions' – which may be the first use

of this elusive term, presumably invented by Tatlin in the absence of any suitable nomenclature. Tatlin employed bottles, tin cans, broken glass, nails and planks of wood in his structures. The critic Sergei Isakov writing on these reliefs mentions one in his office made of 'small pieces of tin, cardboard and piping', presumably among the first art works in modern European culture to have been assembled from rubbish and junk, anticipating the creations of the Dadaists and Kurt Schwitters.[11] Tatlin announced his newest reliefs to the world at the 0.10 in a manifesto which challenged the one issued at the same time by Malevich on Suprematism.

In 1916 Tatlin arranged an exhibition in Moscow called Magazin (The Shop), for which he invited contributions from Malevich and other artists, including Lev Aleksandrovich Bruni (1894–1948), who briefly experimented with three-dimensional reliefs.[12] Next year, the year of revolution, Tatlin, Rodchenko and Yakulov worked on the decoration of the Café Pittoresque, the artists' café in Moscow.[13] Unfortunately, most of Tatlin's reliefs no longer exist and only poor photographs remain. His 'painterly-reliefs' and 'relief-constructions' of 1913–14 are innovatory in their absolute independence of natural forms and traditional figuration; and thus, they are, in a sense, a close parallel to Malevich's language of Suprematism.

Tatlin was not a prolific painter; and he never developed a consistent style. By 1911 he had evolved a manner which, as in *The Fish-seller* and *Self-Portrait as a Sailor*, was both laconic and rhythmic, much as in the old icons. He applies the paint drily and sparingly, leaving unpainted areas of canvas when necessary. The emphatic planes, the exploitation of pictorial space and the shading by firm brushstrokes reveal the influence of contemporary French painting as does the limited colour range. The *Nudes* of 1913 are tautly constructed, simplified in contour, warmer in colour and abounding in repeated rhythms. Here the indebtedness to the icon is even greater. Tatlin continued to paint portraits, flowers and nudes throughout his career but in an increasingly naturalistic way. One senses in the paintings and reliefs an awkwardness of mentality, a brashness, a clumsy originality, and a kind of visual obstinacy which fitted him to assume the leadership of the avant-garde during the early years of the revolution and to secure for himself a degree of state patronage in those years. He was foremost among the younger artists in engaging in theatrical design and production (Plate 111); and

the protean nature of his activities further serve to give his character an elusive quality. Tatlin seems to have faced the world with a harsh, almost philistine indifference, with a bold-faced materialism, and, for the most part, to have concealed his ideals and wilder dreams.

Not unnaturally, perhaps, since they were not subject to the exigencies of military service, some women painters of distinction emerged during the war years, notably in the two major Futurist exhibitions previously mentioned: Tramway V of February 1915 and 0.10 of December 1915, both financed by the artist Ivan Albertovich Puni (1894–1956), grandson of the composer Pugny, and his wife Kseniya Leonidovna Boguslavskaya (1892–1972).[14] These two exhibitions, which, as we have seen, brought together Malevich and Tatlin and revealed them as leaders of two schools opposed to each other in fact if not always in theory,[15]

111. Vladimir Evgrafovich Tatlin: Costume design for Glinka's *Ivan Susanin*, 1931. Watercolour, 31.5 × 45 cm. Moscow, Central Theatrical Museum

also served to demonstrate the talents of their followers.[16]

Nadezha Andreevna Udaltsova (1885–1961) had imbibed a wide range of artistic culture ranging from Symbolism (especially in the work of Borisov-Musatov), seventeenth-century Dutch painting and medieval stained glass to French Cubism, of which she probably knew more than any of her Russian contemporaries. She worked with Tatlin, taught with Malevich, and married the painter Aleksandr Davidovich Drevin. She rejected the pretensions of the Cubists to have analysed form and, instead, used their flat planes as a method of pictorial construction, also working with a brighter palette. An instance is her *Guitar* (1914) in which she first describes an oval on the white rectangular canvas and then proceeds to break the guitar and sheet music into overlapping planes complete with letters and numbers. By 1916 she had begun to experiment with some of the elements of Suprematism, usually in gouache on paper, but presenting a number of differently shaped planes pressing down on each other as in her *Untitled* works of 1920. It is clear that she was ill at ease with this stark language and quickly moved back to the more decorative area of Cubism.[17] Her friend Lyubov Sergeevna Popova (1889–1924), an artist of the highest calibre with a remarkable sense of colour and a powerful ability to absorb Cubism, then Suprematism and, still later, Constructivism, was far more adventurous and enthusiastic than Udaltsova although she also shared her deep commitment to the avant-garde.[18] Her *Seated Nude* of 1913 shows a similar use of planes and curves to Tatlin with whom she worked at this time. Her work began to differ from that of the French Cubists in that she no longer sought to maintain a balanced flatness on the pictorial plane of the canvas and worked towards an emphasis on volume. Her *The Traveller* (1915) while recognizably Cubist also seems alive with Futurist energy – it also marks the limit of her realism, for from 1916 her pictures grew increasingly non-objective (Plate 112). She began a series entitled *Painterly Architectonics*, followed in 1920 by *Painterly Constructions*, and finally in 1921 *Spatial-Force Constructions*. In these works she moves from what look roughly like paintings of constructions to more painterly works in which lines cross and crisscross, seeming to float above and partially obliterate faint lines drawn with dry white paint or dim words and numbers which appear to belong with the paper or canvas. The influence of Tatlin is stronger than that of Malevich;

but Popova was entirely her own mistress. This truly original artist gave up easel painting from 1920 when she concentrated on teaching and textile design until her death in 1924.

Aleksandra Aleksandrovich Ekster (1884–1949) studied initially in Kiev and then in Paris where she rapidly became familiar with leading members of the literary and artistic avant-garde.[19] Her knowledge of Cubism, Futurism and Orphism invested her with a distinctly cosmopolitan aura. Ekster was essentially urban, and a work such as *Firenze* (1914–15) is an attractive *assemblage* of decorative Cubist devices rather than a cohesive picture. By 1916, as her *Dynamic Composition* demonstrates, she had grasped some of the visual components of Suprematism although she was a great admirer of Tatlin and owned one of his first relief-constructions. The swirling movement and the sense

112. Lyubov Popova: *Composition*, 1920. Gouache, 33.5 × 25 cm. Private Collection

of volume so evident in her work found its true expression in costume and stage design during the war years. Afterwards, in 1918, she founded her own teaching studio in Kiev from which emerged several leading stage designers such as Tyshler, Shifrin, Rabinovich and Tchelitchev. From then on she worked in textile design and theatrical design. Another member of the group was Olga Rozanova whose brief career will be described later.[20]

Among the men Mikhail Menkov, Ivan Klyun and Ivan Puni were to become adherents of Malevich, despite the fact that the latter experimented for a while with constructions of a somewhat empty but amusing nature in which the Suprematist motifs – if rectangles, semi-circles, blocks and other geometrical shapes can be so called – are occasionally at odds with the materials used. Mikhail Ivanovich Menkov exhibited with Malevich in 1915, 1917 and 1919, but faded out of the art scene after that date and has passed into obscurity, perhaps undeservedly. Ivan Vasilievich Klyun (1870–1943) studied in Warsaw and then in Moscow in the studios of Roerburg, Fisher and Mashkov; and came to full maturity in the years between the outbreak of war and the revolution. He exhibited with many groups.[21] In 1907 he met Malevich; and painted his portrait in 1912. He also linked himself with Kruchenykh and Matyushin whose *Faktura slova* (*Facture of the Word*) he illustrated in 1923. Klyun was, perhaps, too talented for his own good. He began his career as a Symbolist as in *Portrait of the Artist's Wife* (*Consumption*) of 1910, in which the frail figure of his wife is seen against a frieze of flowers, rocks, trees, moving figures and her own corpse – there are distinct affinities with the Blue Rose painters. Later, in 1916, in the *Secret Vices of the Academicians* (1915–16), which he illustrated, he wrote a scathing denunciation of the Symbolists in his 'Primitives of the Twentieth Century'. By that time he had moved through Cubism and Futurism (his *Landscape rushing by* of 1914–15 with its brilliantly painted wooden segment, telephone wire and fragments of porcelain reflects the Futurists' preoccupation with speed although it is also distinctly and individually Cubist), and by 1917 was seeking for a synthesis between Suprematism and Tatlin's constructions. He quickly and efficiently adopted the Suprematist idiom although he introduced an element of his own: circles, sometimes overlaid by other smaller circles or rectangles, the edges of which fade away into the background of the canvas (Plates 113 and 114). In 1919 he began to speak of the congealed

113. Ivan Vasilievich Klyun: *Suprematist Composition*, 1921.
Oil on canvas, 51.5 × 49.5 cm. London, Fischer Fine Art Ltd

and motionless forms of Suprematism in clear dissatisfaction with the work of Malevich. Influenced now by Ozenfant, he moved to a form of Purism concentrating on varied presentations of groups of bottles.

Klyun had thrown himself full-heartedly into revolutionary activity: almost inevitably he taught at the Vkhutemas, joined Inkhuk, and exhibited at the Tenth State Exhibition – Non-Objective Creation and Suprematism – in 1919. However, he stoutly maintained the validity of easel painting, exhibiting with OST in 1925 and with the Four Arts Society of Artists in 1926. Never as challenging or as pugnacious an individual as Malevich, he had a far finer sense of colour and, without doubt, could equal his Suprematist works in composition and harmony of shape and colour.

Puni and his wife Boguslavskaya (a wealthy heiress) were both artists of talent but of limited individuality. He studied at the Académie Julian in Paris in 1910; and he and his wife made their home in St Petersburg a meeting-place for artists where Cubo-Futurism was much promoted. In January 1914 they were active in bringing out the Futurist miscellany *Futuristy: Rykayushchy Parnas* (*Futurists: Roaring Parnassus*), with illustrations by Puni, Rozanova and Pavel Filonov. It was confiscated by the censor. The following year they published their own *Suprematist Manifesto* at The Last Futurist Exhibition of Pictures: 0.10. In the immediate post-revolutionary years he assisted with open air agit-decorations in Petrograd and taught in Vitebsk. He left for Berlin in 1920 and settled in Paris where he adopted a style close to that of Vuillard and Bonnard. Puni was probably the first artist to create reliefs, using objects such as a hammer from every-day life, an unusual innovation which he did not follow for any length of time. He also painted several Suprematist pictures; but already by 1917 he had reverted to a naturalistic style and when, in 1922, he denounced Suprematism, his brief flirtation with the avant-garde came to a not-unanticipated conclusion.

The *enfant terrible* of the period was Aleksandr Mikhailovich Rodchenko (1891–1956).[22] He trained at the Kazan art school where he met Varvara Fedorovna Stepanova (1894–1958), whom he

later married. He also attended the Stroganov Art Institute in Moscow. After the revolution his was the guiding spirit behind many new organizations such as Inkhuk (which he helped to found in 1920) and IZO Narkompros; like so many avant-garde artists he taught at the Vkhutein. Stepanova, too, was associated with these agencies but turned her talents more and more to theatrical and industrial design. Rodchenko was one of the most able artists of his generation but it would be hard to describe him as a born painter. He quickly developed a highly individual version of the Cubo-Futurist style in which he was not only concerned with planes but with shredding or peeling figures and objects into myriads of curved and curling fragments which seem to be in ceaseless rivalry for supremacy over each other. He tried whenever possible to use pen, compass and ruler to secure linear accuracy, as in his

115. Georgy Yakulov: Design for the Café Pittoresque, Moscow, 1917. Oil on plywood, 152 × 117 cm. Erevan, Armenian National Art Gallery

114. Ivan Vasilievich Klyun: *Architectonic Composition*, 1920–1. Oil on canvas, 55 × 42 cm. London, Fischer Fine Art Ltd

The Clown Pierrot (1920). There is little that is painterly about these works which is not, however, to deny their significance. His career after 1917 is discussed later.

These artists lived, worked, hated and loved in a whirlwind of feverish excitement. They painted, argued and recited verses in their country *dachas*, their rooms in Moscow tenements, the literary salons of St Petersburg (Petrograd as it became), and in the few cafés which welcomed such ribald and fantastically dressed characters. In 1917 a basement café in Moscow was to become the celebrated (or notorious) Café Pittoresque which the writer Ilya Ehrenburg described in one of his more censorious moments as 'the only café that all the artistic sewers in Europe's capitals would envy',[23] which may or may not be interpreted as high praise. Actually it was intended to rival a similar establishment in Petrograd, The Stray Dog, where Mayakovsy used to recite his verses, and which had been closed by the police in 1915.[24] The decorations of the Café Pittoresque (some of them, oddly enough, in a style reminiscent of Art Nouveau) were undertaken by Tatlin, Yakulov, Rodchenko, Udaltsova and other friends, and included constructions, reliefs and mobiles (Plate 115). There the poet Kamensky and his friends Goldschmidt, Mayakovsky and the Burlyuks recited their shocking verses to audiences of black marketeers, anarchists, scandalized bourgeoisie and secret police.

The Café Pittoresque typifies the hysteria and reckless abandon which marked Russian cultural life in the last days of Tsardom. The hectic mood and triumphant artistic experiments of the years leading up to 1917 can hardly be overstressed.[25] Readers will recognize affinities with the absurd activities of the Dadaists in Zurich whose manic capers were a protest against the insane and devastating slaughter taking place on the battlefields of an allegedly civilized Europe. Little did the artists of Moscow and Petrograd, the majority of whom enthusiastically welcomed Bolshevik government, foresee what was to be its effect on painting – and, indeed, all the arts – in the uncertain years ahead.

11
Art and Revolution

After the downfall of the Tsar, the advent of the Provisional Government and the eventual triumph of the Bolsheviks, artists found themselves in a quandary. The avant-garde generally supported the revolutionary elements, but there were those who felt it could only be a short time before the conservative forces of the church and throne reasserted their authority, and others who did not wish to commit themselves politically. It was the Futurists who most welcomed the new situation, although their attitude was certainly tinctured with self-interest. Many artists joined in a central Arts Union which seemed to be in a position of strength from which it could negotiate with any new government.[1]

Not unnaturally, there was considerable resistance to the Bolsheviks on the part of the official theatrical and artistic agencies which had been directly controlled and financed by the throne. The bureaucrats continued to work at their desks and either ignored the officials who claimed to be their new masters or simply locked them out of the offices. A set of teaching and administrative institutions concerned with the arts came into being. The total organization of artistic life on which Lenin placed great value was given by him into the hands of Anatoly Vasilievich Lunacharsky (1875–1933), a man of wide culture, himself a Futurist writer, whose Commissariat for Popular Enlightenment (Narkompros) created a Department of Fine Arts (IZO) in 1918.[2] The tasks before Narkompros included the preservation of art treasures, the administration of the Academy of Arts in Petrograd, the reorganization of all the Moscow schools of art, and the working-out and rethinking of all matters pertaining to artistic life. The trouble was that Lunacharsky, having only a faint knowledge of the artistic worlds of Petrograd and Moscow, since like many of the Bolsheviks he had lived abroad in exile, did not know how to cope with the Arts Union (Soyuz

Dyatelei Iskusstv), set up in May 1917 combining three groups – the left led by Osip Brik, Mayakovsky and Punin; an uncommitted centre party; and a right-wing group led by the poet F. Sologub. The bias of the groups was towards literature. The left had determined on autonomy and had not the least intention of heeding the Bolsheviks or any other party. It wished to be solely responsible for the reform of the Academy of Arts and for the direction of all artistic institutions while still expecting to be financed by the new state. Its lack of revolutionary and socialist fervour was demonstrated on 12 November 1917, when the Bolsheviks submitted proposals for a state soviet on art affairs, half of whose members would represent the arts and the other half the interests of soldiers, workers and peasants – proposals which were indignantly rejected by the Arts Union which saw no reason why non-artistic delegates should have a vote on the organization of cultural life in the new state. The Union even refused to co-operate with Narkompros in the protection of art treasures. In April 1918, despite protests by conservative elements in the Union, the Academy of Arts was closed and its accommodation divided into free artistic studios largely shared out among the Futurists and their friends. Lunacharsky addressed the Arts Union later in the month and declared that the government stood for the separation of art from the state, and opposed state support of any single group or organization on the grounds that this would inhibit the development of other groups. He admitted that the government had failed to come to terms with the greater part of the artistic intelligentsia and declared, 'We stand for the policy of the active minority and, in art, for union with separate outstanding talents.' This was a policy *faute de mieux* of accommodation, with no apparent consideration of long-term objectives. After this meeting the Arts Union

broke off relations with the government, which can hardly have felt any strong sense of regret.[3]

The artistic group which had been keenest to ingratiate itself with the Bolsheviks after the October Revolution were the Futurists, who had remained on the left wing of the Arts Union and were largely represented by Mayakovsky whose behaviour, however, was discreet in the extreme. He associated himself with the Soviet government in Petrograd, but did not care to join the Bolshevik party because, as he said, they would have sent him to catch fish in Astrakhan. There were others who were less hesitant, among them David Petrovich Shterenberg (1881–1948), a painter in a Cubist style who had been in exile with Lunacharsky and who was now designated General Head of IZO (Department of Visual Arts in the People's Commissariat for Popular Enlightenment) and also head of the Petrograd branch.[4] Another former exile Natan Altman (1889–1970) worked in the Petrograd branch, while Tatlin was in charge in Moscow.[5] The leftist domination of IZO was increased by the presence of Rozanova, Kandinsky, and the art critic Nikolai Nikolaevich Punin (1888–1953) as teaching members. Thus by December 1917, the Futurists (for whom the term leftist is almost synonymous) were dominant in the art section of Narkompros and were arousing consternation among the less liberal Bolsheviks. This became increasingly the case when the Futurists attacked the centre part of the Arts Union (which was largely composed of Mir iskusstva painters and the Cézannists) as well as the extreme right wing. A year later the Petrograd IZO began publication of a journal, *Iskusstvo kommuny* (*Art of the Commune*), to which Mayakovsky, Altman, Punin, Malevich and Chagall contributed. In the fourth issue, dated 29 December 1918, Lunacharsky felt obliged to intervene and ask why Narkompros should be taking great pains to preserve Russia's cultural heritage and yet, at the same time, allow one of its official publications to describe 'all artistic work from Adam to Mayakovsky as a heap of rubbish which ought to be destroyed'. He was embarrassed by the Futurists' intolerance of other schools and their monopolist claims.

Lenin himself was not enamoured of modern art, did not care for the Futurists' street decorations (in which taste he was joined by the Muscovites who found them merely laughable), and was annoyed when the trees in the Kremlin gardens were given coats of green paint which could not be washed off. Even so, Lenin, his wife Krupskaya, and Lunachar-

sky continued to support the arts section against attacks from the workers and other areas of the new Soviet government. The eventual failure of Futurism in the arts, which is to say in both literature and painting, came as much from its own belligerence, intolerance of other groups, rivalry among its own members and inability to renew its own vitality, as from outside factors.

Lunacharsky had long been involved with the Bolsheviks but had also interested himself in several ideologies in the field of proletarian culture, often to the fury of Lenin. In particular he had been drawn to the ideas developed in exile by his brother-in-law and friend Aleksandr Malinovsky (1873–1928), better known as Bogdanov, who argued that the proletariat must proceed to the creation of its own art, that creation, 'whether technological, socio-economic, political, domestic, scientific, or artistic', represented a kind of labour, and that the proletarian would fuse art and work in order 'to make art a weapon for the active and aesthetic transformation of his entire life'. Partly because of natural sympathy and largely because of his own tolerance, Lunacharsky sponsored Proletkult, an organization directed by Bogdanov. By 1920 Proletkult's numbers vastly exceeded those of the Bolshevik party and there was a flourishing group in Germany. Lenin was not favourably disposed to its organization (which he seems to have considered potentially subversive), to its flirtations with religion, or to its narrow preoccupations which he believed were creating divisions within Russian society at a time when he was in the process of making a temporary accommodation with the peasantry and the business bourgeoisie as an integral part of his New Economic Policy. He suggested the absorption of Proletkult within Narkompros and would, perhaps, have dispensed with the leaders of both organizations except that it would have been impossible to replace them with persons who were not themselves Bogdanovists, Futurists or cultural iconoclasts. Both represented obstacles to his policies, especially that of reconciliation with the peasants who formed the bulk of the population and who were a key element in the precarious economy, whereas Proletkult addressed itself to factory workers in modern heavy industry who were to produce their own art. And the Futurists were devoted to the glorification of the machine, industrialization and city life, and to the destruction of the art of the past – as were the original Italian Futurists. Both movements represented a break with the populist ideals of the *peredvizhniki* and the

chauvinistic nationalism of the neo-primitivists.

In the four years which followed the revolution and led up to NEP there was an uneasy relationship between Proletkult and the Futurists although their ideas and actions showed considerable overlap. However, the basic concept of Proletkult – 'that concrete reality could be changed by art and hence by the artistic will' – artistic will of the workers that is – was to be a potent force throughout the 1920s, although Bogdanov had begun to lose interest and had returned to medicine from about 1921. In one sense Proletkult is yet another of the many aesthetic movements which are a peculiarity of the twentieth century and which first announce their presence by declarations, challenges and manifestos and only later by actual works of art, a tendency to which Russian painting was especially prone. Despite Bogdanov's belief that methods of proletarian creation would be based on methods of proletarian labour (which is the type of work characteristic of modern heavy industry), no artistic creation, in the normally accepted sense of the word, was to come into existence. But as we shall see the arguments of Proletkult had a seductive appeal to a nation which saw its future in massive industrialization and which was grappling with the problems of reconciling the apparently opposing needs of the individual and the masses.[6]

It might be asked what opportunities had Russian painters to work and to show their paintings or to prove their allegiance to the new government in these troubled years. Could a government in the throes of establishing its power and fighting off its enemies both ideological and physical spare any time to consider the welfare of the arts or give any of its much-needed money to artists? Initially, at any rate, there were vast opportunities for the Futurists since they controlled the appropriate departments. As has been mentioned, the Academy of Fine Arts in Petrograd had been closed in the summer of 1918, its teachers dismissed, and its works of art alienated on behalf of the nation. It was reopened as Gakhn (Petrograd State Free Art Studios) and then as Svomas (Free State Art Studios) with liberal statutes and syllabuses, with, at various tines, Altman, Malevich, Petrov-Vodkin, Puni, Shterenberg and Tatlin among its teachers. The fatal leaning to dissension appeared, Narkompros stepped in, and the studios were brought under the control of the Academy of Sciences until 1921. This pattern was also to be observed in Moscow where the School of Painting, Sculpture, and Architecture and the Stroganov School of Applied Art were closed down and reformed as Svomas in 1918 and then as Vkhutemas (Higher State Art-Technical Studios) in 1920. Later still, in 1926, the Moscow Institute was to become Vkhutein (Higher State Art-Technical Institute); and in Petrograd the Svomas were to be replaced by a reorganized Academy. In Moscow the painting studios were directed by Tatlin together with A. Morgunov, Ivanov and Mashkov; the technical workshops were controlled by Rodchenko and Rozanova; printing and book production by Aleksandr Shevchenho and Franchetti; architecture by Zholtovsky; art theory and museum organization by Korolev, Malevich and Fiedler; and theatre and films came under the direction of Kuznetsov, Kandinsky and Udaltsova. Tatlin was also head of IZO in Moscow. However, he quickly left these posts to work in the Svomas in Petrograd. Guiding the work of these State Studios were the Inkhuks (Institutes of Artistic Culture) set up in Moscow in 1920, initially under Kandinsky, in Vitebsk under Malevich (1920–2), and in Petrograd under Tatlin and then under Malevich, Matyushin[7] and Punin (1922–6). The central organization in Moscow had a number of contacts in Europe and even in Japan. Its proper task was the investigation of materials and media in relation to artistic developments.

One of the first actions of IZO was to set up under the youthful Rodchenko a Museum Bureau and a Purchasing Fund to which the government promised two million roubles in order to establish museums and art galleries throughout the country, an ambitious scheme in which Kandinsky had a hand. Thirty-six galleries were set up, and twenty-six more were planned when the section was disbanded in 1921. Thirteen of those established were entitled Museums of Painterly Culture, a title allegedly thought up by Tatlin and his friend Punin who also edited the influential *Art of the Commune* which ran from 1918 to 1919 and which informed the public about the new methods of artistic creation. There was also to be an Exhibition Museum and a Historical Museum – the latter was to be a centre for the study of past forms of art. There were also plans for sending works of art to the most distant towns and provinces, an ideal which did not always meet with approval from the artists themselves whose socialist concerns gave way before a regard for the safety of their works. The leading spirit behind many of these innovations was undoubtedly Kandinsky who also drew up teaching programmes for his own studio at the Moscow Svomas and a

more comprehensive, more embracing programme for the Moscow Inkhuk which had opened under his direction in May 1920. It is undeniable that Bolshevik Russia was the first country in the world to exhibit abstract works – paintings and sculptures and constructions – as part of an official policy and on a wider scale than had hitherto been known. This was not done without protests from the older and more conservative artists and also from within the ranks of the mistrustful Bolsheviks.

It has been pointed out that the new government was at first obliged to turn to the Futurists as being the only section of the artistic and cultural world willing to co-operate with it; and it must be said that they gladly welcomed the advent of a revolutionary era. It signalled to them the beginning of a new world in which they would become an integral part of society and within which their artistic experiments would fall into line with the economic, social and political innovations which the revolution had promised. Malevich announced that Cubism and Futurism had been revolutionary forms of art which had anticipated the events of 1917, while Tatlin proclaimed that the Constructivists had already achieved a revolution in 1914 when 'material, volume, and construction' were announced as the 'basis' of the art of the future. Easel painting was (temporarily) abandoned and artists went into the streets to propagate the message of the revolution: they were determined to become a vital and essential part of the new revolutionary society, an integral part of the process of social creation. Their studios, they proclaimed, were to be the streets, the tramways, the factories, the workshops and even the homes of the workers.

Not for the first time in Russian history it was the artists who strove to reform social attitudes, a task embraced with wild joy. At the same time they showed little sense of expediencey, little appreciation of the appalling shortages in the country, blockaded as it was by the Allied Powers, battered by German economic pressures, and torn by civil war. Nevertheless, they did contribute in public fashion to the establishment of the Soviet state. From the first they joined in agitprop, decorating trains, buses and lorries with revolutionary slogans and designs – even the river steamers were pressed into service. Posters, pamphlets and books proclaimed the new Bolshevik state.[8]

The first anniversary of the revolution was celebrated in most major cities by semi-theatrical demonstrations of which the most striking was that

116. Vladimir Vasilievich Lebedev: Design for a poster, *The Apotheosis of the Worker*, 1920. Gouache, 72 × 38 cm. Leningrad, Saltykov-Shchedrin Library

produced in Petrograd by Altman, who decorated the immense square of the Winter Palace with abstract sculptures, Futurist constructions and painted banners. Two years later, in 1920, he staged an enactment of the storming of the Palace in 1917, using a battalion of troops and vast crowds. Altman developed an angular, simple style, shorn of detail, which was well adapted to the decoration of mass demonstrations; he was also a fine portraitist who captured the adventurous spirit of the age in his depiction of Anna Akhmatova and other members of the intelligentsia. He was to leave Russia for Paris in 1929, returning in 1935, and spending the rest of his life in Leningrad. Other artists who participated in these activities were Vladimir Vasilievich Lebedev (1891–1967), the architect brothers Aleksandr Aleksandrovich (1883–1959) and Viktor Aleksandrovich Vesnin (1882–1950), and Aristarkh Lentulov, whose modified Cubist style seemed to catch the revolutionary frenzy. Mayakovsky and Vladimir Lebedev designed outstanding posters, simple, colourful and memorable, for ROSTA (Russian Telegraph Agency) (Plate 116). (Lebedev also

painted many enchanting portraits of women.)

Acting on a suggestion of Lenin's a number of monuments were erected in Petrograd and Moscow but since permanent materials were rarely available, construction methods were poor and design even poorer, the experiment was a comic failure. The single achievement in this respect was the proposal by Tatlin for a monument to the Third International, a spiral tower of open metal work, probably over 1,300 feet high, which slanted precariously to one side, apparently in continuation of the earth's axis, and contained within its framework three suspended sections, for legislative and other purposes, which revolved once a year, once a month, and once a day respectively. The mammoth project, which, it was intended, should proclaim aspects, notably in the legislative and administrative areas, of world communism, was evolved by Tatlin in his studio for 'volume, materials, and construction' where a prototype model was created and exhibited, causing much discussion. In the same year, 1920, it was taken to Moscow, where it was seen by Lenin whose opinions were by no means favourable. While the magnitude of Tatlin's conception is quite breathtaking, his tower, which it seems could never have been built either in Russia or anywhere else in the world at its projected size (in Moscow it was revolved by a small boy turning the mechanism concealed under the platform on which it stood), signifies the end of his futurist dreams: it was ultimately as improbable as Scriabin's immense mystery drama or any of the other Promethean fantasies of Russian art.[9]

Between 1918 and 1921 there were twenty-one State Exhibitions devoted both to groups and to private individuals. In December 1918 a large retrospective was devoted to the work of Olga Rozanova (1886–1918). An early member of the Union of Youth group in St Petersburg and an enthusiastic Futurist, she contributed to the Union journal and together with Malevich illustrated books of poetry by Khlebnikov and her husband Kruchenykh in which layout and decoration, crude in manner, caught exactly the spirit of *zaum*, the non-rational use of words and language. Soon after the advent of Bolshevik power, in June 1918, she joined IZO and took charge of the subsection involved in the organization of industrial art, to which end she travelled throughout the country arousing support for the new state and bringing technical schools into line with the ideals of the ministry. She was possessed of a sturdy, practical turn of mind;

and was engaged in putting up banners and decorations in an aircraft hangar when she died stricken by typhoid fever. Rozanova was influenced by Cubism and to some extent by Italian Futurism but her association with Malevich led her to Suprematism and made of her an altogether more individual artist. Her pictures pre-1914, heavy in style and laden with the letters and words to which the Cubists were addicted, gave way to complex arrangements of the simple shapes associated with Suprematism. What was extraordinary is that she not only created pictures in this style but also used cut-outs of paper and fabric in collage work. These brilliantly coloured works, probably intended as illustrations to poetry, anticipate Matisse's later work. Even more astonishing are a few canvases with a roughly painted stripe in pink or green placed diagonally on a white ground. Such stark minimalism was not to be seen again for almost fifty years; and the powerful, totem-like quality of these pictures, so completely painterly in essence, suggests that Rozanova would have been one of the major artists of her time.

The tumultuous and bewildering and wonderful flood of avant-garde painting appears to come to an end about 1920, just as Futurism and Cubism had both reached a peak some six years earlier. Early in 1918 an exhibition held in the Museum of Fine Arts, Moscow, arranged by the Trade Union of Artist-Painters of the New Art and entitled From Impressionism to Abstract Painting, showed works by Popova, Rodchenko, Stepanova and others, Russian members of the Blaue Reiter, the Cézannists, Kandinsky and a few artists who were new to the scene, including Anton Pevsner (1886–1962) and the graphic illustrator and painter Vladimir Andreevich Favorsky (1886–1964), who as professor and rector (1921–9) of the Vkhutemas set high technical standards and gave generous moral leadership. There followed in 1919 the Tenth State Exhibition: Abstract Creation and Suprematism, a comparatively small exhibition of some 220 works by nine artists.[10] Malevich contributed his famous White on White series already mentioned. He wrote: 'I have broken through the blue shade of colour boundaries and come out into the white. Behind me comrade pilots swim in the whiteness. I have established the semaphore of Suprematism.'[11] As the word 'semaphore' indicates, he was becoming concerned with the transmission of some meaning, however limited. He was also becoming absorbed in the Russian preoccupation with space travel. Rodchenko sent

his *Black on Black*, together with a manifesto which contained M. Stirner's 'As a basis for my work I have put nothing'. Actually, the painting was not entirely black and it did have a degree of figuration, partly of a large circle and shaded lines. But as well as challenging the mysticism in which Malevich had enveloped his work and, perhaps, proving that a painting did not necessarily have meaning in itself, Rodchenko was emphasizing that the very process of manipulation whether in the form of collage or painting or construction had its own intrinsic importance (Plate 117). The impersonality of his earlier work, often in watercolour and ink and untitled, had revealed his indifference to self-expression; and *Black on Black* now marks an appreciation of the value of materials as such. In 1921 at the $5 \times 5 = 25$ exhibition, held in Moscow and arranged under the auspices of Inkhuk, the five contributors – Rodchenko, Stepanova, Vesnin, Popova and Ekster – each showed five works, thus presenting a retrospective of the last year of their 'laboratory' art during which they had tried to resolve problems associated with colour, form and material. Rodchenko presented three canvases bleakly painted red, yellow and blue respectively: they were to be seen together, possibly as a triptych of elementalism, possibly as the three aspects of a single work, a construction of which the components were exclusively three basic colours. He said that the crushing of all the 'isms' in painting was the beginning of his resurrection and that with the funeral knell of colour painting the last 'ism' went to its grave. Self-effacement could go no further than these three important monochrome paintings, *Pure Red Colour*, *Pure Yellow Colour* and *Pure Blue Colour*. In the exhibition his five works were entitled 'Last Painting'. Rodchenko believed he had toppled easel painting from its high status and that he had divested it of all esoteric significance or inner meaning: for him, painting had value only as a craft or as a component in Constructivism, which now became his obsession. He had used photographs in collage work in 1918; and the impersonality – the realism – of photography, a craft which seemed ideally suited to the realism of revolutionary socialism, was to attract his vast capabilities.

The area in which artists had a wide opportunity to assert themselves was the theatre, which now became a stronghold of Constructivism. Tairov's Kamerny Theatre had broken with the tradition of painted settings and used simple shapes – cubes, pyramids and platforms at varied levels, after de-

signs by the leading Futurists. Tairov used the talents of Larionov, Goncharova, Yakulov and Ekster, this last artist providing outstanding designs for *Famira the Lyrist* (1916), and for *Romeo and Juliet* (1921), in which the violence and linear abruptness of the settings and costumes exactly matched the spirit of the production (Plate 118). A year later Tairov directed Racine's *Phèdre* with designs by the Constructivist Aleksandr Vesnin who tried to indicate the sense of impending and relentless tragedy as well as the classicism of the play by an austere use of levels and sloping platforms. When Tairov took his company to France and Germany in 1923 his production of *Phèdre* was hailed by Jean Cocteau as a masterpiece and Fernand Léger wrote to him, 'I assure you that there is nothing in Paris to compare with this.... My dream is to tackle the problem of plasticity on the stage as you have done.' The other leading director was Meyerhold whose early work at the St Petersburg Imperial Theatres had given no indication of his revolutionary fervour. In 1918, however, he commissioned Malevich to design costumes and settings for the first performance of Mayakovsky's *Mystery-Bouffe* on 7 November at the Theatre of Musical Drama in Petrograd. The artist wrote:

> I saw the box-stage as the frame of a picture and the actors as contrasting elements [in Cubism every object is a contrasting element in relation to another object]. Planning the action on three or four levels, I tried to deploy the actors in space predominantly in vertical compositions in the manner of the latest style of painting; the actors' movements were meant to accord rhythmically with the elements of the setting. I depicted a number of planes on a single canvas; I treated space not as illusionary but as Cubist. I saw my task not as the creation of associations but with a reality existing beyond the limits of the stage, but as the creation of a new reality.[13]

None of Malevich's designs has survived but it would seem that there were clear allusions to actuality, to concrete objects. In the autumn of 1920 Lunacharsky recalled Meyerhold from service with the Red Army to take charge of Narkompros's theatre section and to federate the theatres both in Petrograd and Moscow, a task in which failure was inevitable because both cities claimed autonomy. In the latter part of 1921 Meyerhold gave up this

117. Aleksandr Rodchenko: *Untitled*, 1919. Oil on wood, 39 × 21.5 cm. London, Annely Juda Fine Art

impossible task and became director of the newly formed State Higher Theatre Workshop in Moscow, using his authority to discredit his rivals Tairov and Stanislavsky. When he visited the $5 \times 5 = 25$ exhibition that same year he saw a solution to the practical difficulties he faced in working on conventional stages and in his endeavours to form a style of presentation befitting his dynamic theatrical style. The bareness, the austerity and the practicality of Constructivist work appeared to have logical affinities with his own repudiation of naturalism and aestheticism. He was to find Aleksandr Vesnin and Lyubov Popova willing collaborators and his pro-duction of Crommelynck's *The Magnanimous Cuckold* in April 1922 was one of his greatest successes, not least because of Popova's witty Constructivist settings.[14] In the theatre, as in other artistic and cultural areas, Constructivism carried all before it. This should not obscure the fact that during this period and for years to come the theatre fully employed the talents of Benois, Lanceray, Sudeikin and many other artists, generally of the traditional school. In fact, Russian artists always found work in the theatre congenial and stage design was always of a higher quality than anywhere in Europe.[15]

118. Aleksandra Aleksandrovna Ekster: *Bird Market, c.1926.*
Ink and watercolour. Private Collection

12

Malevich and Tatlin: the Inability and Unwillingness of Artists to present a United Front

By 1921, the beginning of the New Economic Policy and the end of the Civil War, when it seemed that the country was at last on the road to peace a fairly permissive atmosphere was tolerated; and many of the intelligentsia believed that during the next years a tradition of cultural variety would be created and even encouraged. As events progressed such a belief was proved false. The relatively liberal cultural life of the twenties was a deliberate choice of Soviet policy in so far as the government had more serious matters to attend to at that time, notably a preoccupation with political consolidation and economic reconstruction in the aftermath of seven years of internal and international conflict which was to engage most of its attention right up to and throughout the first Five-Year Plan of 1928–33. It was also in part the result of the comparatively idealistic interpretation of Marx's theories of culture that were advanced by the liberal ideologists of the early Soviet period, who tried to show that a new culture must follow rather than precede the creation of a proletarian society and that the arts were bound to be eclectic at this stage, having a duty to utilize the best of previous culture and also to provide an independent reflection of reality in the complex era of transition through which the country was passing. Thus, if the period 1900–21 was bewilderingly crowded with groups and movements clamouring for attention, in the years that followed and led up to 1932 the societies which were formed were brought about by a concern for protection and self-preservation; and also, it is true to say in some cases, by a desire to propagate a communist ideology.

In fact, throughout the period the Communist Party encouraged and directed the development of an analogous culture in which, it must be admitted, literature rather than art was considered of prime importance; and in tracing this development it is probably simplest to follow the periodization per-

tinent to civil history. The Marxist writer Bela Uitz summarized the first fifteen years of Soviet art as paralleling the four major steps taken by the Soviets in their creation of a classless society: War Communism, 1917–21; NEP 1921–5; Reconstruction, 1925–8; and Socialist Reconstruction, 1928–32.[1] It is necessary to note the significance of political events in relation to the arts. We have seen aspects of the rivalry which existed among the leftist groups, more especially between the Suprematists and the Constructivists, in the period of 'war Communism', which left them open to attack later. We have also noted the apparent failure of the Proletkult movement. However, as early as 1920 a step was taken by the Communist Party the ultimate consequences of which should have been obvious: it established within Narkompros an agency called Glavpolitprosvet which aimed to spread Communism, and to politically educate citizens, by means of cultural and educational institutions. The view was taken that 'art, like science, must be subordinated to the general tasks of the state'; and artists could hardly plead surprise when in the course of the next decade they were to find their artistic freedom severely curtailed and that they had become servants of the state and of society.

Few if any artists were sufficiently realistic to see what lay ahead of them; and too many of them were absorbed in scoring off points against each other. Naum Gabo said that returning to Russia in 1917 after three years' absence he found Suprematism without question the dominant art philosophy in the avant-garde circles of Moscow.[2] There can be no doubt that Suprematism was the prevailing style; and just as Cubism was adopted by numerous talented artists without reference to the alleged analysis of form by Braque and Picasso, so Suprematism was adopted by Russian painters without reference to Malevich's primary emphasis on emotion. But

whereas Cubism was much followed in Russia, the outside world knew or cared to know little about Suprematism whose impact it was not to feel for almost half a century. By 1920 Malevich – and Rodchenko and others – had announced the death of painting; and the artistic scene, as far as painting was concerned, was to be dimmed by the departure from the centre of the stage of Malevich and Tatlin. There were other important artists, as this account has served to show; nevertheless, at this juncture the further careers of these two men who play so outstanding a part in the work of the avant-garde call for attention – although, as events show, Tatlin concerned himself little with easel painting.

After the revolution Malevich flirted briefly with an anarchist faction in Moscow and joined the Federation of Leftist Artists before entering Narkompros, together with other Futurists, accepting a number of posts as well as teaching at the Svomas. He designed settings and costumes, as has been mentioned, for Mayakovsky's *Mystery Bouffe*, exhibited at the Tenth State Exhibition of abstract art, and held a retrospective at the turn of the year. Also in 1919 he showed works in an exhibition of local and Moscow artists at Vitebsk then under the control of Chagall who was also heavily involved in theatrical work. There is some uncertainty as to the exact course of events but it seems that Malevich was invited to take over the school by Vera Mikhailovna Ermolaeva (1893–1938). The students, several of them hardly more than schoolchildren, wore black squares sewn on their sleeves, and eventually adopted the name *Unovis* (Affirmation of New Art). On the anniversary of the revolution these young and fervent disciples of Malevich and his pedagogical methods decorated the town with Suprematist signs – circles, squares and triangles. Buildings in the main streets were covered with white paint and on this background were painted green circles, reddish-orange squares and blue rectangles. Eisenstein, the film director, said that the walls of the town conveyed the message that its public squares were the palettes of the new art – Unovis.[3] A performance of *Victory over the Sun* was arranged by the students with new settings and costumes by Ermolaeva.[4] Inevitably there was friction with the local authorities and Malevich was forced to leave the school in 1921.

In 1922 he tried to join the newly established Inkhuk in Moscow, but was unable to obtain a position and left for Petrograd with a number of his pupils, including Nikolai Mikhailovich Suetin

(1897–1954), who was to receive the Grand Prix for his design for the Soviet Pavilion at the World Exhibition at Paris, 1937. Malevich was accepted by the Petrograd Inkhuk and began working on his manuscripts dealing with art systems and teaching theory. He had brought the files of Unovis with him from Vitebsk and surrounded himself with former pupils, including Ilya Chashnik and Vera Ermolaeva. In 1923 he assumed leadership of FTO, the section of Inkhuk dealing with formal theory; and also became a member of the guides' office in the Museum of Artistic Culture, the first museum in the world wholly devoted to contemporary art. Together with his students he began an investigation into an architecture for the future, making complex plans and creating models in plaster of Paris. These were suggestive of enormous blocks of flats and skyscrapers thrusting far into the space around them and sparsely decorated, the whole complex approximating, in a sense, to a Suprematist sign. In a manifesto dated 1922 Malevich insisted that man 'is preparing on earth to throw his body into infinity – from legs to aeroplanes, further and further into the limits of the atmosphere, and then further to his new orbit, joining up with the rings of movement towards the absolute.'[5] Regardless of the frailty, fears, or needs of ordinary humanity, he worked to create an 'idealized architecture' consisting of enormous blocks of habitations which he named *planity*, derived from the Russian word *aeroplan*. He also designed for the Lomonosov porcelain factory; and a cup and somewhat cumbrous teapot show his use of Suprematist shapes and decorations. Behind his architectural and other projects was a sense that man should create a new universe in which he would reign supreme as a god.

Malevich's reputation abroad had begun to grow, thanks in part to the crusading efforts of his friend and disciple El Lissitzky and also because of his pictures in the exhibition of abstract art arranged at the Van Diemen Gallery in Berlin in 1922 and later transported to Amsterdam.[6] His architectural models were shown at the Venice Biennale in June 1924, but were not appreciated in Russia. In 1927, through the intervention of Narkompros, he was able to travel to Warsaw where he held a small exhibition of his work in the hotel in which he was staying and then to Germany where more works were shown in Berlin. During this stay abroad he is said to have met Arp, Gabo, Gropius, Hans Richter, Schwitters and Le Corbusier – but it is extremely unlikely that he met the French architect.[7]

On the expiry of his German visa he was obliged to return home, leaving behind paintings and manuscripts, many of which have found their way to the Stedelijk Museum, Amsterdam. When Inkhuk was dissolved in 1927 Malevich was allowed to retain a small flat of two rooms in which he lived with his mother and third wife. He was given a study in the Zubov Institute for Art History in the building opposite his home. In 1930 he gave a course on the theory and practice of painting in the Dom iskusstva (House of Art), Leningrad, and continued working on a history of modern painting. Another invitation to visit Germany seems to have aroused the suspicions of the authorities and he was briefly arrested towards the end of the year.

Between 1931 and 1933 he worked on his architectural models, planned a history of the Futurist movement, continued his study of painting and painted some of the figurative studies and portraits on which he may have worked even when ostensibly engrossed in non-objective art. These are singular works, some of them in a realistic style, portraying peasants and sportspeople and himself as a man of the Quattrocento, which had they come from other painters he would surely have howled down. Sometimes the faces are painted naturalistically whereas the clothing and accessories are heavily stylized. The backgrounds are generally in shades of white and the clothing is in dark red, brown and black paint fairly thickly and evenly applied. A similarity with De Chirico who gave up his metaphysical painting and adopted a baroque style, portraying himself in fancy historical dress, comes to mind. Malevich perhaps saw himself as a man of the early Renaissance; the complete change of style is bewildering. In 1933 he was attacked for his 'formalism', the lack of emotional or ideological content within his pictures. Dissensions with his early supporters arose. He was a sick man, victim of a fatal cancer. On 15 May 1935 he died in Leningrad. He lay in state in his rooms in the former Inkhuk, in a coffin he had designed himself. The funeral procession to the railway station was the occasion for a moving display of public homage. His ashes were buried in a field near his dacha in Nemchinovka and a simple stone decorated with a square, the Suprematist symbol which he had made peculiarly his own, was placed above his grave. The city of Leningrad honoured him by acquiring several of his works and bestowing pensions on his mother and daughter.

Malevich has his place with Mondrian and Kandinsky (whose work after 1920 was certainly influenced by Suprematism) as one of the principal creators of abstract geometrical painting. He once wrote that 'every social idea, however great and important it may be, stems from the sensation of hunger; every art work ... originates in pictorial or sculptural feeling ...', and added that it was high time to realize that the problems of art lie far apart from those of the stomach or the intellect. Indeed, for Malevich, as for Mondrian and Kandinsky and the Pevsner brothers, art was a spiritual activity, both personal and expressive; and industrial design was essentially a secondary activity deriving its nourishment, if not its being, from abstract creation. Even so, looking back over the years, Suprematism, the creation of one man, seems idiosyncratic, and in the hands of his followers, however sincere and serious they might have been, became a set of decorative devices which could be utilized in a utilitarian and non-painterly way. If Suprematism was the language of feeling, it is difficult to see how it then became the language of the revolution and how, later still, it became the language of space travel and part of the language of the decorative arts. It may have been the realization of these illogicalities which sent Malevich back to representational painting. Yet the apparent *non sequiturs* of Malevich's work do not deny his career an immense importance in the history of Russian painting and, much later, in world art or detract from the resolution of his approach and the validity of his achievements.[8]

Nothing, it seems, could be farther from the ideas of Tatlin whose insistence on the importance of materials and whose stress on the utilitarian character of art were to become still more emphatically pronounced in the years immediately following the revolution. Within three years the artistic lines had been drawn and although there was open controversy and widespread discussion of philosophies of art and of actual projects there was little yielding between those who believed that the masses should be served by artist-designers whose work should be universally comprehensible and carried out in the materials and techniques provided by industry, and those who were convinced that art was a matter of individual creation which would eventually benefit mankind because it represented the furthest reaches of the human spirit. Tatlin, Rodchenko and, later, El Lissitzky, linked their creed so successfully with that of the Communist Party that to attack them seemed an attack on the state itself. In the opening years of the 1920s their belief had a political potential which was quite lost when their Constructivism became

part and parcel of the stylistic equipment of artists in Western Europe.[9]

Tatlin distinguished between his own creative attitudes and those of the Constructivists, although he recognized a common body of belief. As in the days of his first reliefs he still insisted on the utilization of basic materials and took man and his needs as the basis of his design work. In 1932, in the catalogue to an exhibition of his works, he wrote:

The Constructivists worked in materials but in an abstract fashion, mechanically applying technique to their art which they treated as a formal problem. Constructivism did not take into consideration the organic relationship between the material and its tensile capacity or its working character. It is only as an outcome of the dynamic force resulting from these linked and mutual relationships that an inevitable and vital form is born.[10]

The plain truth is that Tatlin was not a thinker; he was a dreamer and idealist who, like Malevich, had the greatest difficulty in expressing himself clearly. He had little or no comprehension of the technical difficulties of the projects he thought up: there is not the slightest indication that he had even remotely considered whether his gigantic tower would ever stand up to wind pressure or how it could be sited. He played with astounding ideas, but with so little expertise that he hardly produced a design that could be executed. When in retrospect he denigrated the work of the Constructivists (as in the passage just quoted), he should have accepted that he was himself largely to blame by insufficiently emphasizing that his own interests were mainly artistic and not industrial. His rival Malevich was aware of this, making an effective point in his comments on the Third International Tower:

Tatlin himself maintained that he saw in this monument only a construction of iron and glass; he passed over all its utilitarian functions in silence. For him the most important thing was not so much the combination of utilitarian functions as the union of the artistic side with the material, with function as accessory. The Constructivist assembly of these functions was based on the Cubist formula, which was also basic to the entire building-up of the work. In these activities, it was not the utilitarian but the artistic function in itself that played the most important role. The material was always selected by a sense of its artistic impression and not in relation to its utility.[11]

An outline of Tatlin's career may indicate that the difference between his ideas and those of Malevich were not, perhaps, so very distinctive and that in the ultimate resort he was less obsessed with utilitarianism than his followers such as Rodchenko, and that he was, also, chronically romantic.

On 1 January 1919 Tatlin was appointed head of department at the Free State Studios, Petrograd, where he controlled the studio which investigated volume, materials and construction. In 1920, together with two assistants he worked on a wooden model of his monument to the Third International and exhibited it in his studio on 8 November, the anniversary of the revolution. He published a *Programme of the Productivist Group* in reply to the *Realistic Manifesto* written by the brothers Gabo and Pevsner some months previously. The *Programme* gave a public definition of the term 'Constructivism': it was seen as an act of construction or organization of materials; the inherent and basic belief directing this act was said to arise from the communist and industrial society of which artists were part and which they shaped for the benefit of humanity.[12] This brief statement, in part a defence of his Tower which had been taken to Moscow for the Eighth Congress of Soviets in December 1920, reveals the difficulty of Tatlin's position – on the one hand a continued adherence to the purely artistic form of the relief and counter-relief and on the other a commitment to the utilitarian aspects of artistic design and creation. He was to state his conviction of the importance of the latter in 'Art out into Technology', an essay published in 1932.

Tatlin's character, in a different way hardly less difficult than that of Malevich, aroused opposition in Petrograd; and in 1921 he was the subject of intrigues which resulted in his being left out of the Academy of Arts when it was re-established in September. In November, however, he was appointed professor in the department of sculpture. In December he was invited to Moscow to speak at the Institute for Artistic Culture, headed by Rodchenko, El Lissitzky and others. He was himself helping to establish Ikhk (the Petrograd version of Inkhuk) in which Malevich and Matyushin were to work. An exhibition of new tendencies was held in Petrograd in June 1922 and among the works submitted by Tatlin was a painting almost entirely in shades of pink which appears to indicate a continued adherence to easel painting. In the following year, in memory of the poet Khlebnikov he staged a performance of his friend's *Zangezi* in which he took

part together with his pupils. In those days of bitter shortage and unrelieved cold he built an oven which used the minimum of fuel and gave out the maximum of heat, but it does not seem to have gone into mass production – probably because of those very shortages which occasioned its invention. He also designed utilitarian clothing which although feasible in itself showed little recognition of the drastic lack of material everywhere in Russia. Despite these experiments it is almost impossible to know whether Tatlin's heart was fully involved in the production side of Constructivism – and it should be remembered, he never described himself as a Constructivist.[13] In 1925 he accepted the directorship of the department of theatre and cinema in Kiev, remaining there until 1927 when he returned to Moscow and entered the department for wood and metal studies at the Vkhutein (the name adopted in 1926 for the Vkhutemas). He also taught in the ceramic section. In 1929 he illustrated a book by the Leningrad writer Daniil Kharms. By then he had been granted permission to establish a workshop in a tower of the Novodevichy Monastery, Moscow, and had begun experimenting with the construction of a sort of glider with movable wings. It was yet another of the countless attempts made by man to fly under his own physical power; and, in a sense, mirrors Malevich's obsession with space travel and housing on the colonized planets. Tatlin christened this remarkable structure, more insect- than bird-like, *Letatlin*, combining his own name with elements of the Russian verb to fly. When *Letatlin* was exhibited in 1932 it aroused such controversy that Tatlin was given the opportunity to explain his aims to the Writers' Association.[14] In that year all individual groups and associations of artists were dissolved by decree; and Tatlin, together with other artists, became the subject of official criticism. Nevertheless, his work was exhibited in Moscow in 1933 in an exhibition of Soviet art of the last fifteen years; and his theatre designs were occasionally exhibited or realized on the stage. In 1940 he was commissioned to make a lithographed portrait of Khlebnikov for an edition of the writer's previously unpublished verses. From 1950 to 1953 he lectured at DOSAAF (Moscow Centre for Glider Research). He returned to easel painting, although the dominating interest in the last twenty years of his life was the theatre, for which he designed and made a number of interesting settings which showed that his aesthetic emphasis on the nature of materials and constructions was as strong as ever. His son was

killed at the front in 1943. From 1935 until his death on 31 May 1953 he lived mostly on Maslovka Street, Moscow, in a collective house for artists. His ashes were interred at the Novodevichy cemetery. In recent years his work has become more widely known in the Soviet Union where there are examples in the larger museums.

Interest has been concentrated on Tatlin's famous monument to the Third International and rather less on his flying machine and his reliefs of 1913–14. He seems to have been obsessed by materials and their inherent qualities and to have thought in sculptural rather than in painterly terms. Just as his reliefs seem to be striving to move forward and outward into space, so his tower and glider were born of a romantic preoccupation with the conquest of our environment. Like Malevich, he was possessed with the urge to challenge the cosmos and to extend man's domain beyond the earth. And just as Malevich believed that the pictorial language he had created with his Suprematist signs could become the language of a new Soviet Russia, so Tatlin presented the various revolving sections of his tower as a celebration of world Communism emanating from Moscow. His power to seize on a development and to exploit it to its fullest extreme is important in the history of Russian (and European) art; and his recognition of the distinctive qualities inherent in any particular material, whether wood, metal or glass, was pioneering; and yet, for all the originality of his projects, his ideas seem to have passed either into the realm of the impractical or, like the utilitarian creations of some of his colleagues, into the commonplace vocabulary of industrial design, much of it now singularly old-fashioned if not, indeed, faintly ridiculous.[15] Tatlin was a remarkable man, an artist of great vision and inspiration, but there is no denying that his genius carried with it a tragic self-defeating quality so that he seems to typify the recurring phenomenon of Russian life, the holy fool.

By 1920 Tatlin and his friends, among them Aleksandr Rodchenko, had abandoned easel painting and passed on to 'laboratory art', that is, an investigation of new uses of material and new methods of creation on behalf of the people.[16] Rodchenko, from his prestigious position in Narkompros, Inkhuk and Vkutein, was able to play a lively part in the art world where he moved more and more towards the idea of the 'artist-engineer'. He insisted that the artist must become a technician and that he must learn to use the tools and materials

of modern production in order to funnel his energies into the improvement of the working and living conditions of the proletariat. Work had to be transformed into art and art into work. Rodchenko himself designed utility clothing. At the same time he worked on hanging mobiles which showed once again the Russian concern with space. In 1925 he designed a workers' club for the Soviet Pavilion at the Exhibition of Decorative Arts in Paris.[17] He was associated with LEF (Left Front of the Arts) and Novyi Lef (New Left), thus giving his work an ideological basis, something which Tatlin avoided. He was closely concerned with textile design, photography, photomontage and typography. From about 1919 he had used photographs in collage work and in the twenties he sought increasingly to explore the possibilities of the camera as a multi-perspective observer, a new art form better able to demonstrate and modify revolutionary life. In the mid-thirties he produced photographs of mass activities, including the construction of the White Sea Canal, whose heroic and broad emotional quality link them with Social Realism painting of the same period, but which share some of the falseness of Leni Riefenstahl's propagandist films. Rodchenko felt a measure of official disfavour, largely on account of his earlier photography, but still continued working. In 1935 he resumed painting, producing amazing colourful works reminiscent of Arp's biomorphic shapes such as *Surrealist Abstraction* (1943) and *Expressive Rhythm* (1943–4), in which the meandering lines and flow of gouache over the white paper astonishingly anticipate Jackson Pollock's experiments.

The ultimate impracticality of 'laboratory art' (with its roots in the nineteenth-century arts and crafts movements with their glorification of the craftsman-artist, involved from the conception to the completion of the object both of art and utility) soon became obvious and by 1921 it had acquired a strongly industrial character and the name of Constructivism. In May 1920 there was an exhibition of the Obmokhu (Society of Young Artists) in Moscow at which thirteen Vkhutemas students showed their work which consisted mostly of open-spatial constructions, some suspended from the ceiling, others free-standing, and yet others mounted on easel-like stands. The influence of Rodchenko's hanging constructions of that year was particularly marked. Three of the Vkhutemas artists, Konstantin Konstantinovich Medunetsky (1899–1934) and the brothers Vladimir Avgustovich (b.1899) and

Georgy Avgustovich Stenberg (1900–33), joined in an exhibition in May 1921, which demonstrated their allegiance to the Constructivists. However, they were to find their careers in the creation of cinema and theatre posters, textile designs and the building of theatrical settings for productions by Tairov and Meyerhold. The experiences and achievements of the pre-revolutionary artists who had collaborated with the Futurist poets in the creation of extraordinary typographical productions were not lost on the younger Constructivists such as Rodchenko, El Lissitzky, Klucis and Aleksei Gan (1893–1942),[18] who developed photomontage, a new style of layout often based on Suprematist characters, photographs and typographical innovations.

The man to whom Europe was indebted in the 1920s for its knowledge of these developments was El Lissitzky (1890–1941), born Lazar Markovich Lisitsky in Polschinok, a small town near Smolensk, the son of a Jewish artisan and the grandson of a woodcarver.[19] In 1909 he entered Smolensk High School and because of restrictions on Jews entering higher technical schools or universities went to Darmstadt in Germany to study engineering. During the war years when he was exempted from military service because of poor health he studied architecture and engineering and also began exhibiting his pictures. He joined the staff of IZO Narkompros in 1918; and meeting Malevich and Tatlin became a keen admirer of their work. He was appointed by his friend Chagall to teach graphic art and architecture at the Vitebsk art school and was among those who welcomed Malevich's appointment there and joined his Unovis group. In 1920 he became a member of Inkhuk in Moscow where he was also a professor at the Vkhutemas. He worked in Germany from 1922, returning to Moscow in 1925 and taking up an appointment at the Vkhutemas teaching interior design. He then went back to Germany where he associated with Arp, Van Doesburg, Mies van der Rohe, Moholy-Nagy, Schwitters, Eggeling and Richter, and where he, in turn, disseminated Constructivist and Suprematist doctrines. He was involved with the Dada movement and worked on abstract films. In 1929, after a number of vain attempts to cure his tuberculosis, he returned to Russia where he died in 1941.

El Lissitzky has several claims to fame, among them his work as an illustrator. At the turn of the century there had been a revival of interest among Russian Jews in their own folk art. The Jewish

Ethnographical Society gave material aid to Chagall, Altman, Issachar Ber Ryback, and El Lissitzky who was commissioned as a young man to copy and record the decorations in the old synagogues of the Ukraine and Byelorussia. From 1917 to 1922, under the aegis of Chagall, he illustrated Yiddish and Hebrew books for children. Later he decorated Ilya Ehrenburg's *Shest povesti* (*Six Tales*), and created a remarkable collage for the same writer's *A Journey to America*. His most remarkable work was the entertaining *Story of Two Squares* (written 1920, published 1922), a sequence of ten lithographs telling a science fiction story of how two squares from outer space established harmony in a world of chaos by the assertion of Suprematist forms. There was another meaning: the red squares stood for the Bolsheviks (who were to triumph), and the black ones for the mensheviks. From 1922 El Lissitzky concentrated on designing Russian and German books and exhibition catalogues. He also had considerable influence on the evolution of Constructivist architecture.

Painting was not the major interest of El Lissitzky's life, but he presents a major example of an artist whose painting led to an investigation of space and, more directly, of exhibition rooms. His paintings in oil, gouache and watercolour were strongly Suprematist – Malevich's squares, bars and hemisphericals were sometimes transmuted into three-dimensional forms, sometimes tipped and tilted to secure an incessantly changing vista of multiple perspectives. Painterly qualities as such did not interest him. And whereas pictures were traditionally seen from one viewpoint, he willed spectators, like planets, to circle his pictures, which remained static. He gave these works, precisely and mathematically carried out in whites, greys and blacks, the name of *proun* which signified 'project for the establishment of the new', derived in part from the name given to the Vitebsk school after Chagall's departure. 'A *proun*', said El Lissitzky, 'is a station where one changes trains between painting and architecture.'[20] The architectural aspect is already visible in his *Proun 23, no 6* of 1919. In 1923, by which time he was about to give up painting, he created his first *proun* room for the Grosse Berliner Kunstausstellung; and four years later he improved on this concept with the room he created for Alexander Dorner at the Landesmuseum, Hanover, destroyed by the Nazis in 1936. In these *proun* rooms pictures, reliefs and sculptures were arranged on walls from which projected vertical strips of metal painted black on one side, grey on the other and white on the edges, so that there were changes of colour and character as the spectators moved through the room and past the exhibits. This logical and original principle that modern works of art should be exhibited in the round and in sympathetic and contemporary surroundings, an idea possibly borrowed from the Constructivist theatre, has come to dominate the layout of galleries of modern art.

It is convenient here to mention several artists who in varying ways diverged from the mainstreams of Suprematism and Constructivism. The extraordinary numbers of painters who emerged in Russia in the first decades of this century pose problems for the art historian. In the first place many of them were involved in other activities, constructivism, industrial design, architecture, typography and photography for instance; and in the second place, at least two of them, Malevich and Rodchenko, actually announced the death of painting. The range, variety and abundance of talent, not to say genius, is overwhelming; and, no doubt, the greater knowledge that comes with time – and we are still acquiring documentary knowledge of these artists – will sift out the true and original talents from the merely clever and less able followers or imitators. And it must be stressed that those who diverged were not necessarily among the lesser painters of the period.

Of the two brothers Anton Pevsner and Naum Gabo, the latter had gone to Munich in 1909 to study science and medicine but after attending lectures by the art historian Heinrich Wölfflin had decided to become an artist. The following year he met Kandinsky, read his recently published *On the Spiritual in Art*, and attended the exhibition of the new Artists' Federation in which French Cubist works were shown. His brother Anton (who retained the family name of Pevsner) studied art in Kiev and, for a year, at the Academy of Arts, St Petersburg, but settled in Paris from 1911. On the outbreak of war in 1914, Gabo and a younger brother fled to neutral Norway where they were joined in December 1915 by Pevsner. Gabo had begun to experiment with sculptures of cardboard and wood, which although labelled *Constructed Heads* (1915–16) bore little relationship to actual or naturalistic portraiture. The brothers went to Moscow in April 1917, and the following year Pevsner joined the staff of the Vkhutemas as an instructor in painting.[21] He had always been interested in Byzantine art, in the work of Vrubel, and in the portraits

of Modigliani whom he had known in Paris, and these elements were faintly reflected in his own paintings which were as much Expressionist as Cubist but which did not reveal any markedly painterly gifts. Gabo, despite his close contacts with students at the Vkhutemas, did not accept an official position as his brother did. Like other artists of the time he was interested in space, as can be seen in his project for a radio station in 1919–20. He began work on kinetics; and his *Kinetic Construction* of 1920, in which a metal rod was made to oscillate by means of an electric motor, was to open up a whole new area of sculpture and construction for investigation. Pevsner, unwilling to relinquish the representational world, continued to create works which were partly painted, partly constructional. Opposed to both the emotional or spiritual attitudes behind Malevich's Suprematism and the utilitarian Constructivism associated with Tatlin, they issued a statement of their beliefs, *The Realistic Manifesto*. At the same time they held an open-air exhibition of some Gabo sculptures, three Cubist and one abstract painting by Pevsner and a few works by other artists. The *Manifesto* proclaimed in clear terms 'the limits and possibilities of non-objective art, mostly in terms of sculpture but applicable to painting, with such simplicity and clarity that its precepts are still viable two generations later'. It defines the heritage and obligations which a present generation of artists continues to extend.[22] The brothers' statements were mainly concerned with sculpture, as for instance their belief that the realization of their perceptions of the world in forms of space and time were the only aim of their pictorial and plastic art, although the claim that 'the elements of art have their basis in dynamic rhythm' seems related to the beliefs of Blok and Bely in respect of the earlier Symbolist movement. It might be said that *The Realistic Manifesto* was in essence a restatement of the doctrine of art for art's sake.[23] In 1922, on the occasion of the Van Diemen exhibition in Berlin, in which they participated, they left the Soviet Union and never returned. Their employment of man-made material inspired Diaghilev to commission them to create the costumes and settings for a ballet *La Chatte* (1927) which was certainly unusual although the influence of Ekster's stage and film settings seemed to hang over the proceedings. Pevsner's paintings, for instance *Absinthe* (1922–3) which shows the customary Cubist device of a tilted table with a glass of absinthe and a background composed of variously shaped planes, do not reveal any

marked originality; and the naturalistic landscapes and other pictures of his later years confirm that he was not a born painter. Curiously elusive in character and uncommitted by nature, the two brothers played a minor part in the painting of the revolutionary period.

Gustav Gustavovich Klucis (1895–1944) studied to be a teacher and then attended the Riga Art Institute before going on to the school maintained by the Society for the Encouragement of the Arts in Petrograd. Between 1918 and 1921 he was at the Vkhutemas under Malevich and Pevsner. Indeed, he exhibited with Pevsner and Gabo in the small exhibition held when *The Realistic Manifesto* was issued; and later in 1921 contributed to the Unovis exhibition in Moscow together with other of Malevich's students. He was a member of Inkhuk from 1921 to 1925.[24] In 1929 he was a founding member of the October group, contributing to its first exhibition in 1930: it was intended to serve the concrete needs of the proletariat, the leaders of the peasantry and backward national groups. As a keen leftist and member of the avant-garde Klucis was more than happy to devote his energies to these ends. He worked in the fields of photography, photomontage, graphics and industrial design, creating loudspeakers for use on newspaper kiosks, political platforms and public buildings which he called 'Radio Orators'. He was also associated with advanced literary circles, designing and illustrating books by Kruchenykh, Mayakovsky and others in the early 1920s. The craven but ruthless conservatism of Stalin's regime had no place for so advanced a spirit and Klucis ended his days in a prison camp. His paintings reflect the prevalent force of Suprematism but seem from the first to have been conceived in terms of volume and space as in his *Axiometric Paintings* (1920), using sand and concrete on wood and painted in greys, blacks and browns on a white ground. This is even truer of his series *Dynamic City* painted at the same time. Klucis tends to concentrate his intersecting planes and circles in the middle of his canvas unlike the exploded, centrifugal signs in the Suprematist canvases of Malevich. A photomontage of 1919–20 also entitled *Dynamic City* supplies a gloss to his paintings: on the intersecting shapes we see builders and labourers striving to erect skyscrapers: this seems to suggest that behind Klucis's Suprematist pictures there was a realistic programme.

In the 1930s Klucis returned to the theme of building constructions in a series of naturalistic

paintings. He was clearly an artist of importance, whose concern for texture in painting – in the use of sand and concrete, for instance – was rare among his contemporaries. Linked with Klucis was Sergei Yakolevich Senkin (1894–1963), who shared his interest in the pictorial language of Suprematism without partaking in his philosophy. He quickly moved into the fields of applied art, particularly photomontage, working with El Lissitzky on the Soviet Pavilion at an exhibition in Cologne in 1928. El Lissitzky, Klucis and Senkin form a distinct group within the Suprematism of the early twenties without, however, supporting its aesthetic or esoteric tenets.

The near-hysterical adulation given to Malevich and Tatlin has meant that several artists, Suprematist and Constructivist, of merit and achievement, have been ignored. Possibly this is even more true of those painters who stood aside from the two major groupings. Also overlooked are the *lacunae* caused by those painters who left Russia, with consequent effects upon the art of the following decades.

Many of the artists who figure in the history of Russian painting came from the provinces but were rapidly assimilated into the mainstream of St Petersburg and its academy. After the revolution and the setting-up of the various republics there was a determined effort on the part of the authorities to establish art centres in the provinces and to emphasize the regional contribution to a national art. The area from which much talent flowed was the Ukraine, the birthplace of Aleksandr Konstantinovich Bogomazov (1880–1930), who maintained his residence there although he exhibited, first with the Cubo-Futurists and then with the Suprematists, in Moscow and Petrograd. His Cubist phase soon came to an end largely because his major interest was not in form but in the interaction of line, colour and form, so that his work prior to 1915 has relationships with Rayonism. He retained a fondness for the decorative elements – folk dress, embroidery patterns, armour and missal illustrations – which Abramtsevo had made popular. At the same time he was creating for himself a personal aesthetic which he completed in 1914 as 'Painting and its Elements'. Although this work remained unpublished it gave him the courage to stride further into the realms of the abstract during his remaining years as an artist. Quietly – without any of the stridency which was so marked a feature of the public announcements of both Tatlin and Malevich – he may have anticipated

Malevich in his perception of the Black Square as the 'totality of signs in art'. As yet little is known of Bogomazov's last decade but his place in Russian painting in the first decades of the century calls for urgent assessment.[25]

To a lesser extent this is true of Vasily Dmitrievich Ermilov (1894–1968), yet another Ukrainian artist who linked himself with the avant-garde in Moscow and Leningrad. Ermilov was born in Kharkov where he received his art training, apart from the years from 1912 spent at the Moscow School where he studied under Konchalovsky and Mashkov.[26] He linked himself with the Cubo-Futurists, particularly David Burlyuk and Mayakovsky, but seemed equally interested in Suprematism and Constructivism. On demobilization from a period of military service he worked with Mayakovsky on ROSTA posters and also contributed illustrations to the Futurist album 7 + 3 published in Kharkov, thus initiating his important career as a book designer and illustrator. Ermilov was an artist of marked personality, restlessly searching for fuller expression whether in decorating agit-trains or designing (with Anatolii Petritsky) the interior of the Ukrainian pavilion for the All-Union Agricultural Exhibition held in Moscow in 1937–8, experimenting with the nature of materials as is evidenced in his *Experimental Constructions* and *Constructivist Compositions* of the 1920s, or using varied typographical devices in the memorable posters he created (Plate 119). In particular, Ermilov tried to establish the links between the older elements of Russian painting and the avant-garde, especially in greater use of colour. Ermilov's merits have always been recognized even though his work fell out of favour in the late 1930s.

A contemporary of these artists, whose life, full of promise, even of achievement, ended with tragic briefness when he was 25, was Vasily Nikolaevich Chekrygin (1897–1922), one of the few post-revolutionary painters whose art was religious and philosophical in inspiration.[27] A comrade of Mayakovsky (whose first poems he illustrated) and of the Ukrainian artist Kliment Redko,[28] he trained at the Moscow School. The Futurists did not appeal to him but, like Goncharova and Bilibin, he was influenced by the old icons. It is probably true to say that he was an indirect follower of Aleksandr Ivanov, deriving elements of his style and subject-matter from the latter's biblical sketches with their strange and mystical symbolism. Obsessed by metaphysical themes, largely of physical resur-

rection and the transmigration of souls to other planets, he drew and painted numerous variants of the same picture, striving each time for a more enduring expressiveness and austere sincerity. His groups of the dead awaiting resurrection with awe, delight and fear have a monumental power and uniqueness of vision worthy of Ivanov himself. For a short time before his death in a railway accident he belonged to the Makovets group, founded in 1922 and named after the hill on which the Trinity-Sergius Lavra (now known as the Zagorsk monastery and museum) was founded in the fourteenth century.[29] The Makovets group, which had religious and philosophical aspirations, first exhibited as a group in May 1922 when seventeen artists showed work, including S. V. Gerasimov, A. V. Fonvizen, and A. B. Shevchenko; but neither the Makovets nor Chekrygin had any chance of public success in the artistic world of revolutionary Russia controlled by the followers of Tatlin and Malevich to whom easel painting was ostensibly anathema, and all figurative art, even when, as in some pictures and drawings by Chekrygin, it was used to show in graphic terms the hunger which stalked the country, was considered an affront to the new spirit of the nation.

Another follower of Ivanov was the painter Pavel Dmitrievich Korin (1892–1967), who began his studies in an icon-painter's workshop in the village of Palekh, noted for its painted boxes. He studied at the Moscow School, that home of so much talent at this period, between 1912 and 1916, where he came under the influence of Nesterov. As an act of devotion to the past he made a copy of Ivanov's *Appearance of Christ to the People* in two colours. Maxim Gorky recognized his talents and took him on a tour of the art cities of Italy. He began work on an immense picture to be called *The Exodus of Old Russia* intended to rival Ivanov's masterpiece, making study after study, drawing and painting in isolation. The picture was to have shown a crowd gathered under the arches of the Cathedral of the Assumption in the Moscow Kremlin, its members sheltering against the tempestuous winds of revolution which were so drastically to change their lives. Such works did not find favour in the 1930s and Korin began a new career as a portraitist. And here the monumentality and strength of line which he had cultivated for *The Exodus* are to be seen in his depictions of Aleksei Tolstoy, Saryan, Nesterov and Gorky. In the post-war years there was an increase in his pictorial and penetrative powers as well as in the fluid handling of paint in his decorative

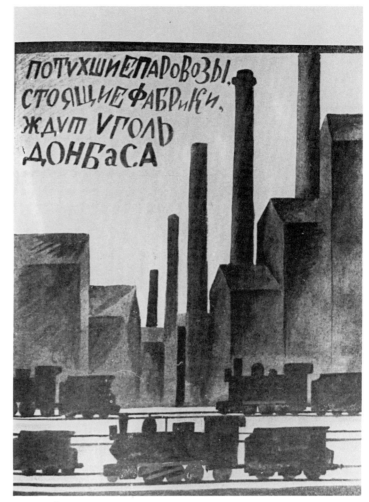

119. Vasily Dmitrievich Ermilov: Design for a poster, *Trains in Need of Drivers*, 1920. Kiev, A. M. Gorki Museum of Art

ensembles and portraits, as is demonstrated by his *Portrait of Renato Guttuso* (1961).

The artist who stands curiously apart from any of the prevailing groups was Pavel Filonov (1883–1941). Born in Moscow and left an orphan when very young he went in 1897 to live with a sister in St Petersburg where he tried unsuccessfully to enter the Academy of Arts. He worked at house-painting, decorating and restoring, and somehow managed to travel down through Russia to the Near Eastern countries and to visit Athos and Jerusalem. During his years in the capital he was given tuition by Dmitriev-Kavkazsky, a kind-hearted Academician and teacher; and his ability was recognized by a number of people including I. Brodsky, resulting in his being admitted to the Imperial Academy in 1908. He was unhappy there and left after two troubled years in 1910. He had noted Goncharova's use of

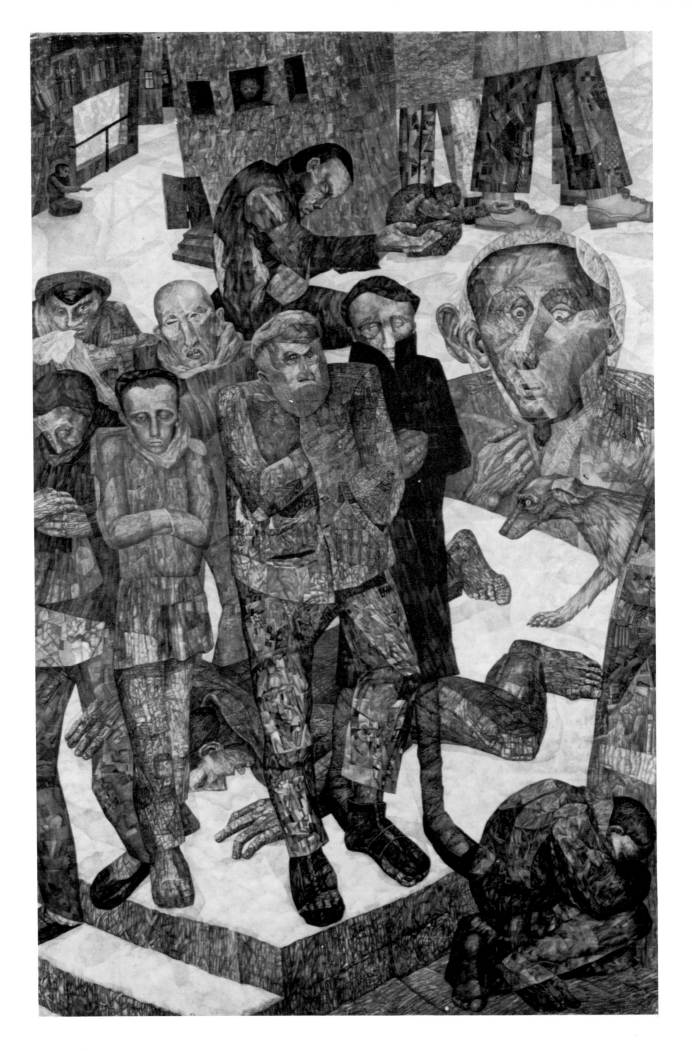

the old icons as a source of pictorial inspiration with enthusiasm and had also grown interested in the hieratic nature of Egyptian art. In 1910 Filonov joined the Union of Youth. Two years later he travelled through Germany and France to Rome, bringing back memories of the work of Rodin and Cézanne who had most particularly attracted him. These influences hardly show in his pictures which, while retaining something of the negroid character of Kuznetsov's early works, show an arrangement of figures and objects which owes a little to child art, a little to icon painting, mosaic, primitivism and analytical Cubism, and much more to his own researches into Oriental and African art as well as that of the Middle Ages.

Filonov frequently worked in watercolour and gouache, not to secure a sweeping, sketchy effect as is usual, but in order to paint the minute details of which he was almost excessively enamoured. Although he painted religious subjects (and occasionally in a manner which recalls the German Expressionists), he was in the forefront of the Futurist movement. In 1913 he designed the costumes for Mayakovsky's tragedy *Vladimir Mayakovsky*, imprisoning his actors between two painted sandwich boards so that they were obliged to move in straight lines against the setting designed by Iosif Shkolnik (1882–1926), another member of the Union of Youth. In January 1914 Filonov contributed illustrations to one of the most famous of Futurist publications, the miscellany *Futurists: Roaring Parnassus*, which was condemned by the censor on the grounds of its allegedly indecent illustrations. The following year he published a long and dramatic poem *Propoven o prorosli mirovoy (A Sermon-Chant about Universal Sprouting)*, to which he supplied his own illustrations. This work has been described by a leading authority on the period as 'a kind of Slavic cantata or oratorio with the first singer and the supporting voice being among the protagonists ... in two parts, both based partly on the folk song about Ivan the Steward and partly on the events of the current war'.[30] The Futurist poet Khlebnikov considered the poem the best work about the 1914–18 war. Filonov's use of language, fragmentary and disjointed, obscure and referential, seems to match the enigmatic, hermetic quality of his paintings. In later years, after the revolution, yet

another poet, Kruchenykh, was to claim Filonov as one of the members of the *zaum* school in Russian poetry, the school which used displacements of accents and emphasis and other linguistic oddities for an extraordinary poetic effect. During these war years Filonov saw active service but managed to continue painting. After the revolution, which he welcomed as did the body of Futurists, he resumed work on his system of 'analytical paintings'.[31] From 1920 he was engaged at Inkhk in the company of Tatlin, Malevich and Matyushin, and participated in a number of exhibitions. His popularity was such that in 1925 he set up a school which flourished until 1928. It finally ended all activity in 1932 when private groups and organizations were dissolved by state decree.

Filonov had already accomplished much of his life's work but he was moved by such events as the Spanish Civil War to produce his *Ravaged World*. He died on 3 December 1941 during the siege of Leningrad. After his death some 300 of his works were presented by his sister to the Russian Museum there. Filonov's canvases and drawings are crowded, almost teeming with carefully placed segments of colour, mosaic-like, from which emerge fragments of a face or a disjointed figure (Plate 120). Sometimes the broken surface brings to mind a wall covered with gleaming but repulsive beetles. At other times one is reminded of Klee as in *Animals stalking the City Streets*, a picture which despite its childish exaggerations and playfulness is horrifying in its savagery and menacing fragmentation. These effects were obtained by a system of fine brushstrokes and precise and faceted dissection of form, serving to create an ordered, taut and dynamic pictorial surface which perhaps owes something to the example of Vrubel. Occasionally his meticulousness dangerously skirts fussiness. So deep is his savage pessimism that even his scenes of people enjoying themselves in cafés and bars have a grim, satirical motivation well suited to the brittle laughter of the post-war years, a little analogous to the malicious cartoons of Grosz and Dix. But Filonov is ultimately concerned to create an accurate and Bosch-like vision of judgement day, a harrowing of hell, an apocalyptic destruction of the human world in which all life suffocates beneath heaps of shapeless creatures, snarling and hideously tormented faces, grotesque and deformed bodies which anticipate the infernos created by Nazi Germany. Yet at times the very deliberateness of his style and the suffocating, detailed content tend to alienate the

120. Pavel Filonov: *Hardships of the People*, c.1930. Oil on canvas, 236 × 153.5 cm. Whereabouts unknown

viewer's sympathy; his pictures are overladen with significance; they are deeply pessimistic about the human condition; and they rarely give any sense of uplift. Nevertheless Filonov, overshadowed by the fame of Malevich and Tatlin, was certainly one of the most interesting and consistent artists of the period and, perhaps, a finer painter than either of the two more widely publicized figures.[32]

Also based in Petrograd was Matyushin. A trained musician by profession Matyushin engaged in a variety of activities, not least among them the publication of Futurist books. He joined Kulbin's Impressionist group and took part in their exhibitions, but broke away in 1909 to assist with the formation of the Union of Youth, showing pictures in several of their exhibitions. In 1912 he met Malevich and Kruchenykh and collaborated with them over the next few years. Between 1920 and 1922 he organized a series of performances based on the work of his wife Elena Guro, herself a talented painter. At the Petrosvomas he conducted classes in Spatial Realism from 1918 to 1922, directed an art laboratory at the Museum of Painterly Culture from 1922, and two years later became head of the Research Department of Organic Culture at the Petrograd Inkhuk. There he worked on the possibility of transposing sounds into visual forms, colour and form perception, and the extension of the physical process of seeing. In this work he was aided by a remarkably self-effacing family composed of Boris Vladimirovich (1893–1960), Ksenia Vladimirovna (1895–1955), Maria Vladimirovna (1897–1942) and Yuri Vladimirovich Ender (dates unknown). All four produced vivid abstract watercolours, part of their research into colour and consciousness no doubt, but valid works of art in their own right. Matyushin's own pictures were entirely abstract as in his *Painterly-Musical Constructions* of 1918 to which the word 'construction' in its usual sense certainly does not apply but which seem rather to present a display of brilliant fireworks or swirling vortices of coloured particles. These scintillating works provide another view of abstraction to that presented by the followers of Suprematism.

Painting from the early 1920s was adversely affected by the departure of some leading artists to Western Europe. Also, as in most European countries, society suffered from a deficiency – not to say mediocrity – brought about by the loss of millions of men during the war. Russia was especially stricken because of the upheavals occasioned by the Civil War and the famine and plagues which swept

the country in its aftermath. As for the emigration of talented men and women from Soviet Russia, it is as well to remember that this was a process which had begun long before the revolution. Yet the departures of Chagall and Kandinsky were major losses, especially since the latter had retained strong ties with his homeland through exhibitions, critical articles and correspondence until his return in 1914. When Marc Chagall (Mark Zakharovich Shagal: 1887–1985) returned in that same year he went to his native town of Vitebsk where he allied himself with a group of Jewish artists, among them El Lissitzky. Thus he represented part of the great upsurge of Jewish pictorial talent liberated by the end of Tsardom.[33] During his years in Paris he had kept in touch with Russian artistic life and made the token gesture of sending back works for exhibition. It might well be that he was more indebted to the Russian primitivist movement – and to Larionov, in particular – than his biographers have cared to admit; and the impact of the *lubok* on his subject-matter has not been adequately assessed. Chagall's creative individuality was shaped by a fusion of the native – that is, the Russian and the Jewish – and the foreign, mainly French: it was certainly not a spontaneous individuality and it was enlivened, revitalized, and enriched by the eight years he spent in Russia from 1914 onwards, decisive years in the deepening of his art. After friction with Malevich, he left Vitebsk and went in 1920 to Moscow where he worked for the Jewish State Theatre. His principal work of the period, a frieze for the vestibule, thought to have perished, has now been recovered. Ironically, Chagall's chief opponent was Malevich whose 'alogic' paintings and use of *svdig* are not so far removed from his own use of personal imagery – the title Malevich gave to one of his pictures, *Cow and a Violin* (1913–14), is just such a one as Chagall might have thought up. He had little in common with the fiercely utilitarian mood of Russia after the revolution and his departure in 1922 was hardly unexpected although throughout his career he spoke of Russia as his native land. It might well be argued that his painting lost in strength if not in charm from 1922 onwards. Kandinsky, who had remained apart from the Futurists during the war years when he lived in Moscow, began work on a programme of artistic studies to be introduced into the higher institutes and schools of art but met with no success. Unwilling to face the shortages and tribulations of revolutionary Russia, he was among the earliest of emigrants in 1921.[34]

The road abroad was taken by numbers of artists who had begun to appreciate that artistic revolutions are hardly the same as political ones. These included not only older middle-of-the-road artists like Benois who had co-operated with the Soviet government to a notable degree, who never entirely severed his links with the theatrical world in Russia, and who retained his Soviet citizenship to the end, but also leftist artists like Aleksandra Ekster who left for Paris in 1924. By then, Gabo, Pevsner, Archipenko, Puni, Zadkin, Roerich, and many of the Mir iskusstva group including Dobuzhinsky, Lukomsky and Sudeikin had also left. Marianne von Werefkin and Jawlensky had never considered returning to Russia, nor had Sonia Delaunay whose sympathies were entirely French at this stage. Chapoval, Charchoune, Tchelitchev, the Berman brothers, Soutine, Annenkov, de Stael, Cassandre and Poliakoff were among the younger painters whose careers either began or were continued outside their native land. Not all these painters were avant-garde. Vasily Shukhaev (1887–1973) and Aleksandr T. Yakovlev (1887–1938) painted in a modified Impressionist style, while Savely A. Sorin (1878–1953) concentrated on portraiture using a style related to that of Somov and Golovin earlier in the century. Boris D. Grigoriev (1886–1939) was probably the most gifted of the portraitists, having an angular style close to English Vorticism and the music of Prokofiev, who was also in self-imposed exile at this time. Many of these artists had a lean time: it was said that Korovin starved in the gutters of Paris. A few were fortunate: Sorin had aristocratic patronage, while Diaghilev patronized one or two others. Few critics or art scholars in the USA or Europe, least of all in Britain, wished to know of artistic developments in revolutionary or communist Russia; and the school of Paris was not prepared to have its reputation for innovation contested in any way whatsoever.

These names must serve as an indication of the immense losses suffered by Russian painting during the revolutionary and post-revolutionary years – through death and emigration. But, as has been indicated, the bitter feuds in which artists so readily participated must also be given due weight in any consideration of the apparent weakening of the country's artistic genius.

13
Proletarianism and the Artist: the Revival of Easel Painting

It has been claimed that the 'proletarian episode', meaning the period in cultural life when art for and of the proletariat was considered especially important, began in the late twenties (the period of the First Five-Year Plan lasting from about the time of the first party decree on literature in December 1928 to the abolition of hegemonous groups in April 1932), but there are cogent arguments in favour of placing proletarianism as a vague ideology operating on the arts at a much earlier date. In fact, although the Proletkult movement as such had been suppressed and its leaders fell into disfavour its doctrines were not altogether unacceptable to the party especially since its theoretical basis that 'Being determines consciousness', which is to say that every culture is the expression of the socio-economic order and the product of a definite class, seemed to be contained within Marxist ideology.

It was the supporters of Proletkult alone who were able to put forward with clarity and confidence an aesthetic based on Marxist thought which had a valid application to revolutionary Russia. At the first convention of Proletkult (Proletarian Cultural Education Organization) held in September 1918, there had been a speech by its leading promoter, Aleksandr Bogdanov, in which he made clear the major aspect of Proletkult's ideology:

Art by means of living images organizes social experience not only in the sphere of knowledge but also in that of the emotions and aspirations. Consequently, it is one of the most powerful implements for the organization of collective and class forces in a class society. A class-art of its own is indispensable to the proletariat for the organization of its forces for social work, struggle, and construction. Labour collectivism – this is the spirit of this art, which ought to reflect the world from the point of view of the labour collective, expressing the complex of its sentiments and its militant and creative will.[1]

This art was, primarily, to be optimistic, even joyous, and had as its hero the worker. It was also idealistic in that it not only depicted that which existed, but also that which was desirable and attainable, creating from that which was insignificant yet characteristic something that was durable, significant and typical. The principal drawback was that there were no artists of quality who were prepared to subscribe unreservedly to the theory. Thus it is impossible to speak of Proletkult artists; on the other hand, it is proper to speak of proletarian artists – that is, those who had risen from the ranks of the proletariat and felt an allegiance to their background, or those who felt that the artist in the new state was, in fact, a member of the proletariat and must work for that class. In this sense, also, we can use the term 'proletarianism' as a force or spirit in painting without necessarily linking it with Proletkult to which it was, nevertheless, indebted.

It cannot be doubted that the Communists realized from the first post-revolutionary days that the various artistic groupings and rivalries during the twenties presented neither a political nor an ideological menace to the central state organization. Sometimes it appears as if the party was content to allow them to exhaust themselves in internecine feuds. In fact, very few of the advanced artists had any real conception of the ultimate aims of the Bolsheviks and they were remarkably ill-equipped for any ideological resistance, for the plain fact is that although they condemned the middle-of-the-road artists as survivals of a bourgeois mentality, they were themselves out of touch with the mass of the workers and, particularly, with the peasantry. Nor had they any understanding of the immediate exigencies of the economic situation. Tatlin's Monument to the Third International and his *Letatlin* were splendid fantasies; while Malevich's Suprematism was essentially idealist and personal and the attempts to give it utilitarian practicality resulted

largely in geometrical decoration. Bearing these considerations in mind we might ask why Proletkult (or, at any rate, proletarianism) was not adopted from the first as the official artistic organ of revolutionary culture and why other agencies and movements were allowed to continue.

In order to understand the official position it is necessary to retrace briefly some of the developments in Russian life and culture from 1917 onwards. Both Lenin and Stalin believed, as might have been expected of sound Marxists, that the future of the Soviet state depended on the establishment of a healthy economy, an economy which although basically industrial would necessarily rely on the co-operation of the food-producing peasantry. When in the terrible shortages and famines of the early twenties it was seen that collaboration was not forthcoming, least of all from the kulaks or wealthier peasants, Stalin decided to subject them to his most drastic operations. While the elements of revenge cannot be discounted in his motives, it is equally possible to regard his actions as being determined simply and solely by the desire to prevent a recurrence of past hardships and to control the peasant agricultural economy on behalf of the total population. In this vital sense, the peasantry was of greater importance to his aims than the proletariat – using the term simply to describe factory workers. It is against this background that one must see the official attitude to the Proletkult (or, more generally speaking, proletarian) movement which was naturally concentrated among the working classes in the larger cities and, above all, in Petrograd. Thus when the support of the peasantry was being entreated, as during the NEP period, proletarianism was kept at bay; by the mid-twenties, however, when the kulaks were being brought to heel and the support of the industrial classes was needed for the establishment of new industries, electricity systems, transport, etc., then proletarianism was given a strong measure of encouragement except in the political sense.

Probably by 1928 and certainly by 1932, Stalin believed he had broken the power of the peasantry, gained effective political control of the country, and achieved a fair measure of success with such feats as the construction of the Dnieper Dam, centrepiece of the Five-Year Plan, and thus no longer needed the support of either the city dwellers or the peasantry to any urgent extent. Stalin had no love of zealots of any persuasion; what he sought was unadventurous mediocrity and, like Nicholas I, submission to one

single will – his own. Which is not to say that he was not motivated by a concept of Russia as a great industrial and Communist state. Though his spokesmen laid down requirements in the cultural field, largely promoting proletarianism while modifying it to suit his own political purposes, his was the motivating spirit; and nowhere was this to be more clearly seen than in the way in which the various artistic organizations were gathered into one massive state union which could be politically controlled – and, yet, at the same time, offer material benefits to conforming artists. Thus, in addition to Proletkult's attempt to formulate an ideology and carry it into practice, there was a wider belief in artistic proletarianism, in painting which would be proletarian in concept, manner and subject-matter. This is particularly true of the mid-twenties; but it is clear that Socialist Realism has claims to being an art of the proletariat.

During the 1920s the visual arts were never, in general, subject to the close scrutiny given to literature; and, in fact, they had a number of journals such as *Izobrazitelnoe iskusstvo*, *Zhizn iskusstva*, *Iskusstvo i promyshlennost*, *Iskusstvo* (the title was used for several artistic journals) and the short-lived but important *Iskusstvo kommuny* (*Art of the Commune*). If the Communist Party itself can be said to have had an official cultural journal it was *Krasnaya Nov* (*Red Virgin Soil*), edited during the years 1921–7 by Aleksandr Voronsky (1884–1943), a man of considerable culture and open-mindedness, who was at the same time an ardent Marxist, supported not only by Lunacharsky but also by the Communist leaders. He saw art as a means of cognition of life, not as a means of organizing a class, but was overruled by less tolerant ideologists and fell into disgrace during the thirties. The Left Front in Art had for its journal *LEF* which published the work of Mayakovsky and other Futurists, Rodchenko and the Constructivists, the OPOIAZ group of literary formalists, and also film and theatre directors such as Eisenstein, Meyerhold and Vertov. Begun in 1923, the journal was renamed *Novy lef* (*New Left*) in January 1927. These publications (and others of a more tolerant nature) were bitterly opposed to proletarian doctrines. Lenin's NEP policy had come as a shock to many of the leftist artists and writers who saw it as a betrayal of revolutionary (and Marxist) ideals and were furious at the freedom extended to the middle-of-the-road personalities who had never professed allegiance to the new government. The members of Proletkult

were equally outraged; and although forcibly weakened by the cutting-off of funds and the opposition of Lenin (so that their numbers diminished dramatically) they made repeated efforts to dominate in the sphere of literature.

In October 1920 the writers in a group named Kuznitsa (The Smithy) organized an All-Russian Conference of Proletarian Writers which then transformed itself into an association called VAPP, which continued until reorganization in 1928 when it recognized its Russian character and became known as RAPP. The Smithy had poetic tendencies and was obsessed (as were Malevich, Tatlin, and other Russian intellectuals) by 'planitarianism' – the creation both on earth and in outer space of new forms of mass housing and urbanization along strictly geometrical lines as far as architecture was concerned. Eventually, a number of the more fiercely proletarian young men left The Smithy and in December 1922 formed the October group which published *Na Postu* (*On Guard*). In the first months of 1926, by which time the leaders of October had gained control of VAPP, the Press Section of the Central Committee of the Communist Party called upon it to organize a Federation of Organizations of Soviet Writers which would include both proletarian and less committed or 'fellow-traveller' groups. In consequence, on 27 December 1926, FOSP came into being and was soon joined by LEF (Left Front in Art). The way was thus opened for the centralization ordered by the Communist Party in 1932 and for the establishment of its proletarian character.[2]

There were developments of a parallel nature in the visual arts. Even before the 1917 revolution artists had tried to form themselves into a union and during the unsettled months after the revolution itself Mayakovsky and his friends attempted to form an Association of Art Activists largely to press their own claims to authority and to fight the 'power-hungry' Mir iskusstva and to oppose the conservative Alexandre Benois and his friends who were intent on preserving the art treasures of the past. It was unfortunate that the artists were unable to agree among themselves even to the limited extent of publishing a common journal. The hatred which existed between Tatlin and Malevich and which bedevilled all their relationships was only too typical of the state of affairs as a whole. The arrogant and intransigent tone adopted by LEF (and Proletkult) both in their iconoclastic attitude to the art of the past (which the Communist Party had vowed to preserve as part of the country's cultural heritage)

and to other workers in areas such as architecture and literature alienated sympathetic politicians and bewildered the masses, and was without relevance to the problems of a devastated Russia. Despite these conflicts a variety of groups was born.

In January 1919 a number of artists including Altman, Mayakovsky and Shterenberg formed Komfut (a union of Communists and Futurists, to which Malevich paid allegiance), which partly linked itself with Proletkult although it was of a far more iconoclastic nature. The movement was short-lived, as might have been expected in view of its non-conformist tendencies. In 1921 under the name of Being there was established a group composed of members of the Jack of Diamonds and some younger artists. They devoted themselves to figurative subjects painted with a freshness of colouring and richness of form, a combination calculated to appeal to the new patrons brought into existence by the NEP. In 1922 came the last exhibition of Mir iskusstva, while more significantly in 1923, on the fifth anniversary of the Red Army, there were exhibitions at the War Museum and the Museum of the Revolution of paintings dedicated to 'heroic realism' and to subjects drawn from daily labour. As in literature there was a steady growth of organizations sheltering behind the banner of proletarianism, all receiving semi-official support from members of the Communist Party: thus AKhRR (Association of Artists of Revolutionary Russia) was formed in 1922 about the same time as RAPKh (Russian Association of Proletarian Artists). In fact, the resolution of the Party Central Committee, dated 18 June 1925, 'on the Policy of the Party in the Sphere of Artistic Literature' sanctioned a degree of 'hegemony', probably, it is to be suspected, on the principle of divide and rule. However, by 1925, the school of 'heroic realism' had gathered to it the Cézannists, Being and other movements. Three years later those artistic organizations which still enjoyed freedom (and this is equally true of architecture) were encouraged to join in central agencies or All-Union links. That same year, which also saw a crisis in Soviet political, social and economic life which inevitably affected the arts, witnessed an order that artistic groups should be precise in revealing their 'class face', for mere words about supporting Communism were no longer sufficient. Throughout the year there were discussions at the Academy (which had reopened soon after the revolution in 1920) and the first All-Union Congress of Proletarian Writers on the question of artistic par-

ticipation in the strengthening of the state, during which all the previous attempts of artists to evolve new forms of art were condemned. The first result of these probings was a reaction in which organizations swung to the right. The group formed in 1924 as Moscow Painters (and largely composed of members of the Jack of Diamonds) was reconstituted in 1927 as the Association of Moscow Artists and appeared to revert to the trends of pre-revolutionary art by repudiating proletarian themes.

The next four years were difficult and dramatic, especially since the proletarian elements were re-gathering strength, although frequently subject to party criticism of their basic political tendencies. This conflict – and a decade of comparative freedom – came to an end with the resolution of the Party Central Committee on 23 April 1932 which stated that 'the confines of the existing proletarian literature and art organizations are becoming too narrow and are hampering the serious development of artistic creation.' It decreed the dissolution of the Association of Proletarian Writers, the integration of all writers who supported Soviet aims into a single union, and the 'Execution of analogous changes with regard to the other arts'. Since a consequence of the resolution was the universal adoption in the following years of the doctrine of Socialist Realism, a doctrine which the proletarians had advanced, ruthlessly at times, as the only possible ideology for a workers' state, this decree must have been a bitter blow. The resolution achieved several political aims, most of which worked to the advantage of the Communist Party, since it removed the power of the proletarian leaders who had grown too powerful for the suspicious party bureaucrats and ideologists, increased the number of artists who now sought the protection of the party machine, and allowed it to control the new monolithic union which it could easily indoctrinate and terrorize.

The effective result of the resolution was the ending of some fifteen years of flexibility and the inauguration of a period of regimentation to which there was no foreseeable end. It must be noted, in the interests of truth, that the doctrine of Socialist Realism did not, as is often stated, find its ultimate and definitive expression in 1932; although its tenets were being formulated and, before long, were to be accepted as dogma.

As far as the fine arts were concerned the proletarian ethos manifested itself specifically in painting during the twenties and early thirties – an area that has received little attention critically speaking because the dramatic developments of the early twenties, particularly in connection with Constructivism, have tended to obscure its achievements. Rodchenko, Tatlin and Malevich all proclaimed the death of painting – and this view was no doubt shared by their followers – but this did not prevent the three of them from returning, sooner or later in their careers, to easel painting. Indeed, some of Malevich's portraits, for instance *Portrait of Una* (1930–3), have the brightness and bravura handling of paint that is characteristic of Socialist Realist painting of the thirties; moreover in several compositions painted in a flat poster-like style of young women holding rakes and other agricultural implements Malevich appeared to indicate a degree of sympathy with the idea of painting as a potent social force. The young Constructivists, however, were adamant that artists should confine their attention to the utilitarian ends of practical design. Although there can be no doubt that the impact and sway of Constructivism have been much exaggerated outside Russia, a degree of courage must have been required of painters who wished to tackle subjects of a realistic or personal nature in a climate which was apparently hostile to pictorial figurative work and to painting of any kind whatsoever. It is too easy to accept the declarations of the Constructivists as to the decline of painting, for painting was in a comparatively healthy state although split into factions.

An important figure who seemed to take aspects from both the painting of the pre-revolutionary years and the post-revolutionary developments in Constructivist design while retaining his own personal style and artistic integrity was Vladimir Andreevich Favorsky (1886–1964), a master of the wood and lino-cut, possibly the finest of the century. Born in Moscow and trained there in the studio of Yuon and in Munich under Hollosy, he also studied philosophy at the universities of both cities. He served with the army from 1914 to 1918, and then became an assistant lecturer in painting at the Moscow Free Artistic Studios. His career was interrupted by service in the Red Army (1919–21) after which he was appointed professor at the Faculty of Graphic Art at the Vkhutemas of which he was also rector (1923–5). Among several other pupils who were to make names for themselves in Soviet art he taught Deineka, Pimenov, Goncharov, Kaversky, Echeistov, Pinov and L. Myulgaupt. Favorsky himself, enriched by a study of the advanced style of his day, seems to have given his pupils courage to

strike out on their own and not to be abashed by the then current rejection of figurative art or defeated by the tribulations which came later in their careers when they were faced by official opposition. A true patriot and man of the people, Favorsky held fast to his ideals of socialist art and resolutely declined to modify his style despite conflict with Stalinist ideologists. Since his death there have been apologies: it has been said that, 'At times, absurd charges of

formalism deprived him of the possibility of exhibiting his work',[3] and a Soviet art historian has written:

> From the end of the thirties, Favorsky, like many of his contemporaries, was subject to a levelling down process which could not but have an adverse effect on his development as an artist. In spite of this, his approach to every new problem which he encountered was so serious that even in this difficult period he created works of lasting worth and beauty.[4]

Favorsky was a painter, stage-designer, sculptor, potter and illustrator, exploiting a style derived from the pre-1914 Futurists, perhaps also from

121. Aleksandr Aleksandrovich Deineka: *Defence of Petrograd*, 1927. Oil on canvas, 209 × 247 cm. Moscow, Tretyakov Gallery

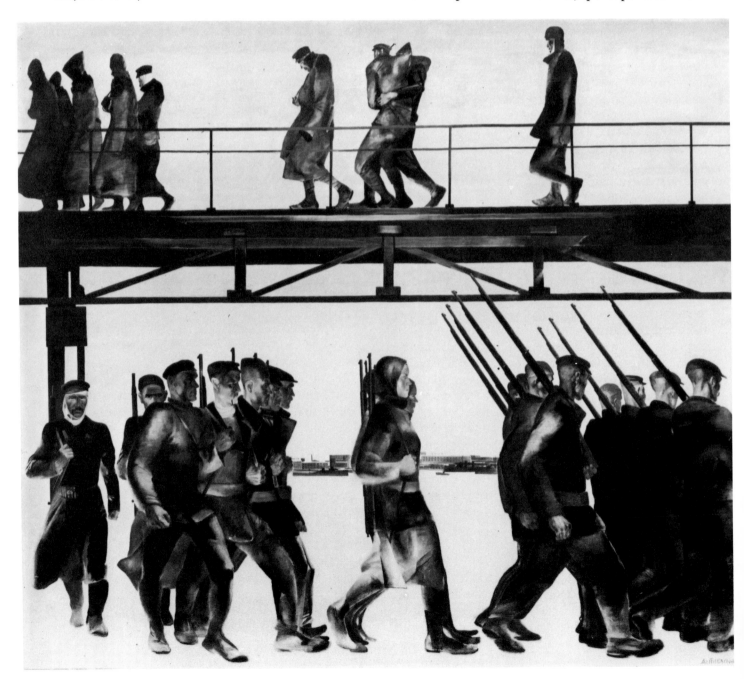

Suprematism, and utilizing the brilliant colours of the Fauves. In a sense, he undertook the role of guide and teacher played by Chistyakov for earlier generations. Above all, it was his steady emphasis on the pictorial and the figurative, even when most laconic, that established his importance as a central if tacit figure behind the scenes in Russian art from 1920 onwards.

The most gifted of the artists who trained under Favorsky was Aleksandr Aleksandrovich Deineka (1899–1969), who was born in Kursk and studied at the Kharkov Art School and the Moscow Art and Technical Studios between 1921 and 1925.[5] Deineka designed book illustrations, mosaic decorations and posters, besides showing ability as a sculptor. Two main characteristics were apparent early in his career: a daring and unexpected freedom in the disposition of his material, which resulted in strikingly sharp contrasts of form and placement, and a sense of monumentality derived perhaps from the neo-classic phase of art in the very early 1920s, more directly from Favorsky, and more distantly but even more potently from Ferdinand Hodler. He used colours as if they had been bleached from the canvas, probably to aid their reproduction as posters or book illustrations. His individuality and purposefulness showed themselves early in 1924 when he organized the Group of Three, together with Yury Pimenov and Andrei Goncharov, and joined in the 'First Discussional Exhibition of the Association of Active Revolutionary Art'. The following year he helped to found OST (Society of Easel Painters), the roots of which went back to discussions begun in 1922 by Yury Annenkov and David Shterenberg. It included Pimenov, Tyshler, Vilyams, Klyun and other young artists. Deineka left it in 1927, not because of criticism of its alleged 'formalism', but because he felt it favoured decorative easel painting unduly: in fact, Deineka not only publicly demonstrated his acceptance of proletarianism by joining the October movement of the late twenties but supported its ethos absolutely. Indeed, this ideology inspired his *Defence of Petrograd* (Plate 121) completed in 1927 and displayed in February 1928 at an exhibition devoted to the tenth anniversary of the Red Army. It remains his masterpiece, a frieze-like composition, almost without perspective, which depicts on two levels, one of the snow-covered earth and the other of an iron bridge, the resolute worker-defenders of Petrograd. The greys, browns and blacks of the bridges and the workers' clothing silhouetted against the near-white background

correspond to the grim determination and steely courage implicit in the theme and are further emphasized by the rigidity of the rifles and the framework of the bridge over which in moving contrapuntal rhythm the wounded citizens retrace their slow footsteps. The schema of the picture is indebted to Hodler's *Departure of the Volunteers in 1813* (1908), and the preliminary studies made for the work, which gives it an additional historical and social dimension. If the Russian people, the great working classes, wished for an image of their revolutionary struggle, their noble sufferings in a greater cause and their fierce patriotism they were given it in this fine work, which is one of the great humanitarian (and proletarian) creations of the 1920s.

In the 1930s Deineka moved on from a series of original works celebrating the dignity of labour to themes of family life and maternity, among them *Mother* (1932), a deservedly popular work in the neo-classical manner. He was clearly attracted to sport and physical culture, finding a deep satisfaction in depicting men and women of all ages engaged in bathing, running, taking showers and sunbathing, subjects which gave scope for his sense of the monumental (Plate 122). From visits to France, Italy and the USA in 1935 he brought back watercolours which showed an unusual austerity, imbued with a quietly satirical quality. This same quality is more strikingly evident in a number of angular, asymmetrical graphic pieces, somewhat in the style of Grosz and Dix, in which he commented on the corruption of life in the West, notably in Germany. His manner of painting had begun to change from the thickly applied but smooth paint evident in *The Defence of Petrograd* to the use of thinner paint used almost like watercolour and finally to an altogether more bravura style typical of the first decade of Socialist Realism. This vividly pictorial manner, impetuous, almost Surrealist in its clarity was well suited to record the heroic struggles of his country against the German invaders, as in his *Defence of Sebastopol* (1942), and the deliberate destruction and cruel devastation they left in their wake as they retreated to the catacombs of Berlin, whose gaunt ruins he depicted in 1945. Deineka too, like so many others in the history of Russian painting who suffered from the oppressions of the state, the church or the censorship, was an unwilling victim – in his case, of the lashes of Stalin's ideological mouthpiece Zhdanov. If the later work of Deineka did not maintain the highest standards nor truly represent his remarkable gifts as a pictorial

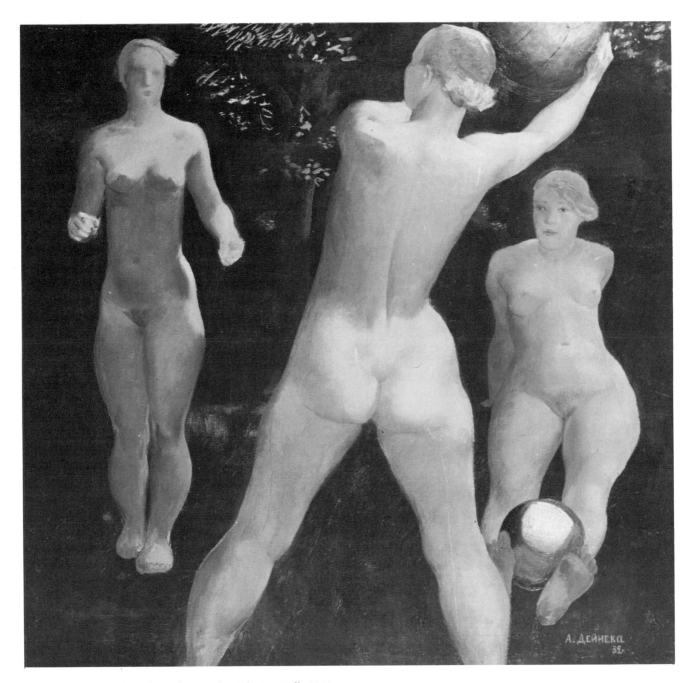

122. Aleksandr Aleksandrovich Deineka: *Playing Ball*, 1932.
Oil on canvas, 123 × 123 cm. Moscow, Tretyakov Gallery

123. Yury Ivanovich Pimenov: *Heavy Industry*, 1928. Oil on
canvas, 260 × 212 cm. Moscow, Tretyakov Gallery

innovator it may be pleaded that he suffered abominable restraints, in spite of which he continually testified to a sense of engagement with the cause of his fellow citizens, a respect for life and for human joy as it finds expression in labour, love, achievement, sport, motherhood and the delight of natural life, and also an absolute, total honesty so that his nudes are painted without any sense of false shame or erotic coyness.

OST was perhaps the most important group of painters in the 1920s although it has as yet not attracted much critical attention outside the USSR.[6] Between 1925 and 1928 it held four exhibitions, all in Moscow, and united most of the distinctive younger painters trained since the revolution. They aimed at technical competence, precision, 'Revolutionary contemporaneity' and the rejection of abstraction on the one hand and excessive narrational

124. Andrei Goncharov: *The Death of Marat*, 1927. Oil on canvas, 161 × 97.5 cm. Moscow, Tretyakov Gallery

125. Aleksandr Arkadievich Labas: *Airship over a Town*, 1932. Watercolour on paper, 44 × 30.5 cm. Private Collection

content (as in the work of the *peredvizhniki*) on the other. They sought a degree of reassuring analogy of aim in the work of Masereel, Grosz and Dix; and learnt from the work of artists as far apart as Hodler and Dufy, from the monumentalism of the one and the brilliant and fluent gaiety of the other. Associated with Deineka were Yury Ivanovich Pimenov (1903–77), who in oils and watercolours painted scenes of the new urban life, designed theatrical décors, and illustrated books, utilizing an apparently sketchy style that often conceals a distinctive sense of composition (Plate 123); and also Andrei Dmitrievich Goncharov (1903–79), who earned his reputation with woodcut illustrations to a wide variety of Russian and foreign books, including *Peregrine Pickle*, but whose *oeuvre* embraced landscapes, portraits and stage settings including *The Death of Marat* (Plate 124) with its deliberately primitive nature (an oddly chosen subject for those unsettled years). Both of these painters – and others

of the OST group – had learned something from the Germanic secessionists, and from Middle European art in general although an equally forceful influence was that of the Futurists.

Peter Vladimirovich Vilyams (1902–47), another student from the Vkhutemas, was a portraitist of some penetration, expressing the character of his sitters, notably Meyerhold, through an inventive angularity, but he was to find theatrical design of particular interest and ended his career as the principal artist at the Bolshoi Theatre where his work was held in the highest repute, combining, as it did, historical exactitude with imaginative selectivity. Aleksandr Arkadievich Labas (b.1900), who studied with the Moscow Cézannists Mashkov and Konchalovsky without being in the least influenced by their impasto technique and heavy outlining, became a member of the Vkhutemas in 1924 after service with the Red Army, and joined OST the following year.[8] He cultivated a sparse manner, reducing and paring away all incidental matter from his paintings, which were generally of urban life and transport, although he created some fantasies of travel by dirigible and Futuristic space projects. Labas's style was to grow increasingly austere as he reduced his people and places to a kind of visual shorthand and further developed his technique of using damp paper on which the colours spread or were allowed to run (Plate 125; Col. Plate 13). Sergei Alekseevich Luchishkin (b.1902) also spurned illusionistic effects, preferring a meticulous manner with which he depicted empty streets and blocks of houses creating a near-surrealist effect not dissimilar to that of Chirico. Among the group were V. Lyushin, K. Vyalov, E. Melnikov and Mecheslav Vasilievich Dobrovsky, all talented but possibly outstripped by N. Shiffrin who was to become a leading theatrical designer.

It is of some interest that another member of OST was to excel in stage design: Aleksandr Grigorievich Tyshler (1898–1980), a pupil of Aleksandr Ekster at Kiev, became the scenic designer for the Jewish Theatre in Moscow and the State Theatre of the White Russian Republic in Minsk, but also painted the portraits of the foremost creative personalities of his day as well as pictures of a decorative symbolism culled from his childhood memories.[9]. Remembering the traders and market people in the Jewish villages and towns of those times he painted picture after picture of women wearing fantastic hats or supporting on their heads extraordinary baskets, boxes, houses and theatres, surrounding them with

an intricate web of strokes. He created a fantastic but tragic world of puppeteers lugging around on their backs portable booths (Plate 126). Like other members of the group he was intrigued by the possibilities of air travel. His designs for *Hamlet*, *Lear* and *Richard III* were astonishing in their aptness and also in their penetration into the spirit of the dramas. At the same time he commented sardonically on the world around him as in his *Sacco and Vanzetti* (Plate 127), and the even earlier *Slaughterhouse* in which man's capacity for bestial cruelty and callous indifference to suffering are graphically and memorably presented. When the total achievements of twentieth-century art in Russia are finally counted Tyshler will be seen to have stood in the forefront.

126. Aleksandr Grigorievich Tyshler: *Fairground Entertainer*, 1964. Oil on canvas, 75 × 50 cm. Private Collection

127. Aleksandr Grigorievich Tyshler: *Sacco and Vanizetti*, 1930. Private Collection

If Deineka was the artist who most successfully created a style which was entirely at one with the spirit of the proletarian revolution and the building of socialist Russia, it was Kuzma Sergeevich Petrov-Vodkin (1878–1939) who furnished the images that were to comfort the ordinary men and women who struggled through these difficult years.[10] His paintings distilled the hopes and fears of those Russians who found themselves in a revolutionary state which they welcomed but which was at times beyond their comprehension. In different ways both Deineka and Petrov-Vodkin concentrated on the timeless and representative moment, on the heroic effort to defend the homeland and rebuild its economic strength, and on the life of the anonymous citizen caught up in great historical events. It has been said of Petrov-Vodkin that he belongs to the pre-revolutionary period, to Russian symbolism;

but it could be more accurately argued that his greatest work came during the revolutionary years. He had studied in Samara, at the Stieglitz School, and at the Moscow School under Serov and Levitan between 1897 and 1905. Intermittently he studied abroad, at one time under Ažbe in Munich. From 1905 onwards he lived in France and Italy and also visited Africa. When he returned to Russia in 1908 he found it difficult to adjust to the artistic climate there, although he exhibited with the major groups. He was exceptional among his generation in that his devotion was given to the masters of the Italian Renaissance – Masaccio, Piero della Francesca and Bellini – as much as to the Symbolists and Expressionists, among whom Puvis de Chavannes and Hodler – the latter so important an influence on many Russian painters – were possibly the most notable. When he began to attract attention as a member of the group centred on Ryabushinsky it was for large paintings employing drastically simple but highly original compositional patterns, often in bright greens, oranges, reds and browns, and using nude boys dancing, wrestling, or riding horses as subject-matter. The spirit becomes that of Matisse rather than Hodler. By 1911 in *The Novgorod Kremlin* he demonstrates his preoccupation with a 'non-Euclidean' perception of space and of the cosmos itself. Buildings loom dizzily above us (Lentulov exploited this effect) no longer vertical but inclined, while a curving horizontal axis placed either high or low or even tilted to one side plays a major part in guiding the spectator's eyes. He also believed that it had an emotional impact on the viewer. This interest in composition (and in technique – oil used almost like tempera – which accounts for the excellent condition of his pictures when those of his colleagues are either cracking or darkening) distinguished him from painters in the different movements who were either agog to exploit the latest manner or trick imported from France or who confined their investigations to the employment of Russian subject-matter. This was the period of his *Boys Playing* (1911) and *Bathing the Red Horse* (Plate 128), which still impress by the noble simplicity of their conception and execution.

A recent critic of Russian painting has lamented that (with notable exceptions) the artists of the first decades of the century were not able to create a homogeneous style and claims that 'Petrov-Vodkin did not fulfil the promise of his beginnings when he was acclaimed by some of the most eminent of

critics'.[11] This statement hardly seems justified in the light of his total career and the fine works of the 1920s in which homogeneity is a ruling virtue. Petrov-Vodkin was among the first artists to welcome the revolution, designed some of the street decorations which celebrated its anniversary and assisted with the reorganization of the Academy of Arts where he was given one of the free studios. In 1925 he helped to found the Four Arts Society of Artists, together with Lev Bruni, Favorsky, Kuznetsov, Lebedev and others. It held three exhibitions in Moscow in 1925, 1926 and 1929, and in Leningrad in 1928; and among the contributors were Klyun, El Lissitzky and Puni as well as the sculptor Matveev. The Four Arts was basically formalist although it stated that within the conventions of the Russian tradition 'painterly realism' was most appropriate to the artistic culture of the time. The group enjoyed little official favour and was criticized both by OST and the Association of Artists of the Revolution (AKhR), but such members as Petrov-Vodkin had, in fact, established a form of revolutionary art as effective as that created by any artist of his generation. His paintings, enduring icons of the years of proletarian struggle, are a firm attestation of his direct and deeply emotional involvement in the lives of workers. *Morning: Bathers* (1918), in which a young woman leads forward her infant son, both naked and unashamed, captures the bright hopes of those early years in unsentimental, modern allegory. *Petrograd 1918* (Plate 129) illustrates yet another facet of the revolution: a working-class mother nursing a child at her breast stands on a balcony beyond which can be seen the squares and arcades of Petrograd sparsely populated with a few clusters of excited citizens discussing the latest events. The picture is a clever adaptation of the old icons of the Virgin and Child and is said to have become known to the religious inhabitants of the city as Our Lady of Petrograd. Although less interested in literature than a number of the painters of his day he had friends among the intelligentsia and his *Portrait of the Poet Anna Akhmatova* (1922) is perhaps even more revealing of her inner strength than the brilliant but theatrical study painted by Natan Altman in 1915.

Petrov-Vodkin's firmly modelled portraits, indebted somewhat to Renaissance examples and also to Cézanne, are too little known relative to his scenes of post-revolutionary life. *Death of a Commissar*, commissioned for the Red Army celebrations of 1928 (at the same time as Deineka's masterpiece, *The Defence of Petrograd*) is, within its dramatic terms, a highly original and inspiring composition made all the more effective by a return to his obsession with high curving backgrounds. Although *Death of a Commissar* (Col. Plate 14) is frequently accounted his major post-revolutionary painting, it perhaps lacks the human touch so evident in an even later work, *The Alarm: 1919* (1934), which depicts an episode from the days of the Civil War when houses were raided, arrests made without reason, and the streets suddenly turned into battlefields between Reds and Whites. It shows that Petrov-Vodkin was still a master of a subtle palette of faded reds, blues, mauves and yellows, and that he had acquired new gifts for quiet suspense and for wringing our hearts over the plight of the ordinary worker caught in a murderous conflict over which he had little control. Petrov-Vodkin, like other artists, bore a heavy load of ideological criticism; and after his death there was a loss of interest, perhaps occasioned by the over-reproduction of pictures of still lifes in a Cézannist style and also, of course, by the events of the war years. In recent times the full strength of his artistic integrity and the sincerity of his devotion to the cause of socialism in Russia have been increasingly recognized.[12]

Inevitably, despite the personal commitment of these artists to socialism (but less to political ideology), the decorative nature of much of their work

128. Kuzma Sergeevich Petrov-Vodkin: *Bathing the Red Horse*, 1912. Oil on canvas, 160 × 185 cm. Moscow, Tretyakov Gallery

129. Kuzma Sergeevich Petrov-Vodkin: *Petrograd 1918*, 1920.
Oil on canvas, 73 × 92 cm. Moscow, Tretyakov Gallery

attracted criticism from the more ideologically
inclined artists and despite preserving a firm degree
of individuality to the end the Four Arts began to
decline in the very late twenties.[13]

Both Deineka and Petrov-Vodkin (and some of
their followers) were painters whose work was
deeply imbued with a consciousness of the revol-
utionary triumphs and the emergence of the new
Soviet man. They were, in their different ways,
monumental artists with a sense of history behind
them, who worked for history to come. They were
also devoted to the cause of the working man and
woman and had an inner and deep-seated optimism
as to the future of Soviet Russia. But they were not
Socialist Realists within the narrow terms of the
Stalinist ideologists; and time and time again suf-

fered from accusations of being formalistic, addicted
to Futurism and pre-revolutionary experimental
(non-*peredvizhniki*) art, and of creating art for the
bourgeois elements of society. None of this was true.
It is tragic that in Russia of the 1930s there was no
one of sufficient courage and independence of mind
to step forward to defend these painters against such
attacks. For the plain truth is that both Deineka and
Petrov-Vodkin were true proletarian artists. With
the possible exception of Filonov, they were the
greatest artists of revolutionary Russia; and yet their
development was frustrated, their promise blighted
and their opportunity for experiment thwarted by
hostility, lack of appreciation, and condemnation by
tyrannical bureaucrats. Through such cruel stupid-
ity Russia wasted a generation of proletarian artists
who could have given Soviet art a reputation which
might well have equalled in another way that now
held by the painters who worked so notably in the
first two decades of the century in both Moscow and
St Petersburg.[14]

Socialist Realism; Coercion of Painters into Disciplined Organizations; Soviet Art

During the 1930s a wave of terror ran through the Soviet Union. Having subdued the kulaks Stalin now turned his attention to the intelligentsia and creative artists who had survived from Tsarist days, as well as to the elements of urban life which in any way threatened the supremacy of his power. Seized with a fear of subversion and of encirclement by the Western powers in alliance with the Fascist and Nazi states, a phobia which was not without a substantial basis, he hit out brutally at all and sundry. 'The life we led in those days was quite exceptional....', wrote Ilya Ehrenburg; 'There was no one in the circle of my acquaintance who could be sure about the morrow.' As in the worst days of Tsarist Russia men slept with their baggage ready packed against midnight arrest. Ehrenburg continued, 'People who had never belonged to any opposition, who were loyal followers of Stalin or honest non-party specialists were arrested....'[1]

Stalin's actions can never be forgiven; but they can at the least be understood. During the 1920s the Soviet government had faced countless external and internal challenges. Within the state there was opposition from agencies and groups with interests in landowning and private industry and commerce, from nationalist groups, especially in the south, and from Trotsky and his followers who were expelled from the Communist Party in 1927. It was not until 1925, almost seven years after the revolution, that the majority of the European powers formally recognized the existence of the Soviet Union so strong were anti-socialist sentiments everywhere. When Lenin died on 21 January 1924, he was aware that, despite the success of the revolution itself, his country was still in turmoil, faced with immense agricultural and industrial problems and ringed around by hostile forces. It was only in 1933 that the USA formally recognized the Soviet state. In that year Hitler came to power; and his proclaimed

intention of carving out an empire for Germany in Eastern Europe became a distinct probability. Stalin had two aims: to make the Soviet Union a formidable industrial power and to establish himself as its supreme leader. Anyone who opposed him was to be destroyed. And yet even his enemies, Trotsky among them, saw that his presence was essential to the firm establishment of the Soviet state. In such an atmosphere there was no justice, no honour, no logic and no reason: terror ruled. Yet it is doubtful whether the ordinary worker with little thought beyond the well-being of his family and immediate circle felt himself threatened or was even conscious of the enormous crimes being perpetrated by Stalin and his henchmen. On the contrary, the majority felt proud of the Soviet progress in industry and the development of hydroelectric power, new canals, roads, railways and air travel, as well as of their improving living standards.

Stalin had his finger on the common pulse and sensed the innate conservatism of the workers, not least in their attitudes to the arts. He saw all aspects of avant-garde culture, including painting, as subversive infiltrations of the purity of Soviet life. It was an attitude in which he did not stand alone, for a kind of reaction, even weariness, had come into public life after the social, sexual and artistic experimentation of the twenties and now manifested itself in a xenophobic attitude to Western culture and in a growing mistrust of all that was avant-garde. The then Secretary of the Communist Party, Andrei Aleksandrovich Zhdanov, kept up a series of relentless attacks on painters, musicians and writers between whom there was, as always in Russian life, a strong interrelatedness, which was intensified by the sense of bewilderment at the inexplicable carnage, mass consignment to unspeakably harsh labour camps, and the pointless oppression and cruelty which they saw around them, and also by a

determination to endure the worst excesses for the sake of their beloved country and its citizens. Shostakovich, Favorsky, Prokofiev, Sholokhov, Tyshler, Akhmatova and Deineka were all subjected to the lash of Zhdanov's tongue while others, less fortunate – Meyerhold, Klucis, Drevin and the poet Osip Mandelstahm among them – were not spared the executioner's bullet or penal imprisonment or exile to the fatal labour camps. Mayakovsky, possessed by public or personal despair, had already taken his own life. And many of the avant-garde were weary. As R. Williams writes, 'The Russian avant-garde was born as a protest against bourgeois pre-revolutionary Russian society: it died of old age in the new revolutionary Russia it helped invent.'[2]

The total result should have been a debasement of cultural life. But on the contrary, these were years when a number of masterpieces which have enriched world culture were created. As well as orchestral and instrumental works Prokofiev composed the ballets *Romeo and Juliet* (1935), *Cinderella* (1941) and *Tale of the Stone Flower* (1953), the operas *Semyon Kotko* and *War and Peace*, the oratorio *Alexander Nevsky*, and the charming *Peter and the Wolf*. Shostakovich composed several symphonies, including the 5th Symphony (1937), one of his masterpieces, and the opera *Lady Macbeth of the Mtsensk District* (1934), which was withdrawn after hostile criticism. Kabalevsky's *Colas Breugnon* (1938) and Khachaturian's ballet *Gayaneh* (1939–42), *Masquerade* (1939), piano concerto (1936) and violin concerto (1940) soon achieved popularity, while Miaskovsky wrote more than ten symphonies during this decade. The theatre director Meyerhold scored two of his greatest successes with Dumas's *Lady of the Camellias* and Tchaikovsky's *Queen of Spades* in 1934–5, although he perished in the hands of the secret police in 1939. There were notable films but Eisenstein's *Alexander Nevsky* (1938) retains a place among the world's greatest. Sholokhov's novel *Virgin Soil Upturned* (1931, sequel in 1960), dealing with collectivization of the peasants, has attained international recognition; and Leonid Leonov's *The Road to Ocean* (1935) managed, within the limits of the censorship, to cast a clear eye over the conflicts within the new Soviet man. Pasternak published his collection of short poems *Second Birth* in 1932; and showed a deeper awareness of the poet's task. Stage design reached even greater heights than it had done in the celebrated pre-revolutionary era.[3]

Meanwhile the Soviet government was grimly proceeding with its avowed aim of transforming Russia into a Socialist state – Socialist in word, thought, and deed. To this end, it supported all artistic forces which proclaimed proletarian aims, but as we have seen it was quite unwilling to support any one group or to give it official legitimacy. It ruthlessly opposed any agency (such as Proletkult) which appeared to have organized political ends. Probably without being conscious of their ultimate intentions or aims the ideologists of the Communist Party were watching developments in the cultural field and waiting for some kind of common policy to evolve from within the ranks of the artists themselves; and if such a common policy did not come into existence or failed to measure up to party requirements they were prepared either to impose one or to select from among the aesthetics of the various groups the one that most suited their purposes. The aesthetic had to conform with the Marxist tenets of the Communist Party and had to be enforceable insofar as any artistic policy can be enforced. During the 1920s divisions within the Communist Party and the government meant that there was neither time nor energy to expend on directives controlling the arts or, at least, directing them along approved paths; but as the decade came to a close the government was more and more able to set about this task, although it clearly preferred the artists to take the initiative themselves – as, in the event, was the case at the First All-Union Congress of Soviet Writers in 1934.

At that Congress Zhdanov defined the duty of writers as the depiction of 'reality in its revolutionary development'. Stalin did not speak at the conference but insisted that the depiction should also include 'cultures, national in form and Socialist in content', thereby affording recognition of the many cultures to be found within the republics of the Soviet Union. Among those who participated in the Congress and welcomed Socialist Realism were Pasternak, Babel, Malraux, Aragon, Toller, and Gorky whose speech outlined the ideology and demanded the creation of realistic works attuned to revolutionary Russia. The only artist who spoke (and who fully supported Socialist Realism) was Igor Emmanuilovich Grabar who has already been mentioned as a painter in the Impressionist style, a former member of the *peredvizhniki*, much respected as a private and public figure. Far from being a doctrine imposed on the country there is ample proof that Socialist Realism originated among the older intelligentsia with socialist sympathies and

that it was a natural and logical evolution of the proletarian articles of faith.

Zhdanov called for 'reality' to be depicted 'in its revolutionary development', and it was to be combined 'with the task of the ideological transformation and education of the working people in the spirit of Socialism'. The artist is 'an engineer of human souls'. Standing, as it does, with its feet on the firm base of materialism, Socialist Realism must embrace a new kind of romanticism, 'a revolutionary romanticism'. In his last words he emphasized that Soviet literature must 'be able to show our heroes, must be able to catch a glimpse of our tomorrow. This will not be a utopia, because our tomorrow is being prepared today by our systematic and conscious work....' Gorky claimed that labour should be the true hero of literature – man organized by the processes of labour but who in turn, 'armed with all the might of modern technology', is transforming labour, making it easier, making it more productive, and raising it to the level of artistic creation.

If the definitions of Socialist Realism given at the conference seem less than precise they were, nevertheless, potent yet capable of varied interpretations by the authorities. It remains the style adopted by (or forced upon, as critics would say) one of the world's greatest powers and most of the countries linked with it for either political, social or security reasons. Without any attempt at understanding its validity as an aesthetic basis for artistic creation there has been an aggressive and unqualified condemnation of Socialist Realism. But at least one of its aspects, the claim that the artist should be a representative servant of the society to which he belongs, was unquestionably accepted in Europe until the late eighteenth century and even later – and not, it might be argued, to the detriment of art, artists or society. The belief in the autonomy of the creator, romantic in its origin, has held sway in European culture for some two hundred years; but it is denied by thousands of artists, not only in the Soviet Union, who would claim to be creatively inspired by an ideology which optimistically envisages the elevation of the masses by a culture born of the desires, the conditions of life and labour, and the political and social faith of those masses. The resulting artistic products must, therefore, be readily acceptable to a classless society such as that of the USSR, and must be distinct from 'the anarchic, irresponsible, individualistic, formalist, and decadent culture of civilizations which are alien and hostile'. The

artistic creations of Socialist Realism, realist in form, inspired by socialist beliefs and nationalist in subject, are intended to exalt the working peoples and their countries, their leaders, their revolutionary struggles, their victories, their achievements and their optimistic faith in the man-made future. Socialist Realism did not, it is important to note, put forward any particular style as being absolutely and imperatively appropriate; and it is as opposed to pessimistic naturalism as to conventional bourgeois art. The subject of the painting dictates its style. Craftsmanship is highly prized. There existed opportunities within the inclusive doctrine of Socialist Realism for individual growth and experiment, as Prokofiev, Shostakovich and Miaskovsky showed within the realm of music; and some few Russian artists, particularly sculptors, gave evidence of the inspiration and strength it brought to their work. But too many artists concentrated on proletarian subjects (or portraits of the revolutionary leaders, especially Stalin) while eschewing a revolutionary style, and compromised their talents by the production of work of a safe but worthless mediocrity. This has led to the ridiculing of Socialist Realism, not without reason, for its seeming adherence to the standards of nineteenth-century academic art, for its easy optimism, and for its facile pictorialism and failure to attain ideals to which it lays claim. Many fine artists, including Léger, Diego Rivera, Orozco, Siqueiros, Guttuso, Ben Shahn and Picasso, have served the cause of humanity and the ideals of socialism by persisting in their own idiosyncratic endeavours no less than those who have, unthinkingly, trodden conventional paths through what they have claimed as Socialist Realism.[4]

It is possible to assert that the more inhibiting features of Socialist Realism were associated with the rise to power of Zhdanov, who became leader of the Communist Party in Leningrad after the assassination of Sergei Kirov.[5] He made himself responsible for imposing an iron control on all artistic expression. In particular, three concepts were used by him to dominate all artistic expression: *partiinost, ideinost*, and *narodnost*. This meant that all creative work had to have a party character, a socialist content and national roots. In reality, in the years following 1934 it was the party character which became the sole criterion of a work's suitability for publication, performance or exhibition.

While there is no need to defend Socialist Realism since it is a perfectly valid ideology, it is not easy to excuse many of the artistic crimes committed in its

name: mediocrity, triviality, obsequiousness and academic respectability became the order of the day. Stalin's taste, utterly unpredictable and wildly baroque, resulted in the creation of an architectural style peculiar to Russia and the first native one to be seen in Moscow since the late Middle Ages. Its wedding-cake excesses, as appropriate to the city as the starker skyscrapers are to New York, cast a romantic grandeur over the city's skyline but found no equivalent in most of the painting of the period, although some of that has a not unattractive brassy flashiness. It is useful to quote from a Soviet history of this period:

> Progress could have been still more significant if the rapid cultural advance had not been impeded by the Stalinist cult, which arose in the 1930s. Unpardonable errors were made at that time, which had an ill effect on cultural life. The work of many prominent Party officials in science and culture was belittled, in order to magnify the status of Stalin. Many men and women dedicated to the Soviet system were classified as 'enemies of the people' and fell victim to repression. Books mentioned disapprovingly by Stalin disappeared from the shelves of libraries, and the valuable works of some scientists were banned ... the Stalin cult did untold damage to the country's cultural development....[6]

Such was the degree of terror (and, it must be admitted, there were artists, sometimes of considerable integrity, whose patriotism and loyalty to the Communist ideal did not allow them to question the events taking place around them) that there was little opposition from practitioners of the fine arts and no necessity, therefore, to impose controls additional to those of 1932. However, in the spring of 1936, two years after the formation of a Writers' Union, a Committee of Art Affairs was set up under the leadership of P. M. Kerzhentzev to supervise artistic productions, including film, theatre and music. The Committee was intended only as an interim arrangement but lasted until June 1939 when a number of its supervisory functions were taken over by Orgkomitet (Organization Committee of the Artists Union), which, it was intended, would take the steps necessary to set up an Artists' Union. The thirty-eight people who served on the Orgkomitet actually established a union, although the conditions of war-time Russia prevented it from having a corporate identity and its territory was limited. After a year it succeeded in setting up Artists' Unions in eleven republics (Azerbaidzhan, Armenia, Belorussia, Georgia, Kirghizia,

Kazakhstan, Tadzhikistan, Karelo-Finnland, Turkmenistan, Uzbekistan and the Ukraine), as well as fifty-three regional groups in other areas which included the Artists' Unions of Moscow and Leningrad. Between 1939 and 1959 there were eighteen full meetings of the Orgkomitet without the formal integration of the unions in any one central body. Control had been relaxed during the war years when patriotism reached new heights and Stalin was exceedingly popular as the national leader. After the ending of hostilities in 1945 the Communist Party once more set about bringing creative artists to heel, again through Zhdanov, now Secretary to the Party's Central Committee and Chief of the Propaganda Administration.

Zhdanov was to give his name to the so-called Zhdanov era lasting from 1946 until 1953, although he himself died in 1948. During this period a degree of fear was felt once again, hard-line party orthodoxy was the rule, and the Soviet arts seemed to be at their most sterile. A secondary order of control was established by the Academy of Arts of the USSR set up in 1947, with Aleksandr Gerasimov imposed as President. It must be said that the tendency to the unification of artistic groups, perhaps a specifically Russian tendency, had already revealed itself before 1932. In 1929 there had been Vsekokhudozhnik (All-Russian Cooperative of Artists); in 1931 came RAPKh (Russian Association of Proletarian Artists); and in 1939 FOSKh (Federation of the Association of Soviet Workers in the Spatial Arts), which managed to unite many groups and to issue its own journal *Brigada khudozhnikov* (*Artists' Brigade*); but these groupings had not seen themselves as agencies of the political establishment or obedient to any one ideology as was to be the case with the projected Artists' Union.

In the conditions that have been outlined it would be futile to expect painting of any quality; and from the thirties onwards there was an increasing poverty of work although an academic standard of technical efficiency was usually maintained, at least by the senior artists. As we have seen the new revolutionary state had inherited various groups of painters, notably the *peredvizhniki* who hardly found it necessary to modify their styles or their aims (or, for that matter, their subjects, since in Socialist Realism they found the logical development of their own *narodnost* tendencies). Other groups consisted of those painters associated with Mir iskusstva who either emigrated in the twenties or went into theatrical or decorative work, those who had belonged to

the advanced groups of the pre-revolutionary years such as the Blue Rose or the Jack of Diamonds, and a number of academic artists. In time these were to become the teachers of the first generation of Soviet painters whose acquaintance with the past was limited by the increasing censorship of books from ..., by the non-exhibition of the superb collections of modern French art held by the museums (having been taken over from the large private collections), and by the lack of any opportunities during the thirties for the more adventurous to exhibit their work.

Those artists who in their proletarian art showed themselves true but unrecognized or rejected children of the revolution have been mentioned previously; and it is to the main body of painters who were in some measure to declare allegiance to Socialist Realism (whether in embryo or in existence) between the approximate dates of 1920 and 1950 who must now be discussed. Among the most enthusiastic were the older members of the *peredvizhniki*. Their ranks included Kasatkin (1859–1930), noted for his scenes of miners and other workers, who had been ousted from his teaching post at the Academy by the Futurists; Abram Efimovich Arkhipov (1862–1930), a former student of Perov, Polenov and Makovsky at the Moscow School, who made his name with genre scenes such as *The Laundresses* (1899–1900), painted in dark colours and a sweeping technique; and Sergei Vasilievich Malyutin (1859–1937), a portraitist and genre painter. Konstantin Fedorovich Yuon started an art school together with I. O. Dudin (1867–1924), and became a popular figure, partly because of his reputation as a teacher and art critic, and partly because he was a prolific exhibitor of genre scenes, portraits and landscapes in which the colourful crowds of pre-revolutionary Russia were replaced with the ranks of the army parading through Red Square. These artists, together with Aleksandr Vladimirovich Grigoriev (1891–1961), Pavel Aleksandrovich Radimov (1887–1967) and Evgeny Aleksandrovich Katsman (1890–1976) founded an organization initially entitled Association of Artists studying Revolutionary Life in 1922. It quickly changed its name to Society of Artists of Revolutionary Russia and almost immediately to AKhRR (Association of Artists of Revolutionary Russia). In 1928 it underwent yet another change of name to AKhR (Association of Artists of the Revolution), and issued its own journal *Iskusstvo v massy* (*Art for the Masses*) from 1929. Like all other groups it

was dissolved in 1932. At one time it had a youth section called OMAKhR (Association of AKhR Youth); and was linked with other artistic agencies. It could be claimed that AKhRR shared many of the aims of OST and similar groups, concentrating as it did on the lives of the proletariat, the peasantry, urban dwellers, soldiers and other members of the revolutionary state: its aims were essentially proletarian:

> Our civic duty before mankind is to set down artistically and documentarily, the revolutionary impulse of this great moment of history. We will depict the present day: the life of the Red Army, the workers, the peasants, the revolutionaries, and the heroes of labour.[7]

AKhRR was to become the largest and most powerful artistic organization of the 1920s. It was violently opposed to the Futurists and Leftists, refusing to countenance any other artistic style than that created by the *peredvizhniki* – that is, nineteenth-century academic realism slightly modified to correlate with the proletarian themes its members adopted as subject-matter. As its declaration stated in 1922, they acknowledged 'continuity in art' and based their work on 'the contemporary world view'. Inevitably, too, these artists generally thought of Moscow as their home and repudiated Leningrad as tainted by Tsardom and reactionary conservative forces.

What AKhRR needed most urgently was a painter of the stature of Repin, who remained a Soviet citizen despite retirement to his home in Finland from where he made encouraging but not particularly committed noises. Although he had comparatively little of Repin's astounding ability, it seemed that Isaak Izrailevich Brodsky (1884–1939) might well be his stand-in as far as academic prestige and respectability were concerned. After study at Odessa he went to the Imperial Academy of Arts where he worked under Repin. Between 1909 and 1911, as a pensioner of the Academy, he travelled throughout Europe. He first exhibited with the Mir iskusstva and then with the *peredvizhniki* and was a member of the Union of Russian Artists. He swung away from his initial essays in the Art Nouveau manner to a detemined realism. After the further organization of the Academy of Arts in 1932 he was to be appointed rector. His mature style remained obstinately dull, basically that of the early *peredvizhniki* as can be seen from the much-reproduced *Lenin in the Smolny Institute* (1930), which is sometimes

adduced as an example of Socialist Realism in action although it actually predates the official adoption of that ideology. Brodsky frequently worked from photographs, which did not enhance the quality of his characterizations. A modest man of wide sympathies, Brodsky was a painter of little pictorial inventiveness – even his detailed landscapes seem to derive from the Dutch masters – but considerable technical proficiency whose example was instrumental in swaying conservative artists to join forces with the Communist Party. After his death his home in Arts Square, Leningrad, was turned into a small museum of his paintings.

A typical member of AKhRR was Evgeny Katsman (1896–1976), an extremely competent, academic painter who found no difficulty in represent-

ing workers of all kinds engaged in the great work of building the new Soviet state and who could also produce still lifes of considerably delicacy. It was this academic stress, this technical proficiency and not entirely its 'heroic realism' which distinguished AKhRR from the equally determinedly proletarian OST in addition, of course, to the more cosmopolitan tendencies of the latter movement.

What OST lacked was a steely leadership; and this AKhRR certainly had. A notable personality was Aleksandr Mikhailovich Gerasimov (1881–1963), who moved easily from 'heroic realism' to Socialist Realism and to whom the world is indebted for *Stalin at the XVIth Congress of the Communist Party* and *Stalin and Voroshilov in the Grounds of the Kremlin* (1938) and other hagiographical items of a sketchy verisimilitude generally resembling highly coloured oleographs. That he was not without ability is proved by his portraits and still lifes. A. M. Gerasimov was president of the Academy of Arts of the USSR from 1947 to 1957; and also

130. Boris Vladimirovich Ioganson (Johanson): *Interrogation of the Communists*, 1933. Oil on canvas, 211 × 279 cm. Moscow, Tretyakov Gallery

dominated the USSR Union of Artists, showing an implacable hostility towards the slightest signs of advanced art and meriting the epithets of 'sinister' and 'evil' which were showered upon him by Western critics and the more courageous of his countrymen. He was succeeded as president of the Academy by Boris Vladimirovich Ioganson (Johanson) (1893–1973) who studied under P. Kelin and at the Moscow School under Kasatkin and Malyutin. He was a member of Obmokhu (Society of Young Artists), where he argued for a completely utilitarian (Constructivist) art. He rapidly abandoned this cause and took up easel painting. In 1922 he helped to found AKhRR; and like so many of its members found it an easy transition to Socialist Realism. He was fundamentally a narrative painter who developed the style initiated by Repin – that is, basically realistic in its concentration on significant visual details but making use of certain features of Impressionism, particularly lively brushwork. His *Interrogation of the Communists* (Plate 130) is thoroughly representative of the romantic aspects of Socialist Realism: it presents a dramatic scene which gives full play to the rich colours afforded by the oriental carpet, the gilt chairs, the smoke fumes, the uniforms of the examining White Officers, and the rough furs and homespun clothing of the Communist prisoners. In the flamboyant grouping of the principal figures there is not only an effective exaggeration but also an exploitation of some of the devices of Futurism. And it must be remembered that Ioganson had also studied under Korovin and spent three years in the provinces (1919–22) designing scenery for theatres: a sense of the theatrical touches his presentation. By the time of his death in 1973 he had come to seem a lone survivor from another era of whose existence few members of Soviet society cared to be reminded.

Ioganson and Gerasimov trained a number of artists, including Anatoly P. Levitan (b.1922) and Yury S. Podlyasky (b.1924), both of them painters of landscapes and of scenes of agricultural life. Among Brodsky's pupils was Vladimir Aleksandrovich Serov (1910–1968), who was at the Academy of Arts from 1927 to 1934 where he learned a flashy, poster-like style. Serov painted numerous historical pictures showing revolutionary and Communist Party leaders, of which a typical example is *Delegates from the Villages visiting Lenin* (1950), and also crude icons of Lenin haranguing the masses, usually painted in atrociously glaring colours. These works, widely reproduced, resulted

in his being recognized as a leader of Socialist Realist art but without in any way adding to its prestige. They actually contributed to his downfall after the death of Stalin, when he was accused of having been one of the artists principally involved in the 'personality cult'. Thus had the revolutionary ideals of AKhRR declined into mere time-serving.

It is clear that of all the artistic groupings of the 1920s it was AKhRR which found it easiest to adapt to the conditions of the thirties and to embrace Socialist Realism which it had, as has been indicated, largely anticipated. However, it failed dramatically to fuse academicism and revolutionary ideals and subject-matter into art of any lasting merit (as Petrov-Vodkin had done in his idiosyncratic way); and it lacked the immense talents of Deineka, Tyshler and Labas who had brought pictorial innovations and originality to OST during its all-too-brief years of existence. Too often AKhRR seemed to be thinking in terms of the *peredvizhniki* or the history painting of earlier centuries re-dressed in revolutionary or national terms, whereas OST evolved a genuine conception of a utopian, socialist life that was coming into existence as the result of hard labour and creative strife. The AKhRR artists gained the ascendancy and held power during the years when the doctrine of Socialist Realism was most rigorously upheld but they failed to contribute to the artistic progress of the homeland they so raucously applauded.

The artists who suffered most and whose treatment is one of the ugliest blots on Stalin's domination of Soviet life after 1932 were those who had belonged to the avant-garde in the first two decades of the century and who were unwilling to modify their styles to any noticeable extent in the post-revolutionary years. These painters had made their names with the Jack of Diamonds, the Donkey's Tail or the Blue Rose; and while their art did not undergo any deep transformations they themselves widened their range of perception and skill. Despite their inoffensiveness they were the subject of abusive persecution until after the death of Stalin when a few of them, restored to favour, became increasingly successful in both the financial and public sense.

Before 1914 Aleksandr Shevchenko contributed large numbers of works to all the important exhibitions, being especially interested in combining primitive art forms with aspects of Cubism.[8] The group Colour Dynamics and Tectonic Primitivism which he had helped to establish held an exhibition in Moscow in 1919 to celebrate the three principles

of structure, 'knowledge of the laws of colour, and knowledge of the material with which we operate in creating the easel painting'. His interest in colour, icons, *lubki* and Byzantine art has been largely unrecognized. The width of his artistic researches was further demonstrated by his association in 1919–20 with a short-lived group known as Zhivskulptarkh (Commission for Painting-Sculpture-Architecture Synthesis) to which Rodchenko and the architect Nikolai Aleksandrovich Ladovsky (1881–1941) also belonged. During the 1930s persuasive attention by the Stalinist ideologists drew him from 'the deserts of formalism' into the straight and narrow paths of realism – which is to say he adopted a simple, almost monumental, neo-classical style in which to depict scenes of Ukrainian life, often of fishergirls or other workers. He managed to retain the curves, flowing lines and contrasting angularities, reminiscent in part of icon paintings. There are similarities with Kuznetsov's isolated and simplified figures and, perhaps, with the neo-classicism evident in Picasso's monumental figures and Stravinksy's symphonic music of the twenties. Shevchenko's relations with Tatlin have not yet been investigated; and it is not unlikely that it was Tatlin who gained the most and whose early style owes the largest debt.

Petr Konchalovsky was rebuked in the 1930s for his lack of identification with Socialist Realism, but this did not deflect him from the colourful, rumbustious and painterly style he had created for himself in which strong outlines, a baroque forcefulness, a Rubenesque abundance, and emphatic form took vital parts. Konchalovsky was friendly with the leaders of his country's cultural life (he painted Prokofiev in 1934) but also maintained links with Picasso and other Western artists (Col. Plate 15). If the use of rich colours, an interest in form derived from Cézanne (but hardly measuring up to the French master's exacting analysis), heavy modelling and interest in ordinary domestic life (although admittedly of a comfortable bourgeois kind), and the realistic depiction of recognizable objects can be admitted to be basically optimistic, it is hard to see why criticisms of 'morbidity' were ever levelled against Konchalovsky. Still less so, with painters like G. M. Shegal (1889–1956), A. Fonvizen (1889–1973), and A. A. Osmerkin (1892–1955) who passed through stages of Cubism and Cézannism to a style not unlike that of Konchalovsky although much more sensitive as in his *Portrait of Anna Akhmatova, White Night, Leningrad* (1939–40),

and *My friend the Artist N. A. Udaltsova* (1948) which shows the weary but indomitable artist sitting, brush in hand, in a corner of her studio.[9] It is impossible to see how their portraits, landscapes and still-life pictures could ever have offended.[10] Pavel Kuznetsov perhaps fared even worse. Between 1919 and 1924 he directed the IZO *Narkompros* and in 1923 was sent by Lunacharsky to establish cultural links in France, particularly with artists in Paris. He then fell increasingly into disfavour despite sincere efforts to invest his scenes of the spacious and untroubled life of the steppes with anecdotal material which might seem relevant to the calls of Socialist Realism.

Robert Falk, a favourite of the intelligentsia, tried to play safe by concentrating on still life. Even in the latter years of his life one of the principal officials of the Artists' Union said that they were trying to bring Falk to his knees, adding that 'Falk doesn't understand words; we shall hit his pocket', little realizing that with a single shirt to his back he was indifferent to all material things. After 1943 he was commissioned to create designs for a small number of theatrical productions and shortly before his death he was granted a small and carefully vetted exhibition in the old premises of the Moscow Union of Painters, the first for almost twenty years. He was spared the insulting remarks on his painting which Khrushchev is said to have made during his commentary on the Manège (Riding School) exhibition of 1962 in Moscow. Crowds wept at Falk's funeral; and not without reason, for an artist of sensitivity and integrity had passed out of Russian cultural life.

A few artists somehow retained official popularity despite occasional criticism of an ideological variety. Such an artist was Ilya Mashkov who commanded high prices for his still lifes in which a careful regard for colour and tactile values is evident. Between 1918 and 1920 he taught at the Vkhutemas and Vkhutein and in 1924 he joined AKhRR. There is little evidence that he progressed beyond his pre-revolutionary style which was always representational but distinctive both in modelling and colouring; and his later work was undeniably monotonous. An interesting but sad case of an artist who tried to adapt himself to the new climate was Sergei Vasilievich Gerasimov (1885–1964), who trained at the Stroganov and Moscow Schools from 1901 under Korovin, Sergei Ivanov and Serov. His first works, shown at the Mir iskusstva, were landscapes of a melancholy nature, a little indebted to Corot.

During the revolutionary period he worked in IZO and the parent body Narkompros, and also joined the staff of the Artistic Theatrical Studios where he helped to plan the mass festivals held in celebration of the revolution. He belonged to the Makovets group between 1922 and 1925, and was a prominent member of AKhRR from 1928. He held important teaching posts in Moscow up to his death. He specialized in exquisite watercolours of landscapes tinged with a twilight romanticism and a sadness which seemed delicately personal. Criticism of his alleged pessimism, an eagerness to demonstrate his support of the Soviets, and a stubborn quest for prestige led him to paint massive canvases such as *The Oath of the Siberian Partisans* (1933) and *For the Power of the Soviets* (1957), whose pretentiousness has proved an embarrassment even to the most fervent supporters of Socialist Realism. During the war years when he was evacuated to Samarkand he had resumed his landscapes in watercolour, seeming to gain in colour and freedom of approach; and he continued to illustrate the Russian classics, work which he found congenial and which brought out his impish humour. As he lay dying in hospital just outside Moscow he painted his last watercolours of the scenery outside his windows. For much of his life Gerasimov laboured under the depressing belief that he had failed as an artist; and certainly once the first official raptures had ended there was little love lost on his monstrous propaganda machines which were so sad a perversion of his true talents.

Among the older artists there were some who managed to placate the authorities and transform themselves into ideologically acceptable members of Stalinist society by less dramatic changes than that of Sergei Gerasimov. One of the most interesting cases was that of Mikhail Nesterov whose rapt novices, dedicated young students, and child saints posed against the rivers, rolling plains, and birch and larch forests of Russia gave way to scenes of contemporary life and portraits of leading scientists and members of the intelligentsia painted with strength and vivacity in a near-Impressionist style. His study of the surgeon S. Yudin (1933), painted in cool whites, greys and blues, is typical of this new manner – despite which he received occasional criticism that he had not changed his art to meet the needs of the new socialist society. Nesterov seems to have shrugged these words aside and continued along his chosen course, preserving his personal and artistic integrity.

A more surprising change was effected by the Mir iskusstva painters. Evgeny Lanceray moved from evocations of St Petersburg in the days of Peter the Great to decorations for the new state buildings and underground stations, also working as an illustrator and theatrical designer. Igor Grabar, a student under Chistyakov and Repin and Ažbe (at Munich, where he was also a teacher), confined himself to pleasing landscapes and still lifes in the Impressionist manner. He was a man of many parts, having trained as a lawyer, been a director of the Tretyakov Gallery, edited the official history of Russian art, and written lively art criticism. Grabar's career is an interesting example of survival in the face of official hostility without any ostensible sacrifice of personal principles. He opposed the Futurists who wanted to destroy the art of the past, as did many of the Constructivists; he defied the Soviets by returning confiscated pictures to their aristocratic or bourgeois owners; he supported the doctrine of Socialist Realism (and spoke at the 1932 conference); and he defied the Communist Party whose ideologists found his work lacking in *partiinost*; and yet always acted without malice or self-interest. Grabar's career and his expertise in self-preservation were by no means unique – and his personal and artistic integrity was shared by other courageous individuals.

On the other hand, some avant-garde artists of the early revolutionary years were actually persecuted, not surprisingly perhaps because the intolerant arrogance they had shown during their control of the official artistic agencies had not endeared them to other artists. In the difficult years of the thirties they had few friends. They found it hard to accommodate to the insistent but nebulous demands of the Stalinist experts on Socialist Realism but a few contrived to work along private paths. Most of them gave up the advanced styles they had previously utilized – although it could be maintained that this was equally true of painters in the West at that time. Life was hard for painters such as Udaltsova, Lentulov, Kuprin, Lebedev, Altman and Aleksandr Davidovich Drevin (1889–1938). Drevin (who was married to Udaltsova) went to art school in Riga and first came to Moscow in 1914. For a while he was under the tutelage of Petrov-Vodkin. Between 1920 and 1921 he was a member of Inkhuk but left, together with Kandinsky, Klyun and Udaltsova, because of the Constructivist-Productivists' rejection of easel painting. He was a professor of painting in Vkhutein and, in 1922, sent work to the First Russian Art Exhibition at the Van Diemen

gallery in Berlin. He spent much time in Kazakhstan and Armenia. There was nothing political about Drevin's painting which, stark and abrupt, was almost entirely lacking in narrative content – a brutal primitivism seems to have been his purpose, a painterly style at once less decorative and possibly more deeply engaged than that of Vlaminck with whom he has some affinities. Typical works such as *Landscape with Two Figures* (1930) and *Garage on the Steppes* (1932) illustrate his manner of working into wet paint, his avoidance of any kind of illusionism and his exceptionally painterly style. He died in forced exile in the Altai region.

Udaltsova's work moved in sympathy with her husband's style from Cubism to an extreme simplicity; and like him she painted scenes of rural life in all its drabness and poverty (Plate 131). She continued to paint to the end of her life, the last survivor of the remarkable group of women artists who enriched artistic life during the revolutionary years. Since she destroyed much of her early work after her husband's arrest it is difficult to assess her total achievement.

Gustav Klucis, a co-founder of the October group in 1928 and a contributor to its exhibition in 1930, had stated that revolution demands from art forms that are absolutely new, forms that have not existed before; he tried in the thirties to move into the less politically exposed area of landscape, but the austere watercolours he produced in this period did not save him: arrested in 1938 he ended his days in a labour camp. Lentulov was described as incapable

131. Nadezhda Andreevna Udaltsova: *Erevan*, 1933. Oil on canvas, 39.5 × 52.5 cm. Private Collection

of drawing a matchbox and Tyshler, Fonvizen and Shterenberg were denounced as 'daubers with evil intentions'.[11] Many of these artists went into the theatre as designers, believing that they were thus avoiding work which could have exposed them to attack on ideological grounds. It is true that there had always been an emphasis on theatrical design, a recognition of the importance of the theatre which is comparatively unknown in the West, but an extraordinary number of artists sought safety in the theatre during these troubled years. Indeed, from 1933, Tyshler produced magnificent designs for a number of plays by Shakespeare, most notably *Richard III* and *King Lear* (Gordon Craig was overwhelmed by this production of *King Lear*), in which his style took on a sinister, serpentine quality akin to the darkness of Shakespeare's evil world.

Pavel Filonov, as we have seen earlier, continued to work along his own individual lines. In 1925 he established his own group, Collective of Masters of Analytical Art, which represented a logical development of his teaching at the Academy of Arts in Petrograd from 1923; and his association with Inkhuk had allowed him to develop his so-called 'Ideology of Analytical Art and Principle of Madeness' partly formulated in the immediate pre-revolutionary years. While Filonov laid stress on the nature of the painting as an object, he equally emphasized the human, intuitive and personal elements which went into its creation. In 1931–3 thirteen members of the group, under Filonov's guidance, made illustrations for a new edition of *Kalevala* which in style and subject-matter showed his influence. This was to be the last effort of the group. In 1930 there was to have been an exhibition of Filonov's work at the Russian Museum in Leningrad but pressure from AKhRR forced its cancellation although the catalogue had already been printed. In 1933, however, he showed seventy-two works in the vast exhibition Fifteen Years of Art in the RSFSR, after which he was not allowed to exhibit until 1941, the year in which he died of pneumonia during the German siege of Leningrad. His sister Evdokiia preserved his pictures, later donating them to the Russian Museum. Filonov's aesthetics have been much studied; the quality of his canvases rather less so. He was certainly a distinctive and scrupulous artist; and yet there seems an inconsistency between his insistence on the importance of intuition and the mosaic-like character of his canvases with their pictorial elements drawn from Expressionism and Surrealism which implied the most

careful working-out and gathering together of ideas and content with no place for the contingent.

This record of persecution and oppression, tragic as it is, does not quite explain the changes within the field of painting from the mid-twenties onwards. Often artists were too involved in their internecine squabblings to grasp what was actually happening in the world around them or to band together in self-defence. It has been perceptively remarked that

> under the pressure of these various antagonisms, some members of the avant-garde began to suffer a serious loss of confidence in their own methods and goals. Once the initial period of enthusiasm and activity – particularly the years 1913–1924 – had passed without favourable response, many of them found it difficult (not surprisingly) to sustain the same degree of conviction that had characterized their original efforts and formulations. Far from advertising the art of their early years, some of them turned away from it: they transformed their styles....[12]

Thus, by 1932, among the older artists there had come a vacuum of exhaustion and a vacancy of direction which the ideology of Socialist Realism seemed to fill. Zhdanov had stated that artists should not depict life with 'objective reality' but in its 'revolutionary development' (that is, in its capacity to change, transform itself, and evolve); and although he indicated there must be a break with 'the old-style romanticism that depicted a non-existent life with non-existent heroes', he admitted 'a new kind, a revolutionary romanticism'. This allowed artists very considerable latitude. And however unpalatable the idea may be to Western critics of Soviet society – and of the political system – Socialist Realism did not represent a break with the central Russian artistic tradition. As has been noted, the *peredvizhniki* had behind them a body of aesthetic-philosophical doctrine devised and enunciated by Chernyshevsky, Belinksy, Stasov and others, doctrines which emphasized both realism in presentation and materialism in choice of subject and overall attitude. No other school of painting in Europe was so strongly fortified by a doctrine which was widely held with such conviction. In this sense, the brief years of abstraction, of Malevich's Suprematism and Tatlin's Constructivism, however important in the history of art, might be seen as an irrelevancy to the central realistic tradition of Russian painting. The painters of the twenties – of AKhRR and of OST – returned to this road, albeit in their individual ways. The continuity of teaching, the maintenance of academic values, and the respect paid to artist-professors reinforced the transmission of traditional values, again a uniquely Russian phenomenon. The fact that art and literature – and, in so far as is possible, music – shared the concept of Socialist Realism shows the cohesiveness of the intelligentsia in facing a new problem. The alleged roots of Socialist Realism in the past were emphasized by reference to early Italian painting: the painting techniques and compositional devices of Masaccio and Raphael, and of Michelangelo and the Carracci among others, are evident in the pictures of Socialist Realist artists – perhaps anticipated by Malevich in the early thirties. All these factors contributed to the buoyant, confident nature of their work. And thus, too, the tenets of Socialist Realism did not seem a monstrous imposition to the younger Russian painters but, instead, an inevitable development.

These younger artists included Petr Kotov (1889–1953), Aleksandr Laktionov (1910–72) and Serafima Vasilievna Riangina (1891–1955); but the painter who more than any other is associated with scenes of sunlit life on collective farms was Arkady Aleksandrovich Plastov (1893–1972), who had studied at the Stroganov Institute and at the Moscow School from 1914 to 1917, where he was taught by Mashkov. His career was entirely in the Soviet era; he devoted his unquestionable abilities to the glorification of the Soviet peasant and farmworker in whose staunchness, spiritual gentleness, diligence and patriotism he saw the true and enduring qualities of Russian life. His great paintings were calls to action, icons of socialism. In *Collective Farm Threshing* (Plate 132), he saw the working-man as having the capacity to change the world around him, not by slavery to machines, but by the exercise of his will as the purposeful citizen of a new and progressive state. Plastov's work, which seems as in, for instance, *The Tractor Driver's Supper* (1951), to be the epitome of the Socialist Realist style, has a confidence which carries it beyond vulgarity; like the work of his contemporaries it displays a liveliness of invention, a sureness of technique, a flamboyant, baroque quality which matches the wedding-cake splendours of Russian architecture of that period and which merits more than the jeers it has received in the West or the senseless attacks made on it by latter-day critics in the Soviet Union itself. The very size of these paintings, many of them intended for public buildings, tends to impress.

132. Arkady Aleksandrovich Plastov: *Collective Farm Threshing*, 1949. Oil on canvas, 200 × 382 cm. Kiev, A. M. Gorki Museum of Art

Among other artists who specialized in depicting the new Soviet man and woman were the admirable Aleksandr Samokhvalov (1894–1971), a pupil of Petrov-Vodkin and a member of the October group, and Fedor Antonov (b.1904), creators in paint of the Soviet citizen. Tolerance was extended to naïve artists whose work was fairly popular during these years, especially if there were associations with the various republics to which the central authority was sensitive.

The general picture during the thirties and forties is of limited success by a number of Socialist Realist painters and – as far as the intelligentsia was concerned – of physical and mental anguish; and the odds against artistic triumphs were heavy, although, as has been said, masterpieces of music and literature were produced. The greatest tragedy – the bitterest irony – is that during these years when punishment and persecution were stronger than encouragement and aid the Soviet Union possessed more artists of true distinction than any other country in the world and could have equalled the vitality and achievement of the first decades of the century and perhaps even surpassed them.

15
The Thaw; Freedom within the Tenets of Socialist Realism; Dissidence among Painters

Stalin's associates realized that sooner or later Germany would attack the Soviet Union but when all attempts to secure an agreement with the Western powers had failed they bought time by signing a Soviet-German Non-Aggression Pact on 19 August 1939. On 1 September Germany attacked Poland and quickly forced its defeat. Russia stepped in to recover lands annexed by Poland in 1920, to safeguard the fate of some seven million Ukrainians and three million Belorussians. In effect, it retook territory up to the demarcation line, the Curzon Line, agreed by the Allies after the 1914–18 war; and thus established securer frontiers. Estonia, Latvia and Lithuania were taken into the Soviet Union, as were Bessarabia and North Bukovina. Since the Finnish frontier passed within twenty-five miles of Leningrad the Soviet government proposed a revision of the frontier area to the mutual advantage of both countries. This was rejected by the Finnish government; a number of provocations took place; Soviet troops crossed the frontier and hostilities began and carried on until early March 1940 when the Finns sued for peace. The Soviet Union offered less generous terms than it had originally done but did not occupy Finland – as it possibly should have done in the light of later events.

During 1940 the Germans overran the greater part of Europe. On 22 June 1941 they attacked the Soviet Union inflicting dreadful wounds on towns and cities, industry and the countryside. There was no doubt that Stalin had not fully grasped German intentions, had ignored warnings from Russian agents overseas, and had weakened his military potential by the indiscriminatory and bloody nature of his pre-war purges. Economically, however, the country was in a stronger state than it had been for many years and the national spirit was high. Even those nationalist groups in the Ukraine and elsewhere that saw in Hitler's invasion a means of

attaining a form of independence were alienated by the deliberate brutalities of the German military forces whose barbarities exceeded by far those of Stalin at his worst. The Russian people saw only too well that the Germans had but one aim – the extermination of the Slav peoples and the total destruction of Slav culture. They saw too, rightly or wrongly, that they had been abandoned to their fate by the rest of Europe. An expert on Soviet history has summarized the position:

> ... on June 22nd, 1941, the Red Army was attacked on a front of 1,900 miles by 170 picked divisions, which not only had enormous bases of munitions and other supplies but also had battle experience in victorious campaigns against many other European armies. Moreover, the armies of Finland, Hungary, Rumania and Italy were under German command at the Soviet Front. The slave labour and industrial resources of 250 million inhabitants of occupied Europe were still at the disposal of the invader.[1]

Against these tremendous odds the Soviet Union triumphed in 1945 but with millions of Russians dead, industry destroyed, towns in ruins, agriculture at a standstill, mines flooded, and with only the vestiges of roads, railways and canals in formerly occupied territories. More than that, dismayed at the turn of events which had brought a victorious Communist state into the very heart of Europe, the Western powers began almost at once a policy of strengthening Germany and suppressing Communism, even using Nazi mass murderers to help them in their task. The intention was to restore the situation as far as possible to that of 1939 when Communism, not Nazism, was seen as the main enemy.

The main task for the Soviet Union became the restoration of its economic strength and military potential in the new situation created by the use of atomic bombs on Hiroshima and Nagasaki by the

Americans. Over 20 million Soviet citizens had died during the war years with immense consequences for industry and the service industries because of the resultant loss of manpower. There was no relaxation. Having been mistaken once Stalin, whose obsession with power seemed to grow daily, was not going to be caught unprepared again. Creative artists and thinkers who strayed from the prescribed ideological road were bullied and bossed into conformity. Scientists, on the other hand, became the darlings of the state and were almost a law unto themselves, so that a number of exhibitions of advanced or experimental or hitherto neglected areas of painting were held on the premises of scientific institutions. No matter how much Zhdanov blustered, artists were no longer in fear of their lives as they had been during the purges of the 1930s, although their situation was far from comfortable. During the war years there had been a degree of relaxation, largely because Stalin wished them to use their talents to intensify the nationalist spirit in the defence of the Soviet Union; in the immediate postwar years he could afford to dispense with their service.

The unexpected death of Stalin on 5 March 1953 which left the masses hushed, frightened and silent was the signal for a long-awaited change in the Russian leadership. A number of surprising events followed quickly one upon another. Khrushchev was declared leader, the power held by the secretary of the Communist Party proving the key to his succession to the leadership. In July, the chief of the secret police, Beria, was accused of crimes against the people: he was executed the following December. Next year, in May, the veteran journalist Ilya Ehrenburg, who had often felt the cold winds of Stalinist terror sweep close to him, published his short novel *Ottepel* (*The Thaw*) in the pages of the literary journal *Znamya*, the title of his work becoming symbolic of the 'thaw' in the arts and literature of the post-Stalin years. The *détente*, in spite of oscillations, lasted for almost ten years, until December 1962. During this period there were wild swings in official policy so that every act of liberality was followed by a call for ideological constraint. The comparative relaxation for which Khrushchev could undoubtedly claim credit was due in part to his own fairly easygoing nature (even after years within the highest echelons of the Communist Party), and a strangely pragmatic approach to cultural matters which he may have considered less important than the party ideologists did.

Khrushchev was well aware of the needless persecutions and murderous oppressions of the past; he was also aware, partly through his own family, of the youthful restlessness in Russia; and he knew well that in order to maintain his own supremacy and carry through reforms in social and political life he needed the support of the younger intelligentsia and of the influential artistic worlds. He himself had contacts among them; and in turn they knew that an exchange of opinions was possible, even by those who disagreed with him and did not fear to say so in public. There was no real fear of loss of liberty for expression of belief on artistic matters. Khrushchev's speeches did not contain restrictive demands but rather exhortations that the old Leninist principles should be maintained. He was sharp-witted, jovial, blunt and approachable; and he did not hesitate to make his opinions public. His own writings and speeches on the arts made during the spring and summer of 1957 were published as *For Close Ties between Literature and Art and the Life of the People* and he also published *The High Mission of Literature and Art*, titles which might have come from the works of Chernyshevsky or Stasov. Although it is impressive that a political leader, a leader of a great world state, could find time and energy for a consideration of the cultural problems of his country, one cannot but admit that his ideas were, in general, both conservative and traditional, with little emphasis on individual creation.

Unhappily, Khrushchev was to earn for himself a distinctive and odd notoriety during the latter years of his time in office. The circumstances afford an instructive example of the conditions under which Russian artists were obliged to work – and which, of course, they were frequently obliged to circumvent. On 26–8 November 1962 a three-day conference devoted to Tradition and Innovation in the Art of Socialist Realism was called by the Institute of the Theory and History of Art (in fact, a branch of the Academy of Arts) and the All-Russian Theatrical Association. During the discussion Vladimir Serov, then president of the Academy of Fine Arts, was interrupted by hecklers and there was a general feeling of unrest in the air. On the day the conference began an exhibition of work by Ilya Belyutin and his pupils was held in the artist's studio. In itself this was something remarkable: Belyutin had opened his studio in 1954, in an old building off Arbat Street, Moscow, and had been visited by patrons, some of them party officials, who had a

taste for 'Formalism' and an interest in the progressive teaching carried on there. In the semi-private showing there were about seventy-five abstract or semi-abstract pictures on view, and sculptures by Ernst Neizvestny. Some 150 specially invited guests and party officials attended the exhibition which lasted only a few hours but which had attracted crowds who made vociferous requests for admission. The exhibition was scheduled to move to the Hotel Yunost on 29 November, after the closure of the conference. Shortly before it was due to open there, however, it was visited by officials from the Ministry of Culture who proposed that it should be transferred to the Manège gallery near Red Square. Here an exhibition entitled 'Thirty Years of Moscow Art', consisting of 2,000 paintings and sculptures, had been in progress for a month: its especial significance lay in the fact that some important artists of the thirties, including Drevin, Falk, Shterenberg and Tyshler, were being shown after years of neglect, as well as younger artists of interest such as Andronov, Birger, Nikonov and Weisberg.

On 1 December, on the deliberate invitation of Serov, the then president of the Academy, Khrushchev and his progressive son-in-law Aleksei Adzhubei, editor-in-chief of *Izvestiya*, toured the exhibits. His comments were mild until he came to some of the more expressionist and personal works by Falk and the other artists when his temper began to build up. When he entered the rooms containing works by the Belyutin group he exploded. His reactions (conditioned in advance by Serov) were predictable: he scolded Furtseva, the Minister of Culture, and Leonid Ilichev, Cultural Affairs expert; expressed violent and vulgar opinions on the nature of modern painting; and addressed some young artists in language which while ostensibly paternal in intent was not of a kind to induce filial respect. At once there was a reaction at official level. A press campaign against cultural deviationists was inaugurated and the works of Falk and his contemporaries (several of them dead and far beyond Khrushchev's abuse) were removed – for a couple of days! An important meeting of the leaders of cultural life was held at the Kremlin. The main speeches were made by Ilichev, now chairman of a newly formed 'ideological committee' which had been established by the Party Central Committee. 'Nothing exceptional or extraordinary has happened ...,' it was stated, 'our Party is satisfied with the state of affairs in the sphere of culture....' But, it was stressed, Formalist tendencies had begun to spread. Even so, no action was taken against individual artists. Probably the immediate victory was that of the conservative forces at the Academy of Art but in retrospect the episode seems to have marked the demise of Socialist Realism as an inclusive and rigidly imposed ideological doctrine, although in theory its tenets were still adhered to even if in an increasingly 'interpreted' sense.[2]

This new freedom had come to be accepted with increasing confidence by the cultural leaders of the nation by 14 October 1964 when Khrushchev resigned office. Artists, writers and musicians were treated with a degree of consideration by the party officials and enjoyed a measure of toleration unknown since the early twenties. Ilichev, whose bark had been considerably harsher than his bite, was transferred to the Ministry of Foreign Affairs and his 'ideological committee' dissolved. Madame Furtseva continued in office well able to withstand occasional onslaughts. In general, the plea submitted to Khrushchev by important members of the intelligentsia had been honoured; it read, 'Without the possibility of the existence of different artistic trends, art is doomed.... We appeal to you to stop this return to past methods which are contrary to the whole spirit of our time.'[3]

It may be useful at this stage to consider the organization of the figurative arts in the USSR. When in 1932 all artistic groups were dissolved it was expected that an all-embracing state organization would be set up. In fact this did not happen until 1957 when the Soyuz khudozhnikov SSSR (Union of Artists of the USSR) was established, although since 1936 there had been a special committee overseeing this aspect of the arts. By the end of the 1950s there was a triple control over all artistic activity within the Soviet Union. At the top was the Ministry of Culture (controlled in turn by the Cultural Section of the Communist Party) which had in its charge all the art museums and the State Purchasing Commission as well as other important agencies. Below it was the Academy of Arts of the USSR, which exercised control over the major art institutes and schools and influenced research, museum work, publishing and the activities of the Union of Artists. It has been a major force since its establishment in 1947 but it could be argued that its power has somewhat diminished and that it has never enjoyed the unquestioned prestige of the Academy of Sciences. Next in order of rank was the Union of Artists of the USSR which appeared to carry the responsibility for the implementation of

directives from above for which its inclusiveness and sheer size made it singularly inefficient. It still controls the lives of many artists and plays a central role in all artistic activity.

The education of a Soviet artist follows the usual pattern in that he passes through a primary school between the ages of seven and 15, spends a further three years at a high school, sometimes of a specialized kind, and then goes to an art school where he will stay for five years. Having successfully graduated, he faces the problem of a career. Like art students throughout the world he usually moves into industry as a designer, specializing in advertisement, typographical layout, fashion design, etc. He may be encouraged to move into the theatre where the work of the designer is highly regarded. In very few instances is he able to devote himself entirely to painting. So far his career has not been very dissimilar from that of a student of the fine arts in Western countries. Should he be interested in painting as a leisure activity there are opportunities to exhibit in workers' clubs, youth centres and trade union buildings. By and large, such exhibitions and those of a more professional nature are not intended as commercial ventures but as a means of winning acceptance into the Artists' Union whose rulings he will be obliged to acknowledge before membership is confirmed. There are very real financial and social gains from membership so that most artists are prepared – in public, at any rate – to declare their hostility to abstract art and to 'Formalism' of any kind. Once elected to the Artists' Union a painter is allowed to submit works for exhibition, for which he is paid twenty-five per cent of the selling price in advance. The buyers are the purchasing committees of workers' canteens, offices, clubs, blocks of flats, and members of the public. While the graphic artist can produce signed and numbered editions of lithographs or woodcuts for sale in the art shops, his profitable market lies with the Unions from which he may receive thousands of roubles for an attractive picture. His works may also be selected for sale abroad by the Soviet export agency. There are other advantages, notably those of cheap accommodation in or around the various Houses of Artists, subsidized studios, holidays and rest cures in the countryside or at the coast, pensions, medical attention and financial assistance. The Union is linked to the artistic printing houses and publications and thus is able to award commissions for illustrations or works on art history. There are over ten thousand members of the Union.

In return for the many positive benefits there are drawbacks: the artist has to accept the ideological function of the Union (in furthering the doctrine of Socialist Realism), its juridical function since only by membership has an artist the right to work and exhibit (he may otherwise by accused of parasitism or anti-social behaviour), its economic function since it has within its powers the right to commission art works and confer material benefits, and its controlling function since it holds the major exhibitions, vets submissions, and controls the art press. As in the majority of countries artistic events are promoted or cancelled or discouraged according to the foreign policies of the government in power; and in this sense, as in others, the Union is sometimes impotent. This was demonstrated during the 1960s when the spirit of *rapprochement* was particularly strong. The French works collected before 1917 and held in the vaults of the museums were put on show at the Pushkin and Mayakovsky Museums in Moscow and at the Leningrad Hermitage. In the first three months of 1963 Moscow was able to see 300 works by Fernand Léger; and even earlier in 1957 there had been an exhibition to celebrate Picasso's seventy-fifth birthday.

It would be false to deny the existence within the Union and the Academy (and sometimes within the government itself) of moderate, even progressive elements which cautiously sought to change the prevailing climate. Thus, from the 1960s onwards there have been token showings of former avantgarde painters such as Goncharova, Larionov, Lentulov, Malevich and Tatlin in the rooms in the Tretyakov and Russian Museums devoted to modern painting, although, it must be noted, only of representational work.[4] In 1962 the Hermitage had an exhibition of contemporary Yugoslav paintings with pictures by the popular primitive artist Ivan Generalich. Some Russian artists have enjoyed large-scale retrospectives, among them El Lissitzky (1960), Rodchenko (1962), Tatlin and Malevich (1962), Falk (1965, 1967), Petrov-Vodkin (1966), Chekrygin (1966), Larionov and Goncharova (1965), Labas (1977), Yakulov (1975), Filonov (1967) and Tatlin (1977). Tyshler, considered by many critics to be the last of the great painters, resumed exhibiting on a larger scale from 1964, his theatrical designs receiving a special showing at the Mayakovsky Museum. The works were carefully vetted but the total effect was to create an awareness among the younger public of their country's most recent heritage.

133. André A. Mylnikov: *In Peaceful Fields*, 1950. Oil on canvas. Moscow, Tretyakov Gallery.

The results were not altogether what might have been expected. On the part of the academic artists there was a turning away from the public and the monumental to the sentimental and naïve, as in *The Storm* (1975) of A. Mylnikov (b.1919), a watered-down version of Somov, or *The Market at Nukha* (1967) by T. Narimanbekov (b.1930) which seems to aim at a primitive quality. In such works the emphasis is on the 'poetic' aspect of Socialist Realism rather than its application to 'concrete reality' (Plate 133). This tendency for painters to investigate the personal and private, the whimsical and the naïve, seems to be marked throughout Europe; and clearly the Soviet Union is not isolated in this respect.[5]

On the other hand, there came into being a number of artistic groups whose work and attitude aroused violent opposition among the Academicians and members of the Artists' Union to which, in fact, several of the artists involved also belonged. These artists, N. Andronov, B. Birger, V. Weisberg, the brothers P. and M. Nikonov, M. Ivanov, M. Mordovin and N. Egorshina, most of them holding academic posts, and calling themselves the Group of Eight (in actuality the numbers varied) held three

exhibitions, the last in May 1966. They had no clear programme and their major aim seem to have been to hold exhibitions outside the control of the Union; their work seemed to take up trends of the 1920s and 30s both in Russia and France and to use them in a decorative manner. While remaining members of the Artists' Union they sought to blur the edges between what was and what was not accepted officially in painting.[6]

It seems that the authorities are prepared to allow considerable freedom to non-official (and other) artists who wish to work in abstract styles provided the results do not carry a political message – and are not publicized. In Leningrad for a short time there existed a group known as Petersburg which adopted an artistic credo called Metaphysical Synthesis as the basis for its work. There were two other groupings, both concerned with kinetic work: Dvizhenie founded by Lev Nusberg, Francisco Infante, Galina Bitt and Krivchikov with others in 1962, and ARGO (Avtorskaya rabochaya gruppa), begun in 1967 as a breakaway movement headed by Infante. Lev Nusberg (b.1937, now living in Paris), a graduate of the Moscow Regional College of Fine Art, who worked in a film studio and with various publishing houses, followed in the steps of Gabo by experimenting with constructions of a kinetic nature which he was allowed to exhibit in the Soviet Union

and outside, notably in Czechoslovakia, Yugoslavia and Italy. Between 1963 and 1974 (he emigrated in 1976), he was represented in some twenty-five exhibitions. Nusberg collected around him a group of ardent young artists who have widened the range of their work to include 'graphic boxes' which have been sold in European galleries. Unlike many of the other non-official artists he has practised a rigorous discrimination in his choice of styles. He and his friends, among them Vladimir Akulinin, Vladimir Galkin and Infante, worked in 'hard edge' styles and did not hesitate to use the brightest of primary colours. They attracted a number of commissions within the USSR – for a kinetic wall-structure and ceiling in a stadium in Leningrad, entrance hall decorations for the editorial office of a newspaper intended for young people, and for kinetic ornaments in a coffee-bar on Gorky Street. Nusberg has stressed that his work is not intended to sing the praises of technocracy nor to use effects that might shock people but is primarily emotive in character, appealing to all the senses, so that viewers are brought to a state of mental balance and harmony.

The significance of the success enjoyed by the Nusberg Dvizhenie group is that it seemed to indicate that the Soviet Union was experiencing something of a return to the Constructivist spirit of the twenties in so far as industrial and domestic styles were concerned. The newer architecture, clean, stark and apparently efficient, called for interior fittings and decorations which were equally and uncompromisingly modern. In such settings the pictures of the traditional Socialist Realist school looked uncomfortable, downright shoddy and, sometimes, laughably absurd. New generations have been educated into socialism, are confident as to the future of their country, and scorn the decadence of the West – and such young people, the new Soviet man and woman, no longer need to be educated by continual reference to semi-photographic depictions of early Soviet history. The trim lines of the new blocks of flats, the elegant fittings of the cinemas, congress halls and theatres, and the improved design evident in clothing and domestic furnishings have effected a revolution in taste. Too often the galleries, themselves old-fashioned and badly-lit, have become academic classrooms for the education of the masses in the history of revolutionary attitudes and activities in the USSR; the vital art of Soviet Russia is to be found outside in the streets, public buildings, and scientific and technical innovations and instal-

lations. It was into this world that Nusberg fitted; and despite cold-shouldering by the Union of Artists his work (and that of his group) was recognized by the Ministry of Building and the Ministry of Radiotechnology. Such was the friction within the Dvizhenie group that Francisco Infante (b.1943) left and founded his own group. He too was inspired by the Constructivists but equally, perhaps, by Malevich and his 'planity', and by the traditional Russian interest in space travel and the setting up of new environments in the earth's atmosphere; neon lights, plastics and other aspects of contemporary technology were employed in his constructions.

Life was not so comfortable for painters who wished to work outside the confines of Socialist Realism. It was impossible to find exhibition venues and they were obliged to rely on the generosity and courage of private individuals such as the composer A. Volkonsky, the art historian Ilya Tsirlin, and the pianist Sviatoslav Richter. It is paradoxical that whereas some of these artists, notably Zverev and Rabin, were allowed to send works to Paris and London respectively, their exhibitions were suppressed within Russia itself.[7] In September 1974 they wrote to the Moscow City Council announcing their intention to hold an exhibition of their paintings on a patch of wasteland. They also took care to invite the foreign press. In the event, the authorities literally bull-dozed the exhibition with considerable brutality, arrested four of the exhibiting artists, and earned headlines in the world press which served to increase their reputation for brutal intolerance. A second open-air exhibition was held later in September in the Izmailovsky Forest Park when seventy or more painters took part. This time there was no direct harassment but there was indirect action. Nevertheless, the authorities had become aware of the effect on public opinion abroad and acted with limited tolerance, allowing exhibitions in Leningrad and Moscow in the autumn of 1975, and in May 1976 in Moscow. They have allowed artists to send their work abroad for exhibition and sale, and granted facilities for the collector Aleksandr Glezer to take several hundreds of pictures by the unofficial artists to the West. In other words, officialdom adopts an entirely pragmatic attitude to these painters. However, there are restrictions on those artists who wish to work entirely in a freelance way unsupported by income from a permanent job: the law provides for the prosecution of idle persons and for those not working for the state under sections dealing with parasitism and is not unwilling to

threaten imprisonment. Some of these 'idle persons', particularly those engaged in creative activities, have been sent for a few months to a mental institution and then discharged with a certificate of schizophrenia and a small monthly disability pension. Rather than submit to compulsory military service or undertake regular work in a factory or office – an attitude which the psychiatrists of the Khrushchev and later eras regarded as symptomatic of mental deficiency – artists have preferred the humiliation of a brief period in a mental home and a pension which has subsidized their 'unofficial' painting.

The sensitivity of the Soviet government to the efforts of the non-official painters to hold exhibitions and attract the attention of the world's press is obvious. The attempts by foreign journalists to see the exhibiting activities as a manifestation of political upheaval and dissent probably did more harm than good in the long run, especially since the concern of the artists was not political in immediate intent. Moreover, it gave the artists too strong a sense of their creative merit; and Western art critics, detached from the emotional struggles of the artists inside the Soviet Union, tended to see in their paintings 'little but a succession of pastiches of all the well-known styles of this century, ranging from Cubism to Conceptual art'.[8] Consequently, those who left for the West, often ultimately for Israel or the USA, have rarely maintained the reputations which had gone before them as major artists of the new avant-garde. In the eyes of at least one critic the standard of unofficial art in the Soviet Union today is deplorable. The excuse has been made in the past that artists were obliged to work in isolation with no knowledge of artistic developments in the rest of the world, but this view seems no longer tenable bearing in mind the nature of the exhibitions of foreign painting that have been held in recent years and the numbers of foreign books on show at international book fairs or available for purchase. It should also be remembered that many governments now see the art produced within their countries as a form of propaganda – claiming, for instance, that it is in some way demonstrative of the democratic way of life or of the particular country's distinctive culture – and it must seem odd to many Soviet citizens that there are within their midst artists who wish to free themselves of all national tendencies. Nevertheless, it would be tragic if the mistakes of the 1930s were to be repeated in the Soviet Union today.[9]

Oskar Yakovlevich Rabin (b.1928) furnishes an interesting illustration of the official attitude (Plate 134). He studied for three years at the Riga Academy of Arts and then spent a further year at the Surikov Art Institute in Moscow. For a time he worked on the railways before taking up a post as a commercial artist but from 1967 earned a living by painting alone. He is the founder of the Lianozovo Group. His wife Valentina (b.1924) who creates whimsical illustrations to folk tales comes from a family of painters; her brother Lev Kropivnitsky (1922–79), who exhibited widely abroad, spent nine years in labour camps. Russian critics have described Rabin's work as shallow in imagery and content; and his so-called 'windows' or 'postcards' of European cities painted in thickly encrusted browns, reds and blues of sombre shades are not especially exciting despite such elements as painted *trompe l'œil* labels, stamps, floating letters, and other collage-like features derived from synthetic Cubism. Many of his canvases are of the urban Moscow landscape covered in winter snow. Rabin's paintings have a modest gentleness and sentimental charm which offer a welcome relief from the brashness of official art although it must be said that his work does not differ noticeably from the run of pictures to be seen in exhibitions sponsored by the Union of Artists. Rabin has now left the Soviet Union; but up to the time of his departure he had been represented in over forty exhibitions, mostly abroad but occasionally in his native land, which given the acknowledged censorship and security controls on the part of the government presents a puzzling situation.

Dmitry Plavinsky (b.1937) is among the foremost avant-garde painters, much collected both in the USA and the Soviet Union. Trained at the Moscow Regional Art College both as a painter and as a lithographer, Plavinsky's work in collage, watercolour and acrylic is Expressionist, at times a little like Filonov's crowded pictures; and his heavily encrusted canvases, such as *Muslim Wisdom* (1964), gleaming with a hierarchical, magical quality, belong to a very recognizable style in Western art of the sixties. Whatever paths Plavinsky decides to investigate he will always bring to his work a competence and reassuring confidence. Associated with him are Anatoly Zverev (b.1931), an Expressionist who uses every combination of media, working with his bare hands, dripped paint, palette knife and brushes to embody his emotions, not always with success; Dmitry Krasnopevtsev (b.1925), who works as a commercial artist in the film industry, paints still lifes, sometimes of identifiable objects,

134. Oskar Rabin: *Kingdom of Prilyki*, 1964. Oil on canvas, 27 × 35 cm. London, Sevenarts Ltd

sometimes of wandering lengths of tubular substances, executed with accuracy of shading and exactness of outline in order to produce a near-surrealist effect; and Boris Sveshnikov (b.1927), who spent eight years in Stalin's labour camps; his elongated figures seem to belong to the decorative styles of Art Nouveau.

The artists who gathered around the sculptor Ernst Neizvestny (b.1925), who left for Switzerland in 1976, included Vladimir Yankilevsky (b.1938), whose abstract works show the varied influence of Klee, Léger, and Dubuffet; Ilya Kabakov (b.1933), a member of the Artists' Union Graphic section, who works in varied styles but who seems to have adopted a simple, poster-like style heavily dependent

on thick outlines; Ullo Sooster (1924–70) from Estonia, whose textured canvases feature isolated free shapes, and who was predominantly a Surrealist, possibly influenced by Max Ernst; Boris Zhutovsky (b.1932), who trained at the Moscow Polygraphic Institute and then worked with Ilya Belyutin; and Anatoly Brusilovsky (b.1932) whose Surrealist photomontages and collages have a sinister, dismaying quality.

Many of these painters have now left the Soviet Union; and to their names should be added others such as the primitivist Mikhail Grobman and Vasily Sitnikov (b.1915). They have been divided among themselves and in their attitude to the authorities: for instance, Mikhail Odnovalov, Viktor Shalkin and Aleksandr Tyapushkin are members of the Artists' Union, while Dmitry Plavinsky, Lydia Masterka (b.1927), a much-praised painter, and Vladimir Nemukhin (b.l925), recognized as an artist of outstanding merit, belong to the

linked Union of Graphic Artists and have received a measure of official recognition. Some artists feel more affinity with one city than another. Thus Vladimir V. Sterligov, who died in 1973, a former pupil of Malevich, taught in a small village outside Moscow and counted among his pupils the sculptor Gennady Lakin and the landscapist Gennady Zubkov (b.1941). Other Moscow artists include the Expressionist Aleksei Smirnov (b.1937), Nikolai Vechtomov (b.1923) and Yuri Sobolev (b.1928). Although perhaps swamped by an excess of Surrealist and Expressionist influences as well as Pop art, these Moscow artists show a lively vigour and eager brashness. The Leningrad painters tend to be more concerned with psychological portraiture, religious faith and mysticism. Chief among them are Evgeny Rukhin (1943–1976), whose psychologically penetrating depictions of men and women indicated talent of a high order; Vladimir Ovchinnikov (b.1941), a bitter satirist; and Benyamin Leonov, a painter of dark, amorphous forms. Little contact with the distant republics or even those of the Baltic is now evident; and it seems that much of this painting, not always correctly linked with dissidence, is almost entirely metropolitan.

The lives and thwarted careers of these artists have aroused so much feeling that it is difficult to assess the quality of their work. Nor is it easy to detect the reasons why some are more fortunate than others in having their work selected for international exhibitions, for although their chances may be restricted in their homeland they may be selected for exhibitions abroad. Thus many of them have had works exhibited in France, Czechoslovakia, East Germany, Italy and even Japan. As early as 1966 a large selection of pictures by the non-official artists toured Poland, the catalogue carrying an introduction by the veteran French Communist leader Paul Thorez.[10] It is perhaps necessary to remember the potency of tradition in the Soviet Union, for some of the celebrated artists of the twenties continued teaching and experimenting throughout their careers: for example, Filonov taught informally up to his death in 1941; Malevich left behind him several influential pupils; and in their separate ways Falk, Konchalovsky, Klyun, Tyshler and Altman continued to attract the sympathies of younger artists.

An area of painting which has been little affected by Socialist Realism (at least as Zhdanov proclaimed it), and for which successive Soviet governments can claim a degree of credit by their provision of art schools, museums and other facilities, is that from the far-flung regions of the country. Under the Tsars these regions had been repressed culturally – and often politically – so that artistic creation (other than that of folk art which had its own distinctive values) had been comparatively unknown there. From its first days the Soviet government encouraged artistic expression in these areas. Martiros Sergeevich Saryan took himself off to his native Armenia where he concentrated on bright landscapes depicting the rolling mountains and plains of his homeland. This change from the mysterious scenes exhibited during his days with the Blue Rose had begun before the revolution but was now confirmed. The painter tactfully explained his groups of fruit and vegetables, scenes of harvesting, land-scapes, and portraits of members of the cultural hierarchy as a form of self-denial occasioned by the need to restore the well-being of his native land and to educate and delight his fellow-Armenians; but there are few Soviet art-lovers who are not aware that his retirement from 'Formalist' painting was forced upon him and that despite his patriotism he suffered under Stalinism. This was equally true of Kuznetsov whose mystical work with the Blue Rose seems to have been incidental to his development as a painter of nomadic life, of bright costumes, and the high curving horizons of Turkestan, using an austere style in which tonality counted for more than pure colour; it was the lack of realistic detail which brought down official displeasure on his head.

In the wake of these artists have come many others from the Soviet republics: Semyon Afanasievich Chuikov (b.1902) from Kirghizia; Boris Fedorovich Domashnikov (b.1924) from Bashkir; Edward Kalnins (b.1904) and Janis Osis (b.1926) from Latvia (Plate 135); Richard Gustavovich Uutma (b.1905) from Estonia; Vladimir Nikolaevich Kostetsky (b.1905), Viktor Vasilievich Shatalin (b.1926) and Tatiana Nilovna Yablonskaya (b.1917) from the Ukraine; Mikhail Savitsky (b.1922) from Belorussia; and Mikhail Greku (b.1916) from Moldavia. An obvious parallel presents itself with the music of Aram Khachaturian, Shebalin, Eshpai, Kazhlayev, Amirov, Gadzhibekov, Melikov, Taktakishvili, Ivanovs and Kapp whose work has been fostered by performances and recordings. And in a number of ways the distant republics enjoyed a measure of artistic autonomy in all the arts that is not always available nearer to the seat of government.[11]

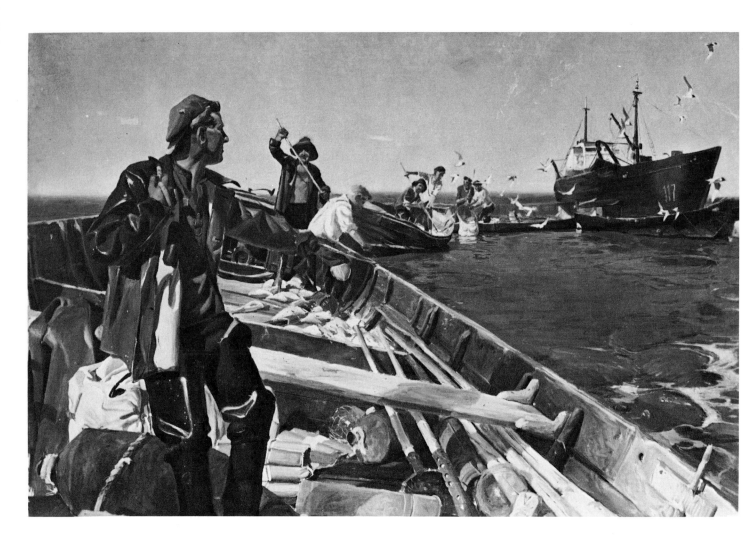

135. Janis Osis, *Latvian Fishermen*, 1951. Oil on canvas, 139.5 × 206.5 cm. Riga, Museum of Latvian and Russian Art

As we have seen several non-conformist artists belonged to the Graphic section of the Union of Artists; and this area has usually escaped the deadening hand of the censors and party ideologists. Graphic work and poster design have preserved a relatively untroubled line of descent from the radical years at the beginning of the century. Favorsky spoke his mind bravely and freely on a number of occasions and refused to change his style. Rodchenko demonstrated an astonishing freedom in his typography and photomontage, as did the older poster artist Dimitri Moor (1883–1946),[12] a freedom which was denied the painters of the same generation. Anatoly Kaplan (1902–80), a Leningrad artist and lithographer, continued to illustrate Jewish tales in an inimitably personal style which has relationships with the earlier, fantastic and more freshly imaginative work of Chagall. Kaplan, who

had to some extent succeeded to the place held by Favorsky, was born in Rgoachev in Belorussia, which connects him with Chagall and Soutine, but moved to Leningrad shortly after the revolution and studied at the Academy of Arts. He was a strong supporter of the Union of Artists. Kaplan's illustrations have many admirers and are eagerly bought by private individuals and museums. Boris Prorokov emerged in the late twenties when his hero was Mayakovsky whose death inspired him to illustrate a volume of his poetry. A fiery but compassionate indignation entered his work during the war years, manifesting itself in the series *This must never happen again* (1954–9), which contained moving episodes dedicated to the massacre of Soviet citizens at Baby-Yar outside Kiev. Bertolt Brecht spoke of Boris Prorokov, a pupil of Moor, as 'That angry artist'.

Book design and illustration and, even more, the poster have long been recognized in Soviet Russia as important art forms. At the very beginning

of the October revolution posters and illustrated song-sheets were distributed to the trenches and the factories from the headquarters of the Russian Telegraph Agency (ROSTA) which displayed political posters in its windows. The theatre also attracted artists of repute; and in no other country in the world are there so many exhibitions of theatrical art.

The sensational events connected with the work of the non-official painters have obscured the fact that qualities of independence and adventurousness are not entirely lacking in some of the younger painters, even those who belong to the Union of Artists. Ilya Glazunov (b.1930) furnishes an interesting example. He is descended from the famous musical family and thus has a background associated with the old intelligentsia. His parents died during the siege of Leningrad and he was reared in the countryside until 1944 when he returned to the city to begin his art studies. After graduating at the Repin Institute of Painting, Sculpture and Architecture, he was allowed to travel abroad and to exhibit in Prague where he won an international award. Stylistically, Glazunov has turned back a page of history since he paints in a style close to that of the old icon painters – a fashionable trend in Russian painting of the mid-sixties – so that his pictures, inclined at times to sentimentality, throw the memory back to Goncharova, Bilibin and Stelletsky who were similarly inspired during their folk art and primitive days. While his large canvases with their evocations of Tsardom, Orthodoxy and peasant life seem to skirt politically troubled areas, the compositions with their emphasis on the flatness of pictorial space and their loose assemblage of subjects represent a new spirit in Russian painting, even if, to Western eyes, of a fairly innocuous order (Col. Plate 16). The young artist Guely Korzhev (b.1925), elected to the Academy of Arts in 1964, was admired for his enormously magnified images painted in intense hues, the absence of half-tones emphasizing their near-photographic quality. Boris Yakovlevich Maluev (b.1929), whose subject-matter and style seem derived in part from Deineka although they have an unmistakably contemporary quality, Vitely Tioulenev (b.1937), whose work has a colourful poetic nature, Pavel Nikonov (b.1930), Tair Salakhov (b.1928), Petr Pavlovich Ossovsky (b.1925), Indulis Zarin (b.1929) and Boris Berzinch (b.1930) have all been praised by the official artistic establishment. Yury Vasiliev (b.1925) was inspired by nuclear physics and space travel to paint geometrical abstracts; and Nikolai Ivanovich Andronov (b.1929) paints landscapes in a non-realistic, semi-primitive style, and has a strong following among the younger generation.

It may well be that those painters who feel themselves in a position of strength because of their acceptance by the establishment will be able to impose 'experimentation in the depiction of reality, and the absorbing of progressive traditions of painting from all countries',[13] whereas the non-official artists have to rely on the influences which reach them haphazardly from the West, work in inadequate premises, and seem unable to investigate a new style with any degree of depth. In fact, the rapid changes of style in the West, the brief movements based solely on fashion, and the growing taste throughout the world for personal depiction of the visible world and the growing revulsion against what is seen as the emptiness of abstract art are factors working against them; and, in consequence, much of their work looks sadly derivative and dated. On the other hand, exhibitions of contemporary Soviet painting tend to resemble the average Royal Academy or Salon exhibition. Nevertheless, there has come about an appreciation of the merits of the boldest achievements of Socialist Realist art.

Open competition with the West in film-making, graphics, theatrical productions, architecture, covers for gramophone records, art books, periodicals, tourist literature, and hotel design and decoration has obliged the government to open the way for young people to study other styles than that associated in the past with Socialist Realism. Youth festivals, major sporting events, international conferences and academic interchanges have brought about an extension of artistic consciousness. Anxious to gain hard currency, the government has come to realize that the painting of the last eighty years is of increasing interest to tourists – and, of course, to Russians – and that it draws crowds and is a potential money-maker. Hence pictures hidden away for years in the basements of the great galleries are being brought out and put on show or loaned to exhibitions abroad; and preparations are in hand for the establishment of a gallery of modern art aided by the generous donations of George Costakis. To date the crowning moment has been the magnificent Paris–Moscow exhibition held at the Pushkin Museum in 1981 when the art between 1900 and 1930 was shown in abundance and with no reservations. Thus the Soviet Union is seeking

less and less to isolate herself from the more positive, humanistic trends of Western European and American art. Yet, it will be tragic if Soviet artists disregard the great national traditions and artistic strengths which they have come to appreciate as their inheritance. Within the terms of Socialist Realism – an important aesthetic doctrine which they will abandon at their peril – her artists know that many styles are possible, and there is no reason why they should feel prevented from personally expressing their attitudes to the world in which they live, within Russian and Soviet tradition and culture.[14]

There has been a slow, almost grudging recognition that the artistic genius of Russia stands level with its triumphs in music and literature. The time is surely much overdue for the realization that this genius has been inherent in the Russian nation from its very beginning, that it did not suddenly come to life at the beginning of this century, and that it was not eclipsed in 1932, that it survived; and that from the tenth century down to the present day, as this account has attempted to establish, it has continued to develop with an astonishing force and fecundity.

Notes

Introduction

1. Tamara Talbot Rice, *Russian Art*, Harmondsworth, 1949, p. 22.
2. L. Uspensky and V. Lossky, *Der Sinn der Ikonen*, Berne, 1952, p. 28, n. 2: 'Considering the great diversity of the situations under which Christian art developed, it is an extreme simplification to derive all Christian painting from the pictures in Egyptian tombs, as is sometimes done: it is correct neither from the point of view of history nor from that of dogma.'
3. Now in the Tretyakov Gallery, Moscow. See: A. Anisimov, *Our Lady of Vladimir*, Prague, 1928.
4. In connection with the decoration of icons there is a cautionary tale told by Samuel Collins, the court physician to Tsar Aleksei Mikhailovich: 'This year a woman, who had decorated her Nikola [St Nicholas] with pearls, and donated him to the church, became destitute. She went to the church and prayed to her Nikola asking him to lend her some of the precious stones, as she had been reduced to such extreme poverty. As the dull fellow did not object, she thought that he had agreed, and was bold enough to take one or two rubies. The pope, who had watched her, denounced her, and the court condemned her to the loss of both her hands, which were cut off three months ago....': S. Collins, *The Present State of Russia*, London, 1671, p. 97.
5. *Krasny ugol* is the customary terminology but the term *krasny kut* is used by K. Kornilovich, *The Arts of Russia, from the Origins to the End of the 16th century*, Geneva, 1967, p. 84.
6. In Russia the best known were the *Siisky Podlinnik* and the *Stroganovsky Podlinnik*.
7. John Stuart argues that it was the art of Suzdal, 'with its striving to attain a lucid transcendental harmony, rather than the belligerent art of Novgorod, that left its mark indelibly on the Russian consciousness'. See: John Stuart, *Ikons*, London, 1975, p. 69.
8. M. V. Alpatov, *Treasures of Russian Art in the 11th–16th centuries*, Leningrad, 1971, pp. 8–9.
9. Alpatov, op.cit., p. 9.

Chapter 1

1. See: J. Carmichael, *A Cultural History of Russia*, London, 1968, p. 37. See also: James H. Billington, *The Icon and the Axe*, London, 1966, p. 13.
2. Quoted in V. Lazarev, *Feofan Grek i ego shkola* (*Theophanes the Greek and his School*), Moscow, 1961, pp. 11–12.
3. *Idem, Andrei Rublev*, Moscow, 1960, p. 19. I. Grabar, 'Ancient Russian Painting', *A Catalogue of Russian Icons*, Metropolitan Museum of Art, New York, 1931, p. xiii, has much the same to say of the colouring used by the icon painters and its relationship with the Russian landscape.
4. V. Lasarev, *Old Russian Murals and Mosaics*, London, 1966, pp. 181–2.
5. Quoted in K. Kornilovich, *The Arts of Russia, from the Origins to the End of the 16th century*, Geneva, 1967, p. 150.
6. See: *EIKON, Mitteilungsblatt der Gesellschaft Freunde der Ikonenkunst*, no. 1, Recklinghausen, 1959, pp. 2 ff., for a summary.
7. Quoted in A. Voyce, *Art and Architecture of Medieval Russia*, Oklahoma U.P., 1967, pp. 224–5.
8. Quoted in K. Kornilovich, op.cit., pp. 166–7.
9. Voyce, op.cit., p. 227, where there are further references.
10. The tendency in Soviet art history is to emphasize the critical and social role of the icon, diminishing its spiritual significance. The importance attached to its realistic elements is, no doubt, an attempt to establish realism as the continuous and unifying quality in Russian painting.
11. Although it must be doubted whether late sixteenth-century icon painting was influenced by the baroque it would seem likely that mannerism made an impact through Ukrainian and Polish Roman Catholicism, especially since these were, in a sense, consciously missionary areas and would disseminate prints and illustrated hagiographical material.
12. Icons are still produced today, both in the Soviet Union and by immigrant painters, but it is difficult to demonstrate anything more than a tenuous link with these early icons.

Chapter 2

1. For a full account of this episode see: Paul of Aleppo, *Travels of the Antioch Patriarch Macarius in Russia 1654–1657*, trans. from the Arabic into Russian, Moscow, 1896–1900. Quoted in Voyce, op.cit., p. 238. See also: N. Andreev, 'Nikon and Avvakum on Icon Painting', *Revue des Etudes Slaves*, xxxviii, 1961, pp. 37–44.
2. *Das Leben des Protopopen Avvakum von ihm selbst niedergeschreiben*, trans. from the Russian by P. Jagoditsch, Berlin and Königsberg, 1930, p. 48. See also: *Avvakum, Archpriest, The Life of, by himself*, trans. Jane Harrison and

Hope Mirrlees, London, 1924.

3. Notably Hans Detterson, who entered Russian service and taught Russian pupils, two of whom, Isaak Abramov and Flor Stepanov, helped with his decorative schemes. Detterson died in 1655 but his place was taken by the Polish Stanislaus Loputski and the Dutch Daniel Vuchters. Little is known of these artists; and undoubtedly there were others who have fallen into obscurity.

4. P. Miliukov, *Outlines of Russian Culture*, ed. Michael Karpovich, Pa., USA, 1948, III, p. 47.

5. It is interesting to note that the decorative quality of the icon was to make an impact on twentieth-century European painting. See: Ya. A. Rusakov, 'Matisse in Russia', *Burlington Magazine*, cxvii, No. 866, May 1975, pp. 284–91.

6. As has already been suggested in connection with the Stroganov school there were influences emanating from Persia and Armenia, most distinctively those of miniature portraits.

7. The frequently reproduced portrait of Yakov Turgenev painted in oils and dated *c*.1700 (Russian Museum, Leningrad), sometimes attributed to Adolsky, is now referred to as being by an anonymous artist.

8. (F. C. Freytag), *Pinselstriche zu einem historisch-philosophischen Gemalde des Menschen und der Menschheit. Aus der russischen Geschichte*, Riga, 1794, pp. 154ff.

9. V. N. Lazarev, 'L'Art de la Russie mediéval et l'Occident', XIIᵉ Congrès International des Sciences Historiques, Moscow, 1970, pp. 52–3.

Chapter 3

1. Carmichael, op.cit., p. 78.

2. Thus the famous remark made by Francesco Algarotti in 1739, after visiting the new city. See: L. Réau, *Saint-Pétersbourg*, Paris, 1913, p. 16, and also *Letters from Count Algarotti to Lord Hervey*, London, 1769.

3. B. Pares, *A History of Russia*, London (1944 ed.), p. 232.

4. In the Royal Collection, Kensington Palace, London.

5. Mikhail Larionov was to base a series of Hairdresser paintings on a popular *lubok* entitled *Barber Cutting Off the Beard of an Old Believer* – the Old Believers insisting on keeping their beards despite Peter's edicts.

6. It was to develop into the Imperial Chancellery concerned with training of Russian artists, recruiting foreign ones, commissioning and buying works of art, care of the Imperial residences, etc.

7. L. Backhuysen (1631–1708); Adam Silo (1674–1757); Adriaen van der Werff (1659–1721); all contemporary with Peter who may have visited their studios.

8. See: F. Dvoräk, *The Great Portraitist*, Prague, 1957.

9. The earliest comment seems to be: W. Weretennikoff, 'Louis Caravaque', *Starye gody*, St Petersburg and Moscow, June 1908, pp. 323–32.

10. See: A. Savinov, *I. Nikitin 1688–1741*, Moscow and Leningrad, 1945; N. Moleva, *Ivan Nikitin*, Moscow, 1972; T. A. Lebedeva, *Ivan Nikitin*, Moscow, 1975. Despite assiduous research the Nikitin brothers remain shadowy figures.

11. See: *Portret petrovskogo vremeni*, Tretyakov Gallery, Moscow, Russian Museum, Leningrad, 1973; *Russian Portrait of the 18th and 19th Centuries in the RSFSR Museums*, Moscow, 1976 (text in Russian and English); and:

12. L. I. Tananaeva, *Sarmatskii Portret*, Moscow, 1979.

13. See: S. N. Kondakov (ed.), *Yubileiny spravochnik imperatorskoy akademii khudozhestva 1764–1914*, St Petersburg, 1914–15, 2 vols; *Russkaya akademicheskaya khudozhestvennaya shkola v XVIII veke*, Moscow and Leningrad, 1937; S. K. Isakov (ed.), *Akademiya khudozhestv*, Moscow and Leningrad, 1940. There is an early account in German: J. Hasselblatt, *Historischer Überblick der Entwicklung der kaiserlichen russischen Akademie der Künste in St Petersburg*, Leipzig and St Petersburg, 1886.

13. See: T. Ilina, *I. Ya. Vishnyakov*, Moscow, 1979.

14. See: L. Nikolenko, 'Pietro Rotari in Russia and America', *Connoisseur*, July 1969, Vol. 171, No. 689, pp. 191–6.

15. Count Doria, *Louis Tocqué*, Paris, 1929, has a useful account of the artist's stay in Russia.

16. An excellent and fascinating account of this period which also includes brief details of the minor Russian decorative artists is to be found in: C. Marsden, *Palmyra of the North, The First Days of St Petersburg*, London, 1949. See also: E. Lo Gatto, *Gli artisti italiani in Russia*, Rome, 1934; L. E. Dussieux, *Les Artistes français à l'étranger*, Paris, 1856; E. Venclin, 'L'Art français en Russie', *Réunion des Sociétés des Beaux-Arts des Départements*, Paris, 1894, pp. 363–86; and there is interesting material in T. V. Alekseeva (ed.), *Russkoe iskusstvo XVIII veka*, Moscow, 1968.

17. See: E. I. Gavrilova, 'Novye materiali k tvorcheskoy biografii Georga Fridrikha Shmidta pervogo professora Akademii khudozhestv v S. Peterburgye', *Russkoye iskusstvo XV III–pervoi poloviny XIX veka* (T. V. Alekseeva ed.), Moscow, 1971, pp. 318–43.

18. See: L. Réau, *Correspondance de Falconet avec Cathérine II, 1767–1778*, Paris, 1921; *idem*, 'Correspondance artistique de Grimm avec Cathérine II', *Archives de l'art français*, Paris, xvii, 1932, pp. 1–206; M. Tourneux, *Diderot et Cathérine II*, Paris, 1889; J. Adhémar and J. Seznec, *Diderot: Les Salons*, Oxford, 1957.

19. Quoted in C. Sterling, *Great French Paintings in the Hermitage*, London, 1958, p. 8. Sterling refers to the *Catalogue des tableaux ...*, which was apparently printed in St Petersburg in French. See also V. F. Levinson-Lessing, *The Hermitage: Dutch and Flemish Masters*, London, 1964, for a useful introduction on the acquisitions of the Russian monarchs, and the valuable *Catalogue: English Paintings in the Hermitage Museum*, ed. A. E. Kroll, Leningrad, 1969.

20. See: H. C. Torben, *Cornelius Hoyer*, Copenhagen, 1961 (English summary).

21. There is an article by Arist Pander on Erichsen's stay in Russia in *Samleren*, Copenhagen, 1930, No. 7, pp. 97–110.

22. A choice between baroque and rococo styles (if they were aware of the differences) must have presented equally great difficulties since Russian painters were obliged to follow the examples of the visiting or resident foreign artists. There is a certain aptness in referring to 'Elizabethan rococo' although it seems never to have been that monarch's intention systematically to inaugurate a new style in Russia itself or to break with the baroque manner favoured by her predecessors. In his *La Russie de 1659 à 1689*, Paris, 1957, V. Tapié writes of 'Russian baroque' in the days prior to Peter the Great and of 'the baroque in Russia' for the art after that time. It is possible to claim that at the end of the seventeenth century there was a difference between the more Russian

'Muscovite' or 'Naryshkin' baroque as described by M. Ilyan, 'Problemy moskovskogo barokka', *Institute of Art History*, Moscow, 1957, pp. 324–39, and the central European baroque which found its home in the Ukraine, centred in Kiev, as described by A. Tsapenko, *Ukrainskaya arkhitektura perioda natsionalnogo podema v XVII–XVIII vv*, Moscow, 1963. See also: A. Nekrasov, *Barokko v Rossii*, Moscow, 1926; F. Shmit, 'Barokko kak istoricheskaya kateroriya', *Russkoe iskusstvo XVII veka*, Leningrad, 1929; and T. V. Alekseeva (ed.), *Russkoe iskusstvo barokko* (1977). A. Angyal, *Die Slavische Barockwelt*, Leipzig, 1961, attempts a differentiation between Ukrainian and Polish baroque. The advent of the baroque and rococo styles and their dissemination within Russia have been comparatively neglected by Soviet art scholars who have concentrated on the emergence of national characteristics.

23. See: I. Sakharova, *Aleksei Petrovich Antropov 1716–95*, Leningrad, 1973.

24. See: T. A. Selinova, *Ivan Petrovich Argunov 1729–1802*, Moscow, 1973; and also the critical essay by the same author in *Russkoye iskusstvo XVIII v*, Moscow, 1968, pp. 157–74. For N. I. Argunov see: V. A. Kulakov, *N. I. Argunov*, Moscow, 1975.

25. See: *Russian Portrait of the 18th and 19th centuries in the RSFSR Museums*, Moscow, 1976, pp. 74–92.

26. See: A. Bird, 'Eighteenth-century Russian painters in Western Collections', *Connoisseur*, October 1971, Vol. 178, No. 716, pp. 78–83.

27. See: G. Waagen, *Die Gemaldesammlung in der Kaiserlichen Ermitage zu St Petersburg*, Munich, 1864; and Kroll, op.cit., pp. 22–3.

28. See: K. Kuzminsky, *S. Rokotov: D. Levitsky*, Moscow, 1939; N. Lapshin, *Fedor Stepanovich Rokotov*, Moscow, 1959; and the exhibition catalogue, *Fedor Stepanovich Rokotov and the Painters of his Circle*, Moscow, 1960.

29. The pioneer study of Levitsky was written by the ballet impresario S. P. Diaghilev, *Russkaya zhivopis v XVIII veke: D. G. Levitsky*, St Petersburg, 1902. As his research assistant he employed V. P. Gorlenko (1853–1906) who had previously published articles on Levitsky and Borovikovsky in the journal *Mir iskusstva*. For recent accounts see: N. M. Gershenzon-Chegodaev, *D. G. Levitsky*, Moscow, 1964; N. Moleva, *Levitsky*, Moscow, 1961; and A. M. Skvortsov, *D. G. Levitsky*, Moscow, 1916. There is also the catalogue of the Levitsky exhibition, Moscow, 1922.

30. G. R. Derzhavin (1743–1816), 'Vision of Mourza', quoted in Gershenzon-Chegodaev, op.cit., p. 369; and L. Leger, *Moscou*, Paris, 1904, p. 110.

31. The earliest account of Levitsky that I know of in English art criticism occurs in J. B. Atkinson, *An Art Tour of the Northern Capitals of Europe*, 1873, p. 278, where he states, 'Some surprise was naturally felt when there appeared at the International Exhibition of 1862 that capital portrait of "Glaphyra Ilymof" (date 1776), a full-length figure of a well-dressed lady, gracefully handling her harp. The picture, which in quality I deem to be one of the very best products of the Russian school, was only inferior to Reynolds in colour and felicity of touch.'

32. It is difficult to see how the essentially painterly style of Gainsborough's portraits could ever have been conveyed in prints of any kind. Levitsky seems to have had a photographic memory so that he could quickly and easily grasp the elements of another artist's style.

33. Presented by Diderot's heirs to the Museum of Art and History, Geneva, where it is still preserved. As far as I know the only other works by Levitsky outside Russia are those in the French National Collection; the National Collection, Malta; and the Labzin portrait in the collection of André Harley, New York, USA.

34. See: N. Mashkovets, *V. Borovikovsky*, Moscow, 1950; A. J. Arkhangelskaya, *Borovikovsky*, Moscow, 1946; and T. V. Alekseeva, *Vladimir Lukich Borovikovsky i russkaya cultura na rubezhe 1890–1990 vekov*, Moscow, 1975.

35. Quoted in S. Lifar, *Diaghilev*, London, 1940, p. 146.

36. See: T. V. Alekseeva, *Issledovaniya i nakhodki*, Moscow, 1976, pp. 36–51, for an interesting account of Firsov.

37. W. F. Reddaway (ed.), *Documents of Catherine the Great*, Cambridge, 1931, p. 163, has a letter from Catherine dated 25 June 1772 to Voltaire in which she rhapsodizes on her love of the English style of garden design.

38. See: A. Fedorov-Davydov, *Russkii peizazh XVIII–nachala XIX veka*, Moscow, 1953.

39. Comparatively little is known of these and other decorative artists: Giuseppe Barozzi (d.1780), Serafino Barozzi (d.1810), Pietro Gonzaga (1751–1831), Paolo Gonzaga (d.1770), Pietro Gradizzi (working *c*.1770), Francesco Gradizzi (1729–93), Bartolomeo Tarsia (d.1765), Antonio Perezinotti (1708–78).

40. See: I. M. Glozman, 'K istorii russkogo naturmorta', *Russkoe iskusstvo XVIII*, Moscow, 1968, pp. 53–71.

41. Quoted in R. Hare, *The Art and Artists of Russia*, London, 1965, p. 117.

42. As far as I know the first Russian artist to find work in Europe was Fedor Ivanovich (*c*.1763–1832), who in the 1790s belonged to the circle of neo-classical artists in Rome. Between 1799 and 1805 he worked for Lord Elgin both in Greece and in England, before taking up the position of court painter in Karlsruhe, Germany. See: K. Obser, *Ekkhart – Jahrbuch für das Badner Land*, 1930; E. M. Velte, *Feodor Ivanovich* (thesis), Karlsruhe, 1974; and A. Bird, 'Feodor Ivanovich: Lord Elgin's Kalmuk', *Apollo*, Jan. 1975, pp. 36–43.

Chapter 4

1. The St Petersburg Society for the Encouragement of the Arts was founded in 1820 to assist artists whom it expected to make copies of the great Italian masters, for ultimate distribution to its patrons and subscribers. Nevertheless, its bursaries were especially helpful to the more independent students. See: P. N. Stolpyansky, *Stary Peterburg i obshchestvo pooshchreniy khudozhvestv*, Leningrad, 1928.

2. See: T. Alekseeva, 'A. R. Tomilov: Mysli po zhivopisi', *Issledovaniya i nakhodki*, Moscow, 1976, pp. 105–25.

3. See: A. Bird, 'A Painter of the Russian Aristocracy', *Country Life*, 6 Jan. 1977, pp. 32–3.

4. Lawrence's portrait of Alexander I was much copied in Russia and is to be found in numerous variants. Dawe's gallery of Napoleonic War portraits is, of course, a striking feature of the Winter Palace, Leningrad. Dawe had two Russian assistants: Alexander Poliakov (1801–35) and Wilhelm Golike (d.1848). See: V. Glinka and A. Pomarnatsky, *The Military Gallery of the Winter Palace*, Leningrad, 1974.

5. Sir Robert Ker Porter (1777–1842) was the subject of an exhibition at the British Library, London, in 1977. See also: E. P. Renne, 'Robert Ker Porter in Russia', *Trud*, Hermitage Museum, Leningrad, 1985, pp. 105–9.

6. There were brief visits by other British artists. For instance, the sculptor Thomas Banks (1735–1805) accompanied his *Cupid* to St Petersburg in 1781 after its purchase by Catherine II and only returned to Britain in the following year.

7. For representative examples by these artists see the catalogue *Great Britain–U.S.S.R., An Historical Exhibition*, Victoria and Albert Museum, London, 1967. See also: A. Bird, 'British Artists in Russia', *Anglo-Soviet Journal*, Dec. 1974, Vol. XXXV, Nos. 1 & 2, pp. 17–22.

8. *The Art of Russia 1800–1850*, catalogue of the exhibition organized by the University of Minnesota Gallery, 1978, is the most informative on this period.

9. See: D. Sarabyanov, 'O natsionalnikh osobennostyakh romantizma v russkoi zhivopisi nachala XIX veka', *Sovietskoye iskusstovoznaniye*, Moscow, 1974, pp. 141–63; and also the catalogue *La peinture russe à l'époque romantique*, 1976–7, pp. 9–14.

10. See: M. Rakeva, *Russkaya istoricheskaya zhivopis*, Moscow, 1979.

11. A. Benois, 'Russia', in *A History of Modern Painting*, ed. R. Muther, London, 1896, Vol. III, p. 412. See also the informative article by O. Mikats on the training of young artists by copying in the Hermitage: *Soobshcheniya Gosudarstvennovo Ermitzha*, Leningrad, 1983, XLVIII, pp. 23–6. Rubens, Rembrandt and Van Dyck seem to have been most copied, but Dou, Murillo, Veronese, Titian, Mengs, Velázquez and Maratti were also popular.

12. G. Heard Hamilton, *The Art and Architecture of Russia*, Harmondsworth, 1975, p. 24.

13. Falconet had to intercede with Catherine II on Losenko's behalf before she would patronize him. The artist died hungry, poverty-stricken and literally worn-out by the indifference of the court and the animosity of his fellow-painters. See: L. Réau (ed.), *Correspondance de Falconet avec Catherine II*, p. 137; A. L. Kazanovich, *Anton Losenko i russkoe iskusstvo seredini XVIII stoletiya*, Moscow, 1963.

14. The major work on Russian romanticism is undoubtedly V. S. Turchin, *Epokha romantizma v rossii*, Moscow, 1981.

15. See: E. F. Petinova, *Petr Vasilievich Basin*, Leningrad, 1984.

16. Bryullov also drew a portrait of Scott. See: G. Leontieva, *Karl Bryullov*, Leningrad, 1983, p. 105.

17. Quoted in Leger, op.cit., p. 114.

18. Quoted in Hare, op.cit., p. 180.

19. Martin (1789–1854) had already exhibited a picture on the last day of Pompeii in 1822.

20. See: M. Rakova, *Bryullov, portretist*, Moscow, 1956.

21. Bryullov saw the Lawrence portrait of Pius VII at Windsor in 1847 towards the end of his life.

22. Quoted in Leontieva, op.cit., p. 157.

23. *Pushkin: Poems, Prose and Plays*, ed. A. Yarmolinsky, New York, 1936, pp. 85–6. In Pushkin's unfinished story 'Egyptian Nights' one of the themes proposed for improvisation by the Italian poet is 'l'ultimo giorno di Pompeii'. It is tempting to see in this fascination with the destruction of Pompeii a sense of doom and of the impending downfall of the Russian empire.

24. See: O. Lyaskovskaya, *Karl Bryullov*, Moscow and Leningrad, 1940; and also E. N. Atsarkina, *Karl Pavlovich Bryullov, Zhizn i tvorchestvo*, Moscow and Leningrad, 1963.

25. The article by Nikolai Prozhogin, 'Karl Bryullov's Paintings in Italy', *Soviet Literature*, No. 9, 1981, pp. 159–68, is an interesting reminder of the degree to which Bryullov's paintings have fallen into neglect in Italy. See also: Y. Glushakov and I. Bocharov, *Karl Bryullov*, Moscow, 1984.

26. Miliukov, op.cit., p. 55.

27. See: A. V. Polovtzev, *Fedor Antonovich Bruni*, St Petersburg, 1907; and A. Savinov, 'Fedor Antonovich Bruni', in *Russkoe iskusstvo*, ed. A. Leonov, Moscow, 1954, pp. 471–86. It is impossible to obtain reproductions of Bruni's work. There are a number in *St Isaac's Cathedral, Leningrad*, Leningrad, 1974. See also: A. G. Vereshchagina, *Fedor Antonovich Bruni*, Leningrad, 1984.

28. Quoted in Hare, op.cit., p. 183. See also *Mastera iskusstva ob iskusstve*, ed. A. A. Fedorov-Davydov, Leningrad, 1968, Vol. 6, p. 295. The majority of artists' texts quoted in this history will be found in these most useful and well-edited volumes.

29. When the painting was finally exhibited in St Petersburg in 1858 it was overshadowed by Yvon's *Battle of Kulikovo*, an even larger painting.

30. Quoted in Hare, op.cit., p. 184; see also A. Botkin, *Aleksandr Ivanov, ego zhizn i perepiska*, St Petersburg, 1880, p. 287.

31. Quoted in M. Delines, 'Deux Siècles de peinture russe', *Figaro Illustré*, Paris, Aug. 1911, pp. 13–14.

32. A. Khomiyakov, *Polnoe sobranie sochinenii*, Moscow, 1878 (2nd ed.), Vol. I, p. 695.

33. M. Botkin, op.cit., pp. 409–10.

34. Quoted in M. Gorlin, 'The Interrelationship of Painting and Literature in Russia', *Slavonic and East European Review*, London, Nov. 1946, p. 137.

35. In an obituary notice in *The Bell*. Hare, op.cit., p. 185.

36. See: G. A. Zagyanskaya, *Peizazhi Aleksandra Ivanova*, Leningrad, 1976.

37. An analysis of the relations between Gogol and Ivanov can be found in N. Mashkovtsev, *Gogol v krugu khudozhnikov: ocherki*, Moscow, 1955.

38. Atkinson, op.cit., p. 296.

39. As with many other artists of this period, the religious side of Ivanov's work has been somewhat neglected. The biblical sketches executed in watercolour and gouache with faint pencil outlines have distant affinities with the mystical drawings of Blake and his followers: theirs is a strange and hallucinatory beauty. As part of his scheme of reconciling ancient history and mythology with the Old and New Testaments Ivanov completed 257 drawings. They were published in co-operation with the Russian authorities and the Prussian Archaeological Institute: *Izobrazheniya iz svyashchennoy istorii*, Berlin and St Petersburg, 1879–84. There is also an important essay: M. G. Nekludova, 'Bibleiskie eskizi A. A. Ivanova', *Russkoe iskusstvo xviii–xix veka*, Moscow, 1969, pp. 48–115. Unfortunately these sketches are in a fragile condition and reproduce badly.

40. The major work on Ivanov remains M. Alpatov, *Aleksandr Andreevich Ivanov. Zhizn i tvorchestvo*, Moscow,

1956, 2 vols. An instance of renewed interest in Ivanov and his place in European art is D. Sarabyanov, 'Aleksandr Ivanov i Nazareitsi', *Russkaya zhivopis XII veka sredi evropeiskikh shkol*, Moscow, 1980, pp. 93–106.

41. A useful catalogue of works of this period is *La peinture russe à l'époque romantique*, Galeries Nationales du Grand Palais, Paris, 1976–7.

Chapter 5

1. A. Benois, 'Russia', in *A History of Modern Painting*, ed. R. Muther, London, 1896, Vol. III, pp. 407–53.

2. G. H. Hamilton, *The Art and Architecture of Russia*, Harmondsworth, 1954. Nor does it appear in the second edition, 1975.

3. See: E. Chizhikova, *Vasilii Andreevich Tropinin*, Leningrad, 1971; the exhibition catalogue *V. A. Tropinin i moskovskikh khudozhnikov ego vremeni*, Moscow, 1975; and A. M. Amshinskaya, *Vasilii Andreevich Tropinin, 1776–1857*, Leningrad, 1971. For an earlier work see: N. N. Kovalenskaya, *V. A. Tropinin*, Moscow, 1931. The anecdote comes from M. Delines, *La Galerie Tsvetkoff: deux siècles de peinture russe*, Paris, August 1911, p. 7.

4. There is a poor copy of Kiprensky's portrait of Thorvaldsen (1833) in the Thorvaldsen Museum, Copenhagen. It also possesses a portrait of an Orthodox priest by Kiprensky. On the verso is a study of a nude boy in a style which hardly seems related to the rest of his works. See: A. Hansen, 'Orest Kiprenskij', *Samleren*, Copenhagen, 1938, No. 9, pp. 165–9.

5. There is an extensive literature on Kiprensky much of it related to his apparently revolutionary attitude to authority. Among the most important works are: N. N. Vrangel, *O. A. Kiprensky v chastnykh sobraniyakh*, St Petersburg, 1911; G. Lebedev, *Kiprensky*, Moscow and Leningrad, 1937; E. Atsarkina, *Orest Kiprensky*, Moscow, 1948; V. S. Turchin, *Orest Kiprensky*, Moscow, 1975; I. V. Kisliakova, *Orest Kiprensky, Epokha i geroi*, Moscow, 1977; and D. V. Sarabyanov, *Orest Kiprensky*, Leningrad, 1982, has an excellent selection of illustrations which demonstrate the width and variety of Kiprensky's ability.

6. See: G. G. Pospelov, *Ruskii portretnyi risunok nachala XIX veka*, Moscow, 1967. Sarabyanov sees Kiprensky's portraits drawn in pencil or chalk as a new departure in Russian portraiture, although it is as well to remember the work of Ingres in these mediums.

7. Something of the patriotism and fervour of these war years can be sensed in the caricatures and cartoons of the period. See: T. V. Cherkesova, 'Politicheskaya grafika epokhi otechestvennoy vceny 1812 goda', *Russkoe iskusstvo xviii–pervoi poloviny xix veka*, ed. T. Alekseeva, Moscow, 1971, pp. 11–47; and also J. E. Bowlt, 'Art and Violence: The Russian Caricature in the Early Nineteenth and Early Twentieth Centuries', *20th Century Studies*, Canterbury, England, 1973, No. 13/14, pp. 56–76.

8. Correspondence between Heinitz and Carstens, quoted in N. Pevsner, *Academies of Art Past and Present*, Cambridge, 1940, pp. 196–7.

9. A most interesting account of Kiprensky's sketches for religious, allegorical and historical works is given in T. V. Alekseeva, 'Rannii albom O. A. Kiprenskovo romanticheskovo mirovospriyatiya', *Issledovaniya i nakhodki*,

Moscow, 1976, pp. 52–105.

10. See: E. N. Atsarkina, *Aleksandr Osipovich Orlovsky*, Moscow, 1971; and the exhibition catalogue *Aleksandr Osipovich Orlovsky*, Moscow, 1958.

11. See: A. Federov-Davydov, *Fedor Yakovlevich Alekseev*, Moscow, 1955.

12. An excellent reproduction of this picture is to be found in *Still Life in Russian and Soviet Painting*, ed. I. N. Pruzhan and U. A. Pushkarev, Leningrad, 1970, pp. 13–14.

13. Quoted in Leger, op.cit., pp. 115–16.

14. See: E. N. Atsarkina, *Silvestr Shchedrin 1791–1830*, and *Silvestr Shchedrin: Pisma*, Moscow, 1978.

15. See: Catalogue, *Fedor Aleksandrovich Vasiliev 1850–1873*, Leningrad, 1975.

16. See: E. Ya. Logvinskaya, *Interier v russkoi zhivopisi pervoi polovini xix veka*, Moscow, 1978; K. Mikhailova et al., *Iz istorii realizma v russkoi zhivopisi*, Moscow, 1982; I. Bartenev and V. Batazhkova, *Russii interieur*, Leningrad, 1984.

17. See: E. V. Kuznetsova, *Fedor Petrovich Tolstoi*, Moscow, 1979.

18. See: A. N. Savinov, *I. A. Ermenev*, Leningrad, 1982.

19. See: N. N. Vrangel, *A. G. Venetsianov v chastnykh sobraniyakh*, St Petersburg, 1911; T. Alekseeva, *Khudozhniki shkoly Venetsianov*, Moscow and Leningrad, 1958; and *Venetsianov and his School*, ed. G. Smirnov, Leningrad, 1973.

20. Quoted in Catalogue, *The Art of Russia 1800–1850*, University of Minnesota, 1978, p. 63.

21. Quoted in Niliukov, op.cit., p. 59. See also: A. V. Kornilov (ed.), *Aleksei Gavrilovich Venetsianov: Stati, pisma, sobremennaki o khudozhnike*, Leningrad, 1980, p. 49.

22. Quoted in Hare, op.cit., p. 175. See also Kornilov, op.cit., p. 77.

23. This effect is intensified by the fact that Venetsianov has used pastel, as he does in several of his portraits, increasing the likeness to French eighteenth-century portraiture.

24. See: K. V. Mikhailova, *Grigorii Vasilievich Soroka* (album), Moscow, 1978; and the catalogue *Grigorii Soroka 1823–1864*, ed. K. V. Mikhailova, Leningrad, 1975.

25. See: G. Leontieva, *Pavel Andreevich Fedotov, Osnovnye problemy tvorchestva*, Leningrad and Moscow, 1962; D. V. Sarabyanov, *Fedotov*, Leningrad, 1969; and D. V. Sarabyanov, *P. A. Fedotov i russkaya khudozhestvennaia kultura 40–x godov XIX veka*, Moscow, 1973.

26. Quoted in D. V. Sarabyanov, *Fedotov*, Leningrad, 1969, p. 190.

Chapter 6

1. There is a vast amount of literature on the *peredvizhniki*. See: L. R. Varshavsky, *Peredvizniki*, Moscow, 1937; G. K. Burova, C. I. Gaponova and V. F. Rumyantseva, *Tvorschestvo Peredvizhnik Khudozhvennik Vystavok*, Moscow, 1952–9; and A. Lebedev, *The Itinerants*, Leningrad, 1974. Undoubtedly the most lively and informative account in English is E. Valkenier, *Russian Realist Art*, Ann Arbor, Ardis, 1977.

2. Founded in 1843 as the Moscow School of Painting and Sculpture (later to include architecture) it was distinguished from the very start by its democratic spirit; in exceptional circumstances it allowed the entry of serfs before they had

been enfranchised. It was to be the school of many of the leading painters of the later nineteenth and twentieth centuries. In 1918 it was transformed into the Moscow Svomas. In the 1930s it was renamed the Surikov Institute. In this history it will generally be referred to as the Moscow School.

3. They were competing in the prestigious section devoted to history painting. Had they competed in the despised genre class they could have painted 'The Liberation of the Serfs', a subject which might have been thought to have lain closer to their social consciences. In this case the Academy could not be accused of remoteness from the social questions of the day. See: N. A. Dmitrieva,'Peredvizhniki i impressionisti', *Iz istorii russkovo iskusstva vtoroi poloviny XIX nachala XX veka*, Moscow, 1978, pp. 18–39.

4. V. V. Stasov, *Izbranniye sochineniya*, Moscow, 1952, Vol. II, p. 395.

5. See: N. P. Sobko, *V. G. Perov, ego zhizn i proizvedeniya*, St Petersburg, 1892. O. A. Lyaskovskaya, *V. G. Perov*, Moscow, 1979, demonstrates how ably Perov could use paint.

6. Quoted in V. A. Pritkov, *Lyubimye russkie khudozhniki*, Moscow, 1963, p. 54; see also G. K. Lukomsky, *A History of Modern Russian Painting 1840–1940*, London, 1945, p. 21: 'He found no inspiration in Paris, to which he had been sent, and taking nothing from French painting he returned home. A whole page of history is to be found in this fact.'

7. See: I. N. Kramskoy, *Pisma*, Moscow, 1937, Vol. I, pp. 119–23; and *Russkoe iskusstvo xviii–xix*, ed. N. I. Sokolova, Moscow and Leningrad, 1938, p. 126.

8. See: C. N. Goldstein, *I. N. Kramskoy*, Moscow, 1956.

9. See: A. Leonov, *Maximov*, Moscow, 1951.

10. V. Fiala, *Russian Painting of the 18th and 19th centuries*, Prague, 1955, p.xi.

11. There have been many studies of Repin but the major work remains I. Grabar, *Repin*, Moscow, 1937, 2 vols; and *Repin*, ed. I. Grabar and I. S. Zilbershtein, Moscow and Leningrad, 1948, 2 vols, Moscow, 1969. There is interesting biographical material in F. Parker and S. J. Parker, *Russia on Canvas, Ilya Repin*, Pennsylvania State University, 1980.

12. Vyacheslav Schwartz (1838–69) had already painted several historical works including *Tsar Alexis playing Chess* (1865) and *Ivan the Terrible by the Body of his Son* (1864), thus anticipating Repin's subjects and the *peredvizhniki* move to historical painting. Schwartz was a friend of Perov.

13. Quoted in L. Réau, *L'Art russe*, Paris, 1922, p. 185. Repin's letters have been published: *I. E. Repin: Pisma*, ed. C. A. Nikolaeva, Moscow, 1969, 2 vols. For a brief account in English of Repin's troubled relationships with Mir iskusstva see: Lifar, op.cit., pp. 80–3.

14. For a study of Repin's portraiture see: M. Nemirovskaya, *Portreti I. E. Repina*, Leningrad, 1973. Nemirovskaya deals with Repin's drawings and studies for portraits.

15. See: *Nikolai Nikolaevich Ge*, ed. N. Y. Zograf, Moscow, 1978; N. Y. Zograf, *Nikolai Ge*, Moscow, 1974; and also the catalogue to the comprehensive exhibition of Ge's work held in the Russian Museum, Leningrad, 1970.

16. A. Benois, *The Russian School of Painting*, New York, 1916, p. 138.

17. There is an abundance of material on Surikov whose reputation, although diminished slightly since the hysterical nationalism of the 1930s, is still extremely high. See: S. Gor and V. Petrov, *Surikov*, Moscow, 1933; N. Shchekotov,

Surikov, Moscow, 1944; V. Kemenov, *Istoricheska a zhivopis Surikova*, Moscow, 1963; N. Mashkovtsev, *V. Surikov*, Moscow, 1960.

18. N. A. Radzimovskoy, S. N. Goldshtein, N. A. and Z. A. Radzimovskoy, *Vasilii Ivanovich Surikov*, Leningrad, 1977, p. 232.

19. Before this picture the poet Anna Akhmatova was inspired to write lines on her own probable fate:

> And later as the hearse sinks in the snow at dusk ...
> What mad Surikov will describe my last journey?

Quoted in N. Mandelshtam, *Hope against Hope*, London, 1971, p. 3.

20. Compare Mussorgsky's *Boris Godunov*, 1870, and *Khovanshchina*, 1872; Rimsky-Korsakov's *Sadko*, 1877 onwards, *Maid of Pskov*, 1870–2, *The Tsar's Bride*, 1899; Borodin's *Prince Igor*, published posthumously after 1887; and Serov's *Rogneda*, 1865.

21. See: L. Bespalova, *Apollinarii Mikhailovich Vasnetsov*, Moscow, 1956; N. Morgunov, *V. Vasnetsov*, Moscow and Leningrad, 1941; and also N. Morgunov and N. Morgunov-Rudnitskaya, *V. M. Vasnetsov: zhizn i tvorchestvo*, Moscow, 1962.

22. There is an extensive literature on Nesterov. Among the latest works are A. I. Mikhailov, *M. V. Nesterov*, Moscow, 1958; I. Nikonova, *Mikhail Vasilievich Nesterov*, 1962; and *Iz pisem M. V. Nesterova*, Leningrad, 1968. For a biographical account see: S. N. Durilin, *Nesterov v zhizni i tvorchestvye*, Moscow, 1976.

23. See: F. S. Maltseva, *Aleksei Kondratievich Savrasov*, Moscow, 1977.

24. See: *Ivan Ivanovich Shishkin: Perepiska, Dnevnik, Sevremenniki o khudozhnike*, ed. I. N. Shuvalova, Leningrad, 1978.

25. See: B. Manin, *Kuindzhi*, Moscow, 1976, where there is a full appreciation of the 'luminist' qualities of his painting; see also J. Bowlt, 'A Russian Luminist School?', *Metropolitan Museum Journal*, New York, 1975, Vol. X, pp. 119–29.

26. See: S. V. Kudriyavtseva, *Ilya Ostroukov 1859–1929*, Leningrad, 1982.

27. The late A. A. Fedorov-Davydov, a highly respected art critic and historian, seems to advance the argument that a principal merit of Russian landscape painting towards the end of the century was its employment of human figures so that humanity and the natural landscape are seen as one. See: A. A. Fedorov-Davydov, *Russky peizazh Kontsa xix–nachala xx veka*, Moscow, 1974.

28. Chistyakov has been accorded praise as a teacher which he could hardly have anticipated. See: I. V. Ginsburg, *P. P. Chistyakov i ego pedagogicheskaya sistema*, Moscow and Leningrad, 1940. Although he attracted some fame early in his career with his history painting *Sofiya Vitovtovna* his work is now generally ignored. The reader will note how important a place teachers hold in Russian art and how gladly they seem to embrace their role, at times not without some cost to their careers as creative artists. The Soviet government has always emphasized the importance of this tradition in art, music, dance and other artistic activities.

29. Works such as *Horace reading Satires in the presence of Augustus and Maecenas* demonstrate the extraordinary longevity of the neo-classical school but little enough devotion to the realistic nationalist school.

30. Among the Russian artists who enjoyed high reputations both at home and abroad in the latter half of the century were: Mikhail Aleksandrovich Zichy (1829–1906), Timofei Andreevich Neff (1805–76), Lev Peliksovich Lagorio (1827–1905), Aleksei Petrovich Bogolubov (1824–96), Petr (1821–99) and Ivan (1823–1918) Sokolov, and Fedor Antonovich Moller (1812–74). Moller's work seems to call for reassessment.

31. See: N. Barsamov, *Ivan Konstantinovich Aivazovsky*, Moscow, 1963.

32. Quoted in N. Barsamov, *More v russkoy zhivopisi*, Simferopol, 1959, p. 70. It will be remembered that Turner, another painter enthralled by the sea, was also in the habit of calling upon the poetic muse to furnish verses to accompany his scenes of disaster.

33. See V. V. Vereshchagin, *Exhibition of the Works of Verestchagin*, The American Art Galleries, New York, 1888; A. K. Lebedev, *V. V. Vereshchagin*, Moscow, 1958; A. K. Lebedev, *Vasilii Vasilievich Vereshchagin*, Moscow, 1972; and V. V. Vereshchagin, *Vospominaniya sina khudozhnika*, Leningrad, 1982.

34. V. M. Garshin, *Sochineniya*, Moscow and Leningrad, 1960, pp. 357–8. There is a parallel between Pushkin's poem on Bryullov's *Crucifixion* and the song *Forgotten* by Mussorgsky actually based on a painting by Vereshchagin. Mussorgsky's *Pictures from an Exhibition* (1874) was based on poetic descriptions of ten paintings by his friend Hartmann.

Chapter 7

1. H. Seton-Watson, *The Russian Empire: 1801–1917*, Oxford, 1967, p. 466.

2. N. Berdyaev, *Smysl tvorchestva*, Moscow, 1916, p. 220.

3. *Idem*, *Mirosozertsanie Dostoevskogo*, Prague, 1923, p. 21.

4. J. Bowlt's *Russian Art 1875–1975, A Collection of Essays*, New York, 1976, is ably documented and provides interesting comments and material on a number of issues related to this period.

5. Quoted in Réau, *L'Art Russe*, p. 221.

6. See: C. Paustovsky, *Isaak Levitan*, Moscow and Leningrad, 1961; B. V. Ioganson, *Isaak Ilich Levitan*, Moscow, 1963; A. A. Fedorov-Davydov, *Levitan*, Moscow, 1966.

7. See: V. A. Serov: *Zhizn i tvorchestvo*, ed. I. Grabar, Moscow, 1913; H. Ulyanov, *Vospominaniya o Serove*, Moscow, 1945; I. Zilbershtein and V. Samkov, *Valentin Serov*, Leningrad, 1971, 2 vols.

8. See: S. Yaremich, *Mikhail Aleksandrovich Vrubel: zhizn i tvorchestvo*, Moscow, 1911; *Vrubel. Perepiska. Vospominaniya o khudozhnike*, ed. Y. N. Podkopaeva and E. P. Gomberg-Verzhbinskaya, Leningrad and Moscow, 1963; and the revised version of 1976.

9. Quoted in M. Gorlin, 'The Interrelationship of Painting and Literature in Russia', *Slavonic and East European Review*, London, Nov. 1946, pp. 146–7; the Russian text is to be found in *Vrubel. Perepiska. Vospominaniya o khudozhnike*, ed. Y. N. Podkopaeva, E. P. Gomberg-Verzhbinskaya, Y. V. Novikov and I. N. Karasik, Leningrad, 1976, p. 38.

10. See: V. P. Lapshin, 'M. A. Vrubel na vcerossikskoi vystavke 1896 goda', and also V. S. Turchin, 'Polekhromiya v stankovoi skulpture rubezha vekov', *Iz istorii russkovo iskusstva vtoroi poloviny XIX–nachala XX veka*, Moscow, 1978.

11. Quoted in M. Gorlin, 'The Interrelationship of Painting and Literature in Russia', *Slavonic and East European Review*, London, Nov. 1946, pp. 146–7.

12. J. H. Billington, *The Icon and the Axe*, London, 1966, p. 481; and N. Gabo, *Of Divers Arts*, New York, 1962, pp. 155–6 and p. 167.

13. It seems to me that the pervasive influence of Korovin on painting has been much underestimated, partly, no doubt, because he left revolutionary Russia very early and partly because he was a practitioner and not a theorist. Neither was he a great artist but that is not to decry his innovatory ability. See: K. Korovin, *Zhizn i tvorchestvo. Pisma. Dokumenty. Vospominaniya*, Moscow, 1963; and D. Kogan, *K. Korovin*, Moscow, 1964.

14. See: A. Rusakova, *V. E. Borisov-Musatov*, Moscow and Leningrad, 1966. This monograph has a valuable section referring to the relationships between Musatov and Kandinsky. See also: *Borisov-Musatov*, ed. A. Rusakova, Leningrad, 1975. Musatov's use of colour is discussed in O. Y. Kochik, 'Ob evolutsii svetovoi sistemy V. E. Borisov-Musatova', *Iz istorii russkovo iskusstva vtoroi poloviny XIX–nacha XX veka*, Moscow, 1978.

15. Mir iskusstva is probably the area of Russian painting best known in the West and certainly the most written-about movement; but the reader should be warned that accounts are, as so often the case in matters pertaining to Russian life – cultural life not least – bitterly and apparently irreconcilably opposed. See: N. Sokolova, *Mir iskusstva*, Moscow and Leningrad, 1934; Janet Kennedy, *The 'Mir Iskusstva' Group and Russian Art*, New York, 1977; J. Bowlt, *The Silver Age: Russian Art in the Early Twentieth Century and the 'World of Art' Group*, Newtonville, USA, 1979; and N. Lapshina, *Mir iskusstva*, Moscow, 1979.

16. Diaghilev's sensational life and career have attracted many writers. See: A. Haskell, *Diaghileff. His Artistic and Private Life*, 1935; S. Lifar, *Diaghilev*, 1940; and R. Buckle, *Diaghilev*, 1979. Of major importance is: I. S. Zilbershtein and V. A. Samkov, *Sergei Diaghilev i russkoe iskusstvo*, Moscow, 1982, 2 vols. This contains articles by Diaghilev, letters written by him, interviews, etc., which are otherwise quite unobtainable.

17. Zilbershtein and Samkov, op. cit., Vol. I, pp. 193–4.

18. For a general but useful account of these years see: G. Y. Sternin, *Khudozhestvenniya shizn Rossii nachala xx veka*, Moscow, 1976.

19. See: A. Levinson, *Bakst, the Story of the Artist's Life*, London, 1923; A. Levinson, *The Designs of Leon Bakst for the Sleeping Princess*, London, 1923; A. Alexandre, *L'art décoratif de Léon Bakst*, Paris, 1913; C. Spencer, *Léon Bakst*, London, 1973; I. N. Pruzhan, *Lev Samuilovich Bakst*, Leningrad, 1974; N. Borisova, *Bakst*, Moscow, 1979. There is also the catalogue issued by the Fine Art Society, London, in connection with a commemorative exhibition in 1976.

20. See: M. Etkind, *Aleksandr Nikolaevich Benua, 1870–1960*, Moscow and Leningrad, 1965; and the catalogue issued by Hazlitt, Gooden and Fox, London, with bibliography and introduction by R. Buckle, 1980. See also A. Benois, *Memoirs*, London, 1960–4, 2 vols; Aleksandr Benua, *Vospominaniya*, Moscow, 1980, 2 vols.

21. See: M. Dobuzhinsky, *Vospominaniya*, New York, 1976;

Katalog: M. V. Dubuzhinsky 1875–1975, Tretyakov Gallery, Moscow, 1975.

22. *A. Y. Golovin Vstrechi i vpechatleniya. Pisma. Vospominaniya o Golovine*, Leningrad and Moscow, 1960, gives the best account of Golovin, but a well-illustrated account with English summary is to be found in A. Bassekhes, *Teatr i zhivopis Golovina*, Moscow, 1970. S. Onoufrieva, *Golovin*, Leningrad, 1977, is a useful little book.

23. Roerich is popular in the USSR. There is a small museum in Moscow dedicated to his books and pictures and the works of native art he brought back from his travels; and there is a somewhat similar musuem in New York. See: V. Knysaseva, *N. K. Roerich*, Moscow, 1963.

24. See: S. Ernst, *K. A. Somov*, Petrograd, 1918; and E. V. Zhuravleva, *Somov*, Moscow, 1980. I. Pruzhan, *Konstantin Somov*, Moscow, 1972, supplies a bibliography.

25. See: D. Kogan, *S. Sudeikin*, Moscow, 1974.

26. See: L. Oureklian, *Zhizn i tvorcheski put E. E. Lansere*, Moscow and Leningrad, 1948; O. Podobedova, *E. E. Lansere*, Moscow, 1961; and A. Borovsky, *E. E. Lansere*, Leningrad, 1975.

27. See: M. Etkind, *V. M. Kustodiev*, Leningrad, 1968. Kustodiev's work is very frequently reproduced; much of it seems ideal Christmas card material.

28. See: A. Savinov, *Z. E. Serebriakova*, Leningrad, 1973.

29. A. Benois, *Memoirs*, Vol. II, London, 1964, p. 157.

30. Quoted in Lifar, *Diaghilev*, p. 94.

31. Ibid., p. 71.

32. Among the best works on Russian theatrical design of this period are F. Y. Sirkina, *Russkoe teatralno-dekoratsionnoe iskusstvo vtoroi poloviny xix veka*, Moscow, 1956; M. Pozharskaya, *Russkoe teatralno-dekoratsionnoe iskusstvo*, Moscow, 1970; and M. Davydova, *Ocherki russkogo teatralno-dekoratsionnogo iskusstva*, Moscow, 1974; and *Catalogue: Scenic innovation: Russian Stage Designs 1900–1930 from the Lobanov-Rostovsky Collection*, Mississippi Museum of Art, Jackson, USA, 1982, ed. J. Bowlt.

33. L. Salmina-Haskell, 'Russian Paintings and Drawings in the Ashmolean Musuem, Oxford', *Oxford Slavonic Papers*, N.S., Oxford, 1969, Vol. XI, pp. 6–7.

Chapter 8

1. There are several books which supply a background to this period, among them *Russkaya khudozhestvennaya kultura kontsa XIX–nachala XX veka (1908–1917)*, Moscow, 1980, 4 vols; and D. Sarabyanov, *Russkaya zhivopis kontsa 1900–x–nachala 1910–x godov*, Moscow, 1971, and *Russian Painters of the Early Twentieth Century* (New Trends), Leningrad, 1973 (text in Russian and English).

2. Alexandre Benois has some interesting comments on Prince Tenishev's industrial enterprises in his *Vospominaniya*, Moscow, 1980, Vol. II, pp. 122–3.

3. See: A. P. Botkina, *Pavel Mikhailovich Tretyakov*, Moscow, 1960. *Gosudarstvenniya Tretyakovskaya Galeriya*, ed. Y. K. Korolev, Leningrad, 1981, is a valuable source of information about the Tretyakov family, the atmosphere in which they began collecting, and the formation of the gallery.

4. B. W. Kean, *All the Empty Palaces*, London, 1983, deals with these merchant patrons.

5. However, Shchukin's collection also included works by Burne-Jones, Brangwyn, Whistler, Stevenson and Paterson.

6. The fact that there were exhibitions containing examples of contemporary French art even earlier than the formation of these collections is often ignored. In 1891 Kandinsky was inspired by Monet's *Haystacks* which he saw in a small exhibition of contemporary French painting, part of a trade fair. In 1896 there was an exhibition of French paintings in St Petersburg; see: M. V. Nesterov, *Iz Pisem*, Leningrad, 1968, p. 385.

7. D. V. Sarabyanov, *Russkaya zhivopis XIX veka sredi evropeiskikh shkol*, Moscow, 1980, is a collection of lively essays in which links with European painting in the nineteenth century are singled out for examination.

8. See: N. Pakhomov, *Abramtsevo*, Moscow, 1958; and also: V. Mamontov, *Vospominaniya o russkikh khudozhnikakh*, Moscow, 1950, 2 vols.

9. See: S. K. Makovsky, *Talachkino, L'Art décoratif des ateliers de la Princesse Tenisheva*, St Petersburg, 1906. It could be argued that the influence of Princess Tenisheva on painting was peripheral.

10. M. Osborn, *Leonid Pasternak*, Warsaw, 1932. A son who remained behind in Soviet Russia where his genius as a poet was widely recognized even in the most difficult days of Stalinism was to become famous in the West as Boris Pasternak, author of the novel *Dr Zhivago*. There were exhibitions of his work at the Tretyakov Gallery, Moscow, in 1975 and at the Museum of Modern Art, Oxford, in 1982–3.

11. The first decade of the century is receiving increased attention. D. V. Sarabyanov, *Russian Painters of the Early Twentieth Century (New Trends)*, Leningrad, 1973, gives a list of groupings and exhibitions, while G. Y. Stepnin, *Khudozhestvennaya zhizn rossii nachala xx veka*, Moscow, 1976, gives detailed information for the years 1901–7.

12. O. A. Zhivova, *Filip Andreevich Malyavin 1869–1940*, Moscow, 1967, also demonstrates his gifts as a portraitist.

13. See: A. A. Fedorov-Davydov, *A. A. Rylov*, Moscow, 1959.

14. See: N. Mashkovtsev, *Igor Emmanuilovich Grabar*, Moscow, 1962.

15. See: *Leonard Viktorovich Turzhansky*, exhibition catalogue, Moscow, 1978.

16. See: A. P. Ostroumova-Lebedeva, *Avtobiograficheskie zapiski*, Leningrad, 1935.

17. See: A. G. Romm, *Paul Kuznetsov*, Moscow, 1960; M. Alpatov, *Pavel Kuznetsov*, Moscow, 1968; D. V. Sarabyanov, *Kuznetsov*, Moscow, 1975; and A. Rusakova, *Pavel Kuznetsov*, Leningrad, 1977.

18. See: A. Mikhailov, *S. M. Saryan*, Moscow, 1958; R. Drampyan, *Saryan*, Moscow, 1964; M. Saryan, *Iz moi zhizni*, Moscow, 1971; A. Kamenskizh, *Martiros Sarjan*, Dresden, 1975; and M. Saryan, *Fragments de ma vie*, Moscow, 1976 (in French).

19. See: M. Alpatov and E. Ganst, *Sapunov*, Moscow, 1965.

20. See: J. Bowlt, 'Russian Symbolism and the Blue Rose Movement', *The Slavonic and East European Review*, London, April 1973, Vol. LI, No. 123, pp. 161–81. This essay and other essays on Russian art of the twentieth century are reprinted in John E. Bowlt, *Russian Art 1875–1975: A Collection of Essays*, New York, 1976. The documentation is especially useful.

21. See: M. Etkind, *Mir kak boshaya simfoniya*, Leningrad, 1970.

22. See: N. Molieva and E. Belyutin, *Shkola Ăzbe*, Moscow, 1958.

23. See: C. Weiler, *Alexej Jawlensky*, Cologne, 1959; C. Weiler, *Marianne von Werefkin*, Cologne, 1959; M. W. Werefkin, *Briefe an einem Unbekannten 1901–1905*, Cologne, 1960; and R. Hahl-Koch, *Marianna Werefkin und der russische symbolismus*, Munich, 1967.

24. Kandinsky has been extremely well covered in critical literature. See: W. Grohmann, *Vassily Kandinsky*, London, 1960; P. Weiss, *Kandinsky in Munich – The Formative Jugendstil Years*, Princeton, USA, 1979; and J. Bowlt and Rose-Carol Washton Long, *The Life of Vasilii Kandinsky in Russian Art, A Study on the Spiritual in Art*, Newtonville, USA, 1980.

25. See the accounts in H. K. Rothel, *Modern German Painting*, London, 1957; and idem, Kandinsky, *Das Graphische Werk*, Cologne, 1970, pp. 442–3.

26. For a Russian attempt to disentangle and clarify the status of the various groupings see: V. N. Lobanov, *Khudozhestvenniye grupirovki za poslednye 25 let*, Moscow, 1930.

27. Y. Ovsyannikov, *The Lubok*, Moscow, 1968, and the catalogue *Russkaya Narodnaya Kartinka XVII–XIX vekov*, Russian Museum, Leningrad, 1980, have numerous illustrations of typical examples.

28. Quoted in 'From Easel to Machine', Open University Press, Milton Keynes, 1976, p. 13.

29. Quoted in C. Gray, *The Great Experiment: Russian Art, 1863–1922*, London, 1962; reprinted in smaller format as *The Russian Experiment in Art 1863–1922*, London, 1971, p. 80.

Chapter 9

1. The reader will soon come to realize that between 1900 and 1934 artistic declarations appear to take the place of paintings; and it sometimes seems that art historians and critics are more concerned with manifestos than with works of art. Moreover, readers may occasionally detect an over-reliance on artists' claims and statements which were not, in fact, carried into action with any degree of effectiveness. This attention to the written or spoken word rather than the art work itself tends to mean that even the most minor of artists is the subject of a monograph. No doubt time will perform its usual and invaluable sifting process; but in the meantime these thirty years have received more attention than all the previous centuries of painting. The reader should bear in mind that the aim of this book is to consider painting, not sculpture or constructions or applied art.

2. The exhibition catalogue *Wladimir Baranoff-Rossiné*, Galerie Brusberg, Berlin, 1983, illustrates his move from a striking Post-Impressionist, Seurat-like style to a form of art deco. He left Russia in 1925, was arrested by the Gestapo in Paris in 1943 and died in their hands in 1944.

3. The most famous account of this episode is to be found in B. Livshits, *Polutoraglazy strelets*, Leningrad, 1933; French translation, Lausanne, 1971; English translation, B. Livshits, *The One and a Half-Eyed Archer*, trans. J. Bowlt, Newtonville, USA, 1977. Livshits seems to place the episode in 1912.

4. One of these letters, which is in the Goncharova section of the archives of the Lenin Library, Moscow, was first published by Tatiana Loguine, *Gontcharova et Larionov*, Paris, 1971, pp. 21–3.

5. J. Bowlt, *Russian Art of the Avant-Garde (The Documents of 20th Century Art)*, New York, 1976, pp. 77–8, gives part of Goncharova's impromptu speech. This collection of documents, most of which come from works which are not obtainable outside the libraries of the USSR, is essential for an understanding of the groupings of the first decades of this century and the various declarations of intention, belief and practice.

6. See: W. George, *Larionov*, Paris, 1966; and catalogue *Larionov and Goncharova*, Mayakovsky Museum, Moscow, 1965. A major British showing was *Larionov and Goncharova, Retrospective Exhibition*, Arts Council of Great Britain, London, 1961. The catalogue was prepared by Mary Chamot and Camilla Gray.

7. See: M. Chamot, *Goncharova*, Paris, 1972; catalogue *Goncharova, Pastels, 1900*, Pushkin Museum, Moscow, 1968. There have been numerous exhibitions of works by Larionov and Goncharova but much of their later careers remains unchronicled.

8. See: K. Dreier, *Burliuk*, New York, 1944. Recently there has been a growth of interest in D. Burlyuk within the USA.

9. See: N. Khardzhiev, *Mayakovsky i zhivopis*, Moscow, 1940.

10. The title needs some explanation: in 1910 two French art critics, André Warnod and Roland Dargelès, tied a paintbrush to the tail of a donkey. It was induced to stand with its rear facing a canvas which successive strokes of its tail covered with paint. This was exhibited at the Salon des Indépendants in 1910 as *Sunset on the Adriatic* – and received rhapsodic praise. One wonders whether Khrushchev wasn't making an unrecognized reference when he made his celebrated comment on a painting in an exhibition of advanced art that it looked as if it had been painted by a donkey's tail.

11. None of these artists contributed to the Jack of Diamonds exhibition of 1912, an eclectic gathering at which the Blaue Reiter group was well represented as was the French school with pictures by Derain, Van Dongen, Gleizes, Léger and Picasso, as well as the Cézannists and painters of the Union of Youth including Aleksandra Ekster and Kulbin.

12. M. Larionov, *Luchizm*, Moscow, 1913. The extract is taken from the French translation by R. Loguine and T. Radjine in *Gontcharova et Larionov*, Paris, 1971, p. 31. For detailed comments on this manifesto and on the painting *Glass* see: P. Vergo, 'A Note on the Chronology of Larionov's Early Work', *Burlington Magazine*, July 1972, Vol. CXIV, No. 832, pp. 476–9.

13. A variant of the manifesto appears in *Osliny khvost i mishen*, Moscow, 1913, a collection of articles which was probably intended to rival the Blaue Reiter compilations.

14. The aesthetics of *vsechestvo* ('everythingness') seem to have been the creation of I. M. Zdanevich who apparently delivered a lecture on the subject in November 1913. See: V. Markov, *Russian Futurism*, London, 1969, p. 185. This book is of great value in tracing the links between Russian painting and literature in the period 1900–20.

15. M. Larionov and L. Zdanevich, 'Pochemu my raskrash-

ivaemsya', *Argus*, St Petersburg, Christmas issue, 1913, pp. 114–18.

16. Vahan D. Barooshian, *Russian Cubo-Futurism 1910–1930*, The Hague and Paris, 1976, pp. 67–78, makes a case for Burlyuk as a successful propagator of Futurism.

17. Y. Annenkov, 'Deux destinées accordées', *Gontcharova et Larionov*, Paris, 1971, p. 175. Annenkov wrote criticism under the name of Till.

18. In 1912, under the auspices of the Intimate Theatre, a book was published in honour of Kulbin, giving details of his paintings, etc., as *Kulbin*, St Petersburg, 1912.

19. Headed by Elena Guro, Shkolnik, Matyushin, Spandikov, Bystrenin and Voinov, they seem to have begun meeting as a group in early November 1909.

20. There were several other societies which held exhibitions of avant-garde work, notably The Society of Free Aesthetics inaugurated in 1907.

21. See: A. Grishchenko and N. Lavrsky, *A. Shevchenko*, Moscow, 1919; and catalogue *A. V. Shevchenko*, Moscow, 1966.

22. See: P. Muradov, *Zhivopis Konchalovskogo*, Moscow, 1923; V. Nikolski, *P. P. Konchalovsky*, Moscow, 1936; P. P. Konchalovsky, *Autobiografitcheski ocherk*, Moscow, 1951; P. P. Konchalovsky, *Khudozhestvennoe nasledie*, Moscow, 1964; and R. Neiman, *P. P. Konchalovsky*, Moscow, 1967.

23. See: V. N. Perelman, *Ilya Mashkov*, Moscow, 1957.

24. See: P. P. Falk, *Besedi ob iskusstve. Pisma. Vospominaniya o khudozhnike*, Moscow, 1981; and the catalogue *Robert Falk, Risunki, akvareli guashi*, Moscow, 1979.

25. See: M. Lentulova, *Khudozhnik Aristarkh Lentulov. Vospominaniya*, Moscow, 1969; and the catalogue *A. V. Lentulov*, Moscow, 1968.

26. See: N. Tretyakov, *V. V. Rozhdestvensky*, Moscow, 1956; V. Rozhdestvensky, *Zapiski khudozhnika*, Moscow, 1963; and the catalogue *V. V. Rozhdestvensky*, Moscow, 1978.

27. See: V. Nikolsky, *A. V. Kuprin*, Moscow, 1973; and K. S. Kravchenko, *A. V. Kuprin*, Moscow, 1973.

Chapter 10

1. The literature on Malevich has grown immensely, possibly with a lesser concentration on his actual paintings and works than on his theories and changes of dogmatic stance. In the final account everything must be measured against his works; and fortunately the Stedelijk Museum, Amsterdam, contains over seventy of his pictures although these represent only a limited aspect of his career. The leading authority is, undoubtedly, the Danish art historian Troels Andersen. See: K. S. Malevich, *Essays on Art 1915–1933*, ed. T. Andersen, London, 1969, 2 vols; and the catalogue *Malevich*, ed. T. Andersen, Stedelijk Museum, Amsterdam, 1970. The major Russian work is Larissa A. Zhadova, *Malevich, Suprematism and Revolution in Russian Art 1910–1930*, London, 1982, which is especially informative about Malevich's teaching in Vitebsk 1919–22 and his return to figurative art. Malevich's graphic work is dealt with by D. Karshan, *Malevich: The Graphic Work: 1913–1930, A Print Catalogue Raisonné*, The Israel Museum, Jerusalem, 1975. Charlotte Douglas, *Swans of Other Worlds*, Ann Arbor, Michigan, 1980, traces the development of abstraction in Russia with relation to Malevich. R. C. Williams, *Artists in Revolution*, London,

1978, makes a very convincing case for a theosophical basis to Suprematism.

2. Quoted in Gray, op.cit., pp. 134–5.

3. Quoted in the catalogue *Malevich*, Stedelijk Museum, p. 52.

4. Quoted in G. Vantongerloo, *Reflections*, New York, 1948, p. 32.

5. K. S. Malevich, *Essays on Art 1915–1933*, ed. T. Andersen, London, 1969, Vol. I, p. 19.

6. Quoted in Gray, op.cit., p. 161. The statement does not appear in the catalogue but in Malevich's *Ot kubizma i futurizma k suprematizmu. Novy zhivopisny realizm (From Cubism and Futurism to Suprematism: the new painterly realism)* which was published in Petrograd in December 1915 at the same time as the 0.10 exhibition. A more exact version might read: Artists will acquire the right of absolute creation only when 'we free our art from vulgar ideas and subject-matter and teach our consciousnesses to see everything in nature as the raw material, the shapeless masses from which forms must be made that have nothing in common with nature and not as those objects and forms which are usually described as real.'

7. Quoted in G. Rickey, *Constructivism: Origins and Evolution*, London, 1968, p. 20.

8. Malevich was a prolific writer without any real capacity for expressing himself in words. The incomprehensibility, contradictoriness and clumsiness of much of his writing has been equalled, possibly surpassed, by his uncritical admirers and annotators.

9. The best work available on Tatlin in English is the catalogue compiled by Troels Andersen for the exhibition 'Vladimir Tatlin' held at the Modern Museum, Stockholm, July–Sept, 1968. *Tatlin's Dream, Russian Suprematists and Constructivist Art 1910–1923* is a useful exhibition catalogue produced for the retrospective held in Moscow in 1977. In Hungarian there is L. Zhadova et al., *Tatlin*, Budapest, 1985.

10. Susan Compton, *The World Backwards: Russian Futurist Books 1912–16*, London, 1978, is the pioneer writer on these fragile, scarce publications.

11. Described by the critic S. Isakov, 'K "kontr-relefam" Tatlina', *Novy Zhurnal dlya vsekh*, 1915, No. 12, pp. 46–50.

12. Lev Bruni experimented with three-dimensional reliefs, but soon reverted to watercolours, drawings, and book illustrations. Until his death he was friendly with many leading members of the Soviet intelligentsia. See: V. Rakitin, *Lev Bruni*, Moscow, 1969.

13. See: E. M. Kostina, *Georgii Yakulov*, Moscow, 1979. This well-documented study seems to reveal Yakulov's work as a compound of Persian miniatures and a spiky version of Art Nouveau. His decorations for the Café Pittoresque must have looked old-fashioned even in 1917.

14. Puni was of non-Russian descent and the name is spelt variously as Pugni, Pugny, and de Pougny. In 1920 he and his wife left the Soviet Union for Paris where he further developed an intimate style of painting derived from Bonnard and Vuillard. See: H. Berninger and J. A. Cartier, *Pougny*, Tübingen, West Germany, 1972; and the catalogues *Pougny 1894–1956*, Galérie Charpentier, Paris, 1961–2; *Donation Pougny*, Orangerie des Tuileries, Paris, 1966; and *Pougny*, Haus am Waldsee, Berlin, 1975.

15. The catalogue *0.10* is reproduced in H. Berninger and J. A. Cartier, *Pougny*, Tübingen, West Germany, 1972, pp. 55–9.

16. The catalogue *Künstlerinnen der russischen Avante-garde, 1910–1930*, Galerie Gmurzynska, Cologne, 1980, offers a useful survey to a number of the significant women artists of the period. A number of women artists are listed in the catalogue *The Avant-Garde in Russia 1910–1930: New Perspectives*, Los Angeles, 1980.

17. Little has been written on Udaltsova who certainly had one of the most penetrating minds of the time. There is some material in the pioneering work *Stareishie sovetskie khudozhniki o Srednei Azii i Kavkaze*, Moscow, 1973, actually issued in connection with an exhibition at Vostok.

18. As yet there has not been a monograph devoted to Popova. Two interesting articles are D. V. Sarabyanov, 'The Painting of Liubov Popova', in the catalogue *The Avant-Garde in Russia 1910-1930: New Perspectives*, Los Angeles, 1980, pp. 42–5, and J. Bowlt, 'Liubov Popova, Painter', *Transactions of the Association of Russian-American Scholars in the USA*, New York, 1982, pp. 227–52. Bowlt possibly underplays Popova's revolutionary fervour. The advent to the West of the George Costakis collection has immensely enriched our understanding of Popova's work.

19. See: A. B. Nakov, *Alexandra Exter*, Galerie Jean Chauvelin, Paris, 1972.

20. Some idea of Rozanova's work can be obtained from the illustrations in *Russian Avant-Garde Art, The George Costakis Collection*, ed. Angelica Z. Rudenstine, London, 1981. This volume is invaluable for a study of the period 1910–1930. Costakis himself contributes an enlightening study of collecting within the Soviet Union and also of official attitudes, which are fairly sympathetically presented. The book is enriched by chronological tables compiled by J. Bowlt.

21. Klyun's work is well represented in the George Costakis collection.

22. Rodchenko's brilliant graphic and photographic work reproduces well and his work is familiar in the West. See: *Alexander Rodchenko* catalogue, Museum of Modern Art, Oxford, 1979; G. Karginov, *Rodchenko*, London, 1979; and A. M. Rodchenko, *Statei, Vospominaniya, Avtobiograficheskie zapiski, Pisma*, Moscow, 1982.

23. I. Ehrenburg, *A vse-taki ona vertitsiya*, Berlin, 1922, p. 90.

24. There is no lack of information on this establishment. See: A. Salmon, *L'Art russe moderne*, Paris, 1928, p. 52; and V. V. Kamensky, *Put entuziasta*, Moscow, 1931, which also gives a general view of the period.

25. The period up to 1917 is covered in part by Valentine Marcadé, *Le Renouveau de l'art pictural russe, 1863–1914*, Lausanne, 1971, which is irritatingly constructed but is a mine of items of information which are hard to find elsewhere. For instance, she gives a number of exhibition catalogues and touches on the Jewish contribution to Russian painting.

Chapter 11

1. For an extremely well-documented history of the year 1917 see: V. P. Lapshin, *Khudozhestvennaya zhizn Moskvi i Petrograda v 1917 godi*, Moscow, 1980.

2. S. Fitzpatrick, *The Commissariat of Enlightenment*, Oxford, 1970, although not directly concerned with painting has useful and authoritative background material on this period.

3. Fitzpatrick, op.cit., p. 116.

4. Shterenberg was a painter of very real ability who had studied in Paris at the École des Beaux-Arts and at the Académie Witte. He also exhibited there. He made use of the Cubists' exploitation of displacement and especially of their tilted planes. The catalogue *Shterenberg*, Moscow, 1978, illustrates a selection of his work.

5. Natan Altman was gifted as portraitist, sculptor, and theatrical designer. In his late seventies he carried out designs for a production of *Hamlet* in Kiev. See: *Natan Altman*, catalogue of the exhibition held at the Bakhrushin Theatrical Museum, Moscow, 1978; and M. Etkind, *N. Altman*, Moscow, 1971.

6. There is a useful chapter on Lunacharsky and Proletarian Culture in Williams, op.cit., pp. 23–58.

7. M. V. Matyushin (1861–1934) does not seem to have received any study at length. The catalogue *Die Kunstismen in Russland*, Galerie Gmurzynska, Cologne, 1977, has an essay on Matyushin's spatial system by A. Povelikhina, pp. 27–41.

8. There are illustrations in the catalogue *Art in Revolution*, The Arts Council of Great Britain, 1971, although it is a disappointing compilation with little reference value. I. I. Nikonova and K. G. Glonti, *Agitatsionno Massovoe iskusstvo pervykh let Oktyabrya*, Moscow, 1969, is a basic work on the subject of mass agitation art.

9. Those critics who lament the fact that this tower was never constructed seem oddly unwilling to admit that it was intended to bestride Moscow (or, possibly, Petrograd – Tatlin was never firm on this point), and would have utterly destroyed the visual character of that city. Incidentally, Trotsky ridiculed the entire concept.

10. The title of the exhibition was *X Gosudarstvennaya vvstavka. Bespredmetnoe tvorchestvo i suprematizm*. The majority of the nine artists contributed statements sympathetic to the aims of non-objective or abstract art, but apart from Malevich they tended to emphasize the logical, analytical aspects of their work. *Sovietskoe iskusstvo za 15 let*, ed. I. Matsa, Moscow and Leningrad, 1933, gives these statements and other relevant documents from this period.

11. *Russian Art of the Avant-Garde*, ed. J. Bowlt, New York, 1976, p. 145, gives another translation of this statement. The importance of this book in connection with the artistic credos and manifestos of the avant-garde period cannot be over-emphasized.

12. Quoted in A. Tairov, *O Teatre*, Moscow, 1970, p. 543.

13. Quoted in *Spektakli i gody*, ed. A. Anastasev and E. Peregudova, Moscow, 1969, p. 13.

14. For an exhaustive account of this and earlier productions by Meyerhold see: E. Braun, *Meyerhold on Theatre*, London, 1969.

15. Stage design receives considerable critical attention in the Soviet Union. See: *Khudozhniki Sovetskogo teatra*, ed. N. I. Solokova, V. F. Ryndin and B. I. Volkov, Moscow, 1969, and R. I. Vlasova, *Russkoe teatralno dekoratsionnoe isskustvo nachala XX veka*, Leningrad, 1984.

Chapter 12

1. See: B. Uitz, 'Fifteen Years of Art in the USSR', *International Literature*, No. 4, 1933.
2. Rickey, op.cit., p. 21.
3. Quoted in *V. Mayakovsky v vospominaniyakh sovremennikov*, Moscow, 1963, p. 273.
4. Vera Mikhailovna Ermolaeva had studied at the private school of M. D. Bernstein and L. V. Sherwood in St Petersburg. She visited England, France and Switzerland. In 1918–19 she was one of the organizers of a group of artists called Segodnya (Today), which produced children's books. She taught for three years at Vitebsk and was for a while Rector of the Art Workshops. Her work was shown at the Van Diemen gallery exhibition in Berlin in 1922. She also worked at Ginkhuk and the State Institute for History of Art as well as illustrating children's books. She is believed to have perished in 1937–8, near Karaganda, as a victim of the Stalinist purges. Although close to Malevich for a time she did not use the Suprematist symbols for more than a short period.
5. The manifesto *Bog ne skinut: Iskusstvo, tserkov, fabrika*, Vitebsk, 1922. There are several versions of this document. See: *K. S. Malevich: Essays on Art 1915–1933*, ed. Troels Andersen, London, 1969, Vol. I, pp. 197, 255.
6. This exhibition was aranged by David Shterenberg who had lived in exile before 1917. His friend Lunacharsky appointed him first head of IZO. There has grown up an erroneous idea that this exhibition was arranged by El Lissitzky. Although a variety of work was shown at the Van Diemen gallery it was the Constructivists who had pride of place and thus displayed their new art to the West. Tatlin, Malevich, El Lissitzky, Rodchenko, Archipenko, Kandinsky and Chagall were represented. The public seemed either hostile or indifferent but there can be no doubt that the more alert artists were impressed. See: D. Shterenberg, 'Die kunstlerische Situation in Russland', *Das Kunstblatt*, Potsdam, No. 11, 1922.
7. Zhadova, op.cit., p. 126, believes there was no meeting with Corbusier. Malevich's stay in the West has been documented by Steneberg, *Russische Kunst Berlin 1919–1932*, Berlin, 1369; and H. von Riesen, 'Malewitsch in Berlin', and H. Richter, 'Begegnung in Berlin', in the catalogue *Avant-garde Osteuropa*, Berlin, West Germany, 1967. Less attention has been paid to the fact that Malevich, Popova, Udaltsova, Rozhdestvensky, Matyushin, the Ender family and other members of the avant-garde were among the 97 artists chosen to represent the Soviet Union in Venice in 1924.
8. A. B. Nakov, 'Introduction', catalogue *Liberated Colour and Form: Russian Non-Objective Art 1915–1922*, Edinburgh, 1978, p. 19, presents a very different argument, 'Malevich set aside the limitations of a certain kind of painting in favour of pure thought which, for him – thanks to the experimental character of suprematism – had reached the level of the absolute, dealing with ... universal truths....'
9. There are several essays relating to Malevich and to his background in *Sieg über die Sonne, Aspekte russischer Kunst zu Beginn des 20. Jahrhunderts*, Akademie der Kunste, Berlin, West Germany, 1983.
10. *Vystavka zasluzhennogo deyatelya iskusstv V. E. Tatlina*, Moscow and Leningrad, 1932. The exhibition was primarily devoted to his work on prototypes of the glider *Letatlin*.
11. Malevich's comments appear in a series of articles devoted to aspects of contemporary art. They may well have been lectures in their original form; but the manuscripts have been lost and Malevich recast some sections. See: *Nova generatsiya*, Kharkov, 1929, No. 8, pp. 47–54; and *K. S. Malevich: Essays on Art 1915–1933*, ed. T. Andersen, London, 1969, Vol. II, p. 79.
12. The reader should be warned that there is considerable controversy as to the use of the term 'Constructivist'. Gabo and Pevsner preferred to use 'Constructic', presumably a word of their own creation.
13. By this time Tatlin seems to have renounced his counter-reliefs. See: I. Matsa, 'Constructivism: a historical and artistic appraisal', *Studio International*, London, April 1972, Vol. 183, No. 943, p. 143: According to the minutes of the meeting of the INKHUK Society of 23 March 1922, with Brik in the chair and the secretary Tarabukin recording the proceedings, 'Tatlin with reference to his counter-reliefs stated that they were utterly useless objects which he would no longer make....'
14. It has been said that in the autumn of 1933 the *Letatlin* was tested on a hill in Salkovo, a village near Zvenigorod.
15. There is a photograph of a chair constructed after one of his drawings in the catalogue *V. E. Tatlin*, Moscow, 1977.
16. A. B. Nakov, *Liberated Colour and Form: Russian Non-Objective Art 1915–1922*, Edinburgh, 1978, pp. 18–19, presents the provocative argument that Russian non-objective painting found itself caught, from 1919 onwards, 'in the trap of its own conceptual immaturity'. He considers that 'the short interlude of the "workshop" period (1919–21) was a subterfuge' and that artists such as Rozanova side-stepped 'the fundamental questions' of the painting of the time. Furthermore, 'production in theatre, typography, architecture and design' was a 'subterfuge'.
17. Rodchenko was awarded the Silver Medal at the International Exhibition for his creations.
18. Aleksei Gan (1893–1942) was originally attached to TEO *Narkompros* (Theatre Section of *Narkompros*) from which he was dismissed by Lunacharsky because of his extremism. His *Konstruktivizm*, Tver, 1922, indicated a move from experimental Constructivism to an applied, industrial form. Gan may have died during the Stalinist purges. In addition to his creative work he was an editor of *Sovremennaya arkhitektura* (*Contemporary Architecture*) and *LEF* during the years 1920–8.
19. The literature on El Lissitzky is large, especially bearing in mind his comparatively minor role in the history of art. See: N. Khardzhiev, 'El Lissitzky – konstruktor knigi', *Iskusstvo knigi 1958–1960*, Moscow, 1962, pp. 145–61; H. Richter, *El Lissitzky: Sieg über die Sonne. Zur Kunst des Konstruktivismus*, Cologne, 1958; S. Lissitzky-Küppers, *El Lissitzky: Life, Letters, Texts*, London, 1968; J. Tschichold, *Werke und Aufsatze von El Lissitzky (1890–1941)*, Berlin, West Germany, 1971; catalogue *El Lissitzky*, Galerie Gmurzynska, Cologne, 1976; and catalogue *Lissitzky*, Museum of Modern Art, Oxford, 1977.
20. E. Lissitzky and H. Arp, *Die Kunstismen*, Erlenbach-Zurich, 1925, contains several pronouncements on the involvement of architecture and painting, such as, 'Proun ist die Umsteigestation von Malerei nach Architektur'.
21. Part of the interview given by Gabo to the artist and writer

G. Rickey and quoted in Rickey, op.cit., pp. 23 ff.

22. Rickey, op.cit., p. 23.

23. For details of the *Realist Manifesto* see: *Gabo*, Cambridge, Mass., 1957, p. 151. The title misled the officials of the time who allowed it to be printed when paper and labour were very scarce because it was labelled 'realist'. It was actually a *Constructivist* manifesto; and that term is employed in the text. See also the catalogue *Naum Gabo, Antoine Pevsner*, Museum of Modern Art, New York, 1948; P. Peissi and C. Giedion-Welcker, *Antoine Pevsner*, Neuchâtel, 1961; and A. Pevsner, *A Biographical Sketch of my Brothers, Naum Gabo and Antoine Pevsner*, Amsterdam, 1961.

24. In his 'Introduction' to *Russian Avant-Garde Art: The George Costakis Collection*, London, 1981, p. 21, S. F. Starr writes of Gan's outburst, 'Death to Art!', and the general avant-garde turn towards industrial designs in the years 1922–4, that the 'move, which was defended at the time as the logical result of the inner development of modernism and of its embrace of the Revolution, had the paradoxical effect of leaving the realm of "art" to the conservatives. The Realist majority could now claim to be the sole spokesmen for the traditional values of art, which they did with great effectiveness throughout the last half of the 1920s.' This claim can be disputed but it has a distinct logic. See L. Y. Oginskaya, *Gustav Klucis*, Moscow, 1981.

25. According to A. B. Nakov, op.cit., p. 23, extracts from this treatise were printed in the catalogue of the Circle exhibition held in Kiev in 1914. In 1922 he was invited to teach at the Kiev Institute of Art and died in that city of tuberculosis in 1930.

26. See: Z. V. Fogel, *Vasily Ermilov*, Moscow, 1975.

27. Chekrygin has been somewhat neglected in the West, partly, it is to be supposed, because the metaphysical, mystical nature of his work does not appeal to collectors of the avant-garde and partly because figurative art has been distinctly unfashionable. See: catalogue *V. N. Chekrygin. 1897–1922. Risunki*, Moscow, 1969; and L. Zhegin, 'V. Tchekryguine', and V. Chekrygin, 'De l'ébauche d'une nouvelle étape d'un art paneuropéen', *Art et poésie russes, 1900–1930: Textes Choisis*, Centre Georges Pompidou, Paris, 1979, pp. 192–8. See also: N. Misler, *Pavel Florenskij: Scritti*, Rome, 1983.

28. *Kliment Redko, Dnevniki, Vospominaniya, Stati*, ed. V. I. Kostin, Moscow, 1974, is interesting for the light it throws on this decorative painter and for its informative references to Chekrygin.

29. The Zagorsk monastery (now partially a museum), near Moscow, was built on a hill known as Makovets; the name serves to emphasize the spiritual and other-worldly preoccupations of the group, which held its last exhibition in 1925.

30. V. Markov, *Russian Futurism*, London, 1969, p. 208.

31. Filonov wrote a draft of his theory of analytical art in 1914–15, again in 1923 when it was published as *Deklaratsiya Mirovogo rastsveta* (*Declaration of Universal Flowering*), and included extracts from it under the title 'Ideologiya analiticheskogo iskusstva' in the catalogue to the exhibition of his work which was to have been presented at the Russian Museum, Leningrad, in 1930. The catalogue was printed in 1929 ready for issue but AKhR artists and party ideologists prevented the opening of the exhibition. The *Declaration* is to be found in *Art et poésie russes, 1900–1930: Textes Choisis*, Centre Georges Pompidou, Paris, 1979, pp. 199–204. 'Ideologiya analiticheskogo iskusstva' ('Ideology of Analytical Art') is printed in *Russian Art of the Avant-Garde*, ed. J. Bowlt, New York, 1976, pp. 286–7.

32. The first mention of Filonov in English seems to have been A. Marshak, 'The Art of Russia that Nobody Sees', *Life*, 4 July 1960, pp. 40–50. The very serious repercussions caused by this publication are related by G. Costakis in 'Collecting Art of the Avant-Garde', *Russian Avant-Garde Art, The George Costakis Collection*, London, 1981, pp. 72–3. Filonov's hermit-like character and heroic devotion to his work and his interest in theatrical production, book illustration, poetry and literature in general as well as his links with the outstanding personalities of his age and the efforts he made to maintain a collective school of artists have attracted the attentions of critics and novelists. He appears as Rogov in the novel by O. Matyushin, *Pesn o zhizni*, Leningrad, 1946. The major work on Filonov is J. Križ, *Pavel Nikolaevich Filonov*, Prague, 1966. Also see: catalogue *Pervaia personalnaia vystavka Pavel Filonov 1883–1941*, Novosibirsk, 1967; 'P. N. Filonov', *Sto pamiatnykh dat, khudozhestvennyi spravochnik*, ed. M. Ostrovsky, Moscow, 1973, pp. 13–15; J. Bowlt, 'Pavel Filonov: An Alternative Tradition?', *Art Journal*, New York, Vol. 34, No. 3, 1975, pp. 208–16; 'Pavel Filonov: "The Ideology of Analytic Art and the Principle of Craftedness"', ed. K. Sokolov, *Leonardo*, Boulogne-sur-Seine, 1977, Vol. 10, pp. 227–32.

33. Marcadé, op.cit., pp. 228–32, offers an interesting consideration of Chagall not so much as a synthesis of the Russian and Jewish geniuses but as a purely Jewish painter of Hasidic origin. The complications arising from the traditional Hebraic opposition to visual representation are discussed in E. Szittya, *Soutine et son temps*, Paris, 1955, pp. 13–22. For further works on Chagall see: M. Chagall, *Ma Vie*, Paris, 1931; F. Meyer, *Marc Chagall*, Paris, 1964; and the catalogue *Chagall*, ed. S. Compton, Royal Academy of Arts, London, 1985.

34. The *emigré* painters and writers formed their own circles in Berlin, Paris and New York and issued journals and other publications, among them *Zhar-Ptitsa* (The Fire-bird), Berlin, 1921–6, 14 issues. In connection with Grigoriev and his companions see: L. Réau, 'Un groupe de peintres russes', *Art et Décoration*, Paris, Sept, 1921. On the whole these painters fared badly and several later returned to the Soviet Union.

Chapter 13

1. Quoted in M. Slonim, *Soviet Russian Literature*, Oxford and New York, 1967, p. 34. See also: Fitzpatrick, op.cit., pp. 89–109.

2. For a literary history of this period see: E. J. Brown, *The Proletarian Episode in Russian Literature, 1928–1932*, Columbia, NY, 1953.

3. Anonymous obituary notice in *Soviet Weekly*, 7 Jan. 1965.

4. M. Alpatov, 'The Art of Favorsky', *Vladimir Favorsky*, Moscow, 1967, pp. 10–11. This particular passage is omitted from the same essay (in a different translation) in a popular publication: *Lenin Prize Winners: Soviet Fine Arts*, Moscow, 1970, pp. 120–43.

5. See: A. Chegodayev, *A. A. Deineka*, Moscow, 1959; V.

Sysoev, *Aleksandr Deineka*, Leningrad, 1971; M. N. Yab-
lonskaya, *A. A. Deineka*, Leningrad, 1964; and B. M.
Nikiforov, *A. Deineka*, Moscow, 1934.

6. See: V. Kostin, *OST*, Leningrad, 1976.

7. See: O. Beskin, *Y. Pimenov*, Moscow, 1960; and E.
Loguinova, *Y. Pimenov*, Moscow, 1970.

8. See: catalogue *Aleksandr Labas*, Moscow, 1976; and E. I.
Butorina, *Aleksandr Labas*, Moscow, 1979.

9. See: F. Sirkina, *A. G. Tyshler*, Moscow, 1965; and also
catalogue *Aleksandr Tyshler*, Moscow, 1966.

10. There is an increased interest in the work of this artist. See:
V. Kostin, *K. S. Petrov-Vodkin*, Moscow, 1966; catalogue
Kuzma Petrov-Vodkin 1878–1939, Russian Museum,
Leningrad, 1966; Y. Rusakov, *Petrov-Vodkin*, Leningrad,
1975; Y. Rusakov, *Risunki Petrova-Vodkina*, Moscow,
1978; and V. Kostin, *Petrov-Vodkin*, Leningrad, 1976 (text
in French and Russian).

11. V. Marcadé, op.cit., p. 171.

12. Petrov-Vodkin was the author of several books including
Samarkandiya (1923), *Khlynovsk* (1930), and *Prostranstvo
Evklida* (1932). These books which are of an autobiograph-
ical nature were reissued in 1970.

13. For the work of this excellent artist see: V. Petrov,
Vladimir Vasilievich Lebedev, 1891–1967, Leningrad, 1972.
Lebedev's early books for children are still reprinted; and the
simple designs such as *The Apotheosis of the Worker* for
ROSTA are well known.

14. Something of the liveliness of the early twenties as far as
the non-Futurist and non-Constructivist artists were con-
cerned is conveyed by Y. Annenkov, *Dnevnik moikh vstrekh*,
New York, 1966, 2 vols. Annenkov was a founder-member
of OST.

Chapter 14

1. I. Ehrenburg, *Memoirs 1921–1941*, London, 1963, pp.
423–4.

2. R. C. Williams, *Artists in Revolution*, London, 1978, p.
188.

3. B. Thomson, *The Premature Revolution, Russian Litera-
ture and Society 1917–1946*, London, 1972, takes the op-
posite viewpoint.

4. *Russian Art of the Avant-Garde, Theory and Criticism
1902–1934*, ed. J. Bowlt, New York, 1976, pp. 288–97,
gives the relevant information. Despite frequent statements
to the contrary the ideology of Socialist Realism is far from
precise; and creative artists were quick to seize upon such
freedom for experiment as it offered.

5. Andrei Aleksandrovich Zhdanov was, in his way, a man of
some greatness. More than anyone else he was responsible
for the successful defence of Leningrad during the Nazi siege
when his superhuman efforts helped to maintain the morale
of the citizens.

6. *A Short History of the USSR*, Institute of History, Academy
of Sciences, Moscow, 1965, Pt. 2, pp. 369–70.

7. *Russian Art of the Avant-Garde, Theory and Criticism
1902–1934* ed. J. Bowlt, New York, 1976, p. 266.

8. See: catalogue *Aleksandr Vasilyevich Shevchenko 1883–
1948*, Moscow, 1975.

9. See: *Osmerkin: razmishleniya ob iskusstve. Pisma. Kritika,
Vospominaniya sovremennikov*, ed. A. Y. Nikich, Moscow,
1981.

10. Before the 1914 war Fonvizen was known as Von
Wiesen.

11. I. Ehrenberg, *Memoirs, 1933–1941*, London, 1963,
pp. 81–96.

12. Angelica Z. Rudenstine, 'The George Costakis Collection',
catalogue *Art of the Avant-Garde in Russia: Selections
from the George Costakis Collection*, New York, 1981,
pp. 10–11.

Chapter 15

1. A. Rothstein, *A History of the USSR*, Harmondsworth,
1950, p. 312.

2. See: 'Krushchev on Modern Art', *Encounter*, 1963, April,
Vol. XX, No. 4, pp. 102–3. The report is unsigned, there is
no means of checking its veracity, and good reasons for
suspecting its authenticity. However, for another version see:
I. Golovshtok, 'Unofficial Art in the Soviet Union', *Unofficial
Art from the Soviet Union*, London, 1977, pp. 87–8. On the
other hand Khrushchev liked the modern decorations of the
Palace of the Pioneers on the Lenin Hills and actually
proposed the artists for the Lenin Prize.

3. Useful comments on this period are supplied by A. Werth,
The Krushchev Phase, London, 1961; and S. Schwartz,
Music and Musical Life in Soviet Russia, London, 1972.

4. For instance, a work already mentioned, *Stareishie soviet-
skie khudozhniki o srednei Azii i Kavkaze*, Moscow, 1973,
issued in connection with an exhibition in Vostok of artists
who had painted landscapes of the Central Asian area, is
highly selective, including only artists whose work had been
proscribed or denigrated in earlier times.

5. The articles and illustrations in journals such as *Iskusstvo*
and *Soviet Literature*, to mention only two of the current
publications which deal with art and related topics, are
sufficient proof of the amount of tolerance extended to con-
temporary artists.

6. The 'unofficial' or 'dissident' artists have received a wide
degree of publicity, mainly from American sources. See:
P. Sjeklocha and I. Mead, *Unofficial Art in the Soviet Union*,
University of California Press, 1967; and catalogue *A Survey
of Russian Painting, Fifteenth Century to the Present*, ed.
G. Riabov, Gallery of Modern Art, New York, 1967.

7. The exhibition 'Aspects of Contemporary Soviet Art',
Grosvenor Gallery, London, 1964, in which some of these
'unofficial' artists were represented did not arouse much
enthusiasm on the part of the London critics.

8. M. Scammell, Preface, *Unofficial Art from the Soviet
Union*, London, 1977, p. ix. This compilation presents the
work and views of the 'unofficial' artists with fairness and
balance and objectivity. It also contains valuable information
relating to exhibitions, publications, etc.

9. Some of these artists must reflect with bitterness that the
world's press which followed their activities so avidly during
their careers in the Soviet Union has shown considerably less
interest in them since their departure. It would be tragic if
they faced the same plight as those artists who fled the
revolution and ended their days in poverty such as Korovin,
Paul Mansurov (b. 1896), Larionov and Goncharova who
told the collector G. Costakis that the French 'don't buy
anything'. These artists gave away more paintings than they
ever sold.

10. See: *Wystawa Prac: 16 Plastykow Moskiewskich*, Sopot

and Poznan, 1966.

11. The catalogue *Russian and Soviet Painting*, The Metropolitan Museum of Art, New York, 1977, gives some idea of the state of contemporary painting; as does less directly the catalogue *Moskva: v Russkoi i Sovetskoi zhivopisi*, Tretyakov Gallery, Moscow, 1980.

12. See: K. Y. Kalaminsky, *Moor*, Moscow, 1961.

13. For instance, A. Baigushev, 'New Trends in Art', *Soviet Life*, Oct. 1965, p. 63, writes, 'The literary handling of subject matter is dying out, and the painter is using the full range of his medium to express himself. This is a result of the long and bitter struggle that the Soviet painter has been waging against the pretentious and the overstated.'

14. G. Costakis, a shrewd observer of the art scene in the Soviet Union, has revealed that V. N. Yagodkin, Head of the ideological section of the Moscow Communist Party Committee, was dismissed and punished for his organization of drunken hooligans in the bulldozing affair in 1974. See: *Russian Avant-Garde Art, The George Costakis Collection*, London, 1981, pp. 73–4.

Bibliography

Works referred to in the main body of the text or in the notes have not been listed here unless they are of exceptional interest or have wider value.

A. Histories of Russian painting in Russian

Grabar, I. (ed.), *Istoriya russkogo iskusstva*, Moscow, 1910–15, 6 vols.

Grabar, I., Kemenov, V., and Lazarev, V. (eds.), *Istoriya russkogo iskusstva*, Moscow, 1953–69, 13 vols.

Istoriya russkogo iskusstva, Moscow, 1960.

Mashkovtsev, M. (ed.), *Istoriya russkogo iskusstva*, Moscow, 1957–60, 2 vols.

Russkaya peizazhnaya zhivopis, Moscow, 1962.

Zotov, A. I., and Sopotsinsky, O. I., *Russkoe iskusstvo: Istorichesky ocherk*, Moscow, 1963.

A. Histories of Russian painting in languages other than Russian

Alpatov, M., *Russian Impact on Art*, New York, 1950.

Benois, A., *The Russian School of Painting*, New York, 1916; London, 1919.

Bunt, C., *Russian Art from Scyths to Soviets*, London, 1946.

Chamot, M., *Russian Painting and Sculpture*, London, 1969.

Conway, M., *Art Treasures of Soviet Russia*, London, 1925.

Farbman, M. (ed.), *Masterpieces of Russian Painting*, London, 1930.

Hamilton, G. H., *The Art and Artists of Russia*, London, 1965; 2nd ed. 1977.

Hare, R., *The Art and Artists of Russia*, London, 1965.

Matthey, W. von, *Russische Kunst*, Zurich and Einsiedeln, 1948.

Newmarch, R., *The Russian Arts*, London and New York, 1916.

Réau, L., *L'Art Russe des origines à Pierre le Grand*, Paris, 1921.

Réau, L., *L'Art Russe de Pierre le Grand à nos jours*, Paris, 1922; reprinted as *L'Art Russe*, Paris, 1968, 3 vols.

Rice, T. T., *Russian Art*, London, 1935.

Rice, T. T., *Russian Art*, Harmondsworth, 1949.

Rice, T. T., *A Concise History of Russian Art*, London, 1963.

Rubissov, H., *The Art of Russia*, New York, 1946.

Wulff, O., *Die neurussische Kunst im Rahmen der Kulturentwicklung Russlands von Peter dem Grossen bis zur Revolution*, Augsburg, 1932.

B. Painting pre-1700 in Russian

Alpatov, M., *Andrei Rublev*, Moscow, 1959; English version, Moscow, 1959.

Alpatov, M. (ed.), *Khudozhestvennye pamyatniki moskovskogo kremlya*, Moscow, 1959.

Antonova, V., and Mneva, N., *Katalog drevnerusskoy zhivopisi*, Moscow, 1963, 2 vols.

Kondakov, N., *Russkaya ikona*, Prague, 1928–33, 4 vols.

Kornilovich, K., *Iz letopisi russkogo iskusstva*, Moscow, 1960.

Lazarev, V., *Iskusstvo Novgoroda*, Moscow, 1947, 2 vols.

Lazarev, V., *Andrei Rublev*, Moscow, 1960; English version, Moscow, 1960.

Lazarev, V., *Feofan Grek i ego shkola*, Moscow, 1961.

Likhachev, N. P., *Materialy dlya istorii russkogo ikonopisaniya*, Leipzig and St Petersburg, 1906, 2 vols.

Muratov, P., *Drevne-russkoe ikonopis v sobranii I. S. Ostroukhova*, Moscow, 1914.

Nekrasov, A., *Drevne-russkoe izobrazitelnoe iskusstvo*, Moscow, 1937.

Ovchinnikova, E., *Portret v russkom iskusstve XVII veka*, Moscow, 1955.

Svirin, A., *Drevne-russkaya zhivopis v sobranii gosudarstvennoy Tretyakovskoy galerii*, Moscow, 1958.

Uspensky, A. I., *Tsarskie ikonopistsy i zhivopistsy XVII veka*, Moscow, 1910–16, 4 vols.

Uspensky, A. I., and Uspensky, M. L., *Materialy dlya istorii russkogo ikonogisaniya*, St Petersburg, 1899.

B. Painting pre-1700 in languages other than Russian

Alpatov, M., *Altrussische Ikonenmalerei*, Dresden, 1958.

Alpatov, M., *Treasures of Russian Art in the 11th–16th centuries*, Leningrad, 1971.

Anisimov, A., *Les Anciennes Icones et leur contribution à l'histoire de la peinture russe*, Paris, 1929.

Avinov, A. (ed.), *Russian Icons in the Collection of George H. Hann*, Carnegie Institute, Pittsburgh, 1944.

Evdokimov, P., *L'art de l'icone*, Bruges, 1970.

Gerhard, H. P., *Welt der Ikonen*, Recklinghausen, 1957.

Hackel, A. A., *The Icon*, Freiburg, 1954.

Kjellin, H., *Aschberg Collection of Icons in the National Museum*, Stockholm, 1956.

Kondakov, N., *The Russian Icon* (trans. E. H. Minns), Oxford, 1927. (A summary of his larger work on the subject.)

Kornilovich, K., *The Arts of Russia from the Origins to the End of the 16th century* (trans. J. Hogarth), Geneva, 1967.

Lazarev, V., *Russian Icons*, UNESCO, 1958.

Lazarev, V., *Old Russian Murals and Mosaics* (trans. B. Roniger), London, 1966.

Lazarev, V., and Demus, O., *Early Russian Icons in the USSR*, New York, 1958.

Litchatschow, D., *Die Kultur Russlands wahrend der osteuropaischen Fruhrenaissance vom 14. bis zum Beginn des 15. Jahrhunderts*, Dresden, 1962.

Muratov, P., *L'Ancienne Peinture russe*, Rome and Prague, 1925. (Text of his contribution to Grabar's *Istoriya russkogo iskusstva*, Moscow, 1910–15, Vol. VI, chaps. 1–11.)

Muratov, P., *Les Icones Russes*, Paris, 1927.

Onasch, K., *Ikonen*, Gutersloh, 1961; English translation, New York and Leipzig, 1963.

Rice, D. T., *Russian Icons*, Harmondsworth, 1947.

Rice, T. T., *Russian Icons*, London, 1963.

Schweinfurth, B., *Russian Icons*, Oxford, 1953.

Skrobucha, H., *Von Geist und Gestalt der Ikonen*, Recklinghausen, 1961.

Skrobucha, H., *Die Botschaft der Ikonen*, Recklinghausen, 1962; English translation by M. V. Rerzfeld and R. Gaze published under the title *Icons*, London, 1963.

Uspensky, L., and Lossky, V., *Der Sinn der Ikonen*, Berne, 1952; English translation published under the title *The Meaning of Icons*, Boston, 1952.

Voyce, A., *The Art and Architecture of Medieval Russia*, Oklahoma, 1967.

Weidlé, W., *Les Icones byzantines et russes*, Florence, 1950.

Wulff, O., and Alpatov, M., *Denkmaler der Ikonenmalerei*, Hellerau bei Dresden, 1925.

Zolotnitsky, L., *Trente-cinq primitifs russes*, Paris, 1931.

C. Eighteenth-century painting in Russian

Aptekar, M., *Russkaya istoricheskaya zhivopis*, Moscow, 1939.

Belyavskaya, B., *Rospisi russkogo klassitsizma*, Leningrad and Moscow, 1940.

Gollerbakh, E., *Portretnaya Zhivopis v Rossii xviii veka*, Moscow and Petrograd, 1923.

Kagonovich, A. L., *Anton Losenko i russkoe iskusstva serediny xviii stoletiya*, Moscow, 1963.

Kovalenskaya, N., *Istoriya russkogo iskusstva xviii veka*, Moscow and Leningrad, 1940.

Lebedev, G., *Russkaya zhivopis pervoi poloviny xviii veka*, Leningrad and Moscow, 1938.

Turchin, V. S., *Epokha Romantizma v Rossii*, Moscow, 1981.

Uspensky, A. I., *Slovar khudozhnikov v xviii veka pisavshikh v imperatorskikh dvortsakh*, Moscow, 1913.

Zotov, A. I., *Akademiya khudozhestv*, Moscow, 1960.

C. Eighteenth-century painting in languages other than Russian

Kaganovich, A. L., *Arts of Russia, 17th and 18th centuries* (trans. J. Hogarth), Geneva, 1968.

D. Nineteenth-century painting in Russian

Bulgakov, F. I., *Nashi khudozhniki*, St Petersburg, 1890, 2 vols.

Burova, G. K., Gaponova, O. I., and Rumyantseva, V. F., *Tvarishchestvo peredvizhnykh khudozhestvennyk vystavok*, Moscow, 1952–9, 2 vols.

Fedorov-Davydov, A., *Russki peizazh kontsa xix–nachala xx veka*, Moscow, 1974.

Gomberg-Verzhbinskaia, E., *Peredvizhniki*, Leningrad, 1970.

Isakov, S. K., *Russkaia zhivopis*, Petrograd, 1915.

Moleva, N., and Belyutin, E., *Russkaia khudozhestvennaia shkola pervoi poloviny xix veka*, Moscow, 1963.

Moleva, N., and Belyutin, E., *Russkaia khudozhestvennaia shkola vtoroi poloviny xix–nacha. xx veka*, Moscow, 1967.

Nikolsky, V. A., *Russkaya zhivopis, istorikokriticheskie ocherki*, St Petersburg, 1904.

Rakova, M., *Russkoe iskusstvo pervoi poloviny xix veka*, Moscow, 1975.

Sakharova, E., *V. D. Polenov, E. D. Polenov: Khronika semii khudozhnikov*, Moscow, 1964.

D. Nineteenth-century painting in languages other than Russian

Fiala, V., *Russian Painting of the 18th and 19th centuries*, Prague, 1955.

Lukomsky, G., *History of Modern Russian Painting, 1840–1940*, London, 1945.

Valkenier, E., *Russian Realist Art, the State and Society; the Peredvizhniki and their Tradition*, Ann Arbor, Ardis, 1977.

E. Twentieth-century painting in Russian

Arseneva, Y. (compiler), *Sovetskaya zhivopis 1917–1973*, Moscow, 1976.

Lapshin, V., *Soyuz russikh khudozhnikov*, Leningrad, 1974.

Nikonova, I. I., and Glonti, K. G., *Agitatsionno-massovoe iskusstvo pervykh let Oktyabrya*, Moscow, 1969.

Sarabyanov, D., *Russkaya zhivopis kontsa 1900kh–nachala 1910kh godov*, Moscow, 1971.

Sidorov, A. A., *Russkaya grafika za gody revolyutsii 1917–1922*, Moscow, 1923.

Sokolova, N. E., and Vanslova, V. V. (eds.), *Puti razvitiya russkogo iskusstva kontsa xix nachala xx veka*, Moscow, 1972.

Sopotsinsky, G., *Sovetskoe iskusstvo, 1919–1957*, Moscow, 1957.

Tolstoy, V., *Sovetskaya monumentalnaya zhivopis*, Moscow, 1958.

Zimenko, V. M., *Sovetskaya portretnaya zhivopis*, Moscow, 1951.

Zimenko, V. M., *Sovetskaya istoricheskaya zhivopis*, Moscow, 1970.

E. Twentieth-century painting in languages other than Russian

Abram, T., *On Socialist Realism*, New York, 1960.

Andersen, T., *Moderne Russisk Kunst 1910–1925*, Copenhagen, 1967.

Belloli, C., *Il Contributo russo alle avanguardie plastiche*, Milan, 1964.

Berger, J., *Art and Revolution: Ernst Neivestny and the Role of the Artist in the USSR*, Harmondsworth and London, 1959.

Bowlt, J., *Russian Art of the Avant-Garde: Theory and Criticism 1902–1934*, New York, 1976.

Bridgers, E., *The Arts in the Soviet Union*, Chapel Hill, NC, 1946–7, 2 vols.

Chen, J., *Soviet Art and Artists*, London, 1944.

Freeman, J., Kunitz, J., and Lozowick, L., *Voices of October: Art and Literature in the Soviet Union*, New York, 1930.

Gibellino Krasceninnicowa, M., *L'Arte russa moderna e contemporanea*, Rome, 1960.

Gray, C., *The Great Experiment: Russian Art 1863–1922*, London, 1962; reissued in smaller format as *The Russian Experiment in Art: 1863–1922*, London, 1970.

Guercio, A., *Le Avanguardie russe e sovietiche*, Milan, 1970.

Hamilton, G. H., *Painting and Sculpture in Europe 1880–1940*, Harmondsworth, 1967.

Holme, G. (ed.), *Art in the USSR*, London, 1935.

Johnson, P., and Labedz, L., *Krushchev and the Arts: The Politics of Soviet Culture 1962–1964*, Cambridge, Mass., 1965.

Kemenov, V. S., *Über den objektiven Charakter der Gesetze der realistischen Kunst*, Berlin, 1955.

Langui, E. (ed.), *50 years of Modern Art*, London, 1959.

London, K., *The Seven Soviet Arts*, London, 1937.

Lozowick, L., *Modern Russian Art*, New York, 1925.

Milner, J., *Russian Revolutionary Art*, London, 1979.

Nikiforov, B. M., *Kurzer Abriss der Geschichte der sowejetischen Malerei von 1917 bis 1945*, Dresden, 1953.

Rudenstine, A. Z. (ed.), *Russian Avant-Garde Art: The George Costakis Collection*, London, 1981.

Salmon, A., *L'Art russe moderne*, Paris, 1928.

Sokolova, N. I., Ryndin, V. F., and Volkov, B. I. (eds.), *Khudozhniki Sovetskogo teatra*, Moscow, 1969. (Introductory essay translated and reprinted with illustration in *Art and Artists*, April 1971, pp. 16–19.)

Umanskij, K., *Neue Kunst in Russland 1914-1919*, Potsdam, 1920.

Vaughan, J. C., *Soviet Socialist Realism: Origins and Theory*, London, 1973.

F. Miscellaneous Catalogues

Exhibition of Russian Art, 1 Belgrave Square, London, 1935.

A Commentary and catalogue by Jack Chen to the Exhibition of Russian Painting of the 18th and 19th centuries first held in London, November 1948, Society for Cultural Relations with the USSR, London, 1948.

Russian Painting from the 13th to the 20th Century: An Exhibition of Works by Russian and Soviet Artists, The Arts Council of Great Britain, Royal Academy of Arts, London, 1959.

Kasimir Malevich 1878–1935, Whitechapel Gallery, London, 1959.

A Retrospective Exhibition of Paintings and Designs for the Theatre, Larionov and Goncharova, The Arts Council of Great Britain, London, 1961.

Two Decades of Experiment in Russian Art 1902–1922, Grosvenor Gallery, London, 1962.

Dansk-Russike forbindelser gennem 500 ar, Kunstindustrimuseet, Copenhagen, 1964.

Chefs-d'œuvre de la peinture française dans les musées de l'Ermitage et de Moscou, Bordeaux, 1965.

Vystavki: Sovietskogo izobrazitelnogo iskusstva, Vols 1–, Moscow, 1965–.

Great Britain–USSR, An Historical Exhibition, The Arts Council of Great Britain, Victoria and Albert Museum, London, 1967.

A Survey of Russian Painting, 15th Century to the Present, Gallery of Modern Art, New York, 1967.

Vladimir Tatlin, Modern Museet, Stockholm, 1968.

Niko Pirosmanachvili 1862–1918, Musée des Arts Décoratifs, Paris, 1969.

Art in Revolution, The Arts Council of Great Britain, Hayward Gallery, London, 1971.

Russian Constructivism Revisited, University of Newcastle-upon-Tyne, 1973.

L'URSS et la France: Les grands moments d'une tradition, Grand Palais, Paris, 1974–5.

Landscape Masterpieces from Soviet Museums, Royal Academy of Arts, London, 1975.

The 1920s in Eastern Europe, Galerie Gmurzynska, Cologne, 1975.

Hermitage: Peinture de L'Europe Occidentale, Vol. 1, Leningrad, 1976.

Russian Pioneers: at the Origins of Non-Objective Art, Annely Juda Fine Art, London, 1976.

La peinture russe à l'époque romantique, Grand Palais, Paris, 1976–7.

60 ans de peinture soviétique, Grand Palais, Paris, 1977.

Russian and Soviet Painting, The Metropolitan Museum of Art, New York, 1977.

Anglo-Russian Relations – The Eighteenth Century, University of East Anglia, Norwich, 1977.

Tendenzen der Zwanziger Jahre, Europäische Kunstausstellung, Berlin, 1977.

Constructivism, Council of Europe, Berlin, 1977.

Die Kunstism in Russland 1907-1930, Galerie Gmurzynska, Cologne, 1977.

Réalisme et poésie dans la peinture russe 1850–1905, Grand Palais, Paris, 1978.

Paris–Moscou 1900–1930, Centre Georges Pompidou, Paris, 1979.

Journey into Non-Objectivity, Dallas Museum of Fine Arts, 1980.

The Avant-Garde in Russia 1910–1930, Los Angeles County Museum of Fine Arts, 1980.

Künstlerinnen der russischen Avantgarde, Galerie Gmurzynska, Cologne, 1980.

Painting 18th to Early 20th Century, Russian Museum, Leningrad, 1980.

Moskva–Parizh 1900–1930, State Pushkin Museum, Moscow, 1981.

Hermitage: Peinture de l'Europe Occidentale, Vol. 2, Leningrad, 1981.

Art of the Avant-Garde in Russia. Selections from the George Costakis Collection, Solomon R. Guggenheim Museum, New York, and Academy of Arts, London, 1981–3.

Sieg über die Sonne, Aspekt russischer Kunst zu Beginn des 20. Jahrhunderts, Akademie der Künste, Berlin, 1983.

Gosudarstvennaya Tretyakovskaya Galeriya, katalog zhivopisi xviii–nachala xx veka (do 1917 goda), Moscow, 1984.

G. General histories of culture and thought in Russian

Istoriya kultury drevnei Rossii, Moscow and Leningrad, 1951–2, 2 vols.

G. General histories of culture and thought in languages other than Russian

Billington, J. H., *The Icon and the Axe, an Interpretive History of Russian Culture*, London, 1966.

Carmichael, J., *A Cultural History of Russia*, London, 1968.

Miliukov, P., *Outlines of Russian Culture* (ed. M. Karpovich), Pa., USA, 1948, 3 vols.

Weidlé, W., *Russia Absent and Present*, New York, 1961.

H. Background works in Russian

Alpatov, M. V., *Etudi po vseobshchei istorii iskusstv*, Moscow, 1979.

Botkina, A. P., *Pavel Mikhailovich Tretyakov v zhizni i iskusstve*, Moscow, 1960.

Chernyshevsky, N. G., *Estetika i poeziya*, St Petersburg, 1893.

Chernyshevsky, N. G., *Esteticheskiye otnosheniya iskusstva k deystvitelnosti*, Moscow, 1955.

Efros, A. M., *Mastera Raznikh Epokh*, Moscow, 1979.

Fedorov-Davydov, A. (ed.), *Mastera iskusstva ob iskusstve*, Moscow, 1969, 7 vols.

Kaptereva, G. (ed.), *Laureati Leninskoy Premii: Skulptura i zhivopis*, Moscow, 1961; English version published as *Lenin Prize Winners: Soviet Fine Arts*, Moscow, 1970.

Khazanova, V., *Sovetskaya arkhitektura pervikh let oktyabrya 1917–1925*, Moscow, 1970.

Kopshitser, M., *Savva Mamontov*, Moscow, 1972.

Kovalenskaya, T., *Iskusstvo vtoroi poloviny xix–nachala xx veka*, Moscow, 1970.

Kratky slovar terminov izobrazitelnogo iskusstva, Soviet Academy of Art, Moscow, 1959.

Kratky slovar po estetike, Moscow, 1963.

Krushchev, A. K., *Za tesnuyu svyaz literatury i iskusstva s zhisnyu naroda*, Leningrad, 1957.

Lapshin, V. P., *Soyuz russikh khudozhnikov*, Leningrad, 1974.

Lebedev, A. K., *Iskusstvo v okovakh: kritika noveishikh techenii v sovremennom burzhuasnom izobrazitelnom iskusstve*, Soviet Academy of Art, Moscow, 1962.

Livshits, B., *Polutoraglazy strelets*, Leningrad, 1933. (Trans. and ed. by J. Bowlt, Newtonville, Mass., 1977.)

Mashkovtsev, N. G., *Iz istorii russkoi khudozhestvennoi kulturi*, Moscow, 1982.

Materialy pervogo vsesoyuznogo sezda sovetskikh khudozhnikov, Moscow, 1958.

Naumov, V. F., *Za ideinost literatury i iskusstva*, Moscow, 1963.

Saltykov-Shchedrin, M., *O Literatury i iskusstve*, Moscow, 1959.

Sarabyanov, D. V., *Russkaya zhivopis xix veka sredi evropeiskikh shkol*, Moscow, 1980.

Smirnova, N., *Sovetsky teatr kukol, 1918–1932*, Moscow, 1963.

Stanislavsky, K. S., *Moya zhizn v iskusstve*, Moscow and Leningrad, 1926–31.

Stepun, G., *Khudozhestvennaya zhizn Rossii na rubezhe xix–xx vekov*, Moscow, 1970.

H. Background works in languages other than Russian

Andersen, T. (ed.), *Art et poésie russes, 1900–1930, Textes Choisis*, Centre Georges Pompidou, Paris, 1979.

Baedeker, K., *Russia*, Leipzig, 1914.

Barr, A. H., Jr., *Cubism and Abstract Art*, New York, 1936; 1966.

Carr, E. H., *The Romantic Exiles*, London, 1933.

Carr, E. H., *Michael Bakunin*, London, 1937.

Carrieri, R., *Futurism*, Milan, 1963.

Cross, A. G. (ed.), *Britain and Russia: Contacts and Comparisons, 1700–1800*, Newtonville, Mass., 1979.

Cross, A. G. (ed.), *'By the Banks of the Thames.' Russians in Eighteenth Century Britain*, Newtonville, Mass. (in production).

Cross, A. G. (ed.), *'By the Banks of the Neva.' Britons in Eighteenth Century Russia*, Newtonville, Mass., 1981.

De Luca, *Archivi del Futurismo*, Rome, 1958–62, 2 vols.

El Lissitzky, *Russia: An Architecture for World Revolution*, London, 1970.

Fülop-Miller, R., and Gregor, J., *The Russian Theatre*, Philadelphia, 1930.

Grohmann, W., *Wassily Kandinsky, Life and Work*, London, 1959.

Haumont, E., *La Culture française en Russie 1700–1900*, Paris, 1910.

Honour, H., *Neo-classicism*, Harmondsworth, 1968.

Kean, B. W., *All the Empty Palaces*, London, 1983.

Larivière, C., *La France et la Russie au 18e. siècle*, Paris, 1909.

Lodder, Christina, *Russian Constructivism*, London, 1983.

Lo Gatto, E., *Gli artisti italiani in Russia*, Rome, 1934.

Lo Gatto, E., *Storia del teatro russo*, Florence, 1952.

Long, R.-C., *Kandinsky: The Development of an Abstract Style*, Oxford, 1980.

Long, R.-C., and Bowlt, J., *Vasili Kandinsky: On the Spiritual in Art*, 2nd ed., Newtonville, Mass., 1984.

Lukomsky, G., *St Petersburg*, Munich, 1923.

Lukomsky, G., *Zarskoye Selo*, Munich, 1923.

Markov, V., *Russian Futurism*, Los Angeles, 1968.

Milner, J., *Tatlin and the Russian Avant-Garde*, New Haven, 1983.

Mohrenschildt, D., *Russia in the Intellectual Life of Eighteenth-century France*, New York, 1936.

Murray, J., *Handbook to Russia, Poland and Finland*, 4th ed., London, 1888.

Nochlin, L., *Realism*, Harmondsworth, 1971.

Pares, B., *A History of Russia*, London (1944 ed.).

Piper, R. (ed.), *The Russian Intelligentsia*, New York, 1961.

Réau, L., *Histoire de l'expansion de l'art français moderne: le monde slave et l'orient*, Paris, 1924.

Réau, L., *Pierre le Grand*, Paris, 1960.

Réau, L., and Lukomsky, G., *Catherine la Grande, inspiratrice d'art et mécène*, Paris, 1930.

Seton-Watson, H., *The Russian Empire: 1801–1917*, Oxford, 1967.

Slonim, M., *Russian Theatre from the Empire to the Soviets*, Riverside, NJ, 1961.

Sumner, B., *A Survey of Russian History*, London, 1944.

Werth, A., *Musical Uproar in Moscow*, London, 1949.

Williams, R., *Russian Art and American Money, 1900–1940*, Harvard, Cambridge, Mass., 1980.

Woroszylski, W., *The Life of Mayakovsky*, London, 1972.

Index